ART NOUVEAU

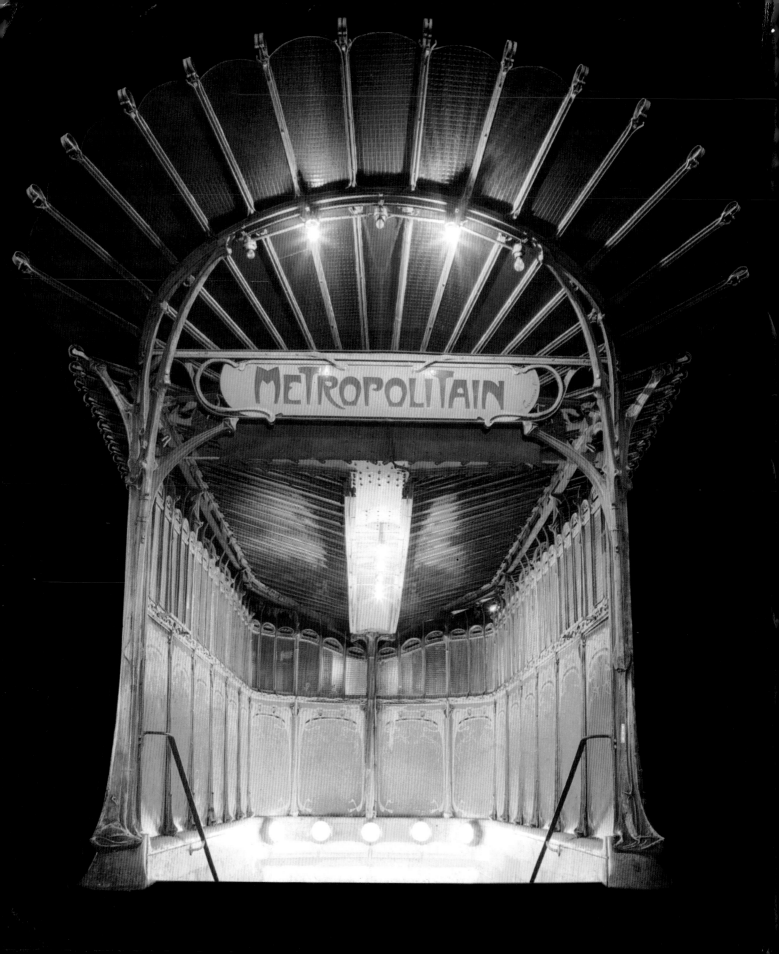

Gabriele Fahr-Becker

ART NOUVEAU

h.f.ullmann

Notes
Where the location of a pictured object is not given, it is either in private ownership or in a colllection not named.
Accents on Catalan proper names in the chapter "Barcelona" follow guidelines laid down by the Casa-Museu Gaudi, Barcelona.
Cover illustration: Hector Guimarch Plate, 1909
Endpaper: Antoni Gaudí i Cornet, Casa Mila, Barcelona 1906-10
III. p. 2: Hector Guimard, Metro-Station "Porte Dauphine," Paris, 1900-01
III. p. 3: Josef Hoffmann, frame for a poem by Rainer Maria Rilke, in Ver Sacrum, I, Heft 9, 1989 (reproduced in original size)
III. p. 380: Carine Cadby, Shirley Poppies, 1901, Photograph, 27.8 x 19.9 cm, The Royal Photography Society, Bath

For Philipp and Sittig

© 2004/7 Tandem Verlag GmbH
h.f.ullmann is an imprint of Tandem Verlag GmbH

Editing: Christine Westphal
Design: Peter Feierabend
Layout: Peter Feierabend, Sanna Salber
Assistant: Sonja Latsch
Appendix: Regine Ermert

Original title: Jugendstil
ISBN 978-3-8331-1042-9 (German edition)

© 2007 for this English edition: Tandem Verlag GmbH
h.f.ullmann is an imprint of Tandem Verlag GmbH
Special edition

Translation from the German: Paul Aston, Ruth Chitty, Karen Williams
Copy-editing of
the English edition: Jackie Dobbyne for Hart McLeod, Cambridge
Typesetting: Goodfellow & Egan, Cambridge

Printed in China

ISBN: 978-3-8331-3545-3

10 9 8 7 6 5 4 3 2 1
X IX VIII VII VI V IV III II I

Contents

The style of an era does not mean specific forms in a specific form of art; each form is just one of the many symbols of life within, each art form is a mere contribution to the style. Yet a style is the symbol of an overall feeling, of an era's attitude to life, and is only visible within the universe of all the arts.

Peter Behrens
Feste des Lebens und der Kunst
[Celebration of Life and Art]
Jena, 1900

Introduction
The Final Chord and A New Beginning

Josef Maria Auchentaller
Book illustration
From *Ver Sacrum*, 1898
Color heliogravure,
202.2 x 202.2 cm

There are three kinds of reader: a first who enjoys without judging, a third who judges without enjoyment, and one in between, who judges with enjoyment and enjoys with judgment; it is this reader who actually produces the work of art anew.
Johann Wolfgang von Goethe[1]

Cube and arabesque

A work of art is created anew by the response of its beholder – or, if instead of Goethe we were to follow the words of Panofsky[2] – it is the beholder's knowledge and experience which cause a work of art to evolve. It is possible to perceive every object aesthetically, whether a product of man or of nature, and it is a personal decision whether we view it aesthetically or not. Yet even if its creator intended, not every work of art is seen in an aesthetic sense. This is dependent on the dominance of certain influential criteria: do I react chiefly to the shape or to the subject, to the idea or to the content, and how do I associate these elements? The artist's intentions need an opposite pole; even consciously executed works of art are dependent on the "qualifications" with which the observer is armed. The conception of a work of art is determined by the observer's visual practice and intellectual and cultural knowledge, which in turn spark off the most diverse associations of ideas.

This short digression is intended to further the understanding of Art Nouveau, on the one hand celebrated as the beginning of the Modern Style and as the first and last uniform style since the Baroque, and on the other dismissed as "ornamental hell", kitsch, and arts and crafts. The aesthetics of Art Nouveau is an aesthetics of contradiction; in order for these contradictions to be experienced as a work of art, a sufficient understanding of the object beheld is required which reaches far beyond visual perception. "Of course, every style is unique, but Art Nouveau is unique among styles."[3] Before the incredibly high quality which Art Nouveau was to contribute to the artistic development of the 20th century can be applied as a criterion, this style, a relatively short-lived phenomenon of 25 years, must be respected as an achievement in its own right. "In the past, numerous artistic directions have called themselves 'modern'. We can disregard the fact that the builders of the first Gothic cathedrals differentiated between 'opus antiquum' and their work, 'opus modernum'. Even Rococo was termed 'style moderne' by its contemporaries. The style we call Art Nouveau was named 'modern style' in England around 1890."[4] Art Nouveau, "New Art", was and still is modern, and was and still is historical. The violent mutation of the turn of the century – the extremes of our present day and age are no fewer – hid the lure of a beautiful death and a catalyst for all kinds of new ideas still relevant to today's world. "We were all Art Nouveau artists. There were so many wild, crazy curves to those Métro entrances and on all Art Nouveau work that I rebelled and restricted myself almost exclusively to straight lines. Yet despite this, I still took part in Art Nouveau in my own way. Even if you are against a movement, you are still part of it."[5] Cube and arabesque (ill. right and opposite page) are the pro and contra of the same movement, whose source lies in the same fund of philosophical, literary, artistic, and socio-reformative thoughts and ideas. It was these "qualifications", the cultural and political background, which shaped this principle of design. A great

Josef Hoffmann
Geometric design, ca. 1905
Pencil and Indian ink, 29.5 x 21 cm

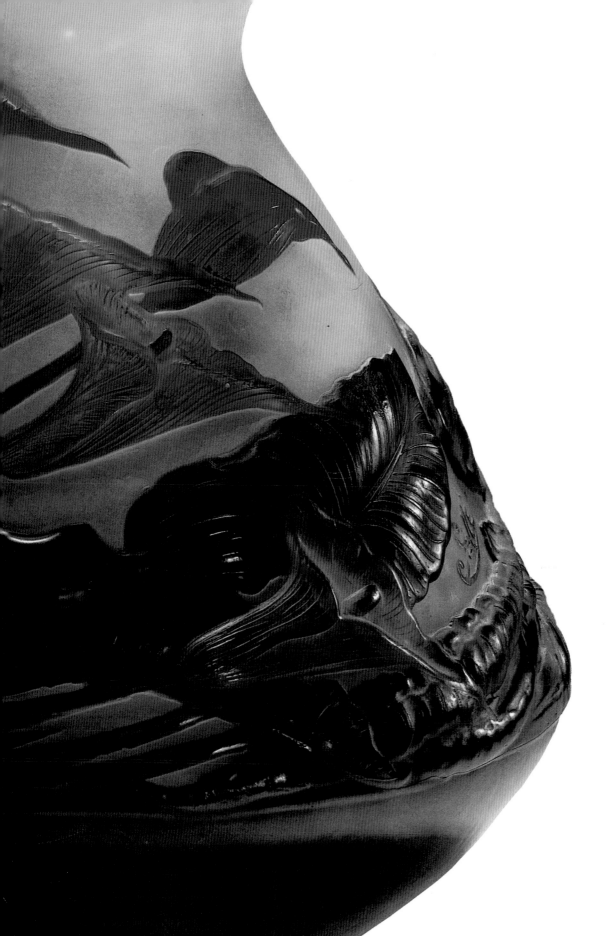

Emile Gallé
Calla vase (detail), ca, 1900
Mold-blown flashed glass, etched
and cut, 35 cm in height
One is left in no doubt that the basic
designs for Art Nouveau's
flickering, feathery, flowing
linearism were provided by nature;
to this is added what the artist
projects on to it, a second major
factor. The natural object takes on
new permutations; it is relieved of its
elemental background and placed in
a new formal and intellectual
context. Its organic physiognomy is
absorbed by the framework of the
mind.

sense of tension is apparent when contemplating Art Nouveau, brought about by the often contrary artistic versions of the different countries and artists. These diverse interpretations and indeed their common basis are particularly well-illustrated in the large number and variety of theories and writings by artists and their contemporaries. Aesthetic Discontent and the Aesthetic Movement, decadence and the beginnings of socialism were mutual starting points for Art Nouveau, as were the manifold artistic trends evident in varying degrees of importance in the individual countries, all of which produced a hive of artistic activity whose effect is yet to be exhausted.

Japan and the West

Japanese art has turned to nature. It teaches ways of feeling and expressing the subtlest changes in nature with the different seasons. An object's beauty remains hidden from the analytical research of the mind. Beauty is revealed in the feeling that binds heart and object.
Kaii Higashiyama[6]

The influence of Japanese art on Art Nouveau and indeed on turn-of-the-century art in general is genuine and has many facets. Its various forms of adoption and orientation show themselves in many guises: in asymmetrical composition, in new motifs from nature and society, in a respect for empty spaces in composition, that is to say the love of voids instead of *horror vacui*, and in the clear beauty of the line. When Samuel Bing exhibited 725 Japanese prints and 428 illustrated books at the École des Beaux-Arts in 1890,

attracting artists from all over Europe, the Japanese model transcended from a stimulus for a handful of painters to a leitmotiv for an entire generation of artists. The first knowledge of Japanese art dates from the world exhibitions. "Japanese art is important as a teacher. From it, we once again learn to feel clearly how far we have strayed from nature's true designs through the persistent tradition of inherited forms, through the persistent imitation of fixed models; we learn how necessary it is to draw from the source; how the human spirit is able to absorb a wealth of magnificent, naive beauty from the organic forms of nature in place of pedantic, decrepit rigidity of form."[7] As Julius Lessing's words illustrate, it was neither the bizarre nor the exotic which left their mark on Western art, but naturalness and simplicity, both of which had been suppressed by the intellect in Europe (ill. right and p. 10). In an essay published in 1899 in *Ver Sacrum*, Ernst Schur brings together Europe's "art of the intellect" with Japan's "art of the nerves."[8]

Japanese art was not only viewed with perspective; it reached into the depths of the soul and was the source of poetic inspiration. The passionate late work of van Gogh, the hero of Modernism, was the product of his familiarity with Japanese color woodcuts. "Here my life becomes more and more like that of a Japanese painter,"[9] he wrote in a letter to his brother, Theo, from the south of France in 1887. Van Gogh was captivated by the light of the bright colors, the vibrant rhythm of the lines and dots, the increased power of expression of simplified outlines and the juxtaposition of decorative

Japan
Fireman's cape (detail), early 19th century
Suede, with the brigade's stenciled emblem (the patterns were made using a special 1000-year-old technique, where drifts of smoke are blown through a template),
95 x 133 cm
Mingeikan – Japan Folk Crafts Museum, Tokyo
The new styles of the Arts and Crafts Movement in England spread across the entire continent and revolutionized design. Art Nouveau refused to continue to differentiate between "lower, applied" art forms and "higher, free" art. The Japanese artist-craftsman was a paradigm for this equality. "What we are trying to do is what the Japanese have always done," proclaimed Josef Hoffmann (see note 10).

Koloman Moser
Wall decoration, December (detail), 1901
Color lithograph, 26 x 30 cm
From *Die Quelle – ein Vorlagewerk mit 71 Tafeln* [The Source: a reference work with 71 plates], edited by Martin Gerlach junior, Gerlach & Schenk, Vienna – Munich
Die Quelle was a reference work of nature's world of shapes and forms. It depicted plants, insects, crystals, stones, and the smallest organisms in detailed enlargements. The graphic work by this Viennese Art Nouveau artist betrays the great influence nature bore on Moser's principles of design. Cube and arabesque are the pro and contra of the same movement whose source lies in the same fund of philosophical, literary, artistic, and socio-reformative thoughts and ideas.

Okinawa, Japan
Wrap, early 19th century
Ramie fiber, hand-painted réservage
decoration, 152 cm in length
Mingeikan – Japan Folk Crafts
Museum Tokyo

Japan
Blanket, 19th century
Cotton, hand-painted réservage
decoration, 114 cm in length
Mingeikan – Japan Folk Crafts
Museum Tokyo
"Japanese art is important as a
teacher. We ... learn to feel clearly
how far we have strayed from
nature's true designs through the
persistent tradition of inherited
forms, through the persistent
imitation of fixed models ..."
(Julius Lessing, see note 7)

planes on the pictorial surface evident in the *ukiyo-e* [pictures of the floating world]. The bold cuts of Toulouse-Lautrec's lithographs (ill. p. 103) also originate from the decentralized arrangements and sectionalized way of seeing things characteristic of Japanese woodcuts. The French aristocrat produced his own version of *Kabuki* scenes and *shunga* [Spring pictures] from Yoshiwara, the entertainments district of Edo (modern Tokyo, ill. opposite page), imitating not only forms, but also the milieu with his motifs from the world of Montmartre. Even Cézanne, a stubborn opponent of the Japanese trend, did not escape its influence. Lurking in the distance beyond his crystalline homages to Mont Sainte-Victoire is Hokusai's equally important Fuji series (ill. p. 12). The list of painters directly and indirectly inspired by the *ukiyo-e* reads like a hit parade of art from 1860–1910: Pissarro, Monet, van Gogh (ill. p. 14–15), Gauguin, Seurat, Signac, Redon, Ensor, Munch, Hodler, Toulouse-Lautrec, Bonnard, Vallotton (ill. p. 13), Vuillard, Beardsley, Klimt, Matisse, and all those omitted from art history's Hall of Fame. The turn to pure surfaces and the moving away from edges is not a phenomenon restricted to graphic art in Art Nouveau; it was also applied to furnished spaces. The consideration of function, properties of materials and work processes – characteristics of Japanese art – was to become an archetype for the design of object art at the turn of the century (ill. above). The new styles taken from the reforms of the Arts and Crafts Movement in England spread across the entire continent and revolutionized design. Art Nouveau refused to continue to differentiate between "lower, applied" art forms and "higher, free" art. The Japanese artist-craftsman was a paradigm for this equality. "What we are trying to do is what the Japanese have always done,"[10] proclaimed Josef Hoffmann in the Wiener Werkstätte's (Vienna Workshops) work program. There was not a master studio in about 1900, whether Gallé's, Lalique's or Tiffany's, which did not produce its own personal Japanese-style articles (ill. p. 17, 23), just as book art and lithographics could not have blossomed without the spontaneity of Japanese art. In Zen, the directness of the heart replaces any kind of dogmatism; in this lies probably the deepest-reaching relationship – which is also the most difficult to describe – in an aesthetic lifestyle. "The world of objects means nothing, yet every common object is absolute. Small things are just as humble and commendable as large things. One doesn't grasp; one is grasped. A Zen work of art also means nothing; it is there. Form is void, void nothing but form. The circle is empty and full. Things and the void between them are equally valid."[11] The teachings of Zen figure in Western architecture without modification. Frank Lloyd Wright and Josef Hoffmann both achieved free-flowing movement between interior and exterior using simple constructions with suitable materials.

Post-Ruskin artists, artist-craftsmen, designers, architects and artist-architects demonstrated a ready acceptance of new forms and subjects, the result among other things of a desire for a new spirituality which would counter the threatening, unfriendly implications of a growing industrial society with a unity with nature both internal and external.

Japan
Bowl, 18th century
Lacquered wood, 12.8 cm in
diameter
Mingeikan – Japan Folk Crafts
Museum Tokyo

Utagawa Kunimasa
The Actor Ichikawa Ebizō, 1796
Color woodcut, *Nishiki-e* [multi-color print], 38.1 x 26.1 cm
Hiraki-Ukiyo-e Museum, Yokohama
The bold cuts of Toulouse-Lautrec's lithographs also originate from the decentralized arrangements and sectionalized way of seeing things characteristic of Japanese woodcuts. The French aristocrat produced his own version of *kabuki* scenes and the Spring pictures from Yoshiwara, the entertainments district of Edo (modern Tokyo), imitating not only forms, but also the milieu with his motifs from the world of Montmartre.

Ornamental organisms

Seven billion years before my birth I was an iris.
Arno Holz[12]

Art Nouveau sought to quash the exhausted clichés of historicism and naturalism not with logic, but with "bio-logic"; the magic of life and of the organic was to exorcise the ghosts of styles past (ill. p. 8). It was no longer considered important to protect oneself from elemental force, but from the noise of cities, from the violence of modern traffic, boxing in everything in its path, from industry and the mechanized masses. The animal and plant world, the incarnation of creation and of natural growth offered ways and means of regeneration (ill. p. 16). "Only three things exist for the creative mind: here am I, here is nature and here is the object I am going to embellish."[13]
The zoologist and natural philosopher Ernst Haeckel (1834–1919) was in tune with the spirit of the times with his monist teachings. In his illustrated writings, *Natürliche Schöpfungsge-schichte* [Story of the Creation, 1868] and *Kunst-formen der Natur* [Art Forms of Nature, 1899], he presented the theory that reality can be put down to one single – spiritual or material – principle. Haeckel was primarily concerned with amorph-ous, plant-like animals – jellyfish, cnidarians, seaweed, radiolarians, algae, corals, and proto-zoa – whose structures were almost devoid of solid, straight lines and featured heavily in the ornamentation of Art Nouveau. He himself de-scribed these "in-between creatures" as "won-derfully ornamented". Another man concerned with natural forms was Karl Blossfeldt (1865–1932), who studied plants in their various stages of growth, enlarging them many times in his detail photographs (ill. p. 21). These served to sharpen artists' awareness of nature and were often directly worked into patterns and designs. The growing interest in natural science and advances in technology at the end of the 19th century permitted the exploration of micro-cosms, phenomena previously hidden from the eyes of man. Through the addition of a con-denser to the microscope in 1872, Ernst Abbe (1840–1905) opened up boundless new oppor-tunities for the natural sciences. Attention was particularly focused on the study of insects, which became incredibly popular. The curved, elastic limbs of these buzzing, fluttering, living organisms lent themselves to Art Nouveau's play of lines like cut-out patterns (ill. p. 17). The iridescent play of colors of butterfly and dragonfly wings, the changing shades of the chitin exo-skeletons of beetles, crabs, spiders, and insects are mirrored in the color schemes of Art Nouveau. The plasmatic character of these "in-between creatures" has an almost secretive affinity with the swelling ornaments of the turn of the century. The bare feelers and tentacles of polyps become lamps and lights; as women's hair they entangle and entwine the art and psyche of the *fin de siècle*.

Katsushika Hokusai
The South Wind Drives Away the Clouds, from *36 Views of Mount Fuji*, 1831-34
Color woodcut, *Nishiki-e* [multi-color print], 26.1 x 38.1 cm
Hiraki-Ukiyo-e Museum, Yokohama
Even Cézanne, a stubborn opponent of the Japanese trend, did not escape its influence. Lurking in the distance beyond his crystalline homages to Mont Sainte-Victoire is Hokusai's equally important Fuji series.

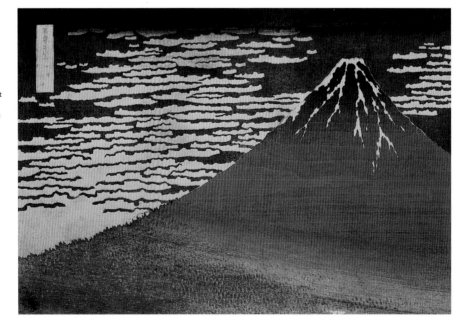

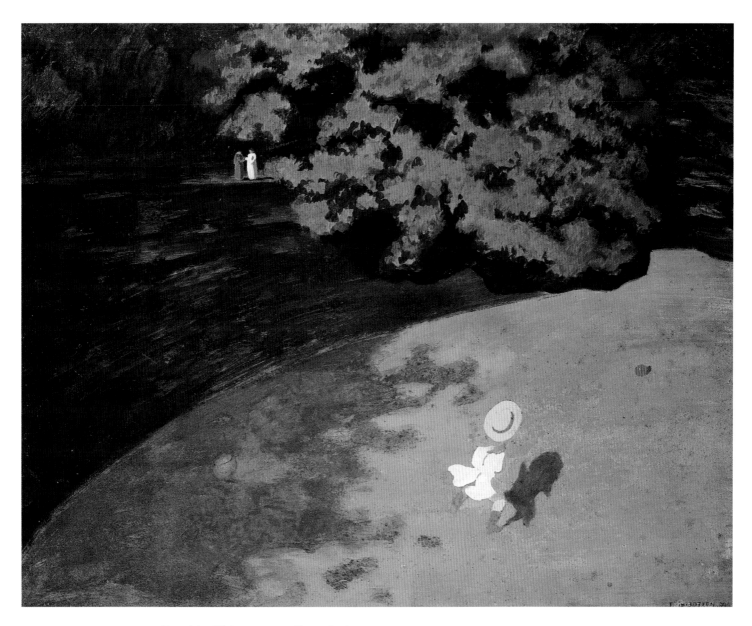

Félix Vallotton
The Balloon, or Corner of the Park with a Child Playing with a Balloon, 1899
Oil on card, 48 x 61 cm
Musée d'Orsay, Paris
Vallotton, the most important wood engraver of his time, clearly demonstrates Japanese influences in his work. Even in his painting, the single figures and elements in his pictures, reduced to their typical movements, have something of the woodcut about them.

Breathing life into nature – Synesthesia

It is not the ornament ... which has "expressed" the inner life of these strange times, but people who have led the life of the ornament; souls themselves have become ornaments.
Dolf Sternberger[14]

One is left in no doubt that the basic designs for Art Nouveau's flickering, feathery, flowing linearism were provided by nature (ill. p. 6); to this is added what the artist projects on to it, a second major factor. The natural object takes on new permutations; it is relieved of its elemental background and placed in a new formal and intellectual context. Its organic physiognomy is absorbed by the framework of the mind. "All shapes suffuse into one another, driving everything equally with emotion, with the soul, moving it 'organically'. In this way, Art Nouveau's ornamental world comes alive; it is a materialization of the 'atmosphere of souls' of which Maeterlinck speaks. It is this peculiarity which distinguishes Art Nouveau from all earlier epochs and ornamental representations. According to the theories of Art Nouveau, even the most abstract figures, even the simplest graphic elements are allotted,

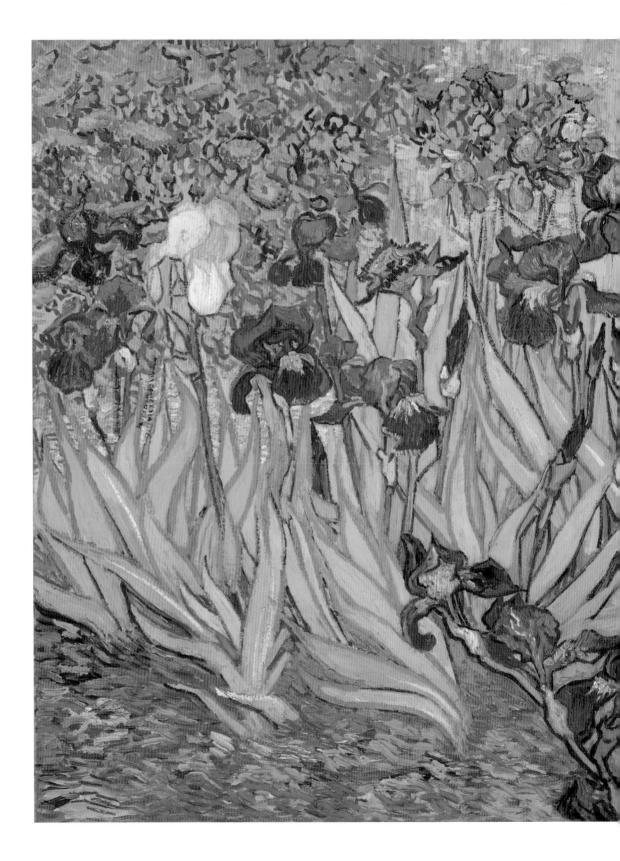

Vincent van Gogh
Irises, May 1889
Oil on canvas, 71 x 93 cm
The J. Paul Getty Museum,
Los Angeles
The passionate late work of van
Gogh, the hero of Modernism, was
the product of his familiarity with
Japanese color woodcuts. "Here my
life becomes more and more like that
of a Japanese painter," he wrote in a
letter to his brother, Theo, from the
south of France in 1887. Van Gogh
was captivated by the light of the
bright colors, the vibrant rhythm of
the lines and dots, the increased
power of expression of simplified
outlines and the fixing of decorative
surfaces to the picture surface evident
in the *ukiyo-e*.

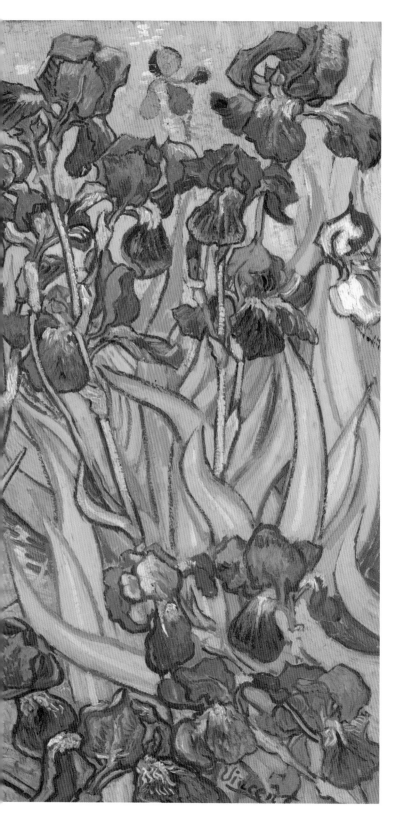

indeed are inhabited by, certain feelings or 'experiences'."[15] Fantasies and emotions are fired which cannot be experienced in reality – a stylistic method the Symbolists have always employed in word, but which becomes visually transparent only with Art Nouveau. The Greek word *symbolon* describes the secret signs by which those sworn to mystic cults recognized one another. Thus the symbol as a bearer of coded messages to a chosen few has the power of revelation.

Symbolic or symbolist art is a trait of every era, yet its meaning has always been different. Art Nouveau was stamped by the decorative emblems of the French and Belgian Symbolists. "… so let's say that Charles Baudelaire must be named the true forerunner of the current movement. Stéphane Mallarmé gave it its sense of secrecy and inexpressibility …"[16] An entire host of artistic media was caught up in this *fin-de-siècle* arabesque: literature, poetry, music, fine and applied art. Proust, Debussy, Verlaine, Maeterlinck, Sibelius, Ibsen, Strauss, Hofmannsthal, Rilke, D'Annunzio, Huysmans, to name but a few authors and composers, were part of the Art Nouveau effort in this dizzy climate of sensual, poetic masterpieces. Artists in 1900 were all striving toward synesthesia, literally a "mutual sensation". Their virtuoso example was Richard Wagner (1813–83), who effected a suggestive synthesis of the senses with his fusion of music, language, and theater. Gustave Flaubert (1821–80) also uses the concept of synesthesia in his novel *Salammbô* (1863). "Her earrings were two sapphire beads bearing hollow

Josef Hoffmann
Tumbler from the Var. F set of
glasses, ca. 1910
Frosted glass with black bronzite
decoration, 10.4 cm in height
Made by J. and L. Lobmeyr, Vienna
Wiener Glasmuseum, Lobmeyr
Collection

pearls filled with liquid perfume. Drops
occasionally trickling through holes in the pearls
wove patterns on her naked shoulders."[17] Smell,
desire, sight – Flaubert touches on all these
senses with his description. Salome, the idol of
the Decadents, is herself an example of synes-
thesia, and often appears as a theme in painting
(ill. p. 19), poetry, and music. Art Nouveau con-
densed synesthesia into reality: great waves of
thick hair, ornamental curves and plant arabesques
resemble the graphic notation of patterns of
sound, and the flowers, whether deadly or
innocent, give off a wonderful bouquet. For
Baudelaire, the fragrance of *Fleurs du mal*[18] was
a parable of the "stupidity, confusion, sin, and the
soiled mind" of his contemporary world. His
poetry cycle is like a compendium of turn-of-the-
century floral mysticism, where one translates
the age-old language of flowers into endless
roundelays of blooms and blossoms.

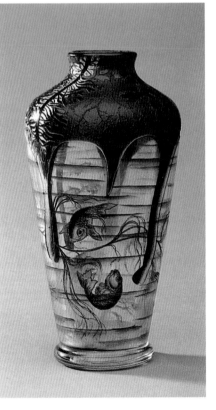

Jean-Antonin Daum
Vase with fish, ca. 1890
Flashed crystal, with oxide
inclusions, glass thread and glass
powder inclusions, engraved, cut and
etched, painted and gilded, 21 cm in
height
Tokuso Takasima attended the
École Forestière in Nancy and there
awoke the interest of local artists –
such as the Daum brothers or Gallé –
for the art of his native Japan.

Above:
Peking
Snuff bottles, 19th century
Cut, flashed glass, 25.5 cm in height
In retrospect, one could say that cut, flashed glass was a
typical product of Art Nouveau. This complicated and yet
"natural" technique of processing glass drew its inspiration
from Chinese snuff bottles.

Eternal femininity

Sex is very similar to torture or surgery.
Charles Baudelaire[19]

The taut span of the senses also served to stimulate the relationship between the two sexes; plants and animal symbols, more eloquent than words, became the emblems of eroticism. Burning embers were explosively rekindled by decadence, and sensuality became accepted in the salons, whereby lasciviousness and vice were aesthetically domesticated and art was used to elevate any tones of obscenity. The motto "back to nature" was a pretext for grasping and handling the concept of the body – the female body – anew. Tense, nervous lines seized the Eves decoratively and willingly wafting through all artistic walks of Art Nouveau, smothered by their manes of hair, swimming in complex waves and swirls of smoke, imprisoned and surrendering. Art Nouveau's female images are the sisters of Dante Gabriel Rossetti's embodiments of femininity (ill. p. 18). For the great Pre-Raphaelite painter, the female body was the "symbol of all beauty." The dreamy poses of his female figures created a "fusion of quivering eroticism and spiritual nobility,"[20] their full, almost greedy lips in sensuous counterpoint with the withdrawn, unfathomable eyes. Yet in Art Nouveau the word "woman" also takes on dangerous undertones, undertones of wicked witches, the man-devouring vamp, the *femme fatale*, the murderess Judith, of blood-sucking vampires, of sin and the dancing temptress, Salome – an endless procession all symbolizing the fears of the stronger sex. Figures of innocence also had their own sensory appeal; the slight figures of young girls about to blossom were smuggled into vignettes and landscapes bursting with symbolism. Puberty was painted by Edvard Munch, who, like many others, also took the Madonna (ill. p. 285) as a model of the self-abandoned female martyr, of the lover and the conceiver, often crowned with flowers and with the flame of sensuality burning behind her closed eyes (ill. p.18).

In an attempt to master this phobia, artists adopted the androgyne, the hermaphrodite, as a favorite motif of unstilled desire. Yet the phobia was inescapable, as the Sphinx, for example, demonstrated. This strange, monstrous mixture of beings was the symbol of man's sexual

Georges Auger
Dragonfly brooch, ca. 1895
Platinum, yellow gold, diamond roses, pink-colored ruby squares, enamel and turquoise, 11.1 x 9.3 cm (Reproduction in the original size)
Within scientific developments, attention was particularly focused on the study of insects, which became incredibly popular. The curved, elastic limbs of these buzzing, fluttering, living organisms lent themselves to Art Nouveau's play of lines like cut-out patterns.

Emile Gallé
Vase with a Japanese base, ca. 1900
Flashed glass with embossed and engraved levels of carving, *intercalaire* [inter-layered decoration], appliqué and marquetry-de-verre, bronze base, 16.5 cm in height
Post-Ruskin artists, artist-craftsmen, designers, architects, and artist-architects demonstrated a ready acceptance for new forms and subjects, the result among other things of a desire for a new spirituality which would counter the threatening, unfriendly implications of a growing industrial society with a unity with nature both internal and external. Art Nouveau sought to quash the exhausted clichés of historicism and naturalism not with logic, but with "bio-logic"; the magic of life and of the organic was to exorcise the ghosts of styles past.

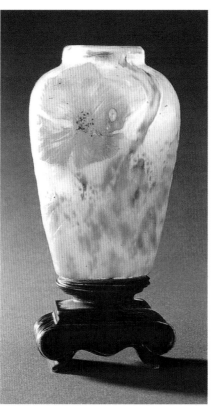

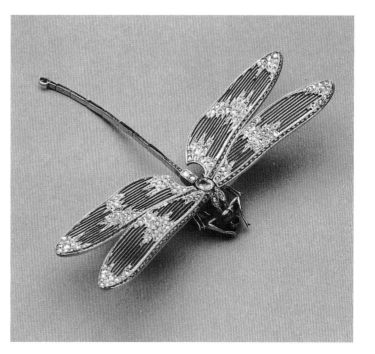

confusion, unable to solve its riddle. Sigmund Freud tried to offer a remedy, giving a scientific basis to hysteria and neuroticism through psychoanalysis.

"This throng of women / Which guides us, indulges us / With their flowing hair / So beautiful in dance,"[21] wrote Stefan George, associating with his poem the graphic rhythm of these nymph-like beings with the new discipline of artistic dance, which reached its climax in the flowing veils of Loïe Fuller. This sweet, heathen prototype is in harmony with Eric Bergson's Pan philosophy and Rudolf Steiner's anthroposophists. Philosophies from Nietzsche's *Zarathustra* to Schopenhauer found expression in the all-embracing art of life and experience.

The collage in 1900

If we said that beauty is idea, then beauty and truth in one sense are the same …
Through this, beauty characterizes itself as the sensual appearance of the idea.
Georg Wilhelm Friederich Hegel[22]

Art Nouveau's countless ciphers and wealth of disparities intermingled and formed the characteristic visage of an era, which still managed to produce an overall sense of design both fascinating and – in an autonomous sense – unified. Technical components were combined with the organic. Functionalism's hymn of praise clothed itself in emphatic words and phrases. The world exhibitions vividly paraded this divergence of styles before the eyes of their visitors. "Some of the illustrations, even the exhibition catalogue, are like collages. When, fifty years ago, Max Ernst was searching for media which would disrupt the middle-classes' understanding of themselves, he

Cornelia Paczka-Wagner
Study of a Head, 1896
From *Pan*, No. 1, Vol. 2, 1896, p. 57
Color heliogravure, 24 x 19.5 cm
Artists in around 1900 also discovered the sensory appeal of figures of innocence; the slight figures of young girls about to blossom were smuggled into vignettes and landscapes bursting with symbolism. The Madonna was also a desired model of the self-abandoned female martyr, of the lover and the conceiver, often crowned with flowers and with the flame of sensuality burning behind her closed eyes. Sigmund Freud tried to offer a remedy in the battle of the sexes, giving a scientific basis to hysteria and neuroticism through psychoanalysis.

Right:
Franz von Stuck
Salome, 1906
Oil on canvas, 115.5 x 62.5 cm
Städtische Galerie im Lenbachhaus, Munich
Gustave Flaubert also uses the concept of synesthesia in his novel *Salammbô* (1863). "Her earrings were two sapphire beads bearing hollow pearls filled with liquid perfume. Drops occasionally trickling through holes in the pearls wove patterns on her naked shoulders." Smell, desire, sight – Flaubert touches on all these senses with his description. Salome, the idol of the Decadents, is herself an example of synesthesia, and often appears as a theme in painting, poetry, and music.

Dante Gabriel Rossetti
Proserpina, 1877
Oil on canvas, 119.5 x 57.8 cm
For the great Pre-Raphaelite painter Rossetti, the female body was the "symbol of all beauty". The dreamy poses of his female figures created a "fusion of quivering eroticism and spiritual nobility" (Wolfram Waldschmidt, see note 20), their full, almost greedy lips in sensuous counterpoint with the withdrawn, unfathomable eyes.

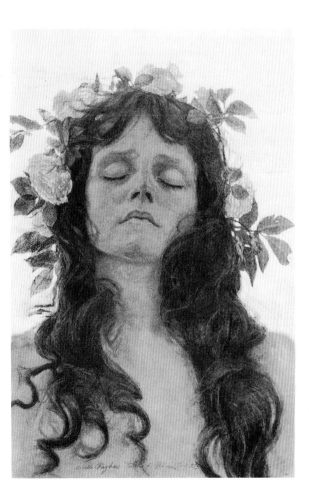

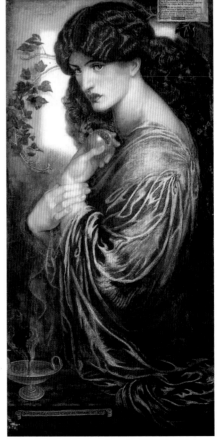

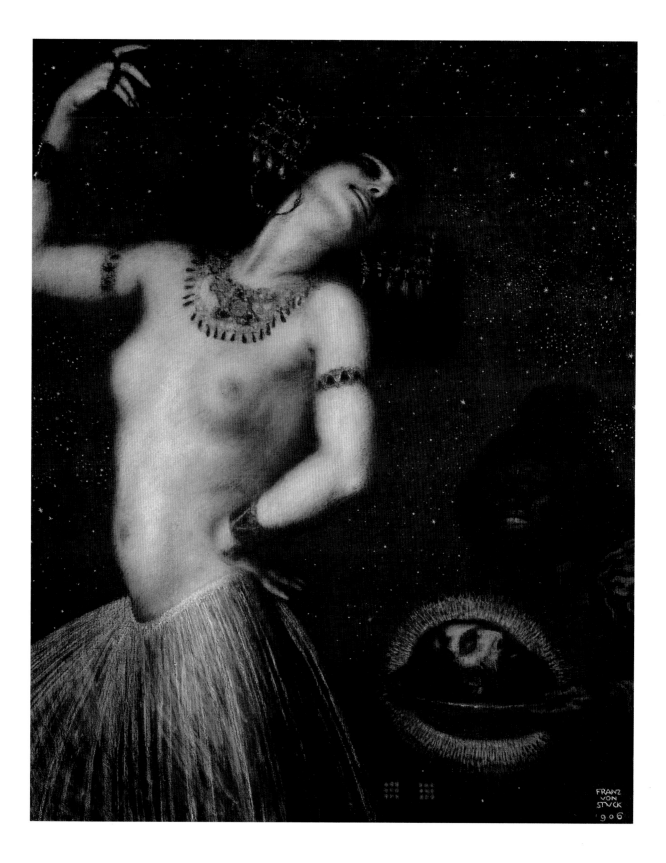

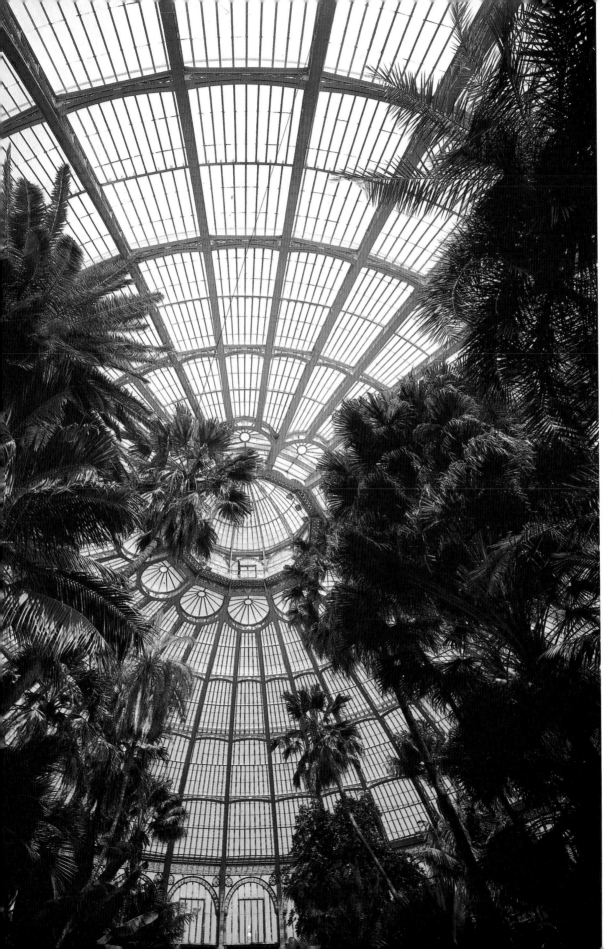

Alphonse Balat, Henri Maquet
Grand Jardin d'Hiver [Great
Winter Garden] at Royal Palace at
Laeken, avenue du Parc Royal,
1875–76
The iron-and-glass constructions
made possible by technical
innovation and promoted by the
world exhibitions were the
harbingers of ecological building –
an ecology of construction which
brought with it the use of new
materials, the use of science as a
constructional foundation. The
economical deployment of new
building matter such as glass and
iron led to transparency and
lightness of construction.

stumbled across these attestations to creative diligence and discovery. The rigidity of the figures, the naive and brutal combination of familiar objects with mechanical ones was surreal *avant la lettre.*[23] The clash of *fin de siècle* and the dawning 20th century threaded through artistic achievements about 1900 like a leitmotiv, giving them their uniqueness and restricting their duration. The iron-and-glass constructions made possible by technical innovation and promoted by the world exhibitions were the harbingers of ecological building – an ecology of construction which brought with it the use of new materials, the use of science as a constructional foundation. The economical deployment of new building matter such as glass and iron led to transparency and lightness of construction (ill. opposite page). However, the growing concern at the end of the last century was that one day architecture would disintegrate into nothing with the increased

flimsiness of the buildings. The result was a kind of hybrid architecture which on the one hand was modern and practical, but on the other ornamentally decorated and heavily "made-up", as a favorite criticism put it. Yet it is this symbiosis of incompatibility which bestows upon these buildings their charm.

The Hall of Machines in Arcadia, the arabesque in *amor vacui* are not two sides of the same coin of "dream and reality"[24] but daily experience reaped from a period of change. Over-ornate, self-celebratory pomp (ill. below left), the expression of a bourgeoisie and industrial age hungry for forms of representation, coexisted alongside objects demonstrating a simple, formal balance we still consider modern today (ill. right). In France, Pierre Cécile Puvis de Chavannes painted his "island of the Blessed", faceless forms bathed in a mist of eternal light (ill. p. 23) and influenced the next generation just as

Beaker from a christening set
Vienna, 1826
Silver, 10.5 cm in height
Die Neue Sammlung, Staatliches Museum für angewandte Kunst, Munich
The 19th century produced not only a capricious mixture of eclectic styles but also objects demonstrating a simple, formal balance we still consider modern today.

Percy Holmes Dobson and Charles Westcott Dobson
Centerpiece
Silver, 250 x 93.3 cm
For Dobson & Sons, London
"Abominable household items ... flow from the inexhaustible springs of bad taste: stepped towers as ink pots, enormous crosses as lampshades ... and a pair of towers crowned by an arch calling themselves 'iron scraper after a Gothic model' ... Those who produce such abominable objects have no feeling for proportion and form, for utility and unity of style ..." wrote the British architect Augustin W. Pugin in 1841.

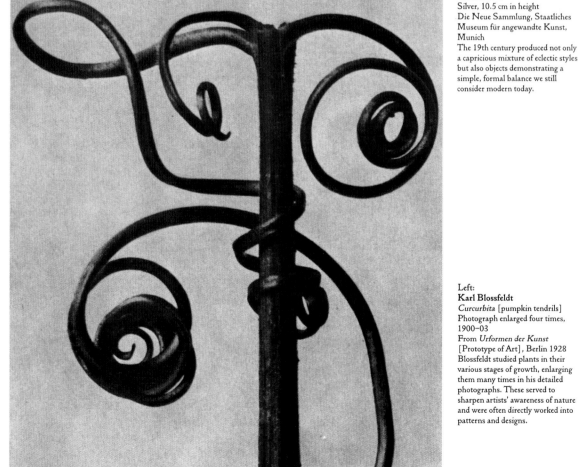

Left:
Karl Blossfeldt
Curcurbita [pumpkin tendrils]
Photograph enlarged four times, 1900–03
From *Urformen der Kunst* [Prototype of Art], Berlin 1928
Blossfeldt studied plants in their various stages of growth, enlarging them many times in his detailed photographs. These served to sharpen artists' awareness of nature and were often directly worked into patterns and designs.

Philipp Otto Runge
Morning from *The Times of the Day*, 1808
Oil on canvas, 109 x 85.5 cm
Kunsthalle Hamburg
Intensifying the ornamental arrangement by way of an extreme choice of frame was one of the main characteristics of Art Nouveau. Even with Runge, the impact of the picture is doubled by his filled surfaces and frame adorned with symbolic figures.

strongly as the prophetic English painter, William Blake, whose dream faces form a linear contrast of the horizontal and the vertical. The lithe bodies of his figures move to an ornamental rhythm and add a sense of spirituality to the ornamentation and events illustrated in the picture (ill. below). In the works of Philipp Otto Runge, one discovers a signal-like coloring of surfaces which paved the way for ornamental design (ill. left). The ornament is immanent as an allegory for the river of life and as a way of ordering the picture. "All forms of imitation have a beginning and an end; an ornament merely has duration. Emulation breathes life and inspires; ornamentation banishes and kills."[25] This inspiring imitation promised by philosopher of history Oswald Sprenger (1880–1936) in his *Untergang des Abendlandes* [The Decline of the West, 1918–22] is provided by the East, by the Orient. The embellishments of Arabian art, the arabesque, the shapes of Far Eastern receptacles, the minarets of the mosques, nomad textile designs, the techniques and decorations used in Chinese glasswork (ill. p. 16), glazing and firing processes for royal ceramics from the Middle Kingdom and in particular from Japan, the land of the rising sun, inspired and liberated the formal language of the West. Half-forgotten stylistic periods closer to home also experienced a revival, especially the Gothic period, which managed to preserve a unity of art, craft, and spirituality. The Celtic catalogue of patterns and designs was also taken as a model, as were the glass objects of antiquity. It was a puzzle of the ages, of the cultures, a collage of decadence and of the intellect: Art Nouveau.

The name of this stylistic period was in full accordance with its diverse ingredients which merged together in dramatic, often astoundingly controversial designs. In all lands and languages, these attributes were termed "new," "young," "modern," "original" and "quite unprecedented". The English name actually comes from Maison Bing, L'Art Nouveau in France, a gallery founded by Samuel Bing in 1895 as an exhibition forum for the new art. It was, however, quite by chance that the German word for Art Nouveau,

William Blake
The River of Life, 1805
Watercolor, pen on paper, 30.5 x 33.6 cm
Tate Gallery, London
Art Nouveau was also heavily influenced by the prophetic English painter, William Blake, who axialized his dream faces in a linear contrast of the horizontal and the vertical. The lithe bodies of his figures move to an ornamental rhythm and add a sense of spirituality to the ornamentation and events illustrated in the picture.

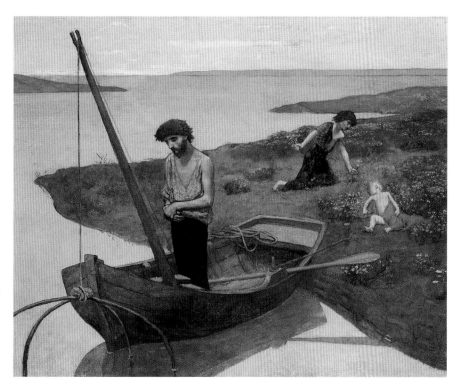

Pierre Cécile Puvis de Chavannes
The poor fisherman
Oil on canvas, 150 x 192 cm
Musée d'Orsay, Paris
In France, Puvis de Chavannes
painted his "island of the Blessed",
faceless forms bathed in a mist of
eternal light. His mood pictures
would strongly influence the next
generation of artists.

Jugendstil, came about. The first part of the compound was taken from the magazine *Jugend* which was first published in Munich in 1896. The magazine itself had nothing to do with the origins and developments of Art Nouveau. In Italy, the term *Lo Stile Liberty* was taken from Liberty's, an Art Nouveau store in London. "Stil," "style," "stile," gradually teamed up with "young" and "modern," two important Art Nouveau hallmarks, to lend voice to the conscious development of a new direction: Modern Style, *Style Guimard* and *Style Métro* are all forerunners of Art Nouveau. The terminologies *Lo Stile florale* and Floral Style paid homage to the style's floral ornamentation. Spain's word, *Modernista*, stresses the newness of the forms. Defamatory word creations such as *Style nouilles* (Noodle Style) in France, *Bandwurmstil* (Tapeworm Style) in Germany and *Brettlstil* (Plank Style) in Austria only served to enliven Art Nouveau's spectrum of modifiers.

The herbarium of different lifestyles and powers of design was fused a second time – almost incestuously – in the "complete" work of art. Turn-of-the-century aesthetics was the domain of the individual, styled down to the last detail, in today's didactics termed an "overall design".

Pride of place in this respect goes to architecture, fluently shifting its function between preserver of bodily warmth and religious building, according to Hans Hollein.[26] Artists bent on creating an *œuvre global* have left us with creations of breathtaking luxuriousness. This intensity – Art Nouveau's strength – also housed the risk of failure. "Narcissus died because he had lost himself to his own mirror image."[27] "When Narcissus died, the flowers in the meadows became so stricken with grief that they asked the river to spare them a few drops of water so they could show their sadness.

'Oh,' answered the river, 'if all my drops of water were tears, I still wouldn't have enough of them to grieve over Narcissus, so great was my love for him.'

'But of course,' said the flowers, 'how could anyone not love Narcissus, he was so beautiful!'
'Was he so beautiful?' asked the river.

'Is there anyone who knows that better than you, who mirrored his face when he bent over your rippling waters and looked at his reflection?'

'I loved him,' answered the river, 'because every time he bent over me I could see my own beauty reflected in his eyes.'"[28]

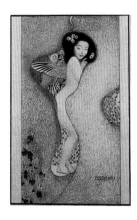

Walter Hampel
Japanese Woman, ca. 1910
Drawing colored with watercolors on
art board, 21 x 13.4 cm
Barlow/Widmann Collection,
Spain

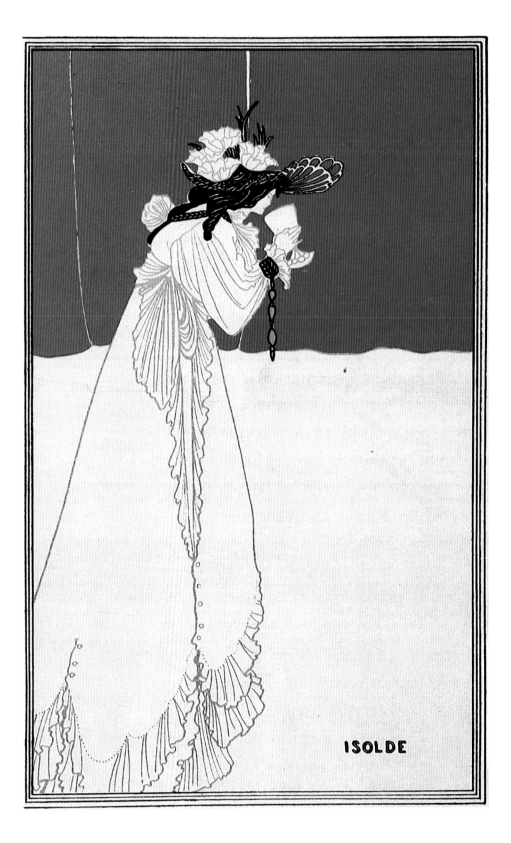

ISOLDE

Ruskin, Morris and the Pre-Raphaelites
England

I confessed that I had resolved to follow the paths of Ruskin and Morris until they had realized their prophecy: the return of beauty on earth and the dawning of an era of social justice and human dignity.
Henry van de Velde[1]

The Aesthetic Movement and Aesthetic Discontent

During the 18th century, Great Britain became the strongest economic and colonial power in the world. It was an epoch which saw the Age of Enlightenment and the great bourgeois revolutions; an epoch during which a young, capitalist economy swept away the old feudal system once and for all, and the Industrial Revolution triumphantly conquered in the factories. It was an age when world history was founded, an age of pathos and the battle for the civil rights and liberties of the individual, an age when culture was made accessible to the general public. In his last will and testament, Sir Hans Sloane bequeathed his art collection and library to the "people of England". Inspired by an insatiable thirst for knowledge and the French *Encyclopédie*, the major social and political reference work of the French Enlightenment, to produce a comprehensive inventory of human knowledge and experience, and embellished by King George III's collection of Egyptian antiquities, Sloane's heritage laid the foundation stone for one of the most important museums in the world. The British Museum, a universal treasure trove, was opened in 1759.

During the next century, England technologically outstripped the Continent; economic expansion reached its peak in 1850, but was unfortunately already revealing its first defects. The process of adapting historicising craftsmanship to technical methods of production was considered torturous. The phrase "Aesthetic Discontent" was coined, representing a growing dissatisfaction with eclecticism in art, with normative historicism and its cluttered decorative forms. This crisis was not restricted to the arts; it was a rebellion against social egotism and the staunchly defended privileges of the ruling class. John Ruskin (1819–1900) was the initiator of the Aesthetic Movement which grew out of this period of Aesthetic Discontent. He called for a "gospel of beauty" in his writings, and fought for a new code of ethics in industry and the creative value of arts and crafts. Ruskin talked of the dignity of work and the degradation caused by the division of labor. His remedy was that all classes should show understanding for the kinds of work that are good for people, that uplift them, that make them happy. The problem was to ensure that a place for craftsmen and artists could be secured in the world of mass production. This aesthetic revolt (to which the movement owed its initial success) was joined by artists, craftsmen, and intellectuals all over Europe. They devoted their full attention to what was happening in England.

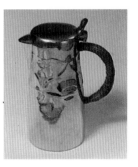

Archibald Knox
Lidded jug, 1903
Tudric pewter, 15 cm in height
For Liberty & Co., London

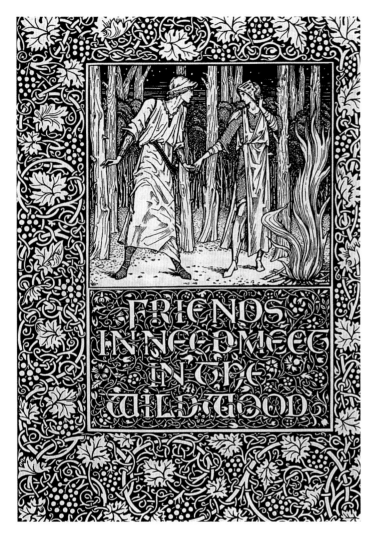

Edward C. Burne-Jones, William Morris
Friends in need meet in the wild wood
From *The well at the world's end*
Wood engraving, 27.8 x 19 cm
Print in Chaucer Type, Kelmscott Press, Hammersmith
1896
In Morris' books, equal importance was attached to type,
illustration, and bordering: Morris designed the three most
important typefaces – Golden Type, Troy Type, and Chaucer
Type – himself. Morris's edition of the works of Geoffrey
Chaucer, with illustrations by Burne-Jones, is the
embodiment of perfect craftsmanship.

A life of beauty – The dandy

Art is a bold attempt to put life in its proper place.
Art alone can protect us from the humiliating dangers
of real life.
Oscar Wilde[2]

Other tendencies besides the call for social
reform had been simmering since the beginning
of the century, all of which shared a common
source: the contempt for a positivism which
believed in progress and which seemed to be
heading for absolute mediocrity in all things.
Sensitive aesthetes saw their only ideal – which
had always been beauty – threatened by the
triviality of the bourgeois world. One feared one
was living in an age of cultural demise. Yet in
these supposed final death throes, a new, highly
individualistic breed of person came into his
own, characterized in England especially by his
cultivation of uniqueness: he was the dandy, the
snob, the incarnation of exquisite, male self-
awareness, who in the form of George Bryan
"Beau" Brummell stood up for an aristocracy of
taste. Half a century later, imitators were to be
found all over Europe. In short, without England
there would have been no Art Nouveau. England
paved the way, even if here Art Nouveau took on
a very different guise from other European
versions.

Art is not something to take its turn after other
needs and desires have been satisfied; it is
man's first desire after his basic animal instincts.
Art is not a "beautification of life"; it is life itself.
It is not art's job to distance us in solemn
moments from the cares of everyday life; insofar
as he considers himself a man of culture, man
should constantly nurture his feeling for art
and express it wherever possible. This was
the quintessence of the new religion Ruskin
preached. Like so many innovators, Ruskin
believed that he should seek his ideal in the past.
The Middle Ages was his Garden of Eden where
people had true artistic ideals. He advocated a
return to the Middle Ages, even in a social
respect, and thus demonstrated peculiarities
which caused him to leave art theory behind and
branch into politics and sociology. Nevertheless,
his social commitment was genuine and led him
to form a close friendship with Thomas Carlyle
(1795–1881), who gave him an insight into socio-
economic issues. Ruskin's desire to put theory
into practice was so strong that as an Oxford
lecturer he demonstrated his views on the
necessity for physical labor by becoming a
working model. He joined the road-builders in
London and broke stones; he swept streets and

William Morris
Windrush, wall decoration, after
1883
Printed linen, 165 x 247 cm
Morris reorganized his company,
which had previously stood under
the sign of medievalism, and now
specialized in printed wallpaper and
textiles, a step which also bought the
company commercial success.
Natural plant and vegetable dyes,
traditional weaving forms, and the
revival of hand-printing all
contributed to the high quality of the
designs.

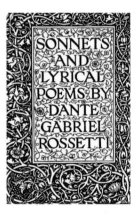

William Morris
Cover for Dante Gabriel Rossetti's
Sonnets and Lyrical Poems
From *Pan*, No. 4, Vol. 2, 1896
Gravure
Besides his involvement with arts
and crafts, Morris continued to write
poetry. He also translated Icelandic
sagas and Greek myths and
published his own works. Morris –
more consistent than any of his
artistic predecessors – saw the book
as an integral work of art, and
consequently set up his own printing
press and publishing house, the
Kelmscott Press, in the London
district of Hammersmith in 1891.
When Morris died in 1896, he had
published over 20 works under the
name of Morris Prints.

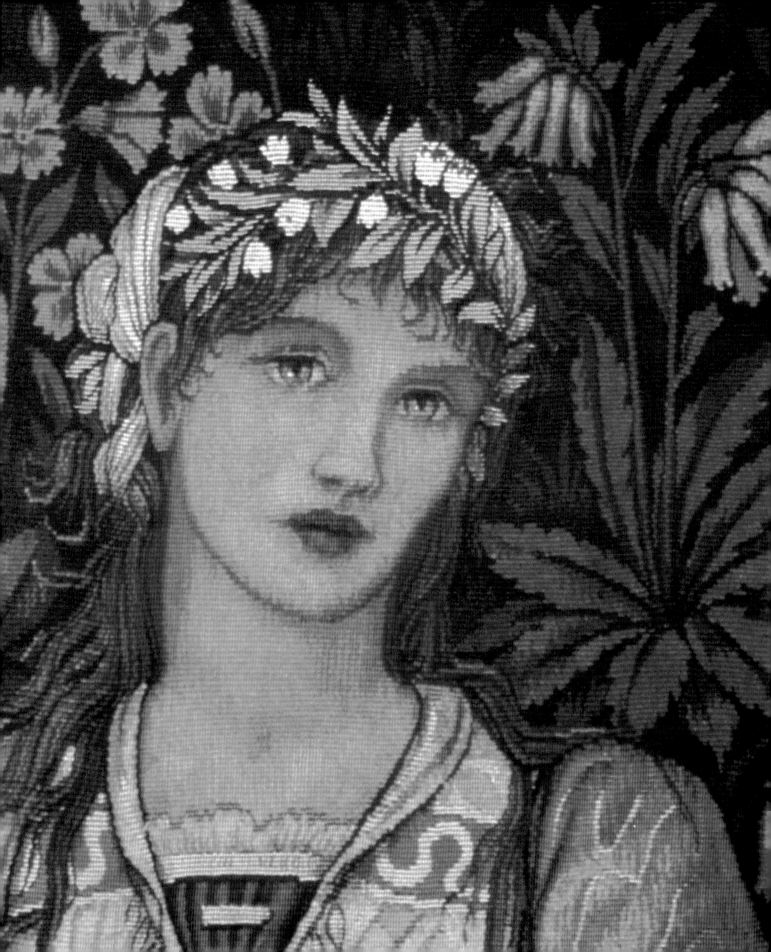

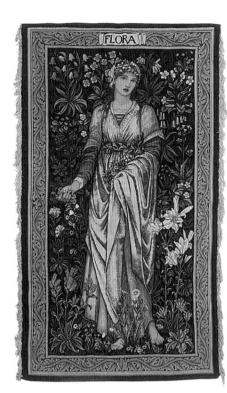

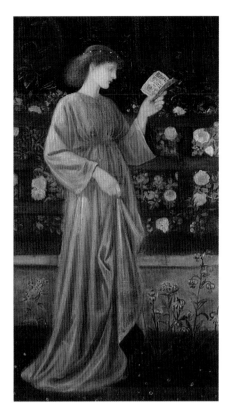

Left and above left:
**Edward C. Burne-Jones,
J. H. Dearle**
Flora, wall hanging, detail (left) and
overall view (above left), ca. 1900
Woven wool, 164.5 x 96 cm
Made at Merton Abbey
The wall hangings made at Merton
Abbey from cartoons by Burne-
Jones are some of the most beautiful
pieces of work produced at that time;
Art Nouveau's rediscovery of the
impact of pictures has its roots in
these spectacular works of art.

trained as a house-painter and carpenter. At the same time, he traveled widely and wrote extensively. These literary works, in addition to a substantial inheritance, earned him financial independence. Yet, as he aged, he became peculiar, an oddball, lonely and embittered. If someone looked into his garden, hoping to catch a glimpse of the famous old man, he went "Boo!" and pulled a face. Nonetheless, the theories he expounded held true, despite so many inconsistencies. One of aesthete Ruskin's greatest merits will always be that he inspired his prize pupil, William Morris (1834–96), to act on his words, and that he vehemently supported the Pre-Raphaelite Brotherhood.

The Pre-Raphaelites

People who dream in broad daylight learn about things which are never revealed to those who dream at night.
Dante Gabriel Rossetti[3]

The initiators of the Brotherhood were the Scot William Dyce (1806–64) and Ford Madox Brown (1821–93). They wanted to unite art and ethics and to replace soulless routine and conventional arrangements with a reverent, vivid study of nature. Their model was Italian painting before Raphael. For them, Raphael had spoilt art with his superficial paintings which were the epitome of the High Renaissance. The great master of the Pre-Raphaelite Brotherhood was Dante Gabriel Rossetti (1828–82) who, starting from the naive simplicity of the quattrocento ideal, wandered ever further into a wonderful, neurotic land of dreams. Many characteristics of Pre-Raphaelite painting are mirrored in Art Nouveau: solemn composition, strong axial alignments riddled with symbolism, and the myth of woman. "Her choice beauty was completely harmonious, yet had a slight trace of melancholy. She appeared tortured by very bitter memories. Her smile was wistfully attractive."[4] This was mingled with a highly developed sensitivity for line and color.

Edward C. Burne-Jones
Princess Sabra, or *The King's
Daughter*, 1865–66
Oil on canvas, 105 x 61 cm
Musée d'Orsay, Paris
Many characteristics of Pre-
Raphaelite painting are mirrored in
Art Nouveau: solemn composition,
strong axial alignments riddled with
symbolism, and the myth of woman.
"Her choice beauty was completely
harmonious, yet had a slight trace of
melancholy. She appeared tortured
by very bitter memories. Her smile
was wistfully attractive." (Frédéric
Boutet, see note 4)

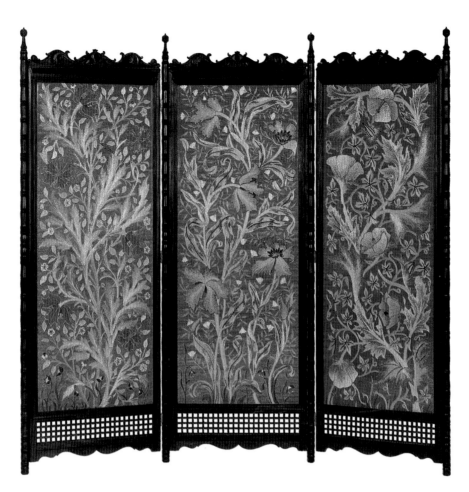

May Morris
Screen for the Sanderson family's drawing room, Bullerswood, Chislehurst, Kent, ca. 1889
Silk embroidery, carved mahogany frame, 184 x 186 cm
Made by William Morris & Co.

The link between the Pre-Raphaelites and Art Nouveau and William Morris was Edward C. Burne-Jones (1833–98) (ill. p. 29), the youngest of the Brotherhood, who transmuted symbolism to decoration: "Symbolic form becomes magnificent, sumptuous ornamentation."[5] The friendship between Morris and Burne-Jones dates to their student days at Exeter College, Oxford. Together they discovered the ideas of Ruskin and Carlyle, and medieval literature (ill. p. 26), particularly that of Geoffrey Chaucer (ca. 1343–1400) and Sir Thomas Malory (ca. 1408–71). They became committed medievalists and visited numerous old churches, including journeys to the cathedrals of northern France. These trips strengthened their conviction that they did not want to devote their life to the church, as they had originally intended, but to art: Morris chose architecture and Burne-Jones settled for painting.

William Morris – whom all Art Nouveau artists claim as their mentor – was like his spiritual father, Ruskin, in that he was repelled by capitalism. Yet he did not look to the past, but rather to the future, where people would be "art-loving creatures", free from the clutches of capitalism and of the industrial world.

William Morris and the Arts and Crafts Movement

My home is my castle.
William Morris

"He [Morris] came to arts and crafts in a rather unusual way. He got married and started to set up a home, yet found no furniture in any of the London stores that he wanted to have in his house. So he decided to make all his furniture and furnishings himself. This could be seen as the first step towards the founding of his company, William Morris and Co. Morris really had learned and practised a number of crafts, yet his company did not develop into any old

handicraft business. It also produced beautiful printed books. One could safely say Morris's company reformed book printing, yet book printing is not a craft; far more, it is the first in a serial production of great style. ... William Morris, writer, painter, craftsman, and socialist, was totally dedicated to reform. This, or rather the desire for a complete change in human culture, was the bond which held his various activities together. ... The results stretch far into our century and far beyond the borders of England. ... Even the Deutscher Werkbund, founded in 1907 and still active, was shaped by Morris's influence; it was also to play a major role in extending the reaches of this influence."[6] In tune with the principles of medieval art as depicted by Ruskin in *The Stones of Venice* and in *The Seven Lamps of Architecture*, a group of artists came together for the building of Morris's Red House. "Morris commissioned Philip Webb to build him a house which, at the time it was built in 1858, was shockingly simple. And Morris tolerated this, for his house was designed to meet the simple needs of a middle-class citizen and craftsman. He decorated the rooms himself, together with his painter friend, Burne-Jones. ... Yet Morris packed as much decorative art as possible into the clear framework of the rooms. Morris's house can clearly be treated as the paradigm of his doctrines, of how art blossoms forth from the work of the craftsman and of how the craftsman's work is already more than just a basis for art. ... The first time I was there [at The Red House] was many long years ago. I was quite cheeky: I simply rang the bell. The architect's wife answered the door. ... I took the opportunity of asking her: 'Dear lady, with all due respect, what is it like living in the great man's slippers?' She replied: 'It's not like you think it is. This house is so human, the atmosphere is good and livable in that one can be quite happy here without even giving a thought to Morris. I am

Philip Webb
The Red House, entrance facade, Bexley Heath, Upton, 1858
"Morris commissioned Philip Webb to build him a house which, at the time it was built in 1858, was shockingly simple. And Morris tolerated this, for his house was designed to meet the simple needs of a middle-class citizen and craftsman. He decorated the rooms himself, together with his painter friend, Burne-Jones. ... Yet Morris packed as much decorative art as possible into the clear framework of the rooms. Morris's house can clearly be treated as the paradigm of his doctrines, of how art blossoms forth from the work of the craftsman and of how the craftsman's work is already more than just a basis for art." (Julius Posener, see note 7)

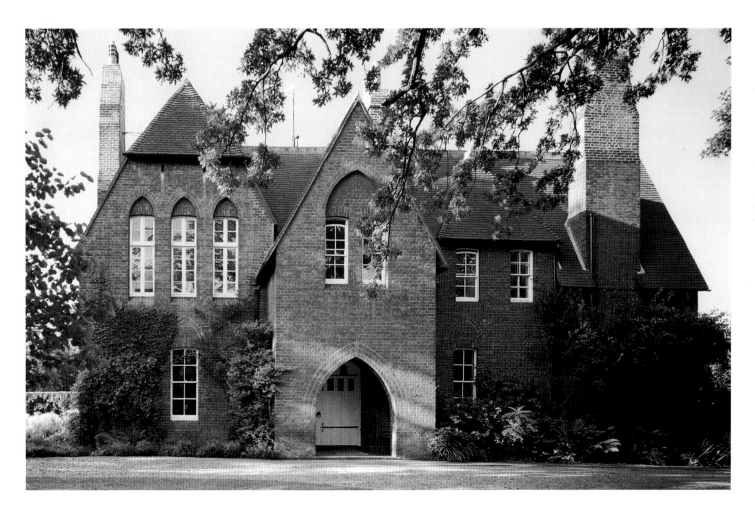

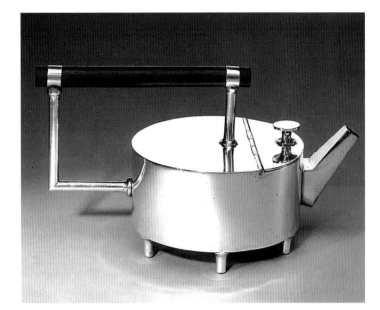

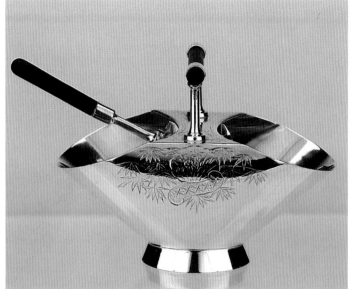

Christopher Dresser
Teapot, 1879
Plated, ebony handle, 12 cm in
height and diameter
Made by James Dixon & Sons
Christopher Dresser, a
contemporary of Morris, was the
first to produce work void of
ornamentation but with severe lines
where, with the minimum use of
materials, form and decoration were
secondary to the presence of the
substance, and where the actual
function of the object stood in logical
relation to the design. The result was
a formal discipline which has echoed
through the designs of the 20th
century.

especially happy for the children.' This Red
House was a manifesto. ... And I tell you, it is a
real delight, a quite charming, habitable house. It
cries out against poor design, against shabbiness
and trash, where the true form is hidden beneath
decoration or where decoration makes the form
bearable."[7] With all the revolutionary socialism
Morris preached, art and the artist were both the
starting and finishing point. There is a famous
story of a friend who paid Morris a visit one
day and found him working hard at his bench.
He asked Morris: "What beautiful things are
you making there, William?" Morris answered:
"By the sweat of my brow I'm making simple
furniture that is so expensive only the wealthiest
capitalists will be able to buy it."[8]
Morris created a kind of sect, made up of the
artist craftsmen of the Arts and Crafts
Movement and their followers and customers.
This group did not wish to discredit the machine
entirely, however. On the contrary, they believed
that designing models and choosing materials
for industrial manufacturing processes should
be jobs designated to artists. This was not
considered a form of degradation, but as a new
task and challenge for the productive artist.

The Guilds

The beauty of form is nature's inner reason made visible.
Karl Friedrich Schinkel[9]

The Arts and Crafts Movement found concrete
expression in the various societies and organ-
izations formed in England during the second half
of the 19th century. The Century Guild, a
workshop for interior design, was founded by
Arthur Heygate Mackmurdo (1851–1942) and
Selwyn Image (1849–1930) in London in 1882.
The association produced all kinds of decorative
work and it is often difficult to ascertain which
artist designed what as, in accordance with the
ideal of the medieval guild, work was presented
as the product of a cooperative. In 1884, the first
issue of *The Hobby Horse*, a journal which
publicized the Century Guild's ideals and
achievements, was published. "[This] was, at the
time of its appearance, a work quite unique of
its kind. Never before had modern print been
treated as a serious art, whose province was to
embrace the whole process, from the selection
and spacing of the type and the position of the
printed matter on the page, to the embellishment
of the book with appropriate initials and other
decorative ornaments."[10] *The Hobby Horse* was
the first of many magazines in England to aid the
popularization of the new art in England and on
the Continent (ill. p. 35). Apart from John Ruskin's
rather less successful St George's Guild, the
Century Guild was the first association of artist
craftsmen to put into practice methodically the
ideas of the Aesthetic Movement; it was the first

Christopher Dresser
Sugar crystals bowl and spoon, ca.
1875
Silver-plated metal and ebony
Sugar bowl: 12 x 17 x 9.5 cm
Spoon: 14.3 cm in length
Made by J. W. Hukin &
J. T. Heath, Birmingham
Musée d'Orsay, Paris

to turn away from the gothicizing devices initially so admired, and – as shown by Mackmurdo's graphics, for example – to produce early evidence of an almost Continental Jugendstil. The Art Worker's Guild was founded in 1883, the Home Arts and Industries Association in 1889 and the Wood Handicraft Society in 1892. Among the initiators and leading members of these organizations were Charles Robert Ashbee (1863–1942), Walter Crane (1845–1915), William Morris, Arthur Heygate Mackmurdo and Christopher Dresser (1834–1904). Dresser, a contemporary of Morris, was the first to produce work void of ornamentation but with severe lines where, with the minimum use of materials, form and decoration were secondary to the presence of the substance, and where the actual function of the object stood in logical relation to the design. The result was a formal discipline which has echoed through the designs of the 20th century (ill. opposite page, p. 37, p. 43). Dresser did not only contribute greatly to applied art in England; he was also one of the great protagonists of Japonisme, awakened by a journey to the Far East in 1876. He went on to organize the relatively short-lived Art Furniture Alliance, whose members manufactured furniture and metalwork in the Japanese style. He was also inspired by Pre-Columbian and Asian pottery and by the vocabulary of forms of Islam, India, China, classical antiquity and the Celts.

Morris & Co. – Merton Abbey – The Kelmscott Press

In 1861, the pioneering cooperative became a constitution, namely that of Morris, Marshall, Faulkner & Company. The company aimed to produce all sorts of ornamentation and ornamental objects. Its founder members were William Morris, Peter Paul Marshall (1830–1900), Charles J. Faulkner (1834–1892), Philip Webb (1831–1915), Dante Gabriel Rossetti, Ford Madox Brown and Edward C. Burne-Jones. In 1875, the original partnership was disbanded and the enterprise was renamed Morris & Co. Morris reorganized the company, which had previously stood under the sign of medievalism, and now specialized in printed wallpaper and textiles (ill. p. 27), a step which also bought the company commercial success. Natural plant and vegetable dyes, traditional weaving forms and the revival of hand-printing all contributed to the high quality of the designs. Morris's commitment to his new avenue of design was at its peak when he bought the textiles factory at Merton Abbey in

1881. The wall hangings printed here from cartoons by Burne-Jones are some of the most beautiful pieces of work produced at that time; Art Nouveau's rediscovery of the impact of pictures has its roots in these spectacular works of art (ill. p. 28, p. 29). Walter Crane and Charles Francis Annesley Voysey (1857–1941) also designed wall hangings for Morris, who expanded his company in various directions. In the 1890s, Morris bought the Pimlico furniture factory in the Netherlands and began making tiles and jewelry, also concentrating on working with glass. He was no longer interested, as at the beginning of his career, in antiquarian glass windows, but in simply decorated drinking glasses, manufactured at James Powell and Sons' workshop in Whitefriars, London. The elegant design of the thin glasses was a stark contrast to the "glass art" of his contemporaries and found few buyers. Today we can recognize in them the antecedents of modern glass design (ill. p. 33).

Besides his involvement with arts and crafts, Morris continued to write. He also translated Icelandic sagas and Greek myths and published

Harry James Powell
Cup, before 1902
Blown optical flint, with thread inlay and cut decoration, 21 cm in height
British Museum, London
The elegant design of the thin glasses manufactured by James Powell and Sons workshop was in stark contrast to the "glass art" of his contemporaries and found few buyers. Today we can recognize in them the antecedents of modern glass design.

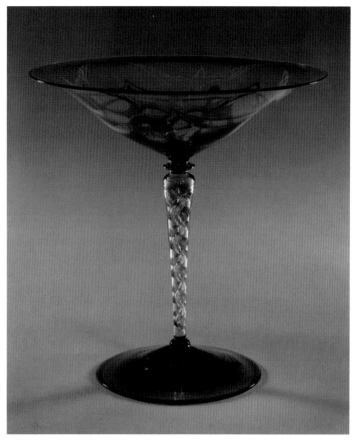

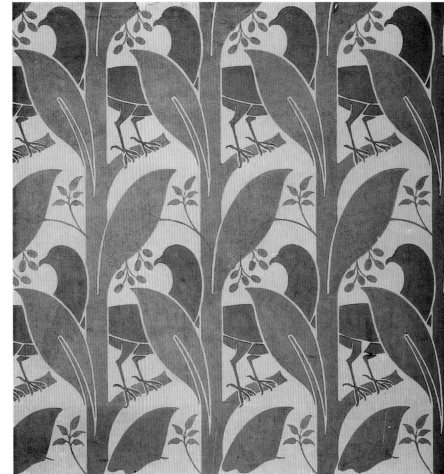

Charles Francis Annesley Voysey
Thank-you card, 1901
Three-color print on a colored
background, 57 x 51.5 cm
Made by Essex & Co., Battersea,
London
Whitworth Art Gallery, University
of Manchester
The architect Charles Francis
Annesley Voysey rejected the notion
that architecture is an "occult being"
and stressed that like any other form
of art, architecture had its roots in
good, quality work and should have
some connection with everyday life,
with the good life, where well-made
objects are treasured. He
consequently expanded his range of
activities to include graphics, and
furniture, carpet, wallpaper, and tool
design. He was thus a true Art
Nouveau artist in the best sense of
the word, an *architecte d'art*, as his
famous French colleague, Hector
Guimard, liked to call himself.

his own works. Morris – more consistent than
any of his artistic predecessors – saw the book
as an integral work of art, and consequently set
up his own printing press and publishing house,
the Kelmscott Press, in the London district of
Hammersmith in 1891. When Morris died in
1896, he had published over 20 works under the
imprint of Morris Prints. Equal importance was
attached to type, illustration, and bordering:
Morris designed the three most important
typefaces – Golden Type, Troy Type, and Chaucer
Type – himself. Morris's edition of the works of
Chaucer, with illustrations by Burne-Jones, is the
embodiment of perfect craftsmanship, and his
artists' printing press was to be a decisive
contributory factor to the further development of
book art (ill. p. 26).

The Dial – The Studio

The magazine *The Dial* was published by Charles
Ricketts (1866–1931) and Charles Shannon
(1863–1937) as early as 1889 in an attempt to
bridge the gap between tradition – printing
inspired by the Middle Ages – and Art Nouveau's
graphic forms of expression (ill. opposite page).
Woodcuts printed in *The Dial* in 1893 were
expressly referred to as "an experiment in line"
The magazine which took over the role of
intermediary to the Continent was *The Studio*,
established in London in 1893. Acting as a kind of
representative for current trends and events in
English art and the numerous craft guilds, *The
Studio*'s influence spread throughout the whole
of Europe, and as a reciprocal action introduced
similar efforts in other countries to interested
parties in England by publishing essays and
illustrations from abroad. Special issues were

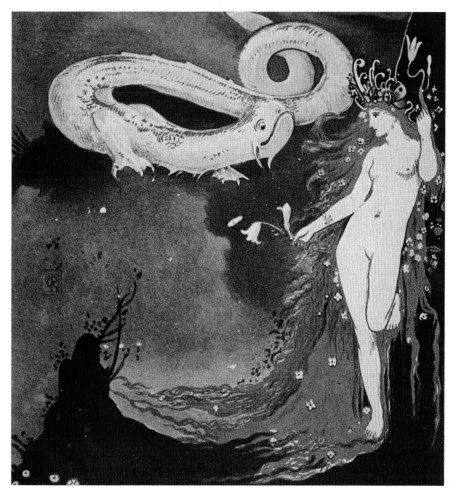

Charles Ricketts
The Great Worm
From *The Dial*, No. 1, 1889
Color lithograph, 24 x 16.5 cm
The magazine *The Dial* was
published by Charles Ricketts and
Charles Shannon as early as 1889 in
an attempt to bridge the gap between
tradition – printing inspired by the
Middle Ages – and Art Nouveau's
graphic forms of expression.
Woodcuts printed in *The Dial* in
1893 were expressly referred to as
"an experiment in line".

Arthur Heygate Mackmurdo
Cover for *The Hobby Horse*, 1893
Woodcut
In 1884, the first issue of *The
Hobby Horse* was published, a
journal which publicized the
Century Guild's ideals and
achievements. "[This] was, at the
time of its appearance, a work quite
unique of its kind. Never before had
modern painting been treated as a
serious art, whose province was to
embrace the whole process, from the
selection and spacing of the type and
the position of the printed matter on
the page, to the embellishment of the
book with appropriate initials and
other decorative ornaments."
(Aymer Vallance, see note 10)

printed, devoted to the École de Nancy or the
Wiener Werkstätte, for example. Without doubt,
The Studio was the most important source of
information on trends and developments in turn-
of-the-century art. Other significant "trendsetters"
were the regional and national exhibitions staged
by the Arts and Crafts Exhibitions Society, which
brought together individual communities of
craftsmen. According to its rules, the exhibitions,
accompanied by a full program of events, were
intended to acquaint a broad section of the public
with the leitmotiv of arts and crafts as a single
entity.

Charles Robert Ashbee – The Guild and School of Handicraft

*We are here to lead you back to the realities of life, to show
you how to use your hands and your heads which your
machines have already made over half of the population
lose.*
Charles Robert Ashbee[11]

The hidden problems behind all reformist and
aesthetic ideas become evident if we take a look
at the fate of the designer Charles Robert
Ashbee, one of Morris's followers (ill. p. 39). The
Guild and School of Handicraft grew out of a
small workshop Ashbee set up in 1888 in
London's East End. "Ashbee collected a group
around him who thought the same way as he
did. But they soon discovered that they could
not afford to stay in London. They made very
expensive luxury items. Ashbee himself was a

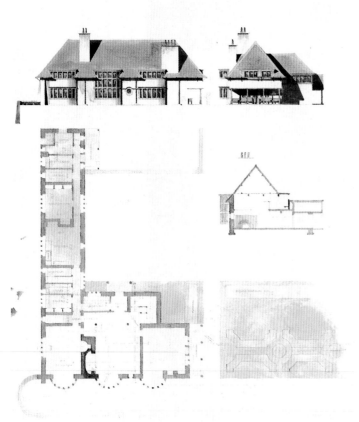

Charles Francis Annesley Voysey
House for A. Currer Briggs, Lake
Windermere, Lancashire, 1898
Watercolor
Victoria and Albert Museum,
London

year previously, the group had disbanded, and
Ashbee, the man of reform, had had to ask some
very rich people for help, hoping they would
continue to support the experiment as a hobby.
His endeavor was the tragicomical lid on the Arts
and Crafts Movement."[13]

Ashbee was a generation younger than Morris;
he had already become accustomed to "modern
life" and had, as Lenin put it, been corrupted by
reform. In the end, Ashbee's ideals boiled down
to special rights for artists and craftsmen – very
much out of step in the age of capitalism.

Ashbee's Guild was finally wiped out by
Liberty's. The farmer craftsmen were unable to
withstand competition from a company which
manufactured quality products in series and sold
them at low prices. Only really wealthy people
could afford to buy objects like the ones Ashbee
made, such as elegant Art Nouveau silverware.
Liberty's was, quite simply, much cheaper. Yet
despite this, the Guild of Handicraft was a father
figure for the countless organizations functioning
in the same spirit on the Continent. In 1902,
Ashbee was made an honorary member of the
Munich Art Academy and made a lasting impres-
sion on that institution. The Wiener Werkstätte
was founded following the example of Ashbee's
Guild; van de Velde acknowledges the influence
of Ashbee, and the Deutscher Werkbund carried
on the movement initiated by the English
"socialist and artist craftsman", as Hermann
Muthesius ironically called him.

Charles Francis Annesley Voysey – The house as a work of art

*... he was just a craftsman who could know nothing of the
power, majesty and splendor of that wonderful occult
being we call architecture.*
Richard William Lethaby[14]

The architect Charles Francis Annesley Voysey
rejected the notion that architecture is an "occult
being" and stressed that, like any other form of
art, architecture had its roots in good, quality
work and should have some connection with
everyday life (ill. above), with the good life,
where well-made objects are treasured. He
consequently expanded his range of activities to
include graphics, and furniture, carpet, wallpaper,
and tool design. He was thus a true Art Nouveau
artist in the best sense of the word, an *architecte
d'art*, as his famous French colleague, Hector
Guimard (1867–1942), liked to call himself.
Voysey's development was that of Morris in
reverse; whereas Morris went from literature

silversmith."[12] (ill. opposite page). Nevertheless,
the Guild's principles were based on non-
capitalist theories; individual product designs
were developed in group discussions. "As
Ashbee couldn't stay in London, he and his
friends moved in 1902 to Chipping Campden, a
town in the countryside not far from Oxford.
There they planned to set themselves up as
farmers and craftsmen. There was, of course,
also an ideology behind this exodus; or perhaps
one would be more correct in saying that Ashbee
slapped an ideology onto it. In any case, Ashbee
developed his theory of the farmer craftsman
down to the last detail in his book *Craftsmanship
in Competitive Industry*, published in London in
1908. This was late indeed: it was, in fact,
Ashbee's last attempt to save or rather to re-
establish the group in Chipping Campden. The

Christopher Dresser
Jug, 1874
Glazed Böttger stoneware, silver lid,
17.3 cm in height (with lid)
Made by Watcombe Pottery,
Torquay, Devon
Badisches Landesmuseum
Karlsruhe, Museum beim Markt –
Angewandte Kunst seit 1900

and crafts to concentrate also on architecture, Voysey came from architecture to explore other forms of artistic expression. The Red House Philip Webb built for Morris was undoubtedly the catalyst for the tremendously influential English Country House Movement. The Red House (ill. p. 31) was, however, seen as the architectural manifestation of the ideas of the Morris circle and not as the independent revival of house-building as had been originally intended. The next generation of artists united both factions of the movement, combining innovations in house-building and handicrafts, and came up with interior design, the flagship of Art Nouveau. It was the logical conclusion of the whole aesthetic process. Yet the architect now faced a much more complex range of tasks than his forefathers had. The house, a simple unit of accommodation, should become a work of art. Architects started to consider seriously the various functions of the house and in England were reminded of the medieval manor house in the process, of the estate as an intricate amalgam of necessary, functional buildings. The planning of Voysey's own house is highly concentrated yet architec-turally matches the simplicity of its medieval model. This simplicity heralded him as a pioneer of modern architecture. The various permutations of English manor house adopted by the Continent between 1900 and the 1930s were more suburban villa than manor house (the latter being a feature of the country), thus no longer effecting a strict cohesion of form and function. An interview with Voysey was published in the first issue of *The Studio* in 1893; its contents were greedily devoured and quickly put into

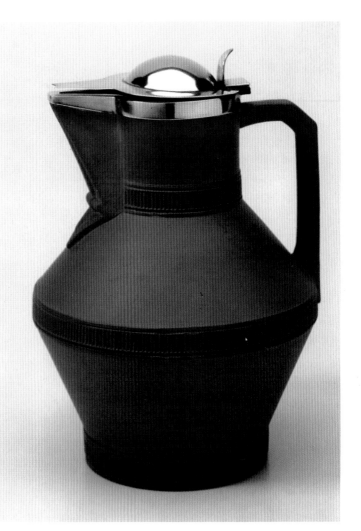

Charles Robert Ashbee
Dish with handle, 1905–06
Chased silver and amethyst, 18 cm in length (with handle), 10.7 cm in diameter
Made by the Guild of Handicraft
Badisches Landesmuseum
Karlsruhe, Museum beim Markt –
Angewandte Kunst seit 1900
"We are here to lead you back to the realities of life, to show you how to use your hands and your heads which your machines have already made over half of the population lose." (Charles Robert Ashbee, see note 11)

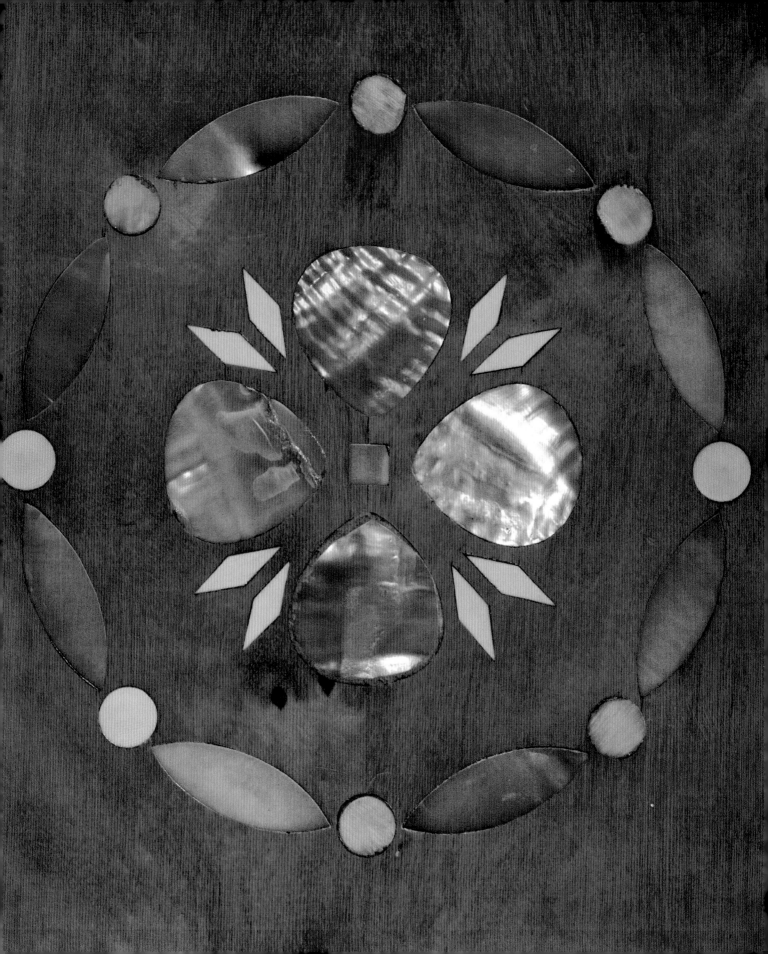

Mackay Hugh Baillie Scott
Chair with armrests, detail of the
back (left page) and view of the back
(right), 1900–01
Beech, ivory, mother-of-pearl,
82 x 61.8 x 39.5 cm; exhibited in
Dresden in 1903 at the Deutsche
Werkstätten für Handwerkskunst
(German Workshops for Arts and
Crafts)
Baillie Scott borrowed some of the
sweeping decoration on his furniture
designs from pictures by Burne-
Jones and in his artistic euphoria
often exceeded the level of
ornamentation usual in England at
that time. Baillie Scott received
many commissions from the
Continent, where his cheerful and
seemingly less static creations had
quickly met with an enthusiastic
reception.

practice by avid "reformers" on the Continent. The architect Mackay Hugh Baillie Scott (1865–1945) also devoted himself to interior design, working as a furniture designer and in many other areas of arts and crafts. He borrowed some of the sweeping decoration on his furniture designs from pictures by Burne-Jones and in his artistic euphoria often exceeded the level of ornamentation usual in England at that time (ill. opposite page and right). Baillie Scott received many commissions from the Continent, where his cheerful and seemingly less static creations had quickly met with an enthusiastic reception.

Arthur Lasenby Liberty – Art and commerce

That beautiful child, art in its shining armor, will face the dragon of commercialism and slay him.
Henry van de Velde[15]

The craft guilds and brotherhoods in England vehemently opposed any form of commercialization, however thinly disguised, yet it was one of their own kind who was to commercialize arts and crafts on a scale previously unheard of. Arthur Lasenby Liberty (1843–1917) became *the* entrepreneur of Art Nouveau. Liberty had trained in business and, as the manager of the Farmer and Rogers department store in Regent Street in London, soon developed a commercial center for all kinds of arts and crafts, specializing in goods from the Orient. Spurred on by his success, and heeding the advice of his friend William Morris, Liberty opened his own store in 1875. He initially concentrated on increasing his stock of imports from the Middle and Far East and also designed his own collection of Oriental materials and wallpapers. His first team of employees was small and included Hara Kitsui, a Japanese man who was to become a source of reference for English artist craftsmen. Liberty's soon counted a growing number of English designers among its staff, including Dresser and Voysey, who reaped ideas from Liberty's Eastern Bazaar.

Impressed by the efforts of the Aesthetic Movement, Liberty tried in his own way to rejuvenate the applied arts, and his success was such that the words "Liberty" and "Art Nouveau" were often used interchangeably. The Liberty label was obtainable all over Europe, in Canada and in South Africa, sometimes in subsidiary branches of the store. Today, examples of this "modern English industrial production" fill the museum showcases of the world. The collection (or production) started out

Below:
Charles Robert Ashbee
Design for a cabinet, 1906
Watercolor, stamped "Handicraft
Ltd. 1095, 31.12.1906"
The Guild of Handicraft was a
father figure for the countless
organizations functioning in the
same spirit on the Continent. In
1902, Ashbee was made an
honorary member of the Munich
Art Academy and made a lasting
impression on that institution. The
Wiener Werkstätte was founded
following the example of Ashbee's
Guild; van de Velde acknowledges
the influence of Ashbee, and the
Deutscher Werkbund carried on the
movement initiated by the English
"socialist and artist craftsman", as
Hermann Muthesius ironically
called him.

Archibald Knox
Jug, 1903
Cymric; silver, cabochon stones, 18 cm in height
For Liberty & Co., London
Archibald Knox was Liberty's star designer. The admirer of
Celtic art took up a position in Dresser's studio, where he
encountered Japanese art and functionalism. His Cymric
designs adeptly and economically fused Celtic ornament with
functional line and contour. The Celtic name of the series did
not, however, tempt Knox into producing clumsy
reminiscences of past art.

with embroidery and textiles, rugs and carpets, and fashion and furniture; the Liberty Style quickly came into its own and reached its climax with Liberty's pewter, silverware and jewelry. Liberty's had its own silver hallmark in 1894, but it was not until the spring of 1899 that there was enough work in commission to launch the first Liberty silver series, Cymric. Liberty's formed a partnership with W. H. Haseler in Birmingham, who took over the main body of production. The new company needed creative impetus; it was crying out for talented, original designers. Rex Silver (1879–1965), then just 20, fitted into the scheme perfectly. With great verve, he produced forms and patterns which could be cheaply mass-produced without any loss of quality. Ornamental accents were added to the products in green-blue enamel instead of precious stones (ill. opposite page). Yet Liberty's star designer was Archibald Knox (1864–1933). The admirer of Celtic art took up a position in Dresser's studio, where he encountered Japanese art and functionalism. His Cymric designs adeptly and economically fused Celtic ornament with functional line and contour (ill. left, right and on p. 42). The Celtic name of the series did not, however, tempt Knox into producing clumsy reminiscences of past art.

Knox and Silver also provided designs for pewter objects and jewelry. Liberty's had been importing Art Nouveau pewter from Germany since 1899, primarily from the Kayser company in Krefeld. The material was especially suitable for "forming" the lines of the new style. The success of these imported items prompted Liberty's to create Tudric, its own line in pewter. From 1902 onwards, home-produced pewter objects began to feature in the Liberty catalogues. Their very individual design with modified Celtic forms and plant and flower motifs makes them easy to identify as Tudric pewter (ill. p. 25, p. 43).

The greatest advantage of Liberty's jewelry collection lay in the fact that it was financially accessible to a large section of the population. One did not need to be an expert in precious stones to enjoy Liberty's "gems"; the formal harmony of the object sufficed. The gold and silverwork of Frederick James Partridge (1877–1942), another Liberty designer, achieves a particularly masterly balance between symmetry and ornamentation (ill. opposite page).

Liberty's also provided innovative stimulus with its pottery and ceramic work, and especially with its wide range of imports from Asia. Renowned English manufacturers of ceramics, such as Royal Doulton Potteries (ill. bottom right), owed

Frederick James Partridge
Dragonfly necklace, ca. 1900
Gold, enamel, *plique-à-jour* enamel and moonstones, 40 cm in length
Sold by Liberty & Co., London
The greatest advantage of Liberty's jewelry collection lay in the fact that it was financially accessible to a large section of the population. One did not need to be an expert in precious stones to enjoy Liberty's "gems"; the formal harmony of the object sufficed. The gold and silverwork of Frederick James Partridge, another Liberty designer, achieves a particularly masterly balance between symmetry and ornamentation.

(Attributed to) Archibald Knox
Clock, 1903
Cymric; silver-plated copper, mother-of-pearl, lapis lazuli, 24.5 cm in height
For Liberty & Co., London

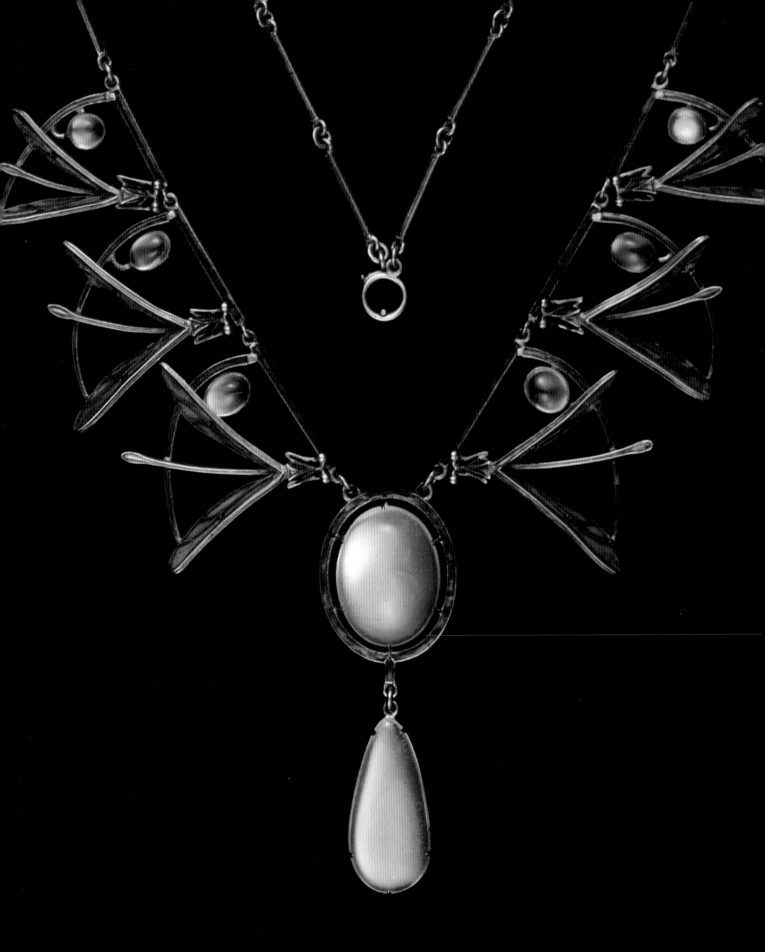

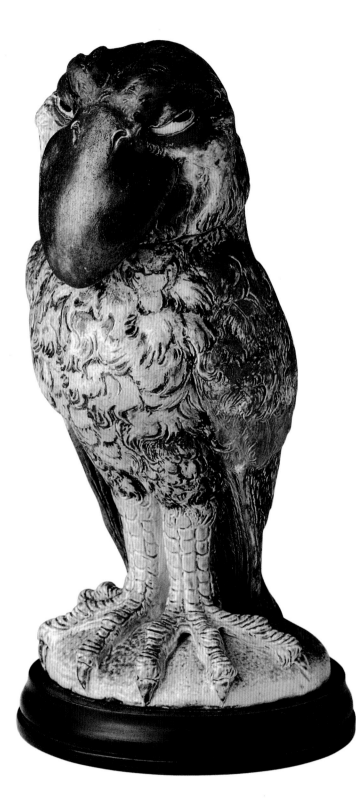

their international acclaim to Liberty's and its brilliant sales and marketing system. Liberty's was also the best promoter of Dresser's favored Clutha glass (ill. opposite page).

Nonetheless, there were designers who achieved recognition without the Liberty machine. These include the rather unconventional Martin brothers. Their commercial success was brought about by their "vegetable ware", containers and tableware in the shape of vegetables with "fruity" decoration. These sales triumphs enabled the four brothers – Robert Wallace (1843–1923), Walter (1859–1912), Edwin (1860–1915) and Charles (1846–1910) Martin – to open their own store and studio in London in 1879 and manufacture objects according to their own whims and fancies. Besides typical Art Nouveau ceramics, the brothers also molded birds and animals from the bizarre to the grotesque and heterogeneous beings wildly alienated from their intended purpose, such as owls as tobacco jars (ill. left). Amorphous shapes were characterized and reduced – a trait typical of Art Nouveau graphics. The Martin brothers certainly had a sense of humor – black humor which was very British.

(Attributed to) Archibald Knox
Vase, 1899
Cymric; silver, enamel, cabochon stones
19.5 cm in height
For Liberty & Co., London

Royal Doulton Potteries
Potpourri "Sung" vase, ca. 1900
Stoneware, underglass painting, flambé, with wooden base and lid, 28.3 cm in height
Designed by Arthur Eaton
Liberty's also provided innovative stimulus with its pottery and ceramic work, and especially with its wide range of imports from Asia. Renowned English manufacturers of ceramics, such as Royal Doulton Potteries, owed their international acclaim to Liberty's and its brilliant sales and marketing system.

Martin Brothers
Owl, tobacco jar, April 1899
Ceramic with colored salt glaze, 32 cm in height
Besides typical Art Nouveau ceramics, the Martin brothers also molded birds and animals from the bizarre to the grotesque, wildly alienated from their intended purpose, such as owls as tobacco jars. Amorphous shapes were characterized and reduced – a trait typical of Art Nouveau graphics. The Martin brothers certainly had a sense of humor – black humor which was very British.

Walter Crane – Line and form

Outline drawing is, so to speak, the be-all and end-all of art. It is the oldest form of expression for civilizations on the first level of culture and for every child, and has been preserved for its powers of characterization and expression and as the highest attestation to the art of drawing by the most outstanding artists of all time.
Walter Crane[16]

Apart from the various groups and associations which together made up the Art Nouveau movement, it was basically the efforts of two artists, Walter Crane and Aubrey Vincent Beardsley (1872–98), which helped shape and further the new style. Both men began their otherwise totally adverse careers as followers of Morris and the Pre-Raphaelites. They were also fascinated by the modernist tendencies apparent in the work of William Blake (1757–1827). Blake, the romantic symbolist, had at the end of the 18th century begun to pave the way for a number of trends in art; he challenged the sterile stylistic tendencies of the day with his artistic ensembles and with the rhythmic lines of his paintings and illustrations, later also a feature of crafts designs.

Blake's floating, dreamy figures are caught up in twirling arabesques like drifts of smoke; his bequest, his sweeping line, was adopted by Art Nouveau as its hallmark. This affinity with lines, the way they intertwine and weave densely across surfaces, has been an exceptional quality of English art since the Celts.

Walter Crane belonged to a generation between the Pre-Raphaelites and Art Nouveau and was the mentor of the entire movement. A prominent theoretician, his writings were translated into many languages and exerted – together with his wide range of works – much influence in America and Europe. From 1888 onwards he was the leading member of the Arts and Crafts Exhibitions Society, having a strong hand in the organization of their international program, and was one of the most dedicated members of Morris's Kelmscott Press. Crane's tract, *Line and Form* (London 1900), is considered one of the most important ideological works written by an artist at the turn of the century. "Here we seem to be able to detect a kind of progression in the expressive possibilities of the line – the poles at both ends; the horizontal and the vertical with all

Christopher Dresser
Jug, 1880
Clutha glass with inclusions of silver leaf, 18 cm in height
Made by James Cooper & Sons, Glasgow
For his glassware Dresser used Clutha glass, developed by the Glasgow company Cooper & Sons in the 1890s and named after the River Clyde in Scotland (Clutha in Old English). This green, turquoise-brown or gray-colored glass mass mixed with copper crystals and streaked, striped or peppered with small bubbles is reminiscent of the river's dull waters.

(Attributed to) Archibald Knox
Bowl for confectionery with glass dish, 1903
Tudric pewter, Clutha glass, 17 cm in height
Made by W. H. Haseler, Birmingham
Sold by Liberty & Co., London
The success of Liberty's imported items prompted the store to create Tudric, its own line in pewter. From 1902 onwards, home-produced pewter objects began to feature in the Liberty catalogues. Their very individual design with their modified Celtic forms and plant and flower motifs makes them easy to identify as Tudric pewter.

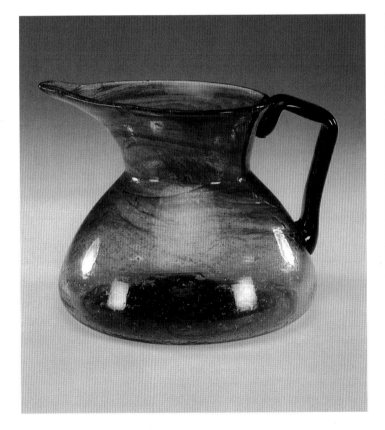

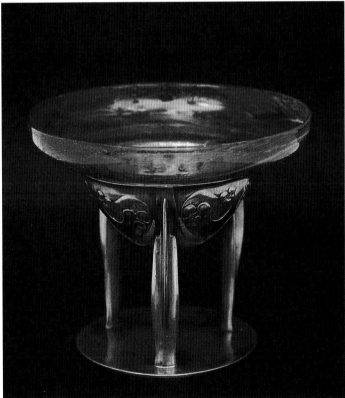

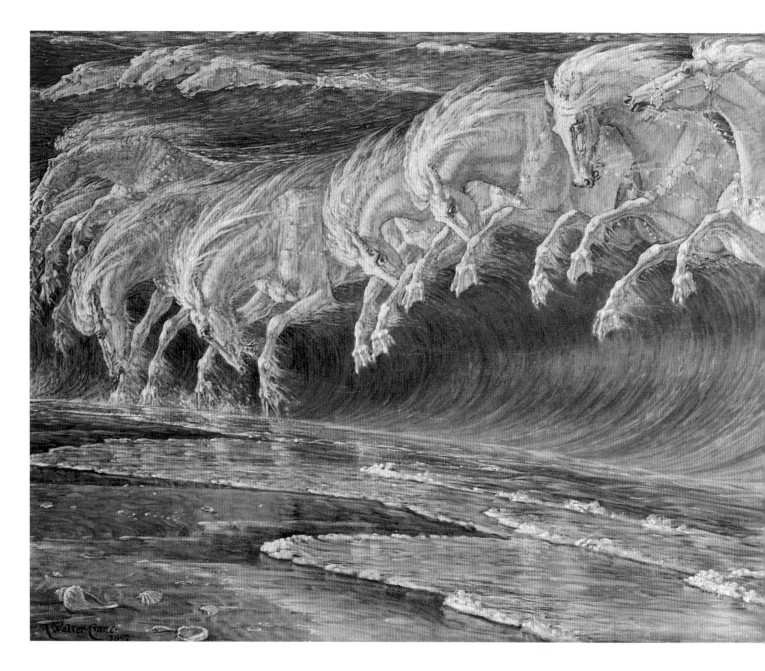

kinds of gradation and transition between them; the line of waves which lends expression to the strong, upward spiral, the meander, the flowing line approaching the horizontal: or the sharp contrast and clash of right angles. The artist can without doubt unleash a great expressive force in his mastery of the pure line. Indeed, the line, as I mentioned above, is a language, a highly sensitive and expressive language with many dialects, which can be adjusted to suit any

purpose and which is indeed imperative for all kinds of line drawing."[17] (ill. p. 47). With his words, Crane seems to be describing the true essence of Art Nouveau, and indeed he lived the ideal of the times in his work. Crane was the personification of the artist-designer: he was a painter, graphic artist, illustrator, and book artist; he designed textiles, glass windows, ceramics (ill. p. 47), jewelry, and posters. Crane loved Florentine quattrocento art, a love he shared with

Walter Crane
Neptune's Horses, 1892
Oil on canvas, 86 x 215 cm
Bayerische
Staatsgemäldesammlungen, Neue
Pinakothek, Munich
Crane's figures are an inimitable incarnation of the spirit of the age in their fairy-tale, dream-like metamorphosis. The omnipotence of Nature is allegorical in its transcription and almost decorative in its elucidation. Neptune's horses

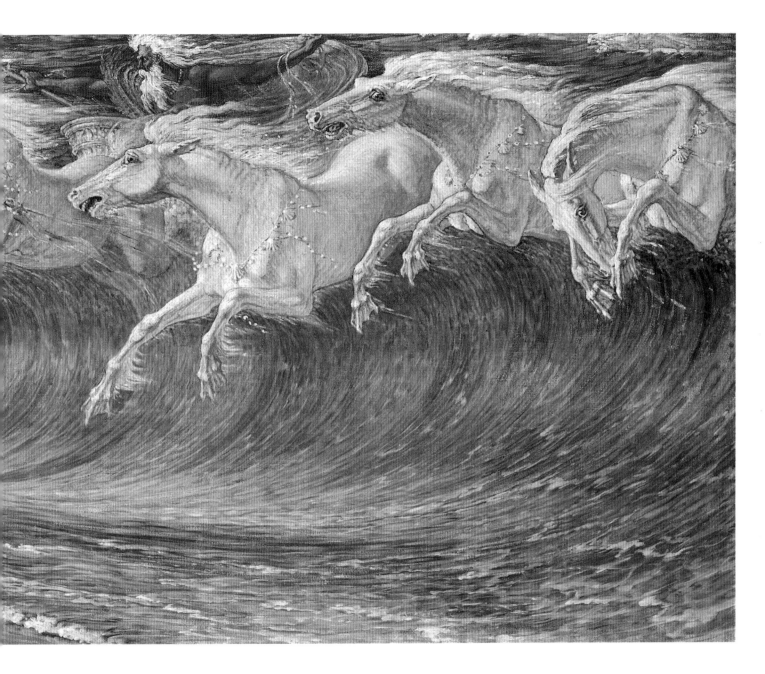

move both within the confines of the balanced lines and at the same time seem to break free, giving strength to the picture's almost surreal subject. The wave motif illustrates the proximity of Crane's painting to Japanese graphics. Yet whereas Hokusai's famous wave in his *The Great Wave – In the Hollow of the Wave off the Coast at Kanagawa* remains firmly rooted to the surface, Crane's wave seems to come alive and burst its bonds.

his friend Burne-Jones, and was deeply impressed by the colored woodcuts from Japan. "The Japanese, who draw with brushes, have become accustomed to executing drawings without the use of preliminary sketches; the charm of their work is evoked first and foremost by the piquant freshness of their brushstrokes which can only be affected using their direct methods. Their main aim is to create a completely intimate relationship between the

eye and the hand, so that the latter accurately records what the former perceives."[18] It is precisely this combination of stylistic methods and original symbolic language which generates the ethereal effect of Crane's book illustrations, paintings, and tapestries. His figures are an inimitable incarnation of the spirit of the age in their fairy-tale, dream-like metamorphosis (ill. p. 46). The omnipotence of Nature is allegorical in its transcription and almost decorative in its

elucidation. Neptune's horses move both within the confines of the balanced lines and at the same time seem to break free, giving strength to the picture's almost surreal subject. The wave motif illustrates the proximity of Crane's painting to Japanese graphics. Yet whereas Hokusai's famous wave in his *The Great Wave – In the Hollow of the Wave off the Coast at Kanagawa* remains firmly rooted to the surface, Crane's wave seems to come alive and burst its bonds (ill. p. 44–45). "Walter Crane [was] a master of line and primarily a genius of decoration, who thus seemed to have more of an effect on handicrafts than on painting … [He] was a born teller of fairy tales…"[19]

James Abbott McNeill Whistler – Mists of Light

**Only truly good painting can give children rosy cheeks.
John Ruskin[20]**

Another of the great inspiring forces living at the turn of the century was James Abbott McNeill Whistler (1834–1903), who also alienated the impressions of nature in his paintings, albeit in a completely different way from Crane. Whistler's influence was restricted mainly to painting, although he occasionally dabbled in crafts, designing house interiors for his friends. His ability to transgress this line probably stems among other things from his admiration for Japanese art, which is not bound by dignity within artistic creativity. In Whistler's work we can recognize the two-dimensionality of

Walter Crane
Illustration for *A Floral Fantasy in an Old English Garden* (detail),
London 1899
Autotype, 19.9 x 14 cm

Then lilies, turned to Tigers, blaze
Amid the gardens tangled maze

Walter Crane
Skoal (Cheers!), vase, 1898–1900
Ceramic, painted in ruby red,
23.5 cm in height
Made by Man & Cie
Iparművészeti Múzeum, Budapest
Crane was the personification of the artist-designer: he was a painter, graphic artist, illustrator, and book artist; he designed textiles, glass windows, ceramics, jewelry, and posters. He loved Florentine quattrocento art, a love he shared with his friend Burne-Jones, and was deeply impressed by the colored woodcuts from Japan.

Japanese surface ornament in the contours of his figures and in his shallow silhouettes, which vanish in the diffuse light like ghosts (ill. p. 48). A cosmopolitan, equally at home in America, France or England, Whistler refused to join one of the guilds. He alienated his objects to such an extent – as an opponent of anything natural he concentrated on portraying the products of his imagination – that Ruskin condemned Whistler's pictures as sorry, inartistic efforts: according to Ruskin, painting which dispersed all lines and objects was not art. Whistler lost a court case against his critic, but held his sway on Art Nouveau painting. Art Nouveau gradually shirked any form of middle-class, academic aesthetics and became a mood medium. "London fog was nonexistent until art discovered it,"[21] said Oscar Wilde, meaning Whistler. Like Wilde, a bogey of the middle classes, full of coxcomb elegance, Whistler was the embodiment of that English phenomenon: the dandy.

Oscar Wilde and Aubrey Vincent Beardsley – The virtue of vice

As the dawn broke, Pierrot fell into his last sleep. Then upon tiptoe, silently up the stair, noiselessly into the room came the comedians Arlecchino, Pantaleone, il Dottore, and Columbina, who with much love carried away upon their shoulders, the white-frocked clown of Bergamo; whither, we know not.
Aubrey Vincent Beardsley[22]

Oscar Wilde (1854–1900) and Aubrey Vincent Beardsley, the darlings of society for only a brief period in their lives, died as outsiders. Yet especially Beardsley's short life seems to reflect all those elements which aesthetically and artistically molded the turn of the century. The dandy, that hero of total artificiality, icily rejecting anything natural and striving for ultimate self-portrayal and absolute originality in an age when rigid hierarchical patterns were beginning to give way to democratic uniformity, was an identity

Walter Crane
Flora's Feast, 1892
Illustration for Flora's Feast / A Masque of / Flowers / Penned & Pictured / by / Walter Crane, 25 cm in height
Cassell & Co. Ltd., London – Paris – Melbourne
"The artist can without doubt unleash a great expressive force in his mastery of the pure line. Indeed, the line, as I mentioned above, is a language, a highly sensitive and expressive language with many dialects, which can be adjusted to suit any purpose and which is indeed imperative for all kinds of line drawing." (Walter Crane, see note 17)

James Abbott McNeill Whistler
Symphony in White, No. 2: The young white girl, 1864
Oil on canvas, 77.5 x 51.1 cm
Tate Gallery, London
In Whistler's work we can recognize Japanese surface ornamentation in the contours of his figures and in his shallow silhouettes, which vanish in the diffuse light like ghosts. A cosmopolitan, equally at home in America, France or England, Whistler refused to join one of the guilds. He alienated his objects to such an extent – as an opponent of anything natural he concentrated on portraying the products of his imagination – that Ruskin condemned Whistler's pictures as sorry, inartistic efforts: according to Ruskin, painting which dispersed all lines and objects was not art.

Beardsley claimed as his own. He was not as committed to social matters as were many artists in England at the time; he was more a follower of *l'art pour l'art*, art for art's sake, predestined to do so by the aestheticism and decadence of the decade in which he lived. He had more in common with Baudelaire's *Les Fleurs du mal* than with the writings of William Morris; his theory of beauty was, like that of Baudelaire, an aesthetics of evil. "I have one aim – the grotesque. If I am not grotesque, I am nothing."[23] He even stylized and ridiculed sexuality. After having one of his teeth pulled out, Beardsley reputedly remarked: "Even my teeth are somewhat phallic". Beardsley's critics dismissed dandyism, claiming it would exhaust itself in its own superficiality and could never be conjoined with creative artistry, yet this cannot be applied to Beardsley. He was an artist of bewildering and unbelievable creative power, and in his short lifetime he managed to conceive a completely new style of drawing which was fundamental to the development of Art Nouveau and which is strongly echoed by all spheres of graphic design today.

Fred Hyland
Ophelia
From *The Savoy*, 1896
Autotype, 19.5 x 14.3 cm

Aubrey Vincent Beardsley: Symbolic lines and the eloquence of black

English Art Nouveau is surrounded by the thin air and pale light of an imaginary Elysium; its life is as if it has been tapped by Merlin's wand, bewitched into becoming static and silent.
Robert Schmutzler[24]

Beardsley offered a new understanding of the frame and pictorial plane, where the decorative line cutting across flat surfaces replaces the three-dimensionalism of reality (ill. p. 24). "All [Beardsley's] depictions lack space and perspective, based for the most part on the contrast of black-and-white surfaces which meet in symbolic lines. These lines can curl in an elegant arabesque around the figures, but can also harshly isolate the figure from its surroundings. Yet it is always that Art Nouveau line, later so famous, and so much more than a mere outline: it expresses the character and being of the figure it has drawn, and does not simply define the figure's contours but is a composite part of it."[25] Beardsley not only united the supposed paradox of artist and dandy, he also made artistic use of his dandyism, of the laws of elegance and distinction so inherent in his drawings. The dandy's motto is everything but nature – a motto which led straight to the black-

and-white style of Beardsley's drawings. Oscar Wilde thus said: "… that a later epoch will ascribe in particular the discovery of the beauty of the color black to the 19th century … The light of the sun only attains its full brilliance in contrast with black."[26]

With the aim of creating something new, Beardsley's art was fed on the stylistic currents and trends of his day. The swan song of the Pre-Raphaelites, whom Beardsley greatly admired, already echoed with the spiral tones of Art Nouveau's cantilena. Yet Beardsley's art was too cool and classic to pay homage to the floral ornament alone. From the Japanese he had learnt to create an effect using only two dimensions without even glancing at the third. Beardsley undoubtedly found the sexual emancipation of Japanese *shunga* [Spring pictures], a collection of erotic woodcuts, an enlightening contrast to prudish, Victorian England; one visitor tells of the shameless prints of Japanese courtesans with their lovers, engaged in complicated acrobatics, which adorned Beardsley's walls.

Genius cannot always be linked to certain influences, yet Beardsley's uniqueness is the result of a congenial mixture of various artists and styles: Art Nouveau, Burne-Jones, Whistler, Greek vase painting, Mantegna and Botticelli, Rococo engravings, and Japonisme. To the great disgust of established art enthusiasts, the first issue of *The Studio* was dedicated to the drawings of an unknown 21-year-old. This scandal secured Beardsley a certain popularity, enabling him to abandon his job as a clerk and devote himself entirely to art. In the wake of that first issue, he received many commissions for book illustrations. Another periodical for art and literature, *The Yellow Book* published by John Lane, owes its existence to Beardsley's friendship with the author Henry Harland. The monthly publication enjoyed great success, partly caused by criticism of its supposedly lewd depictions. "London turned yellow overnight," wrote essayist Sir Max Beerbohm[27] after the publication of the first issue in 1894 (ill. p. 49). Despite this, Beardsley was dismissed as art editor in 1895. He then teamed up with the lawyer-turned-bookseller Leonard Smithers, who dealt mainly in pornography and erotica, and began publishing a rival journal, *The Savoy*, in 1896 (ill. p. 49). The *Sunday Times* praised the new publication as a "Yellow Book" devoid of teething problems. Soon afterwards, Beardsley was forced to abandon his work with *The Savoy* due to tuberculosis of the lung, now at an advanced stage.

Earlier, the production of a Wilde and Beardsley collaboration, *Salome* (ill. opposite page), in 1893 was the perfect consolidation of *fin-de-siècle* art. The synesthetic language of Symbolism speaks out from each illustration, from each written word. Beauty and dreams are depicted by way of an aesthetic mirroring of perversion and ugliness.

Sometimes he attains pure beauty, has an unadulterated vision, as in the best illustrations of Salome … At a first glance it is a devilish beauty which is not even a contradiction in itself. There is a constant awareness of sin, but it is sin which is first transfigured and then revealed by beauty. This sin is fully conscious of its existence, conscious of its inability to escape from itself, and which demonstrates with its ugliness which law it has broken. His [Beardsley's] world is one of ghosts, where the desire to satisfy mortal feelings, the desire for infinity, has exceeded all bounds and has bewitched these gentle, quivering feelings, longing for flight, so that they have become hopelessly rigid. They have sensitivity of the soul and that physical sensitivity which bleeds their veins and paralyzes them in their sumptuous state of dreaminess. They are too thoughtful ever to be truly natural, ever to blossom completely in flesh or spirit … Beardsley is the satirist of an age without conviction and, like Baudelaire, he cannot refrain from depicting Hell without referring to Paradise as a counterpart. He uses the same methods as Baudelaire, a kind of exaggeration, which it would be uncritical to describe as insincere. In that terrible proclamation of evil which he calls *The Mysterious Rose-Garden*, the angel with the lantern and feathered sandals walking among the cascading roses is whispering more than just "sweet sin" … Because he loves beauty, he is gripped by the degradation of beauty; because he captures the superiority of virtue so completely, vice can seize hold of him. And in complete contrast to the "respectable" satirists of his day and age, whose wit and intellect is exhausted in the depiction of a drunkard propped up against a lamp post, or in the lady who pays a false compliment in a salon, he is a satirist who captures the true essence of things. It is always unfulfillment of the soul and not of the flesh which stares out from those greedy eyes … They look so very sad, because they have seen beauty yet have erred from its path.

Arthur Symons, *Aubrey Beardsley's Depictions of Women*, in *Ver Sacrum*, 1903.

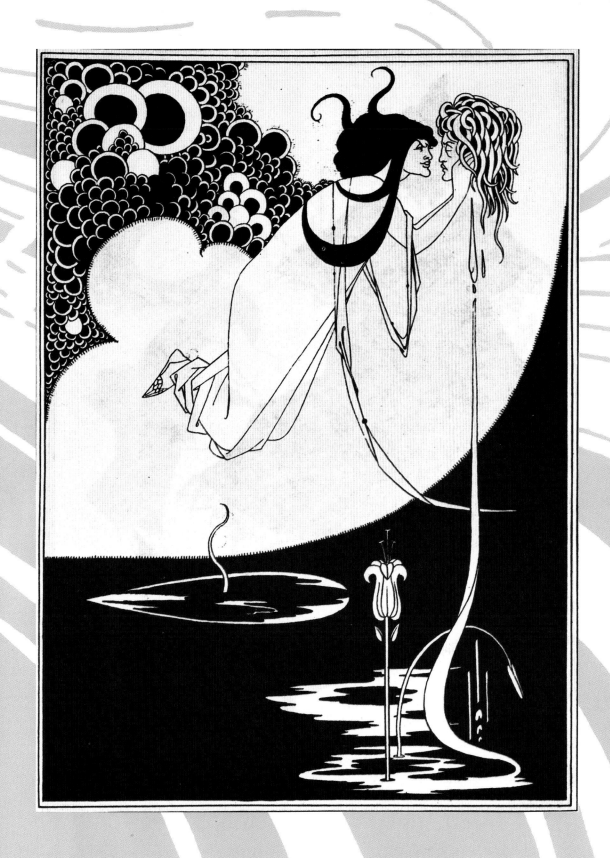

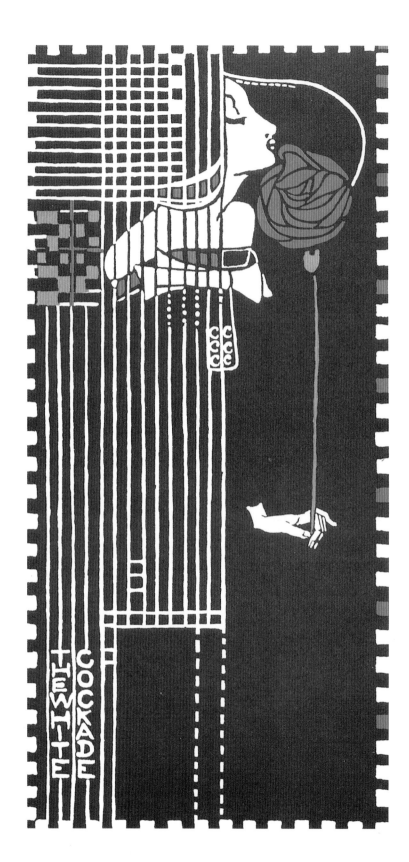

The blossoming of interior design
Glasgow

Margaret Macdonald Mackintosh
Tea room menu, 1901, autotype, 20.9 x 10.3 cm
The main characteristics of Anglo-Saxon form – unnaturally thin artistic figures, elongated stripes and rows in architecture, that is, stretched and linearized proportions – were very much alive in Glasgow in unbroken tradition.

Hill House is sheer poetry. I would even go as far as saying that, in our century, no other house has been built which emanates as much poetry as Hill House.
Julius Posener[1]

Elegant Scottish proportions

On the basis of their work, comparing Charles Rennie Mackintosh (1868–1928) and Antoni Gaudí (1852–1926) – even mentioning them in the same breath – seems not just erroneous, but impossible. Yet both these architects are first-class examples of Art Nouveau and have often served to appease its critics and opponents. One a Scot and the other a Catalan, both artists unleashed their creative powers far removed from the centers of the movement, although their work was shaped by contemporary trends which were also the stylistic basis for Berlin, Brussels, London, and Paris. As with Gaudí's Catalan elements, it is Scotland which gives Mackintosh's architecture its color. It is not known if he was a nationalist like Gaudí; his work does, however, suggest that he was an ardent Scot. Both Gaudí and Mackintosh belong to the Art Nouveau movement, an artistic reaction to the stylistic confusion which preceded it. With Mackintosh, we learn of his apotheosis; with Hill House, we experience how Mackintosh gloriously masters not just Art Nouveau, but also all other influences.

Charles Rennie Mackintosh – Purified architecture

He is a purifier in the field of architecture.
Ludwig Mies van der Rohe[2]

I knew the School of Art in Glasgow and saw it as the beginning of a breakthrough in architecture.
Walter Gropius[3]

The Glasgow School of Art (ill. p. 55), Mackintosh's most famous building, belongs to architecture and architects, or rather, to building and the future. This manifesto of simplicity, warding off all false pomp with its block-like, self-contained composition, has become a model for future generations of architects. It is interesting to note that in the first plans for the School of Art, the upper border demonstrated a rather unarchitectural Art Nouveau wave design, whereas the completed building restricts all Art Nouveau elements to decorative metalwork on the windows of the top floor. However radical and sober the building may appear, its overall architectural design is extremely varied; its decor is not merely an ornamental afterthought but harmonizes with the building, and even breathes life into it. The north facade of the Glasgow School of Art is an entire catalogue of surprising moments which give the structure a certain dynamism. "This front actually faces the street, yet the street isn't wide enough to allow one to stand opposite the School in such a way that one can check the front's symmetry or asymmetry. One looks *along* the facade. And looking at it sideways on, the slightly larger depth of the upper windows, twice as high as those on the ground floor, and the heavy sculpturing of the entrance building are far more impressive than any other dimensional relations in the surface projection of the front elevation."[4]

Charles Rennie Mackintosh
High-backed chair, Hill House 1, 1903
Stained ash, 141 x 41 x 35 cm

Mackintosh was a keen reader of the writings of Charles Francis Annesley Voysey and William Richard Lethaby (1857–1931) in which a ceremonial and hollow form of architecture was rejected. Theirs was one of the influences to affect Mackintosh, the influence of a new, everyday kind of building, the need which grew out of the English Country House Movement for a simple house to become a work of art. One should be aware of the fact that a house is something to be used and does not become a building only when decorated with pointed arches and pillars; it gains beauty and dignity from being lived in, from its function as a place of residence. It should also embody the service it fulfills, namely in its structure. Thus it was both the English manor house and so-called "anonymous" Scottish architecture which inspired Mackintosh. Windyhill is a model of this amalgamation of Scottish and English manor house. The severe facade of this functional building is covered with gray harling, Scottish roughcast plastering, and crowned by gables and chimneys typical of the country (ill. p. 56, p. 57). A rounded external wall encloses the staircase bay which was later to become a feature of 1920s architecture, such as demonstrated by Le Corbusier (1887–1965) in his Villa Savoie in Poissy. It was this synthesis of tradition and modernity which greatly impressed post-Mackintosh architects, and eventually offered them a way of building practically yet artistically. It was the Scottish "vernacular" of Windyhill architecture and Hill House which impressed Hermann Muthesius (1861–1927) on his visit to Scotland; he positively enthused about the unconventional language of Mackintosh's interiors. "Once the interior attains the status of a work of art, that is, when it is intended to embody aesthetic values, the artistic effect must obviously be heightened to the utmost. The Mackintosh group does this…"[5] The blossoming of interior design, a recurring theme in Art Nouveau, and here especially interior design by the Mackintosh circle, was full of magic and mysticism. Lethaby called for this magic and mysticism and believed it possible – sometime in the distant future. Muthesius was quite correct to speak of the Mackintosh group, for architecture and architects alone were not enough to lend form to this "poetry of interiors". Other components were gradually amalgamated which resulted in the Glasgow Style, shaped by artists with their own distinctive ideas, and with Margaret Macdonald Mackintosh (1865–1933) at the helm. Of his wife, Mackintosh himself said: "Margaret has genius, I have only talent."[6]

Charles Rennie Mackintosh
Poster for *The Scottish Musical Review*, 1896
Color lithograph, 246 x 101.5 cm
Many draft versions preceded Mackintosh's finished product – the fantastic yet tectonic linear structure is monumentally captured on paper. Some of Mackintosh's most beautiful interior designs were for music rooms. They resemble symphonic arrangements, decorations with thin, vibrating lines like the strings of a harp spread out across the walls, floating over pale splashes of color filling the remaining surfaces.

Poetry of Interiors –
The Macdonald Sisters

The body was nowhere to be found. Instead of the body, there was a flower, its center as yellow as saffron, surrounded by white petals.
Ovid[7]

Mackintosh, Herbert MacNair and the two Macdonald sisters, Margaret and Frances – later The Four – got to know Aubrey Vincent Beardsley, Voysey and Jan Theodoor Toorop (1858–1928), through the magazine *The Studio*. It is indisputable that these acquaintances had a spontaneous yet long-lasting effect on the group. The Symbolist ingredients, threaded through The Four's work like a leitmotiv, probably stem from the Pre-Raphaelites, enriched, however, by the influence of the Belgian lyricist Maurice Maeterlinck (1862–1949), introduced to the group by Toorop. "[These are] tall, incorporeal figures dissolved or woven into delicate webs of stems and threads, with only their heads human or saint-like, slightly inclined, each like the next, with closed eyes and dark, cascading hair – [such are the] figures in a frieze, pale green and pink, for Cranston's Tea Rooms in Glasgow, designed by Charles Rennie Mackintosh and his wife Margaret in about 1900. These same thin sticks make up the strange chair with its painfully high back, more than twice the height of the seat. And the thin lead strips sprawled across the mirror, surrounding pale violet surfaces or nothing at all, free contours which enclose nothing, as if drawn by a tired hand. The cupboards are white and all colors are pale, washed-out. All forms and objects, whether for use or for ornamentation, are slender, thin-boned, fragile, without flesh, dreamily spiritual – a singular ghostly but not unsensual sphere, abstracted, it would appear, and filtered from the angelic figures of Pre-Raphaelite forebears: that is the physiognomy of the Scottish School."[8] The main characteristics of Anglo-Saxon form – unnaturally thin artistic figures, elongated stripes and rows in architecture, that is, stretched and linearized proportions – were very much alive in Glasgow in unbroken tradition (ill. p. 52). The rolling Celtic rhythm of lines breaks up the almost cubic severity. In its basic conception, the so-called Glasgow Style existed before The Four popularized it in Europe and embellished it with external influences. The "blending of a puritanically severe practical form with an almost lyrical disappearance of any useful value"[9] is deeply rooted both in Celtic mythology, handed down through the ages, and in the ghostly symbolic

Charles Rennie Mackintosh
Glasgow School of Art,
167 Renfrew Street, Glasgow,
1896–99 and 1906–09
West facade, 1907-09
However radical and sober the building may appear, its overall architectural design is extremely varied; its decor is not merely an ornamental afterthought but harmonizes with the building, and even breathes life into it. The north facade of the Glasgow School of Art is an entire catalogue of surprising moments which give the structure a certain dynamism.

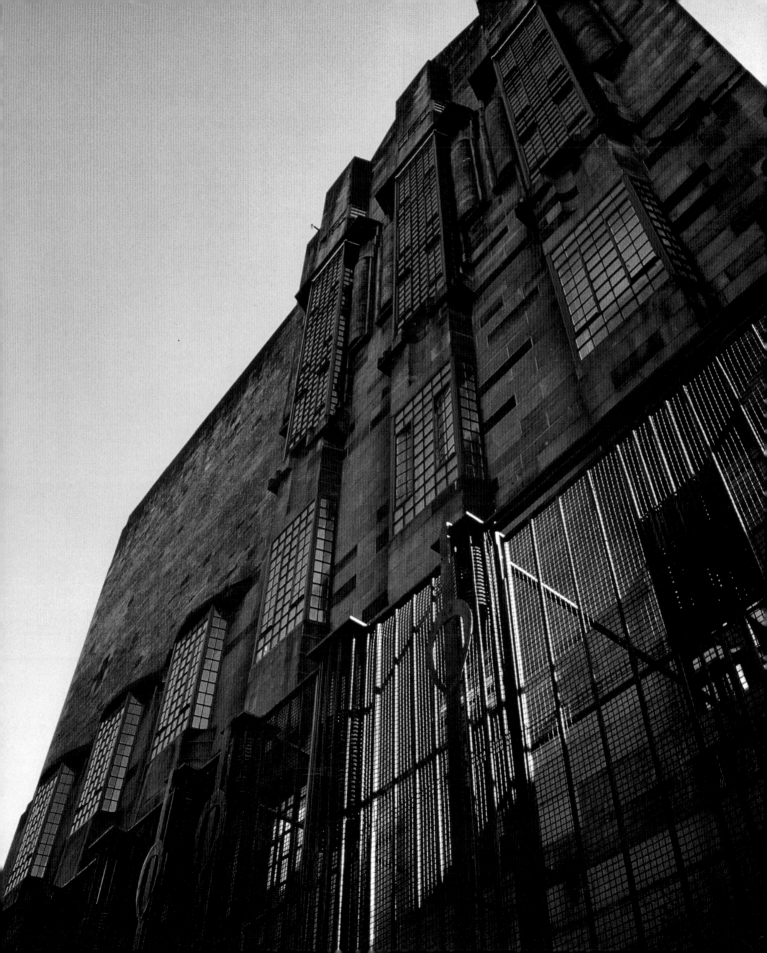

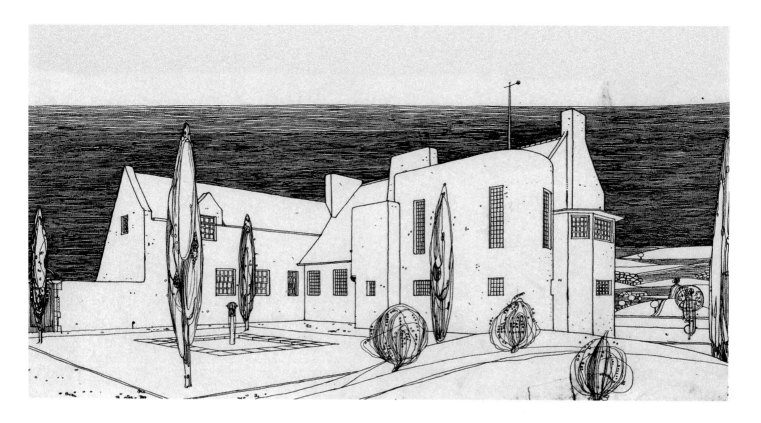

atmosphere of the Scottish moors. The Macdonald sisters' early work includes water-colours with ghostly figures and mystical ornaments from the treasure trove of Celtic legend. These characteristics earned them the nickname "Spook School". The physiognomy and the physical, however, remain sketchy in substance and are rather Pre-Raphaelite. For Dante Gabriel Rossetti, the epitome of the Pre-Raphaelite artist, the female body was the symbol of all beauty, color and thought. He spiritualized the body, for him nothing more than the soul's clothing, and created gentle, graceful figures, airy, floating beings. All sensuousness was concentrated on the mouth, on full, almost greedy lips, in counterpoint with the un-fathomable eyes which seemed to reflect the universe. "History has known no art which represents such an extreme fusion of quivering eroticism and spiritual nobility since Leonardo da Vinci."[10]

The uniqueness and fascination of Scottish Art Nouveau lies in the coupling of almost mannered figurines with the non-representationalism of its architecture and furniture design. Angelic statuettes slot into the architectural grid, their weightless heads like halos rounding off an almost esoteric ornament, made up of the mere husks of bodies and garments and garnished with flowers (ill. p. 60). These celestial beings, created by the Macdonald sisters in metal, embroidery, mosaics, and jet pearls (ill. p. 66), "haunt" furniture, wall paneling, and material. Yet the figures always find their counterpart in the intersecting lattice lines of the furniture, architecture, and layout of the room. The critics believed that the mysticism and parallel asceti-cism of this Glasgow art form was of heathen origin and not serious in its intentions. The London Arts and Crafts Movement dismissed it as totally "unBritish" fantasy; the Continent, its senses sharpened by Symbolism, was more receptive.

Charles Rennie Mackintosh
Windyhill Cottage, Kilmacolm,
Renfrewshire, 1900
Perspective drawing, pencil and pen,
28.9 x 57.2 cm

The Four – The Glasgow Style

Never before has our utilitarianism had opinions voiced on it so sharply and arrogantly.
Julius Meier-Graefe[11]

In 1896, the year of William Morris's death, the Scots took part in an exhibition in London for the first time at the invitation of the Arts and Crafts Society. They were mercilessly dismissed as aesthetes, at best causing astonishment among the observers. Despite this, the editor of *The Studio* decided to travel to Glasgow; the contacts he forged were to be of great significance for The Four. However, Mackintosh's architectural biography does not begin with the Glasgow Style. In 1884, he joined John Hutchison's architects' office and a few years later, in 1889, started work with the architects John Honeyman & Keppie, who had just set up their own partnership. His

first commissions and the numerous prizes he won in competitions enabled Mackintosh to spend time studying in Italy in 1891 and to travel to Paris, Brussels, Antwerp, and London. He became friends with Herbert MacNair (1869–1945) a fellow employee at the new architects' office, a friendship which was to prove extremely fruitful for Art Nouveau. They went to evening classes together at the Glasgow School of Art, where they met the Macdonald sisters, and the congenial bond of The Four was formed, both on a professional and personal level (MacNair was later to marry Frances Macdonald [1874–1921]. In 1897, Mackintosh's design for the Glasgow School of Art was approved and the memory of The Four's rejection in London quickly faded. Building officially started in May 1898; by December of the same year the art school was almost finished. The western half of the building

Charles Rennie Mackintosh
Windyhill Cottage, Kilmacolm, Renfrewshire, 1900–01
Mackintosh was inspired by both the English manor house and so-called "anonymous" Scottish architecture. Windyhill is a model of this amalgamation of Scottish and English manor house. The severe facade of this functional building is covered with gray harling, Scottish roughcast plastering, and crowned by gables and chimneys typical of the country.

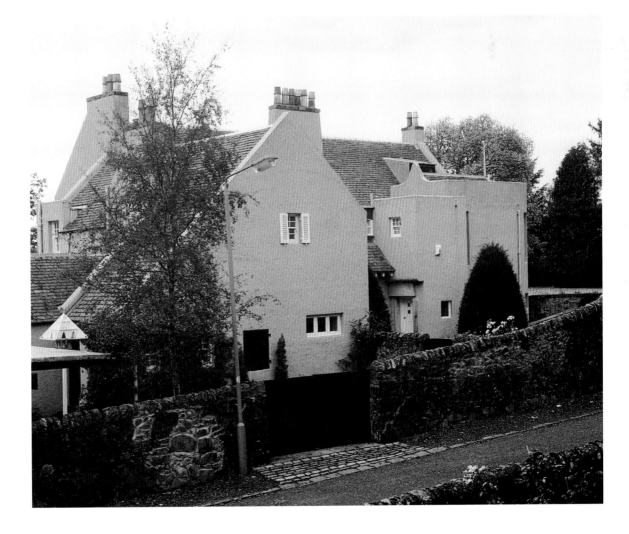

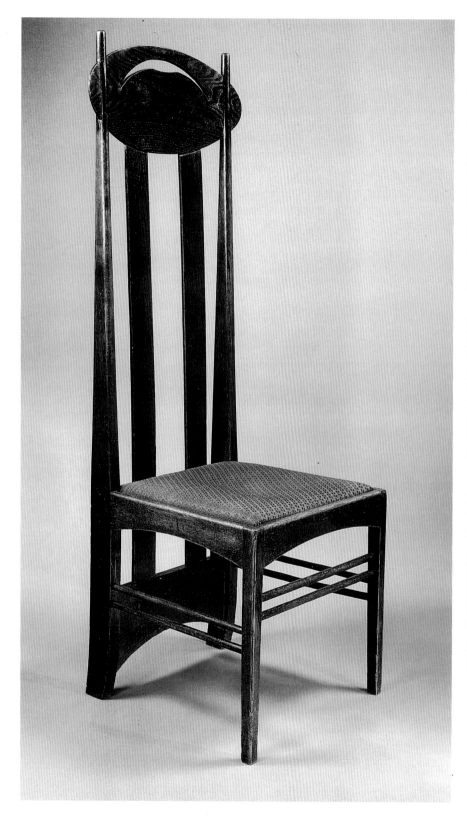

Charles Rennie Mackintosh
Chair for Miss Cranston's Argyle
Street Tea Rooms, Glasgow,
1896–97
Dark-stained oak, recessed rush seat
(reconstruction uses horsehair)
137 x 47.7 x 47 cm
The chair – still a famous piece of
furniture today – contributes to the
overall design of the room with its
high back. Although the chairs
Mackintosh designed for the Argyle
Street Tea Rooms are obviously in
keeping with the tradition of the
Arts and Crafts Movement and bear
the influence of Voysey, they also
display all the characteristics of
Mackintosh's individual style.

Charles Rennie Mackintosh
Ingram Street Tea Rooms,
Glasgow,
View from the gallery of the White
Luncheon Room, 1900, 1907,
1910–11
Reproduction from a contemporary
photograph
The nonconformist Miss Catherine
Cranston became one of
Mackintosh's main clients. She was
a strong supporter of Glasgow's
Temperance Movement and decided
to open tea salons to counterbalance
the city's pubs. Here her guests
would be served in elegant, cultivated
surroundings. Her investment paid
off, as her exclusive Tea Rooms soon
attracted a large clientele.

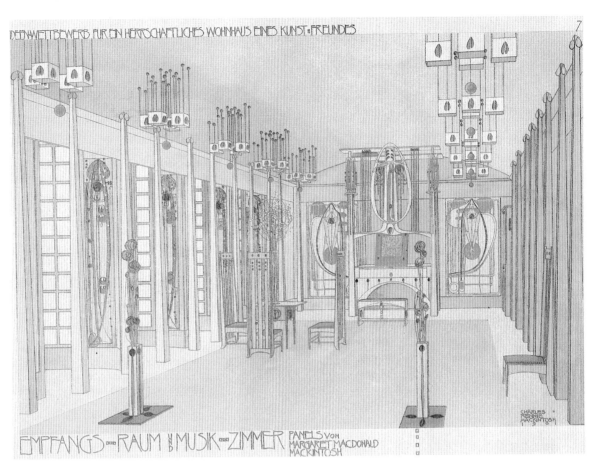

IDEENWETTBEWERB FUR EIN HERRSCHAFTLICHES WOHNHAUS EINES KUNST=FREUNDES

EMPFANGS=RAUM U MUSIK=ZIMMER PANELS VON MARGARET MACDONALD MACKINTOSH

Below:
Charles Rennie Mackintosh
Dressing chair for Miss Cranston's blue bedroom, Hous'Hill, Nitshill, Glasgow, 1904
Oak with upholstered gold-colored seat, 56 cm high, 38 cm deep
In 1903, Miss Cranston commissioned Mackintosh to completely renovate her country house, Hous'Hill, and allowed him great freedom in his work. The many pieces of furniture Mackintosh designed for this house in particular illustrate the vast compendium of his ideas and at the same time point toward a change in his style to include a greater constructive element.

was revised and finally completed between 1907 and 1909. "Building in his [Mackintosh's] hands becomes an abstract art, both musical and mathematical … Here the abstract artist is primarily concerned with the shaping of volume and not of space, of solids not voids."[12] Music did indeed play an important role for Mackintosh, whose vision of a complete work of art was a synesthetic one: he aimed to create an ensemble of the senses. In 1896, after rejecting many draft versions, Mackintosh designed a poster for the *Scottish Musical Review*: the fantastic yet tectonic linear structure is monumentally captured on paper. Some of Mackintosh's most beautiful interior designs were for music rooms. They resemble symphonic arrangements, decorations with thin, vibrating lines like the strings of a harp spread out across the walls, floating over pale splashes of color filling the remaining surfaces. Fritz Waerndorfer, later one of the co-founders and great patron of the Wiener Werkstätte, commissioned Mackintosh to design a music salon in 1901 (completed in

1921). Mackintosh's admiration for the Belgian poet Maeterlinck led him to describe the salon as a living space "for the souls of Maurice Maeterlinck's six princesses". Earlier, in 1900, Waerndorfer had traveled to Glasgow to invite Mackintosh to take part in the Eighth Secession Exhibition in Vienna, which opened on November 4, 1900. The Four's appearance in Vienna became something of a sensation. The Scottish Room was contrived as a tea salon, with all the furniture positioned in such a way that the middle of the room was empty. A vase with flowers arranged *ikebana*-style (a homage to Japan) was the only centerpiece. These "spiritual rooms" did not merely instill a general enthusiasm, even emotion, in the onlookers; Viennese artists also began to work The Four's ideas into their own designs. Mackintosh's friendship with Josef Hoffmann (1870–1956) dates to the Secession (the movement away from traditional Viennese style), as does the growing displeasure with the cliché forms of official Secession art which led to the founding of the Wiener Werkstätte. Besides

Charles Rennie Mackintosh
Reception room and music room, 1901
Sketch of the interior, competition entry for the *Haus eines Kunstfreundes* [House for an Art Lover]
From *Meister der Innenkunst*, II, 1901–02
Indian ink, silver, gold, 21 x 33 cm
According to Hermann Muthesius, who wrote an introduction to *Meister der Innenkunst*, Mackintosh fulfilled the entry conditions of the competition like no other with his design for the *Haus eines Kunstfreundes*: it was radically modern and uncompromisingly aesthetic

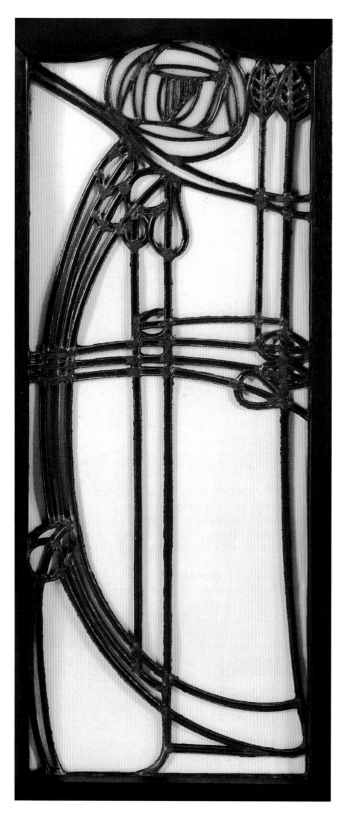

Hoffmann, the work of many other Art Nouveau artists such as Joseph Maria Olbrich (1867–1908), Peter Behrens (1868–1940), Frank Lloyd Wright (1869–1959) and the De Stijl artists, reveals the legacy of Scottish forms. Many major exhibitions contributed to the publicizing of the Glasgow Style. As well as participating in the International Exhibition of Modern Decorative Art in Turin in 1902 and their earlier triumphant success at the World Exposition in Paris in 1900, The Four were also represented at exhibitions in Munich, Budapest, Dresden, Venice, and Moscow. Although the group considered they were confronted with very disadvantageous exhibiting conditions in Turin, they managed to produce a masterpiece. They manufactured huge, stenciled banners as orientation for the public and thus created an attractive entrance to the Scottish section. Behind the banners, the rather feminine Rose Boudoir in pink, silver, and white with its skeletal structures only served to substantiate the critics' "Spook School" nickname for the Macdonald sisters.

Nonetheless, Mackintosh's influence in Germany, not to be underestimated, was not so much due to these exhibitions but to the competition launched by the German periodical, *Zeitschrift für Innendekoration* in 1901. Although the "Scottish genius" submitted an incomplete entry, he was nevertheless awarded a special prize and had his work published in a portfolio entitled *Meister der Innenkunst* [Masters of Interior Decoration] alongside designs by Mackay Hugh Baillie Scott and Leopold Bauer. According to Hermann Muthesius, who wrote an introduction to the portfolio, Mackintosh fulfilled the entry conditions of the competition like no other with his design for the *Haus eines Kunstfreundes* [House for an Art Lover]: it was radically modern and uncompromisingly aesthetic (ill. p. 59).

Tea Rooms – Stylized refinements of buildings with a purpose

It is not the body which should inhabit these chambers of thought; these are chambres garnies for beautiful souls. Julius Meier-Graefe[13]

The Scots' sublime conceptual works of art, their overrefined, almost overdeveloped atmospheric interiors extracted a mild criticism from Muthesius: "… Whether such enhancement is appropriate to our everyday rooms is another question. Mackintosh's rooms are refined to a degree which the lives of even the artistically educated are still a long way from matching. The

Left:
Margaret Macdonald Mackintosh
Glass window, detail of a cabinet, 1898–99
Cabinet: oak, 159 x 202 x 42.5 cm

Charles Rennie Mackintosh Margaret Macdonald Mackintosh
Cabinet, detail of the cabinet doors, 1902
Wood, painted white and sculpted, with glass, silver-plated metal and mosaic glass on silvered panels, 154.7 x 98.6 x 39.8 cm
Made for Mrs. Rowat, 14 Kingsborough Gardens, Glasgow
The uniqueness and fascination of Scottish Art Nouveau lies in the coupling of almost mannered figurines with the non-representationalism of its architectural and furniture design. Angelic statuettes slot into the architectural grid, their weightless heads like halos rounding off an almost esoteric ornament, made up of the mere husks of bodies and garments and garnished with flowers.

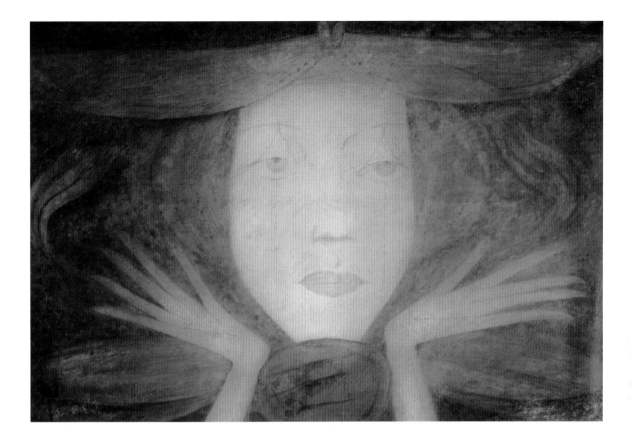

delicacy and austerity of their artistic atmosphere would tolerate no admixture of the ordinariness that fills our lives. Even a book in an unsuitable binding would disturb the atmosphere simply by lying on the table. Indeed, even the man or woman of today – especially the man in his unadorned working attire – treads like a stranger in this fairy-tale world. There is no possibility for the time being of our aesthetic cultivation playing so large a part in our lives that rooms like this could become commonplace. But they are milestones placed by a genius far ahead of us to mark the way to excellence for mankind in the future."[14] Despite his reservations, Muthesius was unable to ignore this blossoming of interior art and delegated it to the future – a bold statement, for the future was to be less aesthetic and rather sober, even martial, with time. Luckily, Mackintosh was still able to find artistically literate customers with elegant taste who gave him free rein with his creations. The Four's strengths lay in the congenial realization of the sophisticated atmosphere of Scottish tea salons. The epitome of the ideal artist-designer, Mackintosh sketched whole interiors (ill. p. 58,

p. 59, p. 64–65) and was also a gifted designer of furniture (ill. p. 53, p. 58, p. 62, p. 63), an influence still traceable today in any good furnishing house. The artistic concept as a whole was always of prime importance; a chair designed for the Willow Tea Rooms, for example, would be ineffective if it failed to fit in with the overall design of the room. The towering back is impractical and the elongated shape of the chair seems rather affected. Only when placed in the room alongside which it was conceived does it receive legitimacy and its own particular appeal. The chair back is an integral part of the structured wall; its full effect is best appreciated when viewed from the front. A chair designed six years previously for the Argyle Street Tea Rooms in 1897 also contributes to the overall interior design. Although the furniture Mackintosh designed for the Argyle Street Tea Rooms is obviously in keeping with the tradition of the Arts and Crafts Movement and bears the influence of Voysey, the chair in question – still a famous piece of furniture today (ill. p. 58) – displays all the characteristics of Mackintosh's individual style. The spatial elements in Mackintosh's

Margaret Macdonald Mackintosh
Detail of a three-part screen, 1909
Oak frame and oilcloth, painting on parchment paper, one panel measures 30 x 43.5 cm
"Tall, incorporeal figures dissolved or woven into delicate webs of stems and threads, with only their heads human or saint-like, slightly inclined, each like the next, with closed eyes and dark, cascading hair ..."
(Dolf Sternberger, see note 8)

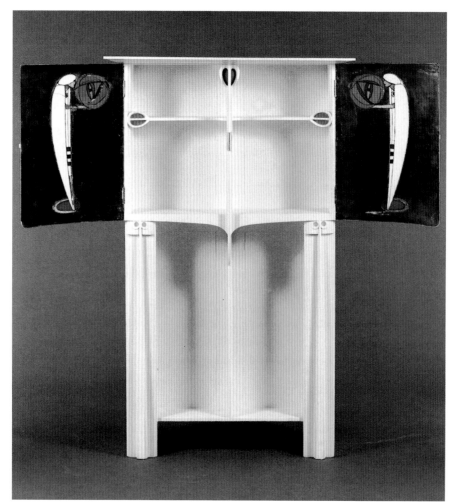

Charles Rennie Mackintosh
Margaret Macdonald Mackintosh
Cabinet, 1902
Wood, painted white and sculpted,
with glass, silver-plated metal and
mosaic glass on silvered panels,
154.7 x 98.6 x 39.8 cm
Made for Mrs. Rowat, 14
Kingsborough Gardens, Glasgow
Further gems of Mackintosh
furniture have been preserved by
another of his female clients. The
feminine coloring of the interior
betrays the influence of Mrs. Rowat,
the lady of the house, who played a
major role in the redecorating
process.

furniture and indeed also in his architectural designs are determined by squares and cubes. Yet the architecturally lucid arrangement is increasingly broken up by delicate floral ornaments spun across the structures, giving the perpendicular form a sense of mystery. The cubic principle underpinning Mackintosh's work becomes clear only when we look beyond the linear latticework. Like Japanese artists, Mackintosh used ornaments on the surface as a kind of support; the hidden penetration of background components creates a decorative whole which does not allow elements to be perceived individually. Mackintosh primarily adopted methods employed by sinkabe kozo, using partitions and painted wooden objects to divide up the room – concepts borrowed from Japanese interior design. Individual objects are arranged in such a way that the often stiff,

severe character of his furniture and constructions is softened by the convergence of the woven lines. The attenuated design has a Japanese quality that is clearly recognizable in the treatment of window grates, fittings and door handles, which are melodically formed out of their supporting surface. Through his attention to the tiniest detail and the apparent triviality of his designs, all of Mackintosh's objects and architecture seem to diffuse a whole spectrum of impressions.

In Mackintosh's own words, the female ingredient, namely that of his wife Margaret, was a decisive factor in his work. Women played an important role in his life, both artistically and professionally. The nonconformist Miss Catherine Cranston became one of Mackintosh's main clients. She was a strong supporter of Glasgow's Temperance Movement and decided to open tea salons to counterbalance the city's pubs. Here

her guests would be served in elegant, cultivated surroundings. Her investment paid off, as her exclusive Tea Rooms soon attracted a large clientele. Encouraged by the success of her first enterprise, the Argyle Street Tea Rooms (ill. p. 58), she bought two more buildings and a piece of land and opened the Ingram Street Tea Rooms (ill. p. 58), the Buchanan Street Tea Rooms and the Willow Tea Rooms.

With these commissions, Mackintosh was able to unleash his true genius without any stylistic or financial restraints. In complete artistic freedom, he created rooms which resembled his dreams come true: "… narrow panels, gray silk, very, very thin wooden supports, verticals everywhere. Small, right-angled cupboards with heavily pro-truding plates, smooth and plain. Upright, white and serious, they stand like girls taking their first communion – yet not quite, for somewhere a hint of decoration has been added, or a large silver fitting, like a hidden jewel; and on the inside, shyly elegant lines nestled in bas-relief, never disturbing the silhouette, like a faint, distant echo of van de Velde. The charm of these proportions, the aristocratically effortless security with which an ornament of enamel, colored glass, semiprecious stones or worked metal is inlaid"[15] lend all of Mackintosh's visions their inimitable brilliance; they owe their existence to his symbiosis with Margaret.

The Macdonald sisters had opened a studio for applied art as early as 1894; designs were supplied by Mackintosh and MacNair. Yet the two men did not merely come up with designs for materials, wall paneling, metalwork, and other commodities; they also supplied ideas. In 1899, MacNair accepted a post as Instructor for Decorative Design in Liverpool, causing the partnership to disband. In spirit, however, the style of The Four lived on. Again it was Miss Cranston who granted Mackintosh total creative freedom in 1903 with her commission for Hous'Hill. The many pieces of furniture Mackintosh designed for this house in particular illustrate the vast compendium of his ideas and at the same time point toward a change in his style to include a greater constructive element (ill. p. 59). A curved, open-work screen divided the living room into two sections; a similar screen was used by Ludwig Mies van der Rohe (1886–1969) in 1930 in the Tugendhat House in Brno. Mackintosh's acquaintance with Miss Cranston was a lucky coincidence, yet it also bore the irony of fate; Mackintosh was a heavy drinker, and Miss Cranston a teetotaler, yet he designed her private rooms and tea salons to perfection.

Charles Rennie Mackintosh
Washstand for Miss Cranston's blue bedroom, Hous'Hill, Nitshill, Glasgow, 1904
Oak with ceramic tiles and lead glazing,
160.5 x 130.5 x 51.7 cm

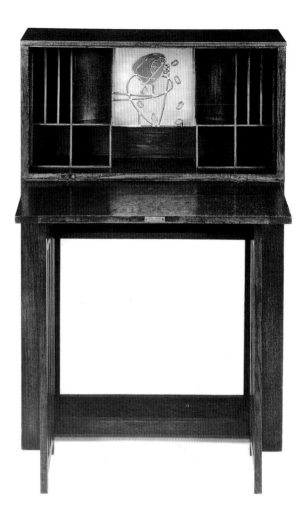

Further gems of Mackintosh furniture have been preserved by another of his female clients. The parents of Jessie Newbery, a friend of Mackintosh's whose husband was the director of the Glasgow School of Art, owned a terraced house in Kingsborough Gardens. They commissioned Mackintosh to refurbish the property. The feminine coloring of the interior (ill. opposite page) betrays the influence of Mrs. Rowat, the lady of the house, who played a major role in the redecorating process. Mackintosh was to receive further important commissions, yet the veracity of his architectural achievements manifests itself most convincingly in Hill House (ill. p. 53, p. 64–65, p. 66).

Charles Rennie Mackintosh
Bureau for Miss Cranston's blue bedroom, Hous'Hill, Nitshill, Glasgow, 1904
Oak with lead glazing and glass,
115.5 x 76 x 30 cm

Following double page spread:
Charles Rennie Mackintosh
Hill House, Upper Colquhoun Street, Helensburgh,
View of the master bedroom, 1902–04
"Hill House is sheer poetry. I would even go as far as saying that, in our century, no other house has been built which emanates as much poetry as Hill House."
(Julius Posener, see note 1)

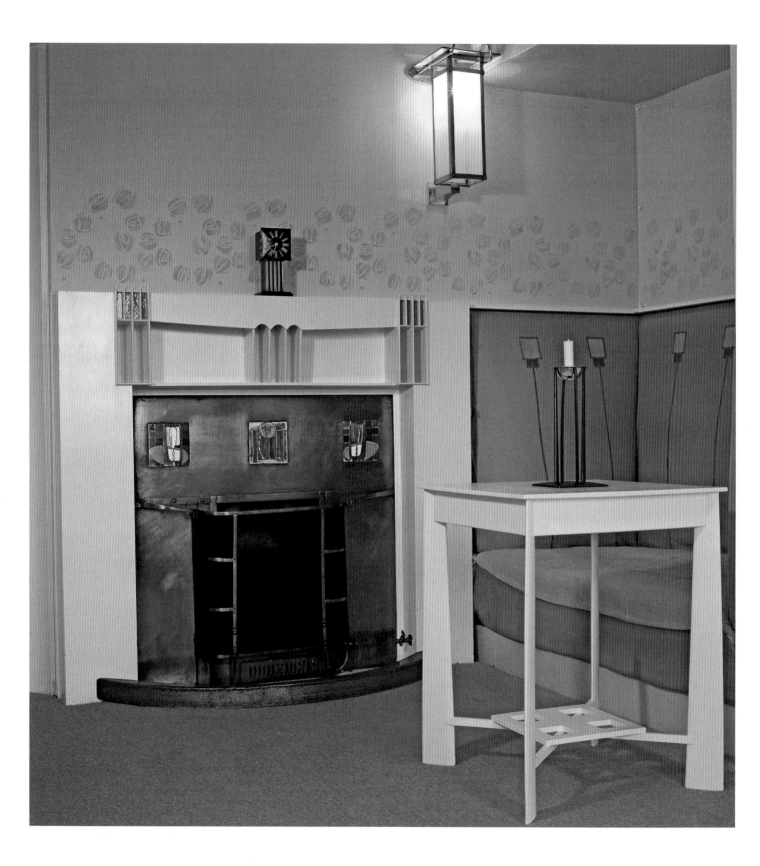

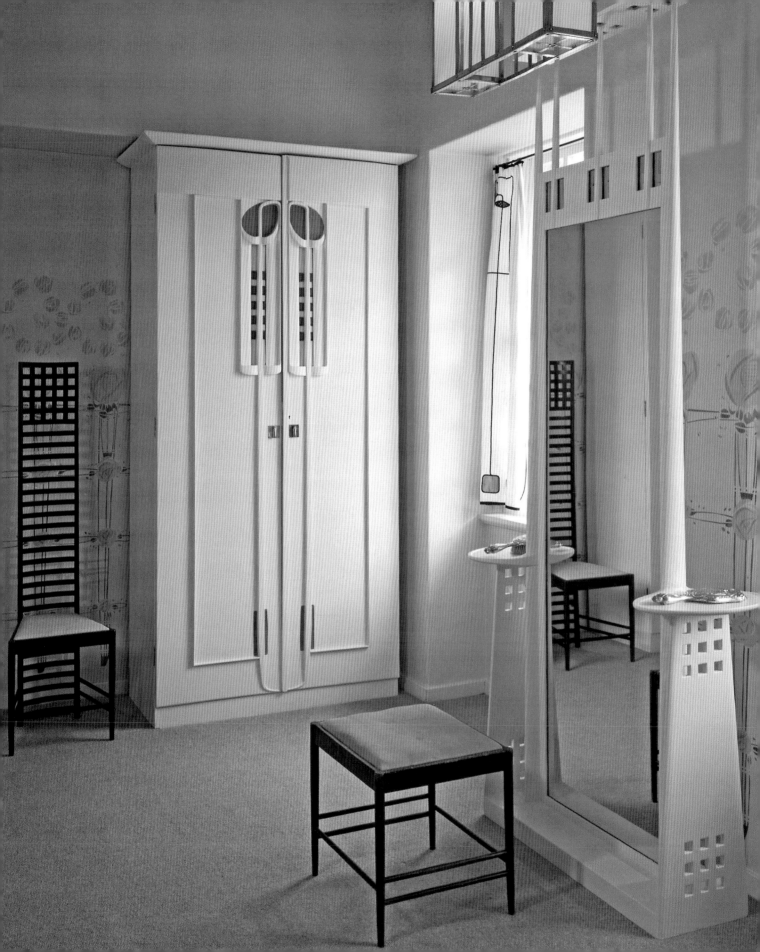

Hill House – Scotland's Ultimate Artistic Whole

The composition forms an organic whole, each part fitting
into the rest with the same concord as do the passages of a
grand symphony.
Ludwig Hevesi[16]

During 1902 and 1903, Mackintosh built Hill
House for the publisher Walter Blackie in
Helensburgh, an exclusive residential area near
the sea. Together with Hoffmann's Palais Stoclet
in Brussels, Hill House is considered to be Art
Nouveau's ultimate artistic whole in an
intellectual sense. "There are architects who like
to differentiate between inside and out ... this is
not true of Hill House. True to the teachings of
English architecture, it is possible to determine
which rooms are where merely by looking at the
exterior of the house; indeed, here one could
even speak of a particular precision. … One can
say that here the building's functions are
represented by the house's exterior with great
clarity … Looking at the interior, one will notice
that Mackintosh's stylized furniture does not
intrude on the general design. All parts of the
room come alive. I would like to point out again
the bay in the drawing room with its relief on the
wall, if I may call it that, endowed with a
decorative momentum with which the furniture –
both fixed and movable – fits in. The furniture is
also architecture in itself; squares play almost as

important a rôle for Mackintosh as they did a little
later for Peter Behrens. The lighting (and this has
been conceived with great thought), the designs
of the walls, and the furniture all work together to
form a single unit."[17]

Once the west wing of the Glasgow School of
Art had been finished in 1909, there were
increasingly fewer commissions. Whereas archi-
tects' offices in Vienna flourished and Behrens
and Olbrich were able to establish themselves,
Mackintosh's career took a downturn. The cause
for this may have been his characteristic unwilling-
ness to compromise and his increasing depen-
dence on alcohol. Unlike the famous Wiener
Werkstätte Fledermaus chair, Mackintosh's

Frances Macdonald MacNair
The Spirit of the Rose, ca. 1900–05
Silk embroidery on linen,
51.5 x 51.5 cm
Celestial beings, created by the
Macdonald sisters in metal,
embroidery, mosaics, and jet pearls
(ill. p. 66), "haunt" furniture, wall
paneling, and material.

Charles Rennie Mackintosh
Collioure, Pyrénées-Orientales
*Summer Palace of the Queens of
Aragon*, ca. 1924–26
Watercolor, 38.1 x 43.2 cm
During his period of "exile" in the
Pyrenees, Mackintosh devoted
himself almost exclusively to
landscape painting. His paintings
clearly bear the mark of the architect.

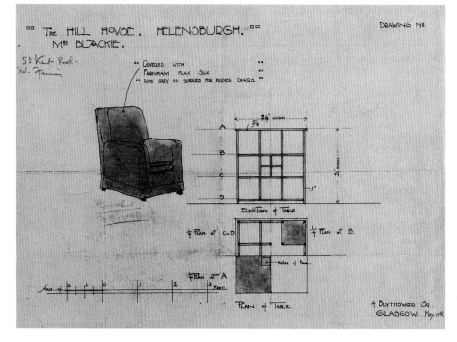

Charles Rennie Mackintosh
Table and chair, Hill House,
Helensburgh, May 1908
Design in ink and wash on artificial
silk, 29.7 x 42.5 cm

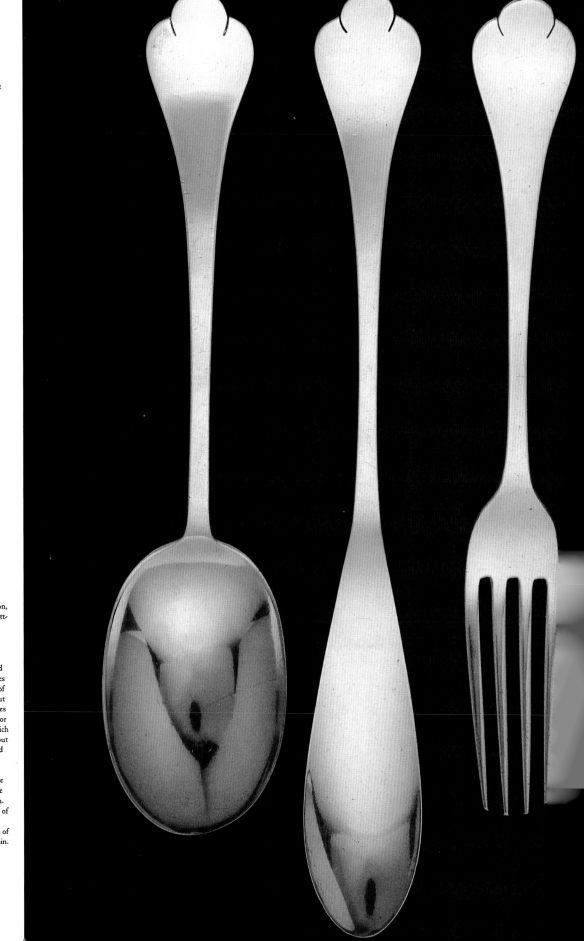

Charles Rennie Mackintosh
Fish knife, fork and dessert spoon
for Miss Cranston's Ingram Street
Tea Rooms, Glasgow, 1905
Silver-plated metal
Knife: 21 cm long

Page 69:
Charles Rennie Mackintosh
Stairs, 78 Derngate, Northampton,
commissioned by Wynne J. Bassett-Lowke,
1916–18/19
Wood, lead glazing and glass
It is a tragedy that Mackintosh's
personal situation, alcoholism, and
unfortunate financial circumstances
heavily influenced his work. One of
the few building projects carried out
during his London period illustrates
that it was neither lack of genius nor
waning architectural creativity which
caused him to concentrate his output
on textile design. He demonstrated
his usual excellence in the
remodeling of a Victorian terraced
house in Northampton for Wynne
J. Bassett-Lowke, a member of the
Design and Industries Association.
The sensational geometric designs of
the facade and staircase are today
considered to be the first examples of
Modern Style architecture in Britain.

furniture designs were not suited to mass production. Furthermore, his furniture was also technically deficient, as he preferred to work with simple craftsmen from the boatbuilding industry, a poor choice compared with the expensive carpenters who worked for the Art Nouveau artists in London, Nancy, Paris, and Vienna. To this was added the general economic depression which hit Glasgow in 1910. A patriotic Scot, Mackintosh must have been terribly resigned when he moved down to London in 1915. He and his wife left England in 1923 to spend a few years in the French Pyrenees, in Port-Vendres, probably for financial reasons, as the cost of living in this region was then very low. Here, Mackintosh devoted himself almost exclusively to landscape painting. His paintings clearly bear the impressive mark of the architect (ill. p. 66). It is a tragedy that Mackintosh's personal situation, alcoholism and unfortunate financial circumstances heavily influenced his work. One of the few building projects carried out during his London period illustrates that it was neither lack of genius nor waning architectural creativity which caused him to concentrate his output on textile design. He demonstrated his usual excellence in the remodeling of a Victorian terraced house in Northampton for Wynne J. Bassett-Lowke, a member of the Design and Industries Association. The sensational geometric designs of the facade and staircase are today considered to be the first examples of Modern Style architecture in Britain (ill. opposite page).

The second event was very different and could almost be described as something of a sensation: the appearance of the Glasgow architects in Vienna. (Here I refer to the related couples, Mackintosh and MacNair, husbands to the two Macdonald sisters.) At more or less the same time as the movement began on the Continent, in the year Morris died, these young Scots took part in the Arts and Crafts Society Exhibition in London for the first time. After one had spent two years hoping they would improve, they were dismissed for demonstrating totally unBritish fantasies. They do indeed effect a blending of a puritanically severe practical form (as exhibited by Charles R. Mackintosh's wonderfully simple architecture) with an almost lyrical disappearance of any useful value. The interiors are like something out of a dream: narrow panels, gray silk, very, very thin wooden supports, verticals everywhere. Small, right-angled cupboards with heavily protruding plates, smooth and plain. Upright, white and serious, they stand like girls taking their first communion – yet not quite, for somewhere a hint of decoration has been added, or a large silver fitting, like a hidden jewel; and on the inside, shyly elegant lines nestled in bas-relief, never disturbing the silhouette, like a faint, distant echo of van de Velde. The charm of these proportions, the aristocratically effortless security with which an ornament of enamel, colored glass, semi precious stones or worked metal is inlaid, delighted the artists, and especially the Viennese, who were beginning to feel a little bored with the constant, solid efficiency of English interiors. Here there was something of mysticism and asceticism, by no means in the Christian sense, with lots of heliotrope fragrance, manicured hands, and gentle sensuality, just as one would wish. Compared with previous rooms stuffed full of objects, these interiors were almost devoid of any furniture; there were simply two straight chairs on a white carpet with backs as tall as a man, gazing silently at each other across a small table, crazy, ghostly ... This slightly perfumed, decorative atmosphere was the product of the Macdonald sisters. ... Their unnaturally billowing figures kept reappearing in worked metal, embroidery, glass mosaics on walls and objects, cautiously distributed, fabulously decorated – and next to them, barren surfaces. For as I have said, the masculine foundation enables an appreciation of the sophisticated charm of the unadorned. Here the Scots delivered a lesson which continued to take effect long after their experiments with paper flowers, wire, and amethysts had been forgotten.
Ludwig Hevesi, *Altkunst – Neukunst*, Vienna, 1903.

World expositions and the bourgeoisie
Paris

Henri de Toulouse Lautrec
Yvette Guilbert or *Femme de profil (Mme. Lucy)*, 1896
Watercolor on card, 56 x 48 cm
Musée d'Orsay, Paris
"He [Toulouse-Lautrec] has a room in a brothel," wrote Jules Renard, "and gets on well with all the ladies that have unaffected feelings, who are alien to respectable women and wonderfully good at being models." The crippled painter found "unaffected feelings" in the world of Montmartre, far from the emotional hypocrisy of the bourgeoisie. Nonetheless, he did not idealize the milieu. He drew whores large and small with great affection but without sentimental gloss – and if no drawing paper happened to be available, then on tablecloths, the margins of newspapers or marble slabs: no *chronique scandaleuse* but deeply moving compositions of admirable conciseness.

Par de lentes métamorphoses,
Les marbres blancs en blanches chairs,
Les fleurs roses en lèvres roses
Se refont dans des corps divers.
Théophile Gautier[1]

L'art pour l'art – Fin de siècle

Victor Cousin (1792–1867) noted in his *Cours de Philosophie*: "il faut de la religion pour la religion, de la morale pour la morale, de l'art pour l'art. Le bien et le saint ne peuvent être la route de l'utile, ni même du beau."[2] Referring to Cousin, Théophile Gautier (1811–72) applied the catchphrase *l'art pour l'art* – art for art's sake – to poetry, so characterizing an aestheticism that exists for its own sake, pure and on its own terms, arising solely from the idea of beauty. The splendor and texture of precious stones, sumptuous materials and metals, exquisite scents, the romance of untamed fantasies and narcotic dreams, the life of the *demimonde*, the suggestive appeal of sounds and rhythms, of line and color – these were the accessories of Art Nouveau of Parisian provenance. With their polychromatic word colors, glittering and gleaming like gems irrespective of their meaning, the French poets of the Decadent Movement and Symbolism created an ambience of sensuous preciousness. For Rimbaud, Baudelaire, Gautier, and Verlaine, it was not a question of conjuring up a rational language but rather of compressing hallucinations into words and images. In Symbolist poetry, aromas, sounds, and colors blend into a unity. Paul Verlaine (1844–96) wrote: "I love the word '*décadence*'. It glistens with purple and gold. It coruscates fountains of fire and the gleam of precious stones. It summons up painted courtesans, circus spectacles, panting gladiators,

the leaping of wild animals, flames consuming exhausted human races …".[3] "Exhaustion," "weariness," "over-fatigue," "boredom" are all favorite words of the Decadent Movement, and the overwroughtness of a total art of the senses does unquestionably contain the germ of decline and fall – the *fin-de-siècle* state of mind. The refined savor of decay imparted itself to the aestheticism of *fin-de-siècle* art as well, and indeed became an agent of Art Nouveau. The "charm of sweet death" and "yearnful awakening" – both belong to Art Nouveau; emancipation, reform, and innovation were the counterparts of an art based on an aesthetically exhausted mood of doom.

The fact that overbred *l'art-pour-l'art* beauty was initially termed "Modern Style" in France, that is, characterized as an English influence, may seem astonishing; astonishing also inasmuch as the decorative elegance of Art Nouveau creations and their originators had little in common with the tracts of John Ruskin (1819–1900) or Arts and Crafts "cottage artists". The artists of Art Nouveau did not dream of applying their creativity to a useful or social end – works of arts seemed to them free of utilitarian restrictions. Yet there are connections: in the Pre-Raphaelite cult of beauty there is a school of thought linking England with *l'art pour l'art* and the Symbolists; a further point of reference is the visual language of William Blake (ill. p. 22) for which no models exist in the real world. Blake is the illustrator of subconscious visions whose metaphors resemble the French poetry of Symbolism. *Les fleurs du mal*, the "flowers of evil", of the Frenchman Charles Baudelaire (1821–67) are subsequently personified in *fin-de-siècle* England by Oscar Wilde and Aubrey Vincent Beardsley.

Hector Guimard
Tulipe Métro
Lamp (detail), Paris, 1899–1900
Painted cast iron, glass
"Now we see springing from the asphalt sprays of metal flowers, arrays of water plants, tulips radiating light, saturated with the fruitful, bubbling sap of the Paris underground."
(Maurice Rheims, *Kunst um 1900*, Munich, 1965)

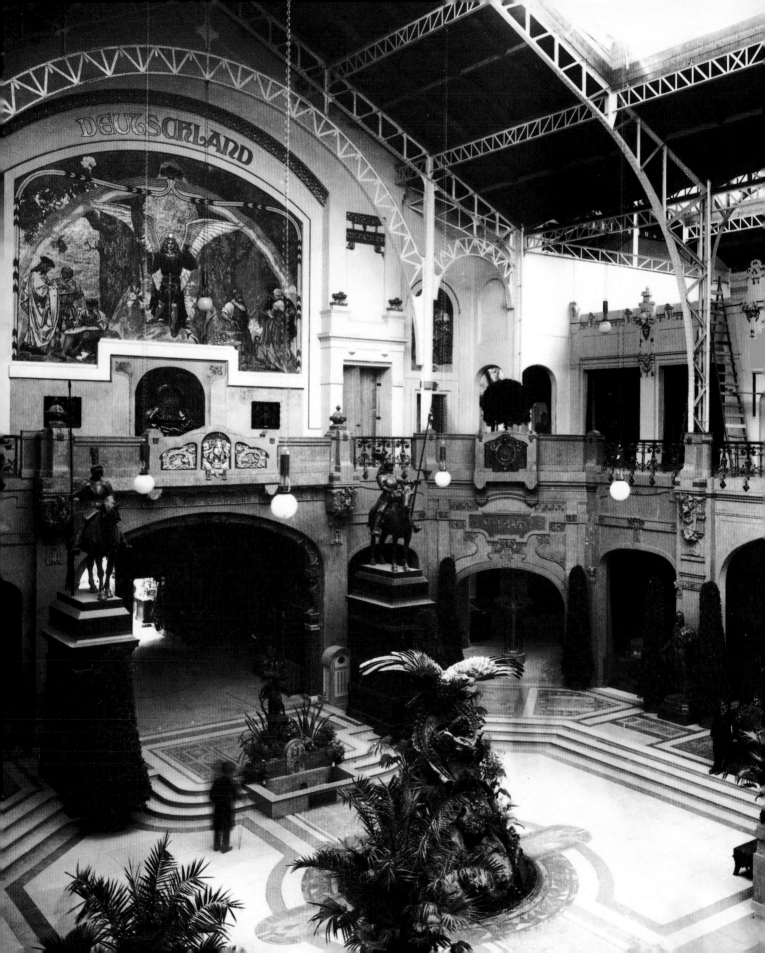

World expositions –
The "absolute bourgeoisie"

**By exploiting the global market, the bourgeoisie has
rendered production and consumption in every country
cosmopolitan.
A contemporary witness[4]**

Internationalization replaced national isolation
and self-sufficiency not only in material but also
in intellectual output. Nonetheless, though it
became common property, the latter fortunately
preserved its national individuality. Of prime
importance in bringing about such international
exchanges in the 19th century were the world
expositions, which after 1900 went out of
fashion in their turn with the growing develop-
ment of communications systems. These "vanity
fairs" even managed to impress the French
dandy Gautier, for all his aesthetic introspection.
As he wrote of the Paris World Exposition of
1867: "Art stood side by side with Industry. White
statues rose between black machines. Painting
spread out alongside the rich materials of the
Orient."[5] The whole fascination is expressed in
these lines – the encounter with the exotic, the
alien, art that could keep pace with progress and
the nascent aesthetics of the machine. Modern
powered machines possess an animal character
and a peculiar beauty in their construction. Thus,
in 1867 visitors in Paris went to see not only the
World Exposition but also the New Paris – Paris
Nouveau – that had sprung up under Napoleon
III and his Prefect Baron Georges-Eugène

Haussmann (1809–91). It represented the first
gloriously successful urban design for a modern
metropolis. The Third Republic's World Exposition
of 1878 in Paris turned out less brilliantly, as
traces of the Commune insurrection of 1871 –
the Paris Commune had set itself the goal of
transforming the unified French state into a
federation of sovereign communities and making
socialism a reality – were still clearly visible. In
contrast, 1900 saw a world exhibition that
exceeded all previous exhibitions in expense and
splendor – the beginning of a new century was
being celebrated. In place of the functional steel
constructions of 1889 – with their focal point the
Eiffel Tower (ill. above) – a baroque ceremonial
architecture appeared that made no bones
about its historical borrowings. Most of the
exhibition pavilions were likewise less than
successful, their bizarre forms and abstruse
motifs belonging to an illusory fantasy world
constructed of architectural clichés (ill. opposite).
A monstrous archway adorned the entrance,
dedicated to "Electricity" and lit up with over
3,000 colored light bulbs. Moving pavements
were dreamt of, and everything was to be electri-
fied; the Metro was already operating. The neo-
Baroque opulence of the trinity of the Grand and
Petit Palais with the Pont Alexandre III gives the
bank of the Seine even today the intensive flair of
the *Belle Époque*. It is a paradox of Art Nouveau
that it came into being within the artistic frame-
work of the selfsame *Belle Époque* it sought to
reject. We still look back with nostalgic melancholy

René Lalique
Corsage spray, 1905–06
Gold, *plique à jour* enamel, glass,
diamonds, 6 × 15 cm
Musée des Art Décoratifs, Paris
Lalique, who spent his
apprenticeship in England, had an
almost unlimited repertory of forms
at his disposal. Even so, his choice of
applications (corsages, necklaces,
brooches, and diadems) was
conservative.

François Eugène Rousseau
Vase, between 1885 and 1891
Flashed glass, with oxide gold leaf
inclusions, 14 × 15 × 9 cm
New Collection, National Museum
of Applied Art, Munich
Like many of his colleagues,
Rousseau profited from Japanese
art. He created flashed glass with
surface effects reminiscent of the
treacle glazing used on Japanese
stoneware. Even for his thicksided,
mostly crackle, glass pieces and vases
that feature gold-leaf inclusions and
cloudy colorations produced with
metal oxides, he preferred to use
East Asian forms.

to the era before the First World War, which is associated for us with dazzling society life, increasing prosperity, general modernization, the carefree pleasures of balls, assemblies, theaters and racecourses and a flourishing of the arts. Meanwhile, luxury and affluence were enjoyed by only a relatively small number of privileged people – the working class, peasantry, and provinces had no share in them. The *Belle Époque* was a manifestation of the bourgeoisie, which had superseded the nobility in the important positions of state and society. The "absolute bourgeoisie", as Jean Duché calls them, also owed its rise, absurdly enough, to the revolutions of 1830, 1848, and 1871, which the bourgeoisie had cleverly turned to advantage, thereby triumphing not only over the aristocracy but also over the masses. The aristocracy took refuge in pleasure, idleness, and aestheticism, which hastened its downfall; in contrast, the artists of the Decadent Movement became the embodiment of an "intellectual aristocracy", whose mortal enemy was the "bourgeois".

At the same time, those that turned the aesthetic program of Art Nouveau into reality at the turn of the century were dependent on that same bourgeoisie, as "the seeds of the iridescent flowers of this art could unfold only in the fertile,

well-prepared soil that the material culture of the grand bourgeoisie offered".[6] Moreover, toward the end of the 19th century, the bourgeoisie had, after all, put into practice what Karl Marx, with one eye on the Social Revolution, had demanded: "… that it can create its poetry not from the past but from the future. It cannot begin with itself until it has cast off the superstitious belief in the past. The Revolution must have its dead buried in order to get on with its own substance."[7] But, however much the practioners of Art Nouveau believed they had distanced themselves from the "mustiness" of the 19th century, Art Nouveau still satisfied above all a demand for luxury. Jewelry by René Lalique (ills. pp. 85, 87, 88, and above), vases by Georges de Feure or François Eugène Rousseau (ill. above) or furniture by Eugène Gaillard (ill. p. 94) carried high prices. It may be observed without irony that the philosophy that expressed itself in Art Nouveau certainly did not correspond to the opportunities and sensibilities of the rapidly growing proletariat. Attitudes to the "new art" were, however, ambivalent within the bourgeoisie itself as well. The limits of morality were still too tightly set to allow a libertine philosophy in the Decadent spirit.

Hector Guimard: Le Style Métro

Il faut arranger avec goût ce morceau de fer; il faut le disposer logiquement, avec méthode, et c'est dans cette voie seulement que vous trouverez la véritable beauté.
Hector Guimard[8]

The president of the Métro company, Adrien Bénard – a solid bourgeois – nevertheless sought out one of the "new artists" to design the surface structures and surrounds of the Metro entrances. Bénard was connected with the Art Nouveau movement and got his way over the contract with Hector Guimard (1867–1942) in the face of public opinion, which had reacted negatively to the first drafts. As we know today, it was a great achievement because Guimard's fantastic creations – a metamorphosis of architecture and nature, ornamentation with a practical application – made him immortal, and led to French Art Nouveau being sometimes called the *Style Métro* (ill. below). The reasoning of contemporary critics seems today rather odd: the green coloring of the sculptured structures was violently condemned as being "Germanic", while the lettering that Guimard designed, for the greeny yellow enamel signs fixed over the front of the entrances and closing the arch of the superstructures was attacked as unreadable and indigestible "to the honor of French taste"[9] (ill. p. 76).

In 1889, Paris reveled in the glories of iron structures, but taste later reverted to its attachment to "wedding-cake style" building. The architect and art theoretician Eugène Emmanuel Viollet-le-Duc (1814–79), advocate of the primacy of construction in architecture, exercised a decisive influence on both Guimard and also the Belgian Victor Horta. Iron was the architectural material of the future because it could also be used flexibly.[10] Unlike the "iron architects" before them, the Art Nouveau constructors Guimard and Horta invented a new Art Nouveau form, in which iron features as a slender, sinewy, statically effective element. The green-painted cast-iron stems and tropical floral pillars of the Métro entrances are an icon of Art Nouveau. "Each of the three fluted – quasi woody – stems rises from a single trunk, one helping to hold up the entrance sign, the two others, which hardly move apart, joining forces once more at the top to provide a support, frame and leaf cover for the fairy-tale glow of the lamp flower. Both below and above they become, of course, somewhat irrationally luxuriant, repeatedly knotted and cartilaginous together."[11]

An exhibition at the Musée des Arts Décoratifs in Paris in 1971 was entitled "Pionniers du XX^e siècle – Guimard, Horta, van der Velde." The three artists are the great inspiration of 20th-century architecture. Though line is their common means

Hector Guimard
Tulipe Métro
Lamp, Palais Royal station, Paris, 1900
Painted cast iron, glass
Guimard's Métro entrances – fantastic shapes that are almost a metamorphosis of architecture and nature, ornamentation with a practical application – made him immortal, and led to French Art Nouveau being at times called *Style Métro*.

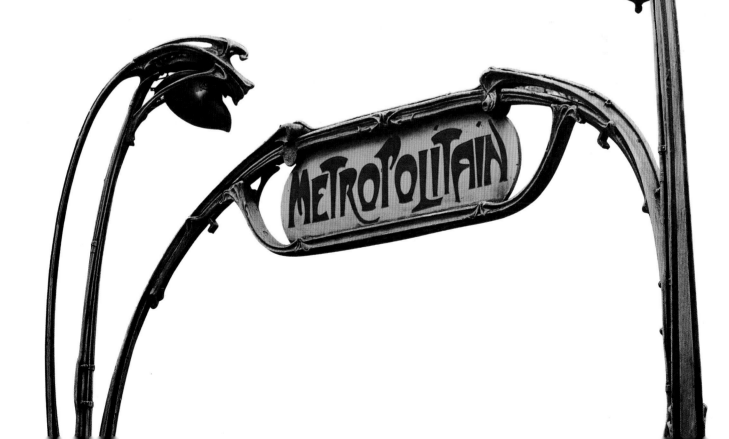

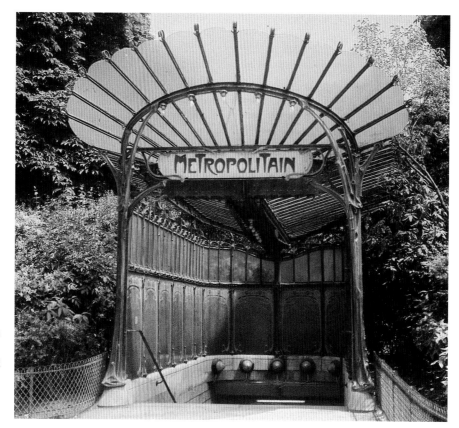

Hector Guimard
Porte Dauphine métro station,
Paris, 1900–01
In his roofing for the Métro entrance
porches, Guimard succeeded in
creating a wonderful synthesis of
glass, iron, and "air". The individual
glass panes are arrayed to each other
almost by suspension, permitting
total transparency without
compromising either the structure or
its stability.

Hector Guimard
Porte Dauphine métro station
Side panels of balustrade, Paris,
1900-01
Glazed tuff

of expression, at the same time they differ in
essential ways in respect of its interpretation and
function. For Horta as a constructor, line was an
accessory, graphic ornamentation that enlivened
his light-flooded iron structures. Van de Velde
meanwhile looked on dynamic, abstract line
as an integral element of montage, whereas
Guimard's architectural work aims for the
spatialization of line. For Guimard, line is not
abstract, but derived from nature without
imitating it: the artist translates its structure, that
is, its principle of growth. In this respect Guimard
is like the great Spanish architect Antoni Gaudí,
though without the latter's three-dimensional
handling of line. "What is consistently avoided
throughout, in everything, is anything parallel or
symmetrical. 'Nature,' says Guimard, explaining
his things in a booming voice and with tremen-
dous arm movements, 'nature is the greatest
builder of all and yet makes nothing parallel and
nothing symmetrical.'"[12]

L'architecte d'art

"Dance of shinbones" – "Knuckle art"
Ludwig Hevesi[13]

In 1894, Guimard won a travel bursary, which he
used not for the customary trip to Italy but to
spend time in England, Scotland, and Belgium.
"The whole ´homeliness of the interior is
stamped on the exterior. Individual homes reveal
themselves outwardly in orderly fashion. That is
very entertaining and reasonable; it also makes it
a pleasure to live there."[14] Absorbing an impres-
sion of the English Country House Movement,
Guimard has here internalized its principles, that
a logically conceived, modest home can likewise
become a work of art on the strength of its
beauty and harmony. The aim and purpose of a
building are, as it were, its "decoration". The
decor springs from the duty to take account
of the needs of the occupants while guarantee-
ing them, over and above pure usefulness, an
individually fashioned, cultural milieu. During his
trip to Belgium, Guimard got to know Horta and
the buildings of Paul Hankar (1859–1901). "Now,
Horta said one day to Guimard, half in jest, 'I

Lucien Gaillard
Comb, ca. 1900
Carved ivory, gold, chalcedony,
10.6 cm long

don't use flowers as a model but their stems. Guimard was struck by this. At once, a jumbled picture sprang into his mind of something that we should like to call Stem Style. ... However, what we have called Stem Style runs through the whole house, inside and outside. The whole range of grilles, banisters, wall surfaces, glazing, mosaic floors, runners and furniture, all designed by Guimard, display this ornamental style."[15] (ill. p. 82–83). Guimard was not content with fashioning architecture; he became the *architecte d'art*, as he called himself, that is, a craftsman of all the arts, in the Art Nouveau sense. Here again the English model is evident, the architect Charles Francis Annesley Voysey having already rejected the elevation and special position accorded to architecture over the applied arts. As an artist-craftsman, Guimard thus set to work on a plate with as much circumspection as on an architectural component (ill. p. 80). The elements are all composed in harmony and worked out in the tiniest detail. Preference is given to malleable materials such as cast iron, bronze, and flexible metals. Here, Guimard attains the greatest perfection; the poetry of Art Nouveau is wrought

more successfully here than in his work in wood. Guimard won his first major commission from the widowed Mme. Fournier for the construction of Castel Béranger, a residential building with 36 units. He managed to persuade his client to alter a first, more historicizing draft, produced before his travels abroad, in favor of an *art du geste*, the art of curvilinear frame. As with Mackintosh, it was a female client who granted him carte blanche to create an architectural masterpiece. "And the owner, a worthy bourgeois widow called Madame E. Fournier, has allowed her architect a completely free hand to charge about as he deems fit. Truly, this lady deserves the Légion d'Honneur."[16] "The curve, the true affective line, is the favored terrain of his ornamental imagination."[17] (ill. p. 105) Perhaps a better appreciation of this "affective line" is the secret of a female clientele. Thus, one may note features shared not only with the French rationalists of the late 18th and early 19th centuries but also a link with the lyric poets of Symbolism. Guimard too made use of surprising effects in his building works. Though the various components – even the fiercely opposed *rocaille*

Pages 78, 79:
Hector Guimard
Inner lobby and view of door to a room, Hôtel Paul Mezzara, 60, rue La Fontaine, Paris, 1911
The Hôtel Mezzara is laid out round a large, two-story patio and surrounded by a gallery that obtains daylight via a glass window in the ceiling. In contrast with earlier buildings, this residential-cum-studio building is relatively sober, but even so, in its details it displays the typical *Style Guimard*.

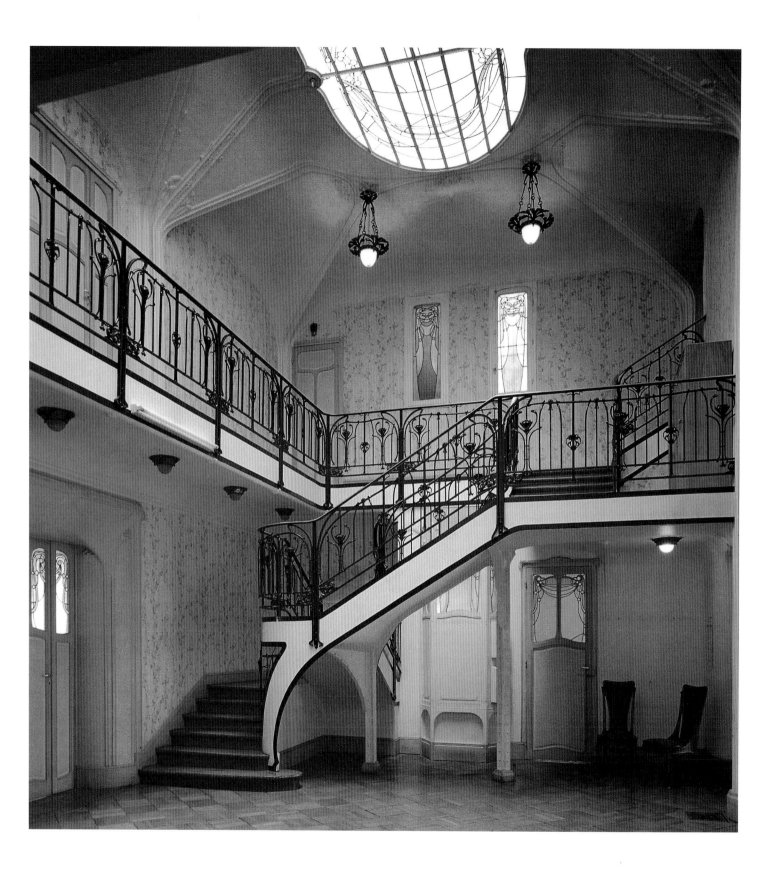

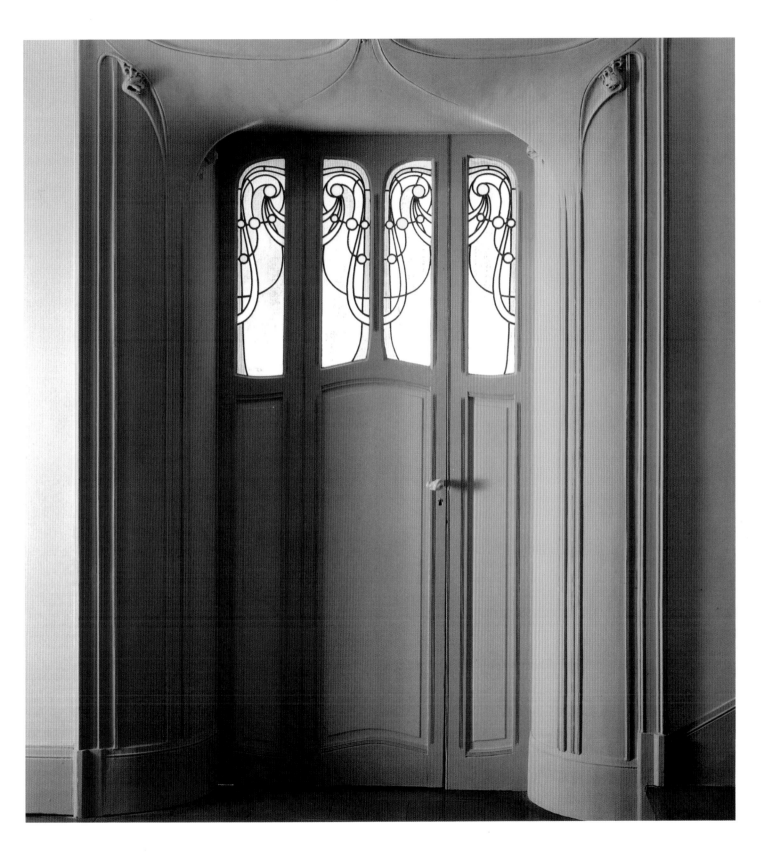

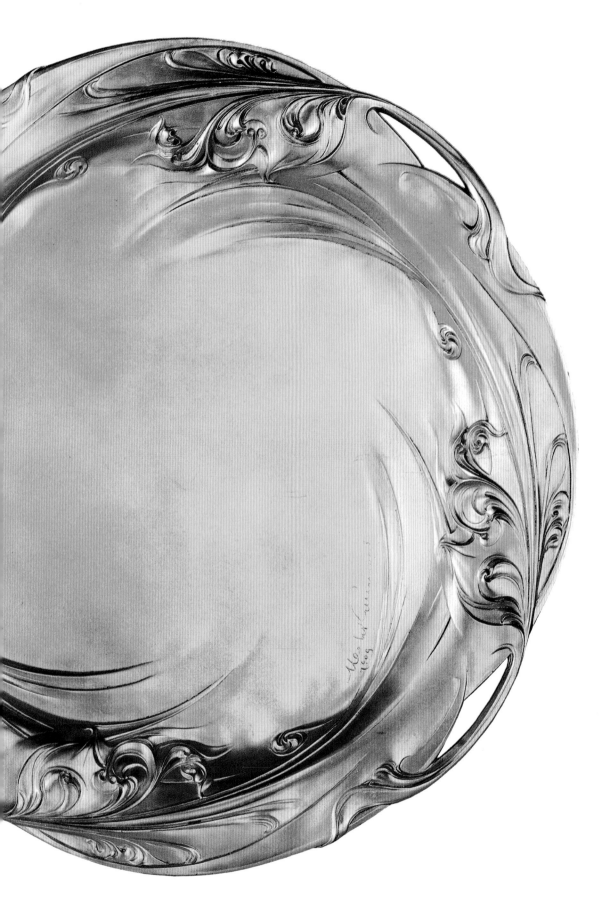

Hector Guimard
Plate, 1909
Bronze, gilt, diameter 36 cm
Musée des Arts Décoratifs, Paris
Guimard was not content to design
architecture. He saw himself as an
architecte d'art, an "art architect",
which in the context of Art Nouveau
means a craftsman of all the arts.
English influence can be seen in this
– the English architect Charles
Francis Annesley Voysey had
already rejected the elevation and
special position of architecture above
the applied arts. As an artist-
craftsman, Guimard set to work on a
plate with as much circumspection
as on an architectural component.
All elements are composed in
harmony and worked out in the
tiniest detail. Preference is given to
malleable materials such as cast iron,
bronze, and flexible metals. This is
where Guimard attains the greatest
perfection, and his metal works are
almost beyond comparison with his
creations in wood.

around 1900 – combine to make a whole, works of art are, unlike nature, multi-dimensional, the unity being reestablished only in the eye of the beholder (ill. p. 83). Numerous building commissions testify to Guimard's creativity. At the opening of the Humbert de Roman concert hall in 1901, critics described the gigantic steel and glass hall as a "druidic grove", since the iron ribs were perceived as the boughs of a colossal tree. (The hall was demolished a few years later.) There followed private houses, public buildings, and his own house. The Hôtel Paul Mezzara of 1911 is laid out around a large, two-story patio and surrounded by a gallery that obtains daylight via a glass window in the ceiling. In contrast with earlier buildings, this residential-cum-studio building is relatively sober, though in its detail it displays the typical *Style Guimard* (ills. pp. 78–79). "It [the patio] served the client, who was a textile manufacturer and wanted to combine home and workplace, as both reception hall and showroom. Perhaps this is why the wrought iron balustrade is relatively simple and the decoration very delicate, with free-standing structural ironwork that carries the staircase and white-painted roof."[18] The marriage of glass, iron, and "air" in the Hôtel Paul Mezzara is as successful a synthesis as the wonderful roofings over the entrance porches to the Métro. In the latter, the glass panes are arrayed to each other almost by suspension, permitting total transparency without compromising the construction or its stability (ill. p. 76). Even opponents of Art Nouveau find in Guimard's oeuvre the perfect expression of a style that, over and above all functionality, manifests qualities that have become rare in the field of modern architecture, namely, elegance and imagination, musicality and poetry. Through his formal inventions, shaped by the ornamental gesture, Guimard has remained one of the great sources of inspiration to this day (ills. pp. 71, 76, 78, 79, 82–83). It is also instructive that Guimard left a deep impression on the painters of the 20th century, particularly Picasso and Dalí. The latter could be described as Guimard's real rediscoverer while the Frenchman was still alive. Thus, parallel to a Guimard exhibition at the Museum of Modern Art in New York in 1970, Dalí organized his own exhibition at the Knoedler Gallery there under the title of "Hommage à Guimard."

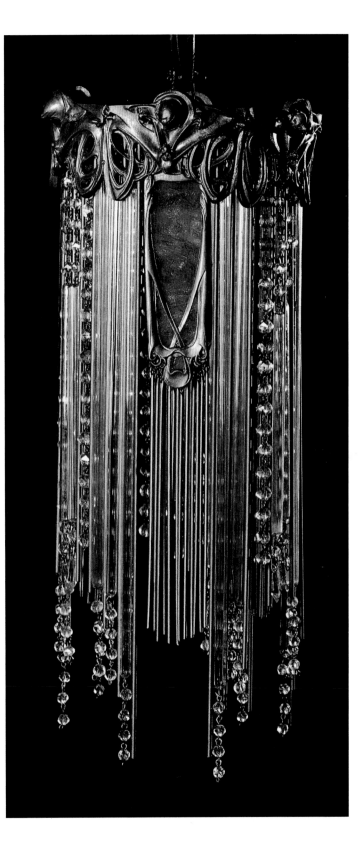

Hector Guimard
Ceiling lighting, from 1909
Chased bronze, gilt, colored glass, glass beads, glass tubes, setting of brass and copper, 41 × 19 cm
Musée d'Orsay, Paris
Guimard did the design in 1909 and had it patented on August 18 1910.

La divine arabesque –
Debussy and Bergson

Il m'a dit: Cette nuit j'ai rêvé,
J'avais la chevelure autour de mon cou,
J'avais tes cheveux comme un collier noir
Autour de ma nuque et sur ma poitrine ...
Pierre Louÿs[19]

Hector Guimard
Balcony railing (detail), ca. 1909
Cast iron
"What we have termed Stem Style
runs through the whole house, inside
and outside. All the many grilles,
banisters, wall surfaces, glazings,
mosaic floors, runners, furniture –
each designed by Guimard – feature
this style of ornamentation."
(Ludwig Hevesi, see note 15)

Admirers of Guimard speak of the musicality and poetry of his architecture, thereby expressing their sensations by means of other artistic media. It is evident here how interwoven the arts had become under Art Nouveau and what inroads symbiosis and synesthesia had made. This is *l'art de geste*, that around the turn of the century manifested itself in poetry and music, as in art (ill. below). The melodic garland, the resolved ornament, Debussy's *divine arabesque*, in fact freely unfolding melismata in general, are creations of this kind. The arabesque was a form used by Claude Debussy (1862–1918) again and again – restrained and sublimated in *Pelléas et Mélisande*, and as a symbol of nature in *La mer*. Floating and transparent, sensuous and yet cool, the line of the "divine arabesque" is here the symbol of an esotericism transposed into the decorative. It is no accident that the first concert dedicated entirely to works of Debussy took place at the La Libre Esthétique Gallery in Brussels, in 1884. The "interplay of lines" united all arts, and the fact that there was also a common "cradle" is shown by the cover of *La mer* in 1905, bearing Hokusai's *View of Fuji seen from the trough of a wave in the open sea outside Kanagawa* (1831–32),

Right:
Hector Guimard
Metro cartouche, balustrade of
Abbesses station, Paris, 1900
Cast iron
Guimard was another who used
surprising effects in his structures.
Though the various components –
even the fiercely opposed *rocaille*
around 1900 – make up a whole,
works of art (unlike nature) are
multi-dimensional, and unity is only
restored in the eye and the feelings of
the beholder.

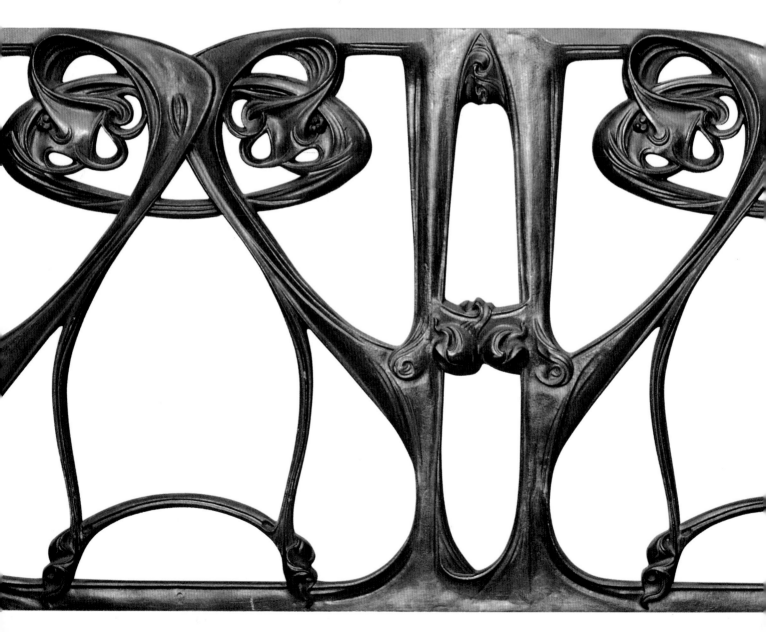

probably the most influential and most famous wave in art history.

The "divine arabesque" in the compositions of Debussy occurs in numerous variants – exactly the same variants as in the fine arts and applied art. In the setting of Mallarmé's eclogue *Prélude à l'après-midi d'un faune*, the arabesque appears as an ornamental, decorative pattern; in the "Chansons de Bilitis" from *La chevelure* by Pierre Louÿs (1870–1925), the "rocking arabesque" is a symbol for the entwinement of two lovers in the tresses of the woman. The pictorial symbolism of long female hair flows through the whole Art Nouveau style much as the arabesque does. In many of its forms, Art Nouveau appears as precisely a phenomenon of the arabesque itself. "In Art Nouveau, the arabesque becomes a universal gesture of artistic expression ... Every line generates a counterline, just as every movement calls forth a countermovement in the sense of an unending oscillation; formal oscillations expressing spiritual oscillations whose specific mood (*état d'âme*) is expressed (in the graphological, symbolic sense) through the characteristic style of lines. It is in the rhythm of the arabesque that the philosophy of this art finds form. The arabesque becomes a way of experiencing the world."[20]

The term "arabesque" long subsumed the whole formal language of the Islamic East – geometric and plant forms as much as living motifs. In his *Questions of Style* published in 1893, Alois Riegl (1858–1905) was the first to restrict the arabesque to Islamic art and its typical fork-leaved tendril, a

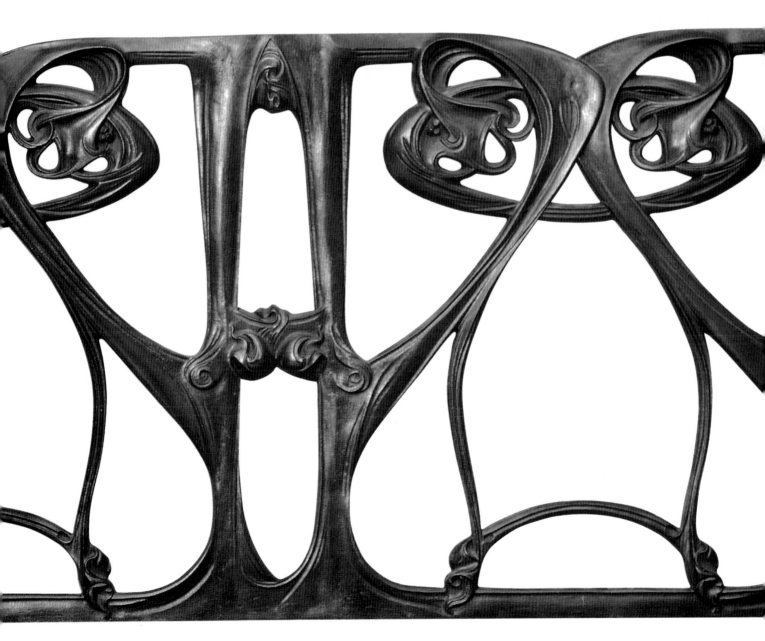

motif rather remote from nature. The followers of Islam are of the opinion that it is not the job of the artist to record in images reality as optically perceived or experienced, that is, to confer permanence on transitory earthly forms, as it is against the divine will. Here, it is not so much in ideological respects as in the formal approach that the delight in ornamental meditation and aesthetic asceticism accords with Art Nouveau feeling.

Fin-de-siècle Europe succumbed less to the formal charm of the arabesque than to the rhythmic alternation of movement that it produces on the surface to be decorated. The French painter Odilon Redon (1840–1916) (ill. p. 100) saw events in space under the aspect of two-dimensional arabesques: "It is, without allowing a precise explanation, the reflex of a human expression which a supple imagination has woven into an interplay of arabesques; and its effect on the spirit of the beholder will, I believe, prompt him to visions whose importance will rise and fall in accordance with his sensitivity and imagination."[21]

If Debussy is to some extent the musician of arabesques and Art Nouveau, one could call Henri Bergson (1859–1941) the philosopher of these phenomena. Bergson's support for Art Nouveau was quasi-spiritual. Though he never expressed a direct opinion on Art Nouveau, or indeed on any other contemporary artistic movements, the concepts of *durée* (duration) and *élan vital* (vitality) – central to his intuition-driven "philosophy of life" – provide non-material terminology for Art Nouveau in the continuous sweep of organic lines. In his essay *La vie et l'œuvre de Ravaisson*, a contribution to *La pensée et le mouvant* of 1904, Bergson quotes Leonardo da Vinci's *Trattato della pittura*: "The secret of the art of drawing lies in discovering in every object the particular way in which a sinuous line develops as a generative axis into a whole, just as a wave spreads outwards from the centre and gives rise to numerous ripples."[22]

Developing this theme, Bergson postulates, in agreement with the French philosopher Jean Ravaisson-Mollien (1813–1900): "Living things are characterized by wave-like or serpentine lines. Every living thing snakes along in its own fashion. The aim of art is to express precisely this serpentine motion."[23]

We may justly claim that these "wave-like" or "serpentine" lines have, in terms of art history, a profound inner affinity with the *figura serpentina* or the *disegno interno* of the Mannerists. If there is a difference between the philosophy of Bergson

Paul-Elie Ranson
Tiger in the jungle, 1893
Color lithograph, 55.7 × 39.5 cm
The sinuous dragon shapes of Sino-Japanese art, motifs used there as interwoven ornamentation, are adapted by *La Revue Blanche* artist Ranson in an arabesque, Art Nouveau manner.

Left:
Julien Caussé
The Ice Fairy,
ca. 1900
Chased and patinated bronze. Base: founded opal glass, 39.3 cm high
Museum Bellerive, Zürich

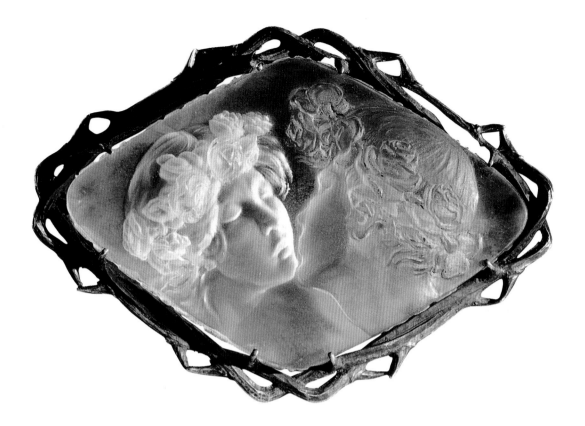

and Art Nouveau, it might be described as follows: whereas Bergson aimed to comprehend the virtually existent real intention behind concrete things, Art Nouveau attempts to express wave-like or serpentine lines directly as waves or serpents. Where the main concern of the philosopher was to explore "the simple thoughts that correspond to the infinite variety of forms and colors", the concern of Art Nouveau was to understand thoroughly "the infinite variety of forms and colors" themselves and become reality thereby.

Where serpents are depicted, "woman" is never far away, and flowing tresses also feature in this context. In *La chevelure*, poetically extolled by Louÿs and set to music by Debussy, Art Nouveau seems to become immersed or sometimes even entangled in female tresses – yet without seductive, innocent and at the same time depraved woman there would be no Art Nouveau of Parisian cast.

"Her eyes and the diamonds shone in a single flame" (Gustave Flaubert)

J'ai vu le diable, l'autre nuit;
Et, dessous sa pelure,
Il n'est pas aisé de conclure
S'il faut dire: Elle, ou: Lui.
Jean Paul Toulet[24]

Femme fatale or saint, sinner or Ophelia, Chastity or *diable* – this was the question posed by a whole generation of artists, interpreting an apparently still-unsolved riddle in quite different ways, both in the answer and the stylistic devices used. The very enquiry seems at any rate to have been thoroughly stimulating, bequeathing us seductively lovely creations in almost every material imaginable (ill. p. 84). Luxury objects and jewelry, both readily associated with the fair sex, were particularly suitable media for transplanting the subject in a manner appropriate to both meaning and material, thereby also satisfying the desire for synesthesia (ill. p. 88, left). To this day the female form counts as an outstanding "selling point". In his treatise on Oscar Wilde, Enrique Gómez Carrillo (1873–1927) provides an, as it were, sensational description of Salome in which all male fears and desires are sublimated: "… Only the painting of Gustave Moreau lifted for him the veil from the

René Lalique
The Kiss, brooch, 1904–06
Silver, molded glass, 4.9 × 7 cm
Musée des Arts Décoratifs, Paris
At the 1901 exhibition of the Paris Salon, Lalique included in his collection for the first time jewelry made of crystal glass – the first move toward a new artistic creative material.

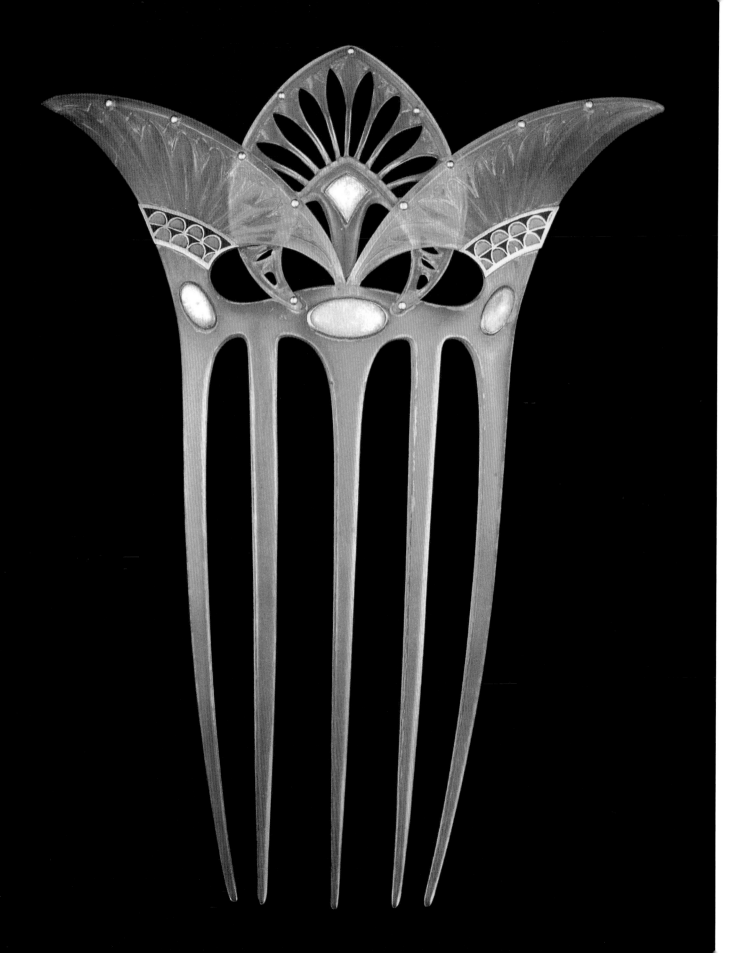

soul of the legendary dancing princess of his dreams. He often repeated the famous words of Huysmans to us: 'She is almost naked. In the frenzy of the dance the veils have become undone, the brocades have fallen to the ground and only more jewels cover her body. A very small girdle embraces her hips, and between her breasts a precious jewel shines like a star; a chain of garnets coils itself lower around her loins, and over the shadow of her pudenda gleam emeralds. 'This seemed to him an unsurpassable portrayal. And five years later, in the hours of sleeplessness, fever and hunger in his prison cell, Wilde repeated the words to himself mechanically: 'Between her breasts a precious jewel shines like a star'."[25]

René Lalique: Poetic jewelry – Polished poetry

Parle moi doucement sans voix parle à mon âme.
Marceline Desbordes–Valmore[26]

"Gems" that vie with the lustre of the stars, that form a perfect reality of the poetry, music, and philosophy of life of the era – such is the fabulous jewelry created by the jeweler René Lalique (1860–1945). Lalique was one of the most celebrated artists of Art Nouveau, endowed with brilliant craft skills that mastered every challenge without effort. Like Gallé, he was able to coax truly poetic appeal from his material. "What held friend and foe, enthusiasts and vituperators, apologists and faultfinders, casual exhibition-goers and scholars alike irresistibly fast in front of Lalique's showcase and drew them under the spell of his great art was a trait in the great master's being – the secret magnet that since the beginning of time has brought the common herd crowding around the individual – a gigantic ego!"[27] These are the glowing words of a

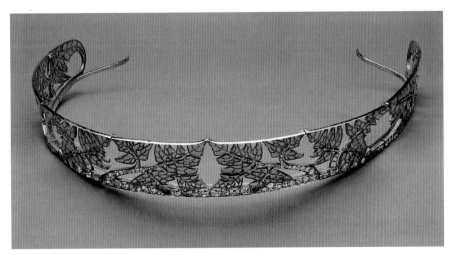

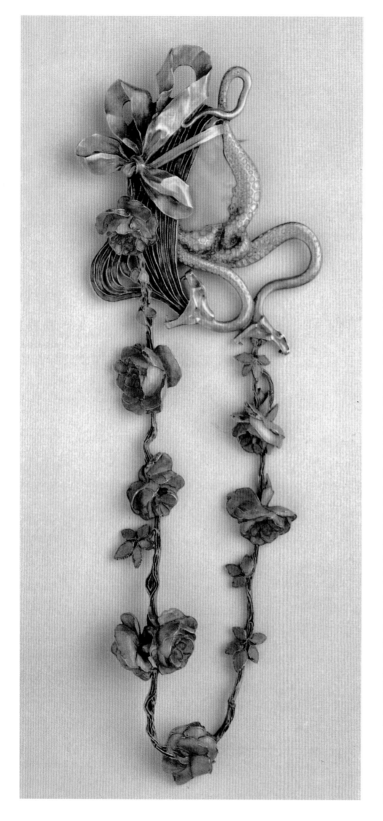

Viennese art critic, and a wood engraving called *La vitrine de Lalique* [Lalique's Showcase] by Félix Vallotton (1865–1925) documented the dense crowd of people standing in front of the "gigantic ego's" exhibition showcase at the 1900 World Exposition in Paris. The magnet that drew the public was a showcase that – like something devised by Joris-Karl Huysmans (1848–1907), a disciple of the cult of overrefined beauty – gave shape to the pictorial world of Symbolism. In front of a bronze grille of stylized butterfly women and under a firmament with suspended bats, the sensation of the World Exposition met their gaze: spirit-filled creatures of a between-world, heavy with symbolism, formed of exquisite materials. "A great dragonfly captivated the public. Its wings are made from delicate gold latticework that even moves on hinges. A threatening eye was represented by the artist with flowing enamel into which he fused little flecks of silver to enhance the effect. These very dark green surfaces are glitteringly accentuated with small diamond insets, while the other parts of the wings are filled out naturalistically with transparent enamel. The long body is studded with green chrysoprase, alternating with small fields fused with dark blue enamel. Seductive beauty turns gruesome when the menacing claws of the insect are revealed, a mixture of mole spades and cockerel's claws. The eyes of the dragonfly are formed by two dark scarabs. The green head of the insect turns out on closer inspection to be something completely new – a smiling female face that, again in an ambiguous allusion, is in the process of being either disgorged or gobbled up."[28] This exotic and "deviant" treasure was acquired in 1903 from the artist himself by the equally legendary multi-millionaire Calouste Gulbenkian (1865–1965) for his collection.

Today the collection, along with other important works by Lalique, can be seen in the museum Gulbenkian founded in Lisbon, Portugal. On the occasion of Lalique's death, he wrote to the artist's daughter: "His [Lalique's] place is among the highest in the history of art. His very personal genius, his exquisite imagination, will be admired by future *élites*. I am very proud to own what I believe is the major part of his work; it occupies a very privileged position among my collections."[29] Yet Gulbenkian was not alone; the great museums of the world snapped up Lalique's jewelry, and moreover at exorbitant prices. A museum in Leipzig, for example, acquired a dress ornament (ill. left) and an ornamental comb (ill. p. 87 top right) for several thousand gold

René Lalique
Brooch, ca. 1900
Gold, *à jour* enamel, diamonds, 6.25 cm high

francs. Lalique moved in both aesthetic and aristocratic circles and was acquainted with the eccentric Count Montesquiou (ill. p. 73), whose favor was also curried by Gallé and in whom he eventually found an admirer. The path to fame was nonetheless arduous. A gifted graphic artist, Lalique opted for gold work, completing an apprenticeship that left him, with his modest material means, hardly any time for artistic studies. After spending two years in London, the center of the new style, he returned to Paris in 1880 and designed jewelry for the great jewelry houses such as Cartier. When he had made himself independent with his own small business, he continued at first working on commissions. The breakthrough came when Lalique was able to exhibit his own creations at the annual salons, which from 1885 allowed artistic pieces from the field of applied art to be admitted as exhibits. The goldsmith of the *Belle Époque* had not spent his apprenticeship in England unprofitably. His superb design drawings – 1,500 of them survive – show the influence of the British workshops. The drafts are made to scale, on papyrin; for all their phantasmagory, they possess a geometric framework akin to the design procedure of the medieval stonemasons, who always had a – hidden – set of rules underlying their patterns (ill. opposite, right). Against this background, Lalique's immense stylistic achievement becomes palpable. His repertoire of forms was a novelty, though the jobs given to him were, of course, conservative – corsages (ill. p. 74), necklaces, brooches, and diadems. Diadems are among the oldest and most exclusive pieces of jewelry, and became extremely important for *fin-de-siècle* jewelers. With his predilection for plant forms and symbolic shapes, Lalique virtually reinvented the diadem, partly in terms of form, partly by using unusual raw materials (ill. p. 87). That artistic value is not necessarily a consequence of material value is evident from Lalique's work, but even today the fact is still not always appreciated. Whereas the fossilized jeweler's art of the Empire fiddled around with precious stones, the ornamental artists of Art Nouveau, led by Lalique, worked with simple materials with purely representational value, thereby opening up new opportunities for expression. The art of enamel technology flourished as never before; there were no limits to the skill and invention of the enamelers. In enamel, the color palette of Art Nouveau – mixed, matt tones – could be recreated almost perfectly. In addition to the nuances of color, there was a whole range

of new materials: polished semiprecious stones, amber, mother-of-pearl, ivory, tortoiseshell, pearls, base metals, and horn. The natural, organic material horn fitted in well with the organic shapes of Art Nouveau, and Lalique dazzled the public with ornamental combs of horn shaped and carved into flowers, waves, and butterflies (ill. p. 87). Despite the "cheap" material, work of this kind quickly became fashionable, as it possessed exotic appeal even for the bourgeoisie. As Samuel Bing says in his work on Japanese forms: "Japanese women were the first women of all to wear combs in their hair ornamentally …"[30], so a modern air of Japonisme was adopted.

Besides Lalique, other leading ornamental artists such as Lucien Gaillard (1861–after 1945) (ill. p. 77) and Georges Fouquet (1862–1957) designed ornamental combs. The latter, a scion of the Fouquet jewelry dynasty, took over his father's business in 1895 and immediately turned over production to the Art Nouveau style, employing designers and technicians who had studied previously with Lalique. Besides Japanese and oriental influences, Fouquet used Egyptian styles for decorative ensembles (ill. p. 86). Attracted by the *genre Lalique*, numerous jewelers fell in with the Art Nouveau line, and almost all Art Nouveau artists in Paris took up the medium of jewelry, including Eugène Grasset, Alfons Maria Mucha,

Alfons Maria Mucha
Poster design for *Gismonda*
(detail), 1894
Tempera on canvas, 198 × 67 cm

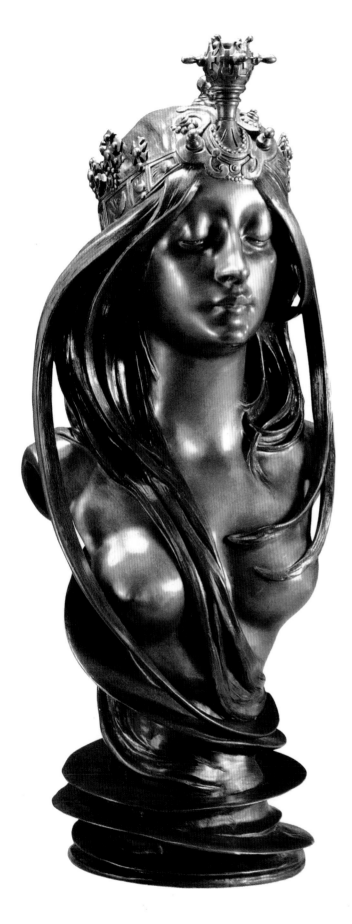

and Georges de Feure. The long-established jeweler Vever found in his sons, Paul and Henri, successors who were not only complete hands at the new style (ill. p. 87) but who even published in 1908 a 700-page book about French ornamental artists – a stimulating reference tome with reports on workshops, exhibitions, and production methods of this grandiose art form around 1900.

At the Paris Salon exhibition in 1901, Lalique exhibited for the first time ornamental pieces from crystal glass – the first step in a move towards a new medium for artistic creation. Where before 1900 he had been the protagonist of a new ornamental art, during the 1920s he became a celebrated artist in glass, in whose work the philosophy of an era was once again reflected.

Le Style Parisien: Alfons Maria Mucha –Jules Chéret – Eugène Grasset

Ces nymphes, je les veux perpétuer.
Stéphane Mallarmé[31]

A thematic thread that linked, indeed entwined, all these "art-makers" of around 1900 was – as already indicated – flowing hair and what came attached to it, namely woman. At the same time, allure manifested itself not just in art but also in flesh and blood. There were the great courtesans such as Bel Otéro or Cléo de Merode, indisputable "accessories" of the *Belle Époque*, and the great muses, like the tragedienne Sarah Bernhardt and the dancer Loïe Fuller. Both inspired artists in all aspects of their creation. Lalique designed diadems for the divine Bernhardt, although he had more or less rejected theatrical jewelry as artistically mediocre. Fouquet engaged the all-round genius Alfons Maria Mucha (1860–1939) as a designer, thus vicariously sharing in the immigrant Bohemian artist's fame. Mucha and Bernhardt could be relied on for bizarre notions and eccentric taste. A theatrical poster commissioned by the actress in great haste at Christmas 1894 conferred overnight on the hitherto unknown artist a halo that even now makes him seem one of the great figures of the turn of the century. The drama of the poster for *Gismonda*, a play by Victorien Sardou (1831–1908), caused a huge sensation and so entranced Sarah Bernhardt that for the next few years she gave Mucha an exclusive contract (ills. right and p. 89). Henceforth he assumed responsibility not just for all the actress's posters but also for her stage sets and costumes. Thereafter he was inundated with

Alfons Maria Mucha
Gismonda, poster, 1895
Color lithography, 217 × 74 cm
The first poster for Sarah Bernhardt and the Théatre de la Renaissance gave Mucha an artistic breakthrough virtually overnight and brought him fame. Sarah Bernhardt is portrayed in the costume of Gismonda in the last act of the play; her impressive pose and rapt facial expression became the prototype of French poster art around 1900.

Left:
Alfons Maria Mucha
Nature, bust, 1899–1900
Patinated bronze, gilt, silver-plated, 67 cm high
Execution by Pinedo, Paris
This bust shows all the features of the artist's style, and the representation of the indeterminately enigmatic character of the *Belle Époque* feminine type, which at times ruled all Paris, became an ideal outside France as well.

graphic commissions, for advertising posters, calendars, menu cards, magazine titles and *panneaux décoratifs* [decorative panels] (ill. left). Thanks to this – and his outstanding talent – Mucha developed into one of most creative artists of Art Nouveau. His work unites Byzantine traditions and contemporary stylistic features with the application of more delicate, softer colors in a new synthesis of unique individuality. Young women with dreamy expressions dressed in flowing robes are so to speak his "trademark" (ill. right). He himself never spoke about Art Nouveau and its theories and principles – "I do it my way" was his only observation.[32] Bold arabesques of thick female hair feature not only in his graphic work but also in ornamental designs and on textiles, in interiors and sculptural work. The bust entitled *Nature* (ill. opposite) incorporates all the characteristics of his style. In its representation of the indeterminately enigmatic character of the *Belle Époque* feminine type, which at times ruled all Paris, it became the ideal of female beauty outside France as well. In 1902, Mucha published *Documents décoratifs*, a pattern book of his ornamentation with suggestions for its practical application. Otherwise he remained reticent, disappearing from the art scene in Paris to live alternately in his homeland and America.

It was not just *Gismonda* that overwhelmed onlookers from the elevation of a hoarding. Never before had Paris seen so many artistic posters as it did around 1900. Visitors to the World Expositions were to be intensively courted, in order to promote the booming sales of industrial products. Posters extolled everything, ranging from bicycles through medicines to visits to the local nightspot. They caused a stir, and soon attracted collectors as well. Way back in 1868, improved printing technology had opened up new opportunities, and with the invention of color lithography in 1879 – a prerequisite for the artistic poster – the way opened for its march of triumph. Toulouse-Lautrec waxed enthusiastic about a Bonnard poster for "France Champagne" and hung it up in his workshop alongside Jules Chéret's poster for the Moulin Rouge. However, it was his own poster *La Goulue* that would revolutionise the whole genre and pioneer the development of advertising art later.

Jules Chéret (1836–1932), perhaps the most popular decorative painter and poster artist in France, represented the urbane, Parisian style within French poster art, creating as it were the "pin-up girl" of the *Belle Époque*. In an almost Rococo manner and with Impressionist coloring,

he depicted figures of graceful young women of delightful radiance, which Paris loved (ill. p. 93). He made a significant contribution to the development of the poster, and considered snappy advertising texts in matching typefaces to be one of the most important parts of the poster. He felt that, to some extent, the typeface holds the key to the picture and should in every case be done by the artist himself. He drew the design on the block himself and supervised the proofs – what looked down from the hoardings of the city so light-footed and playfully had a solid crafted basis. In 1894, he designed a poster for an exhibition of Eugène Grasset (1841–1917), whom he esteemed. Grasset's rather Pre-Raphaelite, pensive young female figures are less fashionable (ill. p. 92 left). Born in Lausanne of an old artistic family, Grasset was, like the English, a reforming spirit, and in 1905 he published a textbook called *La méthode de composition*

Alfons Maria Mucha
La Topaze, [Topaz], panneau décoratif [decorative panel], (reduced version), 1900
Color lithographie, 60 × 24 cm

Alfons Maria Mucha
Job, poster, 1897
Color lithography, 52 × 39.8 cm
Thanks to his outstanding talent, Mucha developed into one of the most creative artists of Art Nouveau. His work combines Byzantine traditions and elements of contemporary style with the application of delicate, soft colors, to create a new synthesis of unique individuality. Young women with pensive gazes wearing flowing robes are his "trademark".

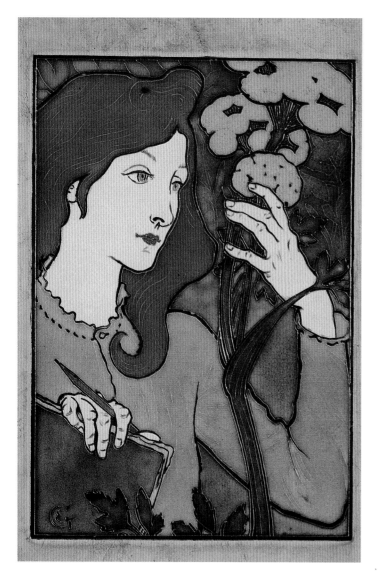

Eugène Grasset
Drawing, color plaque, 1894–95
Modeled stoneware, glazed in color,
60 × 42 × 3 cm
Born of an old artistic family,
Grasset was, like the English, a
reforming spirit and, in his textbook
*La méthode de composition
ornamentale*, published in 1905, he
set out a convincing and enthusiastic
case for the principles of
democratizing art in the sense of an
aestheticism uniting all areas of art.
He put his own ideas into practice,
and set to work in all aspects of
applied art.

Maison Bing, L'Art Nouveau

*Art Nouveau is a nonsense; art cannot be new since
it is eternal.*
Alfons Maria Mucha[34]

Out of these manifold ingredients of the diverse
stimuli and reflexes that electrified the cultural
atmosphere of Paris in the 1880s and 1890s, a
foaming cocktail was mixed on the threshold of
the new century that, like every exclusive drink,
required a name. Godfather at the christening
was Siegfried (Samuel) Bing (1838–1905), a
Paris-based citizen of Hamburg who is often
described as the impresario and philosopher of
Art Nouveau. On December 26 1895, he opened
a gallery in the rue de Provence in order to give
"new, young" artists in Paris a "place". The
gallery was called Maison Bing, L'Art Nouveau.
Bing thereby created a kind of collective term for
everything, irrespective of its heterogeneity, that
was distinct from the artistic taste that had ruled
hitherto. The Art Nouveau idea did admittedly
encounter criticism at first: "People were sorry
for Bing. He was considered the victim of a
treacherous coup by revolutionary artists who
knew how to exploit his naivety. Edmond
Goncourt, who had steeled himself to behave
like a dignified gentleman at the exhibition, raised
his arms as a sign of abhorrence once in
the street", according to the French press.[35] In
contrast, the English periodical *The Studio*
celebrated the Galerie Art Nouveau as the great
event of the artistic season. It honored a man
who, since 1888, had published a *Treasury of
Japanese Forms* in German, English, and French,
thereby making a substantial contribution to a
change in taste; a man who had spoken
up for contemporary art, not in the least from
naivety but with great commitment, and who
moreover had promoted arts and crafts as well
as the great Norwegian painter Edvard Munch.
What roused feelings so much were the furniture
and interior decorations of the Belgian Henry van
de Velde – sneeringly apostrophised by the
Goncourt brothers as "Yachting Style", glassware
by Karl Koepping (ill. p. 263) and Louis Comfort
Tiffany (p. 313 ff), the work of Otto Eckmann (ills.
pp. 228, 260), glassware by Harry James Powell
(ill. p. 33) and the creations of the wood sculptor
François Rupert Carabin – in retrospect, heroes
of Art Nouveau one and all. In the period that
followed, however, under the pressure of
"Parisian circumstances", Bing made concessions.
He justified the compromise as attempting to
revive "grace, logic, and purity", which were
considered fundamental elements of French art.

ornamentale, setting out a convincing and enthu-
siastic case for the principles of democratizing art
in the sense of an aestheticism uniting all aspects
of art. As a theoretician, he had already appeared
in print in 1896 with his book *La plante et ses
applications ornamentales*, which became a hand-
book of "flower mysticism". "If these reserves
are used right, an infinite variety of forms and
models can be found for all conceivable articles
and objects," wrote Grasset in his publication, in
which he included 160,000 varieties of plant. [33]

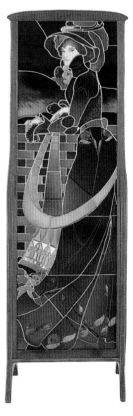

Georges de Feure
Stained-glass window, ca. 1900
Leaded glass with enamel,
221 × 70 cm
Prompted by Samuel Bing, de Feure
worked in all areas of arts and crafts,
proving himself master of the
flawless, beautiful line. It adorns his
salons as filigree arabesque work;
everything is of fragilely beautiful
proportion and every object is imbued
with a feminine Art Nouveau
aestheticism. He had much success at
international exhibitions such as the
Secession Exposition in Munich in
1897 and in Turin in 1902. The high
point was, however, the one-man
exhibition staged by Bing in 1903.

Jules Chéret
Purgatif Géraudel [Géraudel purgatives], 1890
Tiled panel, iron frame, color glazed, 121.5 × 81.5 cm
Probably the most popular decorative painter and poster
artist in France, Chéret represented the urbane, Parisian style
within French poster art, creating as it were the "pin-up girl"
of the *Belle Époque*. In an almost Rococo manner and with
Impressionist coloring, he depicted figures of graceful young
women of delightful radiance, which thrilled Paris.

Jules Chéret
Jacket of the German edition of
Marcel Prévost's book
Pariserinnen [Parisians], Paris –
Leipzig – Munich, 1896
Color lithography, 19 × 26.5 cm

It was only with this effectively neo-Rococo output that he appeased the public and exhibited an "Art Nouveau style" that concurred with the taste of the *Belle Époque*. From then on, Parisian Art Nouveau was identified with the rich, delicate furniture of Eugène Gaillard (ill. p. 94, right) and Georges de Feure and the rather sculpturally baroque work of Georges Hoentschel (ill. p. 94, left). Despite (or perhaps because of) this, Toulouse-Lautrec had an apartment done out in Yachting Style.

Feminine Art Nouveau aestheticism: Georges de Feure – Eugène Gaillard

An additional aspect of the fragility of the materials used in the arts and crafts of Parisian Art Nouveau (glass, enamel, porcelain, horn, fruit woods) and of the floral motifs, fragile fauna and delicate female figures is the Rococo sentiment reflected in many artistic products (ill. p. 95). Eugène Gaillard (1862–1933) and George de Feure (1868–1943) produced costly, upmarket items of furniture in which all sharpnesses were avoided in favor of smooth transitions and the lines of ornamentation are sculptured and touchable. At the World Exposition in 1900, Bing helped these pieces to gain the recognition hitherto denied them. "The firm of L'Art Nouveau,

which is run by S. Bing, one of the main proponents of the style, exhibited a whole range of rooms designed by top-rank artists. We find *inter alia* a dressing room designed by de Feure; furniture made in natural ash wood, designed in refined, simple forms with really ingenious applied metal mounts and covered with a woolen material in delicate reseda colour which is embellished with stylish and extremely discreet linear patterns. There is a dining room by Gaillard with furniture designed on expansive lines; the walls are painted to match the lines on the furniture. … They are all luxury articles – every table costs several hundred francs … at any rate, these prices are low in comparison with those asked, and paid, for period furniture, where above all it is pricey material that counts."[36]

Prompted by Bing, de Feure worked in all areas of arts and crafts, and henceforth the Art Nouveau style in Paris was virtually synonymous with de Feure's style. He proved himself to be a master of the flawless, beautiful line. It adorns his salons as filigree arabesque work; everything is of fragilely beautiful proportion (ill. p. 92) and every object is imbued with a feminine Art

Nouveau aestheticism. He had much success at international exhibitions such as the Secession Exposition of 1897 in Munich and again in Turin in 1902; the climax was Bing's one-man show for him in 1903. He supplied Limoges with designs for highly delicate porcelain, he was active as a designer of jewelry, textiles, and glassware, and made a valuable contribution to book graphics. The son of a Dutch architect and a French mother, de Feure grew up in the Netherlands and became acquainted with Symbolism while apprenticed in the book trade. His admiration for the painter Pierre Cécile Puvis de Chavannes (ill. p. 23), who helped him to the best of his ability, took him to Paris. As a watercolorist and set-designer, he began his career under the pseudonym van Feuren. He owed his profound interest in book illustration and interior decoration to his upbringing. Over and above Art Nouveau, he was also active as an Art Deco artist, and painted the interior of the Restaurant Konss in Paris, built by the Berlin architect Bruno Möhring (1863–1929). The graceful "ornamental objects" of *fin-de-siècle* art, as for example produced by André-Fernand Thesmar (1843–1912) (ill. p. 95, left),

Georges Hoentschel
Chair, 1900
Algerian plane, 102 cm high,
55 cm wide
Musée des Arts Décoratifs, Paris
The furniture of Georges Hoentschel is opulently Baroque. Though his pieces have an undeniable touch of the representational, they are to be considered primarily as "sculpture", that is, floral objects.

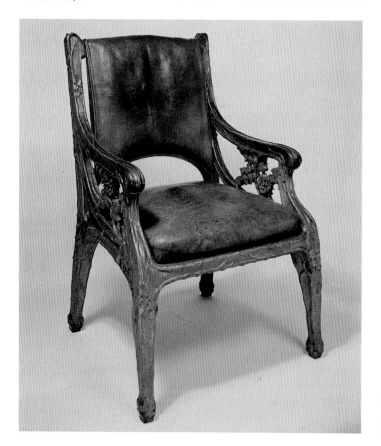

Eugène Gaillard
Cabinet, for Samuel Bing, L'Art Nouveau, 1901–02
Fruit wood, 184 × 107 × 37 cm
After the exhibition in Samuel Bing's gallery, the Art Nouveau style in Paris was identified with the rich, delicate pieces of furniture made by Eugène Gaillard and Georges de Feure.

belong to the delicate world of Rococo. More opulently Baroque is the furniture of Georges Hoentschel (1855–1915). Though his pieces have an undeniable touch of the representational, they are to be taken primarily as "sculpture", that is, floral objects (ill. opposite).

Symbolism in stone – Jules Aimé Lavirotte

Baroque abundance is likewise a feature of Jules Aimé Lavirotte's blend of architecture and decoration. His block of flats in the Avenue Rapp in Paris is also "Symbolism in stone". Salvador Dalí acknowledged the building as the first example of "hysterical sculpture" or "prolonged erotic ecstasy"[37], akin to his own Surrealist imagery. Thanks to its "unprecedented" nature and because of its "ornamental automatism", the facade of this "architectural sculpture" was awarded first prize in a creative competition in 1901. The jury was impressed by the masterly application of ceramic tiles on the building itself as well as in the interior. But the real appeal of this architecture lies in the manifestation of an omnipresent sexual imagery. Right in the entrance we encounter Lavirotte's almost obsessive, compulsive fetishism. The phallus on the door paneling and the vaginal surround obviously represent a sexual act – a vision that is repeated several times on the building. The provocation is nonetheless done with exquisite craft and tremendous *élan vital* (ill. p. 96). In glaring contrast is Frantz Jourdain's department store for Samaritaine, begun only two years later. It is a building that even today looks "contemporary" (ill. p. 97). In comparing the two, the words of the architect Pierre Jeanneret (1896–1967), a cousin of Le Corbusier, come to mind: "My house is practical. I am grateful, as I am grateful to the railway engineer and the telephone company. My heart you have failed to move."[38]

Masters of fire: Potters and glassmakers

Simple and yet "moving" in the haptic sense are the ceramic pieces of the artists of the "Groupe des arts du feu", as they are aptly called in French. The fame of late–19th century French pottery extends far and wide. Ever since the Vienna World Exposition of 1873, the superiority of French ceramicists has been noted without qualification

André-Fernand Thesmar
Bowl and stand, 1897
Plique à jour enamel, silver, fired gold, 13 cm high
The graceful, playful "ornamental objects" of *fin-de-siècle* art, such as those produced by André-Fernand Thesmar, for example, belong to the delicate world of Rococo.

Ernest Cardeilhac
Sugar bowl with spoon, ca. 1910
Silver-plated metal, ivory, 18.7 cm high
An additional aspect of the fragility of the materials used in the arts and crafts of Parisian Art Nouveau (glass, enamel, porcelain, horn, fruit woods) and of the floral motifs, fragile fauna and delicate female figures, is the Rococo sentiment reflected in many artistic products.

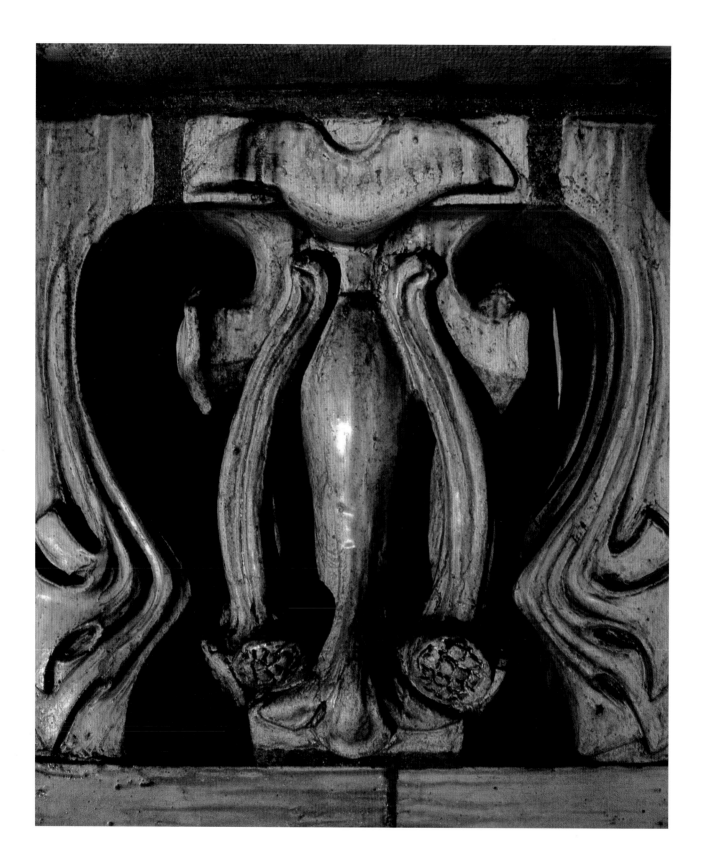

Jules Aimé Lavirotte
Entrance to block of flats at 29
Avenue Rapp, Paris, 1900–01
The appeal of this architecture lies in
the manifestation of an omnipresent
sexual imagery. Lavirotte's almost
obsessive, compulsive fetishism
becomes evident even in the
entrance. The phallus on the door
paneling and the vaginal surround
obviously represent a sexual act – a
vision that is repeated several times
in the building. The provocation is
nonetheless done with exquisite craft
and tremendous *élan vital* [vitality].

in critical reports. French supremacy in the "arts of fire" dates to the establishment in Paris of a ceramics studio by the Alsatian Joseph–Théodore Deck (1823–91). Numerous Art Nouveau potters were turned out by this studio, and it was here, with the technology of new glazing processes, that the foundation was laid for the quality of work that later won such admiration. Edmond Lachenal (1855–1948) was a pupil of Deck and shared his teacher's delight in experimenting (ill. p. 99). He developed the *émaille mat velouté* process, in which acid is used to give the glazing base a velvety top coating. "Velvety" also describes the mixed, matt colors of his pottery.

The special position of the potter Jean Carriès (1855–94) is aptly summed up in the title of Arsène Alexandre's monograph: *Jean Carriès, imagier et potier, étude d'un œuvre et d'une vie* [Jean Carriès, image-maker and potter, a study of an oeuvre and a life]. Carriès was a creative spirit and inventor of genius, a protagonist of *émaux-mattes*, the matt enamels whose warm glazing tones became a hallmark of all French potters. The subtle surfaces of his pots (ill. p. 98) provide a high order of pleasure to the senses. The work of Auguste Delaherche (1857–1940) demonstrates particularly clearly how artistic creation and virtuoso mastery of materials are united in Art Nouveau. The fantastic color tones of the pots

arise in the end only during firing, which must be closely controlled by the artist throughout. Delaherche's early pots feature plant motifs (ill. p. 99), which are strongly outlined and applied with thick layers of colored pastes. Gradually, however, Delaherche gave up using figurative ornament and used nuances of color alone as decoration.

All the "masters of fire" share a reverence for Japanese stoneware. The Japanese pots exhibited within the framework of the 1878 World Exposition had left an indelible impression. The sublime glazes of Japanese pottery and the canon of plain forms shaped the work of the *arts du feu* artists, who, as Delaherche once declared, were creating works of art, not "pots" (ill. p. 99).

François Eugène Rousseau (1827–91) was both a potter and a glassmaker, and his glassware work deeply impressed and inspired Gallé. Rousseau had likewise profited from the newly discovered art of Japan; he created cased glassware with surface effects that are reminiscent of the treacle glazes of Japanese stoneware. Similarly, he preferred to use Far Eastern forms, creating thick-sided, mostly crackle, glassware that displays inclusions of gold leaf and cloudy colorations made with metal oxides (ill. p. 74). Glassmaking as an art in Paris was undoubtedly overshadowed by Nancy; nonetheless, a somewhat "light" –

Frantz Jourdain
Facade of Samaritaine department
store, Paris, 1902–05
In glaring contrast to Lavirotte's
architecture is Frantz Jourdain's
department store for Samaritaine,
begun only two years later, a
building that even today looks
"contemporary".

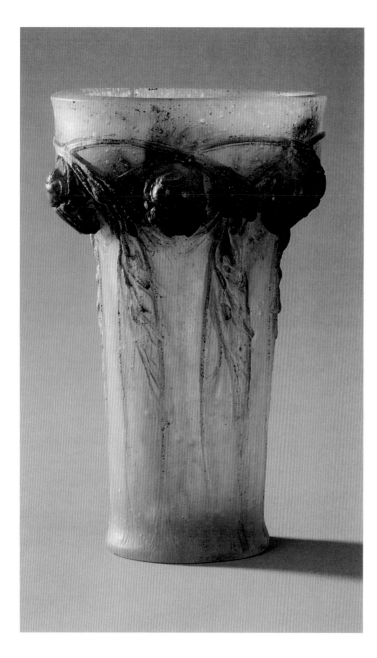

Jean Carriès
Vase, ca. 1890
Stoneware, glazed in relief, crazed
treacle glaze, 20 cm high
Carriès was a creative spirit and
inventor of genius, a protagonist of
émaux-mattes, matt enamels whose
warm glazing tones became a
hallmark of all French potters. The
subtle surfaces of his pots provide a
high order of pleasure to the senses.

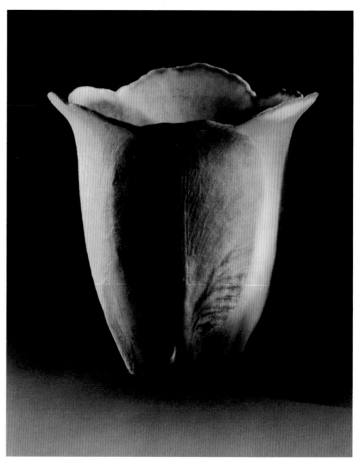

François-Emile Décorchemont
Goblet, 1907
Pâte de verre, 20.5 cm high
Pâte de verre is a mixture of colored
oxides with molten glass, fired like
stoneware. Besides Décorchemont,
Dammouse also worked in this
unusual raw material.

Albert-Louis Dammouse
Coupe iris [iris cup], ca. 1910
Pâte de verre, 8.8 cm high, 8.3 cm diameter
Musée des Arts Décoratifs, Paris
The small graceful vessels of Dammouse have a weightless
transparency. They are decorated in relief with friezes from
the Art Nouveau repertoire of insects, flower umbrils, and
marine plants, or shaped with openwork sides filled in with
translucent enamel. The rather rough surface of the glass
paste forms a contrast to this delicate work, as an additional
stylistic device. The result was fragile masterpieces of aloof
charm.

Clément Massier
Vase, 1891
Stoneware, dark red body, luster
glaze, 21.8 cm high

Edmond Lachenal
Snow on bamboo, vase, ca. 1900
Stoneware, decoration in relief, fired,
high-fire alkaline glaze, 32 cm high
All the "masters of fire" share a
reverence for Japanese stoneware.
The Japanese pots exhibited within
the framework of the 1878 World
Exposition had left an indelible
impression. The sublime glazes of
Japanese pottery and the canon of
plain forms shaped the work of the
arts du feu artists, who, as
Delaherche once declared, were
creating works of art, not "pots".

Auguste Delaherche
Vase with peacock-feather decoration, ca. 1889
Stoneware, 42.5 cm high
Musée des Arts Décoratifs, Paris
The early pots of Delaherche feature plant motifs, strongly
outlined with thick layers of colored pastes. Gradually,
however, he gave up using figurative ornament and used
nuances of color alone.

both in formality and in material – variant of Art Nouveau glassware was evolved, including creations in *pâte de verre* (ill. p. 98), a mixture of colored oxides with molten glass that was fired like stoneware. The artists who worked with this unusual raw material, François-Emile Décorchemont (1880–1971) and Albert-Louis Dammouse (1848–1926), were originally ceramicists. Their small, graceful vessels have a weightless transparency. They are decorated with friezes in relief from the Art Nouveau repertoire of insects, flower umbels or marine plants, or shaped with openwork sides filled in with translucent enamel. The rather rough surface of the glass paste forms a contrast to this delicate work, as an additional stylistic device. The result was fragile masterpieces of aloof charm (ill. p. 98).

A living arabesque – Loïe Fuller

In ever bolder serpentines, she waxed into a giant ornament, whose metamorphoses of turbulent flaring up, subsiding and engulfment in darkness and curtain appeared in our memories like symbols of Art Nouveau.
Friedrich Ahlers-Hestermann[39]

The muse of Art Nouveau as a whole was the dancer Loïe Fuller (1862–1928). Beside the ubiquitous flora and fauna, no motif appeared so frequently in Art Nouveau as the by then legendary American (ills. right and p. 101) and her Dance of Veils. Around 1900, we encounter her figure, wreathed in high-whirling veils from which her dainty head and moving arms emerge, in almost every artistic discipline and in the work of almost every artist (ills. p. 251, 312). This "arabesque incarnate" fired the imagination. The cultured world lay at her feet, and the Loïe Fuller phenomenon became the subject of countless grave discourses. She herself viewed the matter more pragmatically: "My costume was so long that I could not avoid constantly treading on the hem and so saw myself forced to hold it up with raised arms and leap around the stage like a winged spirit. Suddenly applause broke out in the auditorium and people shouted: 'It's a butterfly! A butterfly!'"[40] This took place in an obscure little play called *Quack* in which Fuller appeared in New York in 1891. The play itself soon closed, but the Serpentine Dance conquered Art Nouveau. Her fluid movements were congenially matched to the "linear dream" of the time, and Loïe Fuller did everything to fan the flames. She shrouded herself in exquisitely thin veils, and developed a sophisticated choreography involving

colored lights, thereby turning herself into "total art". With her dance, she succeeded in creating a visible connection between Symbolism, Art Nouveau, and a new conception of color and light. With shrewd business sense, she also had her ideas patented, such as the stage lit from below. She enjoyed her greatest triumph at the World Exposition in Paris in 1900. A special theater was constructed for her on the exposition site that, with her inside, represented a perfect Art Nouveau object. Just as Mucha attained stardom via Bernhardt, Fuller enabled the hitherto only modestly successful sculptor François-Raoul Larche (1860–1912) to win immortal fame. Her erotically expressive, back-lit performances gave Larche the idea of setting a lamp bulb inside the whirling veils of his bronze statue of Fuller. It was a most avant-garde inspiration for the time (ill. opposite), establishing him as the originator of a key Art Nouveau work. Yet Loïe Fuller was not just the muse of the three-dimensional arts. Toulouse-Lautrec created an unsurpassable representation of her Dance of Veils (ill. right), and she also inspired Stéphane Mallarmé (1842–98), who dedicated numerous poems to her, and Claude Debussy, who decided that his music was never more perfectly interpreted than through her. She was also a friend of the husband-and-wife physicist team Pierre and Marie Curie.

Henri de Toulouse-Lautrec

I have set myself the task of being true, not idealistic. Perhaps this is a mistake, but it is impossible for me to overlook warts . . .
Henri de Toulouse-Lautrec[41]

Henri de Toulouse-Lautrec (1864–1901) is not to be pigeonholed as an Art Nouveau artist – such an attribution would be unfair to this extraordinary genius. However, his influence on, and indeed his participation in, the events around 1900 was too great to pass him by unmentioned in the context of our subject. The hallmarks of his artistic creations – ornamentally simplified visual fields, the drama of detail, the contrast between empty and full fields, the delight in unexpected silhouettes, the passion for the truths of the human face, the physiognomies of clothing, attitudes, and gestures – shaped the whole graphic style of Art Nouveau (ill. p. 103).
Without becoming a mere reporter or portrait painter, he was the only one to follow the demand of Honoré Daumier (1808–79) that "il faut être de son temps" [one must be of one's

Odilon Redon
Ophelia, design for *La Revue Blanche*, ca. 1900
Pastel, 49.5 × 66.5 cm
"Le peintre comme le lithographe s'affirme Prince du Rêve." [Like lithographers, painters stand forth as Princes of Dreams.] (Thadée Natanson, in *La Revue Blanche*, June 1894)

Henri de Toulouse-Lautrec
Loïe Fuller, 1893
Color lithography, partly tinged with gold dust, 37.5 × 25.3 cm
The dancer Loïe Fuller was not only the muse of the figurative arts, such as in Toulouse-Lautrec's unsurpassable representation of her Dance of Veils. She also inspired Stéphane Mallarmé, who dedicated numerous poems to her, and Claude Debussy, who decided that his music had never been more perfectly interpreted than by her. She was also a friend of the husband-and-wife physicist team Pierre and Marie Curie.

time], and he passed beyond the succession of visual experiences to explore the psychological realm of moods and feelings, directing his attention to the enigmatic and at the same time existential, where he acted as witness and sympathizer. "He [Toulouse-Lautrec] has a room in a brothel," wrote Jules Renard (1864–1910), "and gets on well with all ladies that have unaffected feelings, that are alien to respectable women, and are wonderfully good at being models."[42] The crippled painter found "unaffected feelings" in the world of Montmartre, far from the emotional hypocrisy of the bourgeoisie. Nonetheless, he did not idealize the milieu. He drew whores large and small with great affection but without sentimental gloss, and if no drawing paper happened to be to hand, then on tablecloths, in the margins of newspapers or on marble slabs – no *chronique scandaleuse* but deeply moving compositions of admirable succinctness (ill. p. 70). Facial features almost in caricature, glaringly lit dramatic outlines – these are his stylistic devices. Like Baudelaire in his "fleurs du mal.", Lautrec in his pictures attempts to express the inexpressible by means of aesthetic shocks. Yet, that a certain Art Nouveau character exists in the composition of his posters with their linear oscillations, is undeniable. The phrase "a provoked life" may serve to describe the existence of this aristocrat of the bohemian world, a term coined by the German poet Gottfried Benn (1886–1956) to sum up the artist's extraordinarily intensive, concentrated and thereby truncated career. Toulouse-Lautrec did not take part in the epoch-making abstract discussions of his time; as befitted a risqué, intuitive way of life, he submitted his work and thereby himself for discussion. His figures, stylized in images of extreme moment, are representatives of their era but in the same moment timeless images of human disposition.

François-Raoul Larche
Loïe Fuller, table lamp, 1901
Bronze, gilt, hollow cast,
45.5 cm high
Bavarian National Museum, Munich
"In ever bolder serpentines, she grew into a giant ornament, whose metamorphoses of turbulent flaring up, subsiding and engulfment in darkness and curtain appeared in the memory like symbols of Art Nouveau." (Friedrich Ahlers-Hestermann, see note 39)

Pierre Bonnard
Child with sandcastle, or *Child with bucket*, ca. 1894
Oil on canvas, 167 × 50 cm
Musée d'Orsay, Paris
Bonnard's poster art stands in a close, mutually stimulating relationship with his painting. The visual conception is developed purely from the color; everything remains open, full of drive, and dynamically rhythmic. The silhouettes of Bonnard's figures have an almost collage-like effect, frankly avowing their affinity with Japanese colored woodcuts.

La Revue Blanche – The graphic line

Although he did not belong to any group with an avowed agenda, Toulouse-Lautrec was nonetheless a lively participant in the shaping of the important art periodical *La Revue Blanche*, first published in Belgium in 1889. The "White Review" was called thus because white is the sum of all colors and a white sheet appears unwritten and open to all opinions and trends. Moreover, its founders were under the influence of Mallarmé's theory of the mystery of the "white page", with which a poet sees himself confronted. The list of the authors published in this "trade journal" of the Nabis – one of the artistic groups devoted to Symbolism – is an almanac of *fin-de-siècle* literature, which together with the graphics of notable artists contributed toward the international fame of *La Revue Blanche*. Félix Vallotton (ill. p. 13), Toulouse-Lautrec and Pierre Bonnard (1867–1947) were the main contributors.

The poster art of Bonnard stands in a close, mutually stimulating relationship with his painting. The visual conception is developed purely from the color; everything remains open, full of drive and dynamically rhythmic. The silhouettes of Bonnard's figures have an almost collage-like effect, frankly avowing their affinity to Japanese colored woodcuts (ill. p. 102). In aesthetic circles, the horizon had long been extended beyond the world hitherto considered civilized and found both the secret code for creative form and philosophical solutions first and foremost in East Asia. The serpentine dragon shapes of Sino-Japanese art, whose motifs form interlinked ornamentation, were, for example, adapted by Paul-Elie Ranson (1861–1909), another contributor to *La Revue Blanche* in an arabesque, Art Nouveau manner.

The finale of Art Nouveau and its almost seamless transition into the following expressive Fauvist period makes it clear that all the elements of abstraction had already been worked out by about 1900. Linear diction is a principle feature of structure for the Fauvists as well, but the harmony is shattered. The euphoria of the arabesque mutates into shrill disharmony.

Henri de Toulouse-Lautrec
Divan Japonais, 1893
Color lithography, 81 × 60.5 cm
The hallmarks of Lautrec's artistic
creations – ornamentally simplified
visual fields, the drama of detail,
the contrast between empty and
full fields, the delight in
unexpected silhouettes, the passion
for the truths of the human
countenance, the physiognomies of
clothing, attitudes and gestures –
stamped themselves on the whole
graphic style of Art Nouveau.

Hector Guimard
Glass wall in stairwell, Castel
Béranger, 16, rue La Fontaine,
Paris, 1895–98
"Falconnier" tiles of blown glass,
named after the inventor. Made by
Société anonyme de verrerie à
bouteilles du Nord, Dorognie "Yet
more amazing historically is the
way of the staircase at the back, a
wall of heavy double-curved glass
panels of alternating shapes whose
very irregularity of surface does
what in terracotta panels had to be
done by the craftsman's will."
(Nikolaus Pevsner, *The Sources
of Modern Architecture and
Design*, Thames & Hudson, 1968)

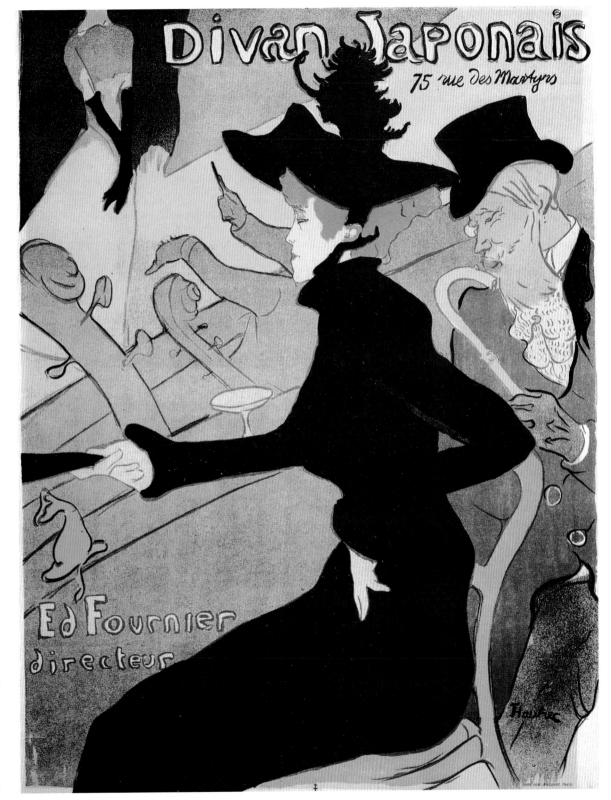

However, what we have called Stem Style runs through the whole house, inside and outside. The whole range of grilles, banisters, wall surfaces, glazing, mosaic floors, runners, furniture – all designed by Guimard – display this ornamental style. He turns it into a complete decorative system such as no one before ever enterprised. The main doorway and the succeeding vestibule are at once prime examples of it. Plant stems shoot upwards, past each other, in among each other, singly or in tufts or sheaves, gracefully dipping and swaying. And for every stem there comes a moment when it is electrified. Then it zips back and forth or bends round in a great loop or – most commonly of all – darts around in the air like the crack of a whiplash. This gives rise to unexpected combinations. Large plump omega shapes emerge, the necks of cobras swelling up, hanging Persian palm fronds, egg-shaped palettes so shredded up that the edges fray into shavings and squiggles, the ends of which keep curling round and round into capricious fishhooks, in between, something like the stylized waves of the Japanese, or like large jellyfish with wide-curved tentacles, and all this with the urge to transform itself into something handwritten, a flourish, which the Italians so aptly call *ghirigoro*. It is quite peculiar. Apparently arbitrary, it yields to a harmony that does not want for decorative force. In the entrance hall, for example, when the whiplashes crack around in gleaming gold before our eyes. Or on the walls of the rooms, when the motif seems like a dense shower of shooting stars. Or on the large glazed areas, ... no, although very original, these are perhaps too anatomical. Fixed in blue, red, and yellow, they are strikingly reminiscent of anatomical diagrams of the blood system: arteries red, veins blue, lymph vessels yellow.

What is consistently avoided throughout, in everything, is anything parallel or symmetrical.

Ludwig Hevesi, *Acht Jahre Sezession, March 1897–June 1905 – Kritik, Polemik, Chronik,* [Eight Years of the Secession Movement, March 1897–June 1905 – A critique, polemic and chronicle] Vienna, 1906

The language of flora and fauna

Nancy

Anonymous
Design for ornament, ca. 1901
From a pattern book of the École de Nancy
The thistle – the armorial flower of the city of Nancy – was the most important ornamental motif of the whole artistic output of Nancy, a symbol of Lorraine's will to resist. It was accompanied by the inscription "Qui s'y frotte, s'y pique" [Touch thistles and be pricked]. It also happened to conform with the floral character of Art Nouveau.

Je recolte en secret des fleurs mystérieuses.
Alfred de Musset[1]

Patriotism as a driving force

In the last quarter of the 19th century, in numerous countries of Europe and in North America, artists had begun to abandon the overworked recycling of historical styles of the past in favor of a self-conscious, artificial style of art. Their motivation for doing so was as varied as their artistic output, and ranged from pure *l'art-pour-l'art* thinking to social commitment. Just as often, the *zeitgeist* presupposed national purposes; pronounced patriotic tendencies, however, occur chiefly in politically oppressed regions. Even if Art Nouveau was from the first an international movement with an aversion to everything nationalistic, it is remarkable nevertheless that, precisely where patriotism was a motivating force behind attempts at reform, Art Nouveau brought forth its most brilliant achievements, namely in Nancy and in Finland.

With Paris ever more dominant as the intellectual and cultural centre of France, the provincial towns had steadily lost importance during the 19th century. To be able to understand the consequence of Nancy for Art Nouveau, account must be taken of the political situation of Lorraine, truncated after the war of 1870. Throughout its thousand-year history, the Duchy of Lorraine had remained powerful and unified. The partition of the north had a shock effect on the province, which in turn released an immense surge of artistic vitality. Strengthen the cultural heritage was the watchword. In addition, refugees from the *départements* of Meurthe-et-Moselle and Meuse-et-Vosges, and also from annexed Alsace, began to pour in. Among them were numerous artistic families such as Daum and Muller, the designer Jacques Gruber and the *ébeniste* Herbst, all of them later leading personalities of the École de Nancy. The cross of Lorraine is not only a trade mark of numerous factories but also a favored decorative motif. Whereas the cross of Lorraine stands for the still undivided province, the thistle (ill. opposite) is the armorial flower of the city of Nancy. In the following years, it became the most important ornamental motif in the artistic output of the École de Nancy – a symbol of resistance, accompanied by the inscription "Qui s'y frotte, s'y pique" [Touch thistles and be pricked].[2] It also happened to conform with the floral character of Art Nouveau.

The close relationship of Lorraine artists with nature derives in part from the general trend of the time, but it is also due to the particular conception of art as *art naturiste*, emphasizing the love of the flora and fauna of the homeland. Reveling in floral decoration meant also attempting to win back a lost paradise. Émile Gallé, *le maître d'Art Nouveau*, decorated the doors of his furniture studio with the motto: "Ma racine est au fond des bois."[3] Consequently, Nancy became in retrospect virtually synonymous with the floral version of Art Nouveau.

Pantheism and flower mysticism

De la flore lorraine, nous avons tiré des applications à nos métiers.
From the manifesto of the École de Nancy[4]

In 1903, the English periodical *The Studio* published a report in which the critic Henri Frantz recalled "living in a city the refinement of which recalls, on a small scale, that of Athens ... It must not be forgotten," he continued, "that in the

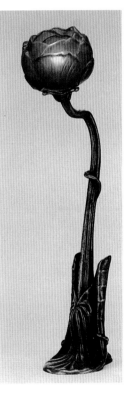

Louis Majorelle
Nénuphar lamp, ca. 1900
Patinated bronze, cast and buffed, glass shade, 59.5 cm high
Execution by Daum, Nancy
Majorelle's designs for the Daum glass factory – lamps and vase stands – belong among the most decorative works of Art Nouveau.

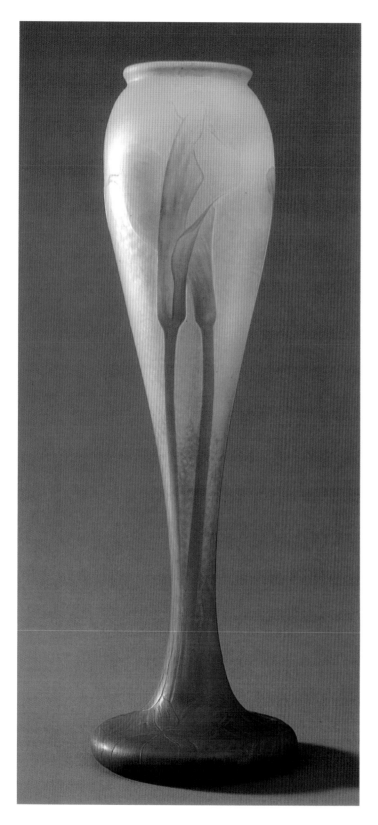

eighteenth century Nancy was a remarkably beautiful, indeed a brilliant city, with its rows of imposing edifices, their facades adorned in a style alike severe and pure, their entrance gates of finely chiseled ironwork, every detail thoroughly appropriate and harmonious, the whole effect forming a perfect feast to the appreciative connoisseur."[5]

Nancy possesses one of the most important creations of the Rococo style, the perfect *vue d'ensemble*, in the Place Stanislas, designed by Emmanuel Héré de Corny (1705–63) and adorned with the celebrated ironwork of Jean Lamour. Further distinguishing features of the specific art in Nancy around 1900 reveal themselves as lightness, a vibrant gracefulness, pastel tones, asymmetry, *rocaille*, and Rococo.

The patriotic character of the École de Nancy is not to be equated with narrow-minded nationalism. The psychological effectiveness of the sensitive masterpieces from Lorraine also rested on the intelligently translated self-awareness of the artists who made them. As may be gathered from the article by Henri Frantz published in England, international recognition had already been gained, but the leading capitals were likewise quickly conquered. The active colony of exiles from Lorraine in Paris, led by the art critic Roger Marx (1859–1913) from Nancy, a childhood friend of Gallé's, exploited growing national feelings to promote "their" artists. His articles about the École de Nancy, written in heavy, Symbolist language, are themselves a witness to the era. Around 1900, the poetry of both Romanticism and Symbolism played an important role in the work of all artists, alongside the symbols of naturally vegetative forces and a subtly conceived flower mysticism. Using a precise study of nature as a basis, artists developed an individual, living language of plant and animal motifs. Incontestably the favorite flowers of the *Belle Époque* were orchids and calla lilies (ills. left, opposite, pp. 115, 118). The literature of Symbolism had established its own flower mysticism in the mid-19th century, the masterpiece of which must undoubtedly be the *Les Fleurs du mal* cycle of poems by Charles Baudelaire (1821–67). The poet took flower mysticism as a parable of the bouquet of "stupidity, error, sin, and filthy minds" of the present world, which he abhorred. Following on from Symbolism, Art Nouveau subsequently established a language of flowers, which served partly to express moods and inclinations, partly to serve purely decorative points of view.

Jean-Antonin Daum
Vase with calla lily, ca. 1895
Glass flashed several times, cut in relief and incised, repoussé sides.
50.5 cm high
With flashed glass, the body is coated with at least two layers of glass. Cutting, incising or etching is used to remove parts of the coatings, producing a decoration in relief or incised into the sides of the glass. The work of cutting, where a little wheel mounted on a flywheel is used, is most closely related to working with a drawing pencil or paintbrush.

Albert Braut
Girl with calla lily, ca. 1900
Oil on canvas, 145.5 × 58.4 cm
Incontestably the favorite flowers of
the *Belle Époque* were orchids and
calla lilies, images of woman. The
literature of Symbolism had already
established its own flower mysticism
in the mid-19th century, *Les Fleurs
du mal* [Flowers of Evil] cycle of
poems by Charles Baudelaire being
considered its chef-d'œuvre.

Gallé and his "comrades-in-arms" had devoted themselves to a form of artistic pantheism, and carried across into their works a "nature display" of wholly sensuous and yet at once intellectual perceptions. The body of a vase is shaped into an onion whose outer skin is beginning to peel; the swirling color threads at the foot of the vase are the source of all plant life – the roots. Night-shades convey melancholy and renunciation, meadow saffron stands for transitoriness. Narcotic plants are bitter-sweet, while the secretive atmosphere of the marsh and its vegetation exercised a magic attraction. The writhing lines of creepers and climbing plants were, as might be expected, very appropriate for the new style. Umbels and panicles fitted in well with the decorative ordering and grading system of Art Nouveau. Blue dahlias were properly decadent, dahlias, wisterias, and magnolias were heavy with scent. Fancy orchids were described by Joris-Karl Huysmans (1848–1907) in *A rebours* (1884), the "bible" of Art Nouveau artists: "The gardeners brought new varieties that seemed like artificial skins shot with red blood vessels; and the majority, as if consumed by leprosy, spread out their pale flesh, spotted with rash and afflicted with lichen; … echinopses [Globe thistles] whose wadding-wrapped blooms had the hateful rose of a mutilated limb …"[6] Callae and irises in contrast were an image of woman, callae because of their sucking bells, irises as symbols of sexual chastity. The *fleur mystique*, the mystic flower, is the lily, symbol of purity, which, soaked in the blood of the martyrs, grows up to the throne of the Virgin. We encounter the whole vocabulary of "flower language" both formally and artistically in every possible branch of *fin-de-siècle* art. Facades, pictures and picture frames all "bloom", pots grow in floral shapes on plant-shaped étagères – it is a floral roundelay without end (ill. p. 117). Yet, with its strong Symbolist bias, Art Nouveau should not be comprehended just in terms of form and art, but as the immediate forerunner of our present. It does not belong among the wholly concluded eras such as the Renaissance, the Baroque period and other art-historical periods.

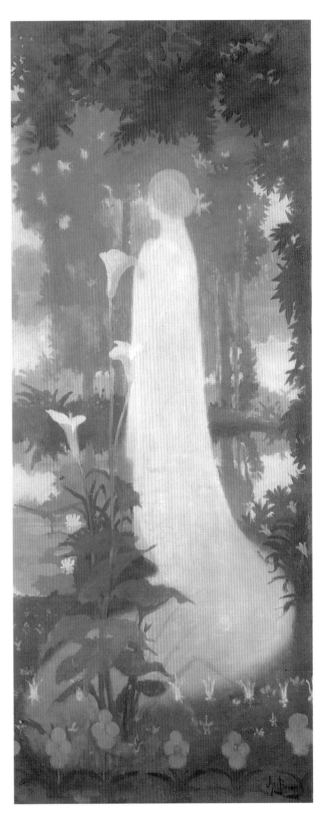

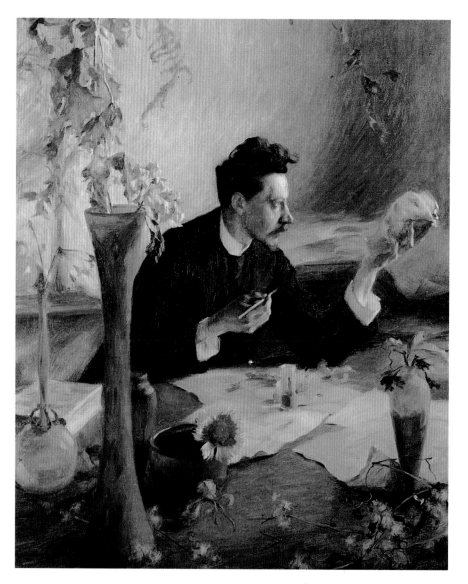

Victor Prouvé
Portrait of Émile Gallé (detail),
1892
Oil on canvas, 150 × 98 cm
Musée de l'Ecole de Nancy, Nancy
"The ambience depicts the lyrical
poetic spirit of Gallé, to which the
treatment of light also contributes as
an integrating element, forming a
kind of halo behind the head of the
subject." (Nancy 1900, exhibition
catalog)

Émile Gallé

The work of Gallé is unfathomable like a mysterious
temple, that no one enters without awe and bewilderment.
Grace and beauty are only the outer clothing. In the
depths of the consecrated area shines the flame of the
spirit.
Roger Marx[7]

The enthusiasm of the art critic Roger Marx for
the work of his friend Émile Gallé (1846–1904)
may seem today rather extravagant, but undoubt-
edly the quote above does sum up the essence
of Gallé's art. His wealth of ideas in the technical
aspects of glass and ceramics, and also in wood,
remain unmatched. However, the real genius of

Gallé unfolds only in the blending of poetry and
philosophy with the physical material. Émile was
born into his craft. His father, Charles Gallé,
married into a mirror business, and his rapid
successes with production encouraged him to
extend his product range to include faience
earthenware, a line that suited his inclinations.
As an ambitious, educated man, he planned the
upbringing of his son very carefully, and sent him
to a classics-biased high school where Émile's
literary and rhetorical gifts in Latin and French
could be nurtured. Brought up in a strict
Protestant household, Émile read the Bible
with his mother every day, but soon added read-
ings more to his own taste. Molded by this

Émile Gallé

Magnolias, vase, 1901
Glass body, flashed several times,
powdered glass inclusions, cameo
cut, repoussé, intercalaire, 25 cm
high (reproduction at original size)
"The artist does not set chemical
reactions in train, nor produce the
flower, insect or landscape, but
portrays vital traits, as it were the
essence of what he sees and
experiences. A scientist may assert
that a weeping willow is no sadder
than other kinds of willow, but for a
sensitive person it is the saddest tree
there is." (Émile Gallé, see note 11)

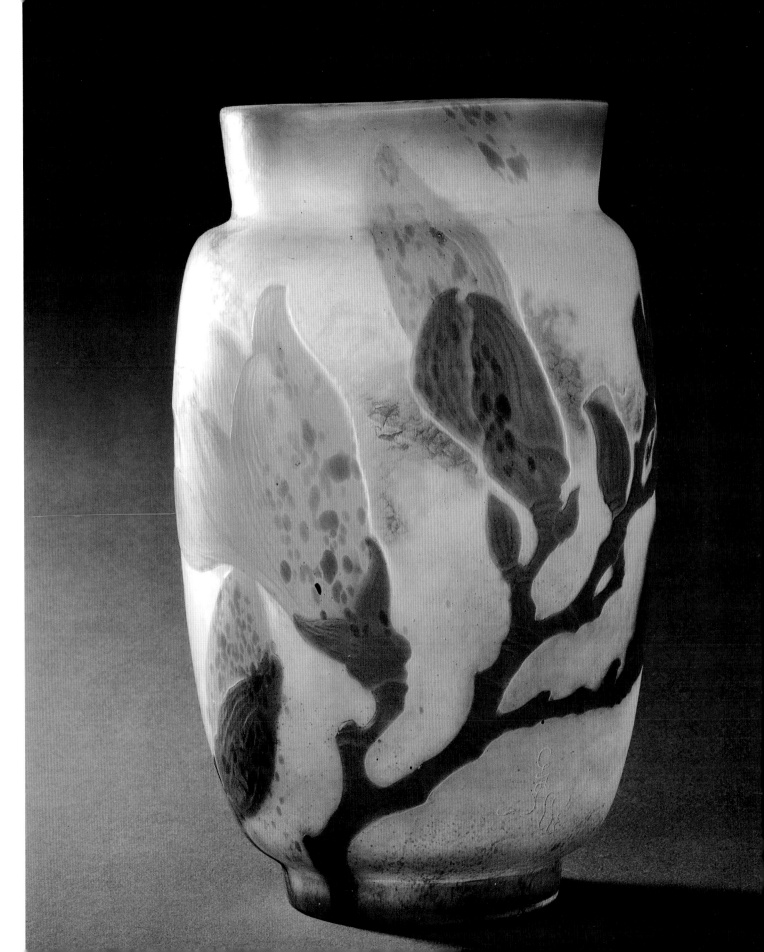

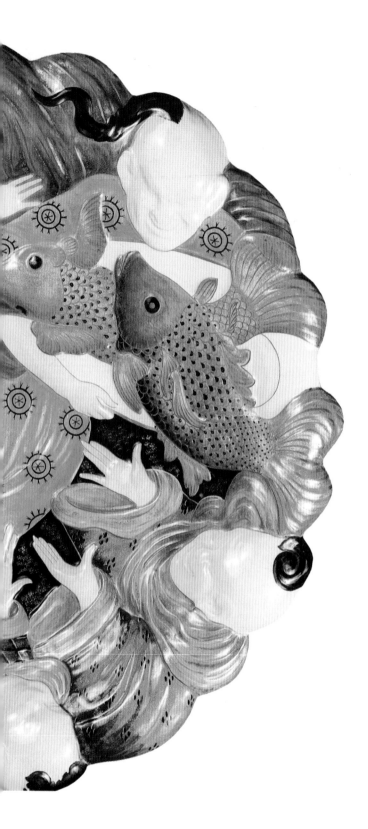

upbringing, all his life he sought to consolidate his standing as a *bon bourgeois*, although, like the main character Jean des Esseintes in Huysman's novel *A rebours*, he lived in a world of abstract beauty far removed from the bourgeoisie. His early emotional attachment to nature showed itself not just in botanical studies and attempts at drawing but above all in contemplation of the philosophy of nature. He was still only 15 when he designed floral motifs for the family business that were translated on to glassware and pottery. The following year he left school and went to Germany, spending the years 1862 to 1866 mainly in Weimar. His studies reveal the wide range of his interests. He enrolled for lectures in art history, botany, zoology, and philosophy, took up sculpture and drawing, and devoted himself intensively to the music of contemporary composers. In 1866, he went to Meisenthal in the Saar Valley, to join the glass manufacturers Burgun, Schverer & Co. His aim was to learn all the necessary chemical processes for glassmaking. His outstanding capabilities were recognized there, providing him with confirmation that he was just the person to revolutionize arts and crafts.

From 1870, Gallé worked in the family stoneware business in Saint-Clément. The rustic tableware produced to his designs have become known as "service de ferme". The figures of cats, dogs, hens, and armorial lions that his rich imagination conjured up, are also much sought after by collectors. He had a congenial working relationship with the painter, sculptor, and designer Victor Prouvé even in these early days, Prouvé's preference for the romanticized Middle Ages making a great impression on Gallé and having a lasting influence on his first enamel decorations on glass.

At the outbreak of the First World War, Gallé was 24 and so was called up. After demobilization at the end of the war, he found himself cut off from his laboratory in Meisenthal and decided, in a fit of restlessness, to go with his father to London and then to Paris. He admired antique glass and Far Eastern art in the Victoria and Albert Museum in South Kensington and in the British Museum, and used his time for studies at Kew Gardens. His encounter with the glassware of antiquity, Venice, and Islam in the Louvre also made a vivid impression on him. Nonetheless, his stylistic borrowings from these were relatively short-lived.

Émile Gallé
Ornamental bowl (detail), ca. 1878
Faience, fired decoration on enamel containing tin, diameter 58 cm
Musée d'Orsay, Paris
Like all his skills, Gallé put the spirit of Japan to the test in his faience work before sublimating it in the unmatched quality of his art glass. "It was from Japanese art that he [Gallé] derived the general scheme, the fundamental principle of his style; but we must not infer that he imitates it in any servile manner. Nothing can be more unlike Japanese art than Monsieur Gallé's work ... Only the idea of the Japanese style is also his; and given that principle he has worked in art by the light of his own instinct and taste." (Henri Frantz, see note 9)

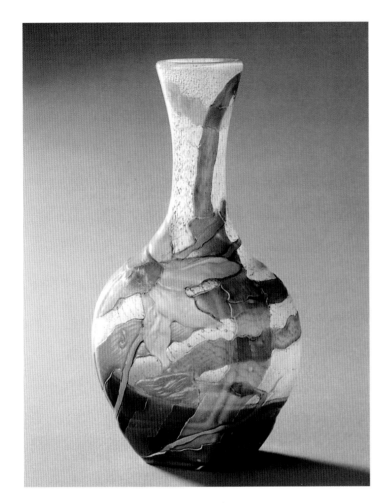

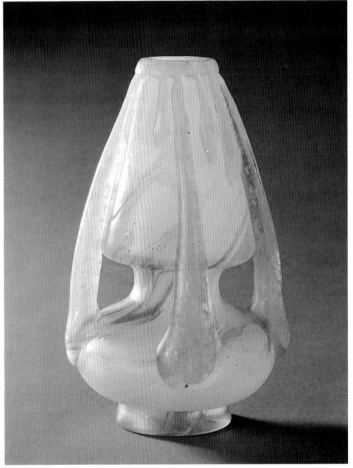

Émile Gallé
Vase with narcissus, ca. 1900
Marqueterie-de-verre, cut in relief and incised on flashed glass sides, oxide inclusions, 21 cm high
With the difficult *marqueterie-de-verre* and intercalaire techniques, colored glass plate, powdered glass or even gold and metals are rolled on to the still-hot glass and immediately worked.

À la japonica

Bénissons le caprice du sort qui a fait naître un Japonais à Nancy.
Émile Gallé[8]

Gallé's enthusiasm for Japanese art, on the other hand, had a permanent influence on his work. His interest had already been awakened in Paris and London, and in the aesthetic approach of Japanese artists he saw his own ideas put into practice. In later years (1882–85), he established a close friendship with the Japanese Tokuso Takasima, who attended the École Forestière in Nancy. In 1897, the art critic Henri Frantz wrote of Gallé: "It was from Japanese art that he derived the general system, the fundamental principle of his style; but we must not infer that he imitates it in any servile manner. Nothing can be more unlike Japanese art than Monsieur Gallé's work ... only the idea of Japanese style is also his; and given that principle he has worked it out by the light of his own instinct

and taste. He finds constant inspiration, nay, even collaboration, in nature. When Monsieur Émile Gallé reproduces plant form he extracts from it its decorative lines and colouring with the most artistic sense. He seems to condense the whole motive of a plant, to give it an attitude, a movement, to draw out its individuality in a very living way, and yet never to lose sight of the object he is designing."[9] On numerous vases by Gallé, one finds his homage to the *spiritus rector* expressed in the inscription "à la japonica". Japanese artists make no distinction between the mineral, plant, and animal worlds. Gallé too seems to plunge the hierarchy of all beings into chaos at first, only to refashion it again in his own vision. These "material powers of imagination" lend his glassware the qualities of perfection. Like all his skills, Gallé put the spirit of Japan in his faience work to the test, before sublimating it in the unmatched quality of his art glassware (ill. p. 112).

Émile Gallé
Vase, ca. 1900
Verre églomisé, intercalaire, marbled, glass base with bubbles and oxide inclusions, 20 cm high
Marcel Proust cites *verre églomisé* associations in his novel *A la recherche du temps perdu* (1913–27): "It would soon be winter; in the corner of the window a white, frosty vein of snow would appear, as on glass by Gallé," and again: "The sea ... plumed with apparently immobile spray, as finely painted as a feather or down by Pisanello and fixed with the unalterable creamy-white enamel with which a covering of snow is embodied on Gallé glassware."

Verres parlantes – "Talking glasses"

Tout les objets ont des contours;
Mais d'où vient la forme qui touche?
Émile Gallé[10]

In his creations, Gallé the lyric poet of glass combined botany, chemistry, art, and ethics, viewed from a poetic viewpoint. Although he was a convinced nationalist, he was at the same time an ardent devotee of Richard Wagner. The striving for beauty and unity, the symphonic in his work, the means of synesthesia, were akin to Wagner's *Gesamtkunstwerk* (synthesis of the arts). In the shaping of his vases, Gallé proceeded as one might on setting out a score; he rarely prepared clear drawings, but gave his craftsmen brief instructions that often came from a poem by Baudelaire or Mallarmé, plus a few fresh flowers and chemical formulæ. This is how the "verres parlantes", the "talking glasses", came into being. "The artist does not set chemical reactions in train, nor produce the flower, insect or landscape, but portrays vital traits, as it were the essence of what he sees and experiences. A scientist may assert that a weeping willow is no sadder than other kinds of willow, but for a sensitive person it is the saddest tree there is."[11]

"If we are to recognize any message at all in Gallé's work, it would have to be its endeavor to teach us true love – love being understood not as a false, social phenomenon but as a deep, spiritual devotion which the individual must search out in himself and further develop. Gallé was trying to tell us that we must try to understand ourselves, accept what we are. We must understand with all our senses and fulfil the role which we play in the development of the universe both as infinitely small biological units and as part of the whole. Gallé bared his innermost soul to enable others for their part to recognize their innermost beings. The language through which he makes this comprehensible is at once most expressive, diverse, and yet simple. It is a language whose vocabulary we all carry in our hearts – the language of nature and life itself."

Glass techniques

Even though Gallé looked on technique as simply the vehicle of his message, his creations are inconceivable without a multiplicity of complicated glassmaking processes (ill. opposite). Moreover, he devoted some attention to the processes in order to write *Notices sur la production du verre* (Nancy, 1884). The production processes of flashed glass with decoration cut or incised in the manner of Chinese "snuff bottles" of the Han dynasty (see also ill. p. 16) is effectively the basic method. The confusing additional wealth of techniques applied can scarcely be identified today, as the techniques were intended not to be recognized, that is, they were thrust into the background in favor of the total impression. Looking for clues can, however, be facilitated by knowing the principal methods of production.

With flashed glass, the uncolored glass body is coated, flashed with at least two layers of glaze. By means of cutting, incision or etching, parts of the additional glaze are removed at this point so that the decoration appears on the sides of the glass in relief or incised. The work of cutting, in which a little wheel set on a flywheel is used, is most closely related to working with a drawing pencil or paintbrush (ills. pp. 109, 114, 115). With etching, the "graveur à l'acide" takes over the treatment of the decoration, employing a solution of acid. With the difficult *marquetrie-de-verre* and intercalaire work, colored glass plate, powdered glass or even gold and other metals are rolled on to the still-hot glass and immediately worked (ills. p. 111, 113). Enamel is used both to paint glass and as a glaze, while the surface can be rendered iridescent and matt or

Émile Gallé
Veilleuse [night light] or incense burner, ca. 1900
Flashed glass, cameo cut, feet and mounting of bronze, silver-plated, 19 cm high

Émile Gallé
Vase (detail), ca. 1900
Flashed glass, cut in relief and incised, *marqueterie de verre*, 28 cm high

Opposite, left:
Émile Gallé
La Main [The Hand]
Glass sculpture, ca. 1900
Colored and marbled *en masse*, blown and shaped, glass embellishments, lifesize

Opposite, right:
Émile Gallé
L'Orchidée, vase, 1900
Flashed glass, cut and applied decoration, 31 cm high
Musée du Château, Boulogne-sur-Mer
Refined orchids were described in Joris-Karl Huysman's novel *A rebours* (1884), the "bible" of Art Nouveau artists: "The gardeners brought new varieties that seemed like artificial skins shot with red blood vessels; and the majority, as if consumed by leprosy, spread out their pale flesh, spotted with rash and afflicted with lichen ... echinopses whose wadding-wrapped blooms had the hateful rose of a mutilated limb ..." (see note 6)

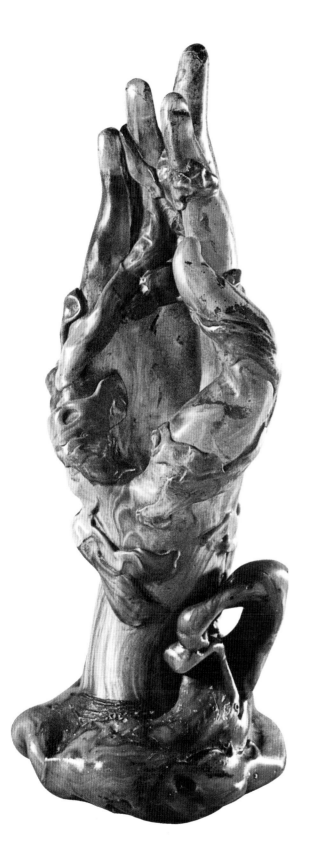
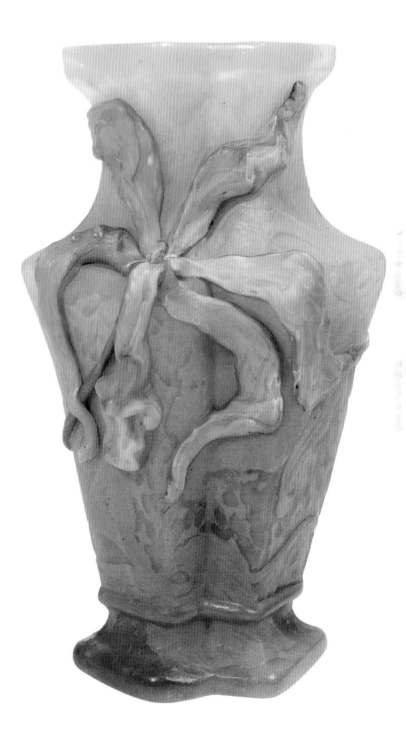

Émile Gallé
Guéridon aux trois libellules, dragonfly table, ca. 1900
Precious wood, carved modeling, marquetry, 76.4 × 61 cm
The legs of this *guéridon* [pedestal table] are three over-lifesize dragonflies, whose naturally curved body shape is exaggerated further. The heads bear the top, like antique caryatids. The original shape of the creatures is heightened to the verge of the grotesque.

shiny. To give a thorough insight into glass technology would require an extensive treatise. Even so, it is the very unexplained secrets and fine tunings that constitute Gallé's art. Marcel Proust (1871–1922) showed himself particularly open-minded in this respect. In his novel *A la recherche du temps perdu* [Remembrance of Things Past] (1913–27), he describes the mirror-image method of conveying ideas, and how structure and colors in nature recall Gallé's glass pieces. Proust makes an association with a *verre églomisé* (ill. p. 113): "It would soon be winter: in the corner of the window a white, frosty vein of snow would appear, as on a glass by Gallé,"[13] and again: "The sea ... with a down of apparently immobile spray, which was as finely painted as a feather or down by Pisanello and fixed with the unalterable creamy-white enamel with which a covering of snow is embodied on Gallé glassware."[14]

Marvels in wood – Flora and fauna

Le décor du meuble moderne aura de l'expression, parce que l'artiste, en contact avec la nature, ne peut rester insensible à la noblesse des formes vitales.
Émile Gallé[15]

"Even more than the vases, Gallé's furniture stands out for being made entirely of elements borrowed from nature. There is nothing here that is not inspired by the immediate world, that the boundless love of the craftsman paired with the tenderness of the sensitive man, the poet and the scholar does not attest for the soil of the homeland. The woods he preferred to use came from his Lorraine homeland. He either carved them and elicited decorative motifs that became an emblem of the material or indicated the function of the furniture, or he used their diverse characteristics of color for the manifold nuances of his nature-bound marquetry motifs. His table tops and the side surfaces of his commodes and cabinets display landscapes with effortlessly integrated flowers, plants, grasses, birds, and butterflies."[16] The desire to display his creations in glass appropriately prompted Gallé to take up cabinetmaking and joinery. In 1884, he set up a furniture workshop, and by 1886 he already had a furniture factory operating, ready to astound the

Lucien Weissemburger
Steps (detail), Maison Bergeret, Nancy, 1903–04
We encounter the whole vocabulary of "flower language", both formally and artistically, in every conceivable branch of *fin-de-siècle* art. Facades, pictures and picture frames "bloom", pots develop florally into plant-shaped étagères, in an unending floral roundelay.

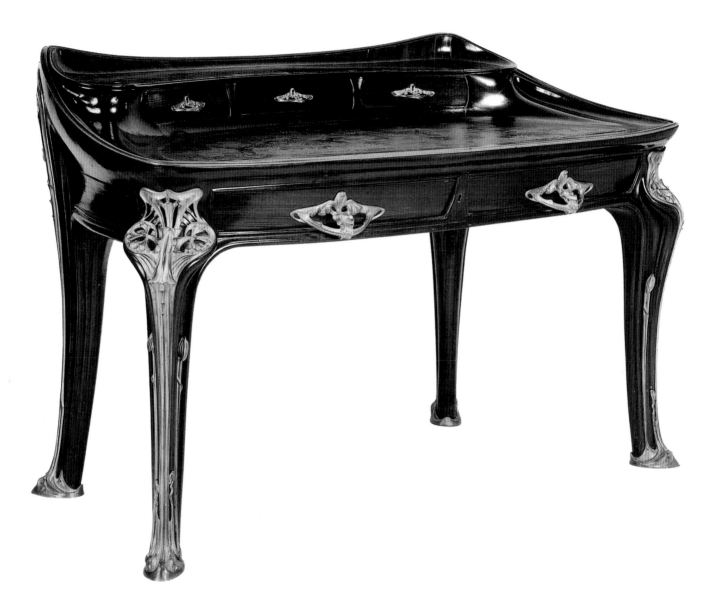

public visiting the World Exposition in Paris in 1889 with miracles in wood. His inspiration was the French Rococo period, examples of which his home town provided. Through the workings of his artistic genius, the étagères, tea tables and smaller pieces of the 16th and 17th centuries were transformed into asymmetrical, floral ornamental objects. Alongside these, he also wrought grander pieces whose over-refined opulence displayed a highly intricate marquetry technique that was inspired by the glass work. Exotic woods are combined with chased fittings, and often there are inscriptions with moral and ethical or symbolic contents. Bedsteads are embraced by moth's wings (ill. p. 116), and on the top of a writing desk can be found the inscription "travail est joie" [work is pleasure]. Gallé the cabinetmaker expanded the personal repertoire of forms that nature furnished him with to include the insect world (ill. p. 116). Though this found application as decoration in his glass work as well, as a source of decorative ornament it came fully into its own only in the furniture. The general predilection of Art Nouveau for insect forms and insect-like motifs has several causes, such as the growing interest in research into nature, the improvement of microscopes by Ernst Abbé (1840–1905) and the popular interest in entomology over and above the purely scientific. There was even a periodical for applied entomology published in several languages. As stylistic models, the shimmering,

Louis Majorelle
Orchid "bureau plat" desk, 1903–05
Mahogany, amourette acacia, gilt and chased bronze, chased and beaten copper, 95 × 170 × 70 cm
Musée d'Orsay, Paris
The Frenchman Charles Cressent is accredited with the invention of the "bureau plat", the desk with a smooth, largely leather-covered, writing surface. He supplied the courts of Europe with costly furniture that was conceived almost sculpturally as unified organisms and whose woods were harmonically combined with ormolu mounts. The particular character of Cressent's work was adapted by Majorelle for his own pieces, which count among the masterpieces of Art Nouveau.

Louis Majorelle
Nénuphar mount of bedside table,
designed between 1905 and 1908
Mahogany, amourette acacia,
marquetry work in various woods,
gilt, chased bronze,
110 × 55 × 45 cm
Musée d'Orsay, Paris
Majorelle's furniture has a unity of
line, and the decoration is reduced to
just the waterlily mounts. *Nénuphar*
is the name of the Egyptian water-
lily. It is an ideal fulfillment of the
contemporary yearning for a
mysterious symbolism. Since
ancient times, waterlilies have been
associated with divine majesty,
immortality, and religion, a symbol
of everlasting nature. If the color
tones and grain of the wood spoke
largely for themselves, the ormolu
mounts were carefully composed.
They became Majorelle's trademark.
Majorelle's mounts are original
works of wrought art, and were to be
seen at numerous exhibitions.

fragile nature of a type of physique that could
almost be termed graphic was particularly
attractive to Art Nouveau artists. The
"nervousness" and the flickering manner of
insects' movements are undoubtedly akin to the
"nervous linear play" of Art Nouveau. On top of
that, these "primitive animals" stand in close
relationship to the origin of life, and their mobile,
elastic limbs fit in particularly well with the
principle of the curved silhouette. "All the
oscillation and pulsation, sprouting and flowering
acts unambiguously as organically living but
amorphous. Natural forms are often reminiscent
of anatomical preparations, and even more
commonly triggered off are associations with that
remarkable between-world of the primitive plant-
like animals of the seabed, whose unpleasing,
indeed repulsive, grace and elegance, and half-
sucking, half-floating existence fascinated the
artists."[17] Gallé noted a "strange similarity with
living creatures" in his ornamentation, which is
"like moths wrapped up into the dusk, slate-grey
moths, beetles with striped carapaces, ladybirds
with small dots, colored flecks of dust on the
wings of large butterflies."[18] The legs of the
dragonfly table he designed in 1900 (ill. p. 116)
are larger-than-life dragonflies, whose naturally
curved body shape is further exaggerated. The
heads carry the top, in the manner of antique
caryatids. The original shape of the animals is
heightened almost to the verge of the grotesque.
The hierarchy within the "levels of dignity" of
decoration and art is finally abolished. Like the
Japanese artist-craftsmen, Gallé seizes upon the
minutest creature and is inspired, stirred by it.
Akitsu, dragonflies, have been a symbol of the
island of Japan since time immemorial.

Louis Majorelle – Les Nénuphars

*Ces richesses de documentation, cette chaleur d'excitation
poétique nécessaire à la composition décorative, l'artiste
assembler de la ligne et du coloris ne les épuisera jamais.
From the manifesto of the École de Nancy*[19]

Gallé's almost ritualistic self-abandonment to
nature was shared by his loyal comrade in the
struggle for the "new art", Louis Majorelle, to
only a limited extent. For the other outstanding
cabinetmaker of Art Nouveau alongside Gallé,
nature was an "admirable colleague", supplying
the decorative motifs and architectural construc-
tion of the furniture, but the structure should
nonetheless remain discernable. In Majorelle's
view, the *ébeniste* should never neglect the
functionality of a piece, which should impress

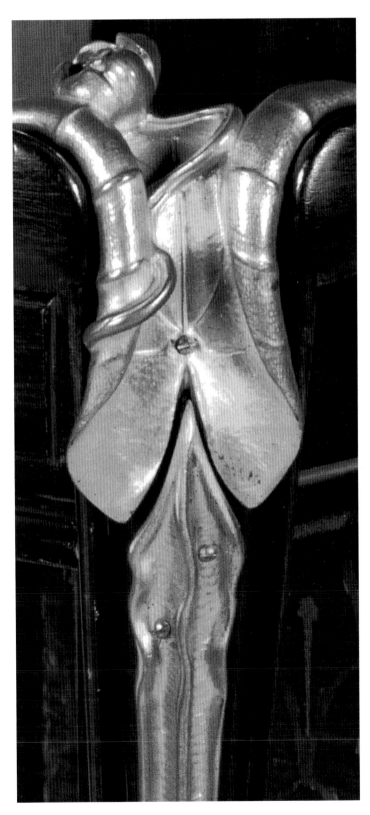

not just for its ornament but for its elegant line and proportions.

Majorelle (1859–1916) gained fame as the "Cressent of Art Nouveau". The Frenchman Charles Cressent (1685–1766) was the most important cabinetmaker of the Régence, supplying the courts of Europe with costly furniture that was conceived almost sculpturally as unified organisms, the wood being harmoniously combined with bronze mounts. He is also known as the inventor of the "bureau plat", a desk with a smooth, mostly leather-covered writing surface and drawers. Majorelle adapted the specific character of Cressent's work for his own pieces, which count among the masterpieces of Art Nouveau (ill. p. 118). His ambition to become a painter had to be abandoned with the early death of his father, when as a 20-year-old he took over the family-owned furniture and ceramics business. Influenced by Gallé, he developed the range of products it made, hitherto principally period furniture, into new fields. The characteristic Majorelle style saw the light of day as early as 1890. Assistance and support came from the designers Jacques Gruber (1870–1936) and Camille Gauthier (1870–1963). Buildings for Majorelle's expanding firm were constructed in

1898 by the leading architect of the École de Nancy, Lucien Weissemburger (1860–1929). It was a time when the suggestive power of Gallé's furniture was still clearly detectable in his marquetry, but at the 1900 World Exposition in Paris Majorelle succeeded in making a breakthrough, establishing his own distinctive style in his creations.

His "Nénuphars" studio was spontaneously acclaimed as one of the most attractive creations of Art Nouveau. The furniture, which has a unified tautness of line, is finished with a spare decoration of waterlily fittings (ill. p. 119). Nénuphar is the name of the Egyptian waterlily. It is an ideal fulfillment of the contemporary yearning for mysterious symbolism. Since ancient times, waterlilies have been associated with divine majesty, immortality, and religion, a symbol of everlasting nature. If the color tones and grain of the wood spoke largely for themselves, the ormolu mounts were carefully composed (ill. p. 119). They contrast in both material and color with the walnut and exotic woods Majorelle used, and they became his trademark. His mounts should be considered as wrought art in their own right, and were to be seen at numerous exhibitions. Besides bronze

Émile André
Entrance gateway, project drawing for the École de Nancy section at the Turin exhibition in 1902,
25.02.1902
Watercolor, 36 × 54.2 cm
Musée de l'École de Nancy, Nancy

La Halle – Glassblowers' Hall
From the brochure *Notices & Catalogue pour l'envoi à l'Exposition Universelle de 1900* of the Verrerie et Cristaux Artistiques de Nancy, Daum Frères, Agence Générale & Exposition Permanente à Paris, 32 rue de Paradis, 1900

and brasswork as furniture mounts, Majorelle also undertook large-scale metalwork such as the famous banisters for Galeries La Fayette in Paris. The banisters are made of wrought iron with polished copper mounts. The ornament is "monnaie du pape", that is, Judas pieces of silver. Majorelle's designs for the Daum glass factory – bases for lamps and vase settings – maintained their high quality until the 1920s (ill. p. 107). His pottery designs were produced by the Mougin brothers. A real Art Nouveau artist, Majorelle was active in numerous fields of craftwork, but his *Gesamtkunstwerk*, his grand synthesis, was the Villa Majorelle in Nancy.

Besides its sophisticated upmarket furniture products, the Villa Majorelle also offered perfectly crafted furniture at reasonable prices, thereby acceding to Gallé's early desire to "adorn the home of every Frenchman with a lovely object."[20] Putting this ambition into practice proved to be one of the most difficult tasks facing the new art. Some success was achieved by Gallé in his series productions, and by the Daum brothers with their glassware. Although in the end every Frenchman did not get his Art Nouveau object, there were nonetheless buyers outside the exclusive elite circle of the arbiters of taste.

Art for all?

They are all objects of luxury: every table by Gallé costs several hundred francs, since both the artist's design and the arduous labor of the cabinetmaker carrying out the design has to be paid for here.
Julian Marchlewski[21]

"It was absurd, but heavenly, and no one regretted admitting 'I was part of it',"[22] wrote Julius Meier-Graefe, an enthusiastic advocate of the new art, speaking of Art Nouveau. At the same time, he was one of the most keen-eyed critics, and he wrote of the Paris World Exposition in 1900: "Everything that France exhibited in the area that interests us here is luxury, sometimes extraordinarily beautiful, but in the last instance – cruel though it may sound – useless. … Yet the key question is, can the new product be commercially possible in the modern sense, industrially useful? Does it meet modern requirements for a rational exploitation of material?"[23] Émile Gallé and the artists of the École de Nancy were thoroughly conscious of the conflict between social demands and their conversion into art. To some extent as counter-objects to his "poems in glass", in 1892 Gallé began to make sketches for pots that would be suitable for series production. This was more a matter of idealism than of commercialism. In accordance with the preachings of William Morris that not just the demand among the rich for "swinish luxury" should be satisfied, for him it was a question of educating a broad layer of the population in beauty and truth. "Art for all" was the watchword, instruction in taste from above. "To be able to manufacture at a reasonable price simple types of pot, functionality of

Le Coupage – Cutting the glass to size
From the brochure *Notices & Catalogue pour l'envoi à l'Exposition Universelle de 1900* of the Verrerie et Cristaux Artistiques de Nancy, Daum Frères, Agence Générale & Exposition Permanente à Paris, 32 rue de Paradis, 1900

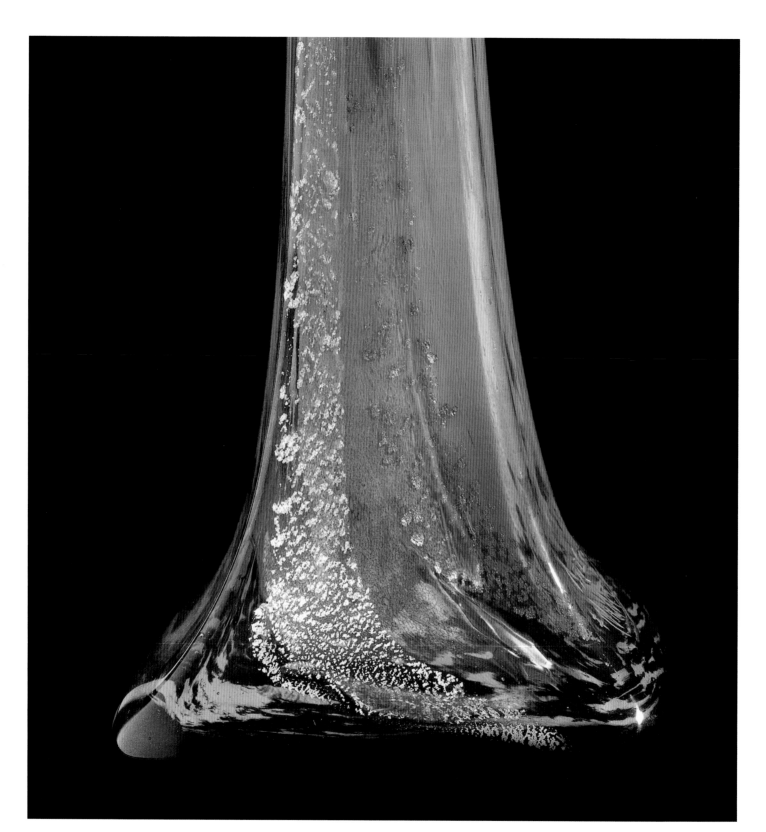

Henri Bergé
Mistletoe, after 1900
Design for mistletoe decoration of
Daum glass products
Pencil, watercolor
Daum Frères Collection, Nancy

Henri Bergé
Mistletoe, after 1900
Design for mistletoe decoration of
Daum glass products
Pencil, watercolor
Daum Frères Collection, Nancy

the objects and an easy-to-add decoration (such as etching) were needed. At the same time, the individual luxury pieces remained as models. This then was the problem: could a work of art, created by artists in work measured in days, be simplified? The quality and spirit of the object – it soon transpired – cannot be stereotyped just like that. Verrerie Gallé succeeded only to a limited extent in serial production, by producing its own pots in another style.

The Daum brothers' glass factory

D'appliquer en industriels les vrais principes de l'art décoratif.
Henri Clouzot[24]

Mass production of sophisticated art glassware – alongside the production of individual pieces – was more convincingly achieved by another glass factory in Nancy, namely that of the Daum brothers, because circumstances were different. This was largely due to the aptitude of Jean-Antonin Daum to realize that glass as a raw material must be continually adapted to meet new artistic demands. He believed that, as well as over-the-top individual creations, appealing objects that, even when produced in series, would not degenerate into cliché, and would retain the charm of the one-off hand-made object in decoration and material, should be made. The leitmotif of the brothers Jean-Louis Auguste (1854–1909) and Jean-Antonin (1864–1930) Daum was already explicit at the end of the 1880s: "d'appliquer en industriels les vrais principes de l'art décoratif" [to apply industrially the true principles of decorative art], that is, to unite art and industry (ill. p. 121). A lucky circumstance for the production was the presence in the factory of a high-quality team of glass artists, including one of France's leading designers, Jacques Gruber (ill. pp. 126, 127), and the potter and *pâte de verre* master Almaric Walter (1859–1942). This is the reason why the firm, which still exists today, became the leading supplier of Art Deco glass, and the factory did not pass into oblivion after the death of its founders, in contrast to the fate of Gallé's firm, which after his early death in 1904 experienced a sudden drop in quality. And for all our critical reflections, we should not forget that, even with the series products, we are still talking about museum pieces.

The desire to convert aesthetic functionality into practice was most easily achieved in lighting. Lamps are in the first place necessary objects of use, a part of interior decoration which was now

Opposite:
Jean-Antonin Daum
Base of a stem vase, ca. 1902
Flashed glass, intercalaire, color and gold inclusions
The Daum factory created vases in monochrome or graded coloration devoid of ornamentation, relying on surface effects. Forms used were of the new simple type. The elongated stem vases, initially unpretentious and straight, changed in time to almost eccentric creations of sophisticated elegance.

Jean-Antonin Daum
Courgette flower, lamp, ca. 1905
Flashed glass, intercalaire, vitrification, iron mounting, 71.5 cm high
With the invention of the light bulb, and the general availability of electricity, the task of supplying a basic human need under new technical conditions released a surge of artistic energy. The volume of output was tremendous. The transparency of glass as a raw material could be used to great effect, and consequently Art Nouveau lamps are among the most appealing products of their time.

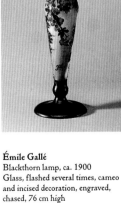

Émile Gallé
Blackthorn lamp, ca. 1900
Glass, flashed several times, cameo and incised decoration, engraved, chased, 76 cm high

Jean-Antonin Daum
Four long-necked vases, 1901–05
Blown and modeled glass, flashed in
color, powdered glass technique,
47 cm to 66.3 cm high
Max Bill, a passionate collector of
stem vases, was an avowed admirer
of vases made in Nancy: "For me,
the perfect factory vases in my
collection count as the peak
achievement of creative craft in the
beauty of their material, exemplary
forms and technical perfection.
There are outstanding examples of
series productions that have
exploited to the full the possible
variations of graphics and coloring."
(see note 26)

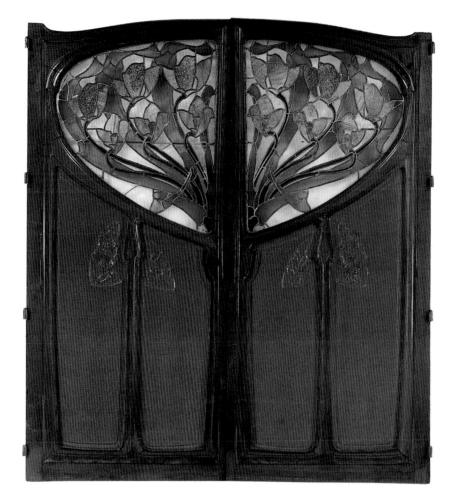

Émile André, Jacques Gruber,
Eugène Vallin
Double door, 1901
Mahogany, chased gilt bronze, glass,
opalescent decoration, 198 × 182 cm
Musée d'Orsay, Paris
Among the best testimonials to the
École de Nancy are the communal
works of the artists that joined it.
They bear conspicuous witness to
the quality of the collective work and
confer a magnificent legitimacy on
the alliance.

to be reformed. The invention of the light bulb
and the general availability of electricity offered
new possibilities. The task of satisfying a basic
human requirement under new technical condi-
tions released artistic energies, and a remarkable
volume of output was the result. The trans-
parency of glass as a raw material could be put to
good effect, as a result of which Art Nouveau
lamps are among the most appealing products of
their time. The motifs and repertoire of forms
used for lamps were the same as for vases,
facades, furniture, and paintings, namely, plants
and insect motifs. Flowers, mushrooms, and
trees (ill. above and p. 123) in particular blend
strikingly harmoniously in their structure in lamps
of all kinds. Additionally, a vase serves as an
outstanding base for a lamp. A wealth of models
existed for this.

But also in the vases themselves new ideas
were put into practice as a consequence of the

series production. The technique of etching was
refined, becoming not only a means of decora-
tion but used as decoration itself, since the
improved technique had led to a separate style of
surface structure. Gallé had achieved great
success with etched models, but the Daum
brothers went a step further. They created
etched vases in monochrome or layered coloring
devoid of ornament, relying on surface effects
alone. Melted down or applied powdered glass
between the layers of glaze achieved subtle
results. Forms followed the new simplicity.
Elongated flower vases (stem vases), initially
unpretentious and straight, were in time trans-
formed into almost eccentric creations of
sophisticated elegance (ills. p. 122, 124–125). Art
Nouveau in Nancy thus remained true to its
roots, as on the one hand the vases themselves
became flower stalks and on the other hand the
marbled color monochromy took account of

Right:
Émile Gallé
Dragonfly cabinet (detail), 1904
234 × 134 × 64 cm
Musée d'Orsay, Paris
Ironwood, oak, mahogany,
jacaranda, mother-of-pearl
incrustations, patinated glass,
ornamental stones, chased and
patinated bronze

René Wiener
Book binding of Roger Marx's
L'Estampe originale, 1894
Inlay work in leather
Design by Camille Martin
The activities of the art critic Roger
Marx, together with Eugène
Corbin, publisher of the periodical
Art et Industrie, made a decisive
contribution to the École de Nancy
in gaining it international
recognition.

the proclamation of the poet Paul Verlaine (1844–96): "Car nous voulons, la Nuance encor,/ Pas la Couleur, rien que la nuance!"[25] Max Bill (1908–94), a passionate collector of stem vases, was smitten with vases made in Nancy: "For me, the perfect factory vases in my collection count as the peak achievement of creative craft in the beauty of their material, exemplary forms and technical perfection. There are outstanding examples of series production that have exploited to the full the possible variations of graphics and coloring."[26] (ills. pp. 124–125)

L'École de Nancy

Nous avons cherché à déduire des documents naturels les méthodes, les éléments et le caractère propres à créer un style moderne d'ornementation, un revêtement coloré ou plastique pour les usages modernes.
From the manifesto of the École de Nancy[27]

A shared enthusiasm among artist-craftsmen – almost all of them around 30 – for the sensation of beauty to be derived from observing nature, was already apparent around 1890. This unanimous movement culminated in 1901 in the founding of the École de Nancy and the formulation of a common statement of beliefs. The École de Nancy existed in name and de facto in 1894, when the leading artists of the region exhibited their works at an exposition organised by the recently founded Société Lorraine des Art Décoratifs. The first purchases for a planned museum of the shared arts were made, and the stylistic concord was tremendous. The concept of an "École de Nancy" first turns up in the writings of the initiator of these endeavors, Émile Gallé, in 1896, in connection with his call, reiterated since 1881, for a return to nature as the sole source of motifs in art. After the overwhelming success of artists from Lorraine at the 1900 World Exposition in Paris, the necessity for an official amalgamation became obvious. Although Nancy had already overtaken Paris, as it had become clear that an independent French Art Nouveau was rooted in Nancy, the group as such did not show to advantage because its exhibits were assigned to the separate branches of art each time. The "Ecole de Nancy, Alliance provinciale des industries d'art" was thus founded on February 13 1901, with sales promotion an additional ambition. The declared goal of the Alliance was to set up joint workshops, the organization of exhibitions, the sponsorship of young trainees and a reform of the educational system in the artistic vocations. This comprised among other things the introduction of regular courses of instruction for crafts in vocational schools. Over and above that, they sought to adapt traditional arts and crafts to the new industrial production processes. Usefulness in all arts and crafts products became the supreme commandment. The flora of Lorraine remained the most important source of inspiration for Art Nouveau from Nancy (ill. p. 129).

The School's governing board consisted of Émile Gallé, Louis Majorelle, Jean-Antonin Daum and the cabinetmaker Eugène Vallin (1856–1922). After Gallé's death, Victor Prouvé (1858–1943) took over the presidency of the board. Many noted artists from the school, academics and literary figures belonged to the École's

Jacques Gruber
Cabinet, ca. 1900
Mahogany, etched glass,
203 × 48.9 cm

Page 129:
Janin & Benoit, Nancy
Glazed double doors, ca. 1900
Mosaic window, leaded glass

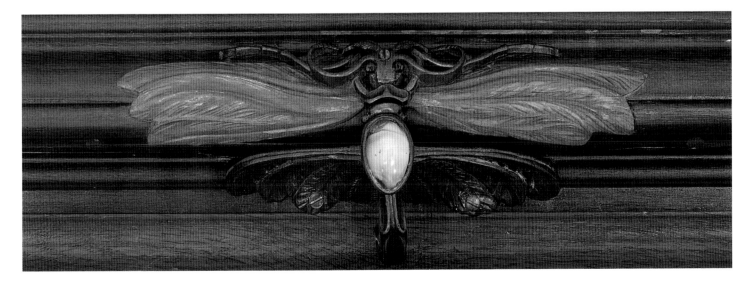

committee. The participation of important artists in the now annual exhibitions increased the fame of their city. They included architect and painter Émile André (1871–1933), the designer Henri Bergé (1870–1937), the architect Lucien Weissemburger (1860–1929), the *ébeniste*, glass painter and sculptor Jacques Gruber (1870–1936), the bookbinder René Wiener (1855–1940) (ill. p. 127), the architect Charles André (1841–1921), father of Émile, and the decorator Camille Martin (1861–98). The art critic Roger Marx should also be mentioned again here as he and the publisher Eugène Corbin, who published the periodical *Art et Industrie*, contributed to the international recognition of the community. Among the best exponents of the École are the communal works, which bear conspicuous witness to the quality of the collective work and conferred a magnificent legitimacy on the Alliance. They include the joint furniture pieces by André, Gruber and Vallin (ill. p. 126) and the close cooperation of Daum and Majorelle (ill. p. 107).

For all its ideals, in time the community fell apart. Once again it was a war that played a decisive role. Just as the end of war in 1871 had brought together so many artistic forces, so the First World War now put an end to everything. Once more, Lorraine became a battlefield. But even before that, a capitalist economy oriented toward cheap mass production had pushed aside the demand for individual, high-quality creations. In addition, bureaucracy hindered the educational aims, and few artists of the École de Nancy were able to successfully resume their activity after 1918 in yet another new style – Art Deco.

Who will not acknowledge that the artist, endeavoring to render a flower, insect, landscape or human figure so as to display visibly its being and immanent feelings, will create a work that is more exciting and emotional than one which is only produced with a camera or a cold scalpel? A naturalistic depiction, however precise, reproduced in a scientific work does not move us because the soul is wanting, while a Japanese artist working from nature is uniquely capable of bringing out the motif of release, or the now mocking, now melancholy countenance of a living creature, an object with substance. In this way, in his passion for nature, he creates real symbols for "forest", the "joy of spring" or the "melancholy of autumn". In ornamentation, the symbol is thus a shining point in the middle of the still, deliberate meaninglessness of foliage and the arabesque. Symbols spur attentiveness on, thought, poetry, art enter the stage. Symbols are points around which ideas become concrete. There would, moreover, be no point in dissuading decorative artists from using symbols that are accepted in poetry without further ado. As long as thought directs the pen, brush or pencil, it cannot be doubted that symbols will continue to enchant people. In any case, the love of nature always brings symbolism with it: the flower loved by all, close to all, will always play an important and symbolic role ...

Employed consciously or unconsciously, symbols bring works of art to life; they are their souls.

In the dawn of the twentieth century, we may surely welcome the renewal of a national "art for all" as a herald of better times. ... And in this way, life in the twentieth century need no longer lack joy, art, and beauty.

Émile Gallé, *Le décor symbolique*, inaugural speech at a session of the Académie de Stanislas, Nancy, May 17 1900. Published in *Mémoires de l'Académie de Stanislas*, Vol. XVII, 5th series.

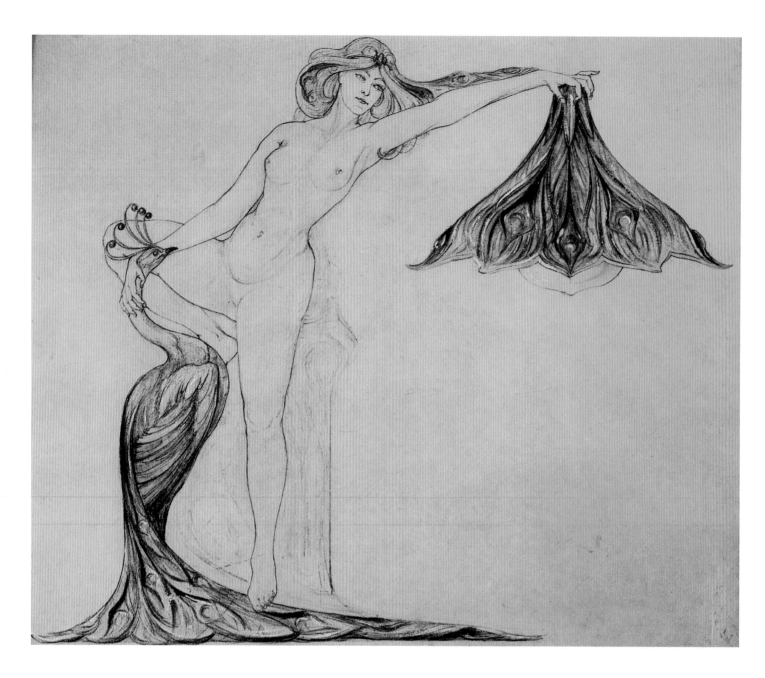

The new architecture
Belgium

*Ce spéctacle à je ne sais quoi de magique, de surnaturel,
qui ravir l'esprit et les sens.*
Jean Jacques Rousseau[1]

Symbolism – a Belgian tradition

If one conjures up an image of the art and culture
of Belgium – once the land between the magnifi-
cent kingdom of Burgundy and the harsh North
Sea – the painters Jan van Eyck and Roger van
der Weyden or perhaps above all the bizarre,
almost surreal world of Hieronymus Bosch and
Pieter Bruegel come to mind, a world full of
unsolved secrets that lingers on in the pictures of
contemporary painters such as René Magritte
and Paul Delvaux.

Every era has had its symbolic or symbolist art,
but the essence of the phenomenon, always an
expression of non-artistic spiritual forces as
well, has to be redefined in every period. During
the 19th century, the new science of psycho-
analysis discovered the world of Bosch's
grotesques almost as textbook examples of its
theories. The artists of the Decadent Movement
appropriated his symbols of seduction such as
fish and snails, and the disproportionality of his
figures likewise found an echo in turn-of-the-
century art.

Consequently, the soil was particularly well-
prepared for symbolist tendencies from France
and England to take root in Belgium, where they
mingled with a local tradition. Symbolism always
has a literary and philosophical undertow that
delves into backgrounds, abysses, dreams. It
enjoys triggering shudders, setting puzzles,
baring inner worlds and visions. The Symbolist
Movement tinged the whole mood of the 1880s
and 1890s, and *fin-de-siècle* artists were one and
all in its grip.

The cross-connections that brought the Symbo-
list movement and the fine arts into contact were
established through numerous publications and
artistic societies. In his esoteric universe, the
writer Sar Mérodack Joséphin Péladan (1859-
1918) made a reality of synthesis. He founded
the Ordre Kabalistique de la Rose et la Croix, a
kind of Templar and Grail order, and wrote in the
manifesto to the first exhibition of the Rosicru-
cians: "Artist, thou art king. Art is the true king-
dom. Once thy hand has written a perfect line,
the Cherubim themselves descend from Heaven
and see themselves therein, as in a looking glass.
Spiritual drawing, soulful line, charged form –
thou givest our dreams substance."[2] "The magic
of irrationalism, the seduction of organic orna-
ment became so irresistible that whole groups
came to thank their cohesion to it and saw them-
selves virtually as plants that contain their own
meaning and essence within themselves without
being dependent on the external circumstances
of their existence and without knowing given
purposes outside themselves."[3] (ill. opposite)

Mallarmé – Maeterlinck – Khnopff

La chair est triste, hélas! et j'ai lu tous les livres.
Stéphane Mallarmé[4]

The poetic head of Symbolism was the poet
Stéphane Mallarmé (1842–98). "Let us say there-
fore that Charles Baudelaire must be designated
as the true predecessor of the present move-
ment. Yet Stéphane Mallarmé gave it the taste
for the mysterious and the ineffable. … Mean-
while, the last enchantment has not yet been
reached: unconditional and disquieting labor
awaits newcomers."[5] Although the works of
Mallarmé were published only in limited editions

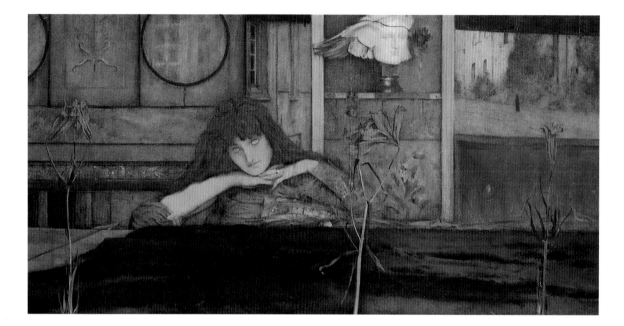

Fernand Khnopff
I lock my door upon myself, 1891
Oil on canvas, 72 x 140 cm
Bavarian National Art Collections,
Neue Pinakothek, Munich
The painting is based on a line from
a poem called "Who shall deliver
me?" by Christina Georgina
Rossetti, sister of the painter Dante
Gabriel Rossetti.

before his death, surveys among poets in 1891 and journalists in 1893 indicated that no other poet attracted homage as commonly as he did, and in 1896 he was elected "Prince des poètes". He was taken up by the young generation of Belgian poets early on, being celebrated in Albert Mockel's periodical *La Wallonie* as the greatest contemporary poet. The appeal of his poetry lies in the foreboding, suspended singsong of the lines; it is characterized by sounds, the music of verse, the meter, as in a mist, an evanescence of the corporeal. "To name an object by its name means destroying three-quarters of the pleasure in a poem, which comes from the delight of gradual understanding; to guess step by step, to suggest – that is the dream. The complete use of this secret miracle that constitutes Symbolism lies in evoking an object little by little, to reveal a spiritual condition, an *état d'âme*, or vice versa, to derive from it a state of mind in a series of decipherings."[6] What counts is not the depiction of the object but the effect that it has.

Mallarmé had a great influence on the Belgian poet Maurice Maeterlinck (1862–1949), and again, as with Mallarmé, it was Stefan George who translated his work for German readers. Maeterlinck's fairy-tale dramas played a major part in introducing Symbolism to German-speaking areas. *La princesse Maleine* inspired Charles Rennie Mackintosh to design a music salon as a chamber for "the souls of the six princesses of Maurice Maeterlinck", in a commission for Fritz Waerndorfer in Vienna. Debussy

set *Pelléas et Mélisande* to music, and Leistikow wrote of him: "I knew of no one who painted better than this poet."[7] "The soul," wrote Maeterlinck, "has become a transparent space in which all our actions and virtues are just scurrying leaves and flowers."[8]

In translating the language of Maeterlinck, Mallarmé, Emile Verhaeren (1855–1916) and Georges Rodenbach (1855–98) into visual terms, no one surpassed the Belgian painter Fernand Khnopff. Khnofpp (1858–1921) blended his Symbolist literary associations with the *quattrocento* painterly philosophy of the Pre-Raphaelites with whom he had close ties of friendship. The painting *I lock my door upon myself* (ill. above) originated from a line in the poem "Who shall deliver me?" by Christina Georgina Rossetti, sister of the painter Dante Gabriel Rossetti. The many sphinx figures in Khnopff's work are not allegories; as Mallarmé interprets them, they are "ideas" of the senses. The sole model for the lasciviously chaste young female figures, seductive, reserved, and yet fascinating, that run through his whole work was his sister Marguerite, in whom he depicted himself as androgynous. "Khnopff thus appears to follow the commands of secret voices from eternity. Maeterlinck is fond of saying that what we speak or do is not important: that is only a simile. What is important lies behind our words and deeds."[9]

The world of figures we encounter in the work of the Belgian sculptor Georges Minne (1866–1941) is, like that of Khnopff, part of literary Symbolism.

Georges Minne
Fountain with five boy figures, 1898
Individual figure of Kneeling Youth,
1896
Marble, 83 cm high; in 1906 it was
erected by Henry van de Velde in the
lobby of the former Folkwang
Museum (today, Karl Ernst
Osthaus Museum), Hagen
The fountain is the most typical and
high-quality sculptural work of Art
Nouveau. The Flemish poet Karel
van de Woestijne (1878–1929)
called this work "Narcissus in
fivefold reflection".

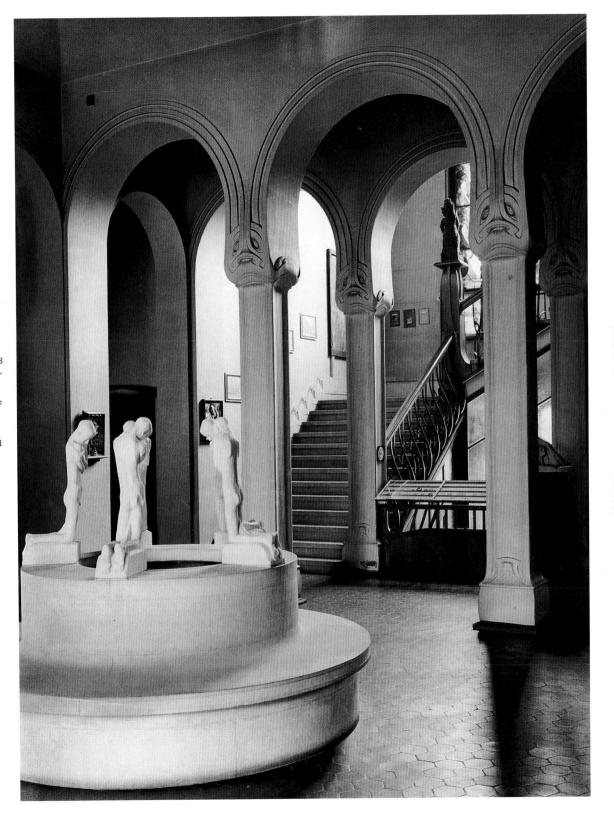

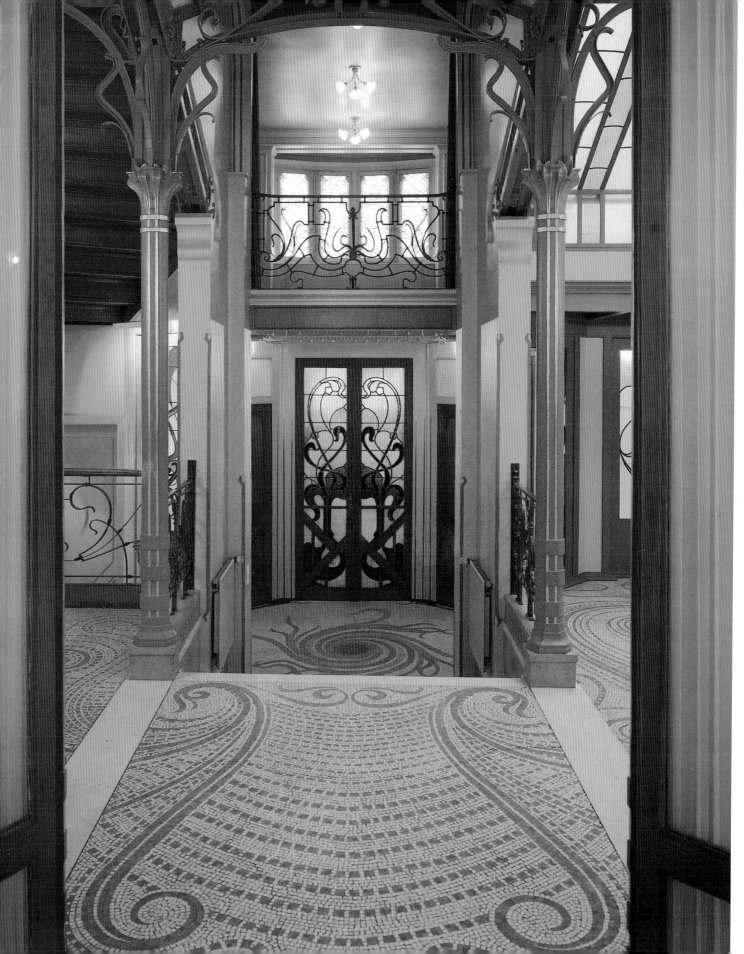

The simplification of outline of his figures makes
the symbol act like a code. Once again, the
parallelism is linked with the de-individualization
of the figure. On the fountain in the former
Folkwang Museum, Minne uses the fivefold
repetition of the same boy-figure to express the
orderliness that leads on to symbolic harmony
(ill. p. 133).

Manifesto of the new style

A spokesman and the driving force of all new
artistic endeavour in Belgium was the lawyer
Octave Maus (1856–1919). In 1881, he founded
the periodical *L'Art Moderne*. He was the initiator
of *Les Vingt*, a group of 20 well-known artists; of
the La Libre Esthétique organization (ill. top left);
and of the La Toison d'Or art salon (ill. top right),
whose numerous activities such as exhibitions,
concerts, and conferences stylistically influenced
the whole of Europe. By 1900, the "Belgian line"
had already become synonymous with Art
Nouveau. Brussels was more progressive and
receptive than Paris, so that many artists who
had no response there joined the organizations
listed above. They included Gauguin, Toulouse-
Lautrec, van Gogh, and Whistler. Thanks to the
many artistic circles, the art of the poster and
calligraphy enjoyed a considerable boost. A
catalog by *Les Vingt* issued in 1888 is laid out so
that each of the exhibiting artists had a page to
himself on which to display his works. All their
advertising output was similarly designed by the
participating artists.

Beside these auspicious intellectual circum-
stances, material conditions were also favorable in
Brussels. Because Brussels was a banking town
there were patrons who were willing both to
enthuse and to pay. Ernst Robert Curtius noted
this fact with the observation that "the seeds of
the iridescent flowers of this art could only unfold
in the fertile, well-prepared soil offered by the
material culture of the grande bourgeoisie."

Iron and glass – Victor Horta

Let the material speak for itself and appear undisguised, in the shape and proportions that have been put to the test by experience and science and found the most advisable. Let brick appear as brick, wood as wood, iron as iron, each in accordance with the laws of statics appropriate to it. That is true simplicity.
Gottfried Semper[10]

Meanwhile, around the turn of the century, Brussels was not only the capital of Symbolism, but also a center of reformist and Socialist currents. The theories of Ruskin and Morris awoke an enthusiastic response, and helped a strongly developed aesthetic feeling to find an outlet in practice.

As a further source of inspiration for Belgian Art Nouveau the treatise "Entretiens sur l'architecture" by the French architect Eugène Viollet-le-Duc should be mentioned. His demand in the "Entretiens" for the appropriate use of materials was taken very seriously by Belgian architects, and brilliantly put into practice. One could say that, alongside Hector Guimard, the Belgian Victor Horta "invented" the new art of Art Nouveau architecture, in which iron is used as a slender, sinewy, statically effective element. In the entrance hall of the Hôtel van Eetvelde (ill. opposite), built 1895–1901, Horta (1861–1947) achieved the breakthrough into transparency and lightness in the harmonious use of glass and iron.

The result has a delicacy, even fragility, in its static perfection. Inspiration came from Viollet-le-Duc's elaborations in his *Dictionnaire raisonné de l'Architecture française* (1854– 69): "On the day when everyone is convinced that the new style is only the natural, uncontrived fragrance of a principle, of an idea that follows the logical order of things in this world; that the style develops like a plant growing in accordance with a definite law; and that it is not in any way a kind of seasoning that one plucks out of a sack to scatter on a work that in itself tastes of nothing – on that day we can be sure that posterity will award us style. The style exists because the design of the architecture is only a strict consequence of the underlying structural principles: 1. of the materials to be used, 2. of the way they are applied, 3. of the tasks that have to be carried out, 4. of the logical derivation of the detail from the whole. … A distinguishing feature of style is above all that every object is given the form appropriate to it. If a structure clearly brings out the purpose for which it is intended, not much is lacking for it to have style; if it also forms a harmonic whole with the structures in its environment, it certainly has style. … But why insist on the application of principles? Principles are only honesty in the use of form. Style develops more clearly in works, the less the latter deviate from the correct, true clear expression."[11]

Victor Horta
Stair railing (detail), Maison et Atelier Horta, rue Américaine 25, Saint-Gilles, Brussels, 1898
When he was building his own home, Horta felt himself free to use all the construction elements he considered important. Wood was to soar now as well. Every piece of furnishing is constructed on the same static/energetic principle, where wood – like stone – sometimes loses its natural character as material and is similarly transformed into a flowing, sculptural material. The end result is an Art Nouveau synthesis of art, a *Gesamtkunstwerk*.

Victor Horta
Balcony (detail), Maison et Atelier Horta, rue Américaine 25, Saint-Gilles, Brussels, 1898

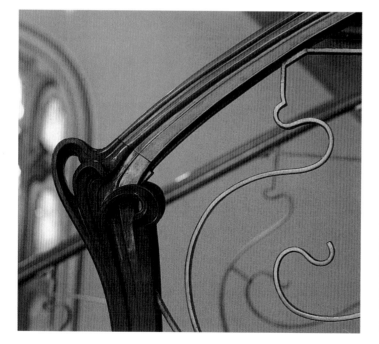

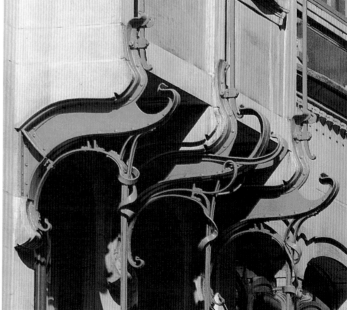

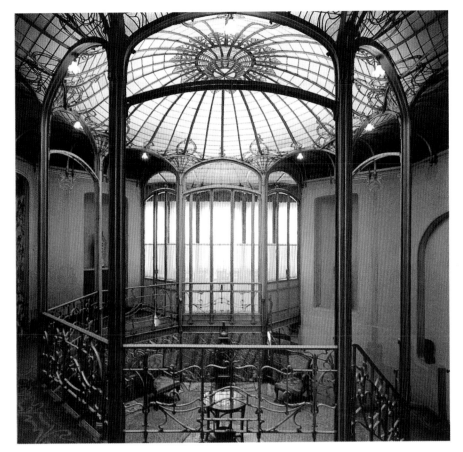

Victor Horta
Entrance lobby, Hôtel van Eetvelde,
avenue Palmerston 2, Brussels,
1895–1901
Much more use was made of iron as
a building material in this building
than in the previous structures by
Horta. Glass partitions between
slender cast-iron struts surround the
central core of the house. The
ornaments grow out of the supports
of the glass ceiling, which pulls
together the octagonal space and
lends it a floating and yet enclosed
lightness.

A visit to the Paris World Exposition of 1889, where he admired the splendid engineering achievement of the Eiffel Tower, and an intensive study of the writings of Viollet-le-Duc led Horta to use iron in architecture undisguised. While he was discovering a new metal style, he also applied his forms to masonry. Like Antoni Gaudí, he treated stone as visibly a structural and at once a sculptural material: stone is set in motion. Alongside his splendid constructions of iron and glass, Horta also used mixed construction in which the iron (or steel) represents the moment of greatest achievement and tension. In addition, he makes use of painting in order to extend the characteristic movement of the iron (ills. pp. 134, 136). The most famous example is the staircase in the Maison et Atelier Horta in Brussels (ills. 136, 141 and 143). Wood too was supposed to soar in sympathy: every piece of furniture and every detail of it was shaped on the same static/energetic principle, whereby the wood – like stone – sometimes loses its material character and is likewise reinterpreted to become a flowing, sculptural material. The *Gesamtkunst-werk*, the synthesis of the arts so beloved of Art Nouveau, is thus brought into being.

The Belgian line

At the bottom of what sea of mysteries do we live?
Maurice Maeterlinck[12]

Born in Ghent, Victor Horta soon abandoned his studies of music in favor of the Ghent Academy of Art. From there he went to Paris, thence to Brussels, where he resumed his studies at the Académie des Beaux-Arts. He was articled at the office of Alphonse Balat (1818–95), a noted Neoclassical architect who in the meanwhile showed his mettle in the Winter Garden of the mansion at Laeken (ills. pp. 20, 138–139). Horta got to know the early English modern style through exhibitions and readings of *Les Vingt*. Book, textile, and wallpaper designs influenced his ornamental style, which made a direct and convincing appearance after some initial conservative designs. Among Horta's first buildings is the Hôtel Tassel in Brussels (ill. p. 134), built

Following pages:
Alphonse Balat, Henry Maquet
Grand Jardin d'Hiver (Great
Winter Garden) greenhouses of the
Royal Palace at Laeken, avenue du
Parc Royal, 1875-76

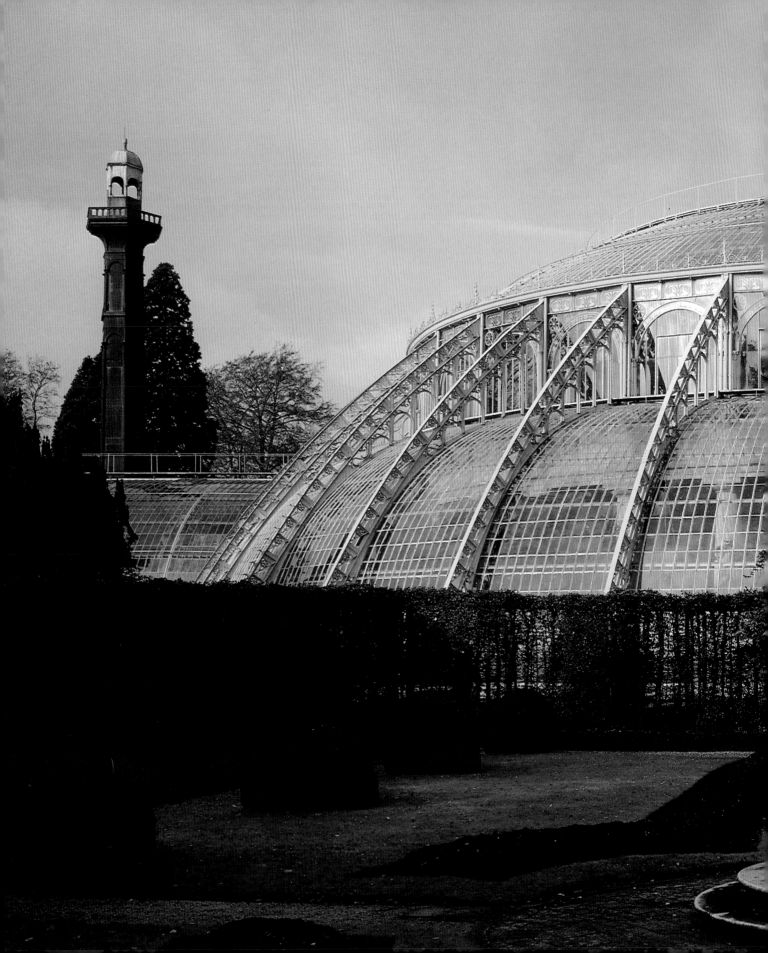

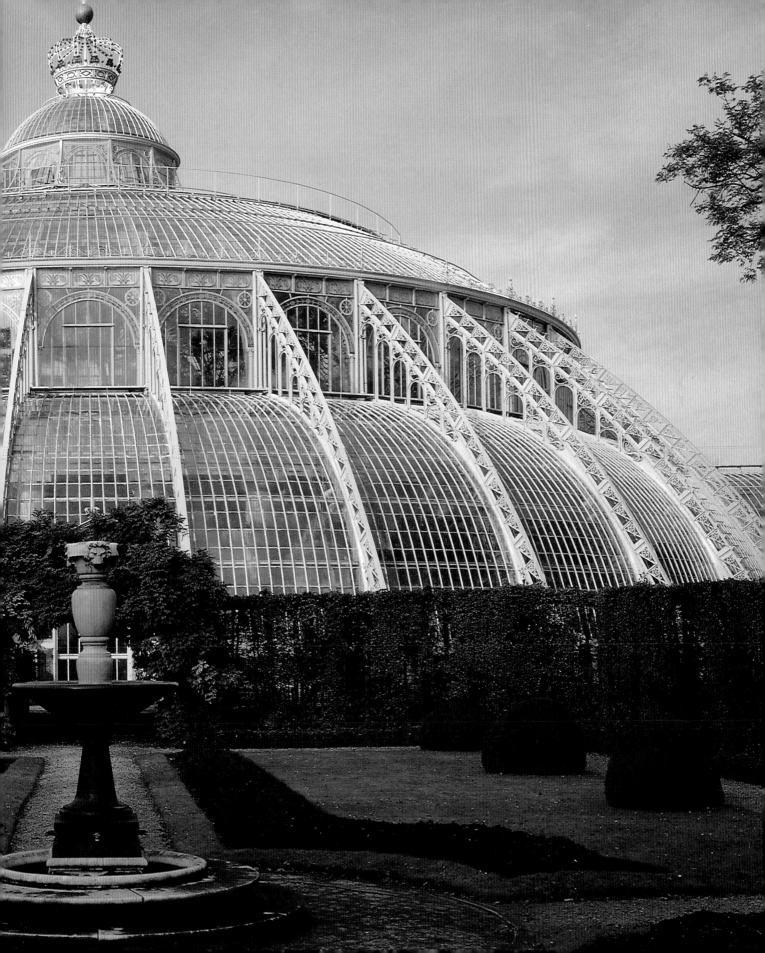

1893–97. The formal elements of the facade are rather restrained, but in detail richly imaginative. With his iron staircases, Horta introduced iron as a material into residual structures (ill. p. 143). The wavy lines of the balustrade and supporting pillars, and the flowing movement between the spaces, is not limited to the horizontal axis but runs vertically through the stairwell. Horta thus not only pioneered the way for iron in domestic use but also designed the first residential ground plans with flowing transitions between spaces on both horizontal and vertical axis, as befitted the "Belgian line" – pure linear dynanism in contrary rotation. At the same time, the ornamental intricacies are not the result of a pure abstract linework but take on the form of organisms resembling bending plants or wisps of smoke (ill. opposite). And, once again, a counter-gesture develops: "The direction of this expansion is definitely from inside outwards, from the ornamental interior first to the construction of the house itself. As the formal arrangement is extended through the whole house, so the opulent profusion of the interiors diminishes. The blossom of the 'ornamental spring' fades into the architectural summer."[13]

Horta's most personal "artistic synthesis" is probably the Palais Solvay. The luxurious furnishings were designed by the artist himself and executed in the most costly materials: "… Un escalier à double volée en marbre vert auquel répondait un plafond vitré."[14] Marble, iron, and glass, in harmonic and yet contrasting combination. In the Palais Solvay, Horta showed himself to be a complete *architecte d'art*, a term that the French architect Hector Guimard coined to describe himself. Ornament whirls over the building materials like swaying wrack, swirled by the water in ever new entanglements. "At the bottom of what sea of mysteries do we live?" wonders Maeterlinck.[15] Horta designed pure Art Nouveau style in swelling, inter-knotted iron bands of almost soft plasticity. The same love of detail is as evident in the Maison Frison as in the

Above:
Paul Hankar
Window of salon, Hôtel Renkin, rue de la Loi 128, Brussels, 1897 (demolished)
Project drawing as implemented
Watercolor
Archive d'Architecture Moderne, Brussels

Paul Hankar
Maison et Atelier Ciamberlani, rue Defacqz 48, Brussels, facade, 1897–98
Hankar bestowed on the studio of the painter Ciamberlani a striking facade that shows echoes of the *quattrocento* architecture of northern Italy. This was a tribute to the client, who came from a distinguished Bolognese family. Passers-by would stop and stare at the exotic building, but the critics also indulged themselves with complacent sneers such as "a real delirum of obsessive originality." (see note 17)

"rhythmic facade" of the Maison du Peuple. With the Maison du Peuple (ill. below), an administration and conference building constructed for the Belgian Socialist Party, Horta took on a completely different sort of building commission that was bound up with the social commitment of the Morris movement. The complex, which was demolished in 1965 despite international protests, was a perfect example of Viollet-le-Duc's demand that details be logically derived from the whole. The skeleton construction with its facade of iron and glass is the forerunner of the modern curtain wall, as used today in high-rise buildings for shelter and to retain warmth. The individual members of the front seem interchangeable and lend the whole building a stunning mobility. The transparency of the glass and fragile struts arouse a desire to fold up the whole structure like a fan. In the Maison du Peuple, with its almost Spartan plainness, Art Nouveau takes on a new form. The building itself constitutes the ornament. The curved line of the

Victor Horta
Stairway, Maison et Atelier Horta, rue Américaine 25, Saint-Gilles, Brussels, 1898
The ornamental embellishments are not the result of an abstract linearity but take the form of organisms resembling inclining plants or wisps of smoke.

Victor Horta
Maison du Peuple, place Emile Vandervelde, Brussels, 1896–99 (demolished 1965)
With the Maison du Peuple, an administration and meeting building for the Belgian Socialist Party, Horta took on quite a different kind of commission, one bound up with the social commitment of the Morris movement. Demolished in 1965 despite international protests, the complex was a prime example of Viollet-le-Duc's demand for a logical derivation of the details from the whole. The skeleton construction, with its facade of iron and glass, is the precursor of the modern curtain-wall used as a covering for high-rise buildings.

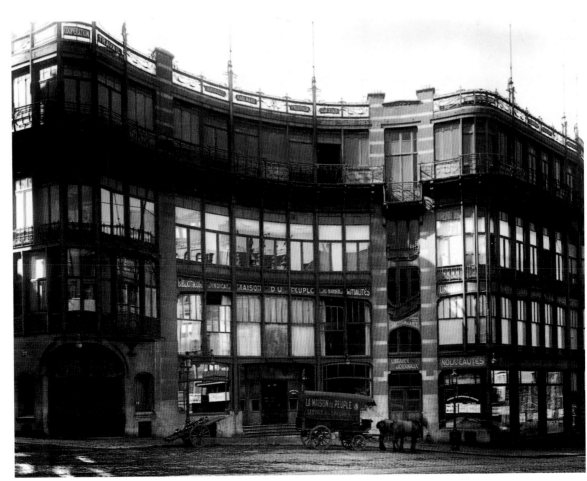

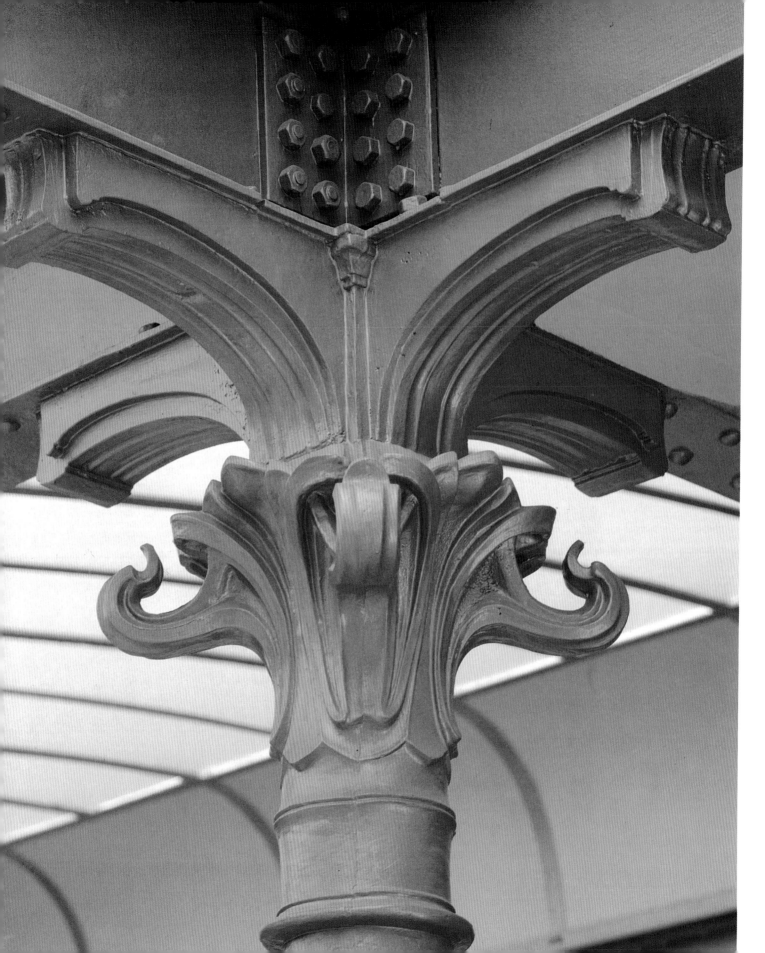

facade, which reaches round without any breaks or hard transitions, is a monumental detail form, the "summer of architecture".

It took another purpose-built building, the Magasin Waucquez, built 1903–06 (ill. opposite), for the commitment to architecture to assert itself. Functional considerations came to the fore, combined with an almost classical feeling for form, which would become a characteristic of Horta's work in the following years.

Like the De Stijl Movement in the Netherlands some 20 years later, Horta extracted apparently hidden elements from traditional contexts and lent them an up-to-date character in new surroundings and explicit synthesis. He combined wood (soft), marble (hard), and iron (brittle) to make a quasi-elastic whole (ill. right). His influence on the succeeding generation is unmistakable, above all in Rudolph Schindler (1887–1953), Le Corbusier (1887–1965) and Louis H. de Konick (b. 1896).

Heyday of architecture – Brussels around 1900

This is the true simplicity, to which one may then devote oneself with all the love of chaste embroidery of decoration.
Gottfried Semper[16]

In 1893, Horta's Maison Tassel was constructed, the great architect's first pure Art Nouveau building. Almost contemporaneously, Paul Hankar built himself a residence in Brussels. Thus, almost with a roll of drums, the era of the "new architecture" opened in Belgium. Like Horta, Hankar (1859–1901) was much influenced by the writings of Viollet-le-Duc, but he was also equally enthusiastic about the English Arts and Crafts Movement, and details of his interiors are often reminiscent of the Scot Charles Rennie Mackintosh. Hankar considered it his main task to unite the fine arts with the applied arts in a decorative synthesis, and in his endeavours he developed an unmistakable style of his own. He had many contacts with artists in the fine arts. He worked closely with the sculptor Alfred Crick (b. 1858) and the painter Alphonse Crespin (1859–1944), who did a large number of sgraffiti on Hankar's buildings. Hankar's significance for Art Nouveau is not limited to his activities as an architect. His commitment to the new style as editorial secretary of the architectural periodical *L'Emulation* and as a member of numerous artistic organisations made a substantial contribution to publicizing it. His education took Hankar from the Academy in Brussels to the architect Henri Beyaert, with whom he shared a predilection for wrought iron and a dislike of sheet iron and cast iron. Besides his own house, Hankar build a studio for the painter Ciamberlani in Brussels (ills. pp. 140. 147). Its striking facade echoes the *quattrocento* architecture of northern Italy, by way of a tribute to his client, who came from a distinguished Bolognese family. The exotic style astonished passers-by, but the critics also thoroughly indulged themselves with complacent sneers such as "a real delirium of obsessive originality."[17] Hankar's designs for shops, restaurants, and galleries are stylistically more homogeneous – abstract Art Nouveau of Belgian stamp. His early death in 1901 robbed Belgium of one of its great inspirations and a leading light of the art scene. Broadly educated, he was involved not only in his profession but also in archaeology, and conducted major excavations in Belgium. No less original than the Maison Ciamberlani are the facades of the amateur architect Paul Cauchie (1875–1945), who trained as a painter and designer. Cauchie's studio and

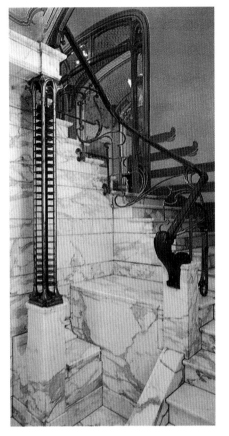

Victor Horta
Stairwell, Maison et Atelier Horta, rue Américaine 25, Saint-Gilles, Brussels, 1898–1901
Horta extracted apparently concealed components from their traditional context and endowed them with an up-to-date character in new settings, in undisguised synthesis. He combined woods (soft), marble (hard), and iron (brittle) to make an almost elastic whole.

Victor Horta
Stairwell, Hôtel Tassel, rue E. P. Janson 6, Brussels, 1893
With the iron stairwell construction at the Hôtel Tassel, Horta introduced iron into residential buildings as a building material.

Victor Horta
Ceiling bearer, Magasin Waucquez, rue des Sables 20, Brussels, 1903–06
In this building (1823–94), Horta was now fully committed to architecture. Functional purpose comes to the fore, combined with a virtually Classicist feeling for form, which would become the mark of his work in the coming years.

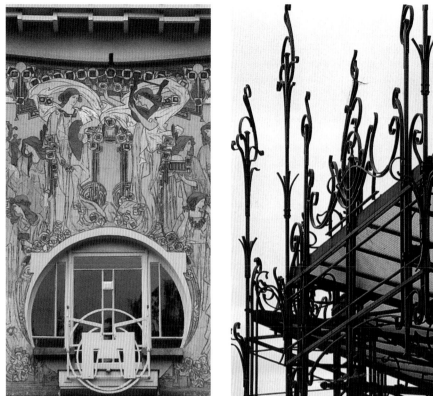

Paul Cauchie
Facade (detail), Maison et Atelier
Cauchie, rue des Francs 5, Brussels,
1905
The facade is a rare but successful
example of fresco in Art Nouveau –
"art on architecture".

Left:
Gustave Strauven
Entrance roofing (detail), business
and residential premises, avenue
Louis Bertrand 65, Brussels, 1906

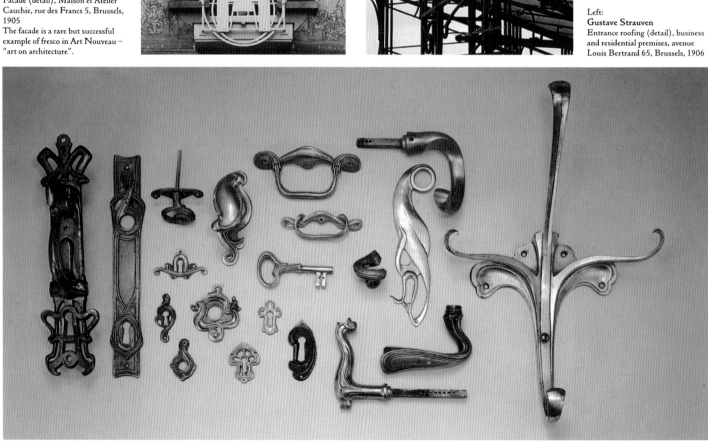

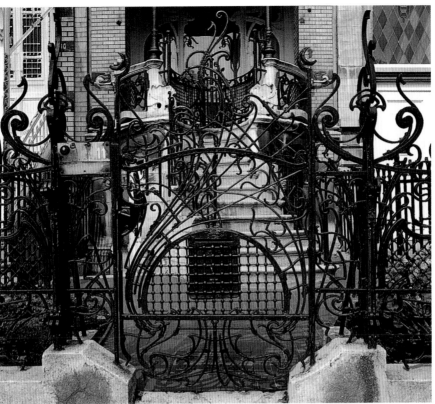

Ernest Blérot
Facade (detail), residential building, place Louis Morichar 41, Brussels, 1900
An example of the "blossoming" architecture of *fin-de-siècle* Brussels.

Gustave Strauven
Gate, home of the painter Saint-Cyr, square Ambiorix 11, Brussels, 1900–03
Strauven shared Horta's stylistic approach and his enthusiasm for iron as a material. In his case, iron was used not in sinewy rectilinearity but to lend a touch of individuality in a graceful "ornamental undergrowth."

Paul Hamesse
Door metalwork, residential and laboratory building, rue des Champs-Elysées 6, Brussels

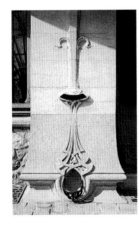

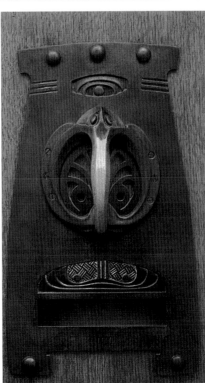

Albert Roosenboom
Drain ornamentation, residential building (former private residence of Roosenboom), rue Faider 83, Brussels, 1900
Impressive detail of floral strip ornamentation that is found all over the "functional" parts of the building.

Opposite:
Victor Horta
Mounts and metalwork, ca. 1895–1905
Musée Horta, Brussels

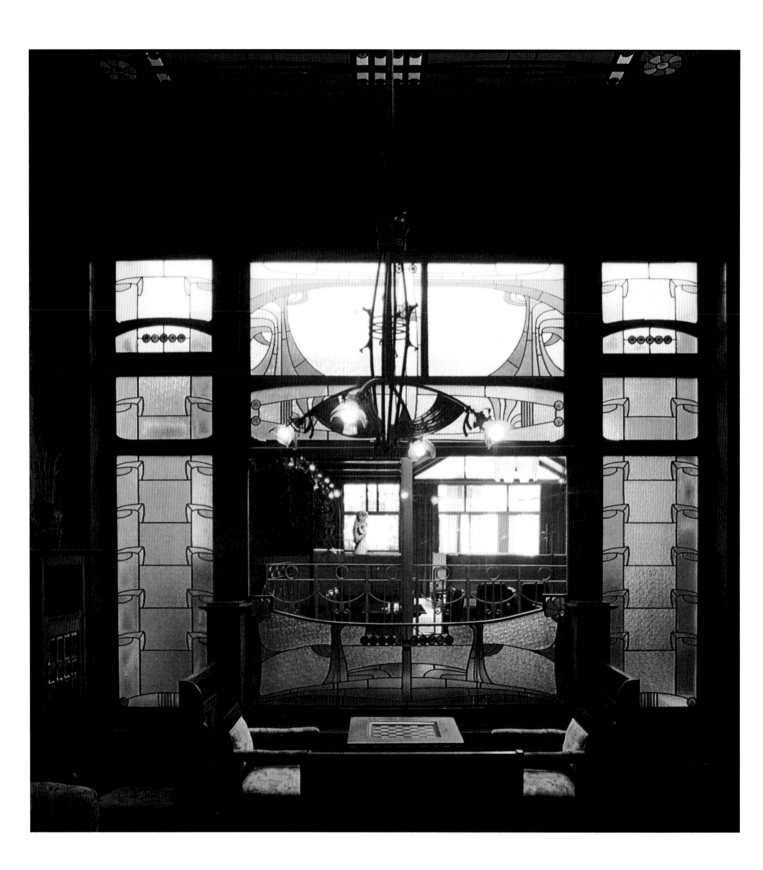

Paul Hamesse
Interior, Hôtel Cohn-Donnay, today
the Café Restaurant Ultième
Hallucinatie, rue Royale 316,
Brussels, 1904
The interior of the present-day café
restaurant is one of the jewels of Art
Nouveau in Brussels.

home (ill. p. 144) is a rare but successful example of Art Nouveau fresco art – "art on architecture". In later years, Cauchie evolved from being the master of individuality and imagination into a builder of social homes. He designed ready-made houses that were cheap and functional. Another distinctive figure of Art Nouveau in Belgium is Gustava Strauven (1878–1919). As a collaborator with Horta, particularly on the Hôtel Eetvelde and the Maison du Peuple, he shared Horta's stylistic approach and his enthusiasm for iron as a building material (ill. p. 144). In his case, it is not used in sinewy straight lines but to give an unconventional shape as a kind of graceful "ornamental undergrowth". A significant example of this is the iron railings round the house of the painter Saint-Cyr (ill. p. 145). Another figure from the Hankar school was the architect Paul Hamesse (1877–1956), whose interior at the Hôtel Cohn-Donnay – today the Café-Restaurant Ultième Hallucinatie (ills. pp. 145, 146) is one of the jewels of Art Nouveau in the capital. Further "pearls" in the "necklace" of the city's architecture include the private residence of Albert Roosenboom, with its impressive details of floral strip ornamentation (ill. p. 145), and the flowery masonry of the architect Ernest Blérot (ill. p. 145). These examples show effectively the level of architectural design that had been achieved in *fin-de-siècle* Brussels.

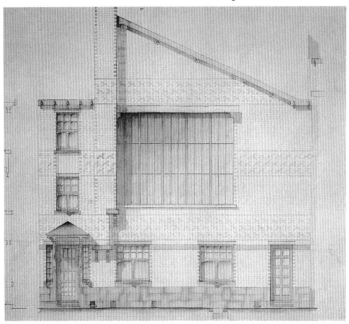

Paul Hankar
Elevation and section of facade, first version, Maison et
Atelier Ciamberlani, rue Defacqz 48, Brussels, 1897
Watercolor
Archive d'Architecture Moderne, Brussels

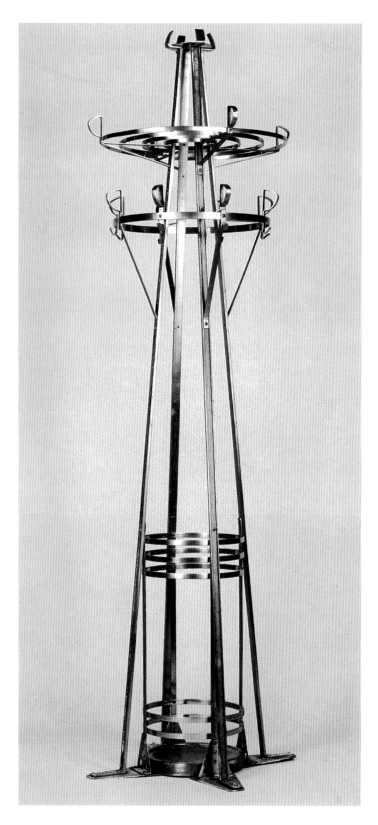

Gustave Serrurier-Bovy – Inventor of jointed furniture

We need a "joiner culture". If applied artists were to paint pictures again or sweep streets, we'd have it.
Adolf Loos[18]

The work of the furniture designer Gustave Serrurier-Bovy (1858–1910) developed as an autonomous style of its own. Its parameters were set by the sober and yet vibrant elegance of British artists. After his architectural studies at the Academy of Fine Arts in his home town of Liège, Serrurier-Bovy opened a shop there selling English furniture. His own work bears an English touch that developed into a characteristic trait – a souvenir of his trip to England, on which he embarked in his enthusiasm for the writings of William Morris.

The vital difference from his English idols such as Charles Francis Annesley Voysey or Charles Robert Ashbee lies principally in his view of the construction of furniture. The box body gave way to a body made of members. The extensive, stylized ornamental figures of his models is transposed into a new context. For example, in his chairs he breaks up the box body into its structural elements and puts them together again with individual bars (ill. opposite). The same principle applied to his interior designs (ill. p. 147). The modular system of his work and its Cubist rectilinearity recall the Wiener Werkstätte or Adolf Loos – but it was Serrurier-Bovy who came first. His sense of ornamental disposition and geometric order never led to a unified grid. Every object was developed afresh in its function from within. Like his artistic compatriots from Belgium, he too had a predilection for iron construction (ill. left), just as he got on well and collaborated with the leading established architects. Later, Henry van de Velde took over the member-system of furniture from him and made it famous as the "Van de Velde Style".

Gustave Serrurier-Bovy
Hat rack, for the Pâtisserie Marchal, Brussels, ca. 1903–04
Iron and copper bands,
204 cm high, diameter 52.5 cm
Serrurier-Bovy shared with his artistic colleagues in Brussels the Belgian preference for iron construction, just as he was always glad to collaborate with the leading architects there.

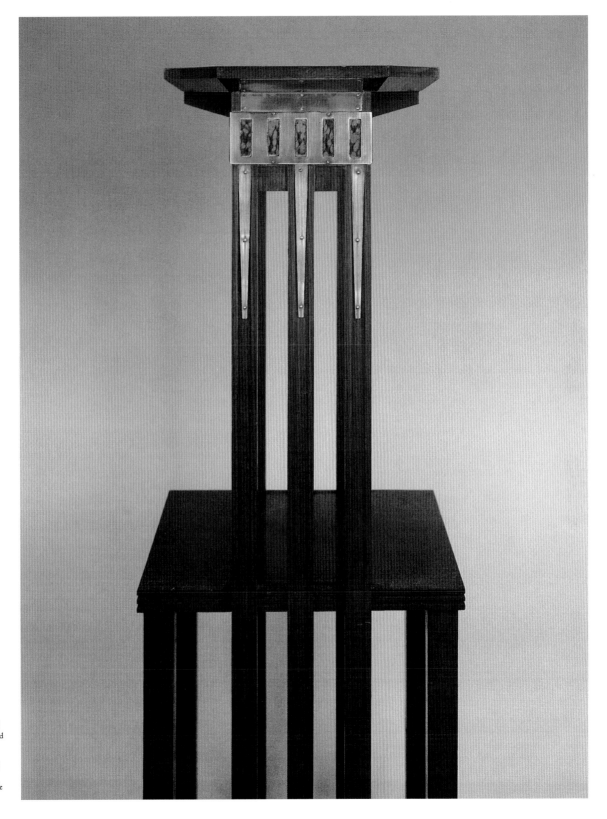

Gustave Serrurier-Bovy
Chair, ca 1902
Wood, brass mounts, enamel, ca.
120 cm high
The stylized ornamental figures of
his English models were transposed
by Serrurier-Bovy into a new
context, in which he dissolved the
box-body system for his chairs and
reconstructed them from the
individual bars. The same principle
was adopted in his interiors.

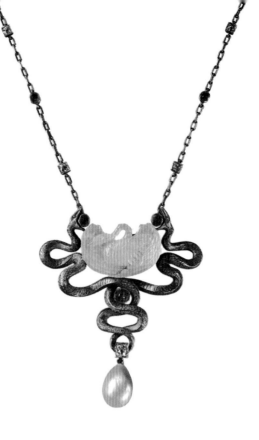

Philippe Wolfers
Day and Night, belt buckle, 1897
Chased silver, fired-gilt silver and
amethysts, 9 x 12.5 cm
(reproduction to original size)

Iron and gold – Sphinx and ivory

Tes yeux, où rien ne se révèle
De doux ni d'amer,
Sont deux bijoux froids où se mêle
L'or avec le fer.
Charles Baudelaire[19]

Belgium as a center of the avant-garde initiated
unusual work not only in the field of painting,
graphics, and architecture but also inspired
creativity in arts and crafts. The repertoire of
motifs was drained, and the new style took a
whole variety of expression. In accordance with
Belgian principles of form, metalwork took a
leading position, as the "style" could be trans-
lated into it most credibly. Thus Fernand Dubois
(1861–1939) designed lighting that appears like a
quotation from Horta's iron components,
demonstrating that they were as effective as
stand-alone forms as they were in an
architectural context (ill. p. 144). The arms of the
candelabra (ill. p. 152) are like branches,
representing a high point of plant design in their
sculptural quality. High praise for Dubois came
from the critic Octave Maus, for whose Salon de
la Libre Esthétique he produced handicraft work.
Like Philippe Wolfers, the giant of Belgian
handicrafts, Dubois made use of "Belgian"
materials such as metal and ivory from the

Congo. His chryselephantine (ivory and metal)
sculptures were wrought, like those of his
teacher Charles van der Stappen (1843–1910), as
works of complete perfection. Stappen's bust
Le Sphinx mystérieuse (ill. p. 153) unites all the
features of *fin-de-siècle* Belgian art and consti-
tutes a virtual incunabulum of this school of Art
Nouveau. *The Sphinx* is the image of literary
symbolism made flesh, the ivory underlining its
mysterious aura. Chryselephantine was used in
the ancient world as a material for costly statu-
ettes for discriminating clients. The Belgian
variant has, in contrast, a very pragmatic back-
ground. The commercial considerations of a king
assisted Belgian Art Nouveau to some of its
most brilliant achievements. Leopold II ruled the
Belgian Congo as his private estate, and so was
anxious to boost sales of African ivory. To bring
ivory into fashion, he offered established artists
the tusks free of charge. The gamble paid off –
the success was overwhelming. Ivory work cele-
brated its first triumph at the Antwerp World
Exposition in 1894, and in the display at the
Belgian Congo pavilion at Tervueren, on the
occasion of the Brussels World Exposition of
1897, the new branch of art stole the show. The
principal works were bought by the state and
remained in the African Museum in Tervueren for
a long time. Today they can be seen along

Philippe Wolfers
Swan with Snakes, pendant, 1898
Opal, chased gold, rubies, diamonds,
pear-shaped pearl
Pendant 5 x 5 cm, chain 40 cm long
(reproduction of pendant to original
size)
This jewel, a one-off, was designed
by Philippe Wolfers for his wife,
Sophie.

with other Art Nouveau exhibits at the Musées Royaux d'Art et d'Histoire in Brussels. Here, too, Philippe Wolfers is the "grand master" among many grand masters.

Philippe Wolfers – Black jewels

Neiger de blancs bouquets d'étoiles parfumées.
Stéphane Mallarmé[20]

Philippe Wolfers (1858–1929) created rarities in which the boundaries between sculpture and appliance, sculpture and handicraft became blurred – a pure luxury art of brilliant technique in which the object is only a medium for the symbolic content. Trained in the workshop of his father, a well-known Brussels goldsmith, in his early years Wolfers designed pricey historicizing pieces of jewelry in a Neo-Rococo style. Even at that time, he was acquainting himself with Japanese craftwork, and adapted its approach to the use of materials for his own quasi-Japanese jewelry. His later outstanding role in Belgian Art Nouveau derived from the fact that his work markedly displayed features of the new style from the mid-1880s. Wolfers had kept a sharp eye on developments in England, and became an all-round artist after the model of the English workshops. He designed bronzes, small items of furniture, lamps (ill. p. 130), glass vases (ill.

p. 152), and, above all, jewelry (ill. opposite and below) decorated with enamel and gems. Only a fraction of his work has been preserved as, in contrast with other Art Nouveau goldsmiths, he had a passion for valuable stones which, when the style went out of fashion, were broken out of their settings. The gleam of precious stones and reflection of the gold ground, which evoke Byzantium and the Orient, are a sign of Symbolist inclinations. In 1899, Wolfers built himself a villa in La Hulpe, and thus became a client of Paul Hankar. Victor Horta was the architect whom he commissioned in 1909 to build him business premises in the rue d'Arenberg in Brussels. Already by 1900 he had branches of his business in Ghent, Antwerp, Liège, Budapest, Düsseldorf, London, and Paris. Besides his activities as a jeweler, he worked as a designer of glassware, in this case principally for Belgium's leading glass manufacturer Val Saint-Lambert in Seraing-sur-Meuse. The Val Saint-Lambert works occupied the site of an old Cistercian abbey, and with a daily output of around 160,000 units ranked among the biggest producers in Europe. Most of these were crystal articles, but there were also Art Nouveau flashed-glass products. The executive artist at Val Saint-Lambert was Désiré Muller, from Lunéville, who did his ornamentation in the Gallé style. Horta, van de Velde, and Serrurier-Bovy also worked for the manufacturer. Wolfers

Philippe Wolfers
Nike [Greek goddess of Victory], pendant, to be worn as a brooch or on a chain, 1902
Chased gold, *plique à jour* enamel, rubies, emeralds, diamonds, cut tourmaline, baroque pearls, 5 x 7 cm (reproduction slightly over-lifesize)

Philippe Wolfers
Large Dragonfly, pendant, to be worn as a brooch or on a chain, 1903–04
Gold, opals, enamel, rubies, diamonds, Mexican opal, 11.5 x 13 cm
Philippe Wolfers made rarities in which the border between sculpture and appliance, art and handiwork was blurred – a pure luxury art of brilliant technique, in which the object becomes just a medium for symbolic contents.

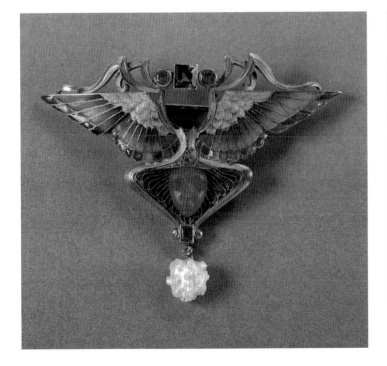

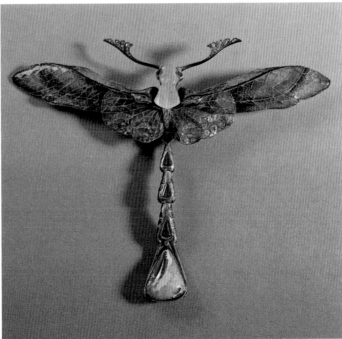

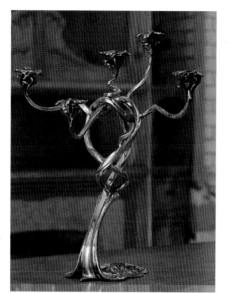

Fernand Dubois
Five-branch candelabra, ca. 1899
Bronze, gilt, 53.5 x 20.5 cm
Musée Horta, Brussels
In 1899, this candelabra, executed in pewter, was exhibited at the Salon de la Libre Esthétique and later included in a Horta display at the International Exposition in Turin in 1902.

Philippe Wolfers
Crépuscule [Dusk], vase, 1901
Crystal glass, flashed, cut, 30.5 cm high
Execution by Cristalleries du Val Saint-Lambert, Seraing-sur-Meuse
Musée d'Archéologie et d'Arts Décoratifs, Liège
The body of the glass is embraced by a bat, the creature of twilight, half-mammal, half-bird, with an almost human countenance, a synonym for the vampire. The bat plays an outstanding role in the iconography of Art Nouveau. The bizarre winged creature is perpetuated in all conceivable materials.

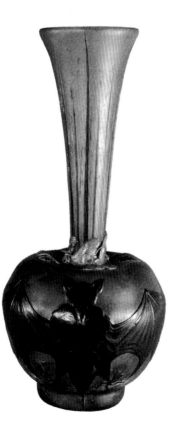

had his glasswork finished by gem cutters in his own workshops, each piece being unique. The vase called *Crépuscule* [Dusk] (ill. below) is a child of Symbolism in both title and representation. Twilight is the domain of ethereal souls, monochromy, and pale dreams. Encircling the body of the vessel is a bat, a creature of dusk, half-mammal, half-bird, with an almost human countenance, a synonym for the vampire. The bat here plays an outstanding role in the iconography of Art Nouveau. The bizarre, winged creatures are perpetuated in every conceivable material. The black glass has the effect of stone that glows only in artificial light. Black as a complement to shimmering color animated the Symbolists' ideas of morbidity. "The dining room was lined entirely in black ... avenues for this purpose were strewn with fine coal dust, the small wash basin bordered with basalt was filled with black ink ... the meal was served on a black tablecloth, and the guests were waited on by black negroes."[21]

Henry van de Velde – doyen of Art Nouveau

A line is a force that, like all elemental forces, is active; several lines brought into contact but in conflict with each other have the same effect as several forces working against each other.
Henry van de Velde[22]

The Maison et Atelier Horta constituted Art Nouveau's *Gesamtkunstwerk*, or synthesis of the arts. Yet, at the same time, it should be added, arose "the theory of line as an abstract medium of expression. This theory originated with van de Velde, which is no surprise as van de Velde was originally a painter. In later times, a serious quarrel blew up between van de Velde and Horta. It was said that the quarrel had personal causes, but artistic reasons certainly came into it. Horta was accused of being glued to construction, while van de Velde distorted the construction by exaggerating the primacy of abstract line. Van de Velde certainly set great store on the abstract character of line. We have met many ornamental motifs of Art Nouveau that are based on lilies, irises or female figures. In contrast, van de Velde's view was that the time for ornamentation made of tendrils, flowers, and women was over. The art of the future should be abstract."[23]
Henry van de Velde (1863–1957), the third and yet the first of the three great Belgians – Horta, Wolfers and van de Velde – did the greater part of his work in Germany. Yet his theories that held

Charles van der Stappen
The Mysterious Sphinx, 1897
Ivory, bronze, 56 x 46 x 31 cm
Musées Royaux d'Art et d'Histoire, Brussels
Van der Stappen finished his chryselephantine (ivory and metal) sculptures to the ultimate degree of craft perfection. The bust shown here unites all the features of *fin-de-siècle* Belgian art and constitutes therefore a sort of incunabulum of Art Nouveau in Belgium. *The Sphinx* is the image of literary Symbolism incarnate, while the use of exotic ivory underlines the aura of mystery.

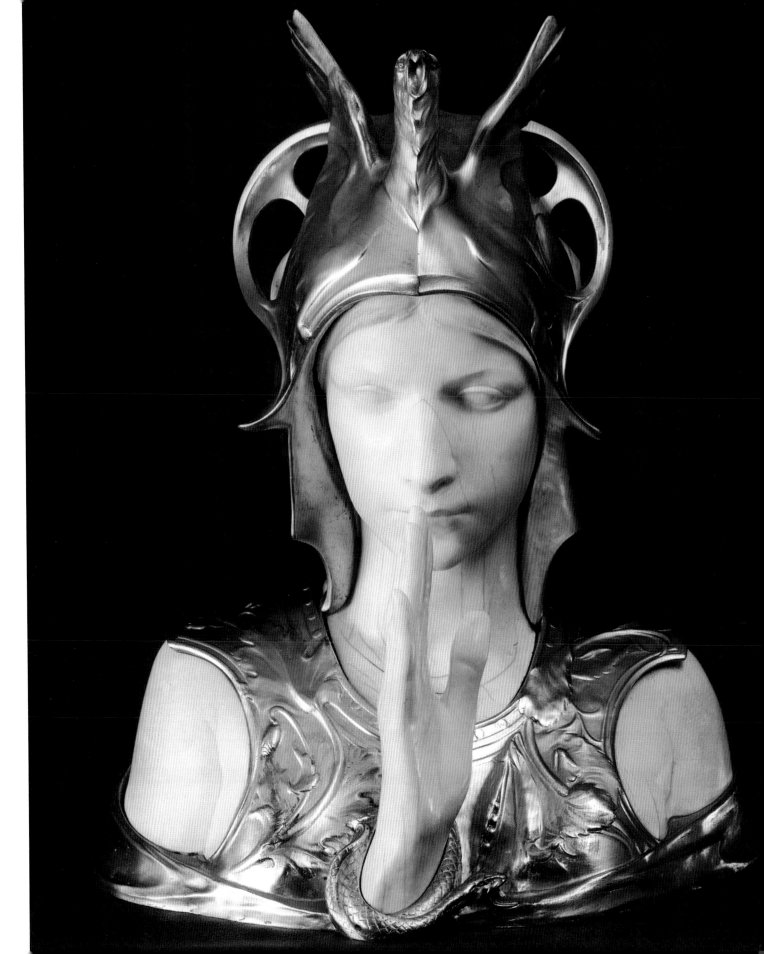

Henry van de Velde
Above: study, exhibited at the Secession Exposition in Munich in 1897, reproduced in *L'art décoratif,* Paris, September 1899, p. 262

Right: Bureau plat writing desk and armchair, ca. 1898–99 (model dated 1896)
Bureau plat: 128 x 267 x 122 cm, Armchair: 72 cm high
Sculptured oak, bronze, copper, lamps of red copper, leather writing surface and chair upholstery
"The sinuous form and playful movement of line attempt to chain the user to the desk and ensnare him in its spell. The desk is almost saying, I can help you in your work, and with me conditions are all set for you to concentrate. The furniture is making its own statement, as it were." (Klaus-Jürgen Sembach, see note 32)

out most promise for the future were developed in his Belgian period. He may therefore be justly entitled to claim fame for helping Art Nouveau make its breakthrough on the European continent and contributing to its golden age. "At the Art Nouveau exhibition in Zürich in 1952, a desk, a chair, and a large picture had been set up together. An 89-year-old man sat there and held forth in a lively and stimulating lecture for today's artistic youth. It was Henry van de Velde. Fifty years earlier[24] he had designed the desk (ills. above and right) and Ferdinand Hodler (1853–1918) had painted the wall painting *The day*. What these two things had in common is called Art Nouveau."[25] It was the first major postwar exhibition devoted to Art Nouveau, and was opened by van de Velde as the doyen of the whole movement. The style was out of fashion and much vilified, and it would be some years yet before it came to be admired again. Van de Velde was the brightest personality, most powerful philosophical talent, and at once most striking and original phenomenon of Art Nouveau, though he rejected the term as disrespectful to the style. He was both a prophet and a shaper of a new aesthetic clarity and harmony. His path from painting to architecture and the crafts was a model for a whole generation of artists. It is therefore wrong to talk of van de Velde in his Belgian period as "van de Velde avant van de Velde"[26] Though his work in Germany is what formed his international image, we are mistaken to neglect the years up to 1901. The characteristic line was already well-formulated in the style of the painter, but took a new turn when the constructional logic was elucidated on objects and innate

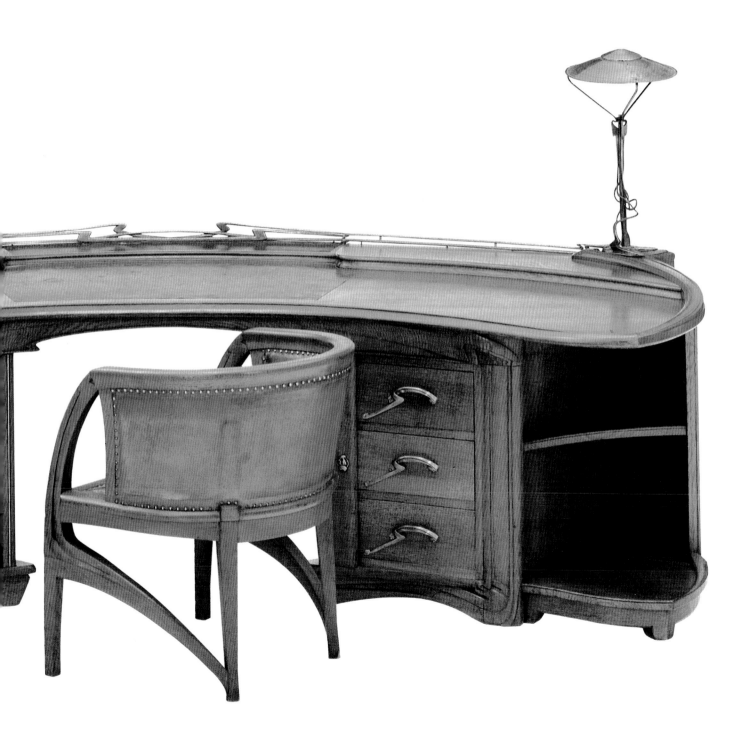

power currents were channeled into them. The decision he made in 1882 to go for the applied arts certainly acted as a release from the creative straits that painting had become for him. "One would do better, in respect of the series of fine, logical interconnections of schools of painting, to heed the group of artists that suddenly switched over to industry recently. They plan an unlimited expansion of the three-dimensional arts right back to the earliest industrial beginnings, and a struggle will begin for the appropriate means and effects that they consider appropriate for reviving out-of-date ornamentation from the archives. No one can be averse to the idea of conferring an artistic character on everyday things and appli-ances that – for how long! – have been bereft of a sense of their service and appeal."[27] At the last salon of *Les Vingt*, in 1893, van de Velde exhibited his tapestry *Angels' Vigil* (ill. above), which marks his transition within artistic disciplines. The tapestry is a translation of his theory of the reciprocal influence of colors on one another and their relationship. In form, it displays a modern insight into the rhythm of line. A contemporary critic said of the embroidery: "the composition is at once naive and solemn; it reminds one of illustrations for fairy stories by Maurice Maeterlinck."[28] With that, the circle of the specifically Belgian version of Art Nouveau closes.

Henry van de Velde
Blue tea gown, ca. 1895
Museum voor Sierkunst, Ghent
"The same forces," declared van de Velde of his activity as a fashion designer, "that drove me – though not an architect – to draw up the plans for our house, and to design furniture, lamps, and other objects, think up wall hangings, mats, and carpets without ever having thought of the production of such things, induced me to apply the principle of rational design, the fundamental method of all my work, to women's clothing as well."

Henry van de Velde
Two armchairs, for an interior for the banker Bauer, rue de l'Association 65, Brussels, 1896
Padauk wood (a precious wood with colored streaks), velours upholstery, 88 x 66 cm
The later decisive features of Belgian Art Nouveau are traceable even in the rather plain furniture of the early period, in the emphasis on structural and ornamental details combining to make an indissoluble whole.

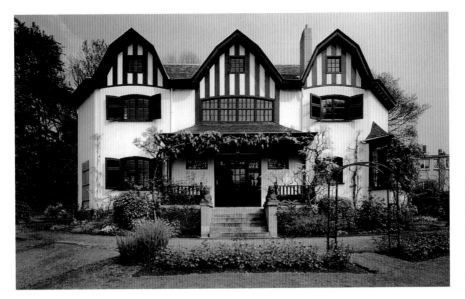

Synthesis of art

*Even when I had given up painting, the demon of line did
not leave me, and when I designed the first ornaments,
they arose out of the dynamic interplay of their elemental
forces.*
Henry van de Velde[29]

In accordance with his original wish to become a
painter, van de Velde, a native of Antwerp, had
enrolled for the Academy there from 1881–83,
and subsequently continued his studies until
1885 at the studio of the painter Durant in Paris.
He admired van Gogh, Louis Anquetin, Emile
Bernard and the Pointillistes, but at the same
time he absorbed the influences of Japanese
woodcuts and developed them in his pictures
(ill. left). Fired by the exhibitions and publications
of *Les Vingt*, in 1889 he joined the group. There
he made the acquaintance of the Englishman
William Finch (1854–1930), who introduced him
to the writings of John Ruskin and William
Morris, and to English arts and crafts. The
encounter with the reformist ideas of English
artists lent shape to his own thoughts and
objectives. Following a physical and psycho-
logical crisis in 1890, he reconsidered his situ-
ation as an artist, and ended up by following his
real vocation, thanks to the deep impression that
Morris had made. Measured by the conventions
of his time, what he did was revolutionary. He
carried out a reevaluation of all artistic disciplines,
in which painting had hitherto always occupied
the top position. Julius Meier-Graefe called van
de Velde, after his lecture on "William Morris,

Above:
Henry van de Velde
Abstract plant composition, ca. 1893
Pastel, 47 x 49 cm
Kröller-Müller Museum, Otterlo
The study is one of the last works
painted by van de Velde. It shows
clearly the influence of Japanese art
and the later dynamic rhythm of arts
and crafts work.

Henry van de Velde
Wallpapers (detail), ca. 1897
Paper, painted

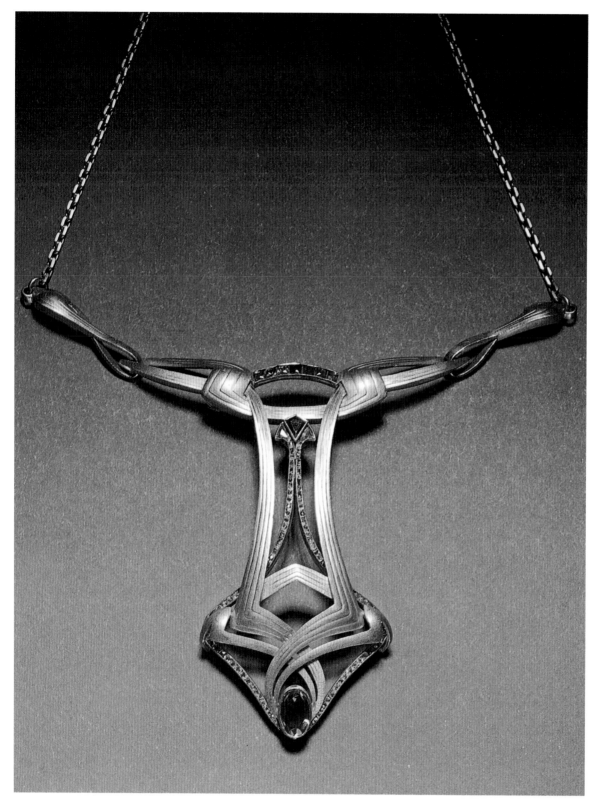

Henry van de Velde
Necklace, ca. 1900
Gold, sapphires, emeralds,
7 cm high, ca. 11 cm wide
(reproduction over-lifesize)
Neue Sammlung, Staatliches
Museum für angewandte Kunst,
Munich
"A line is a force that is active, like
all elemental forces; several lines
brought into contact but in conflict
with each other have the same effect
as several forces in conflict with each
other." (Henry van de Velde, see
note 22)

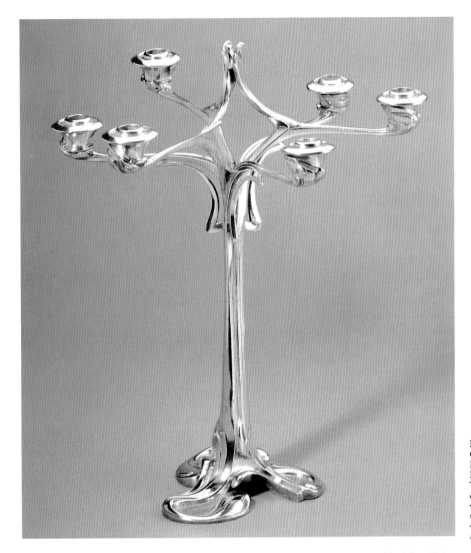

Henry van de Velde
Candelabra, 1898-99
Beaten silver, 59 cm high
Bröhan Museum, Berlin
The final conquest of the third
dimension by line was achieved by
van de Velde in exemplary fashion in
this silver candelabra. Previously
wrongly dated to 1902, it was
actually made earlier, in 1898.

Page 161:
Henry van de Velde,
Octave van Rysselberghe
Stairwell, Hôtel Otlet, rue de
Florence 13, Brussels, 1894
In graphic art, linear rhythm still
served as a bearer of mood. In this
respect, van de Velde found himself
in concord with the stylistic devices
of Symbolism, yet his pure Art
Nouveau work retained – in purified
form – a personal stamp. This
becomes clear in the interior design
of the Hôtel Otlet.

craftsman and socialist" in the Maison du Peuple in 1898, the "immediate succesor to Morris".[30] Van de Velde's initial enthusiasm for Morris is clear when one recalls that he selected upholstery by the English artist for his first pieces of furniture. However, he soon replaced this with his own designs, since the Victorian patterns seemed too fragmented. In 1895, van de Velde, the self-taught architect, built himself a refuge in Bloemenwerf House (ill. p. 157) in Uccle, near Brussels, entirely in the manner of the Red House by Morris (1859). Morris had had the latter built, in the face of all conventions, wholly to suit his own ideas and requirements (ill. p. 31). Van de Velde's retreat into a self-inflicted hermit's existence did not last long. His creative ambition sought influence in the external world. Through the activities of the art salon La Toison d'Or, van

de Velde came into contact with Julius Meier-Graefe (the inventor of *Pan*) and Samuel Bing, the "inventor" of Art Nouveau, which was the name of Bing's gallery in Paris. In 1896, van de Velde and four French artist colleagues – Émile Bernard (1868–1941), Maurice Denis (1870–1943), Georges Lemmen (1865–1916), and Paul Elie Ranson (1861–1909) – took on the job of fitting out four rooms at Bing's art dealer's shop. These rooms, with the addition of a rest room, were exhibited at the Dresden arts and crafts exhibition of 1897, as a result of which van de Velde became known internationally. Though these interiors may display weaknesses compared with the perfection of later designs by van de Velde, we already find here an exciting juxtaposition of the two principles of surface and space. In addition, it was the scale of the new

kind of venture that constituted the significance of Bing's initiative: " … it [the salon] corresponded so extraordinarily to an outstanding need that its opening marks a particular date in modern artistic life that will retain its importance. It is the first salon to serve both art and the public at the same time, from a single point of view that cannot be more highly conceived. Bing understood that art belongs in the home, not in large exhibitions …"[31]

The figurative line

The rich variety of artful combinations that characterizes van de Velde's work was a result of its very range. He had proven his skill in handling two-dimensional surfaces, an art he refined in illustrations for the Flemish periodical *Van Nu en Straks* (of which he was cofounder) and posters for exhibitions and advertising purposes. Subsequently, his growing architectural and structural work developed his skills in a third dimension. In his graphics, the rhythm of line served to create atmosphere. In this, van de Velde found himself in accord with the stylistic approach of Symbolism. Nonetheless, his pure Art Nouveau creations (ill. opposite) still carried his individual signature. In the rather plain furniture of the early Belgian style, the elements that were later decisive are already recognizable in the assertion of constructional and ornamental units to make an indivisible whole (ill. p. 156). Like Serrurier-Bovy, he broke up the English box-body furniture concept into structured bars and components. The final conquest of the third dimension by line was achieved by van de Velde in exemplary fashion in a silver candlestick (ill. p. 159), which – previously wrongly dated – was actually made as early as 1898. In his jewelry designs around 1900 (ill. p. 158), spatially hungry line is changed back into dynamic linear ornament. "Inside Belgium, van de Velde, with his particular artistic ambitions, remained an isolated figure. The most successful modern architect at the time was Victor Horta, who only once briefly engaged van de Velde as a collaborator. Less self-assured than this most practised of artists, van de Velde must have felt himself a novice beside him … Berlin presented itself as a welcome escape … It was an almost monitory essay by Julius Meier-Graefe that paved the way for his move. His real career had begun – brilliant, almost extravagant, but no longer so full of the fine scruples as the early, uncommonly honest things had displayed them."[32]

The difference that lies between the new and the naturalistic ornamentation is as large as that between something conscious, something right, and something wrong; between something healthy that gives strength because it is as it should be, and something else that is left to caprice, that somewhere once borrowed a motif from nature but which with the same right could have wanted the opposite; between something in accordance with the effective laws of the harmony of forms and determined by them, and something disorderly, chaotic, that proceeds from the wonderful interconnection of all things with the laws of nature. Anyone who has absorbed these laws and is imbued with the influence of lines on each other cannot feel impartial. As soon as he draws a curve, the one he places opposite it cannot be separated from the concept that lies enclosed in every part of the first; for its part, the second affects the first, changing it, and the first remodels itself in relation to the third and all others that will follow.

All lines from which forms later arise must be brought into such harmony that all effects are calculated and neutralized. This is the task of anyone who takes up the new ornamentation. Everyone knows what the various ridiculous and ridiculed names are that have been given to the new ornamentation; this evening, I can only advise them to call it "natural". … The name does not matter, what matters is that the concept of this ornamentation should be clearly expounded, and the law of conformity will then demand that this ornamentation blend with modern architecture, that is to say, with the architecture that borrows more from the art of the engineers than from that of the contractor, and whose creative basis derives from calculations of the force and its resistance.

Henry van de Velde, inaugural speech at the Royal Academy in Antwerp, 1893.
Published in *L'Art Moderne*, 1893–94.

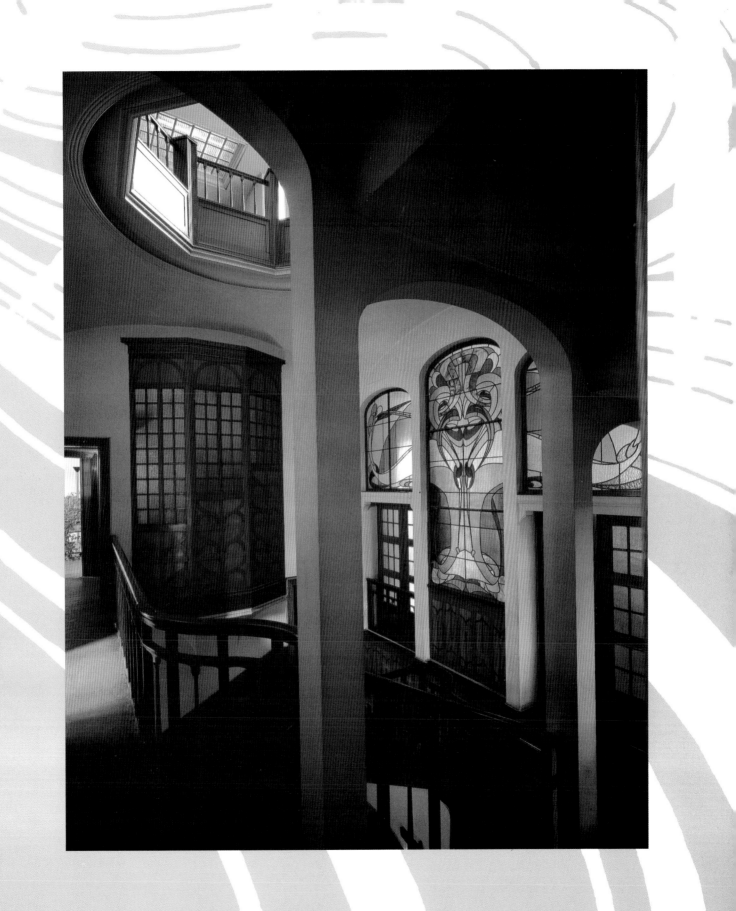

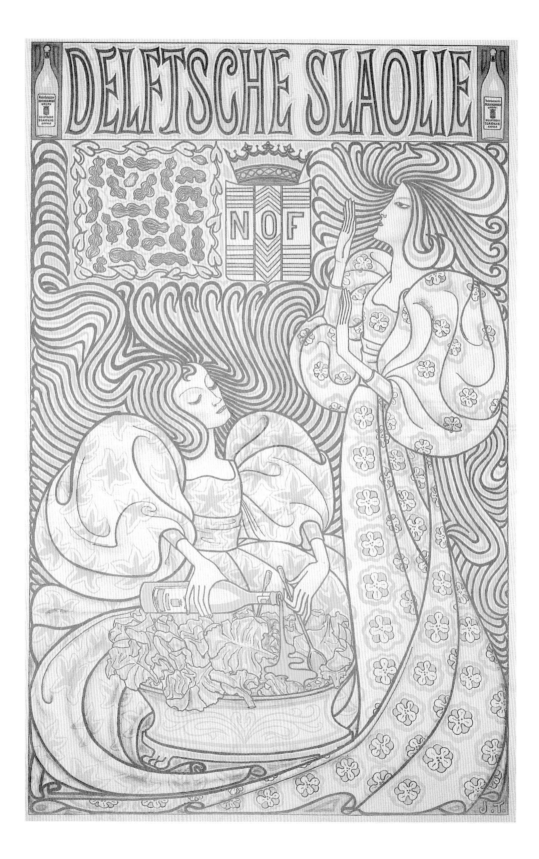

Abstract line and De Stijl
The Netherlands

*The arabesque is, without being capable of precise
explanation, the reflex of a human expression that a
supple imagination has woven into a play of arabesques;
and the effect that this has on the spirit of the beholder
will, I believe, stimulate him to fantasies whose
importance will rise and fall in proportion to his
sensitivity and powers of imagination.*
Odilon Redon[1]

Symbolist arabesques

In the Netherlands, two contrary developments
can be traced around the turn of the century. Both
were aiming at a formal revival, but they could
not have been more different in the character
they took. One school adopted the principle of
Mannerist line; the other manifested an intense
desire for pure form that contained the seeds of
Constructivism.

In Belgium, the Art Nouveau movement crys-
talized primarily in the two centers of Brussels
and Liège. Antwerp took part only peripherally,
but acted as a channel into the Netherlands, to
which it once belonged. Thus, currents of Dutch
art are rooted in Belgian-style Symbolism, but it
was recast with local features. The country had
been closely involved in the development of
modern art through its great artist Vincent van
Gogh (1853–90). The flowing, forceful bundles
of lines that run through his pictures (ill. pp.
14–15) derive from the same energies that
triggered off the arabesque linear gestures of Art
Nouveau. Despite the strict, insensitive Calvinism
of the country, there were forces at work that
were powerful enough to attempt a meaningful,
profoundly emotional experience of the super-
sensory. Whereas, however, the work of van
Gogh is driven to make expressive statements,
the works of the artists of Symbolist mindset

remain firmly in an introverted rhythm of linearity.
Outstanding among Dutch Symbolists is Jan
Toorop (1858–1928), in whose imagination all the
religions of the west and the Far East are fused
into unity. "… touched by the same magic spell
and always as if in a trance – the chalk paintings
of the Dutchman Jan Toorop. Half decorative
wallpaper with endless repetition of the same or
similar elements, half Symbolist representation
of legendary secrets – thin female forms, one,
two, three, six or twelve in a row, all surface and
line, in the same matt color, no light, no shadow,
long-armed, not unlike the spidery shadow-theatre
figures of Indonesia (and certainly indebted to
them as a model), all of them devoured, sur-
rounded, entwined by endless tresses of hair, no
sky or ground, hair above and hair below, hair
even streaming out of bells, trailing up the sides,
spilling out over the edges of the picture, scored
in parallel grooves, occasionally undulating, un-
mindful of the structure of the horizontal and
vertical geometric form. So possessed of his pale
dream figures is this painter that he even con-
secrates Delft Salad Oil, whose manufacturer
commissioned a poster from him (ill. opposite),
with his holy women. Crimped into the ornamen-
tation of their duplicated hair, with exaggeratedly
gothicized, long-fingered hands that protrude
chastely from the huge puffed sleeves like
priceless revelations, they clutch a bottle of oil
and a serving spoon."[2] Toorop's deftly elegant
mastery of symbol-laden arabesques make his
pictures representative of pure Art Nouveau. In
terms of content, they are marked by the tension
between Far Eastern superstition and the
Christian yearning for redemption. Toorop was
born on the island of Java as the son of a Dutch
government official. In the picture of the brides
(ill. p. 65), Javanese influences mingle with

mystic and lyrical components. Beside the inno-
cent human bride in the center, in symmetrical
antithesis, are placed the nun-like bride of Christ
and, thirsting for human sacrifice, the bride of
Satan. These are surrounded by ghostly creatures
derived from Javanese art.

A meeting with Maurice Maeterlinck and Emile
Verhaeren in 1890 made a deep impression on
Toorop's work. As in the literature of Symbolism
generally, fetishism figures largely in the work of
these two poets. Wish-fantasies materialize as
details of the whole, but in such a way as to con-
dense the whole in the detail. A typical fetishist
symbol is long flowing hair, a constantly recurring
feature of Toorop's pictures that also became
virtually a leitmotiv of Art Nouveau in general, as
it had not only symbolic value but suited the
decorative tendency of the style as well. The
strongly expressive linear style of the painter,
graphic artist and craftsman Jan Thorn-Prikker
(1868–1932) opened up new ways from Art
Nouveau into the art of the younger generation
whom he taught. Even more than Toorop, Thorn-
Prikker was a devout Catholic and created a large
number of religious works of art.

Haagsche Plateelbakkerij Rozenburg

Il a taillé, limé, sculpté
Une science d'entêté,
Une science de paroisse,
Sans lumière, ni sans angoisse.
Emile Verhaeren[3]

The elements that were decisive for Toorop in his
work in the fine arts were equally relevant to
applied art, and they lent *fin-de-siècle* Dutch arts
and crafts a wholly individual high-quality tone.
The pots by the designer Jurriaan Kok (1861–
1919) manifest decorative symbolic forms that
also belong to the realm of fetishism. In outline,
such forms take on the shape of stylized female
pudenda, particularly in Art Nouveau book orna-
mentation. Such symbolism was applied most
frequently in the Netherlands – often with erotic
and sexual explicitness (ill. below). In Kok's work,
the contours of the porcelain are linked with the
decoration, which makes use of the whole
palette of flower mysticism (ill. p. 166). Like
silhouettes, the patterns stand out on the sides
of vases like copies from his large collection of
Javanese art. Belgium drew inspiration for its
new art from the colonies, above all the Congo.
The Netherlands enriched its *Nieuwe Stijl* with
imports from Indonesia, which had been colon-
ized way back in 1600. The fantastic mountain
landscapes of the tropical island empire activated
the imaginations of artists as much as the

Anonymous
Brooch, ca. 1910
Silver, bloodstone, diameter 5 cm

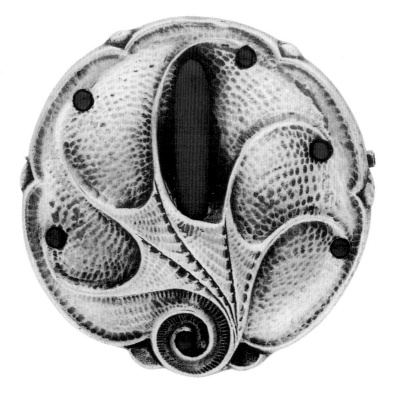

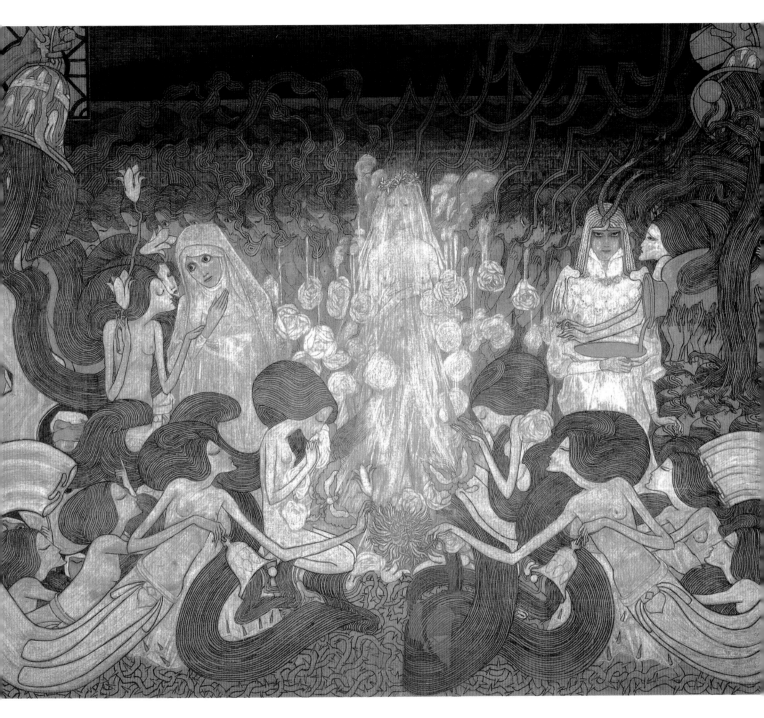

Jan Toorop
The Three Brides, 1893
Chalk on paper, 78 x 98 cm
Kröller-Müller Museum, Otterlo
In Toorop's imagery, religions fuse into unity. On each side of
the innocent human bride, in symmetrical antithesis, are the
nun-like bride of Christ and, thirsting for human sacrifice, the
bride of Satan. They are surrounded by ghostly creatures, in
the manner of Javanese art.

Jurriaan Kok, Haagsche Plateelbakkerij Rozenburg
Coffee pot, ca. 1900
Quasi or eggshell porcelain, color painted, 23 cm high, 15 cm
wide, diameter 15 cm
Painting by Samuel Schellinck
Haags Gemeentemuseum, The Hague
In the Haagschen Plateelbakkerij Rozenburg Jurriaan Kok
found a manufacturer capable of translating his subtle formal
and decorative ideas into reality. After a long search for a
porcelain that would take his unusual designs, in 1899 he
finally succeeded in producing a light, thin-sided frit porcelain
of ivory color and glass-like consistency.

Jurriaan Kok, Haagsche Plateelbakkerij Rozenburg
Vase, 1908
Quasi or eggshell porcelain, color painted, 40.5 cm high
Painting by Samuel Schellinck
Badisches Landesmuseum Karlsruhe, Museum beim
Markt, Angewandte Kunst seit 1900

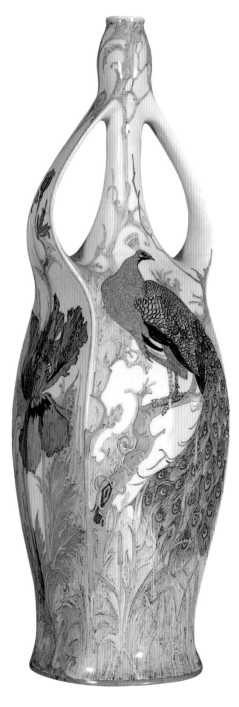

ancient traditions of Javanese craft work (ill. below). The profusion of decorative carvings covering the walls of temple buildings, *Wajang* (the art of the shadow theater) and highly developed batik techniques provided Art Nouveau with a wealth of ornamental patterns. In the Haagsche Plateelbakkerij Rozenburg, Kok found a sympathetic manufacturer who could implement his subtle formal and decorative ideas (ill. opposite). As traditional china clays proved insufficiently flexible for his out-of-the-ordinary concepts of form, Kok, who was director of Rozenburg from 1894, sought the help of the factory's chief chemist M. N. Engelden. The two of them carried out a series of complex experiments to develop a china clay that would suit his unusual designs. By 1899, they managed to produce light, thin-sided frit porcelains of ivory tone and glass-like consistency. The exact composition remains a secret, and is today described as quasi or eggshell porcelain. This stoneware mixture is extremely light. It permits sweeping outlines, curved edges and linear interlacing; it lends

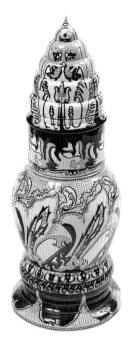

Theodoros Christiaan Adriaan Colenbrander
Haagsche Plateelbakkerij Rozenburg
Lidded vase, 1887
Stoneware, polychromatic underglaze painting, 46 cm high, diameter 17.5 cm
The artistic manager of the Rozenburg factory, the architect Theodoros Christiaan Adriaan Colenbrander, had already introduced light-dark contrast-based ornamentation derived from Javanese batik before Jurriaan Kok came along. However, the vessels are still in the tradition of Dutch cupboard or fireplace decoration.

Dutch East Indies (Indonesia) pavilion, Paris World Exposition 1900
The Netherlands enriched its *Nieuwe Stijl* with imports from Indonesia, which had been colonized back in 1600. The fantastic mountain landscapes of the tropical island empire stirred the imaginations of artists, as did the ancient craft traditions of Java.

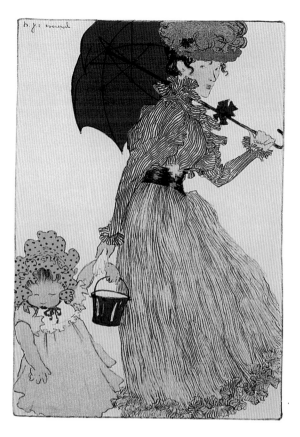

Adolf Le Comte
Delft porcelain tile, 1900
Delft faience, 13.5 cm high
Adolf Le Comte had the knack of
breathing Art Nouveau life into a
traditional pictorial medium with his
depiction of delicate, vulnerable-
looking girl figures that
corresponded to an ideal of the time
– the ideal of a frailty that is both
distressing and moving.

painted surfaces a brilliance. Besides Kok him-self, numerous other designers worked for Rozenburg, following in the path of the *spiritus rector*. Prior to Kok, the factory's architect and artistic director, Theodoros Christiaan Adriaan Colenbrander (1841–1930), had introduced light-dark contrast-based ornamentation derived from Javanese batik. These pots were nonetheless still in the tradition of Dutch cupboard and fireplace decoration (ill. p. 167).

Likewise in the Dutch tradition are artistically designed tiles. Adolf Le Comte (1850–1921) was adept at breathing new, Art Nouveau life into a traditional pictorial medium with his depictions of delicate, seemingly vulnerable girl figures that corresponded to an ideal of the time, of frailty that is both distressing and moving (ill. above).

Circumstances were very different as far as metalwork in the Netherlands was concerned. Here, the output of the English School and Guild of Handicraft found direct successors. In the late

1890s, the elder Frans Zwollo (1872–1945) created large round bowls, principally of beaten brass, and decorated them with geometric orna-mentation in which a closeness to folk art and echoes of theosophical motifs are evident (ill. opposite). A charmingly pretty variant of Benelux Art Nouveau was designed by Henri Evenepoel (1872–99), whose posters combine the extreme detail of Japanese art with French motifs (ill. above). The anti-ornamental school of Art Nouveau was represented by Jan Eissenloeffel (1876–1957) of Amsterdam in his metalwork, who soon gained an immense reputation throughout Europe. Though the gap between the two Dutch styles might seem unbridgeable – one a pro-fusion of ornament, the other purism – they are both an expression of a local artistic impetus that astonishingly manifested itself in the person of Toorop as well, when in later years he created artworks for buildings by Hendrik Petrus Berlage.

Henri Evenepoel
To the Square, 1897
Color lithography, 34.4 x 24.5 cm
Evenepoel's posters combine the
extreme detail of Japanese art with
French motifs.

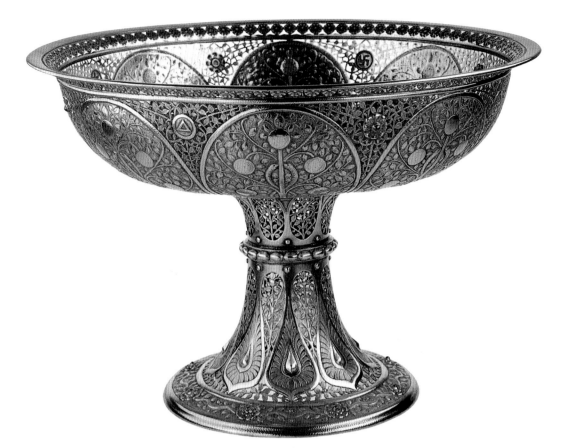

Frans Zwollo senior,
Frans Zwollo junior
Fruit bowl
According to the inscription, this
was commissioned by Mr. G. J.
Verburgt, 1923/24 (reproduction
after the original by Frans Zwollo
senior, 1902)
Silver, gilt, sapphires, 21 cm high
Bowl: diameter 31.3 cm
Base: diameter 16.2 cm
Haags Gemeentemuseum, The
Hague

The non-curving line – Abstraction

*The decoration and function of an object stand once and
for all in conflict. Commonly used objects are, accordingly,
still undecorated these days, even in the hand of the
artistically minded. Only artists are greedily on the
lookout to "beautify" everything. It is the monumental
error of the new Arts and Crafts Movement – on which it
has already foundered or will founder – that it wants to
decorate everything ...*
Cornelius Gurlitt[4]

The "style" of circa 1900 lived off a formal vocab-
ulary of curved plant and rationally rectilinear
shapes. The latter gave rise to an ascetic painting
style shortly before the First World War that
retained only the purity of geometric abstraction.
This constructivist art freed itself of figures but
nevertheless looked back to predecessors in
figurative art. The Dutch De Stijl group around
Piet Mondrian (1872–1944) (ill. p. 175) and Theo
van Doesburg (1883–1931) declared its goal to
be "a balanced relationship between the univer-
sal and the individual" (First Manifesto, 1918).[5]
That went for the participants themselves as
well – painters, sculptors, architects, and writers

all worked together. The artists of this movement
sought a harmonic balance of life through
abstraction and the reduction of colors and forms
in art and design. It was no accident that De Stijl
was formed in the Netherlands; this was not only
where their predecessors were, this was where
the main concerns of the group had already been
formulated in the works of Hendrik Petrus
Berlage and Jan Eissenloeffel. The silversmith
Eissenloeffel had already trained as a draughts-
man before he entered the silverware workshop
of W. Hoeker in Amsterdam in 1896. In the same
year, he took over the management of the metals
department of the Dutch firm Amstelhoek. A
study tour to Vienna acquainted him with the
"Quadratl-Stil" [rectangle style] of Josef Hoffmann,
for which he long retained his enthusiasm. He
found another congenial community of artists
later in the Wiener Werkstätte. In 1900 he spent
a year in Russia, where he studied the craft skills
of Fabergé and refined his enamel technique. An
elegant coffee service (ill. p. 170) won him a gold
medal at the World Exposition in Turin in 1902,
and this was followed by countless international

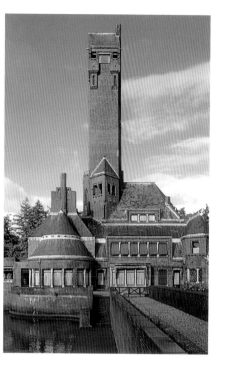

Hendrik Petrus Berlage
Hunting lodge, Otterlo, 1914
and 1920
The striking corner tower of the
Amsterdam Exchange is, as here in
the hunting lodge of the Art
Nouveau patron Kröller-Müller in
Otterlo, a feature of a number of
buildings by Berlage. The towers
attain the same degree of simplicity
of architecture as the other
components, and again the retreating
surface is taken sculpturally into the
corners to avoid "deconstructive"
transitions. The soaring component
of towers as architectural gestures of
almost symbolic meaning occurs in
the work of many Art Nouveau
architects. Those that come to mind
include the Wedding Tower by
Joseph Maria Olbrich or the railway
station by Eliel Saarinen in
Helsinki, which leads on in an
almost direct line to American
skyscraper architecture.

awards. In the new century, Eissenloeffel
worked increasingly with base metals, preferring
brass and copper. He made plain, solid, practical
utensils that are articulated mostly only with
grooves and shaped in basic geometric forms.
The functional designs of his bowls, pots, and jars
became models for modern household utensils
(ill. opposite). At the same time Eissenloeffel
provided a convincing demonstration that strict
form and elegance are not mutually exclusive,
and that an ornamentally severe style can have
the same stimulating effect as a complicated
floral ornamental design. One might be tempted
to see him as an outsider of Art Nouveau art, but
it is precisely in his designs that the concern of
his period for the proper use of materials and for
surface art is put into effect. Eissenloeffel was
recognized as an outstanding craftsman not only
in the Netherlands but also internationally. In
1908, he was called to the Vereinigten Werk-
stätten für Kunst (United Workshops for Art) in
Munich, where he worked until 1909. Like
almost all Dutch artists, he collaborated with the
architect and designer Berlage.

Jan Eissenloeffel
Coffee service, ca. 1900
Silver
Coffee pot: 14.2 cm high, 20.5 cm
wide, diameter 11.5 cm
Haags Gemeentemuseum,
The Hague

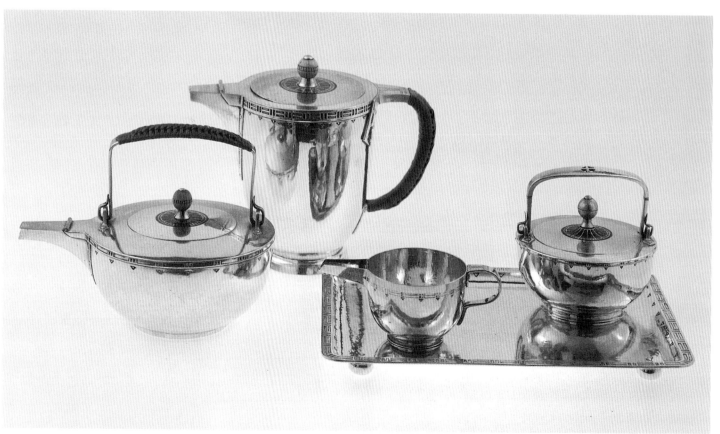

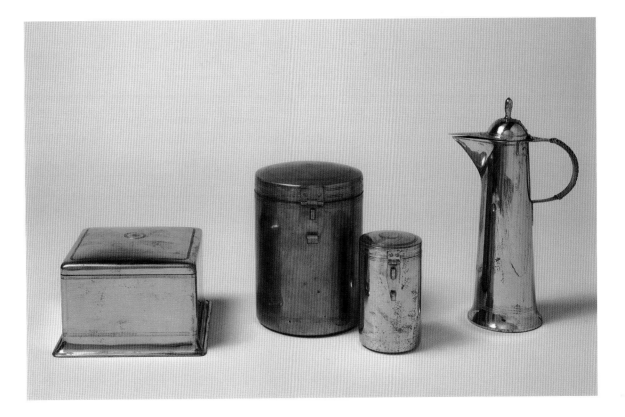

Hendrik Petrus Berlage –
The new architecture

So what is it about, then? It is about having a style again. Not just my kingdom but Heaven for a style! that is a cry of despair – that is the great lost fortune. Illusion/art rules, i.e., to fight the lie, to have the essence, not the illusion.
Hendrik Petrus Berlage[6]

Hendrik Petrus Berlage (1856–1934) studied architecture in Zurich, at the very polytechnic where Gottfried Semper (1803–79) taught from the founding of the institute in 1855 to 1871. As Berlage attended the college from 1875 to 1878, one may consider him at best as a pupil of Semper "once removed". Even so, Semper is one of the two masters that influenced him most. (The other was – as with the Belgian Victor Horta – Eugène Emmanuel Viollet-le-Duc.) Semper's main theoretical work was *Der Stil in den technischen und tektonischen Künsten 1860–63* [Style in the Technical and Architectural Arts, 1860–63], in which he expounds a practical aestheticism that does not start from the history of stylistic forms, as had happened hitherto, but from technical developments. This work had a formative effect on Berlage. Semper represen-

ted the view that craftsmen and architects should use materials in a manner appropriate to them. This is why, for example, he rejected Thonet's technique of bending wood – that was not appropriate to wood, that was treating it like metal. As a counter-example, he cited Egyptian seating. Here, he said, the frame was built right-angled, that is, constructively, "in the nature of timber", while the seat was inserted in this structural frame at an angle, occasionally even curved. Berlage followed this doctrine in his own furniture, tautly articulating it in the service of functional excellence (ill. p. 174). With this philosophy, he exercised a powerful influence on local furniture designers, who, deferring to the proclaimed appropriateness of materials, showed a penchant for "natural" woods. In respect of ornamentation, their designs are sober and uncompromising. In 1900, the furniture business 't Binnenhuis Inrichting tot Meubileering en Versiering der Woning (ill. p. 174) was set up with the aim of promoting the new style and binding various working artists to it in the quest for a synthesis of the arts. In pursuit of this pro-position, the business offered comprehensively designed interiors in its showroom, among others

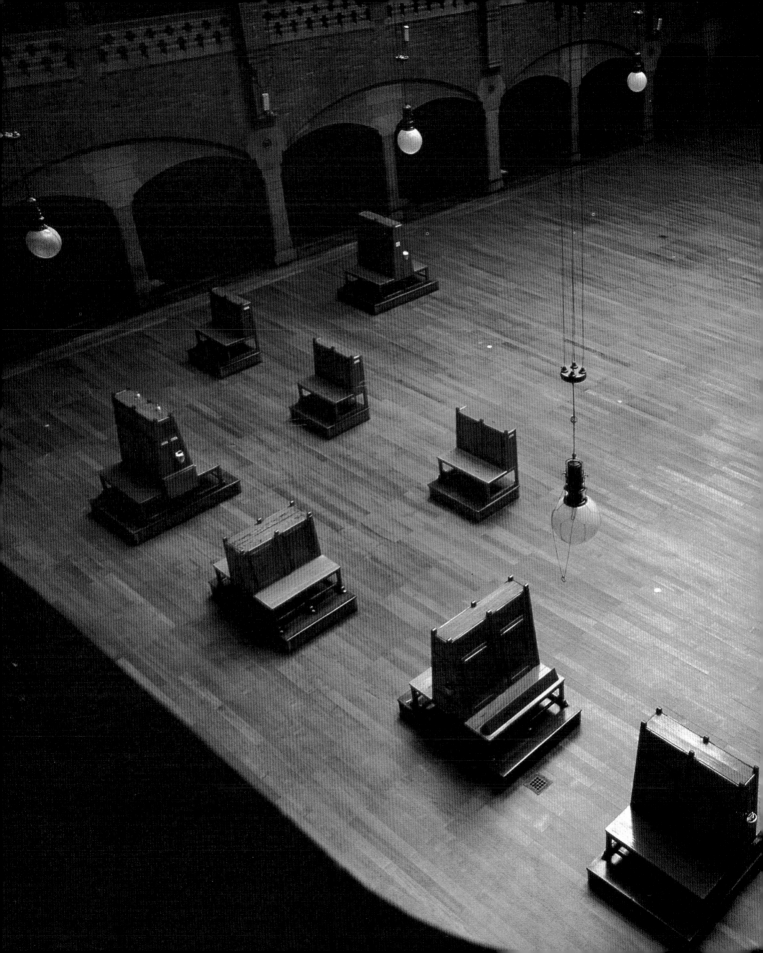

Jacob van den Bosch
Chair, Opus 41, 1900–01
Oak, brass castors, upholstery in
imitation leather, 101 cm high,
75 cm wide

Hendrik Petrus Berlage
Buffet cupboard, 1898
Oak, 260 x 260 x 70 cm
Haags Gemeentemuseum,
The Hague
Gottfried Semper, the great
intellectual mentor of Berlage, held
the view that craftsmen and
architects should use each material in
a way appropriate to it. He therefore
rejected, for example, Thonet's
technique of bending wood. That
was not right for wood, that was
treating it like metal. As a counter-
example, he cited Egyptian seating.
Here, he said, the frame was built
right-angled, that is, constructively,
"in the nature of timber", while the
seat was inserted in this structural
frame at an angle or even curved. In
his own furniture, Berlage followed
this doctrine.

Previous pages:
Hendrik Petrus Berlage
Commodity Exchange, Great
Chamber, Amsterdam Exchange,
Amsterdam, 1896–1903
The clear, consistent constructional
simplicity of the building is
maintained in the furnishing. Every
detail serves to articulate the
architectural principles of Berlage.

by van de Velde, Eissenloeffel, Berlage and Jacob van den Bosch (1868–1948), a designer and member of the management (ill. p. 163 and above).

The second great influence on Berlage was Viollet-le-Duc. The latter's insistence on the primacy of construction in architecture can be traced in many buildings by Berlage, but especially in the Amsterdam Exchange. It is revealing that Berlage replaces the word "logical" in Viollet-le-Duc's writing by "functional" in respect of himself.

Berlage gained the commission for the Amsterdam Exchange, now considered his masterpiece, after a number of (unsuccessful) entries in competitions. The block design, which pulls together the individual components in surface tensions, lays the construction open to view. The individual parts do not break with tradition completely but interpret it in the context of the construction. What Berlage wanted above all was honest architecture, "honest" in the sense of social functionality and openness of design. "The main chamber is a very impressive space … (ill. pp. 172–173). Note for example the columns in the ground floor arcade of the Commodity Exchange. They are in reality not columns but pillars rounded off at the corners. The wall surface would have met a column only tangentially. That was not enough for Berlage. In

his design, the wall surface is continued as part of the surface of the pillar. And now observe with what sculptural precision the resulting problems for the transition to the base and capital are solved – if one may even term them thus! These are no frivolous matters for an architect with a gift for architectural sculpture. Each of his constructional components cut from ashlar manifests a principle, one could say. One could say it is all wall. That is why it is so appropriate that Berlage attempts to introduce metal construction into such a context. This is of course a bold venture, and I should first like to demonstrate that with a small example. You can see here short ceiling bearers made of steel that rest on the walls and support shallow barrel vaults made of brick. That fits together very well. The matter becomes more problematic when it concerns lattice girders spanning the large chamber. Berlage employs several devices to make this leap plausible: in one case, it is ornament on the rivets in the rising part of the main truss just before the bifurcation … finally, reinforcement of the wall under every truss … The ashlar block carries the joint on which the base of the framework is mounted … This is how Berlage brings off the difficult transition from the wall to the lattice girder, which is at the same time the transition from the large mass of the walls and

't Binnenhuis, Amsterdam
Invoice
Reproduction
The firm of 't Binnenhuis Inrichting
tot Meubileering en Versiering der
Woning was established in 1900 in
Amsterdam with the purpose of
promoting the new style and
bringing together various artists in
pursuit of a synthesis of the arts.

the glass roof of the hall."[7] The clear and consistent constructional simplicity is continued in the furnishing of the Exchange. Every detail serves to demonstrate Berlage's principles. The striking corner tower of the Exchange is a feature that occurs in several of Berlage's buildings (ill. p. 170). The towers achieve the same degree of simplicity of architecture as the other building components, and again the retreating surface is linked sculpturally to the corners to avoid "deconstructive" transitions. The tower as an architectural gesture of almost symbolic intent is found with many Art Nouveau artists. We may recall the Wedding Tower by Joseph Maria Olbrich (ill. p. 237) or Eliel Saarinen's railway station in Helsinki (ill. p. 302), which leads on almost directly to American skyscraper architecture.

De Stijl – Concrete art

Art will disappear to the extent that life itself gains balance.
Piet Mondrian[8]

Likewise numerous were the threads that led on from Berlage to the 1920s, not only to the structures of the New Functionalism and Expressionism but also straight (in the figurative sense) to the pictorial works and objects of the Constructivists, who – and this cannot be overemphasized – also once trod a linear, organic path before pure form arose. De Stijl went in two directions, pursuing either the purity of everyday objects or the purity of pure illustrative models. Van Doesburg described this in terms of climate: "The studio of a modern painter should have the atmosphere of 3,000 meters up in the mountains of external snow; cold kills germs."[9] Gerrit Thomas Rietveld's Red and Blue Chair (ill. p. 177) is acclaimed as the manifesto of pure utilitarian objects, and indeed the cradle of De Stijl in general – clear proof that Art Nouveau in all its facets cannot be treated in terms of formal criteria alone but as a fundamental movement of the "for and against" about 1900, which in its effect remained of centennial significance. The puritanical zeal with which the principles of contemporary art were elaborated is set against Art Nouveau only in the external result. The complete working out of individual existence through style alienates from life to the same extent as Concrete Art or Suprematism.

"'Banishing man from art', against which a sagacious philosophical writer of our time (José Ortega y Gasset) has argued, targeting first and

foremost all varieties of 'abstract' art – banishing man from art is no more than the flipside of banishing man into art. Into 'art' or into the 'realm of art' is ultimately into ornamentation. And from our point of view at least, it was introduced by Art Nouveau."[10]

The 19th century was the century of ugliness; our grandparents, parents and we ourselves lived and still live in an environment that is uglier than any before. Let us look around with sober gaze; and if we compare everything with things from earlier times, we come to the conclusion that nothing, but also nothing of everything that our parents and we ourselves commonly use, can be called beautiful, and that what still looks pretty usually dates back to an earlier century.

If we look at the interiors of our homes, we absolutely shudder at the junk we call household equipment.

No chair, no table, no pot but that it only partially satisfies; and the only reason we are not vexed to the point of despair is that human beings unfortunately, or rather fortunately, get used to everything.

If we consider the homes themselves, speculation building – that mass production of the worst sort, against which a single tolerable house by an architect cannot prevail in isolation – has created a type that has probably nothing left in it that one generally calls architecture ...

Rational construction can form the basis of a new art; when that principle is not only adequately instilled but is also generally applied as well, only then will we stand at the portals of a new art, in the moment when the new cosmic feeling, the social equality of all mankind will be manifested, a cosmic feeling not with its ideal rooted in the hereafter, i.e. not in that sense religious, but with an ideal of this world, and so contrasting with it; ... Then art will once again have a spiritual basis that it needs in order to be able to manifest itself as a fully conscious utterance of this cosmic feeling ...

Hendrik Petrus Berlage, *Gedanken über den Stil in der Baukunst* [Thoughts on Style in Architecture], Leipzig, 1905

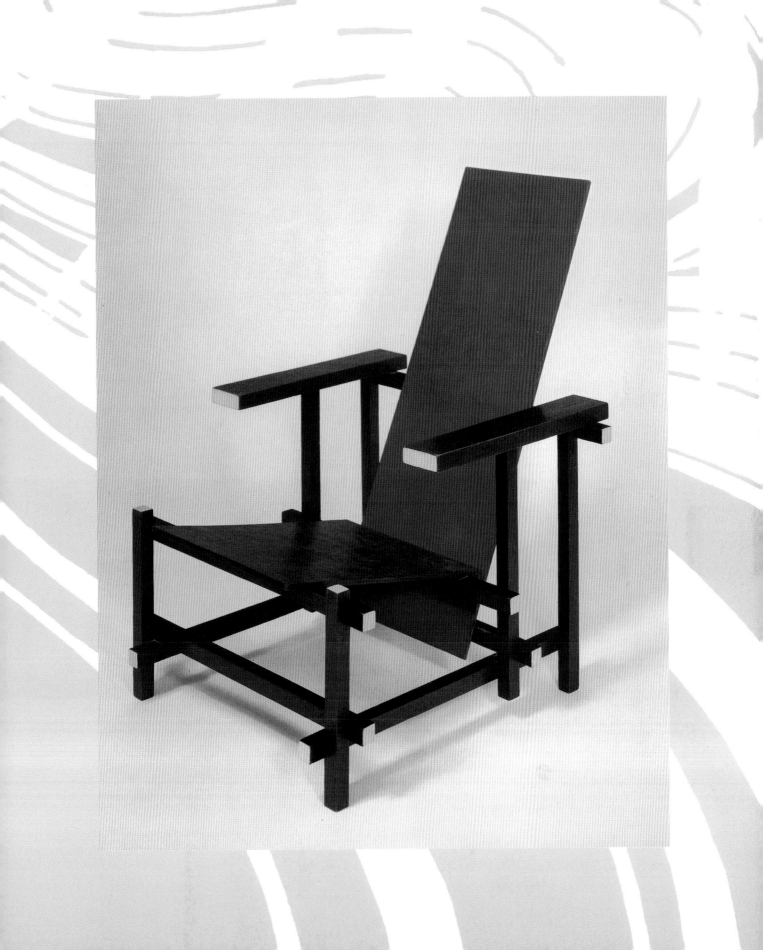

A step into the future
Italy and Russia

Richard-Ginori
Società Ceramica Italiana,
Milan, 1902
Coffee cup, 1902
Design drawing, watercolor,
16.5 x 12.5 cm
Museo della Porcellane di Doccia
Fiorentino
Richard-Ginori, a stoneware factory
with rich traditions, traded from
1896 under the name "Società
Ceramica Italiana". Its products
combined floral motifs with Tuscan
coloring.

Art! Art! That was the faithful, ever-youthful, immortal beloved, that was the source of pure delight, denied to most, reserved for the elite, that was the sumptuous food that made man godlike. How could he have drunk from other cups after putting this one to his mouth.
Gabriele D'Annunzio[1]

Neither Italy nor Russia were protagonists in the splendidly colorful drama "Art circa 1900", but in the final act both supernumaries were drawn into the limelight. To the last decade of this century, the Italian "Stile Liberty" and the Russian "Little Merchant Palaces" style have remained entertaining, sometimes autonomous interpretations of pan-European trends. We do not find a zeal for reform and full-bodied theories that the period has bequeathed us. Art Nouveau remained just an episode in both countries; energies were building up, in order to launch themselves in a sudden, unanticipated bolt from the blue as Futurism and Suprematism. Abstraction in Italy and Russia was not achieved by purifying an ornamental style. It was conceived as a singular act, carried forward by the dynamics of its inherent vision. The floral sumptuousness of architecture around the turn of the century, meanwhile, waxed into a wedding-cake building style of totalitarian pomp. These are the features that allow common treatment of otherwise divergent nations.

Italy

Expositions, the total art shows – Turin 1902

The world expositions of the 19th century were magnificent self-portrayals of economic prosperity and national yearnings for admiration. They offered, in an international context, a balance between what existed and was available on the one hand and what was wanted or hoped for on the other. From washbasins to looms, lawnmowers to adding machines, in short, from everyday articles to political models, thousands of objects were arrayed in a far-shining panorama of a world that was represented as desirable. At the same time, for artists fed up with the old clichés, they served as a cache of overseas crafts skills. Without question, expositions came into fashion reinforced. The establishment of artists' and craft workshop associations that were soon on the agenda around 1900 fueled the urge to communicate the new feeling and creativity. The term international Art Nouveau is often used because the individual Secessions, Écoles, Guilds and Schools carried on a lively interchange of ideas amongst themselves, mostly via exhibitions. In this context, Turin 1902 acted like a drum roll for expositions. For the first time, this great display of handicrafts brought together the entire creative forces of the *fin-de-siècle*. Participating countries at "Torino 1902 – Le Arti Decorative Internazionali Del Nuovo Secolo" were Austria, Belgium, Denmark, England, France, Germany, Hungary, Italy, the Netherlands, Norway, Scotland, Sweden, and the USA. It was an overwhelming performance that transformed the position of Italy, which had up to then stood rather aloof, into a focal point of international artistic forces. The Venice Biennale, which had

Raimondo D'Aronco
Gallerìa Degli Ambiènti
Front, Turin 1902
Contemporary photograph,
28.5 x 23 cm
Gallery of Modern Art, Udine

been founded in 1897, continues the tradition to this day. "A ghastly hubbub and yet a great act of culture, inundated with humbug and barefaced braggadocio and yet a serious testimonial, a magnificent statement of the immense progress made by humanity. ... This is the first impression of the international exposition. After several visits, the spectator who came not just to gawp begins to shake off and try to forget the rackety impression, and to a certain extent he can succeed. The question arises whether one could not do without the ballast, whether an exhibition could not be put on without all this carry-on, without these attractions for the gawper, that flatter his idle curiosity. We think this is not possible, and even if it were possible, the result would be still more braggadocio. For the truth is, all the culture on show is underpinned by capitalism, and capitalism is again inconceivable without brutal competition, glittering trumpery and deceit, everything that, taken together, makes up the fun of the fair. ... And yet the triumph of modern arts and crafts is the triumph of art over machines, over big industry, which now must serve it, and with that the triumph of man over machine is certain. Machine-based industry kills beauty, Ruskin rightly observes, and as a sociologist he adds: 'This same industry has turned us all today into machines, intellectual cripples, each of whom is a *specialist* ...' "[2]

Magic of the Orient – D'Aronco and the Bugattis

La splendeur orientale,
Tout y parlerait
A l'âme en secret
Sa douce langue natale.
Charles Baudelaire[3]

Undoubtedly Ruskin would have delighted in the diversity of the pavilions of so many countries in Turin. Less delighted were the critics, both local and international, over the official exhibition buildings erected by Italian architects: "... uno stile uniforme, che non è altro che lo stile austro-tedesco."[4] Raimondo D'Aronco (1857–1932) had emerged as victor in the competition for the construction of the main pavilion for the Turin exposition. The influence of the buildings of the Viennese architect Joseph Maria Olbrich and the Darmstadt artists' colony can clearly be discerned in his style, which is nonetheless rich in individual touches derived from his encounter with the Orient (ill. p. 179). Already successful as an architect, D'Aronco took part in the national

exhibition in 1891 in Palermo where, thanks to his enthusiasm for Ottoman art, he came to meet the Turkish Sultan, Abdul Hamid. On the strength of D'Aronco's ambitious work, the Sultan summoned the Italian to his court. In June 1893, the new favorite of the cosmopolitan Ottoman ruler arrived in Constantinople (today Istanbul) and succumbed completely to its *splendeur orientale*. He took on numerous building commissions, and his work skillfully combined the essence of Arab architecture with components from European Art Nouveau. D'Aronco threw himself enthusiastically into the restoration work on Hagia Sophia and the repairs on the Great Bazaar. With such commissions under his belt, in 1899 he turned next to making good various sites of destruction left by an earthquake in the Bosphorus area, which he filled with buildings in a neo-Oriental *Stile floreale*. In D'Aronco, this mix of cultures does not result in an exotic fairy-tale architecture but in an extravagant style that occupies a wholly individual position in architectural history. The architect returned home to undertake the pantheon of the Turin Exposition, the Rotonda d'Onore, with a design that displays all the features of *fin-de-siècle* art – a successful fusion of adapted elements reformulated in a new style. The drum and tall, light dome are reminiscent of Hagia Sophia, while the rich, painted ornamentation recalls Byzantine models combined with the cheerful lightness of Olbrich's Secession buildings (ill. opposite).

In a review of the Turin Exposition in the

Carlo Bugatti
Bench, ca. 1900
Wood, vellum, inlays of brass and white metal, beaten brass, painted decoration, tassels, 151 x 246 x 59 cm
A completely circular doorway led into one pavilion at the Turin Exposition that was without parallel. Inside, an astonishing assembly of beaten metal, repoussé leather, tattooed vellum and fine silver inlays exuded a strange, sensuous magic, further reinforced by the brown, gold, and silver tones of paint. The ornamental fantasies of Bugatti are in no way copies or adaptations but creations in the Art Nouveau sense of turning everything into a work of art.

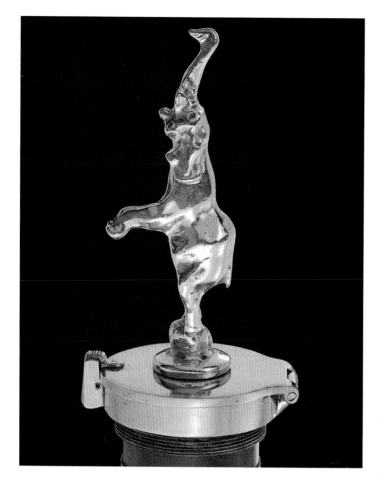

Rembrandt Bugatti
Trained Elephant, radiator cap figure of the Bugatti Royale automobile, 1928 (a slightly modified version of the 1908 sculpture *Eléphant dressé jouant*)
Cast silver, 19 cm high
Schlumpf Collection, Musée National de l'Automobile de Mulhouse
A joint masterpiece of the Bugatti family was the Bugatti Royale automobile, constructed by Ettore – the eldest son of Carlo – and his son Jean. It carried a small elephant figure by Rembrandt on the radiator cap. Between them, the Bugatti family thus reflect a substantial segment of Italian art history. In 1909, Marinetti wrote in the founding manifesto of Futurism: "A racing car whose bodywork is decorated with great pipes resembling snakes with explosive breath, ... a screeching car that seems to run on case shot, is more beautiful than the *Nike* from Samothrace." (see note 5)

Viennese periodical *Neue Freie Presse*, the critical observation is made that Italian arts and crafts resembles too much the gay coat of the harlequin, and it was no compensation that this coat was sometimes of superb cut and first-class workmanship. Only in the characteristics of individual exhibitors does a more thoughtful patterning occur, such as in the furnishings of Carlo Bugatti.

Bugatti's circular doorway led into a pavilion without parallel at the 1902 Exposition. Inside, an astonishing assembly of beaten metal, repoussé leather, tattooed vellum, and fine silver inlays exuded a strange sensuous magic, further reinforced by painted tones of brown, gold, and silver. The creator of this Oriental romanticism undoubtedly met all the criteria of the competition. According to the rules, any works that in any way copied or took over previous styles were disqualified. The ornamental fantasies of Bugatti (1856–1940) are in no way copies or adaptations but creations in the Art Nouveau sense of turning

everything into a work of art. Of course, influences can be traced, as in the international Art Nouveau movement generally – especially those of Joseph Maria Olbrich. Like the latter, Bugatti monumentalized objects into sculptural, architectural creations (ill. p. 180). Added to this were Turkish, Arab, and Egyptian elements (ills. p. 181 and opposite) that had, as befitted the times, a pragmatic background. The firm of Bugatti had business connections with architects from the Islamic world, and had made furniture for, among others, the Constantinople villa of the Khedive's mother (the Khedive was the former Viceroy of Egypt). Echoes of craft traditions led the Art Nouveau artist not just to his own national past but also to non-European models. Exquisite examples of handcrafted work from north Africa and Asia Minor such as tiles from Iznik had been familiar in Europe since 1867, thanks to the great world expositions. Indeed, neo-Egyptian fashions had been popular since Napoleon's campaign, and experienced a revival during the construction of the Suez Canal, which was finally commissioned in November 1869. Later still, the same trend inspired Bugatti to create a series of furniture designs featuring Oriental tassels and asymmetrical minarets for bordering. Symbolism, with its predilection for an almost sultry atmosphere, went one better – we have only to recall Louis Majorelle's *Nénuphars* furniture (ills. p. 107, 119).

Before Bugatti moved to Paris in 1904, he had already organized an extensive furniture production business in Milan, which gained international recognition. His chairs may strike one as fanciful, but they sold like hot cakes. Likewise the tables with ornamental bases and the outlandish screens, the favorite furniture of Art Nouveau. The furniture exhibited in Turin in 1902 was already more strongly marked by rounded, Cubist forms, though without forgoing the unusual materials and ornamentation. The furnishing objects of the Italian designer Eugenio Quarti (1867–1929) were created in the same decorative spirit (ill. p. 184).

As an artistic family, the Bugattis can be traced back to the 15th century, but by 1900 they had become an artistic dynasty. A brother-in-law of Carlo Bugatti was the famous painter Giovanni Segantini (1858–99). His son Rembrandt (1884–1916) was celebrated for his small-scale animal sculptures made of bronze, which he designed in the tradition of the miniature sculptures so esteemed by Art Nouveau. Rembrandt Bugatti worked direct from nature, mostly at the zoos of Paris and Amsterdam. The figures were fash-

Carlo Bugatti
Folding screen, ca. 1900
Wooden panels, vellum, inlays of pewter and brass, hammered copper, tassels, central panel 212 x 51 cm

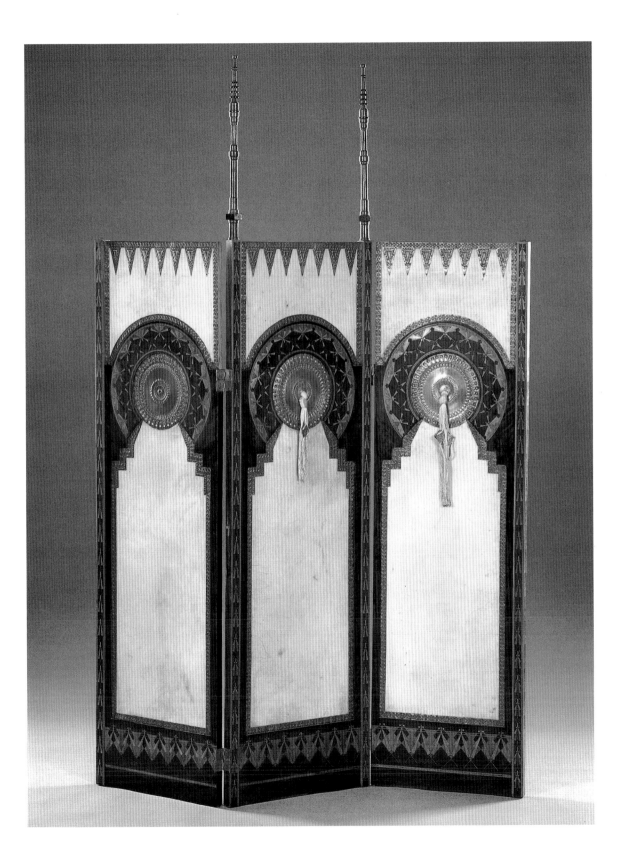

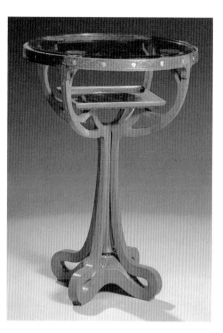

Eugenio Quarti
Occasional table, overall view
(above) and view of table top
(below), ca. 1900
Wood, glass, brass, inlays of brass
and abalone, 70 cm high
Quarti's furnishings are conceived
in a decorative spirit that insisted
on unusual materials and
ornamentation.

ioned as vividly as possible, but the execution was much more impressionistic than naturalistic. A later joint masterpiece by the family was the Bugatti Royale automobile, constructed by Ettore (1882–1947), the eldest son of Carlo, and his son Jean (1909–39), which carried an elephant figure by Rembrandt on the radiator cap (ill. p. 182). The Bugatti family thus reflect a substantial portion of Italian art history. In 1909, Emilio Filippo Tommaso Marinetti (1876–1944) wrote in the founding manifesto of Futurism: "A racing car whose bodywork is decorated with great pipes resembling snakes with explosive breath … a screeching car that seems to run on case shot, is more beautiful than the *Nike* from Samothrace."[5] The Futurists wanted to set everything in motion. As "hieroglyphs", they used zigzag and wavy-line motifs which are as much part of Cubist vocabulary as of Art Nouveau (ill. p. 193).

Cult of Eros and beauty – Gabriele D'Annunzio

Artificial, like worlds carved in
Marble and gold, chimerical spaces ...
Gustave Moreau[6]

The cross-connections and also the dissonances of artistic endeavor in Europe – as in America – around the turn of the century count as one of the most interesting aspects of Art Nouveau. A large number of the artistic products constitute a virtual encyclopedia of decadence and Symbolism, stamped with the handwriting of each country. This Symbolism was a sensuously extravagant, ecstatic art whose representatives, though they followed no program, were bound by a common philosophy of life. Their aversion to the progress-worshiping positivism of the older generation amounted almost to open contempt. They saw its mass-educational optimism as heading for mediocrity. The artificial paradises created by the aesthetes as a countermeasure to the decline of culture and transformed into poetry by Baudelaire were translated by Gabriele D'Annunzio (1863–1938) into reality. Beauty was for him not just an unworldly artificiality. His Italian vitality saved him from copying the example of Des Esseintes, the hero of the Art Nouveau cult novel *A rebours*, and withdrawing into a morbid private pleasure world. D'Annunzio was Narcissus incarnate, living in style-conscious self-love, a genius of literary productivity and eroticism. His cult of Eros and beauty was in keeping with *fin-de-siècle* art. The ambivalent female type of his poetry fulfilled the Symbolist ideal of the *femme fatale*, made flesh in the Eves, Salomes, and Judiths of the art of the period. He looked on his work as a *Gesamtkunstwerk*, a synthesis of the arts, and built himself a villa as a monument to Decadent taste, filled with all the lofty *bric-à-brac* of the era. Whereas the Viennese playwright Hugo von Hofmannsthal was a great admirer of D'Annunzio, the German novelist Thomas Mann thought it necessary to warn his brother Heinrich against the "bellows poetry that has been imported from the lovely country of Italy in the last few years" and the "lush aestheticism of the Latinist D'Annunzio, the rank aestheticism of an ambitious wallower in words."[7] Decadence simply does not appeal to the German psyche. In contrast, the Irishman James Joyce envied D'Annunzio his "linguistic artistry" and his "sensuous love of words, that provided an inextinguishable delight for anyone who heard or read them."[8]

Galileo Chini
Vase, ca. 1900
Majolica, underglaze painting, 45 cm high
International Ceramics Museum, Faenza
Base diameter 14 cm, neck diameter 11.5 cm
Execution by L'Arte della Ceramica, Florence
An unmistakable embodiment of the *arte nuova*, the new art,
is Galileo Chini's Arte della Ceramica factory in Florence.

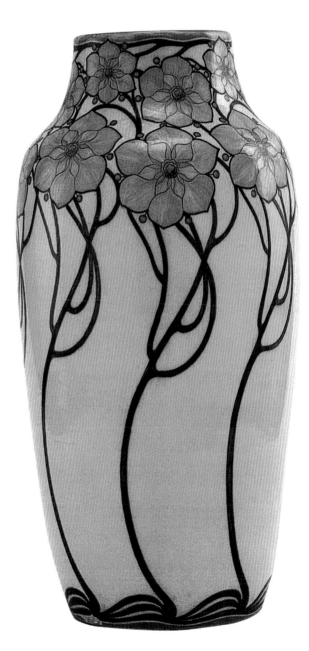

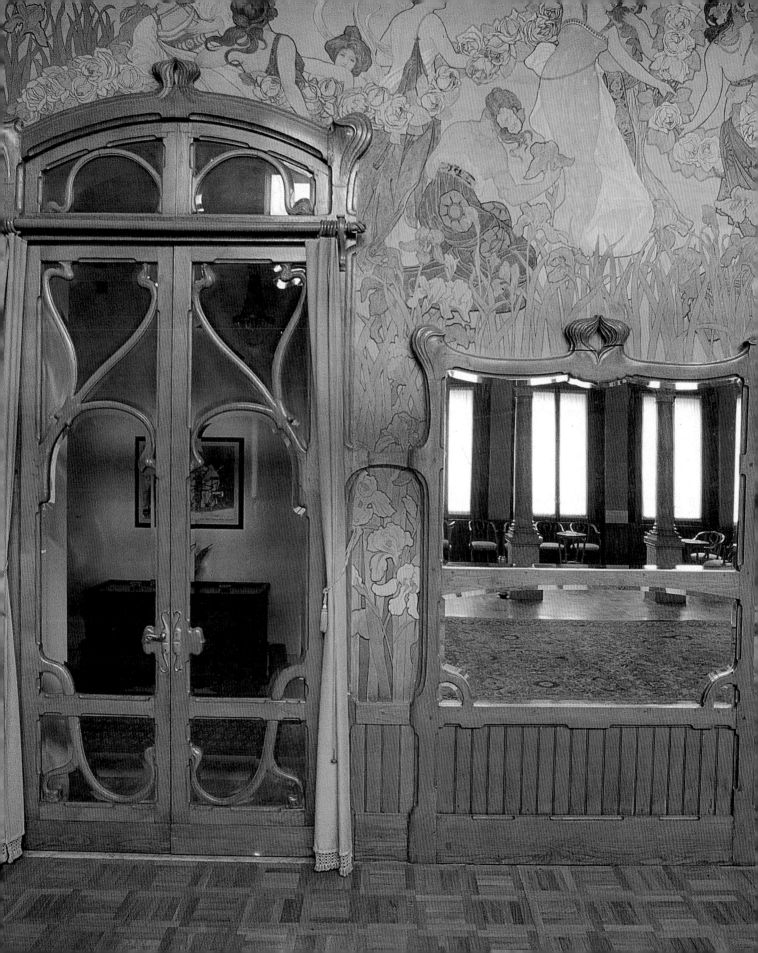

Redundancy and architecture

"The marvelous sensual revelry of Baroque susceptibilities also set the parameters for a definitive version of Italian Art Nouveau."[9] Many architects of the period combined their Baroque inheritance with modern building materials, bringing a cascading, opulent architecture without compare. The buildings of Giuseppe Sommaruga (1867–1917) – for example, his Palazzo Castiglioni in Milan – have a Baroque sumptuousness whose sense of drama recalls the operas of Verdi or Puccini. Less histrionic are the mansions by Giuseppe Brega (1877–1929), which have a more floral charm, as for example the Villa Ruggeri in Pesaro shows (ill. p. 189). On closer inspection, it is not difficult to make out Italian tradition and Italian heritage under the amorphous ornamental overlay of its facade. Brega endowed the eastern wall of the house with two eye-like windows, a flowery element made of reinforced concrete that resembles a nose and an entrance doorway shaped like a mouth – all of which reminds one of the vegetable portraits of Giuseppe Arcimboldo (ca. 1527–93). Closest to D'Annunzio's approach are the "creations" of Giovanni Michelazzi (buildings from 1902), which seem like private obsessions made public. A further important figure in the Italian architectural landscape is Ernesto Basile (1857–1932), who was considered one of the most influential representatives of the Stile Liberty and devoted

as much attention to the interiors as to the buildings themselves (ill. opposite). There are unmistakable French influences in his work – soft, elegant forms and a symbiosis of painting and decoration brilliantly handled. An early follower of Sommaruga's style was the young Giulio Ulisse Arata (1881–1962), but in later years he joined forces with Antonio Sant'Elia, the inspired city planner, and other architects to form the Nueve Tendenze group. Besides the buildings of this group, which thanks to Sant'Elia represented a progressive style, there were examples of graceful Art Nouveau architecture not just in Milan but in almost all Italian towns (ill. p. 188).

Stile Liberty – Futurism

Dynamic arabesques as the only reality created by the artist in the depths of his sensibility.
Carlo Carrè[10]

In an article on the Turin Exposition of 1898 entitled "Il renascimento delle arti decorative", the art critic Enrico Thovez wrote: "… modern decoration should, like the madman in D'Annunzio's dream of a spring morning, only for more sensible reasons than in his case, slip on a green robe in order to expunge from memory the idea of the blood-red color that characterized its past." In his view, what is taking place is a "return to the expressive naturalism of medieval

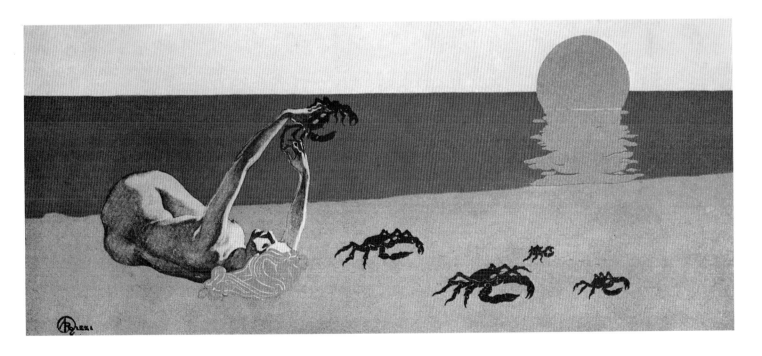

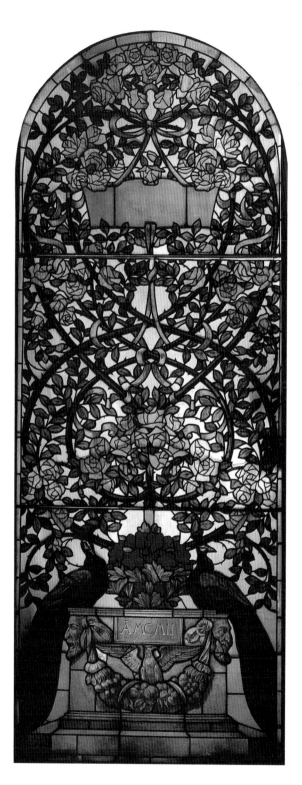

art" and the "redemption of decorative art by plants and animals … in faithful naturalistic form and with unambiguously decorative intentions based on Gothic models, with instruction from the Japanese."[12] D'Annunzio might be the leading "aesthetic" light of Italy, but craftsmen were increasingly oriented toward the English and their reform of everyday objects. The English influence becomes clear when one recalls that the whole artistic activity of the *fin-de-siècle* in Italy is rarely termed *Stile floreale*, whereas the terms *Stile Inglese* or *Stile Liberty* are still used to describe Italian-style Art Nouveau. The latter name was derived from the London-based decorative business of Arthur Lasenby Liberty, whose textiles and furniture enjoyed great popularity in Italy and were sold very successfully. There is a certain irony and of course unfairness in a store being as it were godfather for the whole style of the Novecentisti, which included very individual, high-quality work in many fields. One unmistakable embodiment of the *arte nuova*, the new art, is the Arte della Ceramica factory in Florence of Galileo Chini (1873–1956) (ill. p. 185). Another is the stoneware factory Richard-Ginori. Rich in traditions, since 1896 this had been known as "Società Ceramica Italiana" and combined floral motifs and Tuscan coloring in its products (ill. p. 178). Italy had nothing to offer to counter French supremacy in Art Nouveau glassware. Nonetheless, it had a very strong tradition of glassmaking, for example in Murano, and the quality of glassmaking was continued in glass windows and other glassware. These were not very original, but their decorative and technical quality was very high (ill. left). In printing as well, Italy's role was more receptive than creative, with English and French echoes and playful symbolic motifs from Viennese Art Nouveau, which lent themselves particularly well to illustrating the literary Art Nouveau style of D'Annunzio. The painter and graphic artist Antonio Rizzi (1869–1941) was a sporadic contributor to the Munich periodical *Jugend*, so that his work shows a strong relationship with the Art Nouveau style there (ill. p. 187). A more Italian version of Art Nouveau graphics was created by Marcello Dudovich (1878–1962) in his posters (ill. p. 187). He combined the Stile Liberty with "classical" figures, as they are found in Art Nouveau facades in Milan, nudes in the tradition of Italian sculpture. The Turin Exposition was supposed to help resolve the inner conflict of Art Nouveau, whose ideology swung backwards and forwards between aesthetic exclusivity and the demand that art should

Anonymous
Doorway, Genoa, ca. 1900
There are examples of graceful Art Nouveau architecture not only in Milan but in almost all cities of Italy, like this one in Genoa.

Left:
Giovanni Beltrami
Peacocks, glass window, ca. 1900
Clear glass, enameled, 450 x 150 cm
Execution by Lindo and A. Grassi, master glaziers, Milan
Italy had nothing to offer to counter French supremacy in Art Nouveau glass. Nonetheless, the quality of glassmaking, which boasted a very strong tradition, was maintained in glass windows and glassware which, though less individual, were of a high decorative and technical quality.

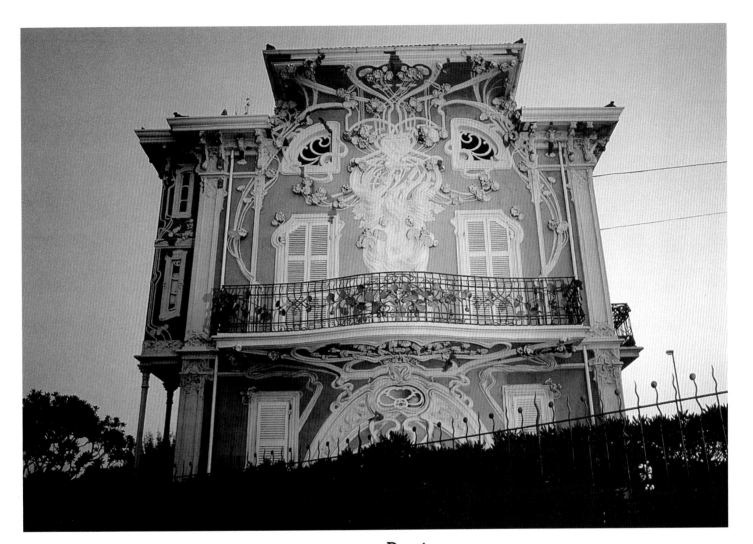

become common property. It remained, nonetheless, chiefly on the side of the costly and beautiful. The most forward-looking artist of the Art Nouveau era in Italy was Antonio Sant'Elia (1888–1916). Schooled in the artistic philosophy of the Viennese architect Otto Wagner, he began to take practical steps to make art common property. He was less interested in individual buildings, more in whole complexes of buildings and city planning on a thoroughly modern technical level. As a pioneer of the Futurists' "town machine", he designed terraced houses, elevator shafts and multilevel traffic systems, thereby setting aesthetic and functional standards for the following decades. Like the painter Umberto Boccioni (ill. p. 193), who was to help Futurism make an international breakthrough, he joined up in 1914 as a volunteer in the First World War. Both of them were killed in 1916.

Russia

Art Nouveau and abstraction

I still believe that, like the cranes, nations migrate into progress ...
Julian Marchlewski[13]

Just as the cradle of Futurism is to be sought in Italy, it is with the Russian artists such as Kandinsky and Malevitch that we find the beginnings of abstraction. Yet, even in Russia, Art Nouveau flowered prior to the pioneering work of these artists. As in Italy, it had its receptive aspects, but it was nonetheless a dynamic and powerful movement. The architecture of the turn of the century in Russia is nicknamed the Little Merchant Palaces style, because, here too, it was the grande bourgeoisie above all who had the desire and the financial means to support the new style.

Giovanni Brega
Villa Ruggeri, Pesaro, 1902
Oreste Ruggeri, owner of a porcelain studio and a promoter of the new style, commissioned Brega to build him a villa. On closer inspection, Italian traditions and Italian heritage can easily be made out under the amorphous ornamental overlay on the facade. Brega adorned the eastern face of the house with two eye-shaped windows, a floral component made of reinforced concrete that looks like a nose and an entrance that is shaped like a mouth. The ensemble recalls Arcimboldo's vegetable portraits.

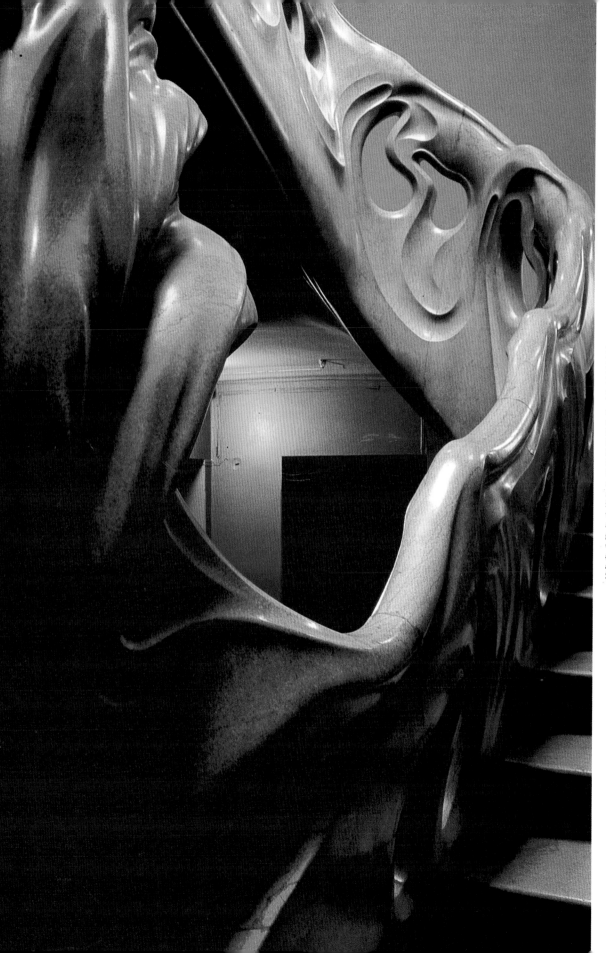

Fyodor Osipovich Schechtel
Palais Rabushinsky (now Gorky
Museum), 2–6 A. Tolstoy Street,
Moscow. Banisters of main
staircase, 1900–02, 1906
The Palais Rabushinsky was
constructed for the Moscow banker
and owner of the *Utro Rossiyi*. It
forms a high point in the output of
the Russian Art Nouveau architect
Schechtel. The building shows him
to be a disciple of *fin-de-siècle*
Symbolism. The asymmetrical form
and severe lines of the roof constitute
an idiosyncratic contrast to the
flowing curves of the mosaic frieze,
the doorway, and window frames,
and to the wrought-iron window
grilles, which are adorned with
undulating spiral motifs. The brown
and cream tones of the frieze depict
an orchid, the favorite flower of
Symbolism.

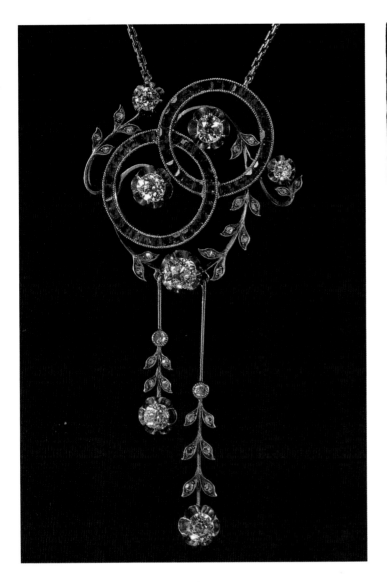

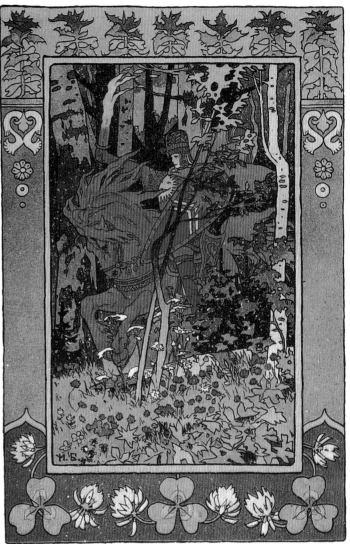

Whereas in St. Petersburg the new buildings tended to fit in more with the classicizing cityscape, in Moscow Art Nouveau buildings had bulky forms with large surfaces and seem to have been influenced more by folk art and Old Russian ecclesiastical and monastic architecture. The most important Russian architect of the local Art Nouveau style was Fyodor Osipovich Schechtel (1859–1926). His representative Art Nouveau buildings are the Palais Rabushinsky in Moscow (now the Gorky Museum) and Jaroslav Station, in which he incorporated unmistakable Old Russian elements in Art Nouveau. The Palais Rabushinsky (ill. opposite) indicates that Schechtel was an adherent of *fin-de-siècle* Symbolism. The asymmetrical form and severe lines of the roof

form an idiosyncratic contrast to the flowing curves on the mosaic frieze, portals, and window frames, and to the wrought-iron window grilles, which are adorned by an undulating spiral motif. The brown and cream-colored frieze depicts an orchid, the favored flower of Symbolism.

In the hall of the Hotel Metropol that he constructed in Moscow, William Franzevich Walkot (1874–1943) was the first in Russia to use components of metal, glass, and reinforced concrete. Besides villas and hotels, cinemas and apartment blocks were also constructed in the new style. Even passenger steamers on the Volga had Art Nouveau saloons. Moscow had its own "Turin" show with an "Exposition of Architecture and Crafts of the New Style" in the winter of 1902–03, at

which not only Russian artists were exhibited but also Mackintosh and Olbrich among others.

For a short time, even the famous Russian goldsmith and jeweler Peter Carl Fabergé (1846–1920), who came from a French Huguenot family, was a disciple of Art Nouveau. His jewelry of this period largely features adaptations of plant, insect, and animal forms. For these, he used gold, silver, and platinum, plus a wide range of semiprecious and precious stones. His Art Nouveau products revived Russian gold work, and he found numerous high-quality imitators in Russia (ill. p. 191).

The influence of the Ecole de Nancy can be recognized in the glassware produced by the factory of the Imperial Russian Court. The influential designers here around 1900 were Petushov, P. Kranovsky and J. Romanov. The last two also worked for the Imperial Russian Porcelain Factory, which closely imitated the style of the Royal Porcelain Factory in Copenhagen and in 1890 was merged with the glassworks.

Moscow proved to be the up-and-coming center competing with conservative St. Petersburg, where a more neo-Romantic pictorial style was in vogue. The fairy-tale illustrator Ivan Yakovlevich Bilibin (1876–1942) was based here, continuing the tradition of Russian popular illustrated broadsheets in an ornamental style of expressive colorfulness (ill. p. 191). He was a member of the Mir-Iskustva Group in St. Petersburg, to which Vassily Kandinsky also belonged, the most momentous talent for the development of all European art. It may be surprising that Marxist criticism of the "non-representational world" equates bourgeois Art Nouveau with abstraction. The autonomous artist does the same as the autonomous bourgeois who transforms objects aesthetically. The artist who thinks non-representationally likewise loses contact with the reality of objects in the interplay of metaphysical forms.

Absolute movement is a dynamic law anchored in objects. The visual structure of objects in this case takes the innate motion in the object into account, irrespective of whether it is stationary or in motion. I draw this distinction in order to make myself understood more easily. In reality, there is no stationary, there is only motion, as immobility is only apparent or relative. This visual structure obeys a law of motion that is characteristic for the body. It is pictorial potential that the object contains within itself and which stands in close relationship with its organic substance.

In this first condition of motion, the object is not seen in its relative motion but understood in its lifelines, which reveal how it would break up in accordance with the tendencies of its forces. Relative motion is a dynamic law anchored in the motion of the object. It is accidental because it concerns above all moving objects and the relationship between mobilized and nonmobilized objects.

The question is to understand objects not only in their innate motion but also when they are in motion. It is thus not just a matter of finding a form that is an expression of this new absolute of speed, which no really modern man can ignore. It is a question of examining how life behaves at speed and in the simultaneity that follows from it.

By lines, we mean the motive tendencies of color and form. These tendencies are the dynamic appearance of form, an illustration of the movement of matter on the course prescribed to us by the construction line of the object and its action.

Into these motive tendencies are inserted color volumes created by color and form and their endless motion.

Umberto Boccioni, "Futurist Painting and Sculpture", quoted from *Futurism 1909–1917*, exhibition catalog, Düsseldorf, 1974.

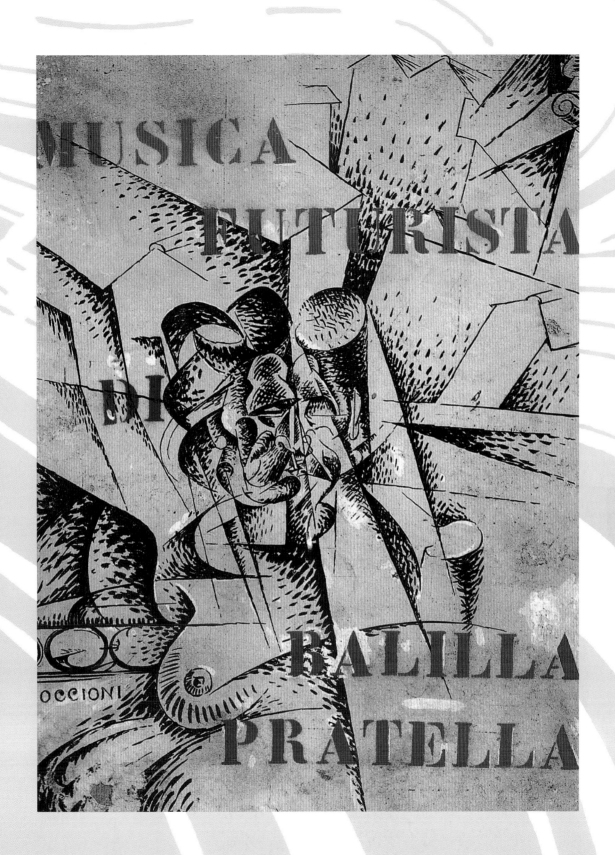

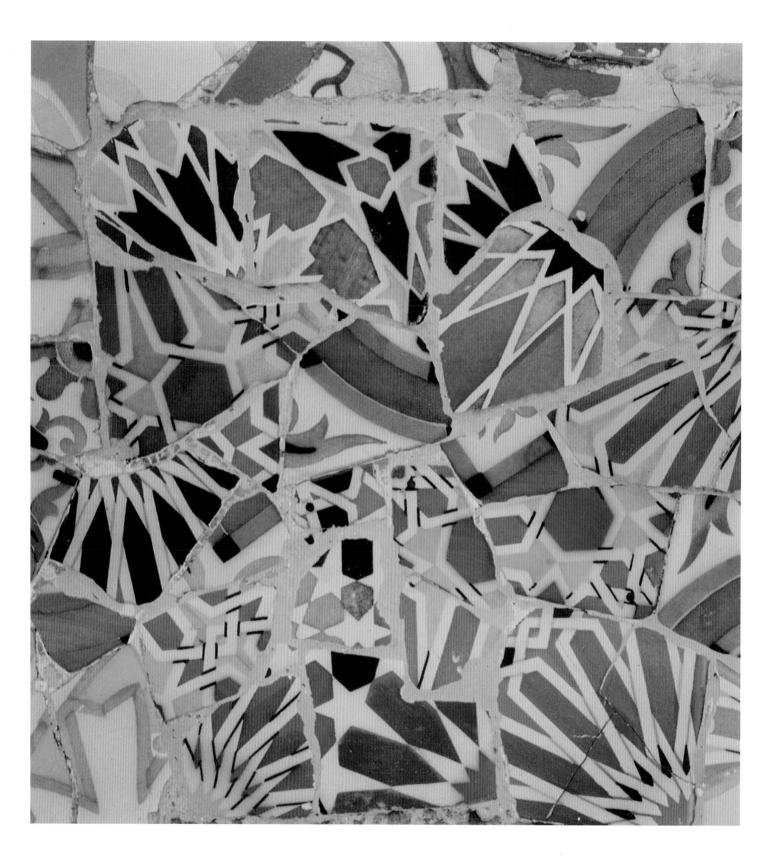

Architecture as a natural phenomenon
Barcelona

Antoni Gaudí i Cornet
Collage, bench (detail), Parc Güell,
Calle de Olot, Barcelona, 1901–14
Pieces of glass, porcelain and
ceramics
The Parc Güell represents a
Gesamtkunstwerk, a synthesis of
the arts, and the system of
"collages", made up of fragments of
stone, porcelain, ceramics, and
plants, is a painting, a sculpture –
the highest expression of creative
imagination.

The first point: the most Catalonian Catalan of all.
Hence the epigraph in this language. We called him
simply "Don Antón".
The second point: the greatest architectural genius,
improviser of all solutions, inexhaustible creator, always
original, natural and always logical, but in a world that
was entirely his own.
The third point: the most pious and devout of any
architect building houses and cathedrals – faith shows
through even the structures of his houses.
Joaquím Torres Garcia[1]

The "Moorish style"

Spain's position within European art history has
always been unusual. The near 800-year con-
nection between Christian and Islamic art was
bound to lead to an idiosyncratic style. In the
Arab parts of the "occupied" country, Christians
developed a Mozarabic style, while the Moors in
the Christian provinces had their own *mudéjar*
fashion. The origin of both styles is to be found in
the complicated surface decoration and disguise
of architectural principles inherent in Islamic art.
In Arab art and architecture, human images are
forbidden – a major reason why ornament, the
only possible form of adornment, was developed
to perfection. With flat surfaces traditionally
broken up into a network of arabesques, contem-
porary international fashions were always trans-
formed into an individual Spanish national style.
The powerful urge to decorate overcame the
cerebral forms of Gothic and broadened the
Baroque into "architectural sculpture". Spanish
piety, which an intense reverence for saints
heightened into dreamlike mysticism, reinforced
the attraction towards a quasi-ecstatic art form.

Antoni Gaudí i Cornet –
Catalan and world citizen

Antoni Gaudí (1852–1926) was Catalan, not
Spanish, perhaps even the "most Catalonian
Catalan of all". He is, therefore, by no means to
be viewed as a product of Hispanic fashions in
art. This is true if only for the fact that the work of
a genius – Gaudí was one of the "blessed" – is
always marked by an inevitable autonomy, which
holds its own even though external forces may
show through. External energies – they were
there, hence perceivable – were interpreted by
Gaudí in a wholly individual, unmistakable
manner, like for example in the "Moorish style"
of his first works, or again, in the progressive,
anti-classicist evolution between color and form
and the extreme asymmetry of his Baroque
three-dimensionality. Gaudí as an outsider, being
an exceptional phenomenon, was nonetheless
part of the movement of the outgoing century
that sought to cope with the ballast of the most
recent past by probing back for "clear" styles
such as Gothic. The writings of Eugène
Emmanuel Viollet-le-Duc, who lauded the
construction principles of Gothic cathedrals and
influenced the architects of around 1900 from
Horta to Sullivan via Guimard, also stirred Gaudí.
However, Viollet-le-Duc parted company with
Gothic structure in introducing the V-shaped
pillar, that is, the double crossarm brace. "The
crossarm brace is a principal feature of the
practice by which Gaudí strives to master Gothic.
Gaudí was an eager student of the writings of
Viollet-le-Duc. However, he is closer to Gothic
technology, that is, to handicrafts, than Viollet.
His main objection to Gothic was directed at solid
and flying buttresses. These could be dispensed
with by angling the pier in the direction of the

Rafael Julio Masó i Valentí
Penholder
Design drawing, watercolor
The architect and designer Rafael
Julio Masó i Valentí sought to
empathize with the original creations
of Gaudí. The results were rather
shapeless but not unoriginal.

thrust of the vault, that is, diagonally, in the resultant of the Gothic parallelogram. The crossarm brace became a principal motif in Gaudí's constructive architecture, as did the branched brace, the tree-like pier, as in the interior of the Sagrada Familia cathedral. For this, Gaudí thought, no iron was needed, as it could be done in stone. Where Viollet trumps Gothic essentially by transferring its principles to a new material, Gaudí masters it *with its own* constructive medium. … Gaudí was a man of handicrafts who asserted that one could produce virtually everything from brick and stone. Certainly it was possible in Catalonia at that time, given the quality of Catalan craft work. In this case, stone almost looks like cast material. With Gaudí, there are no architectural drawings, only models."[2]

Divergence is mostly more conspicuous than convergence. That applies without question in the case of the great names of Art Nouveau architecture, whose common point of departure was evident but took shape in accordance with their personalities, their talents and, above all, their national characteristics. It seems nonsensical, for example, to compare Louis Sullivan's Guaranty Building in Buffalo and Gaudí's Casa Milà in Barcelona, yet the intellectual kinship of the two architects should not be overlooked. "The Sagrada Familia is the greatest work of the entire creative architecture of the last twenty-five years. It is a depiction inherent in stone that is worthy of the spirit!"[3] – these are the words of the *form follows function* architect Sullivan when an American colleague put photos of the temple church in front of him (ill. p. 207, 208). Even if Gaudí rejected iron and steel as "mechanical" building materials, he shares at the same time a starting point even with the American architect

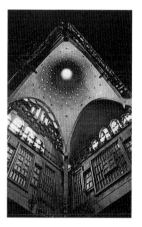

Paco Durrio
(Francisco Durrio de Madron)
Pendant, pre-1904
Cast gold, decorated on both sides,
6.5 x 6.2 cm
Musée d'Orsay, Paris
Durrio is a representative of Spanish Art Nouveau, that is, of an internationally flavored but nonetheless local version of craft work. It is revealing that he lived mostly in Paris, where he exhibited his jewelry with great success at the Salon d'Automne in 1904. The elegant line of his creations is without question so full of expressive three-dimensionality that the Catalan inheritance of the artist cannot be denied.

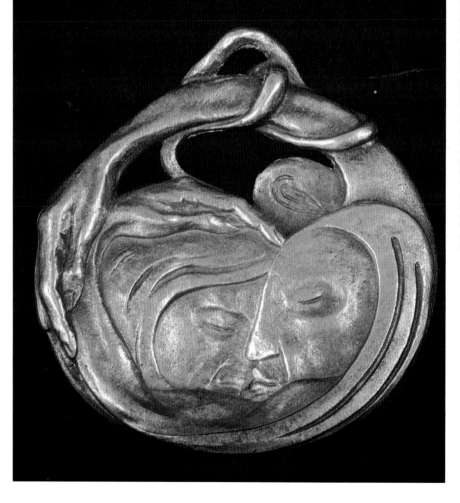

Antoni Gaudí i Cornet
Palau Güell, view into the dome of the central living area, Nou-de-la-Rambla 3–5, Barcelona, 1886–89
Gaudí's first major building commission, for the Palau Güell, came from his sponsor, and later close friend, Count Eusebio Güell, a much-traveled patron of the arts. On his business trips to England, Güell had come into contact with William Morris, and had put together an extensive library of contemporary writings on art theory which Gaudí often consulted. With the Palau Güell, structure and decoration began to fuse – a feature that later became characteristic of his principal works. Gaudí made use of the varied decorative opportunities of structural iron in all their abundance. In addition, he employed flattened brick vaults of Byzantine derivation that even today are copybook examples of stereotomy.

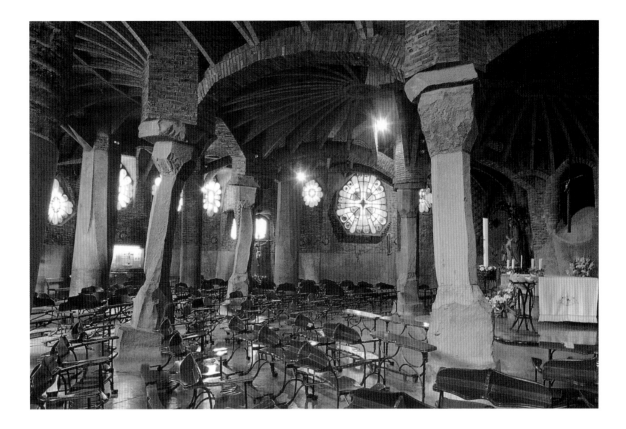

Frank Lloyd Wright. The man of technical fantasies, who used concrete and steel to bring forth a "more plastic art", for whom paneling and frame should relate to each other like "skin and bones", walked the same path as Gaudí. His structures are also like the bones of the human body surrounded by muscles and skin, making up a unity, an organic law.

Catalonia and Europe

Catalonia with its cleons in calico and its Catalan women in cotton is the strength and weakness of Spain.
A travel writer in 1845[4]

Besides the Catalan aspect of handicrafts, there were also political and social conditions that played an important part, as in Nancy, Finland, Darmstadt, and other places. "The Catalans are neither French nor Spanish, but a nation of their own, in language and costume as much as in their way of life. Their impetuousness and energy wholly persuade the traveler that he is no longer in aristocratic, carefree Spain ... and no province of the incoherent entity that makes up the official kingdom de las Españas is less connected with

the crown than this land of revolt, that is always ready to break away," remarked a travel writer in 1845.[5]

The long history of Catalonia's search for independence culminated in the rebellions of the worker movements in Barcelona and the post-1880 terror that ensued in consequence. The first real Catalan organization was the Centre Català, founded by Valenti Almirall. In 1885, Almirall presented to King Alfonso XII the "Memorial de Grèuges", known as the "Memorandum for the Defence of Moral Interests and Catalonia". The Unió Catalanista was set up in 1891 to coordinate the various Catalan entities that then existed in Catalonia. In 1892, the principles for the Catalan Regional Constitution were formulated. These contained not only political but also cultural objectives: "The fact was that Catalonia, by virtue of its Catalanism, felt it was completely and irrevocably part of Europe. If for Mañe i Flaquer [a 19th-century Catalan freedom fighter] regionalism meant the revolt of the *patres familias*, in 1892 it represented a spiritual revolution among the young. It brought with it Impressionism, the music of Wagner, the plays of Ibsen, the philosophy of

Antoni Gaudí i Cornet
Crypt, Colònia Güell, Santa Coloma de Cervelló, Barcelona, 1898–1908 and 1908–17 (unfinished)
The funicular models for the crypt, with which Gaudí worked out the arch and vaulting loadings, were a challenge both structurally and aesthetically. Gaudí identified the natural disposition of the given structural form by hanging canvas bags filled with pellets on strings, the weights being proportional to those of the loadings he had calculated. Thus weighted, the strings displayed the shape of the skeleton of the future church. The "frame" of the Colònia Güell contains all the structural forms devised by Gaudí.

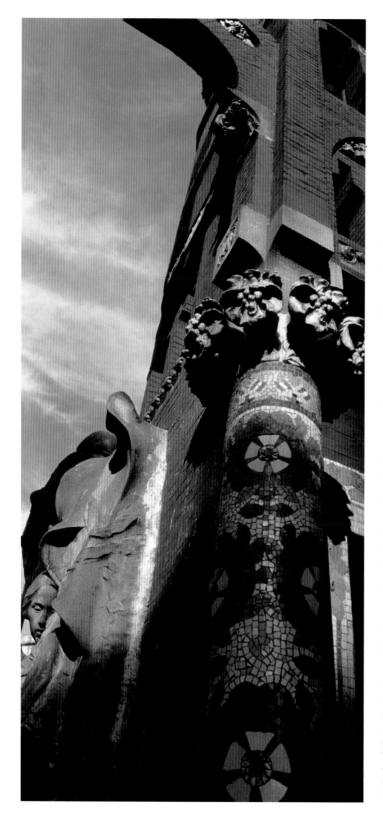

Nietzsche, Modernist aesthetics, the desire for telephones and good roads to Catalonia …"[6] This vital fact of intellectual attachment to Europe on the part of the Catalans made *Modernisme* (the Spanish term for Art Nouveau) possible, yet it developed almost exclusively in Barcelona.

To be a Catalan had momentous consequences for European art history in the 20th century: Pablo Picasso [sic], Juan Gris, Joan Miró, Salvador Dalí, Julio González, Antonio Tàpies, Eduardo Chillida – all of them continued the traditions of their native land (ill. p. 211).

Modernisme: Lluís Domènech i Montaner and Manuel Raspall i Mayol

I'll do you a sketch so that you can take it to the Barcelona Cómica, *we'll see if anyone buys it. You'd laugh – it's supposed to be Modernist, like the magazine it's meant for.*
Pablo Picasso[7]

The word *modernista* crops up in Catalonia for the first time in 1884 in the magazine *L'Avenç* in connection with an exhibition of European arts and crafts in Barcelona. The rapprochement to French Symbolism and the Aesthetic Movement, which affected Catalan literature first, was the breeding ground for the aesthetic movement in fine and applied art. For the occasion of the World Exposition in Barcelona in 1888, the architect Lluís Domènech i Montaner built the Grand Hotel and the Café-Restaurant popularly known as the "Castell des Tres Dragones", the "prototype" building of architectural Modernisme. In Montaner, the many facets of 19th-century Catalan style are palpably brought together. His architecture is based on a kind of late version of historicism, with a special emphasis on the formal vocabulary of Classicism and the Renaissance. The articulation of his facades, mostly on public buildings, is conceived in a rather more traditional architectural style, in contrast with which the interiors display a thoroughly individual, exciting tinge of Modernisme. Full of symbolic and structural ornamentation, the style reflects the rich range of experience of the *fin-de-siècle*. In the Café, columns carry floral capitals, while on the base remarkable Byzantine elements materialize. The virtual reversal of base and capital generates an illusionist reflection. This reflection is justified and continued in the whole "submarine decoration" of the Café, which is "flooded out" with fish and wave motifs. Here, a strong Japanese influence is evident in

Lluís Domènech i Montaner
Palau de la Música Catalana,
Barcelona, 1905–08
The whole interior furnishing of the concert hall, from the lighting to the walls, is broken down into ornamental detail forms. The columns are mostly covered with polychrome pieces of glazed tile or adorned with animal sculptures. The surreal atmosphere is reinforced by the gem-like stained-glass windows and the blazing lights of the branch-like candelbras on the column capitals.

Montaner's work, as this vocabulary refers in both theme and form directly to *ukiyo-e*. Buoyed by the political independence movement, Catalan music also enjoyed a renaissance. The Catalan choir, Orfeó Català, founded in 1891, became a leading cultural force. During 1905-08, Montaner constructed for it the Palau de la Música Catalana in the heart of old Barcelona. This was now Modernist both inside and out (ill. opposite). The richly inventive decoration fuses with the organically structured body of the building in a successful symbiosis. Incorporating elements from numerous sources, Montaner's design is fronted by a facade with a double row of columns and decorated with a sculptural group symbolizing Catalan music. The rooftops recall the peculiar formations of Montserrat, a mountain in the neighborhood of Barcelona. The whole interior furnishing, from the lighting to the walls, dissolves in an abundance of ornamental detail. On the columns, the same trick of hallucination occurs as in the Café-Restaurant. The columns themselves are mostly covered with polychro-

matic glazed tile pieces or adorned with animal sculptures. The surreal atmosphere is reinforced by gem-like stained-glass windows and the blazing lighting from the branch-like candelabras of the column capitals. The importance of Montaner, who with his busy architectural practice was a major contributor to Barcelona's Modernist face, can be gauged from a first review of Gaudí's Palau Güell in *La Illustración Hispano-Americana* of February 1891: "… We shall soon be able to put Gaudí on a par with Domènech i Montaner, the initiator of the architectural renaissance."[8]

The Casa Barbey in Barcelona by architect Manuel Raspall i Mayol (1877–1937) is further evidence of the impressive variety of architectural activity in Catalonia around 1900 (ill. below).

Manuel Raspall i Mayol
Casa Barbey (detail), Barcelona, ca. 1900
"The fact was that, by virtue of its Catalanism, Catalonia felt it was completely and irrevocably part of Europe. If for Mañé i Flaquer [a Catalan freedom fighter of the 19th century] regionalism had meant the revolt of the *patres familías*, in 1892 it represented a spiritual revolution among the young. It brought with it Impressionism, the music of Wagner, the plays of Ibsen, Nietzsche's philosophy, Modernist aesthetics, and the desire for telephones and good roads to Catalonia …"
(*Vicens Vives*, see note 6)

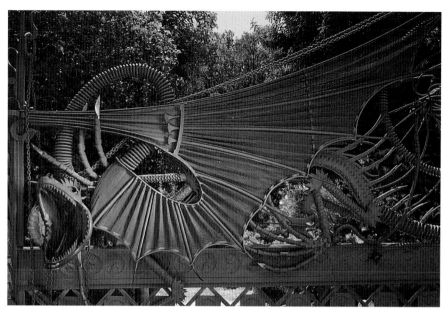

Antoni Gaudí i Cornet
Dragon gate, entrance to Finca
Güell, Avenida de Pedralbes 7, Les
Corts de Sarrià, Barcelona,
1884–87
Wrought iron
The dragon gate of the Finca Güell
must be considered a perfect
testimony to the artistic quality of
Catalan wrought-iron work. It is
hung between brick pillars built on
natural stone bases and swings on a
single vertical axis. The dragon
represents Ladón, the guardian of
the Garden of the Hesperides, who
at Juno's behest stood watch over the
golden apples of the garden. When
Hercules overpowered the "warder",
the fabulous beast turned itself into a
constellation. Gaudí placed the gate
under an antimony-colored orange
tree that crowns the pillar and counts
as a symbol of special wealth.

Door of a residential house in
Salamanca, ca. 1900
With Modernisme, sophisticated,
elegant urban buildings appeared all
over Spain. They incorporated
European stylistic fashions in a
worldly but superficial way, but
improved the cityscape even so.

Aesthetic pluralism

*... this trend indeed inspired a lively sympathy and interest
to the extent that it defined the ambient magic of Barcelona;
for this fact alone one must dutifully respect it. Yet these
are but superficial values and variations of taste ...*
Roberto Pane[9]

Basically two different trends should be distin-
guished: on the one hand, a trend toward sophis-
ticated, elegant urban buildings that incorporate
European fashions in a worldly but superficial
way, improving the cityscape but of less interest
for architectural history; on the other hand,
buildings erected within the framework of a
"Gaudí fashion", which, though often original
and odd, lack the mastery of genius, which
seems indispensible if the daring canon of forms
is to be realized. In the field of arts and crafts,
which in Modernisme played a subordinate role,
a parallel situation obtained. In comparison with
the rest of Europe, the volume of original "new"
arts and crafts work is negligible. This may be
connected with the Spanish – and particularly the
Catalan – view that the architect is a kind of un-
touchable saint and therefore becomes a parable
for art. The aesthetic pluralism so common on
the European horizon tended in Modernisme to
lead to sensual deviations. Paco Durrio, more
formally Francisco Durrio de Madron (1875–
1940), is a representative of Spanish Art Nouveau,
that is, an internationally flavored and yet local
version of handicrafts. It is revealing that he lived
mostly in Paris and exhibited his jewelry there at
the Salon d'Automne of 1904 with great suc-
cess. The elegant line of his creations has with-
out question such an expressive sculptural
quality that the Catalan inheritance of the artist
cannot be denied (ill. p. 196). In contrast, the
architect and designer Rafael Julio Masó i Valenti
(?1881–1935) tried to emulate the original crea-
tions of Gaudí. The results were rather shapeless
but not unoriginal (ill. p. 195). Though we might
be overwhelmed by the genius of Gaudí, we
should not diminish the achievements of Moderni-
sme, while not forgetting that an exceptional
phenomenon is not necessarily followed by a
whole style with even an approximation of the
quality (ill. left). Despite all the lively inventive-
ness, a formal, unambiguous orientation is miss-
ing. The Modernist buildings of Barcelona, along
with their interiors, in themselves very different
and daring, are united only in their rejection of the
historicizing legacy and the frequent borrowings
from the Baroque and Liberty-style naturalism.
To try at any cost to find affinities between Gaudí
and the Modernists would be superficial.

"God's Master Builder" – the correlation between structure, form, and space

Imagination is a power of the soul to see new forms in one's own capacity for thought and, building on what has been learnt, to know how to translate them into structures and works of art.
Juan Bassegoda Nonell[10]

Gaudí the architect and artist was an actively political person who joined several Catalan associations and voted for an independent Catalonia. He was closely attached to his homeland, but in a far-reaching sense. Besides nature, in which he found the orderliness of all things, he saw his homeland as an artistic legacy: "Let us consider," he would say, "what it means to be born in the Mediterranean. It means we are equally far from the blinding light of the tropics as from the spectral darkness of the north. We are brothers of the Italians, and that equips us more for three-dimensional work. ... Catalans have a natural sense of the three-dimensional that gives them an idea of things as a whole and of the relationship among things. The sea and light of Mediterranean lands generate this remarkable clarity, and that is why the things of reality never lead the Mediterranean peoples astray but teach them."[11] The desire for wholeness, proportion and balance breathes life into Gaudí's work. The complex architectural system he cultivated has a high position in architectural history as a one-off

phenomenon. The structuring of the buildings follows static and, as a result, geometric principles, whereby the total form that results from that leads, in its organic view of the unity of nature, that is, the archaic unity of anatomy and geometry, to an expressive appearance. This barely comprehensible principle has often called forth blank stares when, in the face of his sculptural buildings, Gaudí is depicted as an experienced structural engineer and technician. Traditionally, geometry is associated with straight lines, angles, and abstract bodies. In the literal sense, however, geometry is the branch of mathematics that deals with the patterns of planes and space; curves such as parabolas and hyperbolas, paraboloids, arches, and volutes make up Gaudí's canon and are still geometry. With the help of "natural geometry", architects can do without "vehicles" such as pillars and buttresses,, as curves dynamically absorb their loads themselves. Much as he admired the construction principle – of piers and buttresses – of Gothic cathedrals, the "balance" of construction seemed to him feigned inasmuch as the thrust could only be offset through these supporting devices. Gaudí characterized Gothic architecture as "industrial" in its fundamental principle, as it was only apparently balanced by virtue of mechanics. The equilibrium that he sought he found put into practice in the *contraposto* of classic Greek statues, and, quite logically, he therefore termed

Antoni Gaudí i Cornet
Dragon lizard, steps of Parc Güell, Barcelona, 1901–14
Pieces of glazed ceramics
Besides Christian symbols, Gaudí loved classical and oriental mythology. The dragon lizard in the Parc Güell is thus a representation of Python, the guardian of the subterranean waters on the steps of the Temple of Apollo in Delphi, while the frequent motif of a tortoise on the base of columns is a Chinese symbol of order in chaos.

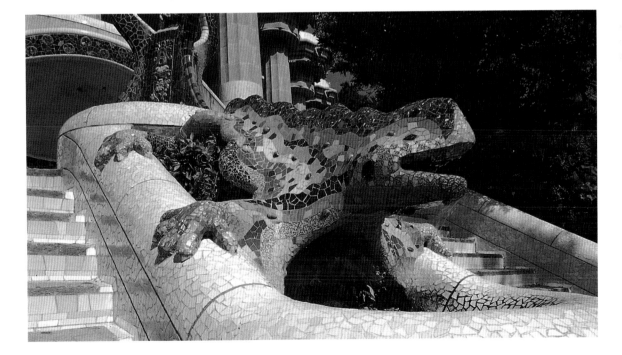

his own work as "Greek". His greatest teacher was always nature. "Do you want to know where I find my models?" Gaudí answered his own rhetorical question by pointing to a eucalyptus tree outside the windows of his studio: "An upright tree; it carries its boughs, and these carry the twigs and the twigs carry the leaves. And every single part has grown harmonically, splendidly, ever since God the artist created it. This tree needs no external assistance. All things are balanced out in themselves. All things are in balance."[12] Parabolic arches, mushroom-shaped capitals, fragile hanging vaults without visible lateral thrust – characteristics of Gaudí's architecture – reconstruct organic growth. He sought the origins of his architecture in the nature of plants, animals, and minerals, yet the architecture lacks the basic features of popular construction. One has only to think of the wall benches made of rustic stone without mortar, or the shell-shaped vaulting. "Have you ever noticed that a stick bends under the load of what it supports. Equally, my columns are stone sticks in which, as can be

easily recognized, the principles of load-bearing and loading are united."[13] In Gaudí's case, "easy to recognize" hardly applies to either the constructive principle or his harmony principles, as it is mainly nurtured by a kind of aesthetic inspiration from the architect himself. The difficulty of a clear interpretation lies in two opposing factors that only a man of extraordinary wit could combine apparently effortlessly in his work. To make comprehension easier, it is of prime importance to keep in mind the ingenious "montage system" of the structures on the one hand, and on the other the contrasting intuition, which is of artistic origin. Gaudí's ideas on form and stability centered from the first on the parabolic or catenary as a linear element, which corresponded to the pressure curve most closely. He also made use of the "false arch", an extreme parabola constructed as a series of cantilevered layers of brick such as on the little houses found in Tarragonese vineyards. The arch is used to support unsupported ceilings, as for example in the roof story of the Casa Milà.

Antoni Gaudí i Cornet
Bench seat, for the Casa Calvet, Barcelona, Calle Caspe 48, 1898–1900
Sculptured oak, 180 cm long
Execution by Casas & Bardés, Barcelona
The furniture from the Casa Calvet is tailored to its functions with the minimum expenditure of material. The osseous shapes have the tension of surrounding muscle from an organic creature.

Symphonic statics

Gaudí cannot possibly be forced into stylistic pigeonholes or historic periods; his work is timeless, a great lesson in elegance, honesty, and spirituality.
Juan Bassegoda Nonell[14]

The most exciting example of both Gaudí's inventiveness and the simplicity of his solutions is the stereostatic model for the crypt of the Colònia Güell (ill. p. 197). The funicular models with which Gaudí worked out the loads of the arches and vaults in the crypt were an aesthetic as well as a structural challenge. He identified the natural disposition of the given building form by hanging up canvas bags filled with pellets, whose weight corresponded proportionally to the calculated loads. Thus weighed down, the strings demonstrated the forms of the skeleton of the future church. The "framework" of the Colònia Güell contains all the structural forms thought out by Gaudí. In his essay "Mozart and Gaudí", Juan Bassegoda Nonell has left us a charming and noteworthy comparison on the subject of artistic intention in Gaudí: "Both masters moved in a world of the Baroque; Mozart at the end of the 18th century, when neo-Classicism and Romanticism were ousting the frivolities of the Rococo; Gaudí in a time of Eclecticism, Modernisme and Novecentismo, all fashions that had virtually no influence on his work, or left at most the faintest of traces.

The common ambience of the Baroque determined the vital character of both masters. The emotion that the listener experiences on hearing the sequence of movements of the Coronation Mass corresponds to what one feels on seeing the crypt of the Colònia Güell, where every fragment radiates inventiveness, the whole an extreme unity, even though it is in fact only a half-finished work …

The compositional work of Mozart surprises us through its unexpected turns and the continuing appearance and layering of themes, each of which surpasses the last. In the same way, Gaudí surprises us with the way he plans original, absolutely new concepts in every part of his structures. …

Taking this as a starting point, knowing by virtue of effort and thorough study what the architectural work of Gaudí means, from here one can begin to set out what everyone, even a child, more or less perceives without knowing the reason why, the whirlpool, the rotor, the turmoil in which the inspiration of Antoni Gaudí was born."[15]

Louis Majorelle
Etagère, 1900
Mahogany, 86 cm high
In contrast to the pure organic furniture structures of Gaudí, Majorelle extracts – with maximum delicacy – a sinew from the organic entity and flexes it in a new, individual form.

Mythology, symbolism and functionality of the organic

Among the many impressions that contemplation of the architecture of Gaudí produces, Catholicism is certainly among the most enduring. The mystically devout framework of reference appears in numerous details, both in the iconography itself and in the symbolism. Where the saints and fathers of the Church had given voice to their religious art by means of literature, Gaudí explained the mysteries with the help of bricks and stone (ill. p. 207). When Monsignore Ragonesi, nuncio of His Holiness Pope Benedict XV in Barcelona, visited the Sagrada Familia in 1915, he called Gaudí a poet, to which the latter answered: "Who would not feel himself a poet at the side of the Church?"[16]

Besides Christian symbolism, Gaudí loved classical and oriental mythology. Thus the dragon lizard in the Parc Güell is a representation of Python, guardian of the subterranean waters on the steps of the Temple of Apollo in Delphi (ill. p. 201), while the tortoise on the base of the column is a Chinese symbol for order in chaos.

The use of allegorical images is a point of contact with Art Nouveau artists outside Spain, as are the new understanding for observing nature and the exquisite forms nature offered. The very dynamism and functional perfection of the so-called lower forms of life served Gaudí to beautify and stabilize his structures. He translated the growth structures of plants and trees directly, to fit his own message. The colors and elegance of flowers, leaves, and fruits were also used to decorate facades and interiors. How much more logical Gaudí was in doing this than, for example, Art Nouveau artists can be especially appreciated on his furniture designs. Louis Majorelle and Emile Gallé are likewise "artists of nature". However, in Gaudí's work organic form is transplanted in the original growth and not in reduction. The furnishings from the Casa Calvet are adapted to their function with the minimal expenditure of material – osseous shapes with the tension of surrounding muscle in an organic creature (ill. opposite). In contrast, Majorelle extracts – with the greatest delicacy – a sinew from the organic entity and flexes it in an individual new form (ill. left). In Gallé's work, nature "reinforces" the innate disposition of the furnishings (ill. right).

Émile Gallé
Workbox, ca. 1900
Marquetry in various fruit woods,
64.5 x 62 x 44 cm
In Gallé's work, nature "reinforces" the natural disposition of the furnishing, whereas Gaudí translates the organic form in its original growth.

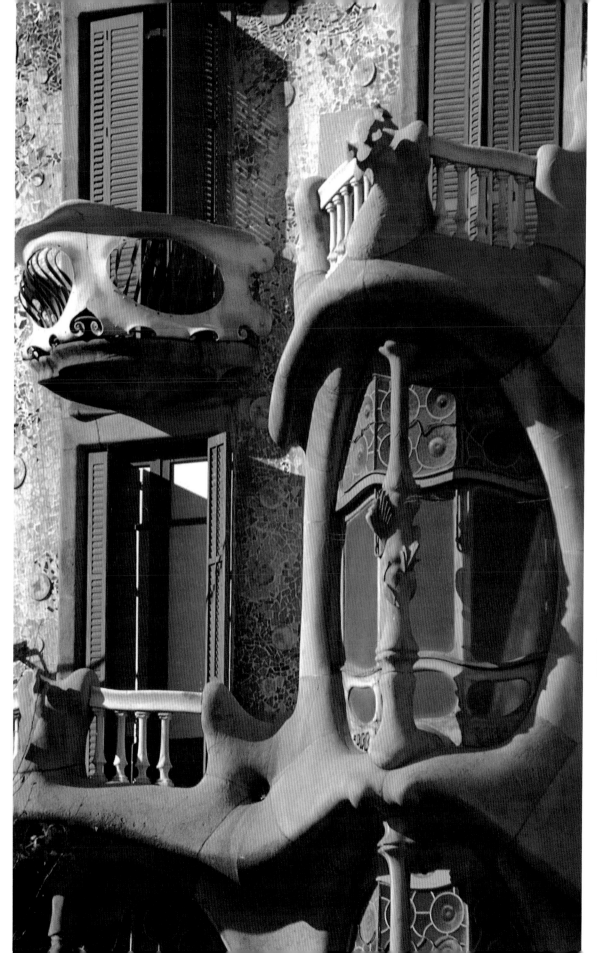

Antoni Gaudí i Cornet
Casa Batlló, detail of facade with
tribune and windows, Passeig de
Gràcia 43, Barcelona, 1904–06
The flowing waves of the facade of
the Casa Batlló are decorated with
glazed mosaic pieces of different
colors and polychrome ceramic
panes. The tribune is made of
natural stone from Montjuic, which,
straightened out and rounded off,
is reminiscent of hand-molded
sculpture. The parabolic brick-built
balconies are also covered with
gleaming ceramic coloring.

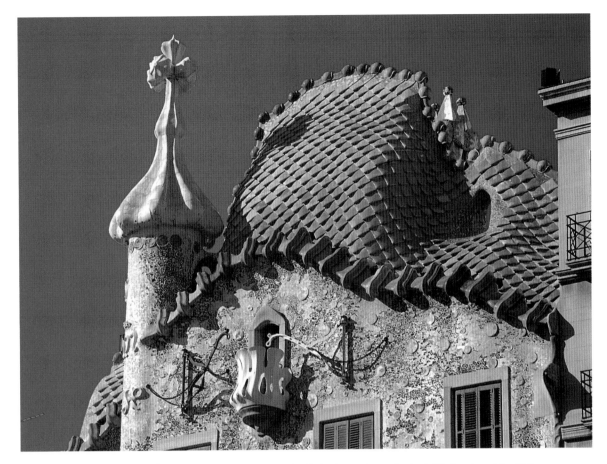

The "Dante of Architecture"

This architecture is completely different from everything that has been seen in this city before.
From a contemporary review[17]

The Casa Vicens, the Villa El Capricho and the Güell Pavilions are effectively a trio of early Gaudí works from before 1888 built in an orientalizing style. Alongside Moorish influences, the interior styling in the fashion of an English manor house shows the effects of the English Arts and Crafts Movement and William Morris's Red House. Gaudí was an eager reader of *The Studio*, a publication that interested him far more than contemporary French periodicals. These buildings, completely new in their unusual features, without forerunners even, could be described as pacesetters for the architecture of Modernisme and Art Nouveau, if they did not already contain the wholly personal autograph of Gaudí in color and structure.

His first major commission, for the Palau Güell (1885–90), came from his client, and later close friend, Count Eusebio Güell, a traveled patron of the arts. On his business trips to England, Güell had come into contact with William Morris and had put together an extensive library of contemporary writings on art theory which Gaudí often consulted.

In the Palau Güell, structure and decoration begin to fuse, and this became a characteristic feature of Gaudí's later masterpieces. Gaudí used the varied decorative opportunities of structural iron in all their abundance. In addition, extremely flattened brick vaults of Byzantine derivation were used which are still today copybook examples of stereotomy. The frescoes of Alejo Clapés plus the sculptural and picturesque built decoration on the roof and facade link up with the inlay work of precious woods and tortoiseshell, elaborate copper work and gilt wrought iron in the furnishing, adding up to a perfect decorative system (ill. p. 200). The front of the Casa Calvet, built 1898–1900, is designed in the Baroque tradition, but nonetheless displays numerous symbolic components. In the gallery on the second floor the visitor notices various types of mushroom, artfully hewn in stone. This is a reference to the

Antoni Gaudí i Cornet
Casa Batlló, roof facing street with cylindrical lateral tower, Passeig de Gràcia 43, Barcelona, 1904–06
The play of colors, integrated into the architectural mass, is continued up to the roof of the Casa Batlló – which resembles the arched back of a lizard – and over the irregularly shaped roof structures. The flowing rhythm of the design gives away nothing of loadbearing and supports within. The whole expressiveness of the architecture lies in the three-dimensional relief and iridescence.

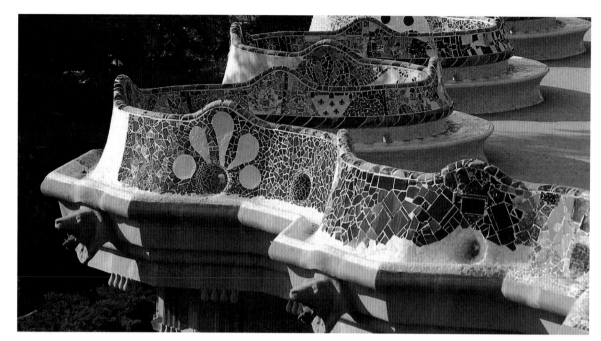

Antoni Gaudí i Cornet
Bench seating, serpentine back-rest
on the cornice of the Doric temple,
Parc Güell, Calle de Olot,
Barcelona, 1901–14
The upper part of the Plaza of the
Parc Güell with the "Greek theatre"
is Gaudí's tribute to the architecture
of antiquity and the Doric order.
The serpentine bench that follows
the cornice is, in contrast, designed
with ergonomic considerations in
mind, as an anti-classical, organic
element. Fragments of stone,
porcelain, glass, and ceramics cover
the seating to make a "pop"
painting.

owner, Pere Calvet, whose hobby was mycology. His namesake, the saint Pere Màrtir, is depicted in the upper section of the facade. The gable is finished off with two crosses, which are scarcely visible from the street, prompting Countess Güell to ask what kind of "complications" they were. Gaudí's answer, that they were "two crosses, complications and confusions indeed for many", shows us a man with a ready wit. That he could handle not only organic problems such as the furnishings for Casa Calvet but also the human problems of architecture is demonstrated by the manner in which he countered the judicial complaint of neighboring nuns that the new building would obstruct their view. His response was an airy succession of obliquely placed arches. These are open and therefore leave the view unrestricted and yet screened.

Painterly and sculptural architectural composition

Amis, la nature nous fait: psst, psst!
Le Corbusier[19]

The 14-year labor on the crypt of the Colònia Güell, begun immediately after the Casa Calvet, was, as already mentioned, Gaudí's architectural credo in its most creative phase. The Parc Güell, that uniquely shaped creation with its sloping walls, its columned halls with vertical ornamental piers and serpentine benches on the cornice of the Doric temple (ill. above) is virtually the apotheosis of his work. This is no longer architecture. The park has become a *Gesamtkunstwerk*, a synthesis of the arts. The system of "collages", made of fragments of stone, porcelain, ceramics, and plants, is a painting, a sculpture, the highest expression of creative imagination (ill. p. 194). The immense craft skills of the Catalan artists who worked with Gaudí are evident here, as on the Casa Batlló, the flowing waves of whose facade are adorned with different colored pieces of glass mosaic and polychrome ceramic panes (ill. p. 204). The balconies have curved cast-iron balustrades, and the balconies themselves, which are made of brick parabolas, are covered on the outside with shimmering ceramic coloring. The play of color, integrated in the architectural masses, is continued up to the roof – which resembles the arched back of a lizard – and over the irregularly shaped roof structures (ill. p. 205). The

flowing rhythm of the design gives away none of the secrets of the supports and loads. The whole expressivity of the architecture is in the sculptural relief and iridescence. The interior spaces are a hymn to light. It floods through the changing colored windows or enters as extensive surfaces. The panes of glass in the salon on the upper first floor leading to the Passeig de Gràcia have no piers; when all the windows are open, a broad panorama opens to view.

The Casa Milà, "La Pedrera" [quarry], is often described as the greatest piece of abstract sculpture, and indeed the impression is given that a giant hand has developed to subdue and shape the great mass. The massive facade, which looks like a sea frozen in motion (ill. below and end-papers) forms – in Gaudí's words – "the highest expression of a Romantic and anti-classical will that views architecture as an event of nature."[20]

The apogee of Gaudí's roof designs is undoubtedly that of the Casa Milà. The surreal and magical atmosphere, based on the interplay of beautiful and strange three-dimensional volumes,

Antoni Gaudí i Cornet
Casa Milà, "La Pedrera" [quarry], facade, Passeig de Gràcia 92, Barcelona, 1906–10
The Casa Milà is often referred to as the greatest abstract sculpture, and indeed the impression is given of a giant hand developing to subdue and shape the mass. The immense facade, which looks like a sea frozen in motion, forms – as Gaudí himself succinctly put it – "the highest expression of a Romantic, anti-classical will that looks on architecture as a natural event."
(see note 20)

Antoni Gaudí i Cornet
La Sagrada Família, general view of the east facade, Calle Mallorca 402, Barcelona, 1882–1926 ff.
When the papal nuncio in Barcelona, Monsignore Ragonesi, visited the Sagrada Família in 1915, he called Gaudí a poet, to which Gaudí replied: "Who would not feel himself a poet at the side of the Church?"

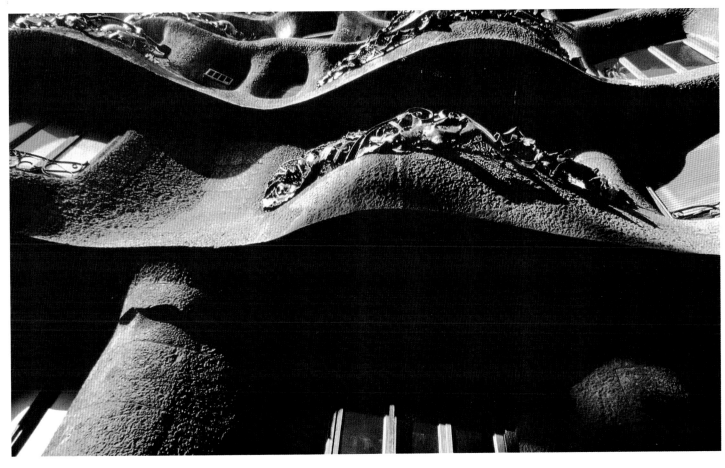

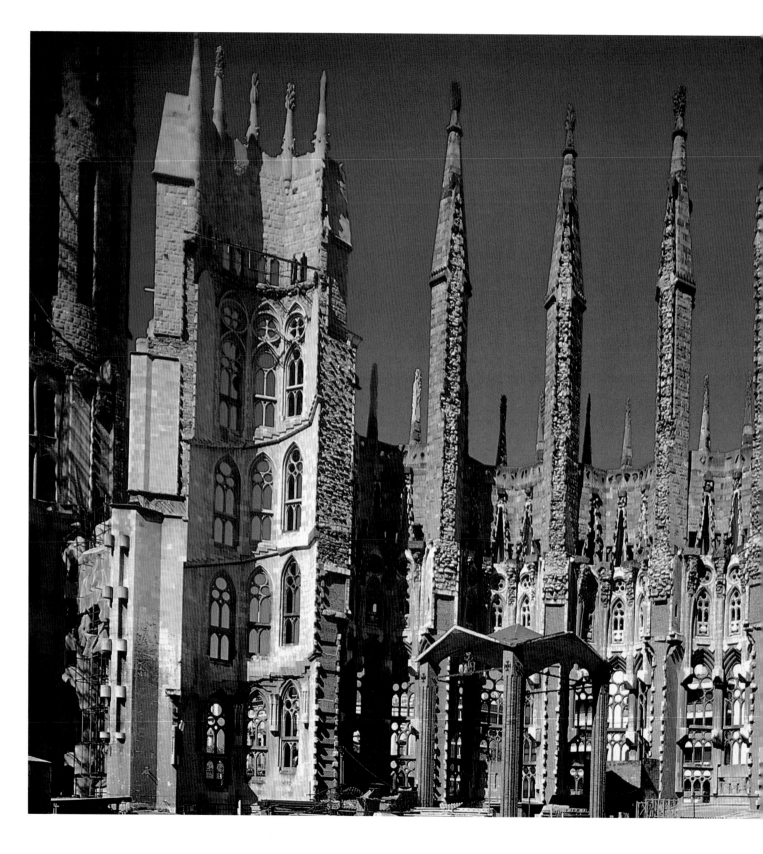

BARCELONA

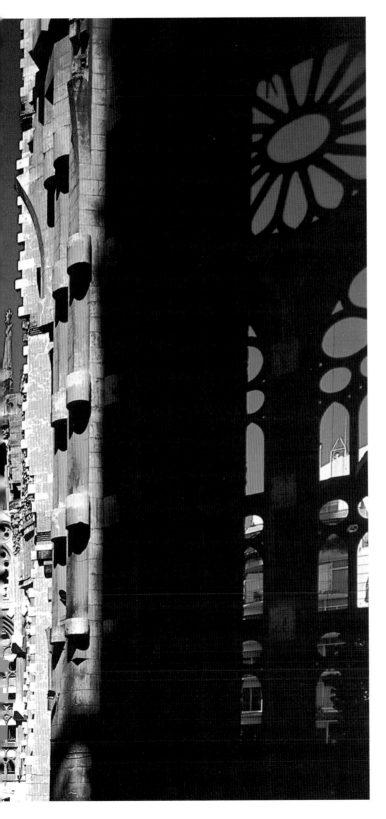

is reinforced by the idiosyncratic mobility of the ground and the various levels. This dramatic creation was, in the end, highly modern. It had no brick walls, no loadbearing walls and a variable ground plan, an "underground garage" and waste disposal unit – "organic" and user-friendly living at a time long before these misused catchwords came into fashion.

La Sagrada Família

Creative forces are the result of love.
J. Hillman[21]

The Sagrada Familia, Gaudí's life's work and devotion, touches people far and beyond any architectural curiosity (ill. left and p. 207). Moreover, the Temple Expiatori de la Sagrada Familia forms a separate chapter in the cultural history of Barcelona. The conception and construction of the building in the manner of a medieval building site has involved generations of architects and clients. Gaudí's legacy is a debit to the city and at the same time an opportunity, a stroke of luck, to follow in the tradition of such historic sites as Amiens, Santiago de Compostela or Cologne, whose cathedrals are moving witnesses of human faith and religious spirituality.

In 1883, Gaudí took over from the architect Francisco Villar the job of continuing the awe-inspiring project with all its religious symbolism. Financed almost entirely from donations, building work often came to a halt as funds dried up. Nonetheless, the model and construction plan were largely complete by 1906. The organization of the nave and vaulting is extraordinary, and is designed to obtain a modulated incidence of light and optimum acoustics. Gaudí's main concern was with the arrangement of the facade on the theme of the birth of Christ, in which the four tower spires with their parabolic profile provide such dynamism and at once such stability as to compel respect from every architect. The sculptural ornamentation of the building and the decorative schemes of the three portals – of Faith, Hope, and Charity – is a gripping and vigorous declaration of Gaudí's piety and attachment to nature. Scenes from the life of Christ are combined with plant and animal allegories and motifs. The reverent amazement of the master builder at the wonder of creation is in every detail of the architecture a parable of genesis in stone.

Toward the end of his life, Gaudí scarcely ever left his workplace, the site office of the Sagrada Familia. On one of his few journeys into the city,

Antoni Gaudí i Cornet
La Sagrada Família, interior of east facade, Calle Mallorca 402, Barcelona, 1882–1926 ff.
"One looked ... straight up into a grey sky. The columns with their tortoise bases and curved palm capitals, the sculptures of the ox and the mole, the animals and the flowers and the Christmas geese, the little birds fluttering around, the rustling leaves, living statues and depictions of stars emerged and vanished like waves spraying between steep cliffs. The parabolic, three-hundred-foot bell towers loomed in pairs over the three gables like stalagmites in a cave." (Kenji Imai, see note 22)

Page 211:
Juan Gris
Le paquet de café
(The coffee packet), 1914
Gouache, collage, and charcoal on canvas, 64.8 x 47 cm
Ulmer Museum, loaned by the Ministry for Family, Women, Further Education and Arts of Baden-Württemberg
It was the Catalans' very sense of belonging intellectually to Europe that made Modernisme – the Spanish term for Art Nouveau – possible. However, the style developed almost exclusively in Barcelona. To be a Catalan had immense importance for European art history in the 20th century: Pablo Picasso [sic], Juan Gris, Joan Miró, Salvador Dalí, Julio González, Antonio Tàpies, Eduardo Chillida – all of them represented the tradition of their native land.

he was run over by a streetcar and was carried – initially unrecognized – into Santa Cruz Hospital, after first aid was denied him because of his tramp-like appearance. His wish to die in hospital like the poor and neglected was granted him.

Six months after the fatal accident to "Don Antón", the Japanese professor of architecture Kenji Imai visited the cathedral, and his description shows how Gaudí was understood beyond all frontiers: "… the melancholy atmosphere, shrouded in gloom, was to be ascribed to the absence of the master. I nodded a greeting to a lad and went back to the site, which was wet with rain. On the site, among patches of grass, were the stone sculptures of the shell and the frog, about six foot in size, and in addition there were the spherical blocks covered with gilt glass mosaics. The northeast facade of the transept and northwest walls of the apse were complete, but not the vaulting. One looked therefore straight up into a grey sky (ill. p. 208). … I went on behind this facade and looked at the walls of the apse. There too were the sculptures of the giant snake, the frog, and the shell. I bid farewell to the rainy temple with sad heart, numb with pain."[22]

To return to origins, to the beginning.

The identification of hearing as the sense organ of faith and of the eyes as those of glory.

Fear is ignorance.

Discussion does not shed light. It just creates *amour-propre*.

The incompetent are cowards. They get nothing right, and that makes them bigger cowards.

Poverty and misery are two pairs of boots. The first leads to elegance and beauty, whereas wealth leads to opulence and complication.

Scientific matters are proven and taught by means of principles, facts by means of experience.

Only one kind of person is authorized to utter stupidities – a fool.

Art is beauty and beauty is the radiance of truth, without which there is no art.

Architects are rulers in the true sense of the word, since they find no ready-made constitution but must enact one. This is why great rulers are called the architects of nations.

Work is the profit on cooperation, and the latter is possible only on a basis of love. People should therefore stop sowing hatred.

Thoughts are not free, they are the slaves of truth. Freedom is not a matter of thinking but of willing.

The recorded words and thoughts of Antoni Gaudí, quoted from Isidre PuigBoada (ed.), *El pensament de Gaudí* …, in *Antoni Gaudí*, exhibition catalog, Barcelona – Munich, 1986.

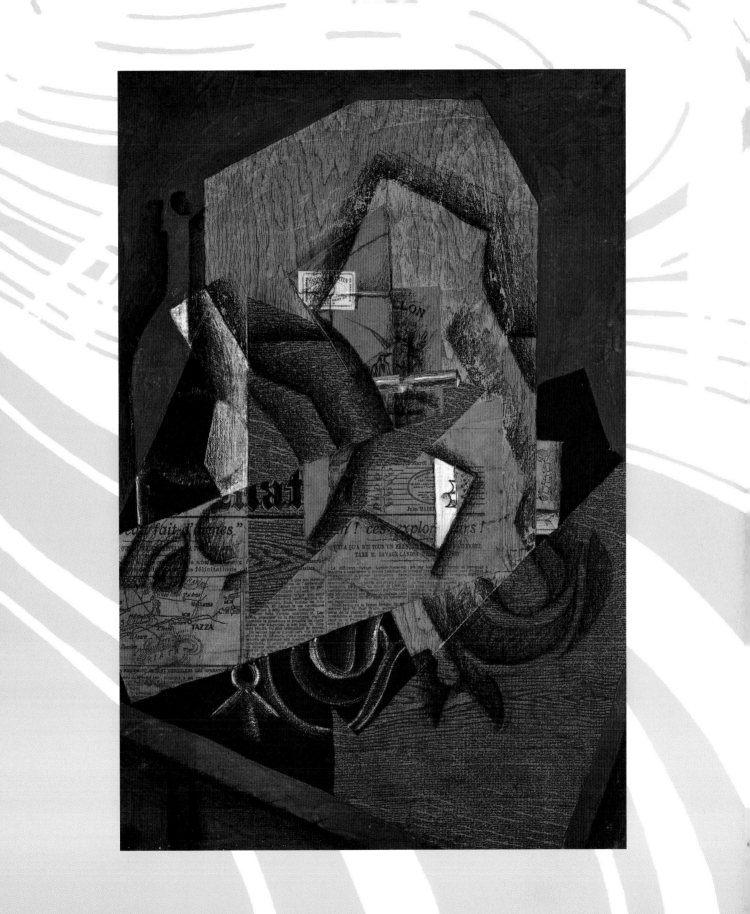

Capital of arts and crafts
Munich

Walls which ghosts still dare to stalk
Ground not yet contaminated by twofold poison;
City of the people and of youth!
Only where Our Lady's spires soar do we think ourselves
home.
Stefan George[1]

A youthful mood in southern Germany –
New Jugendstil, new lifestyle

"City of youth" – the poet Stefan George's
characterization of Munich around 1900 was
highly apt. It was the young generation, artists
and writers not yet or only just 30, who were the
source of all that was witty, frivolous, original,
and exciting. George was right, too, in acknow-
ledging Munich as the "city of the people"; of all
the new movements in art around the turn of the
century, that in Munich – broadly speaking, at
least – remained most closely linked with popular
handicraft tradition. This was undoubtedly due in
part to the atmosphere of ultimately peaceful
coexistence which reigned in Munich, to its
comfortable relationship with the arts, and to a
certain tolerance of rebellious youthfulness.
When tempers grew hot, it was usually due
more to the Bavarian character than to
fundamental differences of opinion. Even as the
Bavarian capital was pervaded by a general spirit
of new departure, it never ceased to affirm the
value of the traditional and the long-standing
alongside the modern, eyebrow-raising and new.
Munich had been spared the excesses of
Wilhelminian historicist pomp, and could start
calmly from the clear, refined classicism of Leo
von Klenze (1784–1864) and Friedrich von
Gärtner (1792–1847). The frenzy of industrial-
ization which had gripped other areas of
Germany in the 1870s had also passed by Munich.
Quietly confident of its own importance, the city

instead allowed its growth to follow a careful,
balanced, and unforced course. Positive factors
all in all, but ones which constantly threatened to
tip over into a certain complacency. The atmos-
phere which flowered in Munich for a while,
above all in the sphere of the applied arts, was
brilliant, full of energy and humor, and yet it was
supplanted after just a few years by a new
Biedermeier style. This boomerang in public
taste was the reflection of a certain mentality:
Munich lacked the private patrons from the
worlds of banking and industry, the upper middle
classes with their refined tastes and avant-garde
sympathies. The glittering artistic heights reached
under the Wittelsbach dynasty now lay in the
past. The "masters" of Munich Jugendstil (the
name given to the versions of Art Nouveau which
flourished in German-speaking Europe) – Peter
Behrens, Otto Eckmann (1865–1902), August
Endell (1871–1925) and Bernhard Pankok
(1872–1943) – packed their bags; if they were to
realize their dream of the total work of art and of
industrial design imbued with artistic value, they
needed "arts managers" such as those in Berlin,
and liberal-thinking potentates such as Grand
Duke Ernst Ludwig of Hesse. Munich, by
contrast, harbored a "latent apathy" according to
the spokesman for the new style, Hermann
Obrist, who also criticized the "distinctive odor
of southern German leisureliness". "Munich is
studded with precious stones of which it takes
no more notice than gneiss its garnets.
Something so far ahead of its time as the new
structural and decorative art (not to be confused
with modern applied art), the new psychological
understanding of art, the new direction of art
teaching – such passionate earnestness, in short,
simply cannot flourish in the soil of southern
German leisureliness[2]." Thus complained an

Hof-Atelier Elvira, facade,
exhibition poster (detail),
1977
Color reconstruction
Designed by Gottfried von Haeseler

August Endell
Hof-Atelier Elvira, facade,
Von-der-Tann-Strasse 15, Munich,
1896–97
The National Socialists chipped off
the colorful facade ornament in
1937, and in 1944 the main body of
the building was bombed.
"Sometimes a building stands out
from the ranks of the ordinary, the
work of a highly imaginative young
architect, expansive and curvaceous,
adorned with bizarre ornament, full
of humor and style."
(Thomas Mann, see note 7)

abstract painting in Munich in 1910, Obrist had
already explored formal principles and theories
which lay very close to a nonrepresentational
philosophy of art.

Munich shone!

*... Her (Munich's) deep-seated artistic culture is less
intellectual than sensual; Munich is the city of the applied
and indeed the festively applied arts, and the typical
Munich artist is always a born master of ceremonies and a
reveler.*
Thomas Mann[3]

"Art is in full bloom, art holds sway, art stretches
her rose-garlanded scepter out over the city and
smiles. Prevailing on all sides is respectful
participation in her propagation, is diligent,
devoted exercise and propaganda in her service,
is faithful cultivation of line, ornament, form,
senses, beauty ... Munich shone. A brilliant
banner of blue silk spanned the skies above her
splendid squares and white-columned temples,
her antique-style monuments and Baroque
churches, and the bubbling fountains, palaces,
and parks of her Residence. Her sweeping,
harmonious vistas, flooded with light and
trimmed with green, basked in the sunny haze
of a first fine June day."[4] For Thomas Mann,
Lübeck represented the "intellectual" and
Munich the "sensual" aspects of life, in the
same principle of antithesis as found in his story
Tonio Kröger. Mann, too, felt the impact of
Munich and the Jugendstil artists based there,
with their "faithful cultivation of line". Both as a
city and above all as a center of the arts *per se*,
Munich had always represented a total work of
art, and it was eager to absorb new ideas. In his
Betrachtungen eines Unpolitischen (Obser-
vations of an Unpolitical Man), Thomas Mann
writes: "My own experience, however ... was
the 'degeneration' of middle-classness in the
genuine old-fashioned sense into the sub-
jectively artistic: an experience and a problem of
overcultivation and training, not of sclerosis ... In
short: what I experienced and created – but I
experienced it only as I created it – was also a
development and modernization of the common
man, albeit not his development into a bourgeois,
but his development into an artist."[5]
Munich had grown young, and the fact that
Jugendstil (literally "youth style") took its name
from a new Munich-based art magazine entitled
Jugend (Youth) was relatively insignificant.
Accompanying its "youth style", Munich had
created a new lifestyle (ill. opposite page). The

angry Hans Rosenhagen in his famous article of
1902, *Münchens Niedergang als Kunststadt*
(Munich's Decline as a City of Art) – an issue still
current today. To go into a decline nevertheless
implies that Munich had previously experienced
a boom as a centre of the arts. The Munich brand
of Jugendstil around 1900 was distinguished
not simply by its high standard of quality and
national, independent character, but also by its
modern, international format. Indeed, one of its
artists – Hermann Obrist – would sow the seeds
of a new art which would ultimately grow into
the *Blaue Reiter* (Blue Rider). Some 15 years
before Wassily Kandinsky arrived at his first

Ludwig von Zumbusch
Cover of *Jugend*, II, vol. 40,
1897
Color lithograph, 29 x 22.5 cm
"And of women a host / who
captivating us enslave us / One with
flowing hair / Another beautiful as
she dances."
(Stefan George, *Teppich des
Lebens*, 1900)

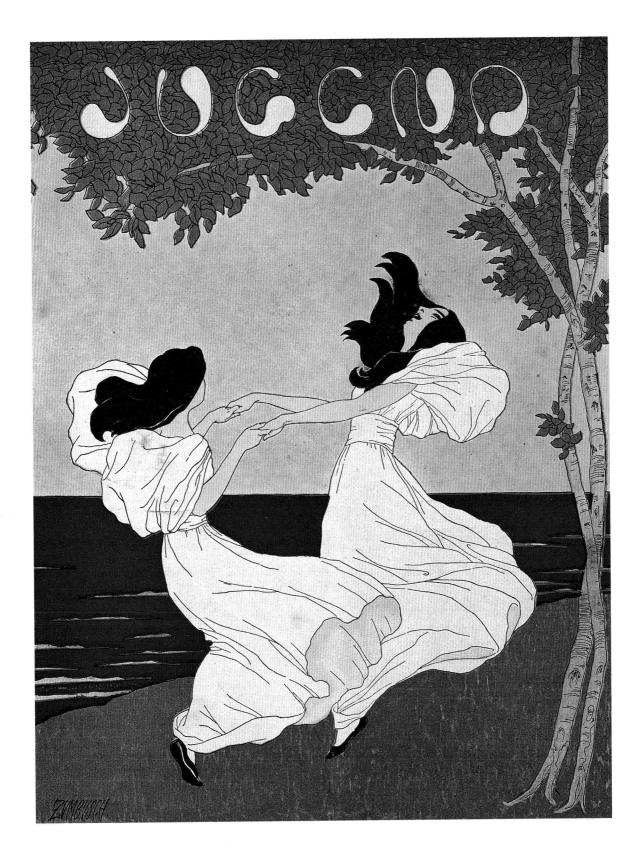

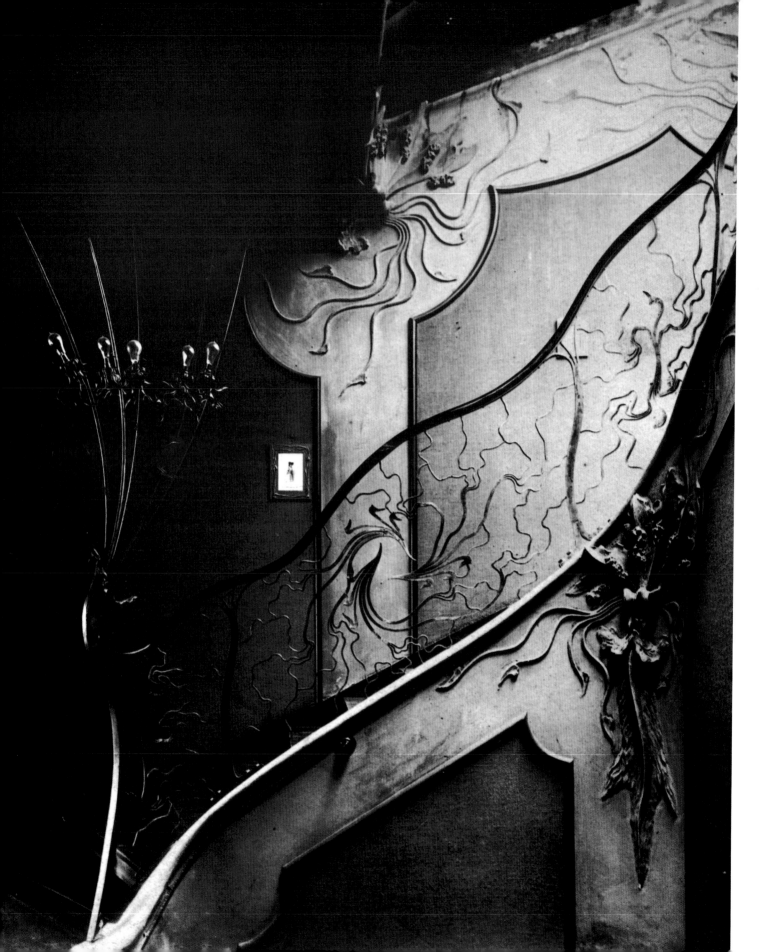

August Endell
Chest, detail of the decoration, 1899
Tin-coated Elm, iron,
45 x 136 x 74 cm
Made by Wenzel Till and Reinhold
Kirsch, Munich
Münchner Stadtmuseum
Endell's furniture designs, with their
powerful, bizarre, often sinuous
vocabulary of forms harboring a
fantastical world of detail, are
particularly impressive.

Richard Riemerschmid
Jug with pewter lid, 1903
Stoneware, salt glaze, painted relief
decor, pewter lid, 18.2 cm high
(without lid)
Made by Reinhold Merkelbach,
Grenzhausen Münchner
Stadtmuseum

city owed its carnival atmosphere to the international members of Bohemian society who came here to party: budding and unrecognized geniuses, demonic Serbs, elegant Poles, brooding Russians and other extraordinary characters, above all "ladies who painted" and artist upon artist upon artist ... It had become the fashion to go to Munich. As Pablo Picasso recommended to a painter friend in a letter: "If you want to learn something, go to Munich!" Munich gave modernism a stage – a stage for modern art, modern literature, and modern living.

August Endell – "Ornamental frenzies"

The goal of all the arts is beauty. And beauty is nothing other than the intense, intoxicating joy which is produced in us by sounds, words, shapes, and colors.
August Endell[6]

The year 1896 was a magical one for Jugendstil. It was the year of *Jugend* and *Simplicissimus*, and the year in which the "cheeky monster" on the facade of the Hof-Atelier Elvira made it impossible to ignore modernism in Munich. "Sometimes a building stands out from the ranks of the ordinary, the work of a highly imaginative young architect, expansive and curvaceous, adorned with bizarre ornament, full of humor and style"[7] (ill. p. 214). Thomas Mann was not entirely accurate in assigning Endell to the architectural profession, since Endell had in fact studied philosophy and psychology. He had been particularly intrigued by Theodor Lipp's lectures on the theory of empathy, which concerned itself with the psychological impact of external impressions – the reactions prompted by lines of a different direction and shape, for example. Under the influence of Lipp's teaching, in 1896 Endell developed an entirely new theory of art, which he aired in an article about an art exhibition. "Someone, however, who has learnt to surrender to the impressions received through his eyes entirely without associations, free of

peripheral thoughts, someone who has felt, even just once, the emotional impact of shapes and colors – that person will discover therein an inexhaustible fount of extraordinary and unimagined delights. In truth, a whole new world opens up before us. And the moment at which our understanding for these things awakens for the very first time should be a major event in everyone's life. It is like an ecstasy, a delirium that comes over us. Joy threatens to obliterate us, the excess of beauty to suffocate us. Someone who has not had this experience will never understand fine art. Someone who has never been sent into raptures by the exquisite swaying of a blade of grass, the wondrous implacability of a thistle leaf, the austere youthfulness of burgeoning leaf buds, who has never been seized and touched to the core of his being by the massive shape of a tree root, the imperturbable strength of split bark, the slender suppleness of the trunk of a birch, the profound peacefulness of an expanse of leaves, knows nothing of the beauty of forms."[8]

Hof-Atelier Elvira

Endell, like so many of the great "architects" of Art Nouveau, was a self-taught architect. His "amateur" building nevertheless served to trumpet the opening of the Munich Jugendstil "season" (ill. p. 214). It was through Hermann Obrist that Endell obtained the commission for the Hof-Atelier Elvira from two unusual women: the feminists Sophia Goudstikker and Anita Augspurg. Together, the three outsiders caused a sensation in a Munich that was still dominated by the Old Masterishness of painters such as Franz von Lenbach.
There was plenty to fuel the gossip, since this free, entirely abstract creation had arisen on the instigation of two women who wore rather mannish clothing and were politically active – a scandal in every respect. It is illuminating to note

Richard Riemerschmid
Mug with pewter lid, 1902
Stoneware, salt glaze, relief decor,
pewter lid, modelling,
15.2 cm high (with lid)
Made by Reinhold Merkelbach,
Grenzhausen

Opposite page:
August Endell
Hof-Atelier Elvira, stairs to the
second story, 1896–97
Endell also designed the entire
interior decor of the studio in a
highly individual decorative style.
He paid particular attention to the
lights, which, in the stairwell, for
example, grow out of the banisters in
the shape of flowers.

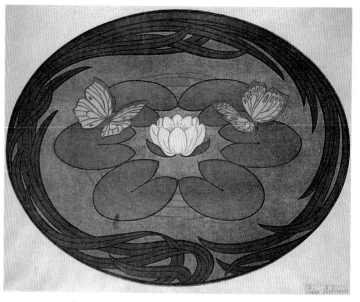

Hermann Obrist
Tree in Blossom wall hanging
(detail), ca. 1895
Satin stitch and rope stitch in silk
on silk rep, 321 x 210 cm
Made by Berthe Ruchet
Die Neue Sammlung, Staatliches
Museum für angewandte Kunst,
Munich
In 1896 Obrist fascinated the art
world with an exhibition of
embroideries designed by himself
and executed by Berthe Ruchet. The
impact of the exhibition was felt far
beyond Munich, and Obrist's works
were lauded by the critics as "the
birth of a new applied art".

that, once again, the so-called "weaker sex" had
proved responsible for one of the most unusual
artistic achievements of the late 19th century,
just as was the case with Charles Rennie
Mackintosh and Hector Guimard. The dragon
design on the facade also contained echoes of
oriental imagery, and the forms of nature
described with such feeling by Endell seem here
to come to life. The facade of the building was
originally green, while the ornamental elements
were painted a different color every year, for
example, yellow or cyclamen red. The sculptor
Josef Hartwig (1880–1956) describes the
execution of the facade ornament in his
memoirs: "... The next day I stood in front of the
new building housing the highly fashionable
'Elvira' photo studio in von-der-Tann-Strasse,
drew a Jugendstil dragon, 13 m wide by 7 m high,
on to the facade through three levels of scaf-
folding, and requested a plasterer to mix the
mortar for the next stage. ... Endell explained its
[the design's] shapes and structures as relation-
ships to nature, to a peach kernel, to fluttering
ribbons or waves rippling over a beach, etc ... the
dragon continued to shimmer for many years in
ghostly silhouette, as an immortal work on the
facade, so to speak."[9]

Endell's work of art would prove all too mortal,
however. In 1937, Nazi Oberbürgermeister
Fiehler ordered the "hideous facade disrupting
the character of the rest of the street"[10] to be
removed, so as not to offend the eye of the
Führer on the Day of German Art, the day on

which Hitler's temple of art, the Haus der
Deutsche Kunst (House of German Art), was to
be inaugurated. The rest of the Hof-Atelier Elvira
was subsequently bombed in 1944.

Endell also designed the entire interior decor of
the studio in a highly individual decorative style
(ill. p. 231). He paid particular attention to the
lights which, in the stairwell, for example, grow
out of the banisters in the shape of flowers (ill.
p. 216). Endell's furniture employs powerful, bizarre,
often sinuous forms harboring a fantastical world
of detail (ill. p. 217). He never copies specific
models from nature, yet we seem to recognize
organic structures – millipedes, waving grass,
snow-capped mountains?

As well as being an artist, Endell was also an
important writer on the art of the 20th century.
He was closely linked with Stefan George's circle
and was himself the author of works of poetry.
He had few pupils, since his extremely
individualistic style was hard to pass on to
others. One Munich artist influenced by Endell
was Gertraud von Schnellenbühel, whose
extravagantly interlacing lines came close to his
own. Her masterpiece, a candelabra with 24
arms, was purchased by Hermann Obrist,
Endell's mentor (ill. opposite page).

Endell left Munich in 1901 and returned to his
native city of Berlin. Here he executed numerous
further commissions, which – after a sensational,
brilliant start – remained rather more respectably
conventional.

Peter Behrens
Waterlilies, 1897
Color woodcut, 51.5 x 65 cm

Opposite page:
Gertraud von Schnellenbühel
Candelabra, 1910–13
Silver-plated brass, 48.5 cm high
Münchner Stadtmuseum
Gertraud von Schnellenbühel was
influenced by Endell, and came close
to him in her use of extravagantly
interlacing lines. Her masterpiece,
this candelabra with 24 arms, was
purchased by Hermann Obrist,
Endell's mentor.

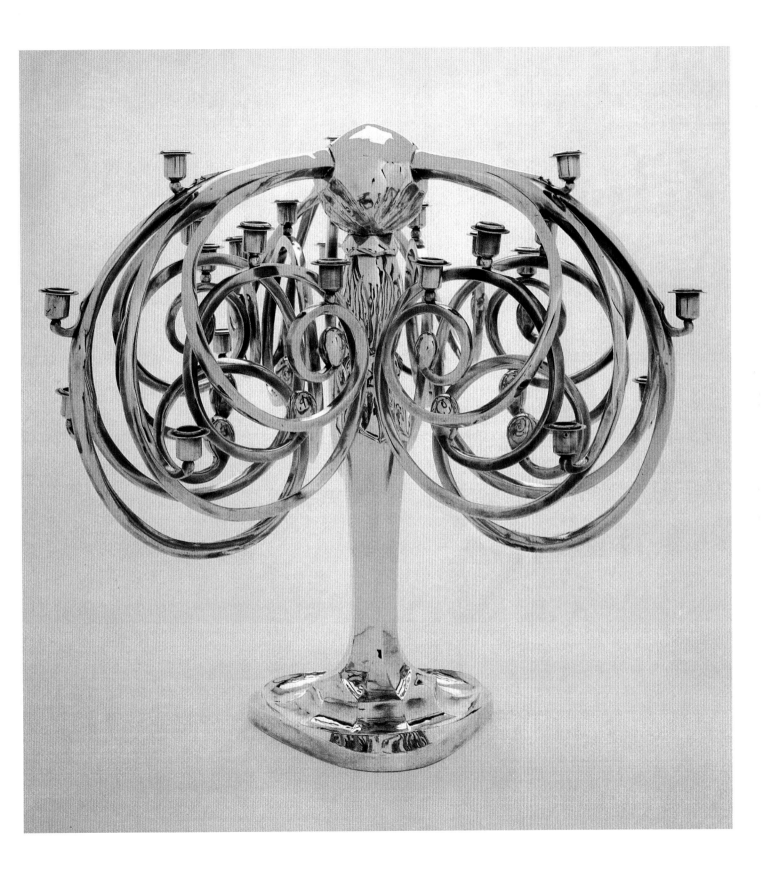

"Blessed be the spiral" – Hermann Obrist

Not just curving lines, but forms – sculptural, physical forms whose outlines are defined by beautiful curves. Intensification of the power of the curve by intensifying the power of the stroke, the force of the pressure, the crescendo of the curve thickness, the breadth of the stroke.
Hermann Obrist[11]

"The starting point for my work was the embroidery of Hermann Obrist, where I encountered for the first time forms that were organically freely invented, not constructed from without."[12] Thus Endell fully acknowledged the visionary Obrist as the inspiration for his own art. The works which Obrist created appear to us today as ciphers of modern art; in conjunction with his brilliant rhetoric, they exerted their influence on the entire circle of Munich artists: Pankok, Paul, Eckmann, Schmithals, and even Behrens. Obrist encapsulated his artistic aims in a single elementary form, or more accurately, an elemental movement: the helix or spiral. "Beatitudinous spirals: the spiral of the blossoming tree, the spiral of the blazing tree, winding spirals, tornadoes, lianas, wisteria, wild vines, staff trees."[13] The key figure in the Munich art scene at the end of the 19th century did not restrict himself to theory, however. In 1896 Obrist fascinated the art world with an exhibition of embroideries designed by himself and executed by Berthe Ruchet. The impact of the exhibition was felt far beyond Munich, and

Obrist's designs were lauded as "the birth of a new applied art"[14] (ill. p. 218). With Berthe Ruchet, his mother's former companion, Obrist had founded an embroidery workshop in Munich with the inheritance he had received upon his mother's death. This allowed him the financial freedom to dedicate himself to his art. The son of a Swiss doctor and a Scottish noblewoman, Obrist initially studied medicine and natural sciences, devoting himself to botanical research and the writings of Darwin, Haeckel, Fechner, Schelling, and Fichte. A protracted middle-ear infection left him with a hearing impairment which at the same time encouraged him to develop his visual faculties. During a semester in Berlin, he had a visionary experience on Peacock Island in Potsdam, when an inner voice said to him: "Leave everything and fashion this."[15] The decision to devote himself entirely to art was made. Obrist notched up his first successes in 1889 at the World Exposition in Paris, where he exhibited ceramic works and furniture (ill. opposite page, below). He also attracted attention at the Munich Glass Palace exhibition of 1897, again with furniture. It is Obrist's sculptural designs and his drawings which – bordering on sheer abstraction – most convincingly embody his revolutionary aesthetic ideas, far ahead of their day (ill. opposite page, above). It is not surprising, then, that he became friends with Kandinsky. The centrifugal forces of Obrist's work, and his fundamental insistence

Hermann Obrist
Design for a monument,
ca. 1895
88 cm high
Kunstgewerbemuseum, Zurich
It is Obrist's sculptural designs and
his drawings which — bordering on
sheer abstraction — most
convincingly embody his
revolutionary aesthetic ideas, far
ahead of their day. It is not
surprising, then, that he and
Kandinsky became friends.

Hermann Obrist
Chest, metal fittings, 1897
Oak, wrought iron,
46 x 132 x 61 cm
Made by Johann Zugschwerdt and
Reinhold Kirsch, Munich
Münchner Stadtmuseum
"Every piece of furniture must be
built first and foremost in line with
its function, and any decoration
must be subordinate to construction
and functional form; it may never, as
in Renaissance and Baroque
furniture, grow profuse and exist
only as an end in itself."
(Hermann Obrist, *Neue
Möglichkeiten in der bildenden
Kunst*, Leipzig 1903)

that the goal of art was not nature, but its dynamism, are also found in the work of the great Catalan architect Antoni Gaudí – in the roof ornament of the Casa Milà, for example. Obrist's ideas thus point to the future, yet simultaneously encapsulate the spirit of the age. His "disciple", the painter Hans Schmithals (1878–1964), translated Obrist's thinking into his pastels: "a file of will and yearning sweeping up the mountain sweep and rush. Centrifugal spiral nebulous"[16] (ill. opposite page).

Munich Jugendstil was not a unanimous style, but comprised two different artistic trends which existed alongside each other and which were not in fact as divergent as they are often made out to be. "We recognize that the naturalists and the champions of absolute ornament are not two groups, since in both naturalism (floralism) and the absolute line there is an equal propensity toward stylization, and in line an equal tendency toward imaginative multiplication. Hermann Obrist can be credited with having recognized and portrayed this. He may be seen as the founder of a new theory, which showed modern art the way."[17] Both ornament as a form of individual expression and the abstract, functional line ultimately have a common contemplative starting point.

The Secession and the "snake painter"

Many paradoxes, Nietzsche in the air. Celebration of the ego and the desires. Libido without limitation. New ethos.
Paul Klee[18]

The art world of the 1870s and 1880s in Munich can be summed up in the name of Franz von Lenbach, an imperious authority whose dominion only began to be questioned with the arrival of a new "prince of painters". In 1889 Franz von Stuck exhibited his *Guardian of Paradise* in the Munich Glass Palace, eliciting a storm of applause – and indignation. Writing about the radiant angelic youth with the bared, muscular arms in his monograph on von Stuck of 1899, Otto Julius Bierbaum recalled: "It created a glaring hiatus within the room, and all eyes turned to it. Amidst the painstaking details of its naturalism, one sensed ... that here was something new, something tumultuous, something fuller, promising greatness ... an angel – but at the same time Hellas, *plein air* – but not from Dachau."[19] From the sumptuous interior of his palazzo on Luisenstrasse, completed that same year, Lenbach thundered his reaction in true Bavarian fashion: "Let him publish his stupid

caricatures in the gutter press, confound it! What a brat! ..."[20] The "brat" was the highly talented son of a miller from Tettenwies in Lower Bavaria, who realized his dream of becoming an artist and who gained initial recognition with his drawings – which did indeed include some caricatures. Stuck was an unruly "natural" who succeeded nevertheless in breaking into the established art scene – a Secessionist rebel who later became a professor (in 1895) and was ultimately elevated to the nobility (in 1906). In order – after this first shock – to undermine Lenbach's all-powerful position as art dictator yet further, and to provide a mouthpiece through which to speak out against the historicism propagated by the art establishment, in April 1892 more than a hundred artists formed the Verein bildender Künstler Münchens (Munich Association of Fine Arts), to which title they added – so as to emphasize its separatist character – "e.V. Sezession" (Inc. Secession). The association included numerous well-established artists, as well as representatives of the avant-garde such as Stuck and Behrens. Lenbach dismissed them all as "criminals" and "modern rogues". The "rogues" would subsequently give him a lot of trouble. The first international exhibition by the Secession was staged during the summer of 1893, not without difficulty. Lenbach did everything in his power to boycott the exhibition and used his position to set officialdom against the upstarts. Despite such resistance, the exhibition was an

Franz von Stuck
Faun playing the Panpipes by the Sea, 1914
Oil on wood, 70 x 79 cm
Museum Villa Stuck, Munich
Stuck also lent visual translation to
Henri Bergson's Pan philosophy.
Not only did he design the logo for
the magazine *Pan*, but he
demonstrated in his painting his
penchant for fabulous creatures,
fauns, centaurs, and Sileni.

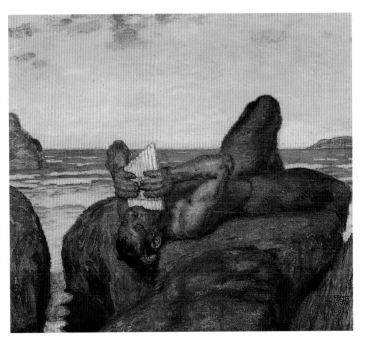

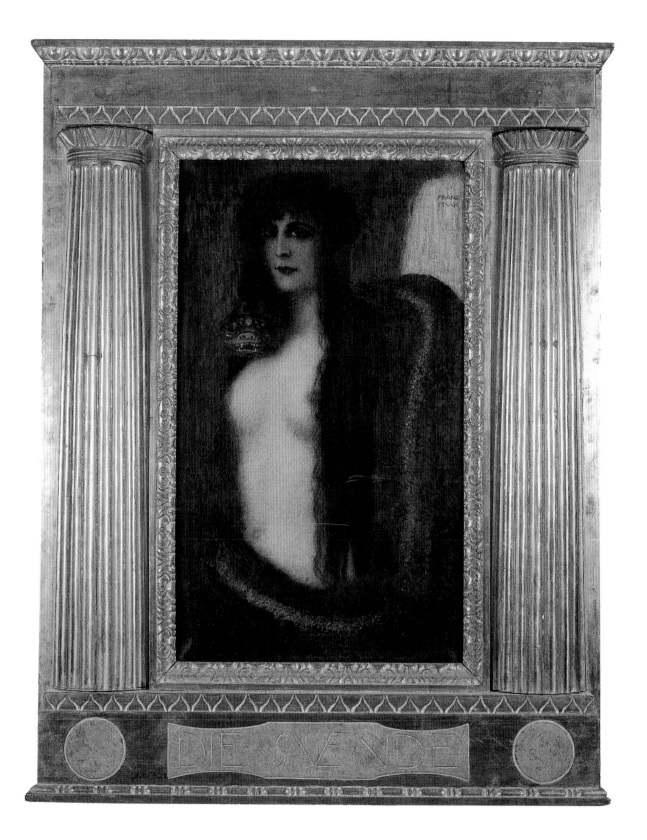

indisputable success, and the next scandal was not far behind. That same year Stuck exhibited a painting that aroused the whole city: *Sin* (ill. opposite page). "At least five times Franz Stuck painted this luscious woman with her jet-black ringlets, her white flesh offering the viewer such a pleasurably perverse contrast to the evil gleam of the snake draping itself around her. She was variously known as *Sensuality*, *Vice* or simply *Sin*, and she documented the much-vaunted sovereignty of the artist who chooses beauty and despises middle-class morality. Strangely, it was largely the members of this latter section of society who thronged beneath her gaze in the Glass Palace."[21] *Sin* heralded the arrival of a new style, and Stuck thereby made his own contribution to the iconology of the female sex – not as worthy, upright, honest woman, but as an eternally naked, shimmering and glittering creation of nature, a prehistoric animal, closely related to the snake and the cat. Here the "Nietzsche in the air" entry in Klee's diary comes into play, with its eulogization and metaphorical discussion of the magnificent beasts. Stuck, the "creative genius in his titanic artistic powers, his healthy sensuality", the "beacon of the Secession which is opening up new worlds"[22], went on to build his own "palazzo" on Prinz-regentenstrasse during 1897 and 1898. As traditional (and certainly not Jugendstil) as it may seem, the Villa Stuck is nevertheless a splendid example of a house, built by an artist, which sought to correspond to the artistic ideal of its day – perhaps Jugenstil in the ideological sense, after all. Traces of the international Art Nouveau style can be found in frieze sequences of floating, arabesque dancers, in the masonry, and in bronze statuettes (ill. right). Stuck also lent visual translation to Henri Bergson's Pan philosophy. Not only did he design the logo for the magazine *Pan*, but demonstrated in his painting his penchant for fabulous creatures, fauns, centaurs, and Sileni (ill. p. 221).

The *grand seigneur* with the paintbrush became the social hub of a self-created Arcadia in Munich, the Athens on the Isar. This frequently causes his truly groundbreaking achievements to be overlooked. "Much of what is taken for granted [in modern painting] today can be traced back to his [Stuck's] initiative and example."[23] In 1895 Stuck was appointed professor at the Munich Academy, where his pupils included Paul Klee, Wassily Kandinsky, Josef Albers and Hans Purrmann.

Munich's Montparnasse – The Decadent Movement and Symbolism

The Virgin smells the lily, the fragrant symbol of virginity, and thinks as she does so of the latest symbolic cauliflower.
The cauliflower has a paradigmatic, poetically mystical meaning: it represents the secret love of the Symbolists.
Text accompanying a caricature by Carl Strathmann[24]

The sense of a new departure pervading the fine arts manifested itself in Secessions. Similar trends can also be identified in literature, albeit under different names. The cult of beauty, aesthetic overrefinement, and satire offered alternatives to the reigning literary conventions. Although not, in Germany, the protagonist of the latest artistic trends, the art of words nevertheless also embraced various forms of expression. In the legendary Schwabing district of Munich, the poet Stefan George became a dominant figure early on. Quite apart from his own activities as a writer, he also translated from French into German the literature and poetry of the Decadent Movement and Symbolism – themselves containing all the themes of literary and visual Jugendstil – as well as some of Ruskin's writings. George thereby served as the agent of Symbolist word painting and the Pre-Raphaelite cult of beauty.

One Munich painter inspired by the Symbolists, and in particular by Bernard Khnopff (1858–1921), was Carl Strathmann. In addition to paintings rhythmically characterized by textile patterns, and as typical of so many of his Munich colleagues, he also executed satirical cartoons. His most famous picture, however, is *Salambo* (ill. p. 224), of which Lovis Corinth wrote in 1903: "Soon, however, the model was sent home, and [Strathmann] gradually covered his Salambo's nakedness with more and more rugs and fantastical garments of his own invention, so that by the end only a mystical profile and the fingers of one hand peeped out from amongst a profusion of ornamental fabrics ... Real colored stones sparkle all over the picture; the harp in particular glitters with imitation gemstones, glued or sewn on to the canvas with extra-ordinary skill."[25] The eccentric Strathmann fitted happily into the avant-garde set which had assembled in Munich.

Stefan George became the center of his own set on Munich's "Montparnasse". Writing about this circle some years later, Max Halbe explained: "It was as if someone had taken orchids, chrysanthemums and heliotrope, and bound

them up into a peculiar, disparate bouquet. But this was precisely the idea behind the programme as a whole: our goal and our declared aim was the strange, the strident, the bizarre, the grotesque, the decadent, the *fin de siècle*."[26] The George circle comprised both major names such as Karl Wolfskehl, Frank Wedekind, and Otto Julius Bierbaum, and minor figures such as the attractive youth Maximin. Virtually a group or class within themselves were the "mad Countess" Franziska zu Reventlow and Lou Andreas-Salomé. In an article entitled *Viragines oder Hetären* (Viragos or Hetaerae [courtesans]), the Countess called for the liberation of women as sexual beings and at the same time, as a child of Bohemian society, made clear her dislike of the Suffragettes. "It is only a short step from loose-fitting dresses to women breathing through gills."[27] Lou Andreas-Salomé wrote a book on Nietzsche and was a close friend of Endell, with whom she spent a summer in Wolfratshausen, staying with Rainer Maria Rilke. She and the poet became lovers. Rilke's work is to a large extent pure Jugendstil, and if one understands religion as something flowing and vague, his *Stundenbuch* (Book of Hours) can be read as a theology of Jugendstil.

Caricature and illustration – *Simplicissimus* and *Jugend*

Can we delight in life? It is so old and flat. /
We must lend our times new vigor. Youth calls on us to act. /
The world will be not be cured with blazing fire or knives, /
But painlessly improved – by being stylized.
Simplicissimus[28]

Like the circle around Stefan George, the group which formed around the publisher Albrecht Langen and his *Simplicissimus* was similarly heterogeneous. The magazine – another child of 1896 – undoubtedly owed part of its celebrity to the scandals which it regularly caused. At the same time, however, it has secured itself a prominent place in the history of caricature and Jugendstil illustration (ill. opposite page). The caricature is stylistically characterized by extreme elongations and contractions of line, and the virtuoso linear acrobatics performed by the graphic artists of Jugendstil lent enormous bite to socio-critical satire. Bruno Paul (1874–1968) and Eduard Thöny (1866–1950) were amongst the brilliant cartoonists contributing to *Simplicissimus*, while from 1902 Thomas Theodor Heine found himself rivalled for the

Carl Strathmann
Salambo, ca. 1894
Oil on canvas, 187 x 287 cm
Kunstsammlungen zu Weimar, Schlossmuseum
"Soon, however, the model was sent home, and [Strathmann] gradually covered his Salambo's nakedness with more and more rugs and fantastical garments of his own invention, so that by the end only a mystical profile and the fingers of one hand peeped out from amongst a profusion of ornamental fabrics ... Real colored stones sparkle all over the picture; the harp in particular glitters with imitation gemstones, glued or sewn on to the canvas with extraordinary skill."
(Lovis Corinth, see note 25)

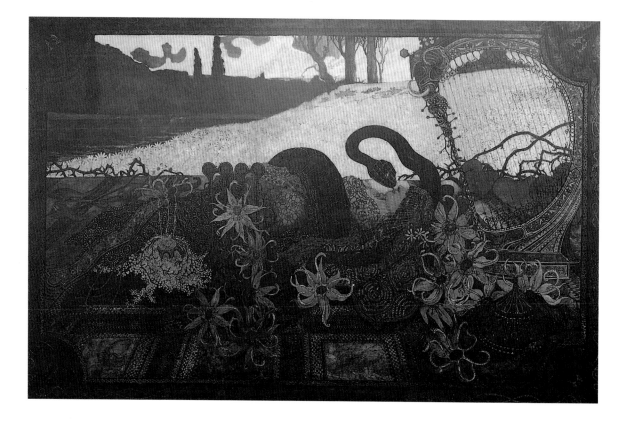

Bruno Paul
The Munich Fountain of Youth
Illustration from *Simplicissimus*,
no. 1250, 1897
Pencil and wash on paper,
38.1 x 60.4 cm
Staatliche Graphische Sammlung,
Munich

Simplicissimus, founded in 1896, owed part of its celebrity to the scandals which it regularly caused. At the same time, however, it has secured itself a prominent place in the history of caricature and Jugendstil illustration. The caricature is stylistically characterized by extreme elongations and contractions of line, and the virtuoso linear acrobatics performed by the graphic artists of Jugendstil lent enormous bite to socio-critical satire. Bruno Paul was amongst the brilliant cartoonists contributing to *Simplicissimus*.

position of top caricaturist by the Norwegian Olaf Gulbransson, with the latter's unmistakable sweeping stroke and economy of outline (ill. p. 212). The extraordinarily multi-talented Heine (1867–1948) can nevertheless be considered the true inventor of the *Simplicissimus* style. Before becoming a master of satirical illustration, he had originally devoted himself to landscape painting. As a bitter opponent of Germany's radical right – something which earned him various spells in jail – he placed his artistic skills in the service of political satire (ill. p. 226). His talent for parody led him to become involved with the political cabaret *Die Elf Schafrichter* (The Eleven Executioners), for which he designed numerous posters. Heine was a consummate master of the art of reducing images to their essentials and then rendering them in what appears to be one single flowing line. This economy never resulted in a loss of elegance, however. Heine's small sculptures also

have a graphic quality and are masterpieces of succinctly soft modulation; one example is his *Devil* (ill. p. 227), one of his favorite subjects. His streamlined linear style is most clearly illustrated in his inimitable vignettes for the magazine *Pan* (ill. p. 261).

Jugend, the journal which unintentionally gave its name to the German version of Art Nouveau, did not follow an ideological agenda and was first and foremost an illustrated magazine of unfortunately anti-Semitic and nationalistic inclination. Its contribution to Jugendstil lay in its publication of color illustrations by Hans Christiansen and ornamental vignettes by Otto Eckmann, as well as drawings by French artists. Christiansen moved to Darmstadt in 1899, while Eckmann went on to become one of the leading names in the applied arts. Having begun his career as a highly regarded Symbolist painter who won numerous prizes and awards, he was subsequently

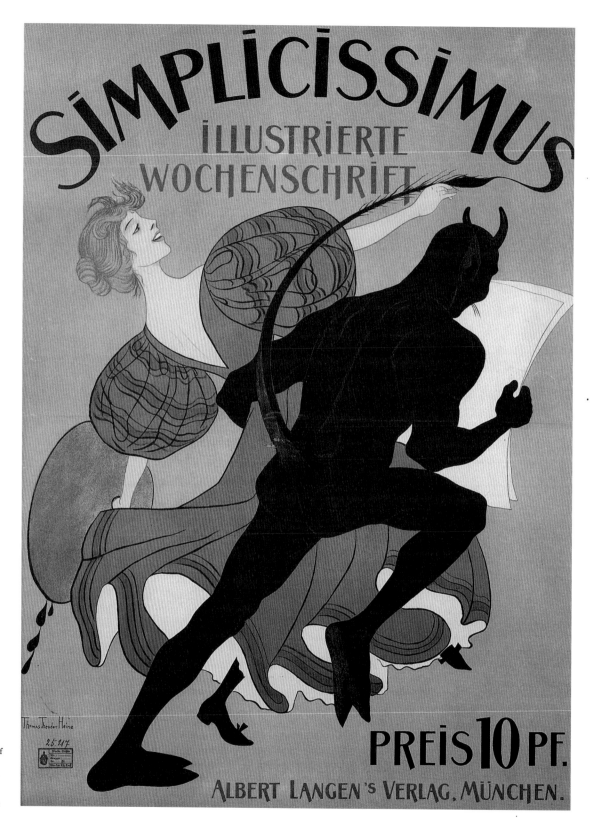

Thomas Theodor Heine
Poster for *Simplicissimus*, before 1900
Color lithograph, 79 x 59 cm
Heine was a consummate master of the art of reducing images to their essentials and then rendering them in what appears to be one single flowing line. This economy never implied a loss of elegance, however.

influenced by Japanese prints and turned first to the graphic arts and then to the applied arts. Within no time at all he was executing designs for ceramics, jewelry, metal and silverwork, furniture, glass, tapestries, and ladies' clothes. The metalwork items which he showed at the art exhibition in the Munich Glass Palace in 1897 were entirely new. In all of these fields Eckmann demonstrated his ability to shape line and plane into ever new vegetal decorative forms (ill. p. 228). As one of the most important contributors to *Pan* and the Darmstadt artists' colony, he too left Munich and devoted himself increasingly to typography; it was he who designed the Eckmann typeface and the most beautiful of the Jugendstil numbers, the seven, for the eponymous weekly paper of the same name (ill. p. 228).

Another Munich-based journal, *Die Insel* (The Island), founded in 1899, was closely linked with illustrational art right from the start. Alfred Walter von Heymel (1878–1914) and his cousin Rudolf Alexander Schröder (1878–1962) decided to publish a magazine that "would mark the start of something new in Germany[29]." They succeeded! Heymel had earned valuable experience as joint publisher of *Pan*, and now set up his own editorial offices in his apartment, exquisitely furnished by Schröder and Heinrich Vogeler – an appropriate environment for the wealthy Heymel. The quarterly appeared for only three years, but it numbers amongst the best of its day and its type. There was not a major turn-of-the-century writer who was not published in *Die Insel*, not an artist who did not contribute to its superior illustration. Peter Behrens designed the famous *Insel* logo which was adopted by the book publishers of the same name in Leipzig.

The Vereinigte Werkstätten für Kunst im Handwerk and the Munich designers

Architects, sculptors, painters, we must all return to crafts!
Walter Gropius[30]

Peter Behrens (1868–1940) ranks amongst the most outstanding artists of his day. The path followed by this universally talented designer may be said to represent the definitive biography of the Jugendstil artist: "... he was a painter, he

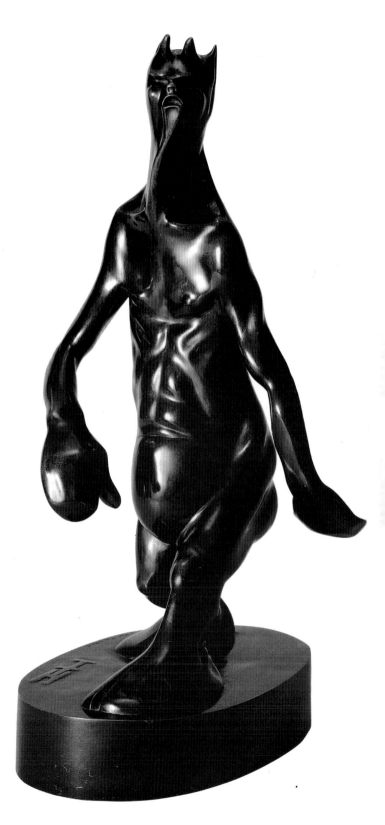

Thomas Theodor Heine
Devil, 1902
Modeled bronze with black patina, 44.5 cm high
Heine's small sculptures also have a graphic quality and are masterpieces of succinctly soft modulation, as here in his *Devil* — one of his favorite subjects.

Otto Eckmann
7, cover vignette for *Die Woche,*
Moderne Illustrierte Zeitung – Alle
sieben Tage ein Heft, Berlin 1899
It was Eckmann who designed the
Eckmann typeface and the most
beautiful of the Jugendstil numbers,
the seven, for the weekly paper of the
same name, which appeared every
seven days.

Otto Eckmann
Waterlily vase, 1900
Bone china, oxblood treacle glaze,
gilded bronze mounting,
54.3 cm high
The metalwork items which
Eckmann showed at the art
exhibition in the Munich Glass
Palace in 1897 were entirely new.
He demonstrated his ability to shape
line and plane into ever new vegetal
decorative forms in every area of the
applied arts.

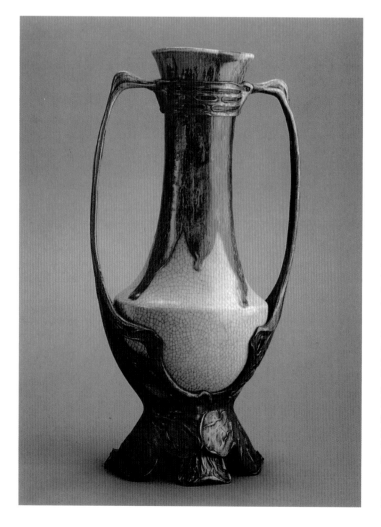

came from painting to Jugendstil painting, from
there to Jugendstil ornament, and ultimately, like
many others at that time, to the applied arts and
from the applied arts to architecture"[31] (ill. p.
218). He embodies the metamorphosis from
painter, from artist in the 19th-century sense of
the word, to industrial designer (ills. pp.
270–273). Even before Behrens went to
Darmstadt and later to Berlin, his influence was
making itself felt in Munich, where he demon-
strated his considerable talents in numerous
works of art. As with Eckmann, Behrens made
an abrupt break with painting; again, the "blame"
lay with Japanese prints. Behrens designed his
first ceramic pieces for a laid dining table
exhibited in Munich's Glass Palace (ill. right). The
critic Georg Fuchs praised them as "one of the
most mature and sophisticated creations in the
modern vein to have been produced in Germany
so far."[32] Behrens' early work already anticipates
the functional style of his later designs (ill.
opposite page). In 1897 Behrens was amongst
the founders of the Vereinigte Werkstätten für
Kunst im Handwerk (Associated Workshops for
Art and Handicraft) in Munich. With the formation
of this association, which was widely considered
a miracle of the modern age, Munich reinforced
its reputation as the capital of arts and crafts. The
Secessionist character of the Munich body of
artists here found its true expression. Munich
now assumed a significant lead over Berlin – a
phenomenon true also of Nancy in regard to
Paris, and of Scotland in regard to England, and
one reflecting a trend characteristic of Finland
and Catalonia as a whole. It would appear that
Secessionist thinking went hand in hand with a
general, sometimes political, sometimes national,
movement towards autonomy. Despite the
associations prompted by its name, and unlike
the later Wiener Werkstätte (Vienna Workshops),
the Vereinigte Werkstätten had very little to do
with the Arts and Crafts Movement in England.
No particular importance was attached to manual
production; instead, top priority was given to
quality, irrespective of technical means. The
pioneering achievement of the Vereinigte
Werkstätten was to bring together artists,
craftsmen, and commercial manufacturers, both
in their own interests and in the economic
and national interest. As such the association
prepared the ground for the later Deutscher
Werkbund and brought together Munich's artist-
designers, former painters and celebrated
draughtsmen – Peter Behrens, Bruno Paul,
Bernhard Pankok, Hermann Obrist and Richard
Riemerschmid – in order to create the ultimate

Peter Behrens
Plate, 1898
Glazed and painted stoneware
26 cm diameter
Made by Villeroy & Boch,
Mettlach
Behrens designed his first ceramic
pieces for a laid dining table
exhibited in Munich's Glass Palace.
The critic Georg Fuchs praised them
as "one of the most mature and
sophisticated creations in the modern
vein to have been produced in
Germany so far" (see note 32).

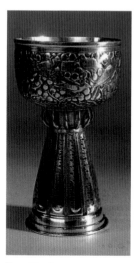

Ernst Riegel
The seven ravens, goblet, 1903
Chased silver, 20 cm high
Barlow/Widmann Collection,
Spain
Riegel, the "story-teller in silver",
settled in Munich after living in
Darmstadt. He always worked
alone.

Hermann Gradl the Elder
Tureen and plate, part of a fish
service, 1899
Porcelain, transfer-printed
decoration, overglaze painting,
gilding
Tureen: 18 cm high
Plate: 23.5 diameter
Made by the Königlich-Bayerische
Porzellan-Manufaktur,
Nymphenburg
Bröhan-Museum, Berlin
When the historicizing stencils used
by the Nymphenburg porcelain
factory to decorate their chinaware
wore out, it was Gradl who helped
win new fame for the company with
his artistic stylization of floral
motifs.

Peter Behrens
Decorative glass, 1898
Glass, blown and worked with a
lamp, with gold rim, 18.5 cm high
Behrens' early work already looks
forward to the functional style of his
later designs.

Jugendstil interior. Pankok was the daydreamer and visionary of the group, but it is precisely these qualities which lend his furniture a special magic. At the 1900 World Exposition in Paris he was awarded a gold medal for his highly original creations (ill. p. 230). Interestingly, he designed his first complete interior for Hermann Obrist, whose own canon of form can be recognized in Pankok's furniture.

Pankok was also strongly influenced by the designer and painter Hans Eduard von Berlepsch-Valendas (1849–1921). A member of the Secession, inspired by the ideals of the English guilds and highly knowledgeable about Japanese art, Berlepsch-Valendas was an individualist whose subtle ornament anticipates much of what would become so characteristic of the artists of the Vereinigte Werkstätten (ill. p. 231). Another artist working alone was the "story-teller in silver" Ernst Riegel (1871–1939), who settled in Munich after Darmstadt (ill. opposite page). Hermann Gradl the elder remained similarly independent. When the historicizing stencils used by the Nymphenburg porcelain factory to decorate their chinaware wore out, it was Gradl who helped win new fame for the company with his artistic stylization of floral motifs (ill. top right). Bruno Paul was another member of the Vereinigte Werkstätten who won a prize in Paris in 1900. He built items of furniture which constituted ornaments in themselves, and he rapidly became the master of the "rectilinear style" (ill. p. 230). His quasi fitted furniture, installed as fixed decorative ensembles, looks forward to his future development of modular furniture and add-on systems (ill. p. 230).

Richard Riemerschmid – Painter and anatomist of handicraft

In contrast to his colleagues, Richard Riemerschmid (1868–1957) never gave up painting, and his Symbolistic, decorative pictures are of high quality (ill. p. 233). Indeed, he differed from his contemporaries in many respects. "A wooden table and a metal lighting appliance (for four electric bulbs) by the German architect Richard Riemerschmid seem at first sight to fall fully into the functional category of handicraft. A small circular tabletop rests on three legs or shanks, which splay out to three sides from the center of the circle and which point their feet with a little kink just above the floor and place them straight down on the ground. From each of these three feet, however, a slender sinew of wood leads vertically upwards to reunite with the

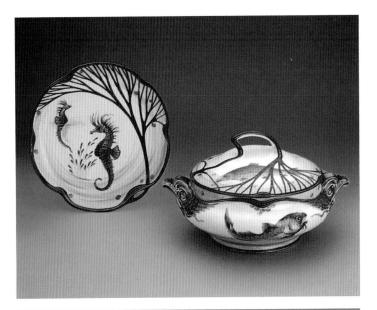

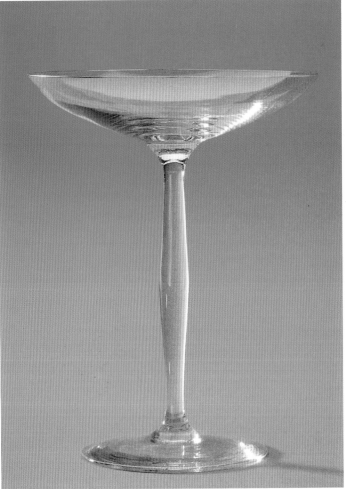

Bruno Paul
Corner cupboard with sofa, model nos. 6076 and 6092, 1904
Lithograph/catalogue page, 22 x 17.5 cm
Archiv Vereinigte Werkstätten, Amira AG, Munich
Paul's quasi fitted furniture, installed as fixed decorative ensembles, looks forward to his future development of modular type furniture and add-on systems.

Below:
Bernhard Pankok
Free-standing closet, 1899
Walnut, spruce, and glass, 167 x 107 x 41 cm
Made by the Vereinigte Werkstätten für Kunst im Handwerk, Munich
Münchner Stadtmuseum
Pankok was the daydreamer and visionary of the Vereinigte Werkstätten artists, but it is precisely these qualities which lend his furniture a special magic. At the 1900 World Exposition in Paris he was awarded a gold medal for his highly original creations.

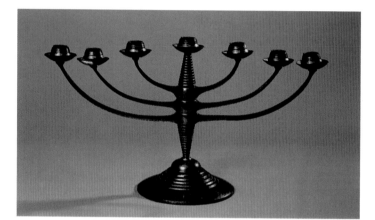

Bruno Paul
Seven-armed candelbra, ca. 1905
Cast brass, 29 cm high
54 cm maximum diameter
Barlow/Widmann Collection,
Spain

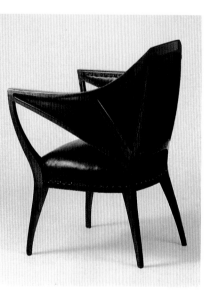

Bruno Paul
Armchair, 1901
Oak, leather, 87.5 x 63.5 x 69.9 cm
Made by the Vereinigte Werkstätten für Kunst im Handwerk, Munich
Bruno Paul built items of furniture which constituted ornaments in themselves, and he rapidly became the master of the "rectilinear style". He won a prize in Paris in 1900.

Above:
August Endell
Door, Hof-Atelier Elvira, Munich,
1896—97

Right:
Richard Riemerschmid
Chair for a music room, 1899
Wood, leather seat, 80.6 x 47.5 x 45 cm
"... for all their functionality, it is precisely [these pieces of
furniture] which, seen through the eye of the imagination,
resemble living organic beings — a leggy foal, a fantastical bird
with wings outstretched — but robbed, in their anatomical
structure, of soft flesh and skin."
(Dolf Sternberger, see note 33)

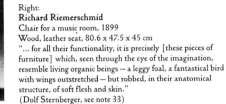

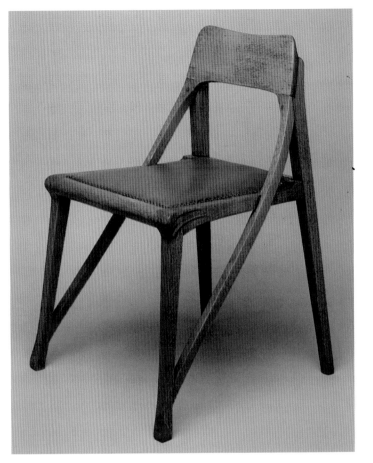

Richard Riemerschmid
Candlestick, 1897
Chased and gilded brass,
37 cm high
Made by the Vereinigte Werkstätten
für Kunst im Handwerk, Munich
Riemerschmid was a functionalist of
a highly distinctive inclination, an
anatomist of handicraft.

Right:
Hans Eduard von Berlepsch-Valendas
Bookcase, 1899
Oak, oak veneer, and elm veneer; fittings of brass and steel,
254 x 100 x 57 cm
Made by Richard Braun, Munich
A member of the Secession, inspired by the ideals of the
English guilds and an expert on Japan, Berlepsch-Valendas
was an individualist whose subtle ornament anticipates much
of what would become so characteristic of the artists of the
Vereinigte Werkstätten.

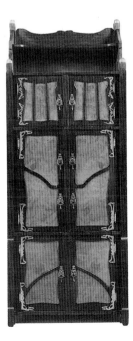

Page 233:
Richard Riemerschmid
Garden of Eden, 1900
Oil on canvas; frame: wood, painted plaster,
160 x 164 (with frame)
Barlow/Widmann Collection, Spain
In contrast to his colleagues, Richard Riemerschmid never
gave up painting, and his Symbolistic, decorative pictures are
of high quality.

tabletop at the rim of the circle. A highly sensual and delicate object whose internal relationships can be emotionally experienced by viewer and user ... Just as the little table evokes memories of bones and sinews, here too [in the case of the lamp], in those places where the systems of bent brass wires are joined, we are inevitably reminded of elbow or knee joints ... Riemerschmid's free and light creations rank amongst the most beautiful in the exhibition. And for all their functionality, it is precisely they which, seen through the eye of the imagination, resemble living organic beings – a leggy foal, a fantastical bird with wings outstretched – but robbed, in their anatomical structure, of soft flesh and skin"[33] (ill. p. 231). Riemerschmid was a functionalist of a highly distinctive inclination, an anatomist of handicraft (ills. pp. 213, 217, 231) and a brilliant architect. The Munich Schauspielhaus theater, today the Kammerspiele, was built to his plans in 1900–01. He went on to become one of the leading designers of the Dresdner Werkstätten (Dresden Workshops) and, like many members of the Munich Vereinigte Werkstätten, was amongst the founders of the Deutscher Werkbund in 1907. The future had begun.

The rewards for our pains are enormous. There are so incredibly many beautiful things immediately accessible to us, yet seen and appreciated by so few of us, a wonderful, magnificent world right in front of our eyes, so exquisite, so colorful, and so rich that there is absolutely no need for us to invent imaginary worlds. Today, the present, reality — these are the most fantastical and incredible of all; all the wonders concocted in literature are utterly paltry by comparison. It is only our stupidity which stops us utilizing this treasure. We don't need another world above the clouds or in the past; the greatest marvels are found here in our own world, in our own day — invisible to the eye which is dull, it is true, but clear and tangible to the eye that sees.
August Endell, *Vom Sehen* [On Seeing], in *Die Neue Gesellschaft*, I, 1905

I believe it is not generally known that, in the bark of our own native trees, we possess the most rapturous symphonies of color that a painter could ever dream of. After rain, for example, when the colors are luminous and fresh, the richest and most wonderful motifs are to be found there. You need to go right up to the trunk and look hard at small areas the size of your palm. Strong colors alternate one with another. Velvety violet, fiery yellow-red, grey with a blue shimmer, bright green — the widest possible range of color nuances are found in a rich spectrum in the boldest contrasts. Only when you have studied the colors of bark close up can you appreciate why tree trunks have such luminous colors from afar. The individual colors are garish and unbroken, but because they lie so close together in such small blotches, they tone each other down without losing their effect.
August Endell, in *Berliner Architekturwelt*, volume 4, 1902

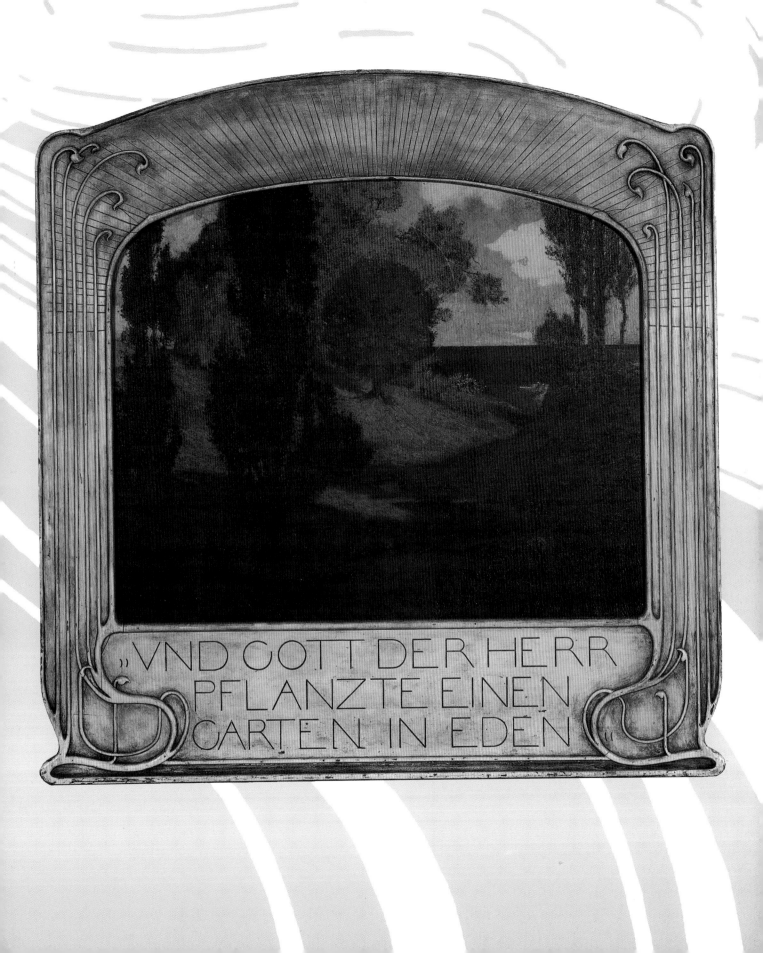

Revolution and art
Darmstadt

*Here is the New which at last, at last we can hold up
against our oppressive inheritance.*
Friedrich Ahlers-Hestermann[1]

Art for all – "Elite art"

Ruskin's "prophesy" – that the invention of a
"New Art" was not in itself enough to ensure the
salvation of the artistic ethos, but that art needed
to form a unity with life in order to be convincing
and credible – marked a decisive shift toward the
concept of applied art. This, however, meant
teaching "style" to the ugly, ostracized world of
industry where the objects of daily use were
actually produced, and where art thus needed to
be "applied". William Morris sought to live the
commandments of his tutor Ruskin and translate
them into deeds. But while revolutionary
resolution characterized his own thinking and
personal life, the fact that he refused to
acknowledge the machine as the most important
modern means of production robbed him of the
opportunity to create a new art. The craftsmen
whom Morris employed, and the clientele who
were able to afford his products, could consider
themselves fortunate. Such craftsmanship was
of little benefit to the rest of the population,
however. This fact did not elude Morris and he
gradually switched from artist to politician,
recognizing that the way of life of the working
classes was not to be improved by an elitist form
of applied art which he himself described as
"ministering to the swinish luxury of the rich".
As a radical liberal, he joined the Democratic
Federation in 1883 and one year later founded

the Socialist League, becoming editor of the
party newspaper *Commonweal*. As a member of
these associations, he dedicated himself to the
liberation of the workforce from its dependency
upon employers.

This flashback is important insofar as the German
Jugendstil artists themselves looked back
directly to Morris in their work. They inherited
from their English forebear the belief that arts
and crafts were not two mutually exclusive areas
of activity. While they originated from the world
of art, they were not afraid to venture into the
"lower" echelons of the applied arts. Indeed,
they went decisively further than Morris by
designing objects for mass production. The
political dimension of Morris's philosophy,
however, remains absent from their work. Their
concern was the artistic enhancement of the end
product; they knew little about the details of the
manufacturing process.

This is not to dispute that there was a political
element to Jugendstil in Germany too, albeit one
less radical and always somewhat ambivalent.
As a rule, any political aims were stated at a
purely aesthetic level. Economic factors, too,
often took the emphasis away from societal
concerns. Thus one of the reasons – if not indeed
the prime reason – for the founding of the artists'
colony in Darmstadt was to secure new
commissions for the arts industry in Hesse. This
is not to belittle the achievements of this unique
initiative, once more set in the "provinces".
On the contrary, it represented the successful
attempt to make a commercial venture simultan-
eously an aesthetic one.

Albin Müller
Tankard, ca. 1910
Glazed stoneware, pewter,
35.5 cm high
Made by Reinhold Hanke, Höhr

Franz von Stuck
*Grand Duke Ernst Ludwig von
Hessen und bei Rhein*, 1907
Oil on canvas, 47 x 52 cm
Schlossmuseum, Darmstadt
"If one thinks of the Grand Duke in
his role of patron of the arts, as an
artist himself, one thinks above all of
the artists' colony that he founded in
1899, of the exhibitions of 1901,
1908, and 1914, of the thoughtful
endeavors of the young generation of
artists and their bold new
departures, of the – at long last, truly
contemporary – association of
beauty with practicality, of art with a
social awareness extending to
handicraft, industry, and commerce."
(Golo Mann, see note 5)

Joseph Maria Olbrich
Playhouse for Princess Elisabeth,
Schloss Wolfsgarten, Darmstadt,
1902
Ernst Ludwig's daughter from his
first marriage died when she was just
eight years old. He himself had lost
his mother when he was ten. The
memory of the little princess is
touchingly preserved in this
playhouse – pure Jugendstil – in the
grounds of Wolfsgarten Palace in
Darmstadt.

Deliverance from on high –
Patronage around 1900

*Don't complain to me about figures. There may come a
time later on when you will thank your Papa for giving
you a closer acquaintance with them. Without rules,
without figures, there can be no ordered existence.*
The banker Osthaus to his son Karl Ernst[2]

With his embrace of politics, Morris took the side
of the working classes – something all too
happily overlooked even today. In Germany, on
the other hand, artists sought to "deliver" the
public from "on high", that is, to improve the
general standard of taste via exemplary designs
for buildings and objects of everyday use. This
led to the reproach that the works of applied art
produced in this spirit ultimately remained
confined to an ivory tower far removed from
harsh reality. Such criticism addressed itself at
the same time to the upper middle classes, and
indeed the ruling classes themselves; in
retrospect, it can be seen as a rebuke to the very
people whose support for the arts made Art
Nouveau possible, and not just as Jugendstil in
Germany – those individuals who rallied to the
side of the artists and artist groups who were
initiating the new style with their progressive
ideas and their break with the past. The
importance of the patron of the arts had by no
means dwindled; on the contrary, as far as the
applied arts went, it was even greater than
before. "Total works of art" began to see the
light across Europe thanks to wealthy, indeed
very wealthy, members of art-loving society:

Walther Rathenau of the AEG company, Karl
Ernst Osthaus, Baron Eberhard von Bodenhausen,
the Belgian industrialist Solvay, the banker
Stoclet, the Spanish industrialist Güell, and the
Viennese banker's son Fritz Waerndorfer, to
name just a few. Aristocrats and millionaires
were even to be found on the "production" side,
as in the case of Toulouse-Lautrec and Louis
Tiffany. Patrons also included art dealers such as
Samuel Bing, the writer Julius Meier-Graefe, the
Darmstadt publisher Alexander Koch and – last
but certainly not least – Grand Duke Ernst
Ludwig of Hesse (ill. left).

Grand Duke Ernst Ludwig of Hesse –
Statesman and sponsor

*Incidentally, while I was in Berlin for the Kaiser's
birthday, I frequently found that many of my so-called
colleagues were so backward in their attitudes that I felt
myself a pure Socialist by comparison.*
Grand Duke Ernst Ludwig of Hesse[3]

Ernst Ludwig of Hesse was the son of Alice, the
favorite daughter of Queen Victoria of the United
Kingdom. The British monarch visited Darmstadt
on many occasions; her grandson was even
more frequently to be found in his second home.
With the cosmopolitan outlook instilled in him by
his background, coupled with his engaging
character, he was almost predestined to tackle
the sensitive task of founding an "artists'
colony". Ernst Ludwig had taken over government
in 1892 at the age of just 24. His first marriage
ended unhappily in divorce in 1901, and his
daughter from that marriage died when she was
just eight years old. Ernst Ludwig himself had
lost his mother when he was ten. The memory of
the little princess Elisabeth is touchingly
preserved in a playhouse – pure Jugendstil – in
the grounds of Wolfsgarten Palace in Darmstadt
(ill. left). In 1905 Ernst Ludwig remarried. His
new wife, Eleonore zu Solms-Hohensolms-Lich,
supported him in his artistic ambitions, such as
the Wedding Tower (ill. opposite page). The
artists' colony in Darmstadt ultimately owed its
foundation to the English element in the Grand
Duke's background and his many visits to Britain.
Extremely interested in the ideas of Ruskin and
Morris, and a great enthusiast of the British
revival of arts and crafts in the domestic sphere,
in 1897 Ernst Ludwig commissioned Mackay
Hugh Baillie Scott and Charles Robert Ashbee to
decorate a number of rooms in his Darmstadt
palace. He proposed plans to build a new Hesse
State Museum, but the designs submitted were

Joseph Maria Olbrich
The five elongated arches crowning
the Wedding Tower, Darmstadt,
1905–08
Institut Mathildenhöhe, Museum
Künstlerkolonie Darmstadt
The inscription on Olbrich's
magnificent Wedding Tower may
have been true of the architect
himself: "Have respect for the Old
and the courage to attempt the New.
Remain true to your own nature and
true to the people you love."

Peter Behrens
Cup, ca. 1902
Chased silver, 11.6 cm high
Made by Peter Bruckmann, Heilbronn
Collection Barlow/Widmann, Spain
The domestic utensils which Behrens designed during his
Darmstadt period are still subordinate to the overall principle
of the house as a "cult building" and do not bear the
hallmarks of prototypes destined for mass production. He
nevertheless produced objects which, while still "ceremonial"
in character, exhibit an ornament which is solely self-derived.

simply too ugly for him; he was already looking to create a total work of art, prompting Minster of State Jakob Finger to comment: "The Grand Duke is hopeless, he's just full of Utopias."[4] But the Landesmuseum project would prove to be the first of the "Utopias" that Ernst Ludwig turned into reality. "What Ernst Ludwig did for the arts in Hesse remains touching and significant, its effects lastingly felt in indirect ways. The means he used – his own, those of the capital and the province – were limited, and the rivalry of the wealthier states – nearby Frankfurt, Berlin, Dresden, Munich – was oppressive. He knew his limits only too well, but he did not allow himself to be discouraged. Money wasn't everything; initiative, imagination, and love were also capable of achieving much. If one thinks of the Grand Duke in his role of patron of the arts, as an artist himself, one thinks above all of the artists' colony that he founded in 1899, of the exhibitions of 1901, 1908, and 1914, of the thoughtful endeavors of the young generation of artists and their bold new departures, of the – at long last, truly contemporary – association of beauty with practicality, of art with a social awareness extending to handicraft, industry, and commerce."[5]

The Grand Duke's monument, the artists' colony, is still the central focus of Darmstadt today. While it undoubtedly reflected his own tastes in art, Ernst Ludwig did not create it to perpetuate his own memory, but because he was aware that, with each new day, he had to prove himself worthy of the position accorded him by divine right, and that he must carry out his duties in a responsible manner. A patriot, he fuelled the cultural and economic development of Hesse in a highly modern fashion, at the same time realizing a project of international importance with artists at the forefront of the latest trends.

Ludwig Habich
Haus Habich, 1901
Print
Institut Mathildenhöhe, Museum
Künstlerkolonie Darmstadt
"Even in 1901, the year of the
remarkable exhibition at the
Darmstadt artists' colony, in which
each of the artists grouped around
the Grand Duke – I shall name only
Behrens, Huber, Habich, and
Christiansen – had built a whole
house to their own designs ..."
(Henry Paris, see note 11)

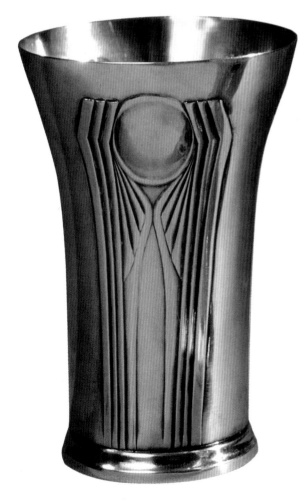

The Darmstadt artists' colony

It is about creating works of art which are complete in themselves and which lend expression, with the greatest sensitivity and simplicity, to a joyous principle of life.
Joseph Maria Olbrich[6]

Grand Duke Ernst Ludwig invited "his" artists to develop the Mathildenhöhe, a park belonging to the Grand Duchy on a hill in the city. Over the following years the Mathildenhöhe would form the site of several exhibitions of architecture. The novel project was conceived as a "document of German art of enduring value". The first task facing the colony was a practical one: if they

Peter Behrens
The Kiss, 1898
Color woodcut, 27.2 x 21.7 cm
In *The Kiss*, an abstract pattern of
intertwining lines is derived from the
typically Symbolist motif of flowing
hair, but at the same time contains
echoes of the interlacing patterns of
Celtic ornament. The "material" of
the design is unquestionably organic,
the imagery symbolic; in its artistic
expression, on the other hand, it is
abstract. The androgynous character
of the two lovers conceals an
additional element of abstraction.

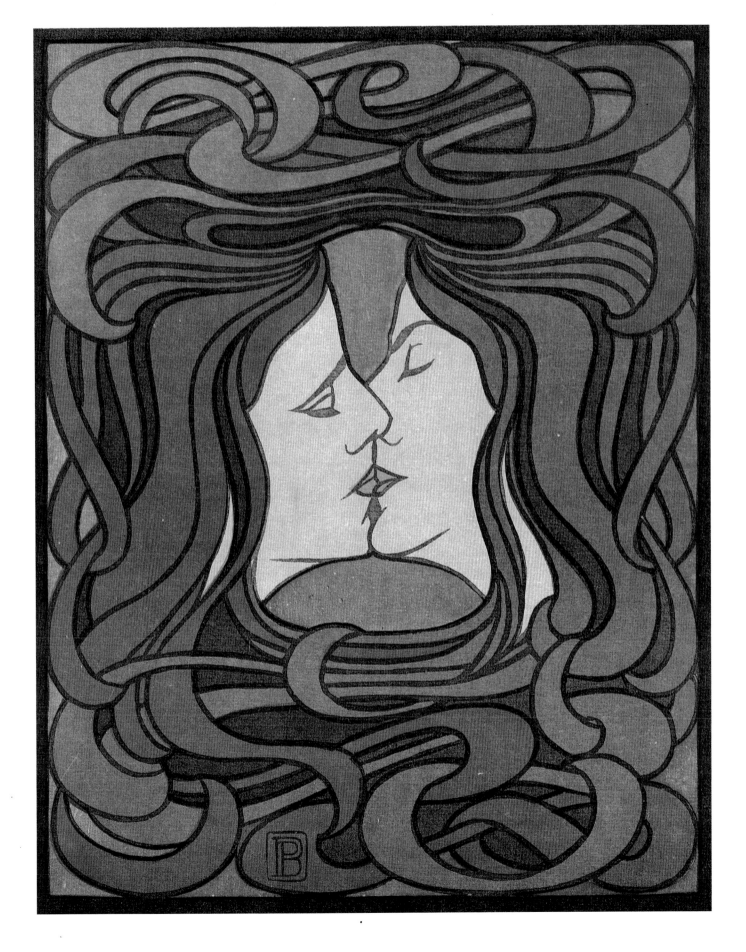

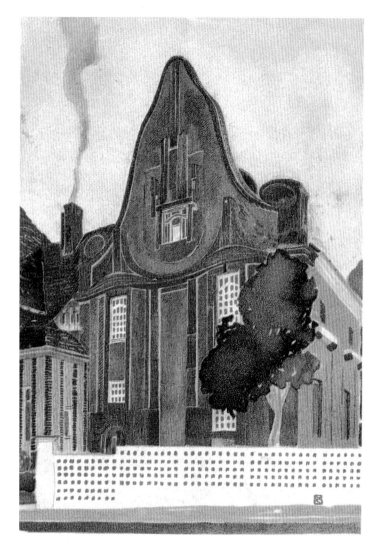

Joseph Maria Olbrich
Postcards of the group of three houses designed by Olbrich on the Mathildenhöhe, Darmstadt, for the second exhibition by the Darmstadt artists' colony, July 16 to October 15 1904
Interior and exterior views of the Grey House (left and far left), the official residence of the court chaplain, 1904
Exterior view of the Corner House (below), 1904
Exterior view of the Blue House (far left, below), 1904
Lithographs
Institut Mathildenhöhe, Museum Künstlerkolonie Darmstadt
In Olbrich's group of three houses of 1904, a new stylistic trend towards structuring and functionalism can be felt, although the buildings nevertheless remain Jugendstil in their imaginative variety. The houses were commissioned by Grand Duke Ernst Ludwig and were to serve as "examples of private homes for citizens of not overly abundant means". With the exception of the chaplain's residence, the houses were for sale and were in fact bought by wealthy individuals. The Blue House was acquired by the wife of the Councillor of Commerce, Frau Knöckel, and the Corner House by Count Büdingen, who was employed by the Grand Duke.

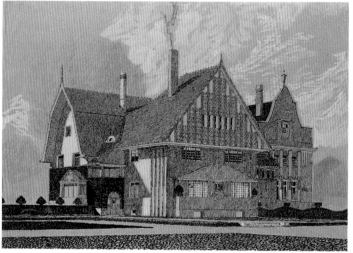

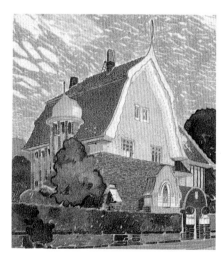

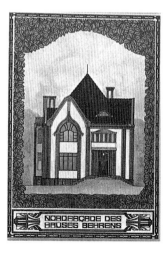

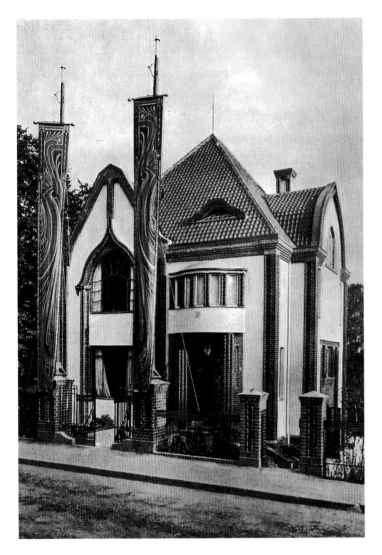

were going to live on site, the artists needed to build homes for themselves. In December 1898 the painter Hans Christiansen (1866–1945) became the first artist to be invited to join the proposed colony. At the beginning of April the following year, a series of articles in the local paper introduced the idea of the colony to the Darmstadt population, on whose support it would naturally also rely. On July 1 1899 the appointment of the following artists was officially announced: Rudolf Bosselt (1871–1938) as sculptor and medalist, Paul Bürck (b. 1878) for book illustration and applied art, Patriz Huber (1878– 1902) for interior design and furniture and Hans Christiansen as painter and graphic artist.

The assignation of these artists to specific disciplines rapidly proved meaningless, however, as both they and later members of the colony were, without exception, active in several fields. In order to increase contact both with industrialists and the public, plans were set in motion to found an association of arts and crafts, to mount an exhibition of Hessian arts and crafts, and to construct an arts and crafts exhibition building – all in all, a massive commitment to the arts.

The first "colonists" had already taken up their posts when, in July, the highly influential appointments were made of Joseph Maria Olbrich and Peter Behrens, together with the sculptor Ludwig Habich (1872–1949) (ill. p. 238). There were now seven artists on the Mathildenhöhe committed to working in Hesse for three years. The oldest was 32, the youngest 20. Each received an annual, non-pensionable salary depending on age, personal circumstances, and previous sphere of activity; in other words, prominence. This material provision distinguished the Darmstadt colony significantly from the numerous other workshops, associations and guilds formed by Jugendstil and pre-Jugendstil artists. Although the artists were provided with free temporary accommodation while their houses were being built, they nevertheless had to pay for the land and the construction costs themselves. They were offered generous financial terms on condition that the houses were finished in time for the first exhibition in 1901. Alongside the individual contributions made by the artists, the main expenses were borne by the Grand Duke. The colony was officially opened as a private enterprise on July 1 1899.

Above:
Peter Behrens
The Behrens House, north facade, Mathildenhöhe, Darmstadt, 1901
Contemporary photograph
Institut Mathildenhöhe, Museum Künstlerkolonie Darmstadt
".... for we shall see that the house [by Peter Behrens] on the Mathildenhöhe stands right on the perimeter of Jugendstil; it is already signposting the way forward from here ..."
(Julius Posener, see note 12)

Right:
Peter Behrens
Banner, the Behrens House, 1901
Contemporary illustration
Vortices and bundles of lines are also to be found on the exterior of the house, where their "energetic lines" draw upon an additional background source: Nietzsche's *Thus spoke Zarathustra*, whose mythos of beauty had captured Behrens' imagination.

Opposite page, below:
Peter Behrens
The Behrens House, north facade, Mathildenhöhe, Darmstadt, 1901
Design drawing
Contemporary illustration

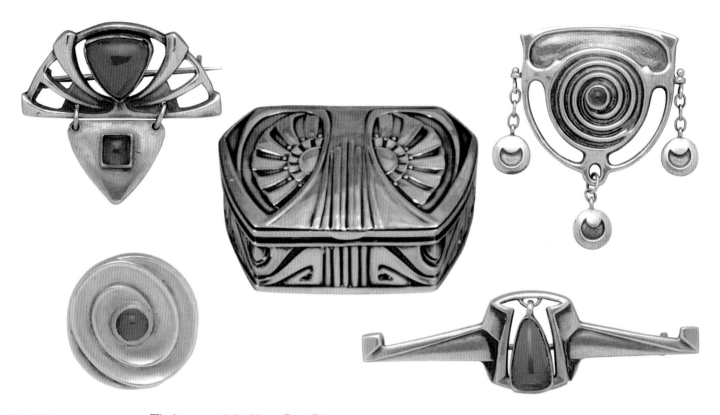

Patriz Huber
Three brooches, a button and a
pillbox (center), 1900–01
Brooches and button: silver, agate,
chrysoprase, 1.7 cm to 3.1 cm high,
2.3 cm to 5.8 cm diameter
Institut Mathildenhöhe, Museum
Künstlerkolonie Darmstadt
Pillbox: chased silver, gilt interior,
2.3 x 6.9 x 5 cm
Made by Martin Mayer, Mainz
Collection Barlow/Widmann,
Spain
Patriz Huber designed jewelry and
silverware for the Theodor Fahrner
jewelry works in Pforzheim, well-
known for its Jugendstil products.
With their spiral patterns and
simple, clear designs, Huber's
creations were such a success that
these prime examples of high-quality
serial production were exported to
England.

The home as cult building – Peter Behrens and Joseph Maria Olbrich

In days to come we will refuse to live in a room where the objects within it do not jointly attest to a common will, a single emotional effect ...
Henry van der Velde[7]

In 1901 the artists colony was itself the object of the first exhibition on the Mathildenhöhe. It was perhaps less "A Document of German Art" (*Ein Dokument deutscher Kunst*), as it was titled, than an exhibition of grandiose, personal documents on and by the colony's artists. Behrens and Olbrich were the two architectural talents who continue to shape the face of the Mathildenhöhe today, albeit quantitatively to very different extents.

The Austrian Olbrich may be seen as the guiding spirit behind the colony, and the buildings which he designed as the most characteristic of the Mathildenhöhe. A pupil of Otto Wagner and one of the "architects" of the Secession, he had already been showered with accolades in Vienna for his Secession building with its floating laurel cupola: "... and then there is the cupola ... the crown of a colossal laurel tree, in real gold leaf ... the impression is magical ... Olbrich was the man on whom all hopes were pinned."[8]

Olbrich would not prove a disappointment in Darmstadt, either. He created total works of art free from any obligation to an ideological or stylistic standpoint: "... art is nothing other than a harmonious and aesthetic staging of life; art is nothing other than living from the point of view of a temperament and its consciousness. Can a school awaken consciousness? No!"[9] Olbrich's Wedding Tower – the vertical accent within the Mathildenhöhe complex as a whole – comes closer to a work of modern sculpture than to architecture (ill. p. 237). In the same way, his design for a studio building for the artists' colony is never a "foreign object", and is less a piece of architecture than an outsize easy chair in need of stabilizing boundaries. His Darmstadt Hall of Decorative Arts resembles a huge ocean liner, a reflection of his preference for keel-like forms. These "surface" as decorative elements on many of his buildings and lend them a sense of forward-thrusting dynamism. If we consider the catchwords defining Olbrich's architecture, it is not surprising that he became a model for probably the most popular Expressionist architect, Erich Mendelsohn (1887–1953). "Olbrich's Wedding Tower makes no allusions to the past ... Olbrich's strength employs all the ideas of his day to liberate the internal laws of

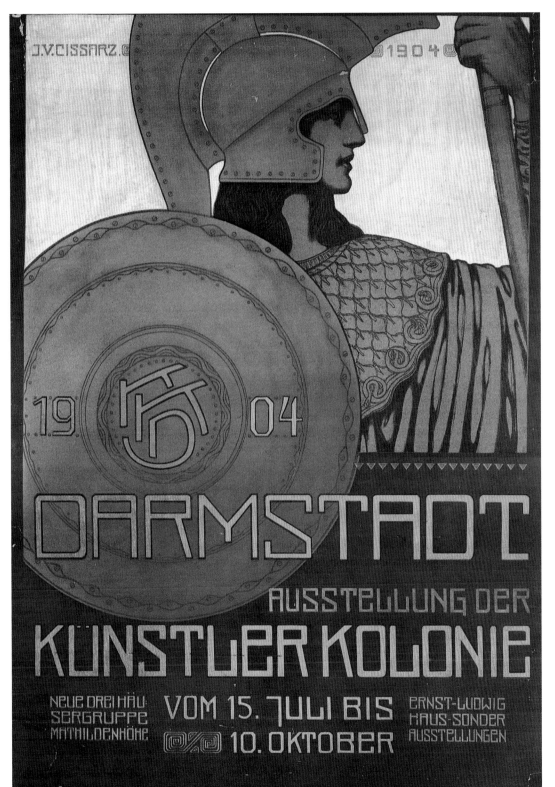

Johann Vincenz Cissarz
Poster announcing the second
exhibition by the artists' colony on
the Mathildenhöhe, Darmstadt,
1904
Color lithograph, 75 x 49 cm
Institut Mathildenhöhe, Museum
Künstlerkolonie Darmstadt
Cissarz was chiefly active in the
spheres of painting and graphics.

architecture which have been overgrown for centuries, and to reinstate them anew."[10] Olbrich was a source of inspiration not just for future generations, however, but also for his contemporaries. "Olbrich embodies modern German art in the most perfect and personal fashion. Even in 1901, the year of the remarkable exhibition at the Darmstadt artists' colony, in which each of the artists grouped around the Grand Duke – I shall name only Behrens, Huber, Habich (ill. p. 238), and Christiansen – had built a whole house to their own designs, I was struck by the elegance of the forms of Olbrich's villa and its wonderfully harmonious unity."[11]

The house by Behrens, however, attracted even greater admiration. It was more spectacular, in the best sense of the word, but also more expensive – it had cost 200,000 marks, as opposed to the 70,000 marks swallowed up by Olbrich's villa (ills. pp. 240, 241). Julius Posener took a closer look at the Behrens house in a lecture: "... for we shall see that the house [by Peter Behrens] on the Mathildenhöhe stands right on the perimeter of Jugendstil; it is already signposting the way forward from here ... What

actually remains here of Jugendstil? Really only that sweeping gable and those two sweeping gables on the roof. If you blank them out of the picture, there is no more Jugendstil. It becomes a house of strict architectural articulation, and you can see from the groundplan that it borders on being a cube. In the years after 1903 the cube becomes Behrens' chief form. This is the front facade which we saw a moment ago. Take a look at these two windows. As you will see in a moment from the plan, the strangest things are happening here: the rooms are being incorporated into the composition of the facade, a rigorous composition. A comparison with the neighboring houses on the Mathildenhöhe, by Josef Maria Olbrich, true Jugendstil houses (ill. p. 240), makes the Behrens house look a little stiff. If you look at this dining room, however, it is of course undeniably Jugendstil, both in the overall concept – see how the ceiling has been developed as if out of a whirlpool – and in the details: see how all the lamps and chairs are developed as if out of a vortex."[12] Behrens elevated the constructional and at the same time ornamental value of line to the position of highest

Hans Christiansen
Spring roundelay, tapestry, 1900
Haute lisse technique, warp: hemp, woof: wool, 121 x 139 cm
Made by the College of Art Weaving, Scherrebeck
Museum für Kunst and Gewerbe, Hamburg

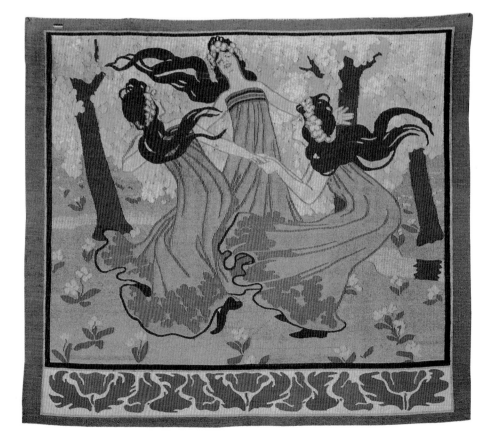

stylistic principle – pure Jugendstil. Since Behrens' artistic career eventually led him to industrial design, there is a temptation to look in his early work for signs of his later canon of form. Olbrich's oeuvre, on the other hand, never reached a "ripe old style", since he had only another ten years after his Secession building in which to pursue his work (he died in 1908). In the homogeneous interior of the Behrens house, we find the same linear principles as in his woodcuts. In *The Kiss* (ill. p. 239), an abstract pattern of intertwining lines is derived from the typically Symbolist motif of flowing hair, but at the same time contains echoes of the interlacing patterns of Celtic ornament. The "material" of the design is unquestionably organic, the imagery symbolic; in its artistic expression, on the other hand, it is abstract. The androgynous character of the two lovers conceals an additional element of abstraction.

Vortices and bundles of lines are also to be found on the exterior of the house (ill. p. 241), where their "energetic lines" draw upon an additional background source: Nietzsche's *Thus spoke*

Zarathustra, whose mythos of beauty had captured Behrens' imagination. Rigorous and "cultured", it permitted no ornament and led to disciplined design. The domestic utensils which Behrens designed in this spirit are still subordinate to the overall principle of the Mathildenhöhe house as a "cult building" and do not bear the hallmarks of prototypes destined for mass production. He nevertheless produced objects which, while still "ceremonial" in character, exhibit an ornament which is solely self-derived (ill. p. 238).

Nietzsche's influence is also apparent in the language of Behrens' own writings. Zarathustra himself seems to be speaking of the forbidding manner of the Behrens house in contrast to the "friendliness" of Olbrich's houses when he says: "What do these houses mean? Verily, no great soul put them up as its simile! ... And these rooms and chambers – can *men* go out and in there? They seem to be made for silk dolls; or for dainty-eaters, who perhaps let others eat off them. "[13]

Hans Christiansen
Pieces from a set of crystal goblets, ca. 1903
Clear glass, gold paint,
6.5 cm to 25 cm high
Institut Mathildenhöhe, Museum Künstlerkolonie Darmstadt
A characteristic feature of Hans Christiansen's work was the "Christiansen rose", as it became enduringly known in the sphere of Jugendstil. The rose motif can be found in every area of Christiansen's art, which – instantly recognizable in its style and outstanding in its quality – made him a brilliant decorative artist to some, and to others a shallow panderer to public tastes.

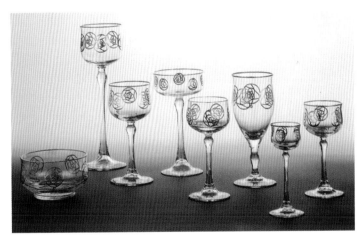

Hans Christiansen
Cigarette case, 1900
Silver, color enamel,
8.3 x 4 cm
Made by Luis Kuppenheim, Darmstadt
Collection Barlow/Widmann, Spain

Left:
Hans Christiansen
Vase, ca. 1898
Chromolithic (unglazed) stoneware, painted, 24.6 cm high
Made by Villeroy & Boch, Mettlach
Institut Mathildenhöhe, Museum Künstlerkolonie Darmstadt
"I interpret my role as an artist as broadly as possible: I want to be able to paint a portrait, but also to design a piece of furniture; I draw caricatures, but also rugs, posters, and indeed originals for every kind of printing process; I design stained-glass windows, but also occasionally a leatherwork screen. My motto is: portrayal of the characteristic in form and color, tailored to function and technique."
(Hans Christiansen, see note 14)

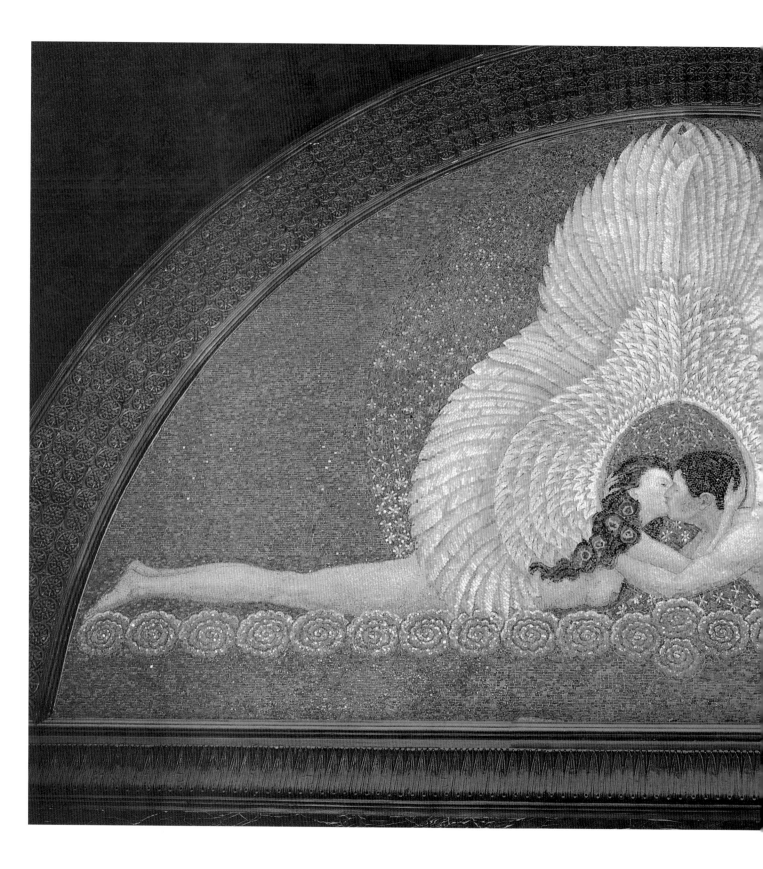

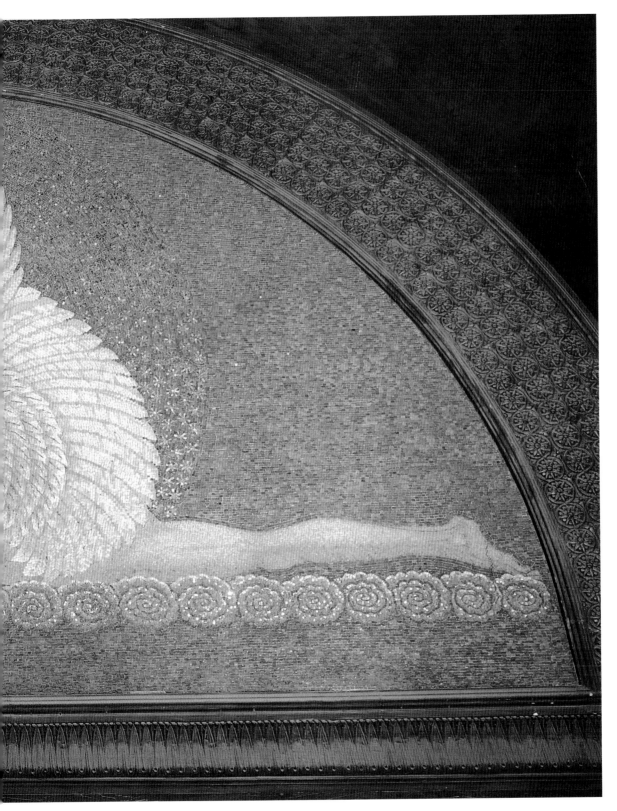

Friedrich Wilhelm Kleukens
Kiss, mosaic, Wedding Tower lobby,
Darmstadt, 1914
In addition to graphic works
inspired by Morris, Kleukens
designed mosaic pictures and
ornaments for the 1914 exhibition
which, like a final reprise,
summarize all of Jugendstil's
thematic and visual appeal.

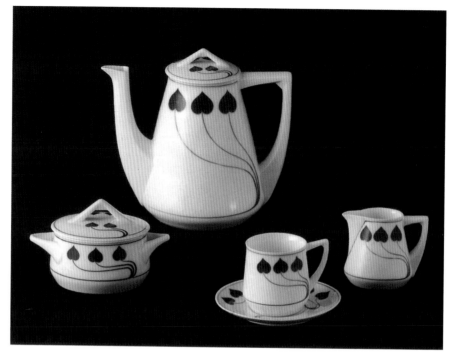

Below:
Albin Müller
Vase, ca. 1910
Faience, 38.5 cm high
Made by E. Wahliss, Vienna
"From my unworldly and idealistic
standpoint, I had dreamed of a
harmonious community of artists, of
lively mutual, intellectual
stimulation, of taking each other's
part, and saw with sadness that none
of it was to be achieved in the real
world. Artists, even more than other
people, are individualists."
(Albin Müller, see note 21)

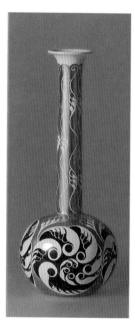

The artists of the colony

The tension inherent in the contradiction between "court architect" and "industrial artist" – the two roles required of the Darmstadt artists – resulted in a number of highly individual creations. Olbrich's group of three houses of 1904 (ills. p. 240) indicate a stylistic shift toward structuring and functionalism, although the buildings nevertheless remain richly inventive and "Jugendstil-ish" in their variety. The inscription on Olbrich's magnificent Wedding Tower (ill. p. 237) may have been true of the architect himself: "Have respect for the Old and the courage to attempt the New. Remain true to your own nature and true to the people you love." For all his Viennese grace, Olbrich's philosophy was close to that of the English Arts and Crafts Movement, as can be seen in the solid forms of his domestic utensils and his use of simple materials. His sheer delight in design also led him to create individual pieces of an emphatically aesthetic nature, their high material value reflecting their use of costly inlay (ill. p. 253). These pieces demonstrate a typical characteristic of Jugendstil, namely its change from or transformation of one artistic discipline into another. Thus architecture – as in the case of the Wedding Tower – is understood as sculpture,

painting as the ornamental component of an overall decor, handicraft as the object of sophisticated and exquisite design. Hence full-scale buildings frequently exude the air of jewelry caskets, just as small items of handicraft are monumentalized into architecture.

Another sharp contrast to the strict linearity of Peter Behrens is provided by the works of Hans Christiansen. The luminous, painterly colorfulness of his oeuvre earnt him the nickname of the "Böcklin of decoration". If Olbrich represented the (Vienna) Secession style in the Darmstadt group, Christiansen stood for (French) Art Nouveau (ills. pp. 244, 245, 250). After studying in Hamburg and Munich, Christiansen spent three years at the Académie Julian in Paris, which remained his second home over the following years. Coming from painting, he became one of Jugendstil's classic all-rounders. "I interpret my role as an artist as broadly as possible: I want to be able to paint a portrait, but also to design a piece of furniture; I draw caricatures, but also rugs, posters, and indeed originals for every kind of printing process; I design stained-glass windows, but also occasionally a leatherwork screen. My motto is: portrayal of the characteristic in form and color, tailored to function and technique."[14] (ill. p. 245).

The author of these pithy lines on the artist-designer was also the author of the "Christiansen rose", as it became enduringly known in the sphere of Jugendstil. This characteristic rose motif can be found in every area of Christiansen's art (ill. p. 245). Instantly recognizable in its style and outstanding in its quality, the motif made him a brilliant decorative artist to some, and to others a shallow panderer to public tastes. "In Rosen" was even the name which Christiansen gave to his villa on the Mathildenhöhe. Christiansen's house offers a sort of correlation to Olbrich's neighbouring villa. Like the houses of his artist colleagues, it demonstrates the same principle of individualistic design as the expression of his own personality. As Christiansen wrote in the catalogue to the colony's exhibition of 1901: "This is no mediocre modern house, and no average person will live here, but one whose world is his own and who has built his nest in line with his own wishes and his own personality ... And I will only be happy when one day it is said: 'Here lived joy in living and in creating!'"[15]

In comparison with the houses of Christiansen, Olbrich, and Behrens, each so closely bound up with the personalities of their owner, the interiors designed by 21-year-old Patriz Huber employed a broad palette of decorative means which the artist tailored to each location. Even critics of the artists' colony acknowledged that Huber came closest to the aim of the exhibition – to present examples of an elegantly stylish form of everyday living. He also designed jewelry and silverware for the Theodor Fahrner jewelry works in Pforzheim, well-known for its Jugendstil products. With their spiral patterns and simple, clear designs, Huber's creations were such a success that these prime examples of high-quality serial production were exported to England (ill. p. 242).

Emmanuel Josef Margold
Biscuit tin for the Bahlsen company, ca. 1915
Printed tinplate, 5.5 x 19.8 x 12 cm
"... in interior ensembles, the restaurant and small *objets d'art*, [Margold] introduced the cultivated and colorful use of ornament, the perfected style of surface decoration from the circle around Josef Hoffmann."
(Paul Ferdinand Schmidt, see note 22)

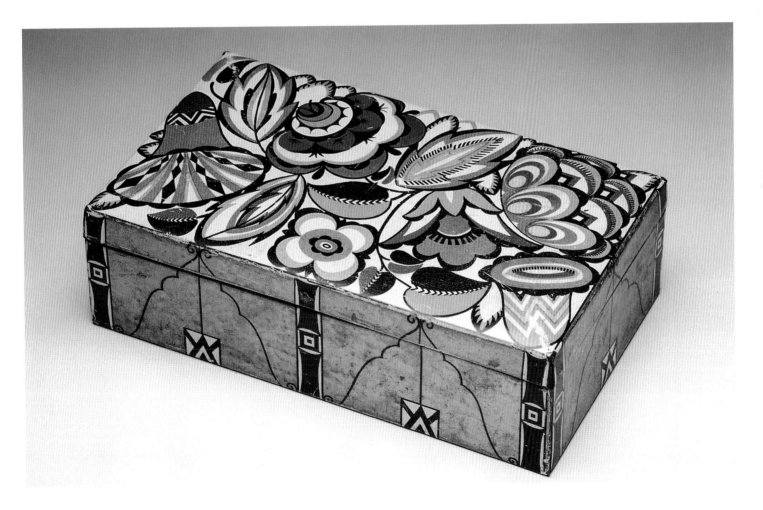

Huber's prodigious talents earned him a notable commission, namely the planning of a villa colony near Posen, which he undertook with his brother, the architect Anton Huber. Before the project could be executed, however, an unhappy love affair led Huber – at the age of just 24 – to take his own life.

High-quality serial items accessible to a broad buying public were also produced by Rudolf Bosselt, including medals and plaques, practical and decorative items of bronze, and ivory and tortoiseshell jewelry. The activities of Paul Bürck, the youngest member of the colony, also centered for the most part on commercial graphics and interior decoration rather than on the "fine" arts. These, then, were the artists who were present from the start of the colony, and who from August to October 1901 put themselves on the line in the exhibition "A Document of German Art".

Exhibitions and "documentations"

Art for the art lovers,
Handicraft for the exclusive circles
of connoisseurs
But the art industry for the people as a whole –
as a giver of bread and joie de vivre.
W. Stöffler[16]

"It is to be a large-scale public celebration and a grand festival of artists," wrote the *Darmstädter Tagblatt* in the run-up to the event.[17] A festival committee oversaw the preparations for this "documentation", and Grand Duke Ernst Ludwig "took a lively interest in all the details."[18] There was a splendid opening, an extraordinary exhibition, and at the end a certain soberness as the anticipated boost to local industry failed to materialize owing to lack of consumer interest. Reviews ranged from enthusiasm to ridicule and frank disapproval. Julius Meier-Graefe was positively venomous: "Ibsen, Goya, Thomas Theodor Heine! None of you have seen the compact majority, that black mass on the breast of one suffocating, that eternally ridiculous, as compact, as black, as ridiculous as I did on that golden morning in Darmstadt". Somewhat more specifically, he expressed his doubts "about the realistic aspects, the practical possibility of turning a town of limited means and lacking trade and industry into a center of commercial importance."[19] Alfred Lichtwark, on the other hand, reached a more positive verdict: "This exhibition will remain in my memory as the first attempt to show the German people in a real-life

example what a private house can be. Those individual things which miscarried or were even somewhat tasteless shall not count against it. The masses are being offered the bread of a new idea, a new idea for them."[20]

Despite some differences of opinion, this "new idea" maintained its momentum and the second exhibition by the artists' colony was staged in 1904, members of the colony having also taken part in various international exhibitions in the meantime, such as Paris in 1900 and Turin in 1902. Alongside financial problems, a crisis of a more personal kind was precipitated by the dominating role assumed by Olbrich. When their contracts expired in 1902, Christiansen, Bürck, and Huber resigned, followed in 1903 by Behrens and Bosselt.

The Grand Duke assumed the entire financial risk of the second exhibition, in order to spare the artists the bureaucratic miseries which had likewise contributed to their departure. As in the first exhibition, the artists' houses – as total works of art – formed the central focus, although individual handicraft products were no longer exhibited exclusively in this context (ill. p. 248). This second exhibition even yielded a small financial profit. From now until the outbreak of the First World War, the colony's exhibition policy became increasingly progressive. Alongside one-man shows, the 1908 Hesse State Exhibition

Ludwig Habich
Tankard, ca. 1900
Stoneware, sharp-fire glaze, treacle glaze, pewter lid with figure modeled in the round, 23.4 cm high
Made by Jakob Julius Scharvogel, Munich

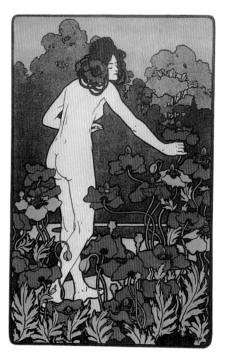

Hans Christiansen
The Lover's Tryst
ca. 1900
From *L'Estampe moderne*
Color woodcut, 34.6 x 22.1 cm
If Olbrich represented the (Vienna) Secession style in the Darmstadt group, Christiansen stood for (French) Art Nouveau.

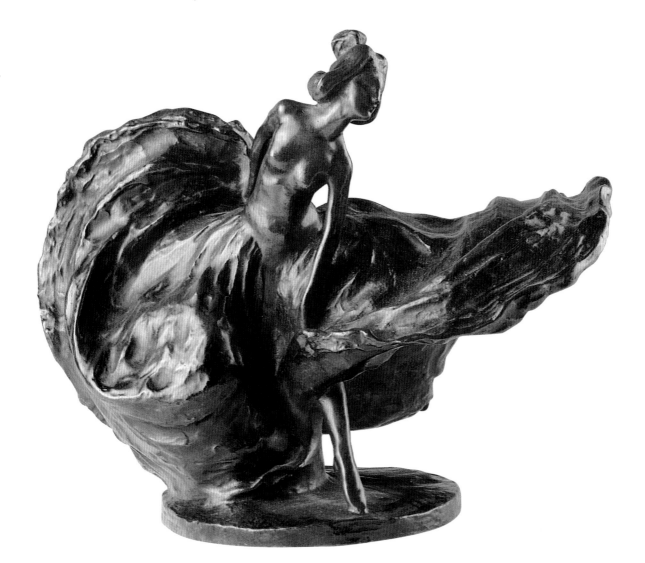

Bernhard Hoetger
Loïe Fuller, ca. 1900
Bronze, 25.5 cm high
Institut Mathildenhöhe, Museum
Künstlerkolonie Darmstadt
The sculptor Bernhard Hoetger had
lived in Paris, where he had met
Rodin and worked in his studio. His
first bronzes were executed in a very
French, powerful Art Nouveau
style; they were Parisian, too, in
their subject, as this highly animated
figure of Loïe Fuller demonstrates.

was a great success thanks to its broad range of exhibits. The third exhibition by the artists' colony offered an impressive summary of all that had been achieved. The bombs of the Second World War destroyed for ever many of its unforgettable works.

"Artists, more than other people, are individualists"

The "Document of German Art" is most clearly documented by the artists who passed through Darmstadt during the passage of time. After the initial departures of 1902 and 1903 already mentioned, Paul Haustein (1880–1944), Johann Vincenz Cissarz (1873–1942) and Daniel Greiner (1872–1943) were appointed to the colony. Cissarz was chiefly active in the fields of painting

and graphics (ill. p. 243). Daniel Greiner was also first and foremost a "utility" artist. Talented and highly talented artists came and went over the years leading up to 1914. A number of them deserve particular mention. Albin Müller's oeuvre embraced every area of the applied arts, whereby his ceramics proved especially successful (ills. pp. 235, 248). His style of ornament is bold and original, full of strong color contrasts and characterized by an elegant "exaltedness" in its contours. In hindsight Müller (1871–1941) expressed his regret that, while the artists' colony had for a while shared and shaped the dream of the total work of art, it had failed to achieve a symbiosis of work and life. "My hopes of and efforts to achieve a friendly coalition amongst the artists of the colony were disappointed from the very start and throughout

Page 253:
Joseph Maria Olbrich
Jewelry box, ca. 1901
Mahogany, mother-of-pearl and
ivory inlay, copper fittings,
40 cm high, 20 x 14.9 cm at the
bottom,
17 x 11.7 cm at the top
Inlay by Robert Macco, Heidelberg
Institut Mathildenhöhe, Museum
Künstlerkolonie Darmstadt
In addition to practical, functional
objects, Olbrich's sheer delight in
design led him to create individual
pieces of an emphatically aesthetic
nature, their high material value
reflecting their use of costly inlay.

my time there. From my unworldly and idealistic standpoint, I had dreamed of a harmonious community of artists, of lively mutual intellectual stimulation, of taking each other's part, and saw with sadness that none of it was to be achieved in the real world. Artists, more than other people, are individualists."[21]

Their formal language was also individual. One of the most important contributions to the colony's last exhibition was the sculptural ensemble by Bernhard Hoetger (1874–1949) in the plane-tree grove. It took as its subject the circle of life – a theme which recurs in the work of artists internationally about the turn of the century. Hoetger had lived in Paris, where he had met Rodin and worked in his studio. His first bronzes were executed in a very French, powerful Art Nouveau style; they were Parisian, too, in their subject, as his highly animated figure of Loïe Fuller demonstrates (ill. p. 251). His successes in France were not without impact in Germany, and he was offered numerous one-man shows. Over the following years Hoetger abandoned his cultured Paris style in favor of an art imbued with social criticism.

A Viennese note was sounded one last time in Darmstadt by Emmanuel Josef Margold (ill. p. 249), who "in interior ensembles, the restaurant and small *objets d'art*, introduced the cultivated and colorful use of ornament, the perfected style of surface decoration from the circle around Josef Hoffmann."[22] Friedrich Wilhelm Kleukens, a member of the colony from 1907, was the first head of the Ernst Ludwig Press which did so much for book design. In addition to graphic works inspired by Morris, Kleukens designed mosaic pictures and ornaments for the 1914 exhibition which, like a final reprise, summarize all of Jugendstil's thematic and visual appeal (ill. pp. 246–247). As evidenced by the establishment of its own printing press, book design at the Darmstadt colony was of great importance, so much so that even the facades of its houses were frequently dubbed "built book illustration" (ill. p. 234) – total works of art everywhere, true "Festivals of Life and Art" (*Feste des Lebens und der Kunst*), as Behrens titled the ideological essay which he published in Jena in 1900.

They are angry, those false prophets, to find their wise words proved wrong – that there will be no new style in art, that there will never be a new style, that it can only evolve out of the old, that it cannot be invented. In this last point they are not entirely wrong. There are now indications that there will be a new style, not developed out of the old, that it is in part already here, at least in its infancy. If one keeps one's eyes open and maintains a happy optimism and a faith in beauty, one will recognize that something is in the process of becoming which resonates more profoundly with our lives than those deliberately bizarre forms which, for all their "modern" exterior, are usually just cheap goods delivered by people who seize upon the latest novelty as a means of making money. Whether one calls such goods after magazines or artist groups, one neither belittles the achievement of those who create them nor honors the efforts of those who made them. Fashion follows its ridiculous swings. The style that is currently in the process of becoming operates more at an inner level; it is neither arbitrarily invented nor playfully compiled out of the old. We have grown earnest, we take our lives seriously, we place a high value on work. We have worked a lot and evaluated a lot and we are weary of playing, of playing with the past. Through working, we have learnt to understand our age and our own lives; what good to us is the masquerade of a past long gone and impenetrable to us today? We recognize the value of our work and are creating standards of value for ourselves. We feel that we have attained something in the sphere of practical life that was never there before and which will never be lost, and this feeling makes us happy. There is a palpable sense that we are entitled to joy, to a measured tranquillity, to a well-earned wage for our work. It is surely clear that the serious man who is dedicated to hard work will find no pleasure in games and romantic dreams ... We can apply our forces to advance even further and will then have greater and higher needs; these, too, we will satisfy with powerful and beautiful forms. We are moving towards a new culture – our own.

Peter Behrens, *Feste des Lebens und der Kunst*, Jena, 1900

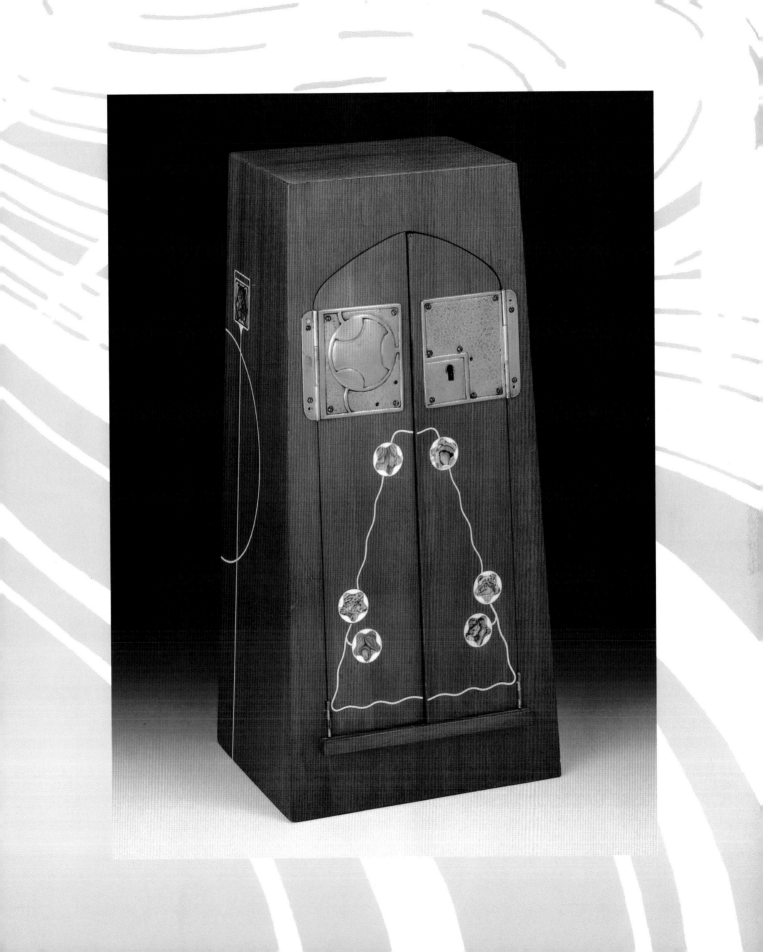

DIE SCHÖPFUNG DER WELT

ALS Gott anfing, den Himmel und die Erde zu schaffen, da war die Erde wüst und leer, und Dunkel deckte den Ozean, aber der Geist Gottes schwebte über dem Gewässer. Da sprach Gott: Es werde Licht! Und es ward Licht. Und Gott sah, daß das Licht gut war, und Gott trennte das Licht von dem Dunkel, und Gott nannte das Licht Tag, das Dunkel aber nannte er Nacht. Und so ward ein Abend und ein Morgen, ein erster Tag. Dann sprach Gott: Es sei eine Feste inmitten der Gewässer, die scheide die Wasser voneinander. Und Gott

Berlin

Ephraim Mose Lilien
Illustration to Genesis 1: 1–6 in
Die Bücher der Bibel, Berlin and
Vienna 1908
Halftone (reproduced in actual size)
Lilien drew his inspiration from
English book illustration, whereby
he relinquished the latter's decorative
overprofusion in favor of
intertwining lines which fill the page
in ornamental fashion.

When we arrived at the very end of the 19th century, there was no more time to lose, and those preoccupied with the idea of a new style suddenly grew restless and feverish.
Henry van de Velde[1]

Berlin – Jugendstil versus Wilhelminism

In line with the general political and social structures prevailing around 1900, Jugendstil had developed not in a centralized fashion in the capital of the German Empire, but in a number of different centers, above all Munich, Darmstadt, Dresden, Weimar, Leipzig, Hagen, and Worpswede. In each case Jugendstil assumed a clearly different form and significance. Berlin became a reservoir for all these diverging trends and remained a magnet for cultural activities of all kinds. The situation in the German metropolis at the end of the 19th century can best be summed up as Jugendstil versus Wilhelminism. Kaiser Wilhelm II appointed himself dictator of taste and arrogantly presumed to know what merited the designation of "art": "Art which goes beyond the laws and boundaries laid down by myself is no longer art; rather, it is handicraft, it is manufacturing, and that is something which art must never become."[2] With these emphatic words, the Kaiser was lashing out at the very phenomenon which was emerging in Berlin around 1900 and which would prove so influential in the future: the handicraft – the functional object of everyday use – was becoming art. The urgent desire for innovative change, the growing awareness that there was "no more time to lose", now resulted not just in decorative artistic daydreams, but in clear steps towards overcoming the problems posed by mechanical production methods and modern city life. The

slogan "art for all" now extended to the practical and functional. However diverse the face which Jugendstil – or that which was subsumed under its name – may have presented in Berlin, it was at all times a protest against the militaristic Wilhelminism and bourgeois capitalism which had flourished since the founding of the Empire in 1871. Within the arts, it was a stand against the historicism which had been perpetuated not least by the Kaiser's own attempts at painting in the style. Any deviation from the well-trodden path of heroic historicism implied a risk. Hence His Majesty denigrated not only the arts and crafts, but felt "seasick", as he put it, at the sight of a piece of van de Velde furniture, whose linear dynamism left him in a very bad way. In the face of such stuffy narrow-mindedness, it is understandable that the liberal-thinking, educated Grand Duke Ernst Ludwig of Hesse should feel the way he did: "Incidentally, while I was in Berlin for the Kaiser's birthday, I frequently found that many of my so-called colleagues were so backward in their attitudes that I felt myself a pure Socialist by comparison."[3]

The "Munch affair" – Walter Leistikow – Secession

It was against this backdrop that a scandal unprecedented in the cultural sphere now erupted. On November 5 1892 a comprehensive exhibition of works by the Norwegian artist Edvard Munch (1863–1944) opened in the Round Room in the Berlin House of Architecture, with the artist in attendance. After the vernissage, a storm of indignation broke out. "Court painter" Anton von Werner described the exhibition as an insult to art, as obscene and vulgar, and

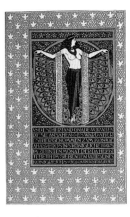

Friedrich Wilhelm Kleukens
The Book of Esther
Insel-Verlag, Leipzig 1908
Printed by Ernst Ludwig Presse,
Darmstadt

Page 256:
Ludwig von Hofmann
Paradise, 1896
Color heliogravure, chalk,
24.3 x 19.2 cm
Hofmann united frame and picture
into a whole, succinctly
recapitulating his subject in
emblematic images on the frame.

Page 257:
Walter Leistikow
Headpiece and footpiece to *Auf der
Kuppe der Müggelberge
(Semnonen-Vision)* by Theodor
Fontane
From *Pan*, no. 1, vol. 2, 1896, p.1
Halftone, 37 x 28.5 cm

Theodor Fontane

Auf der Kuppe der Müggelberge

(Semnonen-Vision)

Ueber den Müggelsee setzt mich der Ferge.
Nun erklettr' ich die Müggelberge,
Mir zu Häupten rauschen die Kronen
Wie zu Zeiten der Semnonen,
Unsrer Urahnen, die hier im Eichwaldsschatten
Ihre Gottheitsstätten hatten.

Und die Spree hinauf, an Buchten und Seen,
Seh' ich wieder ihre Lager stehn
Wie damals beim Aufbruch. Tausende ziehn
Hin über die Dahme . . . Der Vollmond schien.

Am Eierhäuschen hebt es an:
Eine Vorhut, etliche dreißig Mann,
Ein Bardentrupp folgt von Friedrichshagen,
Wo jetzt noch Nachkommen die Harfe schlagen,
Bei Kiekemal und bei Kiekebusch
Blasen Hörner den Abschiedstusch.

Auf Flößen kommen Andre geschwommen,
Haben den Weg bis Schmöckwitz genommen,
Bis Schmöckwitz, wo, Wandel der Epochen,
Jetzt Familien Kaffee kochen.
Aus der „Wuhlhaide" treten, wirr und verwundert,
Geschwindschritts immer neue Hundert
Und bei Woltersdorf und am Dämeritz-See
Sammelt sich schon das Corps d'armée.

Jetzt aber — der Dämeritz ist überschritten —
An des Zuges Ausgang und inmitten
Erblick' ich Mädchen, erblick' ich Fraun,
Alle thusneldisch anzuschaun,
Alle mit Butten, alle mit Hucken,
Draus blond die kleinen Germanen kucken —
So ziehn sie südwärts mit Kiepen und Kobern,
Von der Müggel aus die Welt zu erobern.

(1)

demanded its closure. A fearsome row broke out, with whistling and yelling, and the rumpus eventually degenerated into a brawl. A week later Munch's pictures were taken down. In contrast to the flood of scathing criticism, only a few voices spoke up in Munch's favor. The consequences of the "Munch affair" were nevertheless profound: it would ultimately lead, albeit some years later, to the founding of the Berlin Secession. One painter with a highly sensitive eye for Munch's work was Walter Leistikow (1865–1908), who at the time of the scandal wrote in the *Freie Bühne*: "... that is seen, that is experienced, that is felt. Someone who can put something like that into words, or paint, or song, how shall I put it, his is a poetic nature; he looks out at the world which he loves through a poet's eyes."[4] Leistikow, who immediately became friends with Munch, was a painter of Berlin landscapes and came very close to Jugendstil in his compositions. Feelings and moods are symbolized in arabesque, mutually corresponding contours in his pictures of lakes and forests (ill. opposite page). His scenes of nature, infused with melancholy, are clearly influenced by Japanese prints in the two-dimensional reduction – at times merely to silhouette – of their pictorial elements, in their frequent use of diagonals, and in their lattice or grille-like organization of forms against an expansive landscape. Peter Behrens recognized the quality of Leistikow's work early on: "Two mutually dependent elements need mediators between them – painters who maintain the importance of contour through their mastery of the plane, draughtsmen who know how to feel in a painterly fashion. Leistikow is one of these."[5] The pebble had been tossed into the water and its ripples now began to spread. In protest against the closure of the Munch exhibition, and at Leistikow's instigation, the group *Die Elf* (The Eleven) was formed, analogous to *Les Vingt* (The Twenty) in Brussels. *Die Elf*, who included Max Liebermann (1897–1935), Max Klinger (1857–1920) and Ludwig von Hofmann (1861–1945), prepared the ground in Berlin for the new art. Subsequently, 1898 saw the foundation of the Berlin Secession. In 1906, however, this split into the New Secession and the Free Secession, a move prompted by the feeling amongst many members that Liebermann had driven the original association into the arms of Berlin art dealer Paul Cassirer. The group *Die Brücke* (The Bridge), formed in 1905, also led on from the Secession.

Left:
Theo Schmuz-Baudiss
Vase (detail), April 1903
Porcelain, underglaze painting,
30.9 cm high, 7 cm diameter
Made by the Königliche Porzellan-Manufaktur, Berlin
Badisches Landesmuseum
Karlsruhe, Museum beim Markt –
Angewandte Kunst seit 1900
Schmuz-Baudiss's vases, often very large, with their *pâte sur pâte* decoration, have a particular charm. *Pâte sur pâte* (lit. "paste on paste") is a difficult process in which layers of slip are carefully applied one on top of the other with a brush, until a relief pattern is achieved. Mild greens, grays and pinks further enhance the "softness" of Schmuz-Baudiss's porcelain.

Fidus (Hugo Höppener)
Waltz, from the portfolio *Dances*,
1894
Color lithograph, 35.9 x 24.1 cm
The esoteric Fidus – as his teacher Diefenbach baptized him – combined naturalistic figures, children of Helios, with abstract forms.

Walter Leistikow
Lake Schlachtensee at Dusk,
ca. 1895
Oil on canvas, 73 x 93 cm
Preussischer Kulturbesitz, Berlin
In Leistikow's pictures of lakes and
forests, feelings and moods are
symbolized in arabesque, mutually
corresponding contour lines.

Pan – Julius Meier-Graefe

This was the true purpose of *Pan*. A sort of herbarium! It
was up to us, he argued, to make it a spawning ground for
new life ... He also said all sorts of things about the serious
state of affairs in the German arts and hard work and that
Pan signified not just the cloven-hoofed god, but the
universe, the cosmos.
Eberhard von Bodenhausen on Julius Meier-Graefe[6]

The winds of change blowing through Berlin
were coming from the north, and not just through
the works of Munch. A debate on Nietzsche's
ideas that started in Copenhagen quickly became
international. In 1892 the writers Ola Hansson
(1860–1925), Arne Garborg (1851–1924) and

August Strindberg (1849–1912), together with
the Finn Axel Gallen-Kallela, established their
own regular Scandinavian table in the *"Zum
schwarzen Ferkel"* winebar, where they were
soon joined by Berlin's entire Bohemia.
Strindberg was the uncrowned ruler of the
group, until the Germano-Polish poet Stanislaus
Przybyszewski (1868–1927) appeared and
married the beautiful Norwegian author Dagny
Juell. Dagny was the muse of the "Ferkel" set,
adored, feared and probably at one time
"possessed" by Strindberg and Munch. The
glittering couple took over the leading role in this
legendary literary circle, whose "conferences"
Meier-Graefe described in his memoirs: "The

Eckmann

reason for our meetings was first and foremost to surrender ourselves with almost holy devotion to the pleasures of alcohol, in order to attain that state of intoxication in which the soul is unloosed and reality left far behind."[7] The magazine *Pan*, published for the first time in April 1895 and quarterly from then on until the spring of 1900, was born at the very same table. Its passage was assisted by numerous midwives, but its true father was the writer, art critic and champion of Jugendstil Julius Meier-Graefe (1867-1935). And as he predicted, *Pan* became a cosmos, or more accurately a microcosm of all that was happening on the international art scene around 1900 – heterogeneous but brilliant, of high artistic and literary quality, and still the best testament to its era even today. Otto Julius Bierbaum (1865–1910) was in charge of the literature side, Meier-Graefe the fine arts. They set out their aims in the first edition: to further the arts in the spirit of an organic understanding of art, embracing the

entire sphere of artistic endeavor and seeing true artistic life only in the close proximity of all artists." *Pan* served as a direct medium of art, above all in the sphere of illustration. The quality of its printing, moreover, has never been equaled. It was available in a normal edition, a deluxe edition and an artist's proof edition, with each number containing original prints by prominent artists of the day. It was financed and published by a "Pan Cooperative Society". The editors-in-chief were Meier-Graefe and Bierbaum, and after their departure Caesar Flaischlen and Richard Graul. In contrast to the eloquent, ironic Meier-Graefe, Flaischlen was a rather more effusive type. The cosmopolitan Meier-Graefe was the most dazzling figure in the field of international arts promotion around the turn of the century, a "travelling salesman for Art Nouveau". It was to him, more than anyone, that Germany owed its links with the international art scene. Originally from an industrialist background,

Otto Eckmann
Night Herons – Three Philosophers, 1896
Color woodcut, printed in watercolor on Japanese vellum, 26.5 x 46 cm
"With Eckmann, sentimentality in ornament was perhaps extinguished for good. He was, if not its final mainstay, nevertheless the one who lent ornament enough attraction to arouse the desire to preserve it ... He always made me think of Chopin. Neither of them troubled themselves with the pure line of construction ... His fingers quiver on the line like those of a violinist on the strings." (Henry van de Velde, see note 10)

Meier-Graefe rejected the family career and, after a number of study trips, chose instead to dedicate himself to writing. He was 27 when *Pan* was founded and was already acquainted with all the members of the Aesthetic Movement in England, the Parisian avant-garde and the Munich Secession. Over the following years he became friends not only with the giants of German Jugendstil, but also with Toulouse-Lautrec and Munch. He wrote passionate articles in support of Jugendstil, founded a joint company with Samuel Bing, took the side of Alfred Dreyfus – the French Jewish army officer wrongly accused and convicted of treason – and persuaded Henry van de Velde to come to Germany. In 1897 Meier-Graefe founded another magazine, *Dekorative Kunst* (Decorative Art), and two years later opened the art gallery La Maison Moderne in Paris. He also helped organize exhibitions by the Wiener Werkstätte and in 1904 published the comprehensive *Entwicklungsgeschichte der modernen Kunst* (History of Modern Art). These were just some of the incredible activities of a man who, on a trip to Russia in 1915, was imprisoned in Siberia for nine months, and who upon his release campaigned with unflagging energy on behalf of the works of Vincent van Gogh and embraced the new art of the 20th century. In 1932 Meier-Graefe left Germany for good and went to live in France. Of Jugendstil, he later wrote in hindsight: "It was crazy, but divine, and no one regrets saying they were part of it."[8]

The total work of art in print

I go to the lithograph and find life.
I am filled with courage and fear, imagination and slowness,
the desire to discover and a concern for my safety.
Who belongs to whom, the stone to me or I to it?
Paul Wunderlich[9]

The editorial committee of *Pan* included some of the most important patrons of modern German art, figures from industry and the arts, amongst them Wilhelm von Bode, Baron Eberhard von Bodenhausen, Count Harry Kessler, Alfred Lichtwark, Otto Erich Hartleben and Karl Koepping. Sitting on the board was Karl von der Heydt, whose own magnificent collection now forms the core of the museum in Wuppertal that bears his name. *Pan* was available by subscription only; copperplate printed on Japanese vellum, its mailing list included Tsar Alexander of Russia. Eventually, however, its exclusivity proved too much of a financial handicap; by 1900 it had only 500 paying readers, and the magazine ceased publication.

It would take only a few lines to list the famous and important artists and writers of the day who did not contribute to *Pan*, and a whole book to name those who did – including virtually all the artists appearing in these pages. One name which nevertheless deserves to be singled out is that of Otto Eckmann, the "giant" of lettering and ornament (ill. opposite page). Upon Eckmann's death in 1902, van de Velde wrote: "With Eckmann, sentimentality in ornament was perhaps extinguished for good. He was, if not its final mainstay, nevertheless the one who lent ornament enough attraction to arouse the desire

to preserve it … He always made me think of Chopin. Neither of them troubled themselves with the pure line of construction … His fingers quiver on the line like those of a violinist on the strings."[10] Another major contributor to *Pan* was the master of the vignette, Thomas Theodor Heine, who perfected his use of the "tendril" as a means of animating the plane and of cultivating dynamic line in asymmetries, curves and above all in the amalgamation of the organic with the functional (ill. p. 261). Another of the outstanding *Pan* artists was Ludwig von Hofmann, a painter of archaic figures in springtime settings. His recapitulation of the content of his paintings in emblematic images on the frame served to unite picture and frame into a whole, and thereby made him the representative of the "total work of art" within painting (ill. p. 256). The esoteric Fidus – as Diefenbach baptized his pupil Hugo Höppener (1868–1948) – combined naturalistic figures, children of Helios, with abstract forms (ill. p. 258). Ephraim Mose Lilien (1874–1925) drew his inspiration from English book illustration, whereby he relinquished the latter's decorative overprofusion in favor of intertwining lines which fill the page in ornamental fashion (ill. p. 254). Melchior Lechter (1865–1937), on the other hand, also following in Morris's footsteps, arrived at an economy of lettering and image of almost epic austerity (ill. p. 261).

Dreams of flowering glass – Karl Koepping

The applied arts were represented in the pages of *Pan* by Karl Koepping (1848–1914), one of magazine's joint editors and himself an artist (ill. opposite page). Trained as a painter, he moved on to etching and ultimately to glass. Inspired by the Art Nouveau and Tiffany glassware exhibited in Paris by Bing, he drew upon his earlier qualification as a chemist and started experimenting with glass. Since his first efforts were not as successful as he had hoped, he turned to Friedrich Zitzmann (1840–1906), an experienced glassmaker who had spent a few years working in Murano – the center, near Venice, of an important glass industry since the 13th century – and who had the technical expertise necessary to realize Koepping's bizarre designs. The collaboration lasted only a few months, however, since Zitzmann failed to honor his obligation not to use Koepping's designs and specific manufacturing processes in his own glassware. Argument over the copyright is still going on today (ill. opposite page). The attractiveness of

Koepping's glassware lies in the virtuoso handling of the material, which bears no external decoration but becomes an ornament in its own right. His glasses take the shape of flowers whose wafer-thin goblets float on curved stems. Through his contacts with Bing via Meier-Graefe, Koepping was able to exhibit his works in Paris. According to a review of the annual Salon du Champ de Mars of March 1897: "There are a few things, however, deserving distinction, and I will place in the first rank the blown glass by M. Karl Koepping … M. Koepping's glass is delightfully simple and light, and supremely artistic. How infinitely preferable this plainly treated, graceful material, which is really glass, to the over-elaborate metallic complications of Tiffany."[11]

A potpourri of expressive forms

Here I sat waiting, waiting – but for nothing
On the far side of good and evil, now enjoying
the light, now the shade, the whole just a game …
Friedrich Nietzsche[12]

Light and shade, playfulness and seriousness – art in Berlin and the rest of Germany around 1900 embraced all this and more, offering the viewer an inexhaustible spectrum characterized both by its high quality and its profound formal contrasts. Many artists explored equivalent forms of expression in different media not just in theory, but also in practice. Thus, the endlessly repeated pattern of the divine arabesque was not confined to the pages of *Pan*, but expanded outwards into the sphere of three-dimensional design, spreading to furniture, glass, porcelain, pewter, and silverware. However, the opponents of ornament also began an active search for a new, "contemporary" form of expression which replaced ornament with pattern. "But even the cheapest, most worthless cotton dress can bear a print, while ornament – wherever it appears – has something distinctive about it. While there is no truly 'modern' ornament, there are certainly modern forms of 'pattern'. To take an extreme instance: a prime example of an 'abstract' pattern is the camouflage familiarly seen on military vehicles – and of which a major painter, Georges Braque, described himself the inventor with a certain pride … "[13] The luxurious jewelry by the Berlin artist Wilhelm Lucas von Cranach (1861–1918), a descendant of the famous German painter Lucas Cranach, is pure, "uncamouflaged" Art Nouveau (ill. p. 262). Cranach, too, started out as a painter before turning to jewelry. He was alone in Germany in producing works

Wilhelm Lucas von Cranach
Pendant, ca. 1900
Gold, ruby cabochons, diamonds, translucent enamel and freshwater pearls, 7 x 5.5 cm
Made by Gebrüder Friedländer, Berlin
Collection Barlow/Widmann, Spain
The luxurious items of jewelry designed by the Berlin artist Wilhelm Lucas von Cranach, a descendant of the famous German painter Lucas Cranach, are pure Art Nouveau. Wilhelm, too, started out as a painter before turning to jewelry. He was alone in Germany in producing works comparable in quality with those issuing from France – something which earned him corresponding recognition at the Paris World Exposition of 1900.

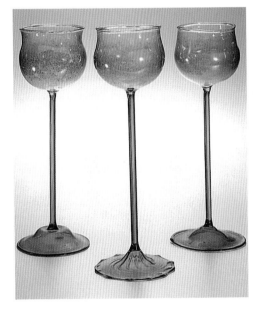

Friedrich Zitzmann
Three stemmed glasses, ca. 1899
Glass, blown and worked with a
lamp, 21.5 cm to 22.2 cm high
Kunstmuseum im Ehrenhof,
Düsseldorf

Karl Koepping
Decorative glasses
Original etching, 25 x 15 cm
From *Pan*, no. 3, vol. 2, 1896,
p. 253
"There are a few things, however,
deserving distinction, and I will
place in the first rank the blown
glass by M. Karl Koepping ...
M. Koepping's glass is delightfully
simple and light, and supremely
artistic. How infinitely preferable
this plainly treated, graceful
material, which is really glass, to
the over-elaborate metallic
complications of Tiffany." (Review
of the annual Salon du Champ de
Mars exhibition, Paris 1897, see
note 11)

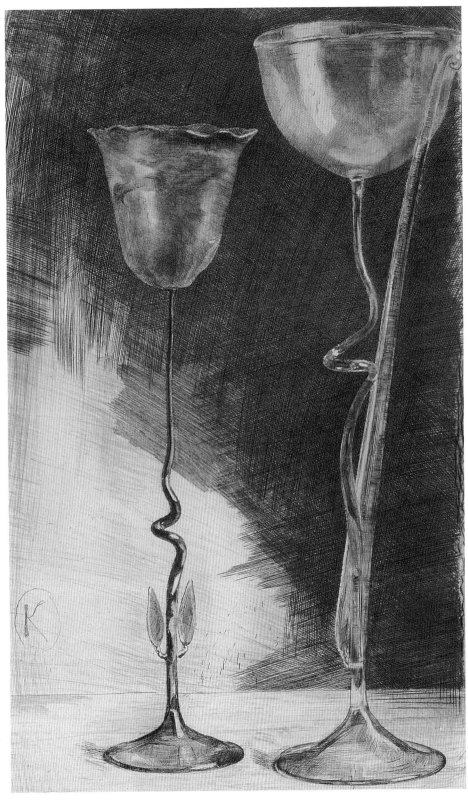

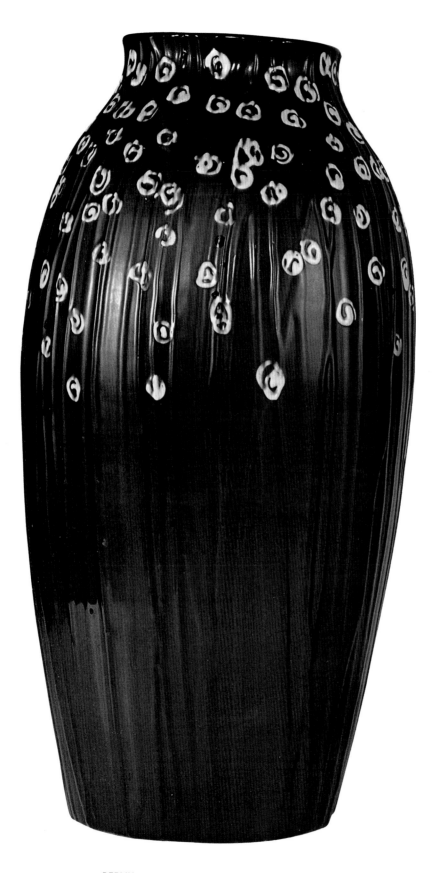

Left:
Max Laeuger
Vase, 1904–10
Glazed and painted earthenware,
39.5 cm high
Made by the Tonwerke Kandern,
Baden
Laeuger, who came from a
background in painting, used the
clay body of his earthenware as the
substrate for a rich, multicolored
representation of flowers, bending
branches and slender grasses which
enclasp the vessel in a sort of
framework.

Opposite page, top right:
Julius Konrad Hentschel
Items from the *Crocus* service, ca.
1899–1900
Porcelain, underglaze painting,
coffee pot: 21 cm high
Made by the Königlich-Sächsische
Porzellan-Manufaktur, Meissen

Centre right:
Otto Eduard Voigt
Serving plate from the *Saxonia*
service, 1904
Porcelain, sharp-fire painting,
34 cm long
Made by the Königlich-Sächsische
Porzellan-Manufaktur, Meissen
The famous porcelain works in
Meissen was initially hesitant to
embrace the new Jugendstil trend.
It nevertheless went on to produce
some of the best examples of
Jugendstil porcelain, employing
designs by Henry van de Velde,
Richard Riemerschmid, Otto
Eduard Voigt and Julius Konrad
Hentschel.

Bottom right
**Königlich-Sächsische Porzellan-
Manufaktur, Meissen**
Flamingos, centerpiece, ca. 1900
Porcelain, underglaze painting,
18.5 cm high
Collection Barlow/Widmann,
Spain

Opposite page, far right:
Max Laeuger
Vase, 1903
Glazed and painted earthenware,
32 cm high
Made by the Tonwerke Kandern,
Baden

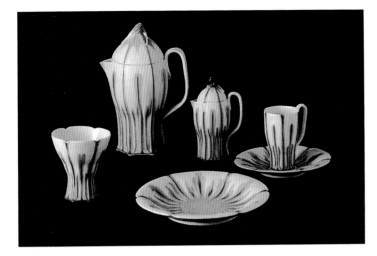

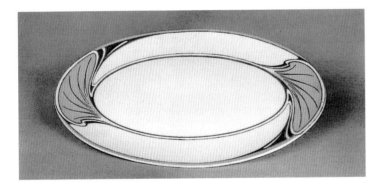

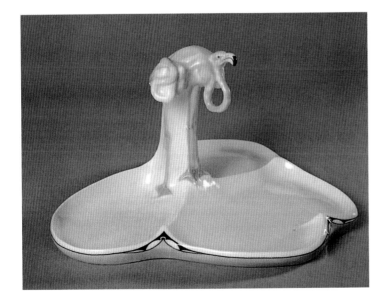

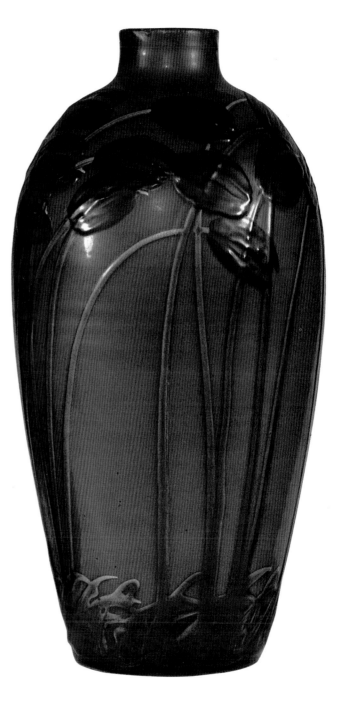

comparable in quality and originality with those issuing from France – something which earned him corresponding recognition at the Paris World Exposition of 1900. In order to be part of the new style, the royal porcelain works in Berlin – the Königliche Porzellan-Manufaktur (KPM) – also employed a painter, Theo Schmuz-Baudiss (1859–1942), as a designer. Schmuz-Baudiss "painted" his designs, chiefly landscapes and city panoramas, in underglaze on to the porcelain. His vases, often very large with their *pâte sur pâte* decoration, have a particular charm (ill. p. 258). *Pâte sur pâte* (lit. "paste on paste") is a difficult process in which layers of thinned clay are carefully applied one on top of the other with a brush, until a relief pattern is achieved. Mild greens, grays and pinks further enhance the "softness" of Schmuz-Baudiss's porcelain.

A pioneer in the field of porcelain manufacturing and decoration was Hermann Seger (1839–93), also employed by KPM, who gave his name to "Seger porcelain". This sintering mixture, obtained through a complex process, is particularly suitable for metal glazes, permitting an animated, abstract decor of flowing streaks of color (ill. opposite page). The famous Meissen porcelain works were initially hesitant to embrace the new Jugendstil trend. They nevertheless went on to produce some of the best examples of Jugendstil porcelain, employing designs by van de Velde, Riemerschmid, Otto Eduard Voigt (1870–1949) and Julius Konrad Hentschel (1872–1907) (ills. p. 265). At the Paris World Exposition of 1900, ceramic artist Max Laeuger (1864–1952) was awarded the Grand Prix, securing him an international reputation from that point on. His slip decor pieces rank amongst the most attractive "populist" products of Jugendstil. Laeuger, who came from a background in painting, used the clay body as the substrate for a rich, multicolored representation of flowers, bending branches, and slender grasses which enclasp the vessel in a sort of framework (ills. pp. 264, 265). This spherical style of decor, which can be found employed on practical utensils of every material, worked particularly well in metal – a natural consequence of the flexibility of the medium. The superior pewter produced by the firm of Johann Peter Kayser & Sohn AG, based in the Bockum district of Krefeld, had led Liberty to commission its own line from them. Kayser pewter was a special lead-free alloy of tin and silver which lent the material a luminous gleam (ill. right). Symbolistic and floral motifs were "processed" into functional objects with slender, elegant contours. Kayser & Sohn AG numbered amongst the German firms which boasted international success with their Jugendstil products. The WMF – Württembergische Metallwarenfabrik – in Geislingen/Steige was another manufacturer contributing to German Jugendstil with its exuberant floral and figural decors in the French Art Nouveau style (ill. left).

WMF – Württembergische Metallwarenfabrik, Geislingen/Steige
Nymphs, vase, ca. 1900
Silverplated metal, relief decor and modelling in the round,
58.5 cm high
Designed by Albert Mauer
The WMF was another manufacturer contributing to German Jugendstil with its exuberant floral and figural decors in the French Art Nouveau style.

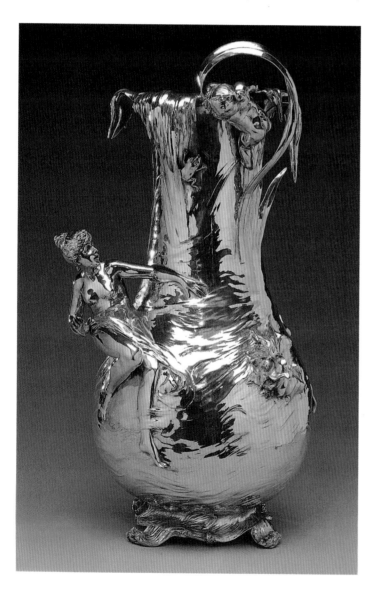

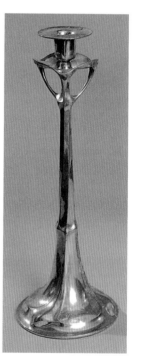

Johann Peter Kayser & Sohn AG, Krefeld-Bockum
Candlestick, ca. 1902
Polished Kayser pewter,
38.9 cm high
Designed by Hugo Leven

Johann Emil Schaudt
Armchair, 1901
Elm, embossed leather,
112 x 52 x 75 cm
Made by the Dresdner Werkstätten
für Handwerkskunst, Schmidt &
Müller
Staatliche Kunstsammlungen
Dresden, Kunstgewerbemuseum
Alongside Behrens, Obrist, Pankok,
Paul, Endell and Riemerschmid,
"local" designers such as Schaudt
also worked for the Dresdner
Werkstätten. Their furniture
encapsulated a specific "Dresden
style" which was markedly devoid of
pathos, and which struck a balance
between the strong geometry and the
exuberant Symbolism that
represented the two popular stylistic
options of the day. Clarity and
simplicity would subsequently
become synonymous with the
Deutsche Werkstätten.

Hermann Seger
Vase, ca. 1900
Porcelain, oxblood glaze,
14 cm high
Made by the Königlich-Sächsische
Porzellan-Manufaktur, Meissen
Seger was a pioneer in the field of
porcelain manufacturing and
decoration, and gave his name to
"Seger porcelain". This sintering
mixture, obtained through a
complex process, is particularly
suitable for metal glazes, permitting
an animated, abstract decor of
flowing streaks of color.

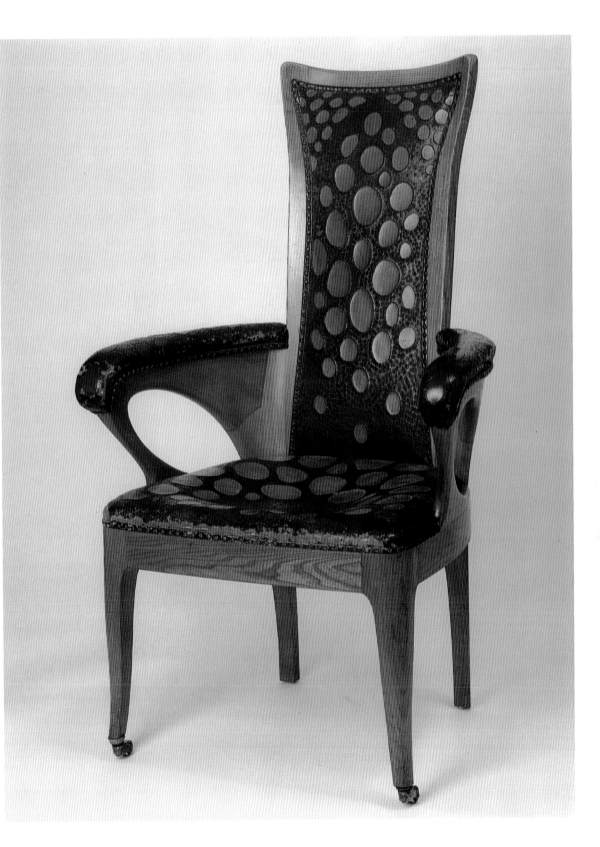

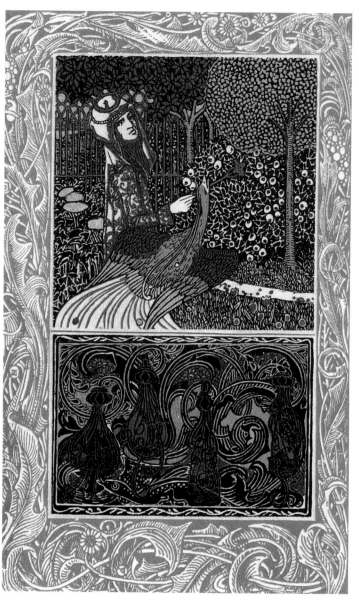

Heinrich Vogeler
Frontispiece and title page to
Der Kaiser und die Hexe [*The Emperor and the Witch*] by Hugo von Hofmannsthal,
Insel-Verlag, Leipzig 1900
Halftone, 20.2 x 25.3 cm
"[The illustrations to] *Der Kaiser und die Hexe* by Hugo von Hofmannsthal confirm that his calm linear art, so homogeneous in its effect and yet within itself so rich, is suited like none other to accompany the train of noble letters like a song."
(Rainer Maria Rilke, see note 14)

Jugendstil from Saxony

Meissen was not alone in securing the applied arts in Saxony their "positive image". In 1899, only shortly after the foundation of the Vereinigte Werkstätten für Kunst im Handwerk (Associated Workshops for Art in Handicraft) in Munich in 1898, the Dresdner Werkstätten (Dresden Workshops) were formed. The goal uppermost in the minds of the Dresden designers was to produce exemplary furniture and objects at an affordable price. Around 1902 this idea led to the foundation of the Werkstätten für deutschen Hausrat (Workshops for German Household Goods). In 1907 the Werkstätten für Wohnungs-einrichtungen, München (Munich Workshops for Interior Furnishings) amalgamated with the Dresdner Werkstätten to form the Deutsche Werkstätten Dresden-Hellerau und München (German Workshops of Dresden-Hellerau and Munich). Behrens, Obrist, Pankok, Paul, Endell and Riemerschmid all worked for the Dresdner Werkstätten, which also produced furniture in collaboration with "local" designers such as

Johann Emil Schaudt (b. 1871) (ill. p. 267). Such furniture encapsulated a specific "Dresden style" which was markedly devoid of pathos, and which struck a balance between the strong geometry and the exuberant Symbolism that represented the two popular stylistic options of the day. Clarity and simplicity would subsequently become synonymous with the Deutsche Werkstätten. The capital of Saxony reinforced its status with numerous exhibitions featuring the works of both regional and international designers.

Worpswede – lineament and plane

The far north of Germany also saw the foundation of design workshops. The Worpswede Werkstätten für einfache Einrichtungen und Möbel (Worpswede Workshops for Simple Interiors and Furniture) was set up in Tarmstedt, near Bremen, by Heinrich Vogeler (1872–1942), the "Morris of Germany". Like the influential Englishman, Vogeler became a committed

Lucian Bernhard
Poster advertising Adler typewriters
ca. 1909
Color lithograph, 69 x 94 cm
Printed by Hollerbaum & Schmidt, Berlin
Die Neue Sammlung, Staatliches Museum für angewandte Kunst, Munich
To the artistic spectrum which evolved, with such fascinating formal diversity, between 1900 and the beginning of the First World War in 1914, belonged the advertising poster, a favorite genre of Jugendstil and one often far ahead of it.

Peter Behrens
AEG turbine hall, Moabit, Berlin, 1909
With his appointment, in 1907, to the AEG's artistic advisory board, the Jugendstil "ego euphoria" of Behrens' Darmstadt days passed into history, and he assumed a new role as designer of – as we say today – the corporate identity of a modern utility.

Socialist, and in his latter years a Communist. He is nevertheless remembered as the creator of romantic, fairytale-like etchings and drawings which added an important artistic dimension to book illustration around the turn of the century. Within the framework of the Worpswede school of painters, initiated in the village of the same name by, amongst others, Otto Modersohn and Fritz Mackensen, Vogeler ran his own printing press. The poet Rainer Maria Rilke, with whom he was acquainted, described Vogeler's "ornamental dreams" thus: "The art of encapsulating all of spring, all the wealth and abundance of the days and nights, in a flower, in the branch of a tree, a birch or a languishing girl – none was so skilled in this art as Heinrich Vogeler … [The illustrations to] *Der Kaiser und die Hexe* [The Emperor and the Witch] by Hugo von Hofmannsthal confirm that his calm linear art, so homogeneous in its effect and yet within itself so rich, is suited like none other to accompany the train of noble letters like a song."[14] The harmonious linearity of Vogeler's art attracted many imitators, resulting in a veritable Vogeler boom around 1900. His atmospheric illustrations nevertheless remained beyond compare (ill. p. 268).

To the artistic spectrum which evolved, with such fascinating formal diversity, between 1900 and the beginning of the First World War in 1914, belonged the advertising poster, a favorite genre of Jugendstil and one often far ahead of it (ill. p. 269).

Peter Behrens – From artist-designer to industrial designer

The material in itself is dead and lifeless. It is only given life by form, breathed into it by the creative will of the artist … the value of the work of art lies in the emotional satisfaction of an inner urge for redemption, not in the value of the material.
Walter Gropius[15]

The words of Bauhaus founder Walter Gropius encapsulated the new understanding of art. The artistic object was no longer the costly material, nor its ornamental cloak, but the form – the design. "The objectivity which set in from now on was essentially a further logical step in the programme, although it appeared at first sight as a countermovement, a reaction – which indeed it was as regards ornament. Although this latter did not disappear altogether, it visibly froze under the cold shower of condemnation. The rhythm, playfulness and inventiveness which had made the works of artists such as Eckmann, Pankok, Endell, Christiansen and many others so delightful, even the magnificent, wrestling lines of van de Velde – all these shriveled and dried up. Like the imaginary games played by children marching in a military 'left-right-left', it was as if someone had shouted 'Halt!'. From 1902 the dynamic and the animated, the glide and dance of line, form and color gave way to the motionless abstract figure: square and circle, rhombus and oval, an ordered juxtaposition of

Peter Behrens
Synchon, electric clock designed for AEG, Berlin, ca. 1910
Brass, rolled metal, glass, 26 cm diameter
"Behrens' job was not just to build factories, but to take charge of all aspects of formal design at the AEG, from the lettering of its adverts and brochures to domestic appliances, electric kettles and arc lamps, right up to the AEG's buildings. Everything was entrusted to just one person's hands, and it is rather strange that they should have been the hands of the painter Peter Behrens. There must have been some clever people at the AEG."
(Julius Posener, see note 17)

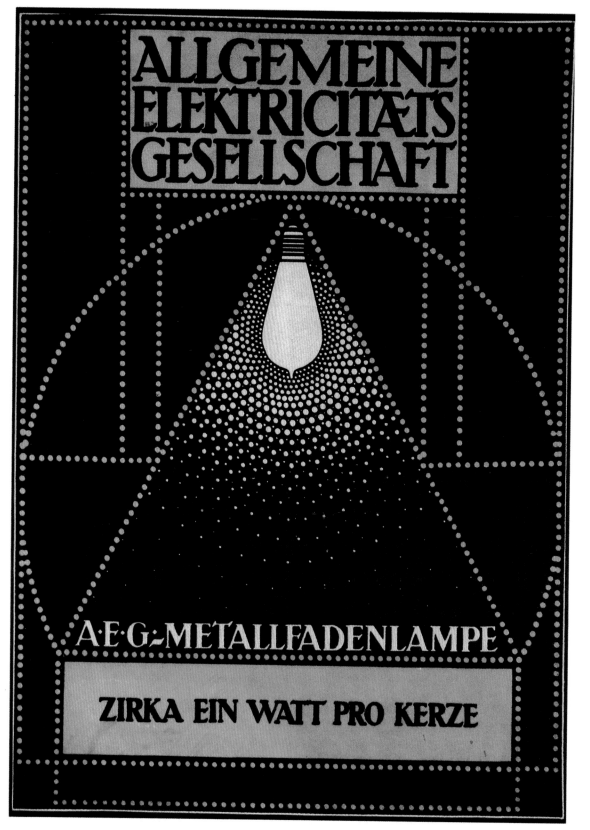

Peter Behrens
Design for a poster advertising an
AEG metal filament light, 1907
Color lithograph, 67 x 52 cm
Printed by Hollerbaum & Schmidt,
Berlin
AEG company archives,
Frankfurt/Main

compact individual motifs. It was Peter Behrens, in particular, whose austerity would establish a new yardstick and whose development towards tectonic form took place absolutely parallel to the geometricization of his ornament; thus he covered, emphasized, clarified the surfaces of his architecture by segmenting them with black rectangular or circular forms on a pale background, not dissimilar to the effect of the Baptistry in Florence."[16] In the person of Peter Behrens, we can follow the aesthetic shift – both in his work and in his career – from painter to industrial designer. The author of the quotation above omits, in the list of artists to whom he attributes the qualities of rhythm and playfulness, to include Behrens, himself the master of the vital line in his early work. The comparison between Behrens' later architecture and the Florence Baptistry is an appropriate one, and at the same time shows that Behrens did not halt on the command "Halt!", but advanced logically towards a classical style – "classical" not as a stylistic term, but in the sense of a quality of achievement, in Behrens' case a completed artistic evolution which lent his designs a fundamental definitiveness. In line with such heady terminology, the turbine hall which he built for the AEG general electricity company in Berlin was also called a "cathedral of industry" (ill. p. 270). With his appointment, in 1907, to the AEG's artistic advisory board, the Jugendstil "ego euphoria" of Behrens' Darmstadt days passed into history, and he assumed a new role as designer of – as we say today – the corporate identity of a modern utility (ills. pp. 272, 273). "Behrens' job was not just to build factories, but to take charge of all aspects of formal design at AEG, from the lettering of its adverts and brochures to domestic appliances, electric kettles and arc lamps, all the way to the company's buildings. Everything was entrusted to just one person's hands, and it is rather strange that it should have been the hands of the painter Peter Behrens. There must have been some clever people at the AEG. I have always tried to find out whether Walther Rathenau, himself an intelligent man, had a hand in it, although I suspect not. It was Walther Rathenau's opinion that art should not be mixed with everyday life, and that the two were entirely separate realms. But this was precisely what the Werkbund sought to do: to carry art into life, to create – as Peter Behrens did – the artistic factory, the artistic utensil."[17] Peter Behrens achieved the goal which the Werkbund had set itself: the unadorned functional form as art (ill. p. 271). The classicism mentioned earlier,

Peter Behrens
Three logo designs for AEG,
1908 and 1914
AEG company archives,
Frankfurt/Main

Peter Behrens
Low-consumption arc lamp for
AEG, 1907
Painted metal
AEG company archives,
Frankfurt/Main

Peter Behrens
Roof terrace of the AEG small
motors factory, Brunnenstrasse,
Berlin, 1911
AEG company archives,
Frankfurt/Main

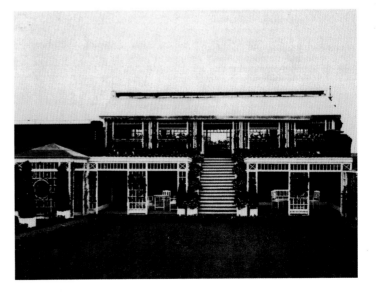

Henry van de Velde
Ceiling lamp, ca. 1906
Brass, glass, 75 cm long
Kunstsammlungen zu Weimar,
Bauhaus-Museum

Henry van de Velde
Two vases, before 1902
Stoneware, sharp-fire and flowing glaze, 24.8 cm and 27 cm high
Made by Reinhold Hanke, Höhr

the *reductio ad elementa* of antique form, finds its echo in Behrens' turbine hall, which is at the same time contemporary and progressive. As an indication of just how powerful an influence – both immediate and indirect – this "cathedral of industry" exerted on the future, it is interesting to note that Behrens' assistants on the project included the three leading architects of the 1920s, if not of the 20th century: Walter Gropius, Ludwig Mies van der Rohe and Charles Edouard Jeanneret, subsequently known as Le Corbusier.

Henry van de Velde – The abstract line – Karl Ernst Osthaus

Yesterday van de Velde showed me his grandiose designs for the Schelde waterside in Antwerp, which are similarly based entirely on the rhythm of enormous masses (skyscrapers).
Count Harry Kessler[18]

Rathenau rejected the "artification" of everyday life, since he believed it carried the danger of rendering art banal. Henry van de Velde, one of the central figures of Jugendstil, never produced designs for industry nor tailored his art to the requirements of mass production, but his theoretical deliberations nevertheless culminated in "modernism" and the founding of the Werkbund in 1907. Van de Velde recognized early on that the era of tendrils, flowers, and the female sex as ornament was over; the art of the future would be abstract. From now on his art was dominated by the primacy of the "abstract line"

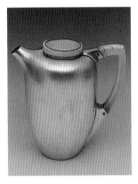

Henry van de Velde
Coffee pot, 1904
Chased silver, ivory, 16.5 cm high
Made by A. Th. Müller, Berlin

Henry van de Velde
Salon of the court hairdresser
François Haby, Mittelstrasse 7, Berlin, 1901
Contemporary photograph
In the new interior which van de Velde gave the salon run by court hairdresser François Haby, he reveals his fanciful Jugendstil side one last time. In this connection, Max Liebermann is alleged to have let slip the biting remark that he didn't actually sport his intestines as a fob chain either.

(ill. opposite page). While van de Velde also lent his support to the promotion of Thuringia's small-scale industries, he remained the urbane artist-designer favored by idealistic patrons. The aim of this symbiosis of capital, intellect and art was an "elevation", as Goethe might have termed it, to higher planes. No one was better suited to fulfill such a task than the cosmopolitan van de Velde. After early commissions in Berlin (ill. below) for Baron Eberhard von Bodenhausen, van de Velde made the acquaintance of Karl Ernst Osthaus and Count Harry Kessler, two patrons who were to play a fundamental role in shaping his career. Osthaus (1874–1921), the aesthete son of a industrialist millionaire from Hagen, was granted permission by his father to dedicate himself to what he was good at – which was not manu-facturing. In the spring of 1901 Osthaus read an article on van de Velde by Meier-Graefe. Its numerous illustrations documented the unity of a new style of life and art. The article resulted in Osthaus requesting an "audience" with van de Velde by telegraph. The fruits of their meeting were prodigious. Under Osthaus's patronage the new style took on an impressive propagandistic role. Van de Velde went on to build the Folkwang Museum in Hagen, while the Deutsches Museum in Handel und Gewerbe (German Museum of Trade and Industry) founded by Osthaus made a name for itself with lectures and touring exhibitions, as well as with the high-quality books published by its own press. The Karl Ernst Osthaus Archive in Marburg provides a wonderful document of Jugendstil in excellent

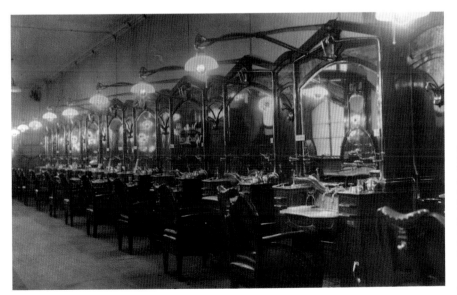

Pages 276, 277:
Henry van de Velde
Villa Hohenhof, bay window with dressing-table in the bedroom and winding staircase up to the second storey, Hagen, 1908
The Villa Hohenhof for Karl Ernst Osthaus – the home as the realm of the individual, artistically designed right down to the last detail, as the synthesis of all its furnishings, and as an "interior design" around which everything revolved in primarily Jugendstil style.

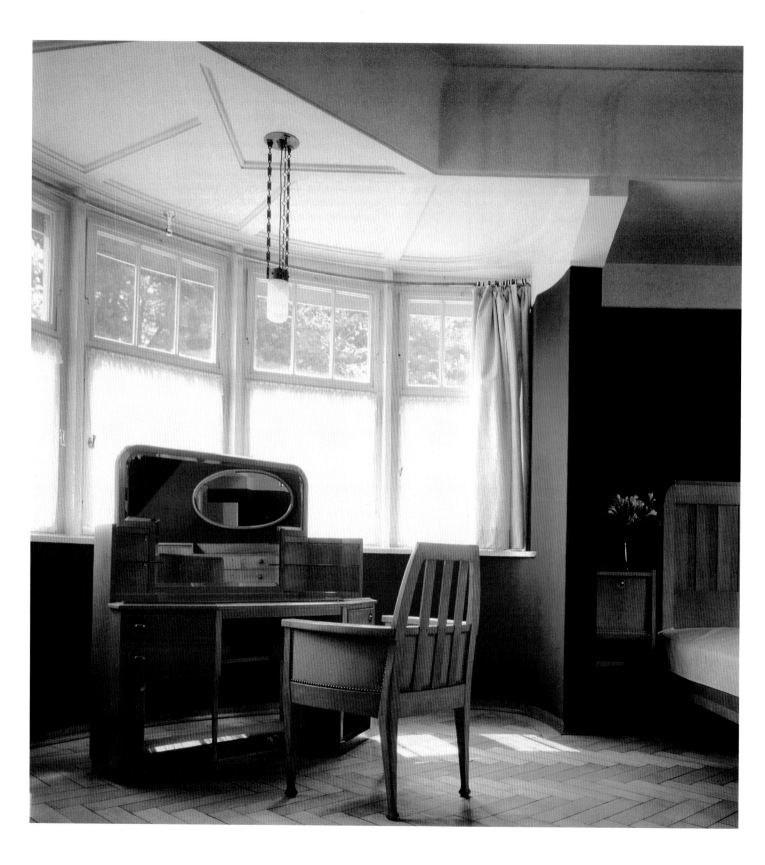

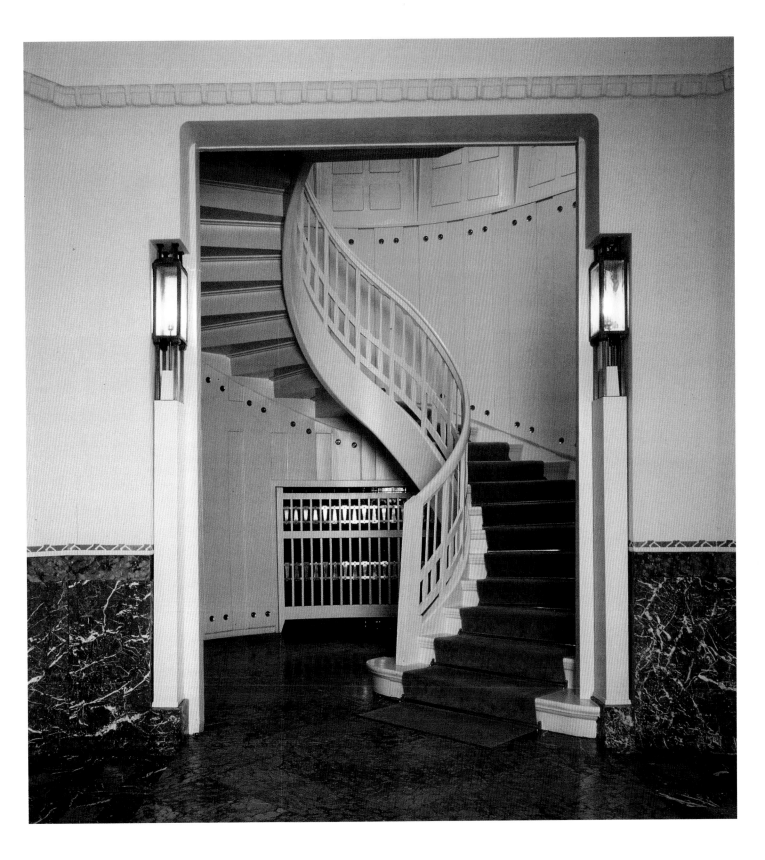

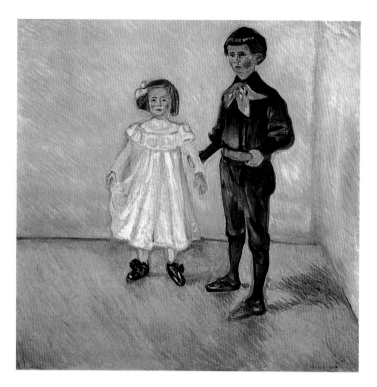

contemporary photographs. In 1908 Osthaus commissioned van de Velde to build the Villa Hohenhof – the home as the realm of the individual, artistically designed right down to the last detail, as the synthesis of all its furnishings, and as an "interior design" around which everything revolved in primarily Jugendstil style (ills. pp. 276, 277). Van de Velde was awarded numerous other commissions of this sort, including the Springmann house in Hagen, the Fröse house in Hanover, the Henneberg house in Weimar, and the Villa Esche in Chemnitz, to name but a few. Esche, a hosiery manufacturer, numbered amongst the impressive ranks of those "arts managers" who designed not simply their private retreats but also their environment – in this case, Chemnitz. Esche was also a patron of Edvard Munch, who painted his children (ill. left).

Weimar and Count Harry Kessler – From Goethe to the Bauhaus

Art presents itself as an outlook on life, rather like religion and science and socialism too.
Rainer Maria Rilke[19]

In 1901 the Grand Duke of Saxe-Weimar offered Henry van de Velde, the universally talented Belgian artist, a post in Weimar. It was part of a larger effort to awaken the small, forgotten city from its enchanted slumber, an ambitious plan initiated by Count Harry Kessler (1868–1937) and Elisabeth Förster Nietzsche, sister of the philosopher. Kessler was a European *par excellence*: educated at international schools, his mother was Irish and his father a banker in Paris. In Berlin Kessler hosted a salon which brought together members of Europe's cultural elite. Van de Velde furnished the interior of Kessler's Berlin apartment and that of his sister in Paris. During this period the two urbane figures developed a close friendship. Kessler lent his patronage to every sphere of Jugendstil, whereby he made a particularly outstanding contribution to typographical art, founding the Cranach Press, which published bibliographic gems designed by famous artists. He acquired unusual status as a writer and politician, and his memoirs of 1935 – *Gesichter und Zeiten* (Faces and Times) – paint the fascinating picture of an entire epoch. The support offered by the Grand Duke in Weimar fell far short of that provided by Ernst Ludwig in Darmstadt – and Kessler was robbed of some of his illusions – but Weimar was nevertheless shaken out of its sleep until the end of the Weimar Republic. Even though the commissions

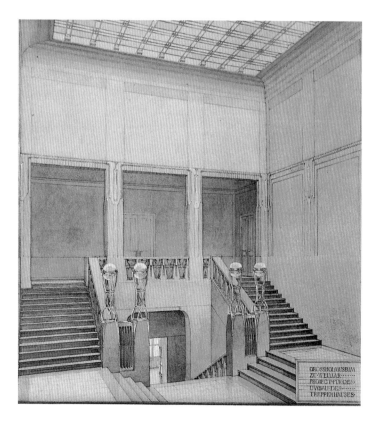

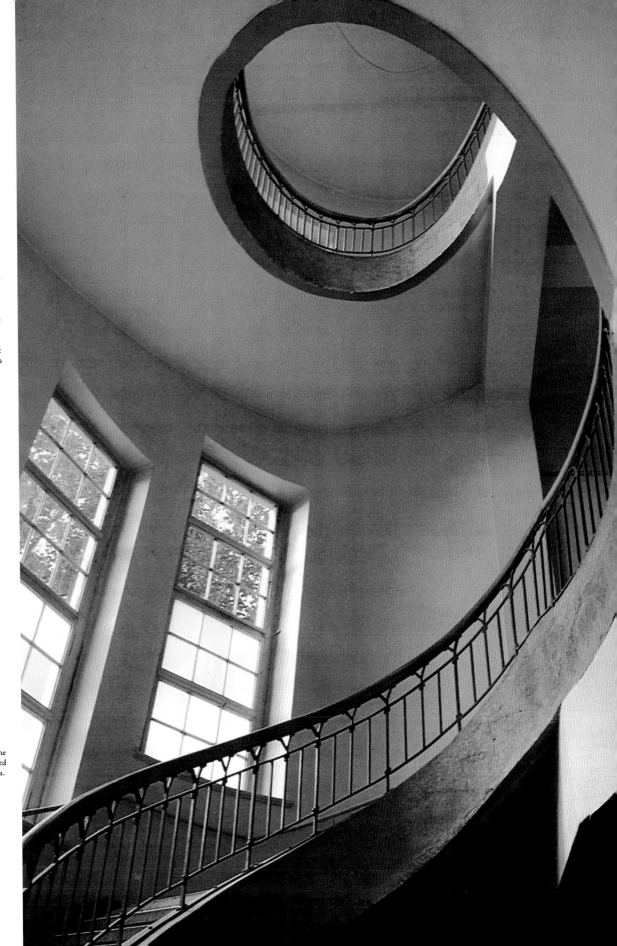

Opposite page, inset left, and right:
Henry van de Velde
Garden facade and stairwell, Grand-
Ducal Saxon Academy of Fine Art,
Weimar, 1904–11
The merger of the Grand-Ducal
Saxon Academy of Fine Art and the
Grand-Ducal Saxon School of Arts
and Crafts resulted in the opening,
on April 1 1919, of a new type of art
college – the Weimar State Bauhaus
headed by Walter Gropius.

Page 281:
Henry van de Velde
Doorhandle, Nietzsche Archive,
Weimar, 1902–03
Van de Velde arrived at a highly
successful solution for the Nietzsche
Archive which he was commissioned
to design within a historicizing villa.
The entrance door lends a further
distinguished note to the whole.

which van de Velde had hoped to receive from the government never materialized, his time in Weimar was nevertheless a fruitful one. His first commission to attract attention was the Nietzsche Archive which he redesigned on behalf of Nietzsche's sister. The highly successful solution which he implemented within a historicizing villa is dignified by the entrance door (ill. opposite page). Following the foundation – in the Weimar Museum in December 1903 – of the Deutscher Künstlerbund (German Association of Artists) as the central organ of all the Secession movements in Germany, plans were drawn up to renovate the Grand-Ducal Museum and to build a new School of Arts and Crafts (ill. p. 278). The support lent to these projects by the Grand Duchess's mother Pauline ceased upon her death in 1904. Van de Velde had already been granted teaching rooms and premises in 1902 through her patronage, but the new building housing the School of Arts and Crafts – for which van de Velde had first submitted unsolicited plans in 1904 – was finally opened in 1907. The artistic capital, too, was put up in the end: the merger of the Grand-Ducal Saxon Academy of Fine Art and the Grand-Ducal Saxon School of Arts and Crafts resulted in the opening, on April 1 1919, of a new type of art college – the Weimar State Bauhaus headed by Walter Gropius (ills. pp. 278, 279).

Most geniuses are unintelligent, while the rest are drained by the mighty taxing of their eminent organ. Van de Velde has the enormous gift of an extraordinary intellect. Without doubt a great genius, the greatest in our movement, which doesn't mean a great deal, and a manifestation which will endure through all time, which says a lot more; but at the same time an equally great intelligence, and that is a unique phenomenon. Others are instinctives, dreamers, exceptions who have made psychologists think of pathology; this one is fully conscious. A person who is well aware of his prodigious talent and has the abnormal will to exploit all of its riches. This duality, which helps only the artist craftsman to unity, is once more to be encountered in van de Velde. One is constantly surprised by the artist and at the same time constantly struck by his steely resolve, pursued with an inexorable logic which even those who dislike modern taste and modern art cannot fail to acknowledge. The two things are inseparable: even where van de Velde seems to have abandoned himself to the freest inspiration and purest ornament, one is tempted to establish a logical basis for his art; we shall see that such proof indeed exists.
Julius Meier-Graefe on Henry van de Velde in *Dekorative Kunst*, vol. 3, 1898/99

In Henry van de Velde we honor a ground-breaking pioneer and an incorruptible character. Even today, his works in Weimar, Hagen and Cologne remain in our minds as milestones in the history of modern architecture. It is with particular delight that I constantly remind my students of van de Velde as the most energetic and spirited founder of the new art of building.
Ludwig Mies van der Rohe on the occasion of Henry van de Velde's 70th birthday on April 3 1933, in *Henry van de Velde, Wegeleitung zur Ausstellung im Kunstgewerbemuseum Zürich*, Zurich, 1958

National consciousness in the "Light of the North"
Scandinavia

Norway and Finland

Be faithful to the light!
How softly
its blazing colors
all die away into white!
Only the flames
of *all* our knowledge
allow a glimpse of the pure!
Bjørnstjerne Bjørnson[1]

The light and luminosity of the North

"Light of the North" (*Licht des Nordens*) was the title of an exhibition staged in Düsseldorf in 1986 which offered, for the first time on a large scale, an overview of Scandinavian painting – an unknown and neglected factor when compared to French painting, for example. With the exception of Edvard Munch, Akseli Gallen-Kallela (1865–1931), and Anders Zorn (1860–1920), the exhibition was an introduction to strangers. These "unknowns" from the North astonished the public with the quality of their painting, their expressive use of line and their luminous palette, evoked by a light which is clearer, brighter and more intense than that of central Europe. Interest in Scandinavian art has grown since that exhibition, but it nevertheless remains largely uncharted territory with numerous blanks on the map. Even comprehensive studies on Art Nouveau still devote little attention to Finland, Norway, Sweden, and Denmark, and invariably lump them together under the heading of "Scandinavia" – with inexcusable laxity, since each of these countries made its own, substantial contribution to the art of the turn of the century, and none more so than Finland. In the present book we will discuss Norway and

Finland together, followed by Denmark and Sweden. The reasons for this are artistic and at the same time political: Denmark and Sweden maintained a peaceful alliance over many centuries, and this expressed itself in a common cultural vocabulary.

Art Nouveau – Cultural heritage lent modern expression

From the 14th century, Norway was under the rule of Denmark and Sweden and finally achieved sovereignty only in 1905. Finland was effectively occupied by Russia as from 1808 and declared its independence in 1917. For both countries, the years before and after the turn of the century were years of struggling for their freedom and battling to establish their independence, all of which left a profound stamp upon the intellectual and cultural developments of the day.

The growing sense of patriotic identity prompted a new flowering of nationalistic ideas. For those countries which had not yet gained independence, it now became particularly important to raise their profile with a distinctive culture of their own. The huge World Expositions provided a welcome first forum for their efforts. Norway regularly took part in these international exhibitions, presenting brightly colored weavings, carved furniture, and glass cabinets formally inspired by stave churches and displaying bottles of aquavit (a grain- or potato-based spirit flavored with caraway seeds) and tins of herring in oil. The folkloric character of these entries, it must be said, did not make a major contribution to international cultural exchange. It was only with the emergence Europe-wide of the idea of a renewal of art that Norway and Finland began to

Oluf Tostrup
Lamp, before 1900
Enamelwork, 22.2 cm high
14.3 cm diameter
Kunstindustrimuseet, Oslo
Norway did not want to forgo the production of Art Nouveau "knick-knacks" altogether, and manufactured "curios" in the traditional enamel technique so popular around 1900.

Harald Oskar Sohlberg
Night Glow, 1893
Oil on canvas, glaze technique,
79.5 x 62 cm
Nasjonalgalleriet, Oslo
Harald Oskar Sohlberg painted
magnificent examples of landscapes
as "vehicles of mood" using a
transparent glaze technique. He is
probably the most "Nordic" of all
the Norwegian painters in the
clarity of his light and his almost
surreal vision of nature.

Edvard Munch
Madonna, 1895–1902
Lithographic chalk, ink,
needle, 60.5 x 44.2 cm
Munch Museet, Oslo
Munch lent the portrayal of his
Madonna an expressive linearity and
a symbolic meaning. Seen through
his eyes, the relationship between the
sexes seems to be first and foremost
one of torment: "Woman in her
different nature is a mystery to
man." (see note 4). Woman as saint
and whore – this is the provocative
message of his *Madonna*.

look back to their artistic traditions and their genuine folk art. Art Nouveau acknowledged the artistic validity of folk art in its own right; as a result, it was no longer viewed in isolation as something separate from the rest of the arts. This also meant that certain stylistic characteristics of folk art could serve as an inspiration and a starting point for new works. Norway and Finland had no shortage of sources in this regard. Pronounced patriotic tendencies, which are found above all in politically suppressed regions, encourage people to reflect upon their origins.

Hence favorite themes tend to be the life of the people, myths, legends, and the native landscape. Although Art Nouveau was from the very start an international movement – something which usually implies a rejection of everything "local" – it nevertheless produced its most dazzling achievements in precisely those places where patriotism was one of the driving forces behind renewal – for example, in Nancy, Finland, and Norway. Norway's contribution largely concentrated upon painting.

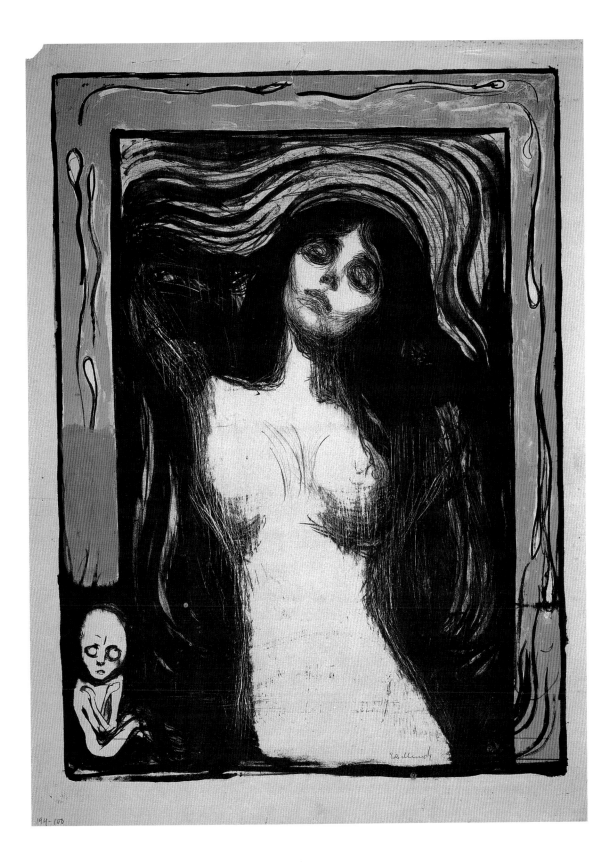

194-100

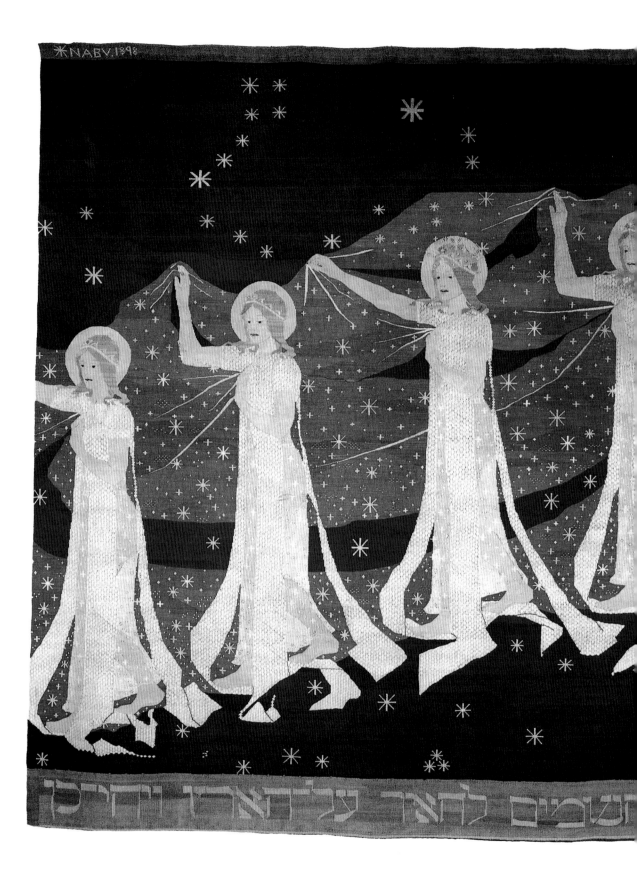

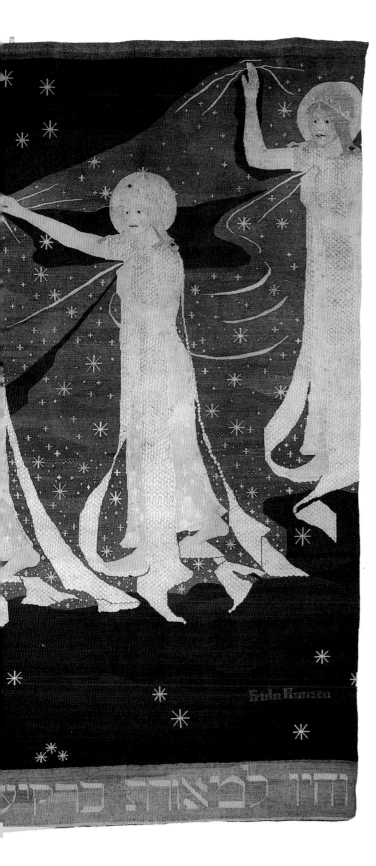

Edvard Munch – Portraits of human emotion

These pictures, which currently still seem rather incomprehensible, will – I believe – be much easier to understand when taken all together. They deal with love and death.
Edvard Munch[2]

Thanks to his outstanding importance, the great Norwegian artist Edvard Munch is seen less as a Norwegian than as a sort of "international cultural asset", and certainly not as an Art Nouveau painter. And while we do not wish to dispute this last point, his person and his work are nevertheless proof that *no* artist at the turn of the century, not even Munch, was left untouched by the structural characteristics of Art Nouveau – the apotheosistic end of an era accompanied by the dawning of a new age – nor by its literary, intellectual, and sociological bases, which expressed themselves in various ways depending on nationality and disposition of the artist. Munch's oeuvre became the forum for a confrontation between Nordic spirit and French form, a confrontation which in turn became a new and vital component of Art Nouveau painting as a whole.

It was an era in which a definitive image was sought of the concept of "woman", far removed from genteel lady or even female individual. Themes such as the beautiful animal-woman, the sphinx, the vampire, the *femme fatale*, the seductive serpent and Salome were cultivated and stylized in the painting of Symbolism. Munch lent the portrayal of his *Madonna* an expressive linearity and a symbolic meaning (ill. p. 285). "This oral undulation is visibly amplified by the sexual dimension introduced by aspects of the male – sperm and fishes – whose presence wistfully implies the union between mother and son, the fulfillment of which is forbidden under the prohibition of sexual relations between mother and child. The scene dissolves into a quagmire under the pressure of social dictates."[3] Seen through Munch's eyes, the relationship between the sexes appears to be first and foremost one of torment: "Woman in her different nature is a mystery to man."[4] Woman as saint and whore – this was the provocative message of his *Madonna*. It is interesting to note that Thomas Mann, in his novella *Gladius Dei* (1902), interwove Munch's *Madonna* and Franz von Stuck's *Sin* (ill. p. 222) into a collage in order to create the ultimate "sinful" picture. Stuck's *Sin*, with its sumptuous, cool colors and gemlike brilliance within its opulent gold frame, also

Frida Hansen
The Milky Way, tapestry, 1898
Wool, silk and cotton,
transparent weaving technique,
260 x 330 cm
Museum für Kunst und Gewerbe,
Hamburg
The technique of transparent
weaving offers an artistic means of
lending the pale figures and the veil a
transparent, floating effect.

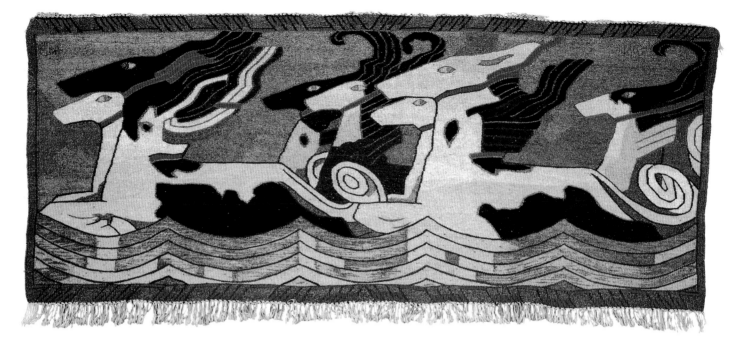

Gerhard Peter Munthe
The Horses of the Sea, tapestry, 1907 (design 1899)
Weaving, 172 x 69 cm
Nordenfjeldske
Kunstindustrimuseum, Trondheim
Munthe's tapestry designs were inspired by ancient Norwegian tradition and derived their subjects from mythology and the realm of fairytale. His illustrations to the *Heimskringla*, a history of the Norse kings by Snorri Sturluson (1179–1241), yielded some of the most beautiful designs, as for example *The Horses of the Sea*.

became famous. Munch and Stuck were born in the same year, 1863, and before the turn of the century held each other in the highest esteem. Whereas Stuck became a "gilt frame" painter, Munch's *Madonna* has nothing soft or luxurious about her, and is inescapably encircled by closed, wavelike lines, the "locks" of her own hair.

Landscape as a vehicle of mood

The Symbolist world view fermenting its way across the whole of Europe also reached the North and Munch. Alongside idyll, decadence, and earthly paradise, there also arose images of fear and despair, sorrow and melancholy – like the visions of D'Annunzio: "In vain our lives! Before us, shadowy, without a torch, death puts on its finery."[5] "A fear of life has accompanied me ever since I could think," wrote Munch in his diary[6], and he gave his pictures titles such as *Fear*, *The Scream* and *Death*. A favorite theme around the turn of the century was the three stages of womanhood. Amongst the many artists fascinated both by the subject and the formal possibilities of the motif was Jan Toorop in his *Three Brides* (ill. p. 165). Munch also drew upon the theme in his *Dance of Life* and *Girl on a Bridge*. "Now life reaches out its hand to death. The chain is complete. It links a thousand generations who have died to the thousand generations that are coming."[7] Munch interpreted landscape painting, a genre so important

for Art Nouveau and Scandinavia, in a similarly symbolic way: "Nature is the means, not the ends. If one can achieve something by altering nature, one should do so. A landscape will have a certain effect on someone who is in a good mood. By creating a landscape, one will arrive at a picture which corresponds to one's own mood. This mood is what counts. Nature is only the means. To what extent the picture looks like nature is not important."[8]

Magnificent examples of landscapes as "vehicles of mood" were created by Harald Oskar Sohlberg (1869–1935) using a transparent glaze technique. Sohlberg is probably the most "Nordic" of all the Norwegian painters in the clarity of his light and his almost surreal vision of nature. In 1894 Sohlberg's work received an important mark of recognition with the purchase of his *Night Glow* (ill. p. 284) by the Oslo National Gallery. Over the following years the National Gallery would become one of the most important patrons of new trends in art, thanks to its director Jens Thiis, a close friend of Munch and later his biographer.

Duplicity of nature and style – Tapestries

The fairytale demonstrates a tendency toward two-dimensional, even linear figures and objects. It is as if the characters of fairytale were paper figures from which you could snip off little pieces here and there without them changing in any fundamental way.
Max Lüthi[9]

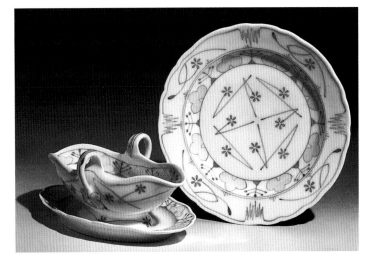

Originally a landscape painter, Gerhard Peter Munthe (1849–1929) acquired his international reputation only from 1890 with tapestries woven to his designs – Norway's most important contribution to the decorative arts around the turn of the century. It was Jens Thiis who provided the stimulus for a revival of the traditional techniques of weaving. He set up a weaving studio in Trondheim and chose the motifs and colors of the works produced there himself. "My idea as regards the studio is to start up something similar to what has already started up (with Norwegian help) in Scherrebeck, in the south of Jutland. ... And I don't see why Norwegian art weaving on Norwegian soil shouldn't earn just as much acclaim and prove just as rewarding as that on German soil. To create a model weaving studio is in my opinion the biggest and best thing we can do to give Norwegian weaving an artistic boost."[10] Thiis purchased numerous watercolors by Munthe, which formed the foundation of the weaving school's artistic production. Munthe's designs were inspired by ancient Norwegian tradition and derived their subjects from mythology and the realm of fairytale. His illustrations to the *Heimskringla*, a history of the Norse kings by Snorri Sturluson (1179–1241), yielded some of the most beautiful designs, for example *The Horses of the Sea* (ill. opposite page).

At Munthe's suggestion, the wool used in the tapestries was not dyed into subtle shades, but was blended during carding so as to preserve the clear Norwegian colors. In all other respects, however, Munthe harbored a certain mistrust toward weaving technology, and above all toward women weavers. On many an occasion he is supposed to have said: "I don't want to be woven by women."[11] However, the second leading figure in the art of tapestry weaving was precisely one such "weaving woman": Frida Hansen's large and impressive tapestries were acquired by all the major museums of Europe, although in her own country she was considered not national enough. For Thiis, at any rate, there was only one artist who would be able to reinvigorate the decorative arts in Norway – and that was Munthe. In fact, Munthe went so far as

Gerhard Peter Munthe
Blue Anemones, dinner service, 1892
Painted porcelain,
Serving dish: 23.8 diameter
Made by the Porsgrund Porcelain Factory
Kunstindustrimuseet, Oslo

Gerhard Peter Munthe
Chair, from the "Fairytale Room", Tourist Hotel, Holmenkollen, 1898
Painted wood, 124 cm high
Norsk Folkemuseum, Oslo

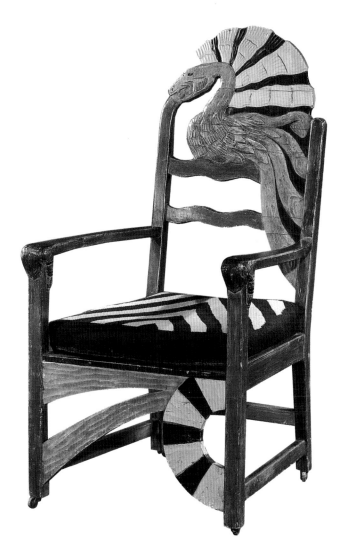

to refuse to exhibit alongside Frida Hansen. Like her "antipode", Frida Hansen (1855–1931) took traditional Norwegian weaving as her starting point, but was more international in her style. Much can be traced to Japanese influence, and her figural style also reveals links with the Glasgow group of artists. Frida Hansen achieved fame with the tapestry *The Milky Way* (ill. pp. 286–287), which she wove for the World Exposition of 1900. It depicts a biblical subject and employs a "transparent weaving" technique which lends the pale figures and the veil a transparent, floating effect.

Globalism and native tradition

We were familiar with the art of the Japanese. There was nothing to connect this art with the styles of the European past. It was the immediate and lively expression of an ancient, thousand-year culture which had developed independently of the West.
M. Osborne[12]

Like Frida Hansen, Hans Stoltenberg-Lerche (1867–1920) stood for "international" Art Nouveau in Norway. His work – stoneware, glass, metalwork – exercised a strong influence on Norwegian applied art. Born in Germany and active chiefly in Italy, he was never considered a

Right:
Akseli Gallen-Kallela
The Tree of Knowledge of Good and Evil, closet, 1899
Wood, carved relief ornament,
129 x 96 x 52 cm
Gallen-Kallela Museum, Espoo

Akseli Gallen-Kallela
Aino Myth, 1891
Oil on canvas, original frame,
153 x 153 (central panel) and
153 x 77 cm (left and right-hand panels)
Ateneum, Helsinki
In this painting the artist wanted to create an allegory of Finland – from its landscape and mythology to its folk art and Karelianism.

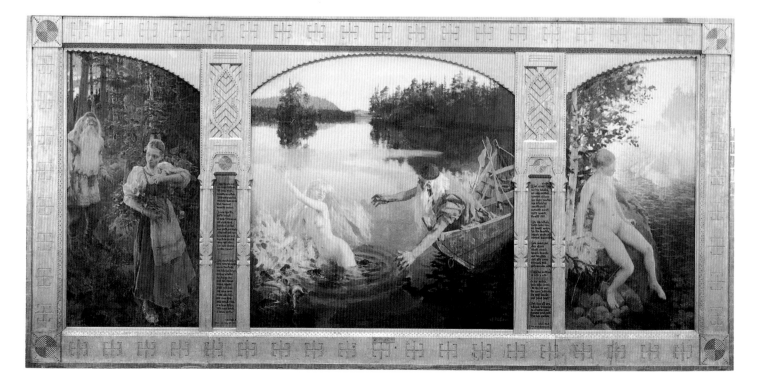

particularly typical representative of his nation, a verdict which also reflected the widespread tendency to view Norway as limited to a "Nordic" form of Art Nouveau. Only in very recent times has attention begun to be paid to the lively and international exchange of ideas taking place in Norway around 1900. In his notebook of 1890, Munthe wrote: "The interest in Japanese art now spreading across Norway has arisen out of our previous neglect of the arts and crafts – an unintentional neglect, in contrast to Japan, which put all its efforts into the decorative arts."[13]

The Aesthetic Movement, originating from England, also gained a foothold in Norway under the same name, significantly assisted by the publication of the book *Japansk Malerkunst* (Japanese Painting) by the Dane Karl Madsen (b. 1855), the first work on the subject to appear in a Scandinavian language. A group of artists had already come together at Fleskum Farm in Dælivannet, near Christiania (present-day Oslo), in the 1880s. Its members had all studied either in Paris or Munich and together cultivated Neo-Romantism and Japonisme. Fleskum members Munthe and Christian Skredsvig (1854–1924) and art historian Marit Werenskiold played a major role in the development of the decorative arts in Norway. Skredsvig, a close friend of Madsen, followed progressive trends in Denmark with great enthusiasm and was responsible for establishing the highly significant link between Munthe and the great Danish "arts and craftsman" Thorvald Bindesbøll (ill. p. 311). It is thanks to Munthe that, for all the outside influences which it absorbed, Norway remained "national" in the positive sense. It was able to appreciate not just the folkloristic "dragon" style of its ancient Viking ships, but also their perfection and formal accomplishment: "In their beauty and their exemplary design (material, technique, plan) they outstripped everything that had ever set sail before."[14]

An optimum design solution had thus already been found centuries earlier on Norwegian soil. Munthe processed the past into individual works of enduring effect (ill. p. 289). Norway did not want to forgo the production of Art Nouveau "knick-knacks" altogether, however, and manufactured "curios" in the traditional enamel technique so popular around 1900 (ill. p. 283).

Left:
Akseli Gallen-Kallela
Finland Awake, stained-glass window, 1896
26 x 37 cm
Gallen-Kallela Museum, Espoo
The fanning of emotions by means of pictorial subject or accompanying lines is Symbolist in origin; Gallen-Kallela, too, infused the mythological and mystical bases of his art with the yearning for a "symbol" felt by almost all the artists of his generation.

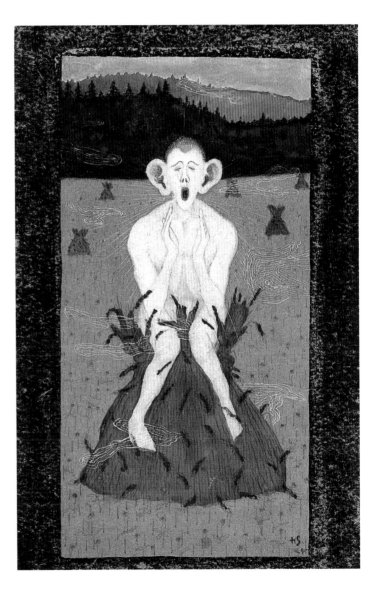

Hugo Simberg
Frost, 1895
Watercolor, 27 x 18 cm
Ateneum, Helsinki
Encouraged by his teacher Gallen-Kallela, who recognized his talents as a watercolorist, Simberg transposed experiences of nature into often frightening figures which at times bear only a general resemblance to humankind. He proclaims the unity of creature and cosmos in his small-format works in impressive fashion. He refused to provide commentaries on his paintings, but hoped that "people, when looking at them, would weep and wail in their innermost heart of hearts" (see note 16).

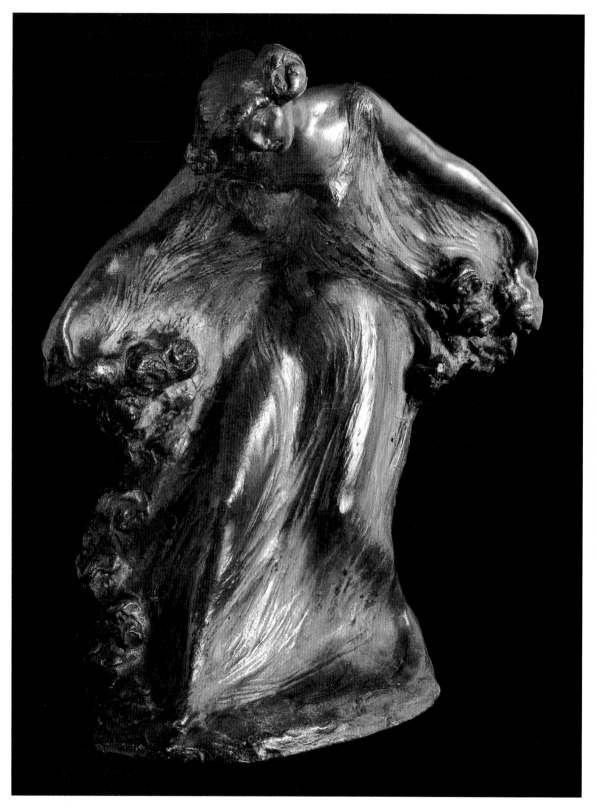

Ville Vallgren
Rose Dance, 1899
Bronze, 28.5 cm high
Ateneum, Helsinki
Ville Vallgren, the "Frenchman"
amongst the Finns, was another who
wanted his art to stir up emotions
rather than simply provide aesthetic
pleasure. His sculptures,
unmistakably *femmes de l'Art
Nouveau*, were nevertheless chiefly
exercises in style: female dancers in
the roundelays of the turn of the
century. Vallgren's homage to
woman fell fully in line with the
spirit of the age; as he himself
acknowledged: "Woman is my god
and I her servant." (see note 17)

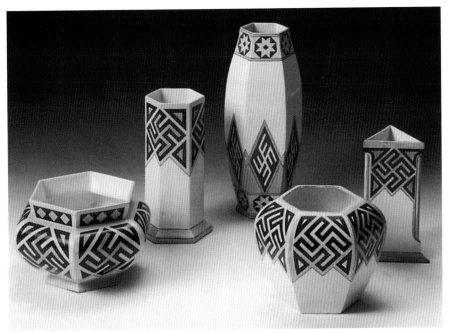

Arabia
Vases in the *Fennia* series, 1902–12
Stoneware, enamel painting,
8.5 cm to 34.5 cm high
Arabia Museum, Helsinki
In the *Fennia* series by Arabia, the attempt to use traditional forms for industrial manufacturing was emphatically successful. The designs were supplied by the architects Saarinen and Lindgren – Gallen-Kallela was probably involved, too – and the series was hand-painted in the factory. Form and decor are an expression of the conscious striving toward a national language of form at an international level.

Akseli Gallen-Kallela – The Finnish soul

... untouched wild nature, the tree-lined lake with berries and moss. At the edge of the lake my small camp with its open fire, a falcon calling into the pale evening, and a pine transferring its needles carefully, one after the other, to the forest floor.
Akseli Gallen-Kallela[15]

Finnish art around 1900 has still received relatively little attention. This is perhaps because the stylistic designation "Art Nouveau" – implying a decorative, vegetal formal vocabulary – does not always characterize the essence of Finnish painting, architecture and applied art from around the turn of the century. Instead their rather more naturalistic flavor was the product of a different set of sociological circumstances. Art in Finland was driven not, as in western Europe, by positivism and industrial wealth, but by a population which was largely rural in structure, and which was struggling to achieve outer and inner independence in difficult political circumstances and in a fringe geographical location. Finnish art around 1900 also drew upon the past – upon saga, myth, and the visual imagery of the *Kalevala*, the Finnish national epic (published in 1849 by Elias Lönnrot). It did not, however, sound the closing bars of the outgoing century.
The central figure in fine and applied art of *fin de siècle* Finland was undoubtedly Akseli Gallen-Kallela. Trained in Paris, he returned home shortly

Ville Vallgren
Door knocker, ca. 1894
Bronze, 51 x 18 cm
Ateneum, Helsinki
The stylized figure is typical of Vallgren's combination of sculpture and applied art.

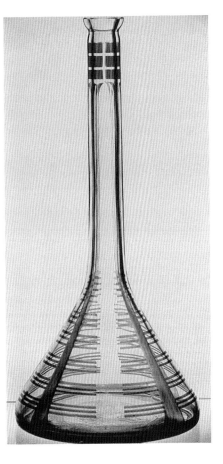

Nuutajärvi Glassworks
Vase, ca. 1900
Hand-painted glass, 20 cm high
Taideteollisuusmuseo, Helsinki

Gesellius, Lindgren & Saarinen
Exterior view of Suur-Merijoki
Manor, Viipuri, Karelia, 1901–03
Watercolor by Eliel Saarinen, 1902
Suomen rakennustaiteen museo,
Helsinki
In 1903 Finland, too, was given its
"total work of art" – Suur-Merijoki,
a dramatic fortified manor house in a
forest setting, with heavy granite
foundations, imposing gateways, a
massive tower, an English hall with
a wide flight of stairs up to the
second story, a billiard room, a
boudoir, and a music room,
furnished in exquisite harmony and
adorned with wrought, woven,
crocheted, painted, plastered, and
sculpted ornament of firmly
established, beautiful simplicity.
Suur-Merijoki was finished from the
very start, so to speak, and its
occupants were required to add very
little of their own. On the contrary:
the house shaped the lifestyle of the
family.

after 1890 and became the impassioned artist
of the "Finnish soul". His austere, animated
stylization derives from the strength of its forms,
without degenerating into a mere striving for
effect (ill. p. 282). He perceived the heroes of the
Kalevala and the *Kanteletar*, a collection of
Finnish folk poetry (published by Elias Lönnrot in
1840), as the personification of the forces of
nature which imbued the land which he loved
and which he portrayed over and over again.
His work is thus often labelled as "National
Romanticism", a highly imprecise designation
popularly applied to smaller outlying countries.

The term "National Romanticism" can be traced
all the way to the first half of the 19th century
and the development of ethnography and
nationalistic thinking. In Norway, a country in
many respects similar to Finland, this develop-
ment proceeded in a more or less linear fashion
up to and beyond the turn of the century. In
Finland, however, National Romanticism in the
sphere of the visual arts was strongly influenced
by the spirit of resistance to Russia which
characterized the years around 1900. This
ultimately led it, in a somewhat ephemeral way,
to seem more "genuine" than early National
Romanticism. Thus, in Finland, the national need
for self-expression, influenced by the ideas of the
German philosopher Georg Wilhelm Friedrich
Hegel, received a stylistic form which would
come to be described as a "Golden Age".

Finland's "Golden Age" – The artist-designers

Gallen-Kallela's first National Romantic work
based on the *Kalevala* was his *Aino Myth* (ill.
p. 290). In this painting, the artist sought to
create an allegory of Finland – from its landscape
and mythology to its folk art and Karelianism. In
practical line with his ideals, he withdrew to
Karelia (the region between the Gulf of Finland
and the White Sea in Finland and north-west
Russia) and devoted himself more and more to
the applied arts. His love of nature was never-
theless accompanied by a cosmopolitan outlook
and international contacts. It was through Gallen-
Kallela that the influences of *Pan* and Jugendstil
reached Finland from Germany. He himself
assimilated these influences into his handicraft
works, but without losing his "nationality". His
preferred material was thus that of his homeland,
wood (ill. p. 290), while one of his stained-glass
windows bears the title *Finland Awake* (ill.
p. 291). The fanning of emotions by means
of pictorial subject or accompanying lines is
Symbolist in origin; Gallen-Kallela, too, infused
the mythological and mystical bases of his art
with the yearning for a "symbol" felt by almost
all the artists of his generation. The Swedish
theosophist Emanuel von Swedenborg (1688–
1772) had prepared the ground in Scandinavia for
the reception of spiritual and transcendental
theories, and in Finland, too, it had become
fashionable to read Baudelaire and enthuse
about Richard Wagner.

One of Gallen-Kallela's pupils, Hugo Simberg
(1873–1917), translated the "marginal experiences"
of the Symbolist way of seeing into his pictures.
He had little interest in folk art and National
Romanticism; for him the original existed only in
the imagination of the artist. Encouraged by his
teacher, who recognized his talents as a water-
colorist, Simberg transposed experiences of
nature into often frightening figures which at
times bear only a general resemblance to human-
kind. He proclaims the unity of creature and
cosmos in his small-format works in impressive
fashion (ill. p. 291). He refused to provide com-
mentaries on his paintings, but hoped that
"people, when looking at them, would weep and
wail in their innermost heart of hearts"[16].

Ville Vallgren (1855–1940), the "Frenchman"
amongst the Finns, also wanted his art to stir up
emotions rather than simply provide aesthetic
pleasure. His sculptures, unmistakably *femmes
de l'Art Nouveau*, were nevertheless chiefly
exercises in style: female dancers in the rounde-
lays of the turn of the century (ills. pp. 292, 293).

Gesellius, Lindgren & Saarinen
Entrance lobby, Suur-Merijoki
Manor, Viipuri, Karelia, 1902
Design drawing, watercolor by Eliel
Saarinen, 1902, 14 x 20 cm
Suomen rakennustaiteen museo,
Helsinki

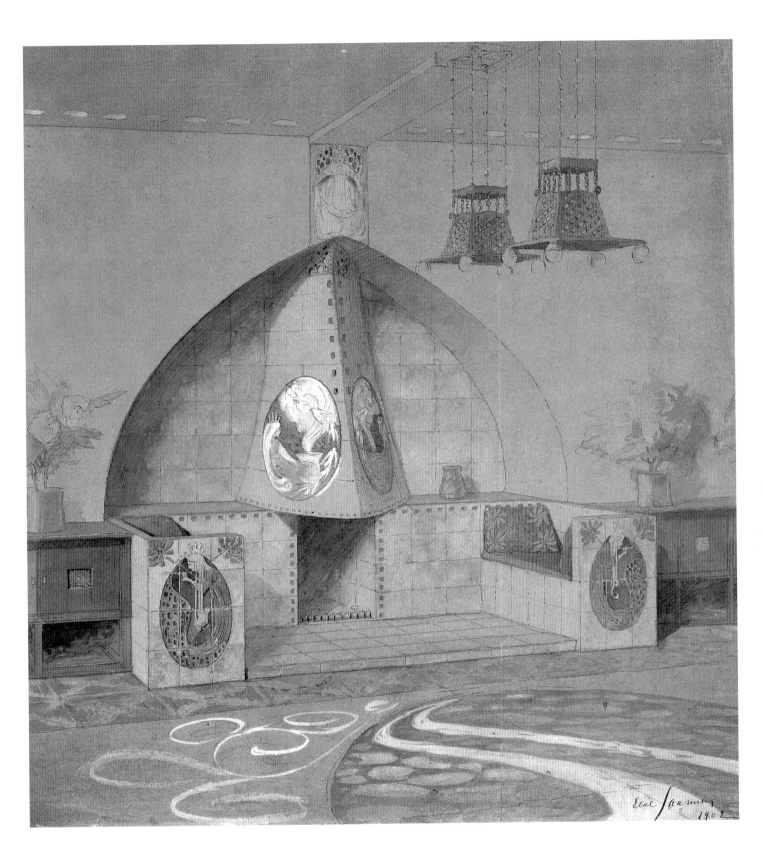

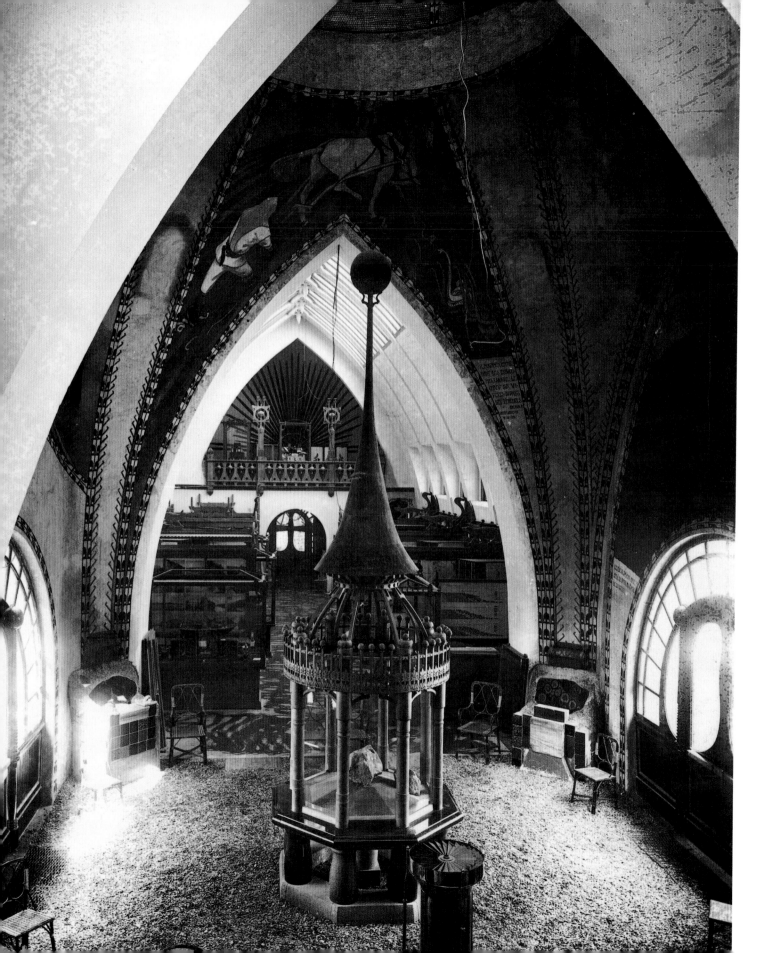

Vallgren's homage to woman fell fully in line with the spirit of the age; as he himself acknowledged: "Woman is my god and I her servant."[17] As one of the group around the Symbolists, he exhibited in Paris in their Salon de la Rose-Croix, to which only works of "noble spirit, beauty, and poetry" were admitted.

A pronouncedly French trend was not the only foreign influence to make itself felt in Finland; the impact of William Morris, too, can hardly be overestimated. The social criticism at the heart of Morris's thinking served to inspire many designers, who from now on saw handicraft as an honest alternative to mass production. In the *Fennia* series by Arabia (ill. p. 293), the attempt to use traditional forms for industrial manufacturing was emphatically successful. The designs were supplied by the architects Saarinen and Lindgren – Gallen-Kallela was probably involved, too – and the series was hand-painted in the factory. Form and decor are an expression of the conscious striving toward a national language of form at an international level. The most beautiful glassware of Finnish Art Nouveau issued from the Nuutajärvi factory: functional outlines fuse with a confident graphic decor (ill. p. 293).

Meanwhile, the English painter and ceramic artist Alfred William Finch (1854–1930), who spent a number of years working in Brussels, founded the more commercially oriented Iris workshops in Porvoo, Borgå. The pleasant linear style of its products met with an enthusiastic reception. Like Norway, Finland also saw a revival of its traditional weaving industry. Armas Eliel Lindgren (1874–1929), who worked with Saarinen, produced designs that were surprisingly Art Nouveau in style (ill. p. 298), while the works of Väimö Blomstedt (1971–1947) remained indebted to National Romanticism.

Finnish architecture

Absolutely the simplest and absolutely the most beautiful pavilion.
On the Finnish pavilion at the Paris World Exposition of 1900[18]

Finnish architecture, with Eriel Saarinen (1873–1950) as its most important representative, exerted a profound influence upon the development of modern architecture. The first built testaments to the departing century arose under the aegis of Karelianism. Like their painter colleagues, the architects in Karelia sought to incorporate the original and unspoilt elements of Finnish culture into their style. They dedicated

Opposite page and above:
Gesellius, Lindgren & Saarinen
The Finnish Pavilion at the Paris World Exposition, 1900, interior and exterior view, 1898–1900
Wood, walls hung with coccolith slabs and painted fabric
The pavilion, a "painted stone imitation", was a triumphant success. This recognition occurred at a time when the Russian empire was beginning to exert palpable pressure against Finland's autonomy. The architecture of a small country fearing for its very existence had earned international acclaim for the first time.

Eliel Saarinen
Chicago Tribune Tower, competition entry, second prize, 1922
Perspective drawing, contemporary reproduction
Suomen rakennustaiteen museo, Helsinki
On November 29, 1922 when the winners of the competition for the *Chicago Tribune* Tower had already been chosen, an entry arrived from Finland. The jury was so impressed by "the colossal beauty of this 11th-hour entry" (see note 21) that it awarded the design second prize. It was the work of Eliel Saarinen, whose son Eero would, in the 1950s and 1960s, become one of America's best architects.

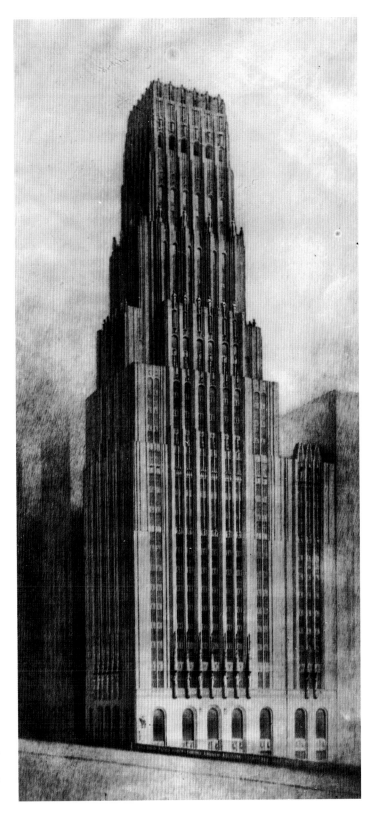

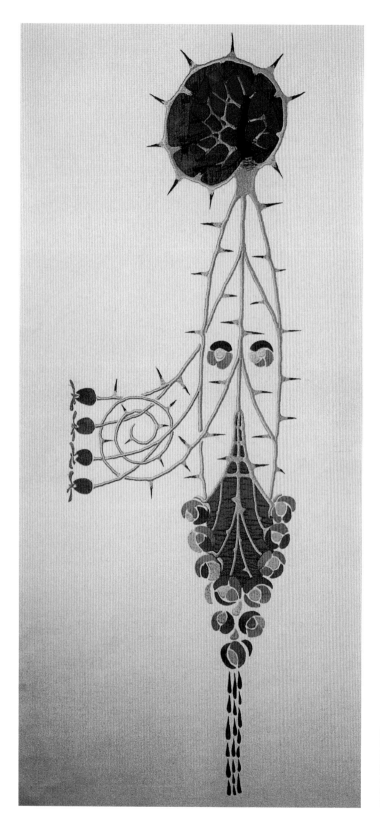

Left:
Armas Eliel Lindgren
Liturgical vestment (detail), 1904
Appliqué on wool, 185 x 189 cm
Taideteollisuusmuseo, Helsinki

themselves to finding new and rational applications for the materials most abundantly available in their homeland, namely granite and wood. These materials had an important symbolic value: at the same time as forming the basis of indigenous architectural traditions, they were also suitable for use with modern building techniques. The almost primitive medieval castles and churches which in Finland greet the viewer at every step now became the source of both stylistic and technical stimuli for modern architecture. The sensible functionalism of vernacular architecture was thus adopted into the first buildings of Karelianism. Around the turn of the century, however, pure tradition was no longer enough for the projects of the young, ambitious generation of architects, who now turned for inspiration to the Arts and Crafts Movement in England – and above all to Baillie Scott, whose well-known watercolor illustrations of interiors in *The Studio* had a great impact in Finland – as well as on the Mathildenhöhe group in Darmstadt and on Art Nouveau in France and Belgium. Amidst these overlapping trends arose the architectural firm of Gesellius, Lindgren & Saarinen, known as GLS. The firm immediately secured itself a leading position by winning the competition for the Finnish Pavilion at the Paris World Exposition of 1900 (ills. pp. 296, 297). The pavilion, a

Gesellius, Lindgren & Saarinen
Hvittorp House, Kirkkonummi,
exterior view, 1901–04
Watercolor by Eliel Saarinen, 1902
Reproduced from *Moderne
Baukunst* [Modern Architecture],
November 1905
Suomen rakennustaiteen museo,
Helsinki

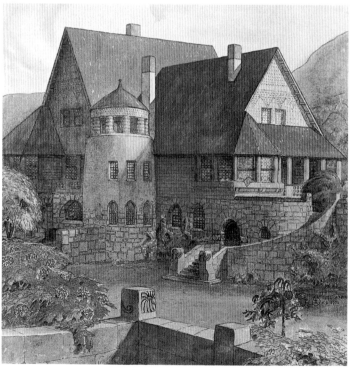

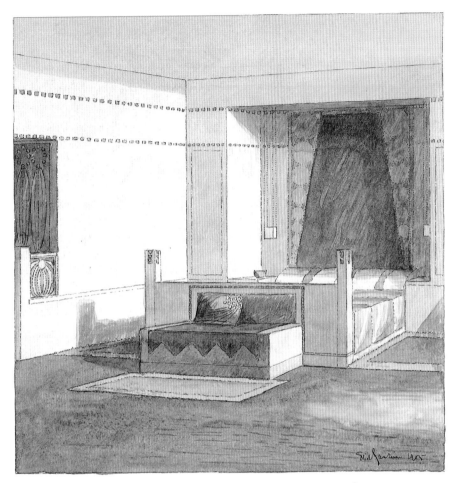

Gesellius & Saarinen
Bedroom, Remer House, Lake
Molchow, Brandenburg March,
1905–08
Watercolor by Eliel Saarinen, 1905,
22.5 x 22 cm
Suomen rakennustaiteen museo,
Helsinki
Another house approached as a total
work of art was the Remer House on
the shores of Lake Molchow north of
Berlin. This "international"
commission also assumed an
international shape, drawing upon
the economic, elegant style of
Wiener Werkstätte interiors and
reflecting the early influence of
Charles Rennie Mackintosh upon
the architects.

"painted stone imitation", was a triumphant success. This recognition occurred at a time when the Russian empire was beginning to exert palpable pressure against Finland's autonomy. The architecture of a small country fearing for its very existence had earned international acclaim for the first time. The new style was thereby firmly established, and even houses in the course of construction were altered correspondingly. Design was dominated by plasticity and a proximity to nature. It was an organic architecture of wood and granite; proximity to nature was achieved by steps and paths, terraces and balconies everywhere, oriels, turrets, and similar details. Interiors were designed in the same spirit: as caves and grottos, lofty halls with groined vaults, niches and inglenooks, stairs and floors at varying levels. Ornament, with its themes drawn chiefly from native flora and fauna, also signified proximity to nature, as did the fabrics, rye matting and furs which covered walls, sofas, and floors in coordinating color schemes (ill. p. 295).

Gesellius, Lindgren & Saarinen

We listen to the sounds, they rock themselves gently into
our minds and we hear magical melodies in our dreams –
we sense a new music – the music of the future …
Whistler's spirit hovers over the waters: all the elemental
forces come from the North or from America …
Walter Leistikow[19]

In 1903 Finland, too, was given its "total work of art" – Suur-Merijoki (ill. p. 294), a dramatic fortified manor house with heavy granite foundations, imposing gateways, a massive tower, an English hall with a wide flight of stairs up to the second story, a billiard room, a boudoir, and a music room, furnished in exquisite harmony and adorned with wrought, woven, crocheted, painted, plastered, and sculpted ornament of firmly established, beautiful simplicity. Suur-Merijoki was finished from the very start, so to speak, and its occupants were required to add very little of their own. On the contrary: the house shaped the lifestyle of the family. It was

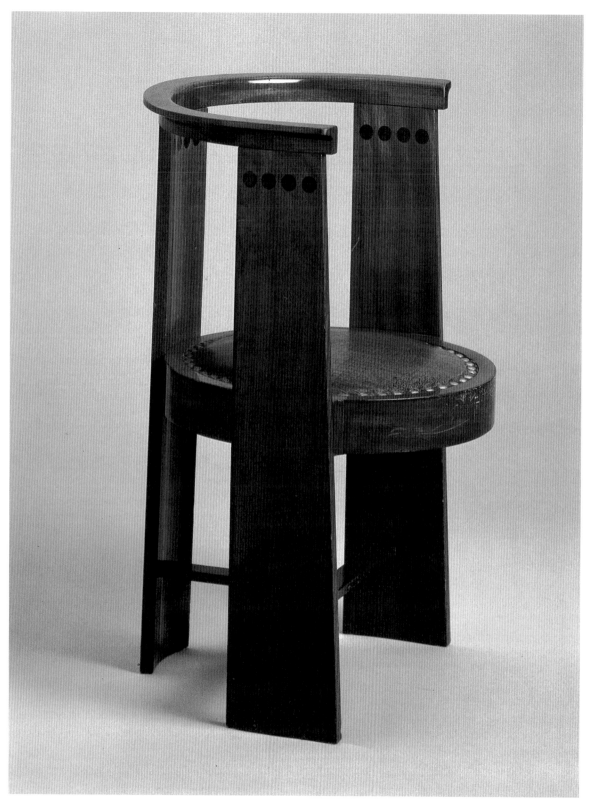

Eliel Saarinen
Chair for Hannes Saarinen, 1908
Varnished mahogany, ebony inlay;
Upholstery: imitation leather with
snakeskin pattern, ca. 90 cm high
Made by N. Boman's joinery
workshop, Kuoplo
Suomen rakennustaiteen museo,
Helsinki
Around 1907 Saarinen developed a
new, unmistakable style of furniture
design; as in his architecture, his
forms became sharper in focus and
more angled.

commissioned by the Wiborg manufacturer Neuscheller; the architects were GLS, and the site Viipuri, at that time the most important town on Finland's eastern border – something symbolic in itself. The house made a profound impression on all its visitors; today that experience is denied us. Suur-Merijoki was destroyed in the Second World War, and since 1944 its grounds have lain on the far side of the Russian border. Those in search of a concentrate of Finnish art around 1900 need look no further than Suur-Merijoki. It represented a synthesis of all the contemporary trends in architecture, the applied arts and painting.

Finnish architects right up to Alvar Aalto (1898–1976) continued to hold on, almost stubbornly, to the dream of the total work of art, in other words to the notion of the environment as a total work of art which, merely by dint of its existence, would be able to affect and influence all of society – a piece of Finnish National Romanticism, something with which Saarinen, the head of GLS, was also closely linked. The creation of the total work of art was his ideal, and went beyond the private house to embrace urban planning as a functioning environmental whole. This goal remained the thread running through his entire oeuvre. His style had its origins in Finland's "Golden Age", where the creation of a Finnish identity was being sought in all sectors of cultural life: in the music of Jean Sibelius (1865–1957), in the poetry of Eino Leino (1878–1926), and in the paintings of Gallen-Kallela. An early effort by the GLS triumvirate in this regard is the "fortified" Hvittorp House (ill. p. 298). Another house approached as a

total work of art was the Remer House on the shores of Lake Molchow north of Berlin. This "international" commission also assumed an international shape, drawing upon the economic, elegant style of Wiener Werkstätte interiors and reflecting the early influence upon GLS of Charles Rennie Mackintosh (ill. p. 299). Around 1907 Saarinen also developed a new, unmistakable style of furniture design; as in his architecture, his forms became clearer and more angled (ill. opposite page).

The evolution of architecture into the 20th century

And you too, my dear, could add warmth and feeling to your style by hanging up the academic dogma of the imitation of nature for good.
Richard Dehmel to Arno Holz[20]

In Finland, the discussion of constructivism and rationalism as design principles at the purely theoretical level was something which followed upon the meeting between the Finnish architect Sigurd Frosterus (1876–1956) and Henry van de Velde. Up till then, the two trends had appeared only in isolated, albeit confident practical experiments. Frosterus's own, noteworthy works went unappreciated, however. He was the only representative of an Art Nouveau trend in design and architecture which had long been discredited in Finland as "swan's neck curves" (ill. p. 301). Frosterus's "style" earned him the reputation of an arch rationalist, something for which his "Belgian connection" gave not the slightest grounds, however. Also fated to be an outsider

Sigurd Frosterus
Dining room on a steamship, 1907
Design drawing, 26.5 x 36 cm
Suomen rakennustaiteen museo, Helsinki
Frosterus's noteworthy works went unappreciated. He was the sole representative of an Art Nouveau trend in design and architecture which had long been discredited in Finland as "swan's neck curves". Frosterus's "style" earned him the reputation of an arch rationalist, something for which his "Belgian connection" – a past stay with Henry van de Velde – gave not the slightest grounds, however.

Selim Avid Lindqvist
Suvilahti Power Station, Helsinki, 1908
Project drawing
Suomen rakennustaiteen museo, Helsinki
Suvilahti Power Station marks the climax of Lindqvist's rich oeuvre. The building is worked in reinforced concrete, and its skeleton of twin pillars and steel girders also defines the exterior.

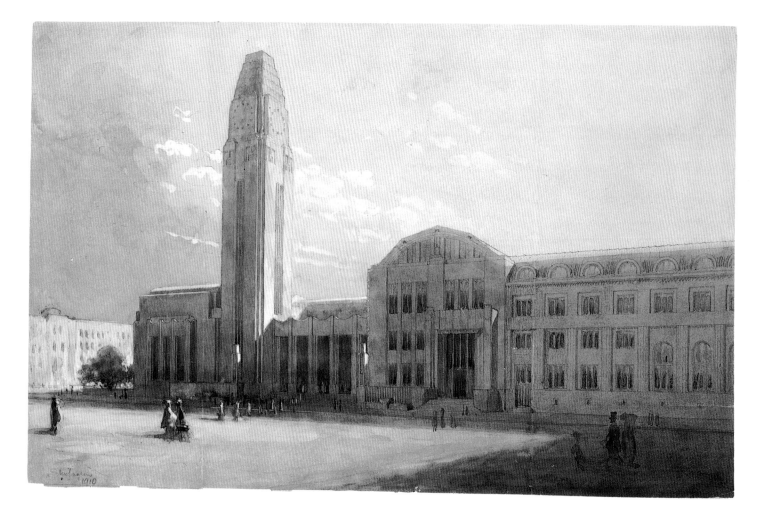

was the architect Selim Avid Lindqvist (1867–1939), who pursued his own linear evolution outside all debate and whose work was closely allied with Viennese Jugendstil, above all with Otto Wagner. Having begun his career still in the age of historicism, he later turned – like Victor Horta – to flexible skeleton buildings with cast-iron columns and pillar-and-glass facades. Suvilahti Power Station (ill. p. 301) marks the climax of Lindqvist's rich oeuvre. The building is worked in reinforced concrete, and its skeleton of twin pillars and steel girders also defines the exterior. This beautiful and logical building shows that even Lindqvist was not left unmoved by the emerging trend toward monumental architecture. Nevertheless, this new trend did not mean that the concept of the total work of art was dead; instead of the private home, however, it now found its realization in monumental buildings such as Saarinen's Helsinki Central Station

(ill. above). Here, the decor increasingly becomes one with the architecture and serves to heighten the effect of the construction. The language of form has crystallized and builds upon clear verticals. Nevertheless, ornament remains an inseparable part of the whole, whereby its task is to accentuate those components of the building of structural interest. Saarinen's decor from now on became almost sparing and abstract; the "bears" and "frogs" of his youth disappeared in favor of a preference for stylized human figures which, incorporated into the vertical structure, fuse with the actual building (ill. opposite page). A vital factor behind the design of the station's high vaulted roof was the introduction of concrete. Both Helsinki Central Station and Saarinen's subsequent works were built in this new material. The competition for the station was held in the spring of 1904, but the complex was not completed until 1914. Saarinen's use of

Eliel Saarinen
Helsinki Central Station, front view, 1904–14, 1919
Watercolor by Eliel Saarinen, 1910
Suomen rakennustaiteen museo, Helsinki
The concept of the total work of art found its realization no longer in the private home, but in monumental buildings such as the Central Station in Helsinki. Saarinen's language of form has here crystallized and builds upon clear verticals. Nevertheless, ornament remains an inseparable part of the whole, whereby its task is to accentuate those components of the building of structural interest. A vital factor behind the design of the high vaulted roof was the introduction of concrete. Both Helsinki Central Station and Saarinen's subsequent works were built in this new material.

verticals is emphatically restated in the soaring clocktower, a beacon signalling Saarinen's future. In 1922 the *Chicago Tribune* held a competition for the design of its new tower (ill. p. 297). Twelve works were initially selected, all of which "would be a credit to Chicago, Michigan Avenue, and the *Tribune*". They included all the eventual prizewinners, with the exception of one late entry, which arrived from Finland on November 29, when the winners had already been chosen. The jury was so impressed by "the colossal beauty of this 11th-hour entry"[21] that it awarded the design second prize. It was the work of Eliel Saarinen, whose son Eero would, in the 1950s and 1960s, become one of America's best architects. The elder Saarinen later built a highly influential school near Chicago. His *Chicago Tribune* design reveals a high degree of formal discipline, placing the former National Romantic in the phalanx of the great architects of the 20th century.

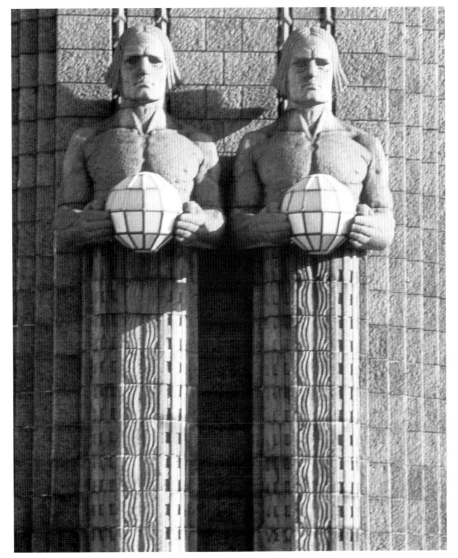

Eliel Saarinen
Helsinki Central Station, figures on the main entrance, 1904–14
Approx. 400 cm high
Saarinen's decor is here sparing and abstract; the "bears" and "frogs" of his youth have disappeared in favor of a preference for stylized human figures which, incorporated into the vertical structure, fuse with the actual building.

Denmark and Sweden

Handicraft is to Scandinavia what painting is to France, music to Germany and the mountains to Switzerland.
Ulf Hård af Segerstad[22]

Einar Nerman
Headpiece to Hans Christian
Andersen, *The Swineherd*, ca. 1910
Halftone

From "sophisticated" handicraft to design

When the photographer Hjalmar Ekdal vowed, in Ibsen's *The Wild Duck*, to elevate the "crafts" to "art"[23], he underlined the dependence of the abstract will to art (to taste) upon the "lower" reality of handicraft. The crucial issue of the period around 1900 was thus one concerning the Norwegian dramatist, too: the possibility of a symbiosis of art and handicraft. This new unity, this new "being" still had two faces, but just one body: the applied arts. The "birth" of this new genre was vehemently pursued in all the countries dedicated to Art Nouveau, with the result that the child had a thousand different faces. Although Scandinavia around the turn of the century was not amongst the driving forces behind Art Nouveau, over the following years it would translate its ideas into works of

unsurpassed quality. After 1920, and even more so after the Second World War, Scandinavian applied art came to dominate the furnishing stores of Europe and was greeted by an enthusiastic public. "For Danes, Finns, Norwegians, and Swedes, the home is the hub of their existence to a particular degree ... The inhabitants of Southern countries spend most of their time outdoors. The opposite is true in the North ... and so it is only natural that the Scandinavian should perceive his home not simply as somewhere to eat and sleep, but as the setting for his family life."[24] The idea of making that setting as cultured as possible, even in the home of the average citizen, fitted perfectly with the doctrines of the champions of Art Nouveau, who wanted to bring art to the people and free it from the stigma of being something exclusively for the wealthy. It was a question of producing objects of everyday use which were both good and affordable. "In the South people get together in restaurants or bars, in the North in their own homes."[25] Hence it was also necessary to redesign and embellish the laid table with silverware and porcelain. The injection of new ideas into porcelain decoration was thus

Erik Nielsen
Fox, 1903
Porcelain, underglaze painting,
7.3 cm high
Made by Den Kongelige
Porcelainsfabrik, Copenhagen
Badisches Landesmuseum
Karlsruhe, Museum beim Markt –
Angewandte Kunst seit 1900

initiated not by the long-established factories of Meissen, Sèvres and Berlin, but by one which, albeit old, had never been amongst the leaders: the Kongelige Porcelainsfabrik (Royal Porcelain Factory) in Copenhagen. The Swedish Rörstrand porcelain works also played a major role for a while.

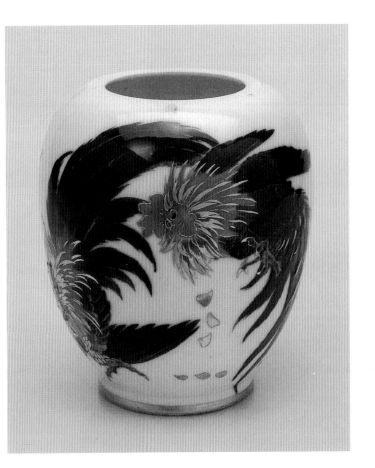

Den Kongelige Porcelainsfabrik – The Royal Danish Porcelain Factory

Who would like to predict how many new forms this same spirit has meanwhile taken, forms which pass amongst us still unrecognized, but all the more powerful for that? Dolf Sternberger[26]

In 1972 the Neue Sammlung in Munich played host to an exhibition from Stockholm entitled "China and the North" (*Kina och Norden*), in which old Chinese and new Scandinavian ceramics were displayed together. Even without a commentary, it was clear to the viewer from which source the modern Scandinavian works were drawing their inspiration. At the end of the 19th century, following the discovery of Japanese pottery, Europe was engulfed by a wave of enthusiasm for the ceramic art of the Far East. The 18th century's love of chinoiserie gave way to a preference for the china of the T'ang and Sung dynasties and an appreciation of undecorated ware, simple forms and harmonious glazes. A description of *chien yao*, Japanese tea bowls produced in China, could be applied word for word to the porcelain produced by the Royal Danish Porcelain Factory in Copenhagen: "… Variations are to be found above all in the glazes, which recall hare skin, birds' feathers, tortoiseshell and splashes of oil. The colors employed are usually dark blue, brown, and green. Their effect is that of a bundle of rays radiating out from a central point, or of clouds. The glaze is applied in several layers which are fired several times, resulting in an ever-changing impression of color depending on the strength of the light falling upon the surface … Leaves and flowers are often drawn in calligraphic shorthand on larger bowls, vases, and jugs."[27] Knud Valdemar Engelhardt, head chemist at the factory, produced objects of the type just described (ill. p. 306). It was the color chemists, more than anyone, who were spurred on by the newly discovered beauty of Japanese and Chinese glazes to unlock the secrets of their production. The factory laboratories became testing grounds for the new "surfaces" which would determine the evolutionary course of

design. Engelhardt's specialities included his crystal glazes, whose craquelure created an "abstract" decor on the sides of the vessel and formed richly inventive patterns. The purchase of the Copenhagen factory by Philip Schou in 1882 marked the beginning of its rise to stardom. The Danish architect and painter Emil Arnold Krog (1856–1931), employed for the factory since 1884 and appointed its artistic director in 1891, created an entirely new type of porcelain decoration which was unmistakably influenced by Japanese color woodcuts. Krog was introduced to Hokusai, Utamaro, and Hiroshige in Samuel Bing's gallery in Paris in 1886. Bing also showed his Japanese collection in Copenhagen on the occasion of the "Nordic Exhibition" of 1888, and thereby made a profound impact upon artistic production both in the city and in Scandinavia as a whole. This encounter with Japan must have acted like a catalyst upon the "renewers" of art. Karl Madsen's book on Japanese painting[28] had already exerted a great influence on the Aesthetic Movement in the North. Madsen was also a dealer in Japanese art

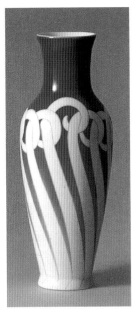

Gotfred Rode
Vase, 1898
Porcelain, underglaze painting, 43 cm high
Made by Den Kongelige Porcelainsfabrik, Copenhagen
Many of the decorative schemes employed on vases such as this one reflect Japanese influences in their stylization and their skillful distribution across the body of the vessel. Amongst the numerous designers working for the Royal Danish Porcelain Factory – truly the "king" of its field – was Gotfred Rode, whose designs pointed the way forward into the next century.

Carl Frederik Liisberg
Vase with cock-fight decor, 1888
Underglaze painting, gold, 13.5 cm high, 7.3 cm diameter
Made by Den Kongelige Porcelainsfabrik, Copenhagen
Badisches Landesmuseum Karlsruhe, Museum beim Markt – Angewandte Kunst seit 1900

Emil Arnold Krog,
Knud Valdemar Engelhardt
Four vases, 1895-1910
Porcelain, multicolored underglaze,
crystal glaze,
8.2 cm to 24 cm high
Made by Den Kongelige
Porcelainsfabrik, Copenhagen.
It was the color chemists, more than
anyone, who were spurred on by the
newly discovered beauty of Japanese
and Chinese glazes to unlock the
secrets of their production. The
factory laboratories became testing
grounds for the new "surfaces"
which would determine the
evolutionary course of design. A
particular speciality of head chemist
Knud Valdemar Engelhardt were his
crystal glazes, whose craquelure
created an "abstract" decor on the
sides of the vessel and formed richly
inventive patterns.

and possessed a profound understanding of the Japanese attitude towards applied and free art. "This is why they have succeeded in painting the same subjects in the same way both in their pictures proper and on faience and lacquer pieces. This is why, without offending good taste and breaking the eternal laws of decorating art, they have made bold use of all possible natural forms in their full free distinctiveness. ... The best painters have not considered themselves too good to give craftsmen model drawings for decorations. In fact, many of them have given important impulses to decorative art by working themselves in ivory, shaping and decorating faience ..."[29] Amongst the protagonists of Japonisme in Denmark were the members of the *Dekorationsforeningen* (Decoration Society), Thorvald Bindesbøll, Pietro Krohn, Joachim and Niels Skovgaard and Theoder Philipsen. Madsen supported their appearance at the "Nordic Exhibition".

The Kongelige Porcelainsfabrik celebrated its first international success at the World Exposition in Paris in 1889, where Krog's underglaze painting was enthusiastically received.

While the decoration he executed in this complicated technique was derived from Danish flora and fauna, its stylization and composition on the body of the object was Japanese in origin. Amongst the many designers working for the Royal Danish Porcelain Factory – truly the "king" of its field – was Gotfred Rode (1862–1937), whose designs pointed the way forward into the next century (ill. p. 305).

"Most porcelain is fashioned into ridiculous dolls"[30], said Winckelmann, in an implicit condemnation of "knick-knacks" way back in the 18th century. The turn of the century nevertheless became the era of the statuette in porcelain, too. These convenient "art works" offered an ideal means of embellishing the average home with art. Statuettes became the sculptures of the private sphere, sculptures which also found a place in the living room.

Once again, the Copenhagen factory assumed a leading position in the field of small porcelain sculpture (ill. p. 304). With its sophisticated technique of underglaze painting, its restrained palette and soft surfaces, it became clear that the factory was able to produce highly stylish

Above:
Aron Jerndahl
Lidded container (detail), 1903
Chased cast tin, relief decor modeled
in the round,
17 cm high, 23.5 cm diameter
Water is rendered as undulating lines
on the body of the container, which
the figures encircle as if in a
whirlpool, emerging and vanishing
again back into the material. The
rhythm established by the violin
player extends in a linear direction
across the surface. The motif is
related to the Dance of Life, a theme
explored in numerous variations by
Edvard Munch as an existential
symbol.

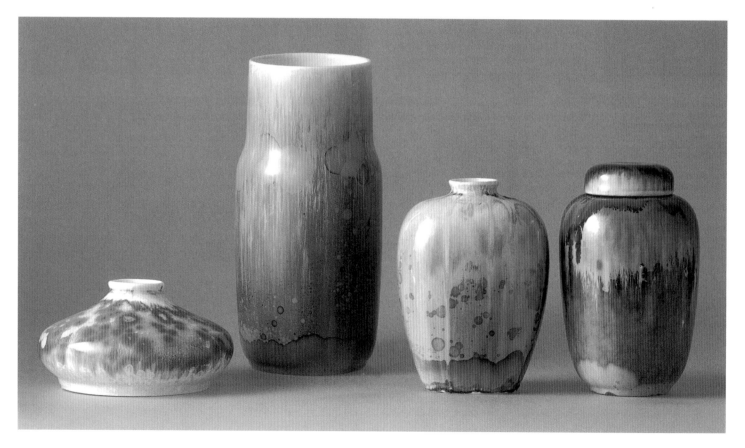

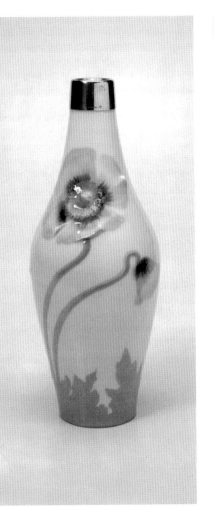

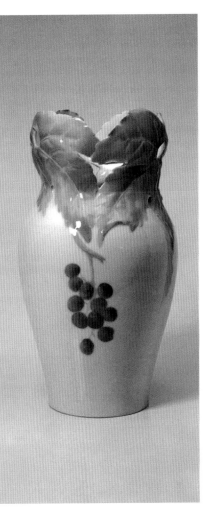

works even in this difficult area (ill. p. 305). The Danish manufacturers Bing & Grøndahl were also successful entrants, with their porcelain figures, in the competition for beautiful design.

The Swedish porcelain company of Rörstrand, based in Lidköping near Stockholm, was similarly successful with works modified from the Danish type. Characteristic of its decorative schemes were plant motifs in relief which "grew" over the body of the object and were usually decorated in two shades of the same color (ill. above). The Rörstrand dinner services and coffee sets, with their flowers in relief or leaves and tendrils in underglaze painting, their economic stylization and muted coloring, may be seen as definitive examples of beautiful tableware.

Mastery in silver – Georg Jensen

Ousting silver out of daily use, and employing it only for special items which are seldom used, is absurd.
Review of around 1900[31]

Georg Jensen (1866–1935), Scandinavia's most famous silversmith, was another who began as a ceramicist. He studied sculpture at the Copenhagen Academy, giving him a confident feel for plastic effect, and then worked in the studio of Mogens Ballin (1871–1914), one of Denmark's leading metalwork artists, who produced everyday utensils in powerful Art Nouveau forms. After an extended stay in France and Italy, Jensen joined forces with Joachim Petersen (b. 1870) to found a small porcelain studio – a venture which was not successful, however. After this "ceramic intermezzo", Jensen turned to his true forte, silver and goldsmithery.

In 1904 he opened his own studio and shop; still running, it is now a large-scale enterprise. His chased silverware is "crowned" by extravagant motifs, drawn primarily from the plant kingdom. Umbels and capsules, and the opium poppy so beloved of the Symbolists, adorn the handles and lids of his curvaceous services, whose highly original style of decoration makes them instantly recognizable as "Jensens" (ill. below). In his jewelry – most of it silver – he combines flower and insect motifs from Art Nouveau with traditional Nordic ornament; semiprecious stones and enamel add colorful accents (ill. opposite page). Just one year after setting up his business, Jensen exhibited his works in the Folkwang Museum in Hagen to great acclaim. The painter Johan Rohde (1856–1935), Jensen's friend and business partner, had a hand in many of the designs, which explains the "painterly" quality of Jensen's jewelry, at times bordering on baroque. In 1918 Jensen moved his business into its own premises. Replicas of his Art Nouveau works are still on sale today.

Visions and "Northern Symbolism"

The "seen-in-a-dream" quality of the North, residing in the Scandinavian twilight and running like a thread through the literature and music of the turn of the century, was something that the Swedish artist Aron Jerndahl (1858–1936) strove to translate into three-dimensional form. Each of his works is unique in the sense of its artistic independence. Fashioned from simple tin, Jerndahl's pieces attempt to express a sense of alienation – an unusual starting-point for everyday objects such as a lidded container (ill. p. 306). Water is rendered as undulating lines on the body of the container, which the figures encircle as if in a whirlpool, emerging and vanishing again back into the material. The rhythm established by the violin player extends in a linear direction across the surface. The motif is related to the Dance of Life, a theme explored in numerous variations by Edvard Munch as an existential symbol.

Equally original and rich in nuance was the jewelry designed by the Danish artist Erik

Georg Jensen
Coffee and tea service, 1905
Chased silver, ivory
5.3 cm to 23 cm high
Jensen's chased silverware is "crowned" by extravagant motifs, primarily from the plant kingdom. Umbels and capsules, and the opium poppy so beloved of the Symbolists, adorn the handles and lids of his curvaceous services, whose highly original style of decoration makes them instantly recognizable as "Jensens".

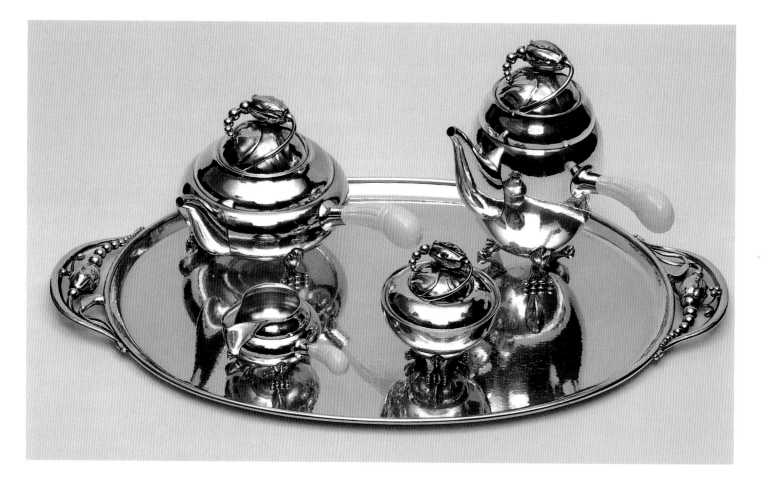

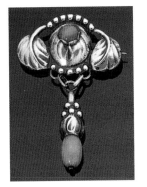

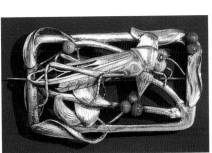

Magnussen, (1884–1961), in which insects serve as a fantastical, eerie ornament which has severed all connection with the obligatory elegance of its French forerunners (ill. above).

From North to South

The supreme "all-rounder" in Danish art was Thorvald Bindesbøll (1846–1908), who contributed to the development of Danish art around 1900 in all areas. He was gifted with a flat, graphically excellent ornamental style which he employed in every sphere of applied art: ceramics, bookbinding, endpapers, illustration, silverwork, posters, jewelry, and architecture. Characteristic of Bindesbøll's style is his translation of vegetal forms into broad bands which condense into points at the ends. The manner, too, in which his decor expresses itself freely in the plane reflects his familiarity with Japanese art (ill. p. 311). His works are lent a distinctive note by his palette, which he concentrated by preference upon the contrast between black and yellow. In his architectural works, Bindesbøll represented the Nordic block-like style also practiced by the Swede Ragnar Östberg (1866–1945), with ornament incorporated into the body of the building (ill. right).

In Sweden, which in the 1920s would become famed around the world for its glass, the glassware produced in the Art Nouveau style was still somewhat eclectic. In the figure of the glass artist Gunnar G:son (= Gunnar's son) Wennerberg, however, we may recognize the "dawn" of Swedish glass art. Formally influenced by the works of Emile Gallé, his cut and etched glasses are of high technical quality and represent Sweden's first "artist glassware" (ill. p. 307). It is essential to note, however, that the exchanges taking place at the international level around 1900 were reciprocal, and did not just travel from the West and the South to the

North in a one-sided fashion. In the field of painting, illustration and poster design in particular, Scandinavian artists exerted an enduring influence upon the rest of Europe; an outstanding example is the Norwegian Olaf Gulbransson (1873–1958), who was active in Germany. As in the case of the Swede Einar Nerman (b. 1888) (ill. p. 304), Gulbransson's strength lay in his almost cartoon-like abbreviation of his pictorial components.

Danish art resembles Dutch art in its fundamental principles. It, too, is honest, serious, unpretentious, sincere, lost in reverie, technically sound, innerly Teutonic, albeit also trained more recently in the French school. It is remarkable just how important a role light has played in painting right from the very start, something which can perhaps be explained by the atmospheric quality of the air of this coastal land ... In the sphere of modern handicraft, the products of the Copenhagen Porcelain Factory are attracting particular attention. It is achieving outstanding results in its animated and naturalistic portrayals of animals and its wonderful shading and coloring. Amongst the Swedes, we must mention Anders Zorn in particular. ... As a sculptor, he is highly gifted in lending powerful expression to inner emotion. He has offered his own important contribution, in bronze, toward solving the problem of combining two naked and intertwined human figures, a man and a woman, into a three-dimensional group which has commonly become known as *The Kiss*. In contrast to the comfortable middle-class atmosphere exuded by Danish pictures and the French perfume which wafts out of many Swedish paintings, namely those from the elegant capital of Stockholm, the Paris of the North, the paintings of fresh snow and springtime yearning by the Norwegians are a breath of the delicious, bracing air in which fishermen and farmers grow up. Far and away the most brilliant of them all is Edvard Munch, highly artistic, multi-talented, tied to no single thematic area or technique, painter, lithographer, portrait artist, psychologist, satirist, landscape painter, and illustrator of his own fantasies. An artist in whose hands forms and contours seem to flow, even though in reality they are clearly defined and firmly fixed, ... a creator who points back to Rembrandt himself in his ability to infuse life into his creations, so that their mouths breathe and their eyes speak ... Occupying a particular place within Russian painting are, of course, the Finns ... Axel Gallen, who – in the fashion of a Jan Toorop – excels in the stylized narration of Norse fables.
Friedrich Haack, *Grundriss der Kunstgeschichte – Die Kunst des XIX. Jahrhunderts*, Esslingen am Neckar, 1904

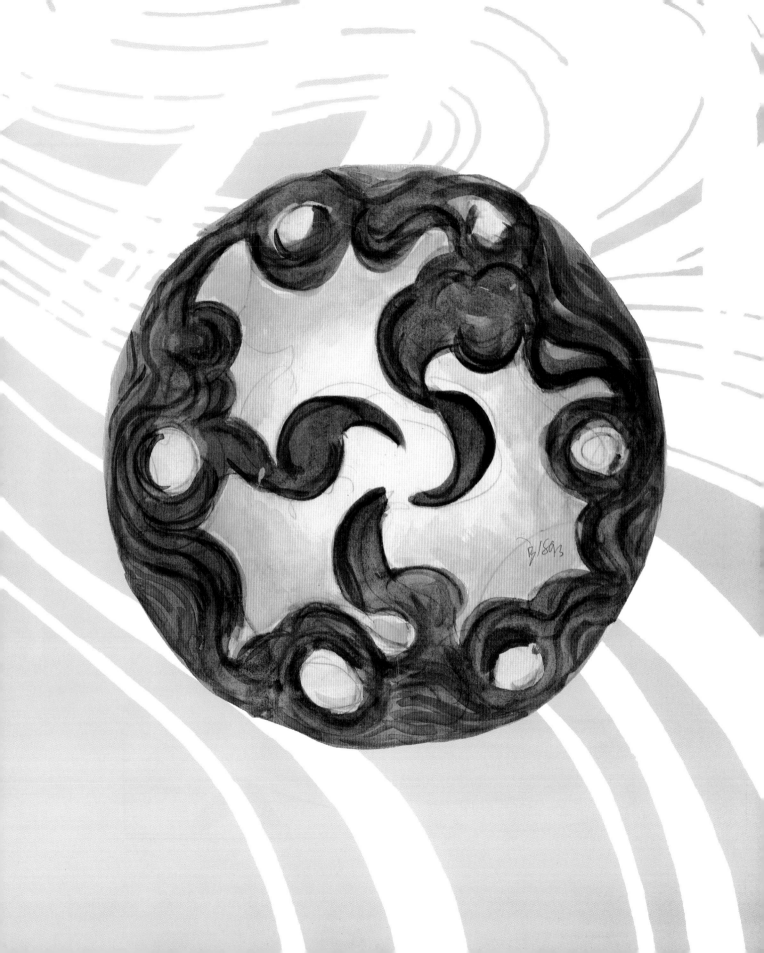

Form follows function
New York and Chicago

William H. Bradley
Serpentine Dance – Loïe Fuller,
1894
Illustration from *The Chap Book*,
December 1 1894,
19 x 11.4 cm
"The American painter Bradley
drew Loïe Fuller – the veil dancer
who, also from America, had been
taking all of Europe by storm since
1893 – vanishing into billows of
flowing cloth, bathed in colored
light, a pure wave of color and light.
This alone is what concerns the
artist, and what has sparked his
imagination. There is only a semi-
ironic allusion to the actual presence
of the dancer. The undulating waves
of her veils are more real than she
herself; they are true form, that
which is present and believable, all
that is visible – the object, the
objectivity of art."
(Kurt Bauch, see note 10)

Forms emerge from forms, and others arise or descend
from these. All are related, interwoven, intermeshed,
interconnected, interblended. They exosmose and
endosmose. They sway and swirl and mix and drift
interminably. They shape, they reform, they dissipate.
They respond, correspond, attract, repel, coalesce,
disappear, reappear, merge and emerge: slowly or swiftly,
gently or with cataclysmic force – from chaos into chaos ...
Louis Henry Sullivan[1]

Functional organism

The delicate balancing act between function-
alism and the organic – a metaphor for art around
1900 – finds its most convincing resolution in the
"pure culture" and architecture of America.
Objects and buildings functionally tailored to the
organic outlasted the sensual delirium of the
turn of the century. Not only did they have a
permanence in themselves, but the principles of
their construction shaped architecture inter-
nationally. Purely superficial ornament, on the
other hand, faded away and became for many
years the object of posterity's derision. Sullivan's
effusive hymn to the power of form found early,
visionary expression in his Chicago buildings. At
around the same time, Louis Comfort Tiffany
was creating his glassware in New York – exotic
blooms grown in an organic hothouse in an
entirely different climate.
The land of unlimited opportunity! Although 19th-
century America was no longer a blank on the
map, its development and lifestyle were still
somehow "exotic" and were greeted in Europe –
in the milieu of decadence – with arrogance or
admiration, depending on mood. The picture of
North America held by most Europeans was
unreal and oscillated between the image of vast

prairies where life was simple and that of rapid
economic progress driven by technology straight
out of science fiction. "The forms of the Old
World, the inheritance of the 'Beaux Arts', the
old colonial style and the 'pure' Greek style all
have a place in this world, but not necessarily out
on the prairie. They may be right for Connecticut
or Virginia, the Boulevard Montparnasse or
Buckinghamshire, but they are not suitable for
the endless open spaces of the New World.
Criss-crossed by the great railroads of the
Midwest, with its new cities founded by hills
men, cattle ranchers, by men who can meat and
export corn, by men with heads full of inventions
and ideas, the country poses special new
challenges.
Whatever we may think about the men who have
made America what it is today, they nevertheless
represent a new phenomenon, and the time has
come to find new forms of expression for the
lives they are seeking to live. There is no
pettiness in their lives, and it is to this that the
sense of unity and expansiveness found in the
works of Frank Lloyd Wright may be attributed ...
To repeat, a style arises organically, and the style
of the 20th century would lack essence and
reality if it did not reflect the influences which
form the background against which the life of our
day is played out."[2] The reformer Charles Robert
Ashbee here offers a sensitive insight into the
background to American Art Nouveau. These
"formative conditions" apply not simply to Frank
Lloyd Wright, however, but also to Louis Comfort
Tiffany.

Louis Comfort Tiffany
Paperweight vase (detail), 1909
Amber-colored casing, color and
luster decor, millefiori technique,
Favrile glass, 16.5 cm high
These masterpieces owe their
"floral" character to a mosaic glass
technique which dates right back to
the Ancient Egyptians. In this
technique, different colored strands
of glass were combined under heat
into a bundle and then sliced into
thin cross-sections whose cut surface
bore the shape of a flower. The
viscous bundles themselves could be
made up of any combination of
colors, placing almost no limits on
the ornamental "flowers" that could
be produced. In the final stage of the
manufacturing process, these
individual cross-sections were then
fused by the glassblower into a single
bloom.

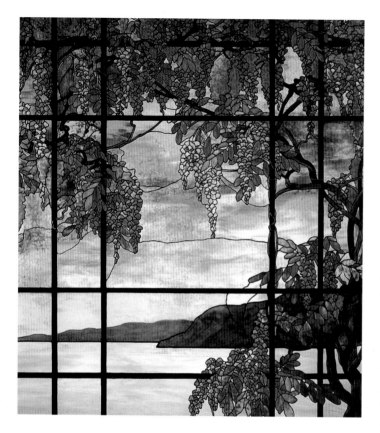

Louis Comfort Tiffany
View of Oyster Bay, stained-glass
window, 1905
Lead glazing, 185 cm high
Tiffany drew his inspiration for this
motif from the place he loved the
best and where he built himself a
house – Cold Spring Harbour on
Oyster Bay in New York. The
window was executed for William
Skinner's New York home.

The American Dream – Louis Comfort Tiffany

*It is all a question of upbringing and education; as long as
people do not learn to distinguish between the beautiful
and the ugly, they will not live with true works of art.*
Louis Comfort Tiffany[3]

The history of the family of Louis Comfort Tiffany
– alongside Emile Gallé, the most popular and
most talented glass artist of Art Nouveau – is a
tale of the "American Dream" come true.
Tiffany's father, Charles Lewis Tiffany, later to
become one of the richest men in America, was
just 25 when, in 1838, he founded Tiffany &
Young, a firm of silversmiths and jewelers, with
minimal start-up capital and the collaboration of a
schoolfriend. The young men initially concen-
trated upon importing jewelry from Europe, but
in the 1850s, as their turnover grew, they started
making their own. The firm's liquidity is impres-
sively demonstrated by some of its acquisitions:
in 1850 it purchased the diamonds formerly
owned by Marie Antoinette, the queen of France
beheaded in 1793; in 1887 it acquired part of the
French crown jewels at a price of over two
million (gold!) francs; and in 1889 it bought the

biggest yellow diamond in the world. The name
Tiffany became a synonym for luxury, not just in
America but all across the European continent,
where the company had showrooms in Paris and
London.

Louis Comfort Tiffany (1848–1933) was thus
born with the proverbial golden spoon in his
mouth, and into a golden age. There seemed to
be no limits to growth; railroads crossed the
country, trading posts became towns, towns
cities, and cities like New York metropolises.
With progress came – to borrow a term from
Lewis Carroll, author of *Alice in Wonderland* – a
high degree of "uglification", although this did
not seem to bother most people, carried along as
they were on the general tide. It was a develop-
ment which disturbed and oppressed Louis
Comfort, however, which in turn alarmed his
family. The artistic leanings expressed by the
young boy, designated to succeed his father as
head of the growing firm, were a cause for
concern. Despite much opposition, however,
Louis Comfort began studying painting in New
York under George Inness (1825–1894) and
Samuel Colman (1832–1920), albeit in a rather
casual fashion, since his definition of "beauty"
went far beyond the merely academic sphere. In
1865, at the age of 17, he crossed the Atlantic to
continue his training in Paris under the painter
Leon Bailly (1826–after 1868), who cultivated the
newly fashionable style of "Orientalism". Inspired
by this, Tiffany traveled to the original arenas of
such art, namely Africa, Spain, and Egypt. In
what proved a key experience for him, he made
an intensive study of the Early Christian mosaics
in Ravenna in Italy and the 12th- and 13th-century
stained-glass windows in Chartres cathedral in
France. He was profoundly and enduringly impres-
sed by the beauty and perfection with which the
materials were worked, but also by their free,
ornamental approach to composition. Tiffany
joined numerous well-regarded artists' associa-
tions during his student years, but in 1878, after
an exhibition of his landscape paintings, he
abruptly switched *métier* and became a decora-
tive – Art Nouveau – artist. Without a doubt,
Tiffany's understanding of art was influenced by
William Morris and the Arts and Crafts
Movement in England and was further inspired
by the enormous fund of "applied art" which he
had acquired during his extended trips through
Europe and Africa. Nevertheless, he always
remained specifically "American". At the Paris
World Exposition of 1900, he showed the
dazzling stained-glass window *The Four Seasons*,
whose message to the visitor was not simply

Louis Comfort Tiffany
Apple Blossom (detail), window,
1899–1928
Lead glazing, 75 x 75 cm high
"In Tiffany's glass panels, it was as
if a piece of the sky, a bed of flowers
or a collection of precious stones had
been melted down and turned into
glass."
(Hugh McKean, see note 5)

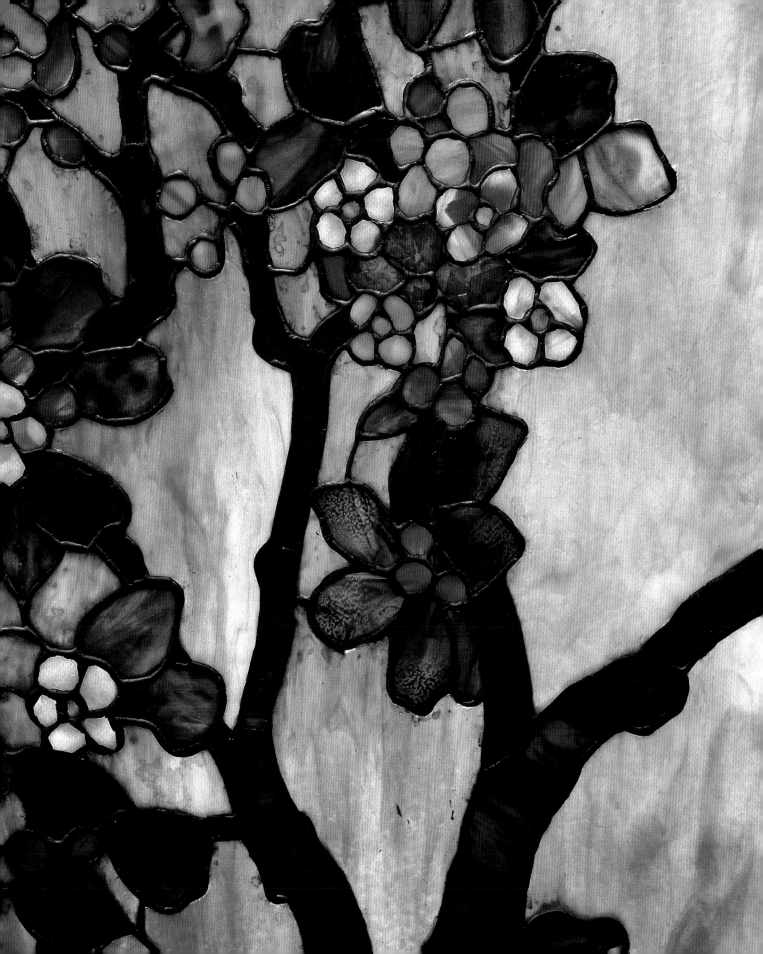

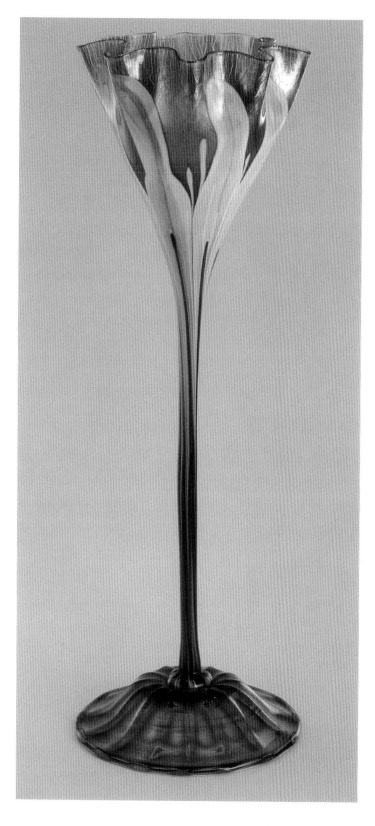

artistic: hovering above the entire scene is the American heraldic bird, a fearless sea eagle, who extends his wings protectively over an inscription which reads: "Wealth, Freedom and Prosperity".

Stained-glass windows – A luminous play of color

I was particularly fascinated by the old glass which was used for church windows in the 12th and 13th century; for me, these stained-glass windows have always been the ultimate in supreme beauty.
Louis Comfort Tiffany[4]

Back in New York, Tiffany became a sought-after interior designer amongst the members of high society. His interiors demonstrate a preference for exotic foreignness, but are designed with invariably surefooted taste. An essential component of these interiors were lead-glazed, colored-glass windows, which owed their origins to the chemical experiments with opalescent glass first conducted in 1876 by the Louis Heydt Factory in Brooklyn, in collaboration with the glass painter John La Farge (1835–1910). "In Tiffany's glass panels, it was as if a piece of the sky, a bed of flowers or a collection of precious stones had been melted down and turned into glass"[5] (ills. pp. 314, 315). Tiffany had found the material which, over the following years, he would make "sing". In 1879 he founded the firm of Louis Tiffany & Company Associated Artists, which employed chemists, designers, and glass experts. Leaving aside Tiffany's complex manufacturing techniques and patented processes, such as his antique-style opalescent glass, the quality of his glass was the result first and foremost of the lengthy and detailed consideration which he gave to its aesthetic appearance. Consequently, too, Tiffany's Chapel and Sullivan's Golden Gate for the Transportation Building – both exhibits at the World's Columbian Exposition in Chicago in 1893 – were spectacular but isolated phenomena within the historicizing "Roman classic" theme of the remaining architecture. The mosaics of Favrile glass, mother-of-pearl and semiprecious stones which adorned the Chapel were greeted as the creations of an original and independent spirit and earned Tiffany an international name. They also brought him into contact with Samuel Bing, so important as a "sponsor" of Art Nouveau.

Tiffany Studios, New York
Vase in the shape of a flower, ca. 1900–05
Favrile glass, 28.6 cm high
Louis C. Tiffany Museum
Nagoya, Japan
In its essence, Favrile glass recalls mosaic glass painting – painting with glass. Pulverized metal or precious metal was coated over the body of the object in a thin layer, in the same manner as cased glass. Depending on the composition of the metal, the coating that resulted was either matt, lustrous or gloss. In the final stage of the process, vapors containing oxides deposited themselves on the outer walls to create a luster effect.

Louis Comfort Tiffany
Vase, 1909
Iridescent Favrile and Lava glass,
9.5 cm high
Tiffany looked back in his work
across the entire history of glass-
making: his so-called Cypriot and
Lava glasses reveal in their surface
structure the characteristics of the
glassware of antiquity – porous,
dotted with bubbles, and marbled
with pale bands of color.

"Favrile" – Invention and inventiveness in glass

His ability to look at a lump of white-hot glass and
visualize precisely what the finished piece would look like
once it was strewn with glass particles, blown, decorated,
and cooled, was almost uncanny.
Hugh F. McKean[6]

On a trip to Europe in 1889, Tiffany met for the
first time not only Venetian glass and the
iridescent glassware of the Roman Empire, but
also the works of Gallé, which excited him not so
much by their design as for their underlying
notion of "art for all". These encounters led to
his decision to devote himself more intensively
to "decorative glassware". He took to heart the
words of Gallé (1846–1904), whose aim was to
embellish the home of every Frenchman with
beautiful art objects. Tiffany had worked for
the Vanderbilts and the Rockefellers, but the
American middle-class home was still as ugly as
ever. In 1890 his response was to found the
Storbridge Glass Company on Long Island. Here
he sought to recreate the "rainbow" luster effect
of antique glassware through chemical pro-
cesses and to manufacture glassware on a larger
scale. New methods were constantly being
developed to these ends.

The number of stained-glass windows which
Tiffany could sell was, by its very nature, limited.
On the other hand, the *Belle Époque's* need for
decoratively styled practical items such as lamps,
vases, and toilet articles seemed almost limit-
less. There was an economic factor in the
equation, too: the manufacture of stained-glass
windows accounted for only a relatively small
proportion of the enamel glass, with its
shimmering hues, available in large quantities.
Tiffany therefore began producing decorative
items of blown glass of a type which he called
Favrile glass, a word derived from the early
modern English word *fabrile*, meaning "relating
to craft", "masterly" (ill. right). The material had
already been employed in windows in the past.
In essence, this luster glass recalls mosaic glass
painting – painting with glass. Pulverized metal or
precious metal was coated over the body of the
object in a thin layer, in the same manner as
cased glass. Depending on the composition of
the metal, the coating that resulted was either
matt, lustrous or gloss. In the final stage of the
process, vapors containing oxides were de-
posited on the outer wall to create a luster effect.
Without the aid of a floral stencil, the decor thus
"blossomed" out of a chemical but handcrafted
process into a vegetal, linear design.

Louis Comfort Tiffany
Vase, 1897
Iridescent cased and threaded glass,
foot of silver-plated metal modeled in
the round, mounting studded with
pearls, precious stones on the base
and collar, 37 cm high
Foot made by Tiffany & Co.,
London
The number of stained-glass
windows which Tiffany could sell
was, by its very nature, limited. On
the other hand, the *Belle Époque's*
need for decoratively styled practical
items such as lamps, vases, and toilet
articles seemed almost limitless.
There was an economic factor in the
equation, too: the manufacture of
stained-glass windows accounted for
only a relatively small proportion of
the enamel glass, with its
shimmering hues, available in large
quantities. Tiffany therefore began
producing decorative items of blown
glass of a type which he called
Favrile glass.

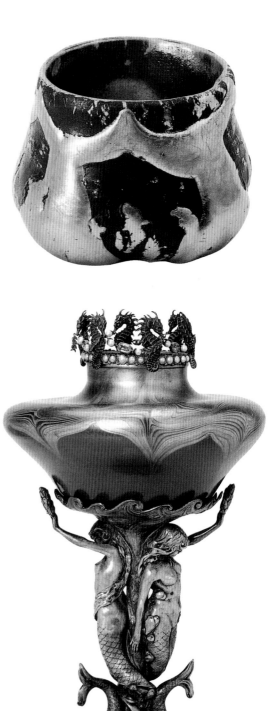

Tiffany glass objects also drew conciously upon the plant kingdom for their overall form. Thus vases echo the shape of opened calyxes, while slender stems bear fragile cups which harden into glass as if by chance (ill. p. 316). Light, color, and movement flow "anarchically" one into the other in these exquisite flowers of the imagination. These "products of chance" were unquestionably the result of supreme artistic and technical skill. There is similarly no doubt that Tiffany had already seen lusterware by the Bohemian Loetz' Witwe company at Lobmeyr's, the famous Austrian glass manufacturer in Vienna.

Nevertheless, the secret of Tiffany's "blooms" lay in the "gardener's" enormous creativity and eagerness to experiment. The famous paperweights by the French firm of Baccarat provided Tiffany with the inspiration for another original group of works (ill. p. 313). These masterpieces owe their "floral" character to a mosaic glass technique which dates right back to the Ancient Egyptians. In this technique, different colored strands of glass were combined under heat into a bundle and then sliced into thin cross-sections whose cut surface bore the shape of a flower. The viscous bundles themselves could be made up of any combination of colors, placing almost no limits on the ornamental "flowers" that could be produced. In the final stage of the manufacturing process, these individual cross-sections were then fused by the glassblower into a single bloom.

Tiffany was also inspired by Monet's *Water Lilies* series. The outlines of his "flora" become blurred, and in place of the flowers themselves we see the light they reflect – glass impressions. Tiffany looked back in his work across the entire history of glass-making: his so-called Cypriot and Lava glasses reveal in their surface structure the characteristics of the glassware of antiquity – porous, dotted with bubbles and marbled with

Tiffany & Co., New York
Lamp, from the Pierpont Morgan Estate, Carolina, ca. 1900
Patined bronze, 48 cm high
Tiffany's holding company also produced less sophisticated objects for everyday use, which nevertheless always retained the flair of the one-off work of art.

Opposite page:
Louis Comfort Tiffany
Jack-in-the-pulpit vase, experimental piece, ca. 1900
Favrile glass, lustered, with craquelure, 40.3 cm high
Tiffany reached the pinnacle of his "formal inspiration" in his *jack-in-the-pulpit* models, exclusive, exquisite vases so called after the spathe of the American woodland herb.

Louis Comfort Tiffany
Wisteria, lamp, ca. 1899–1925
Favrile glass, copper setting, bronze foot, 42.5 cm high
The "stars" of Tiffany's enormous product range were his lighting appliances, an absolutely central feature of the repertoire. In 1882 Tiffany had designed gas lighting for the White House and other important clients. Designing lights allowed him to combine all his main interests – his love of light effects of all kinds, of the iridescent interplay of colors, and of glass as a material.

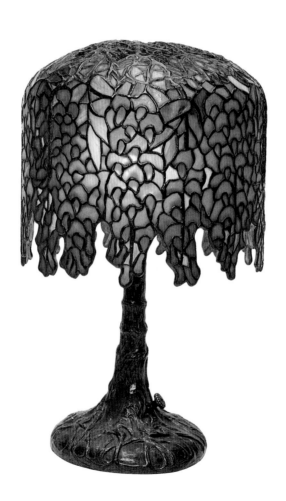

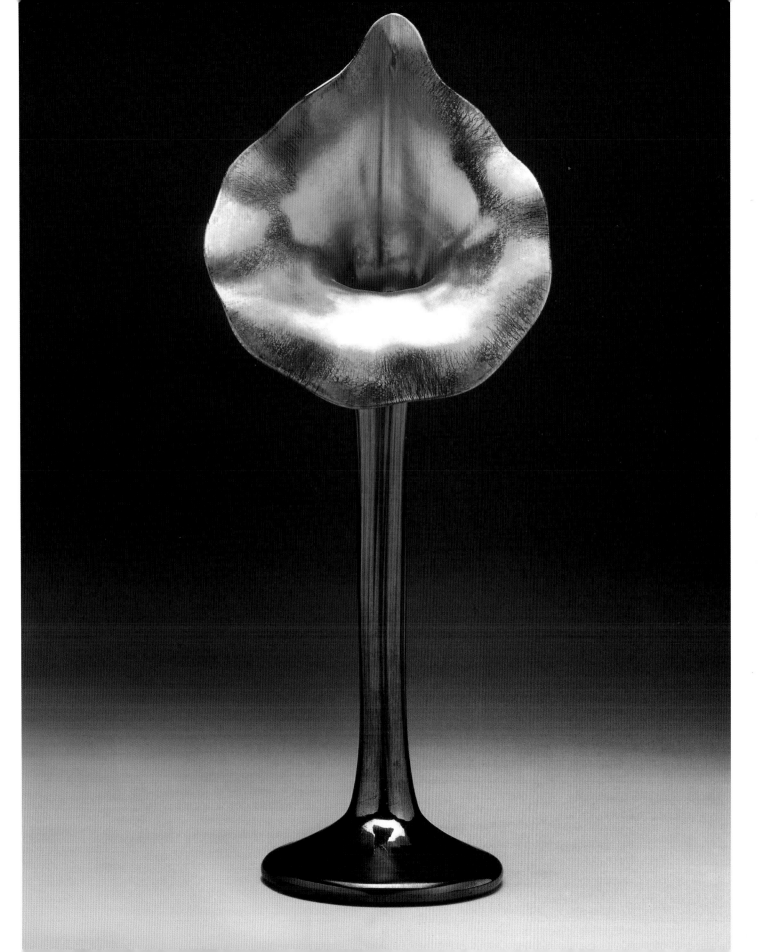

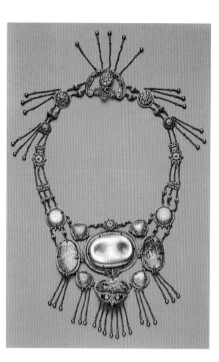

pale bands of color (ill. p. 317). There are Tiffany glasses which have a deceptively metallic appearance and which seem to be made out of bronze or iron.

Persian perfume bottles were the starting point for his "goose-neck" vases, which bend their necks asymmetrically like Oriental vessels designed for sprinkling rosewater. The magician of glass reached a pinnacle of "formal inspiration" in his "jack-in-the-pulpit" models, exclusive, exquisite vases so called after the spathe of the American woodland herb.

The English art critic Cecilia Waern, writing in *The Studio* in 1898, succinctly described the secret of the unvarying quality of Tiffany glass, for all the extravagance of its ornament: "… the shapes are often capricious but with all the sheer waywardness of this exquisite material; they are almost invariably simpler, less slight, less tortured, and more classical in the deepest sense than the blown glass from Europe."[7]

Tiffany lamps – Glass pictures flooded with light

He concerned himself again and again with questions of interior design and lighting, was very interested in growing flowers and gardening and also dedicated himself with great enthusiasm to landscape architecture.
Hugh F. McKean[8]

The "stars" of Tiffany's enormous product range were his lighting appliances, an absolutely central feature of the repertoire. In 1882 Tiffany had designed gas lighting for the White House and other important clients. Designing lights allowed him to combine all his main interests – his love of light effects of all kinds, of the iridescent interplay of colors, and of glass as a material (ill. p. 318). It brought him great satisfaction, too, to know that Tiffany lampshades of stained glass and Favrile glass were bringing beauty into American living rooms – not to mention boosting the company's turnover at the same time. His ambitions for the firm were impressive: its operations included a department supplying complete interiors, furniture workshops, a "sacred art" division, a ceramics studio, a jewelry atelier, a metal workshop and much more. His holding company also produced less sophisticated objects for everyday use, which nevertheless always retained the flair of the one-off work of art (ill. p. 318). The number of Tiffany imitators is

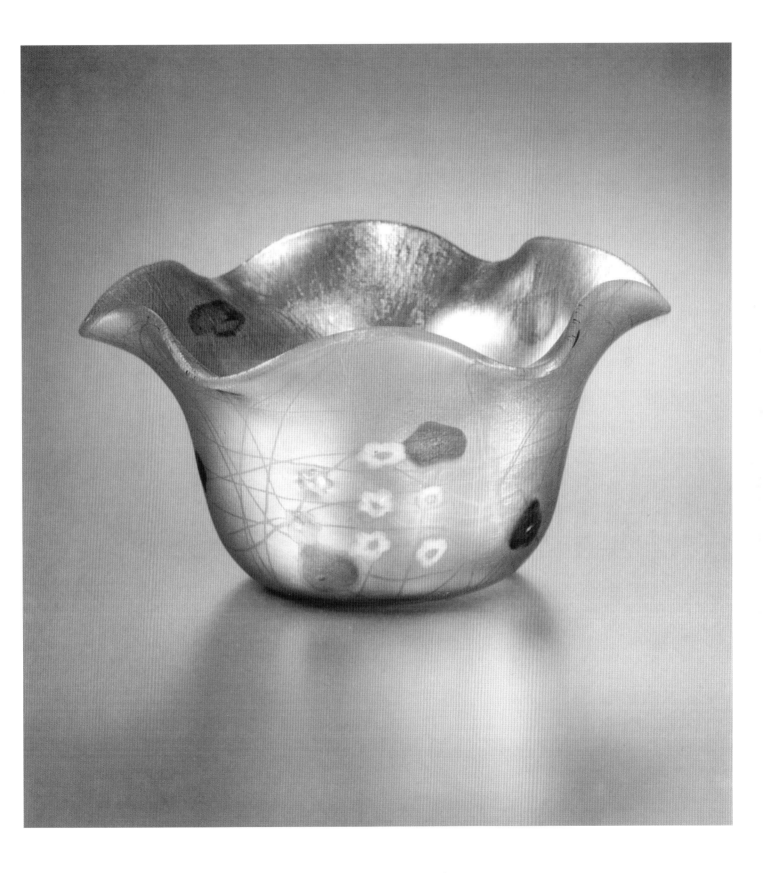

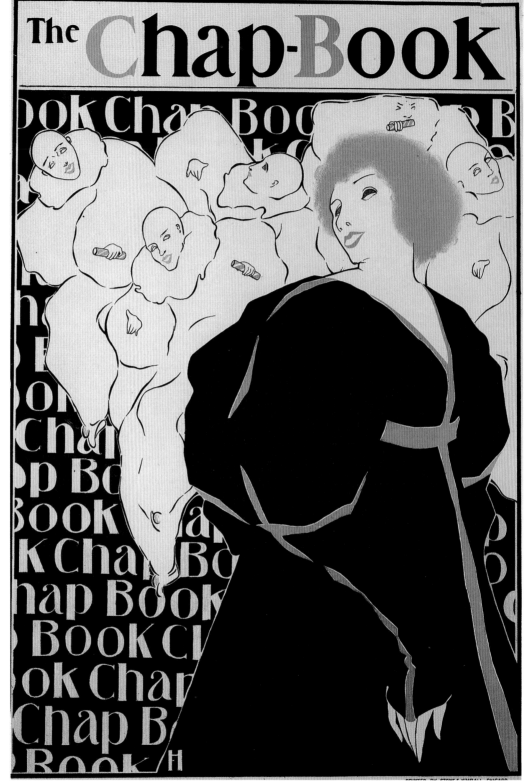

Frank Hazenplug
The Chap Book, before 1898
Color lithograph, 51.8 x 35.6 cm
American graphic art found its own
vocabulary entirely free from stylistic
reminiscences. *The Chap Book*,
which appeared from 1894, was
wholly devoted to this new style. It
was not just a forum for writers and
illustrators from Europe, but a
compendium of the graphic art being
created in the New World.

countless; many of his pupils set up business on their own, including Martin Bach and Thomas Johnson, producers of "quetzal" glass, so called after a Central American bird with shimmering plumage. Influenced by Tiffany, the Steuben Glass Works in Corning, New York, produced decorative glasses with a luster effect (ill. p. 321). Joseph Webb, working for the Phoenix Glass Company, was highly successful with his "pearl satin glass", which he later patented. In his elegant showrooms, Tiffany showed, alongside his own pieces, ceramics by the Rookwood Pottery in Cincinnati, Ohio, which was particularly successful with pieces combining a floral silver casing over a base decorated in slip painting in Japanese style (ill. p. 320).

Like a true Art Nouveau artist, Tiffany also produced his own total work of art. In his home on Oyster Bay, the "non-architect" translated all his knowledge of art into reality. The house was laid out like a seraglio with gardens, inner courtyards, fountains and an endless succession of stained glass: the *Arabian Nights* in New York (ill. p. 314). Even if the end of his life was overshadowed by the problems of the company conglomerate, a photo taken on his 80th birthday shows a vivacious grand seigneur and lover of beautiful cars dressed in a white suit in Miami Beach. Showered with honors, he was the most important American craftsman of his era.

Graphic art

If Rembrandt had known about lithography, who knows what he might have done with it?
From the catalogue to an exhibition of lithographs[9]

The 1893 Chicago exhibition turned the international spotlight not just on Sullivan and Tiffany, but on a third great American artist: William H. Bradley (1868–1962). In 1895 *The Studio* published an in-depth review of his work, emphasizing his talent and comparing him with Beardsley. The bold style of the great English artist had undoubtedly made an impact on Bradley, who trained as a draughtsman. However, it was an apprenticeship in printing that led him to develop his own poster-like style. His technical understanding of the printing process enabled him to translate his ornamental works, tending toward the abstract, precisely into print and to secure himself a leading place amongst the pioneers of change in the sphere of book illustration. Under the influence of Morris, he founded his own press and published the magazine *His Book*. He thereby relinquished the traditional border

Ethel Reed
In Childhood's Country, poster, ca. 1900
Color lithograph, 63 x 29 cm
Ethel Reed, one of the few women artists of Art Nouveau to achieve celebrity, produced illustrations based on sensitive portrait studies. In 1895 she made her career breakthrough with the advertisement for a book by Gertrude Smith. The poster-like style of that design proved a recipe for success, one which she went on to employ in numerous illustrations and posters.

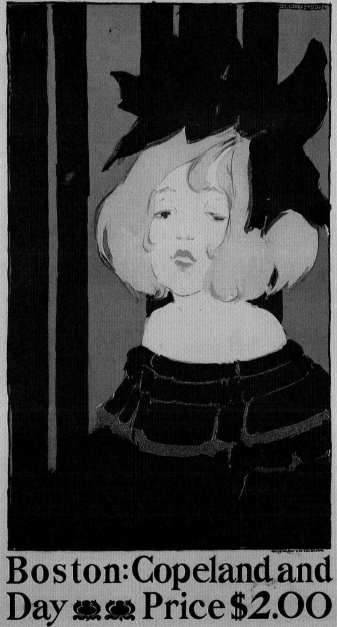

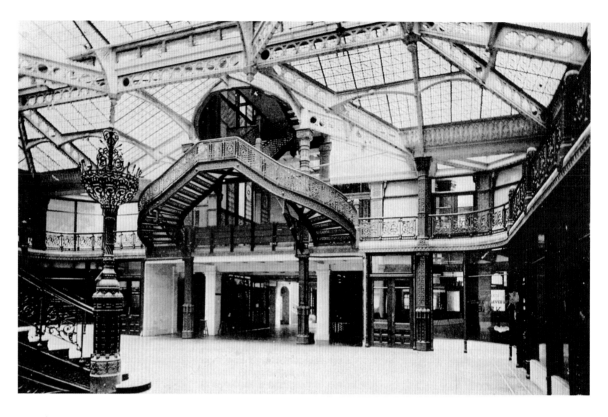

around every page, as employed by the Kelmscott Press, in favor of a new emphasis upon dynamic, whiplash line. Just how far Bradley was capable of escalating this characteristic feature of his style can be seen in a vignette of Loïe Fuller (ill. p. 312). "The American painter Bradley drew Loïe Fuller – the veil dancer who, also from America, had been taking all of Europe by storm since 1893 – vanishing into billows of flowing cloth, bathed in colored light, a pure wave of color and light. This alone is what concerns the artist and what has sparked his imagination. There is only a semi-ironic allusion to the actual presence of the dancer. The undulating waves of her veils are more real than she herself; they are true form, that which is present and believable, all that is visible – the object, the objectivity of art."[10] French echoes can be heard here both in the subject and in the "dancing" sweep of Bradley's line, reminiscent of Jules Chéret. American graphic art nevertheless found its own vocabulary entirely free from stylistic reminiscences. *The Chap Book*, which appeared from 1894, was wholly devoted to this new style (ill. p. 322). It was not just a forum for writers and illustrators from Europe, but a compendium of the graphic art being created in the New World. Ethel Reed (b. 1876), one of the few women

artists of Art Nouveau to achieve celebrity, produced illustrations based on sensitive portrait studies. In 1895 she made her career breakthrough with the advertisement for a book by Gertrude Smith. The poster-like style of that design proved a recipe for success, one which she went on to employ in numerous illustrations and posters (ill. p. 323).

Louis Henry Sullivan

Form follows function.
Louis Henry Sullivan[11]

The Eiffel Tower demonstrated the structural principle of the iron skeleton, as a symbol of technology in all its naked glory. In Victor Horta's Maison du Peuple we can identify an early example of a curtain wall, that is, the structure of the exterior already expresses that of the interior – the walls are, as it were, latched into the skeleton. In the case of Louis Henry Sullivan (1856–1924), "skin and bones" are brought into harmony; ornament is no longer understood as showy decoration, but as architectural stimulation lending emphasis to the details of the "joints" (ill. pp. 328–329). As Ruskin observed in 1849: "We have a bad habit of trying to disguise

Burnham & Root
Rookery Building, 109 South La Salle Street, Chicago, glass-roofed well, 1885–87
Daniel Hudson Burnham and John Wellborn Root opened their joint offices in Chicago in 1873 and provided an exemplary demonstration of steel-frame building in their Rookery Building. The fame of the building also rests on its groundplan, which offered an entirely new solution to the organization of space within a department store.

disagreeable necessities by some form of sudden decoration …"[12]. Some 43 years later Sullivan warned: "I should say that it would be greatly for our aesthetic good if we should refrain entirely from the use of ornament for a period of years, in order that our thought might concentrate acutely upon the production of buildings well formed and comely in the nude."[13] As far as "teetotalism" in ornament was concerned, however, Sullivan never went as far as his pupil Frank Lloyd Wright (1869–1959), who remained entirely abstinent in this regard. *The Grammar of Ornament* by the Englishman Owen Jones (1809–74), published in London in 1856 and in the United States in 1880, was a bestseller. In his book, which became the Bible of modern-thinking American craftsmen, Jones beat the drum above all for a stylized pure form of ornament, for simplification. Surface decoration must remain planar, he argued. In other words, it must adapt itself to the geometric structure and understand ornament in grammatical terms. It is here that Sullivan's decorative principle has its origins. Sullivan had a revulsion, on the other hand, for the rehearsal of historical styles, something he had encountered during his time at the École des Beaux Arts in Paris. Meanwhile, he shared the enthusiasm for engineering and held up as his model a simple technician – himself – who, with no more than an ordinary education, had in 1868 erected a steel bridge across the Mississippi. In 1879 Sullivan went to Chicago, which in 1871 had been swept by a great fire, leaving over a third of the city in ruins. The urgent task of rebuilding the city even bigger and better than before was one which fired the imaginations of architects and engineers alike. It would inspire a building tradition whose first pinnacles were reached in the works by the principals of the Chicago School of Architecture.

The Chicago School of Architecture

Having spent many years over there, I still blush with shame when I think of the ridicule to which German arts and crafts were subjected.
Adolf Loos[14]

The Chicago School of Architecture produced prototypes of modern architecture. It was the School's maxim that a building's design had to fulfill the requirements of economy, function, and well-being, and at the same time accentuate rather than hide the organic function of the building. "[Sullivan] admittedly went far beyond Ruskin, who denied technology and fought

its machines. But his 'philosophy', and the Romantic pathos of his decoration and his prose, were to be the net with which technology could be tamed and if necessary trapped."[15] Sullivan is seen as the father of functionalism, and it was in this spirit that he interpreted the skyscrapers which he designed, as can be seen in the example of the Guaranty Building in Buffalo, New York (ill. p. 325). Sullivan believed that "it is of the very essence of every problem that it contains and suggests its own solution. This I believe to be natural law."[16] He nevertheless appears to have reversed his own "form follows function" formula into "function follows form" when

Louis Henry Sullivan
Guaranty Building, Buffalo, cornice (detail), 1895
Standing in apparent contradiction to Sullivan's "form follows function" is the highly individual ornament which he developed for his architecture: a sharply defined, complex composition of Gothic and Art Nouveau elements.

speaking of the artistic impact of a building: "It
demands of us, what is the chief characteristic of
the tall office building? And at once we answer, it
is lofty. This loftiness is to the artist nature its
thrilling aspect. It is the very open organ-tone in
its appeal. It must be in turn the dominant chord
in his expression of it, the true excitant of his
imagination. It must be tall, every inch of it tall.
The force and power of altitude must be in it, the
glory and pride of exaltation must be in it."[17]
Another apparent contradiction lies in the highly
individual ornament which Sullivan developed
for his architecture: a sharply defined, complex
composition of Gothic and Art Nouveau
elements.

Sullivan's "prototype", always cited as the fore-
runner of modern architecture, is the Carson Pirie
Scott Department Store in Chicago, whose con-
struction is determined by a pragmatic empiri-

cism. As if Sullivan wanted to compensate for
the self-imposed asceticism of the upper storys,
the first and second storys of the plinth zone are
overlaid with a network of exquisite filigree
ornament. Multiplicity, imagination, and animation
not only offer an astonishingly agreeable contrast
to the reflective smoothness of the store win-
dows, but underline the independence of the
decoration, whose validity is unaffected by the
architect's fundamental rejection of built orna-
ment. Sullivan's later buildings – such as the
National Farmers' Bank in Owatonna, Minnesota
and the Merchants' National Bank in Grinnell, Iowa
– are less monumental than his early Chicago
works, but they are particularly impressive demons-
trations of his ability to make "architectural design"
real. They are a three-dimensional translation of
his own words: " ... They [the forms] sway and
swirl and mix and drift interminably"[18] (ill. p.330).

Frank Lloyd Wright
Country house for Avery Coonley,
Riverside, Illinois, view facade from
the garden, 1907
Although Wright designed big
projects, too, he preferred to work on
private houses. The free plan and the
human scale are the two main
principles underpinning his work,
whereby he also attached great
importance to "Nature". In his so-
called Prairie architecture, he fused
all these elements into elongated,
usually boldly composed buildings
with projecting roofs and open
groundplans.

Frank Lloyd Wright
Katsura Rikyu, Imperial Villa,
Kyoto, ca. 1590
The Katsura is not merely a
masterpiece of Japanese architecture,
but can be seen as a medium of
Japanese art *per se*. The German
architect Bruno Taut described the
villa – without false pathos – as one
of the "wonders of the world".

Following double page:
Louis Henry Sullivan
Stained-glass windows, side wall of
the National Farmers' Bank,
National Bank, Owatonna,
Minnesota, 1907-08
Subdivided by pillars, lead-glazed
With Sullivan, "skin and bones" –
in other words the structure and
outer skin of the building – are
brought into harmony; ornament is
no longer understood as ornate
decoration, but as architectural
stimulation lending emphasis to the
details of the "joints".

Daniel Hudson Burnham (1846–1912) and John
Wellborn Root (1849–91) opened their joint offices
in Chicago in 1873 and provided an exemplary
demonstration of steel-frame building in their
Rookery Building. The fame of the building also
rests on its groundplan, which offered an entirely
new solution to the organization of space within
a department store (ill. p. 324). Burnham and
Root also contributed to the sphere of high-rise
architecture; their Monadnock Building demon-
strates the sensitivity with which the two archi-
tects handled not just steel, but also brick: the
textured material is elegantly married with the
building's upthrusting momentum. The steps of
the Rookery Building were one of the first
commissions executed by Frank Lloyd Wright.

Frank Lloyd Wright

Truly ordered simplicity in the hands of the great artist
may flower into a bewildering profusion, exquisitely
exuberant, and render all more clear than ever.
Frank Lloyd Wright[19]

"Morris once said to me, speaking in favor of a
refined style of ornament: 'We do without it,
unless the building to which we are applying it is
itself refined.' Lloyd Wright's buildings fulfill this
demand."[20] Morris's theses, drawn upon by the
Art Nouveau generation of artists, thus also
found expression in the figure of Frank Lloyd
Wright. His designs aim at a tectonic rectangu-
larity, but also take up the dynamic lines which
arise out of ornament; these are no longer
merely aesthetic "appliqués", however, but
place a deliberate emphasis upon structure. An
architectural "noble-mindedness" became Wright's
guideline: "Buildings like people must first be
sincere, must be true and then withal as gracious
and lovable as may be."[21]
Wright came out of the Chicago School, worked
on occasions with Burnham and called Sullivan
his "Lieber Meister" (dear master). While he
may have evolved far beyond his teacher in many
respects, Wright nevertheless matched the
image of the architect created by Sullivan,
namely one who expressed his talents not just
through building, but through his writings and
other forms of art. The European architects who
were training their eyes on America looked for
many years to Wright, and thereby to a very
specific form of American architecture which had
its roots in the experiences of the avant-garde in
Europe. The striking, simple forms of Wright's
buildings are clear and unmistakable. He didn't
invent them; they corresponded to the American

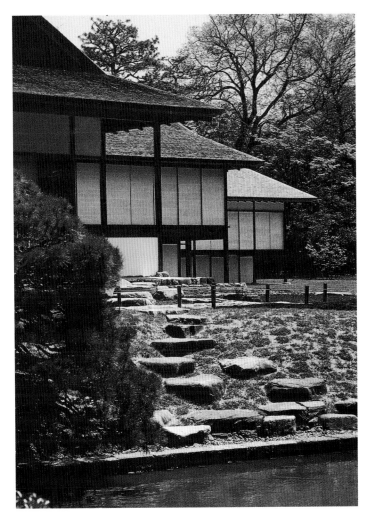

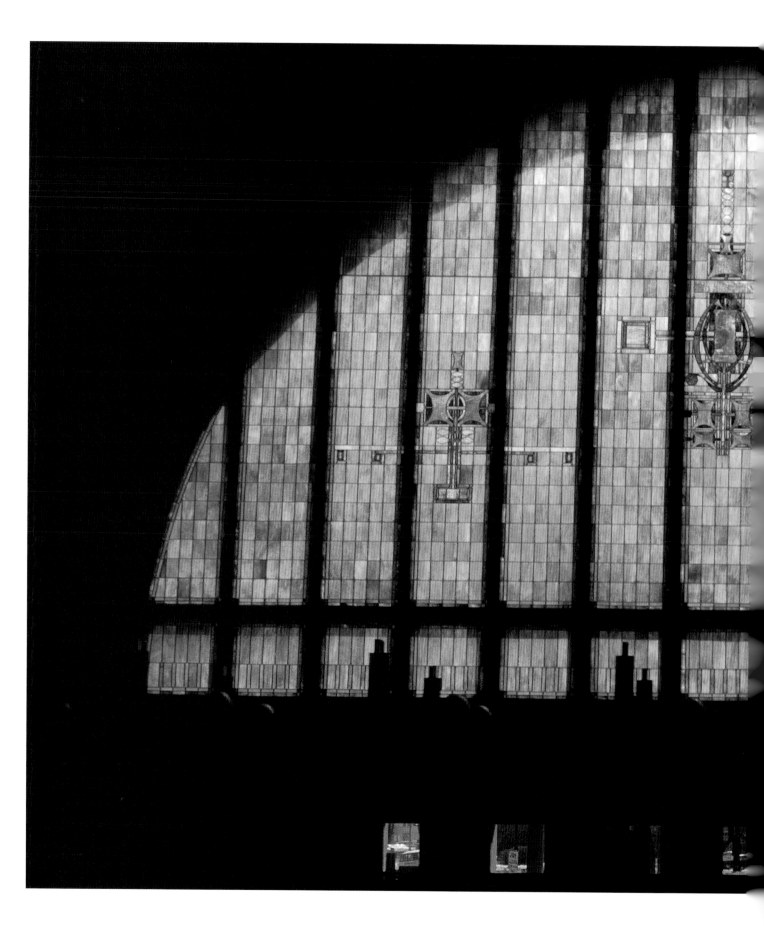

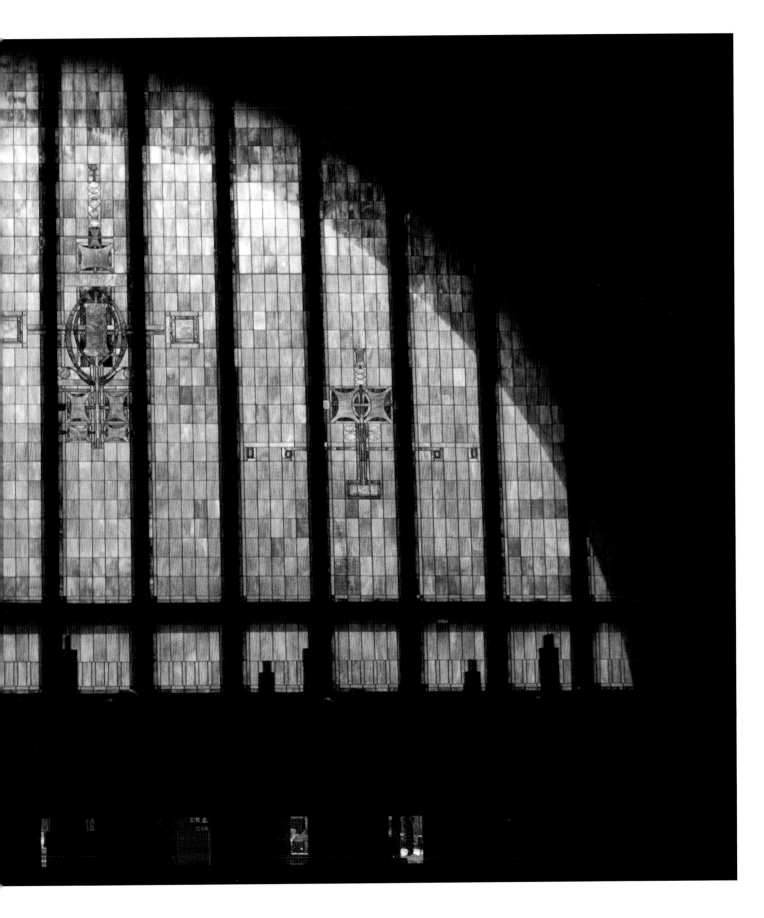

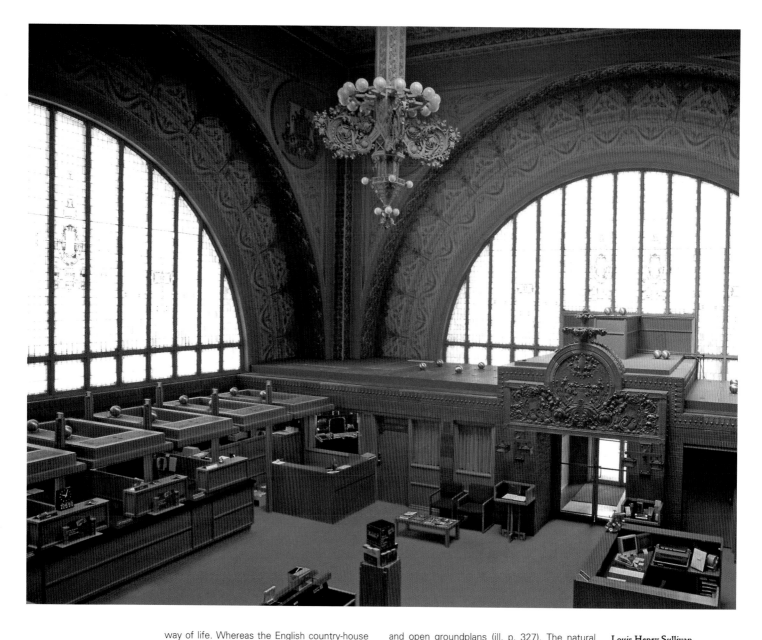

way of life. Whereas the English country-house architects had insisted that every room should be a world in itself, the open groundplan is an American concept, as is the placing of a massive fireplace in the middle of the house, off which the rooms radiate. Although Wright designed big projects, too, he preferred to work on private houses. The free plan and the human scale are the two main principles underpinning his work, whereby he also attached great importance to "Nature". In his so-called Prairie architecture, he fused all these elements into elongated, usually boldly composed buildings with projecting roofs

and open groundplans (ill. p. 327). The natural textures and colors which he retained in his building materials and decorative architectural components fuse tactically and harmoniously into their surroundings. "We European architects frequently look with hungry eyes at our more fortunate colleagues in the New World, with their magnificent sites, their broad expanses of uninhabited land and their cities awaiting artists, and at the munificence of their clients as regards the costs involved."[22]

Louis Henry Sullivan
National Farmers' Bank, Owatonna, Minnesota, banking hall with view of the main entrance, 1907–08.
Sullivan's later buildings – such as the National Farmers' Bank and the Merchants' National Bank – are less monumental than his early Chicago works. It is nevertheless these buildings in particular which demonstrate his special ability to make "architectural design" real and which embody his philosophy in three dimensions: " … They [the forms] sway and swirl and mix and drift interminably." (Louis Henry Sullivan, see note 18)

Zen and Prairie

Architecture provokes moods in people. It is therefore the task of the architect to specify this mood.
Adolf Loos[23]

In addition to the vital factor of liberal-spending clients, the inimitable "Wright style" was made up of another, perhaps all-important, entirely un-American component. "It is frequently possible to identify Japanese influences; we see how he endeavors to match Japanese forms to American circumstances."[24] Wright expressed his concept of the open plan as the organic fusion of interior and exterior space. The principle of open wall elements replaces the window as a hole in the wall and thereby draws upon the traditions of Japanese domestic architecture (ill. p. 333). In the Katsura Rikyu, an imperial villa near Kyoto, Japan the building and its natural surroundings merge to form a perfect unity; the man-made complex is entirely natural in its shape, and the architecture is at the same time a model of utmost simplicity (ill. p. 327). The Katsura is not merely a masterpiece of Japanese architecture, but can be seen as a medium of Japanese art *per se*. The German architect Bruno Taut (1880–1938) described the villa – without false pathos – as one of the "wonders of the world". What European modernism saw as the yawning divide between calculation and spontaneity appears fully resolved in the tradition of Japanese Zen. Meditation creates an inner state of receptive emptiness, just like the disciplined, transparent, light, sliding, unmonumental outer spaces of Japanese architecture. One year after Wright had completed his last building in Chicago in 1915, he left America to design the Imperial Hotel in Tokyo.

The first building by Wright to bear his unmistakable stamp was the Winslow House of 1893. The horizontal emphasis, an opening inwards as well as outwards, the unity with nature are all to be found here (ill. p. 326). In the house which he designed for Frank Thomas in Oak Park, Illinois, the spacious country setting where he had already built himself a house in 1889 (something Walter Gropius would also do in 1938), we can recognize another of Wright's principles: the rhythm which he lends to the structure, and which here serves to underpin the architecture as a whole. The Coonley House in Riverside is a clear illustration of Wright's motto: "... in the nature of materials"[25]. All the materials are employed as appropriate to their nature, whereby the natural "material" of light is also impressively incorporated into the whole.

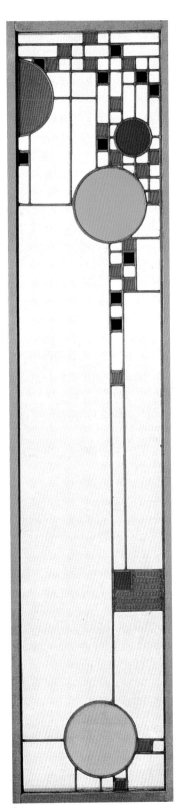

Frank Lloyd Wright
Composition in Light – Interpretation of the American flag, stained-glass window, for the country house for Avery Coonley, Riverside, Illinois, ca. 1912
Glass, zinc bars, painted wooden frame, 153.6 x 30.5 cm
The Coonley House is a clear illustration of Wright's motto: " ... in the nature of materials" (see note 25). All the materials are employed as appropriate to their nature, whereby the natural "material" of light is also impressively incorporated into the whole.

Page 333:
Frank Lloyd Wright
House for Frank Thomas, Oak Park, Illinois, the lobby from the living room, 1901
Wright expressed his concept of the open plan as the organic fusion of interior and exterior space. The principle of open wall elements replaces the window as a hole in the wall and thereby draws upon the traditions of Japanese domestic architecture.

Even though we may not see in Wright's work the characteristics of Art Nouveau as it is usually defined and understood, he nevertheless belongs in the canon of new trends around the turn of the century. "*Organic architecture*. This is the chief principle from which Wright derives all other principles … 'Form follows function'; Wright on the other hand speaks of a relationship between form and function and the functions of a house. Organic is the name he gives to an architecture which is there for people and not for show, and not, either, for art."[26]

Buildings like people must first be sincere, must be true and then withal as gracious and lovable as may be. Above all, integrity. The machine is the normal tool of our civilization, give it work that it can do well – nothing is of greater importance. To do this will be to formulate new industrial ideals, sadly needed.

[...] An artist's limitations are his best friends. The machine is here to stay. It is the forerunner of the democracy that is our dearest hope. There is no more important work before the architect now that [sic] to use this normal tool of civilization to the best advantage instead of prostituting it as he has hitherto done in reproducing with murderous ubiquity forms born of other times and other conditions and which it can only serve to destroy.

[...] This is the modern opportunity – to make of a building, together with its equipment, appurtenances and environment, an entity which shall constitute a complete work of art, and a work of art more valuable to society as a whole than has before existed because discordant conditions endured for centuries are smoothed away.

Frank Lloyd Wright, "In the Cause of Architecture," in *Architectural Record*, 1908

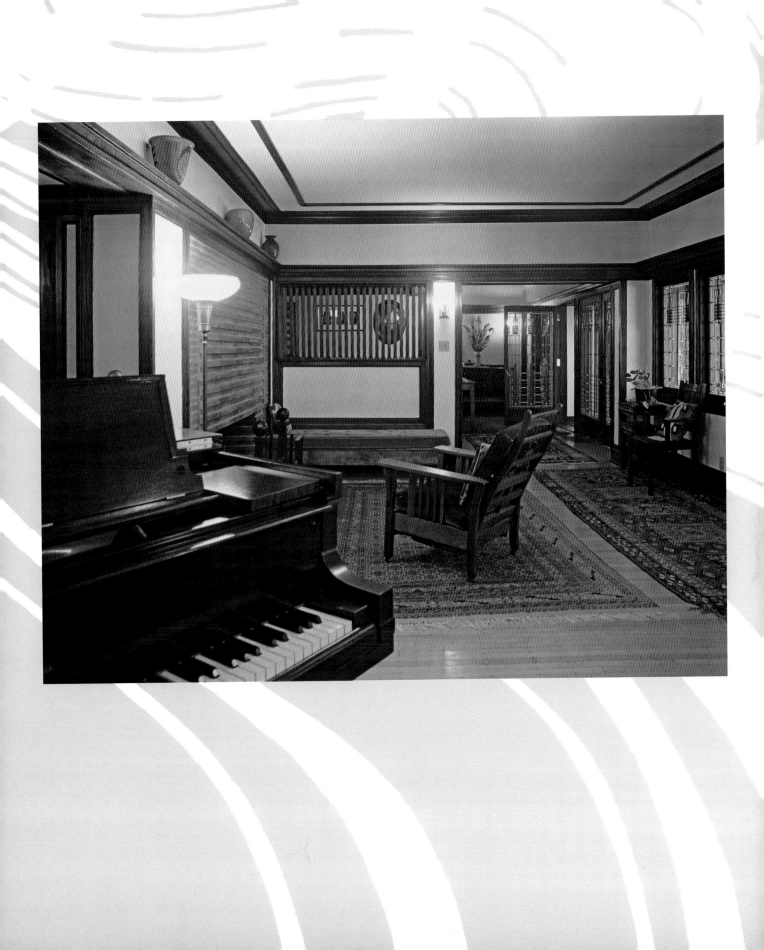

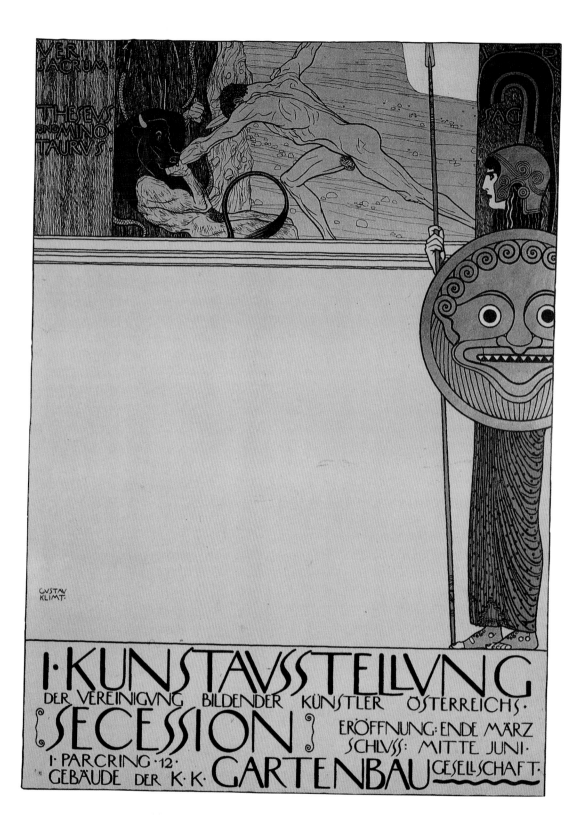

End of an era
Vienna

Let me remind you once again of how things were ten years ago, in the bleak period from 1880 to 1890, when we were cut off from the rest of Europe as far as the arts were concerned. In those days, if I mentioned Vienna in Paris, the reply was always the same: "Là-bas? C'est en Roumanie? n'est-ce pas?". We were an Asiatic province. And in Berlin people thought the Austrians were good only for vaudeville.
Things have changed.
Hermann Bahr[1]

Imperial Royal Vienna – Waltzing in bliss

In 1898 Hermann Bahr (1863–1934) – a man of letters intimately acquainted with every stylistic trend, discoverer of the young Hofmannsthal, champion of Expressionism and fearless defender of the artists of Viennese Jugendstil – issued the challenge that these last would make their own: "Swathe our people in Austrian beauty!"[2] Ten years later Adolf Loos (1870–1933) was raging against the tasteless swaddlings of everything from music to lifestyle: "Ornament is not only perpetrated by criminals, but is itself a crime."[3] Only the philistine "snaps after ornament like a dog after a sausage," mocked Karl Kraus (1847–1936), Vienna's often cynical vocal conscience, who also observed: "We haven't heard, so far at least, whether the implements used for the break-in were made in the Wiener Werkstätte."[4] Such were the "situation reports" from Vienna around 1900, from the growing metropolis in which art was surrounded by controversy like nowhere else. The abrupt juxtaposition of exquisite, undulating linearity, precious, symbol-laden ornament, and rigid rectangularity makes it impossible to categorize the turn of the century under any

hasty, ill-conceived heading (ills. pp. 336, 339). In truth, it is *fin de siècle*, the end of an era, the Decadent Movement grown weak and stylized, but also Art Nouveau, Jugendstil: a new departure and a mutation.
"An Austrian art! Each one of you knows what I mean … when you see the sun shining on the railings of the Volksgarten, with the scent of lilacs in the air and little Viennese girls jumping over their skipping ropes, or when you hear a waltz floating out of a courtyard as you pass, then a strange feeling comes over you, and none can explain why he is so happy that he could cry, but can only smile: That's Vienna for you! This 'that's Vienna for you' is what you must paint."[5] But what was Vienna? The capital of the Austro-Hungarian Empire, whose decline is described by Robert Musil (1880–1942), in his novel *Mann ohne Eigenschaften* (Man without Qualities), published 1930–43, as the "particularly clear collapse of the modern world"?[6] Light-hearted Vienna, where no one took anything really seriously, and where playful elegance, coquettishness, and a sophisticated love of life held sway? Vienna the city of the "cult of femininity," full of living and artificial pictures of beautiful women, the city of the dashing officer? Home of the glittering waltzes of Johann Strauss and at the same time – thanks to Sigmund Freud – the birthplace of psychoanalysis! The magnificent buildings lining the Ringstrasse were a manifestation of upper middle-class culture which profoundly changed the face of the city, even as Socialism was brewing in the suburbs. The capital of a country embracing a wide diversity of peoples and cultures, Vienna was at the same time Grinzing, one of the little wine-growing villages on its outskirts. The definition of life

Koloman Moser
Sherry decanter, ca. 1900
Optic blown glass with "dimples", silverplated brass, 23.5 cm high
Distributed by E. Bakalowits & Söhne, Vienna

around the turn of the century was ambivalent, and embraced both beauty and horror; a yearning for death and a glorification of life formed a counterpoint to which few gave more polished expression than Hugo von Hofmannsthal (1874–1929). The same counterpoint was a characteristic feature of Art Nouveau and Jugendstil. The apparently incompatible simultaneity of reaction and modernism, of naive delight and emphatic seriousness, indeed the very pluralism of Vienna's languages, cultures and peoples, proved instead a fortunate coincidence which found its resolution in an artistic confrontation with complexity.

Coffeehouse culture – The Secession

To the Age its Art, to Art its Freedom
Joseph Maria Olbrich[7]

"The greatest success of the Secession is to have finally provoked Vienna, the ancient city of music, to get heated up – indeed, to 'échaufferize' – about the fine arts. Even the stir caused by Hans Makart in his early years does not compare with this, having been more local in character. Only the battle fought and won by the Wagnerians, in Vienna as everywhere else, measures up to the triumph of the Secession in all the capitals of the world. Within the narrow artistic confines of Vienna, the Secession was an act of audacious youthful idealism. In the spirit of sacrifice and with a willingness to work hard, the nineteen, who have today become seventy, plunged into a fight whose outcome was highly uncertain. How lucky that there are more artists than businessmen amongst them! Had they realized, for example, that the first exhibition would cost 40,000 florins, they would perhaps have lost heart. But they didn't know, and the Viennese public helped. Even this enormous outlay brought a net profit."[8] The year 1897 – the year of the foundation of the Vienna Secession, the sign of the dawn of a new era which was barely less dramatic than the transition from the Middle Ages to the Renaissance – represents the beginning of "modernism" in Austria. As in Munich and Berlin, it signified the drawing of a line under the illusionism and verism perpetuated by the art academies, and the establishment instead of an "interdisciplinary art". Jugendstil, today considered a historical phenomenon, was in its own day the first in a string of "anti-art movements", insofar as it ranked graphic art as well as handcrafted objects amongst the primary arts (ill. p. 352). The Vienna Secession – officially

Gustav Gurschner
Table lamp, ca. 1900
Patined bronze, *turbo marmoratus* shell (South Sea mussel), 53 cm high
In the growing metropolis of Vienna around 1900, art was surrounded by controversy like nowhere else. The abrupt juxtaposition of exquisite, undulating linearity, precious, symbol-laden ornament and rigid rectangularity makes it impossible to label the turn of the century under any hasty, ill-conceived heading.

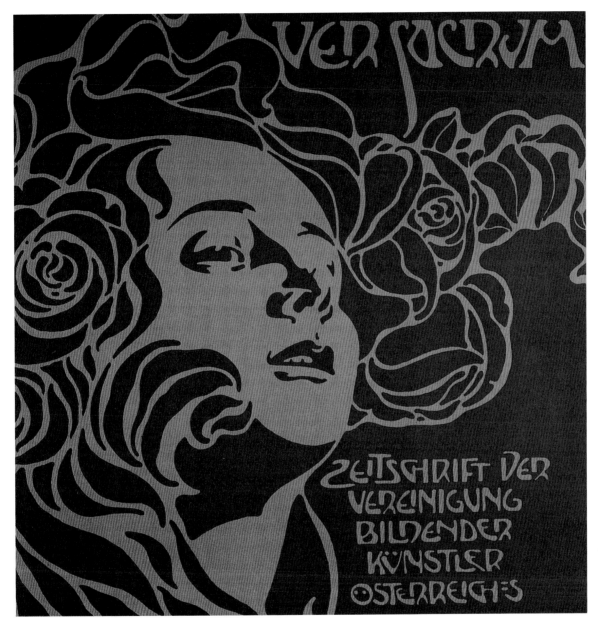

Koloman Moser
Cover for *Ver Sacrum*, II, no. 4,
1899
Color lithograph, 42.5 x 41.8 cm
The title of the art journal was taken
from a poem by Ludwig Uhland
(1787–1862): "You have heard
what God wishes, / Go, prepare
yourselves, silently obey! / You are
the seed grain of a new world, / That
is the sacred spring he desires." (see.
note 11). *Ver Sacrum* is not just an
informative and entertaining
chronicle of the Secession, but – in
the original illustrations which many
artists contributed to its pages – an
exact mirror of its age.

entitled the Austrian Association of Applied Artists (Verein Bildender Künstler Österreichs) – brought together the young and the dissatisfied amongst Austria's artists. Their aims were not revolutionary, but purely aesthetic: they were concerned only with finding the form, the "material" being already at hand – Vienna! It was only natural, therefore, that the Secession should have been founded in a coffeehouse, the second home of every Viennese citizen – in this case, the legendary Café Griensteidl. "Your boots are torn – Coffeehouse! You earn 400 crowns and you spend 500 – Coffeehouse! You can't find any girls you like – Coffeehouse! You're contemplating suicide – Coffeehouse! You hate and despise people but still can't do without them – Coffeehouse! No one will give you any more credit – Coffeehouse!"[9] wrote Peter Altenberg (1859–1919), one of the last European Bohemians, a Viennese François Villon of the turn of the century. Thus, too, the forerunner to the Secession, the Hagen Society (Hagengesellschaft) founded in 1876 (and which in 1900 became the Hagenbund), was named after the proprietor of

the Zum blauen Freihaus restaurant, while the rendezvous for the Siebener Club was the Café Sperl. What finally prompted all of these artist groups to sever the umbilical cord with official-dom was the exhibition policy of the Vienna Künstlerhaus under its president Eugen Felix (1837–1906). Spokesman for the 50 founding members of the Secession was Gustav Klimt (1862–1918). Comparable to Franz von Stuck in Munich, Klimt was the leading figure in the Vienna art scene around the turn of the century, a genius of the Symbolistically decorated pictorial plane (ill. pp. 342–343), in whose shadow he

sketched highly erotic, sensitive nudes on paper. He protected and supported two young, provoc-ative insurgents: "chief rebel" Oskar Kokoschka (1886–1980) and "self-seer" Egon Schiele (1890–1918). Klimt's fellow combatants included Josef Hoffmann, Koloman Moser (1868–1918), Joseph Maria Olbrich, the painters Carl Moll (1861–1945) and Max Kurzweil (1867–1916), and the "architectural giant" Otto Wagner, as well as the "Parisian Czech" Alfons Maria Mucha (1860–1939). "Young rebels" were not the only ones to have a say in the Secession, however. At the head of a delegation which presented Emperor

Gustav Klimt
Music, 1895
Oil on canvas, 37 x 44.5 cm
Bayerische Staatsgemäldesammlungen, Neue Pinakothek, Munich.
In this painting Klimt creates an "ideal plane" which asserts itself in opposition to the modeling of the body. In his works, gold and silver grounds stand alongside zones of oil painting. To a certain extent, Klimt here anticipates the "collage" employed, for example, by Antoni Gaudí in his architecture. The subtle, "textile" quality which Klimt so magically lends the pictorial plane has never been equalled.

Franz Joseph I (b. 1830; Emperor 1848–1916) with an invitation to the First Secession Exhibition was the association's 85-year-old honorary president, Rudolf von Alt (1812–1905). The 67-year-old emperor expressed his astonishment that the young artists were being headed by a man even older than he was himself. "I may indeed be rather old, your Majesty," replied von Alt, "but I still feel young enough to keep starting all over again."[10] The "adolescent" movement was granted recognition by the emperor's attendance at the exhibition, even if this was simply a gesture of good will. In order to verbalize the Secession's artistic activities – something generally obligatory around 1900 – it was decided to publish a monthly art journal: *Ver Sacrum* (Sacred Spring). The title was taken from a poem by Ludwig Uhland (1787–1862): "You have heard what God wishes, / Go, prepare yourselves, silently obey! / You are the seed grain of a new world, /That is the sacred spring he desires."[11] *Ver Sacrum* is not just an informative and entertaining chronicle of the Secession, but – in the original illustrations which many artists contributed to its pages – an exact mirror of its age (ill. p. 357). Virtually ignored was the fact that Adolf Loos, having initially been closely linked with the Secession, later severed his ties but continued to write numerous articles for *Ver Sacrum*.

Adolf Loos
Clock, 1900
Brass, glass, cut by hand, 30-day movement at the rear freely suspended in the housing, 48 x 21.5 x 26.5 cm

Gustav Klimt and the "empty plane"

… only when he rebels against Vienna and his art assumes its most personal expression does Gustav Klimt – following a fundamental law of genius – become the fullest embodiment of Viennese art.
Hans Tietz[12]

In line with the lifting of "class barriers" between the arts, Klimt too turned to graphic art and illustration. The poster which he designed for the First Secession Exhibition (ill. p. 334) provoked an immediate reaction: the censor demanded that trees should be printed over the body of Theseus to hide it. "… Theseus is naturally wearing the simple but pleasing garb of a hero, namely nothing at all … the painter was compelled to conceal half his Theseus behind a number of tree trunks. We may now ask whether Canova's Theseus will also be taken back to his quiet temple dungeon

(the pavilion in the Burggarten), its doors locked and the key thrown into the Danube?"[13] Klimt was already at the zenith of his career and had left academicism behind him with his spandrels for the Kunsthistorisches Museum. Greek antiquity, personified by a young woman, becomes pure *fin de siècle* art in her pose. Curving linearity, undulating lines and the interpretation of woman as *femme fatale* all demonstrate the new "art of synthesis". In his painting *Music* of 1895 (ill. p. 338), Klimt creates an "ideal plane" which asserts itself in opposition to the modeling of the body. In his works, gold and silver grounds – almost Byzantine in character – stand alongside zones of oil painting. These are joined in his *Beethoven* and *Stoclet* friezes by an expansion into the third dimension in the ornamental shape of mosaics, metal, majolica, and semiprecious stones. To a certain extent, Klimt here anticipates

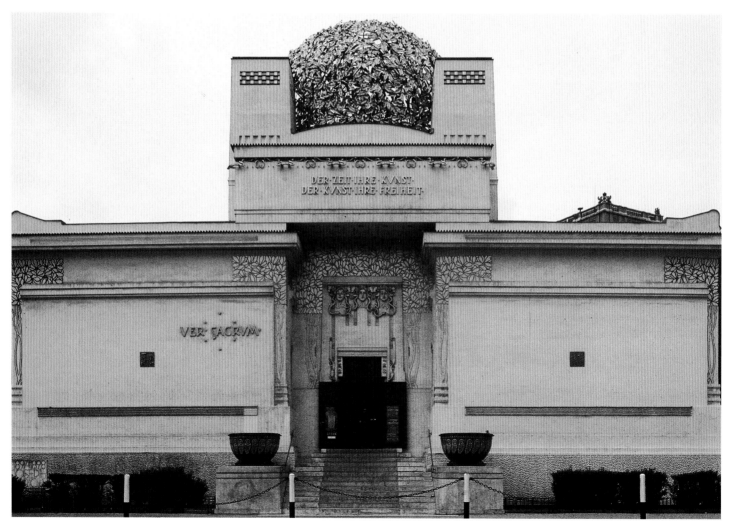

the "collage" employed, for example, by Antoni Gaudí in his architecture. Klimt's luxurious cult of materials had its origins on the one hand in the painting and literature of Symbolism, and on the other in the French tradition of exquisite handicraft and in Charles Rennie Mackintosh. The subtle, "textile" quality which Klimt so magically lent his paintings has never been equalled.

The spectacular opening exhibition by the Secession made an impact upon Klimt's work, too. At the center of the foreign works on display were the cartoons by Pierre Cécile Puvis de Chavannes (1842–98), works by Arnold Böcklin (1827–1901), Auguste Rodin (1849–1917), Jan Toorop and Fernand Khnopff. Khnopff's images of dreamily somnabulent women (ill. p. 132), related to the Pre-Raphaelites, find their way into Klimt's inimitable portraits. "There is always a sensitive eye at work, seeking out the charms of womanhood in each individual. Some enchanting feature resides in every woman, reveals itself in every woman in some sign, and Klimt always discovers it – even in one less attractive. It might be an eye, which he makes shine in such a way that the whole picture seems to be all eye; or a dry, thirsty mouth, which he paints with such eloquence that all else vanishes besides this mouth, or it is the line of her body, the gesture of her hands, or her hair."[14] Klimt's magnificent female portraits, timelessly intuitive, nevertheless caused feelings to run high. It was presumed that Klimt had not just painted his models – immortalized wearing a relaxed smile in often daring poses – but had also become their lover. His ceiling paintings of the three secular faculties for the university, again employing female figures as allegories, caused a scandal; Klimt was deeply hurt by the reactions of his critics. "... the negative response by the majority of the Vienna press, even the feeble accusations of pornography, failed to upset Klimt's feelings. But when a number of university professors and members of parliament also added their voices to the outcry when the painting *Medicine*, destined for the university, went on show, he lost his patience ... The Ministry, understanding and supportive of Klimt, nevertheless had to insist that he delivered the works he had been paid for. Klimt's testy reply: 'I'll not have my work insulted like this any more; if you send soldiers and they shoot, I'll have to surrender, since I can't shoot back.'"[15] While scandalized art philistines dwelled upon the possible obscenities in his pictures, Klimt himself took another, progressive direction in his work. His poster for the First Secession Exhibition (ill. p. 334) shows that the introduction of the empty plane was the concern not only of architects, and that around the turn of the century everything had its own "causative agent". Sullivan and his comrades-in-arms – later Adolf Loos – were propagating the simple, smooth surface and were preparing the way for functionalism. In Klimt's poster, the empty plane also seems to be a sort of wall, as suggested by the cornice at the top. Contradictory elements are combined into a whole; in the tension which infuses the contrast between the empty plane and the figures, there lies an incredible modernity. "... But now I was puzzled. Klimt's earlier works had captivated me, and some of his murals in the Hofmuseum had reminded me of Giorgione, but in this drawing I was suddenly faced with something entirely new which had nothing to do with memories of other Masters. It was already in the distinctive Klimt style ..."[16] Thus Koloman Moser recalled his first encounter with the "empty plane" in Klimt's work. Just how close Klimt the painter, apostrophized as the author of beautiful female portraits and powerful collages of color, came to the architect in his way of seeing can be deduced from Olbrich's commentary on his own Secession building: "It was to become walls, white and gleaming, sacred and chaste. Solemn dignity was to envelop all. Pure dignity of the kind that came over me and enthralled me when I stood alone in Segesta before the unfinished temple ... I wanted to hear only my own emotions in its note, to see my warm feelings frozen into cold walls."[17] Olbrich's words conceal a palpable longing for "plain ornament"; only the fact that his language seems to date from an earlier era distinguishes it from Loos' thoughts on the same subject: "Superfluous ornament and affected additions stupefy the brain, make the senses go stale and squander the energy to work. They are an erotic substitute like graffiti on toilet walls, only less honest, puffed up, spruced up and frozen."[18] Olbrich's talent was recognized, appreciated and encouraged by his teacher Otto Wagner. While Olbrich's first design for the Secession exhibition building was still heavily indebted to Wagner, he ultimately arrived at a consummate and original solution in a building which is stunning even today (ills. opposite page and left). Ludwig Hevesi described the "magical impression" made by its gilded laurel cupola in euphoric terms: " ... the small building is and will always be memorable in the history of Viennese architecture; the old breakers smashed against it, and it stood as a tangible sign of new possibilities."[19]

Opposite page and above:
Joseph Maria Olbrich
Vienna Secession exhibition building, view of the front and detail, Vienna, 1897–98
While Olbrich's first design for the Secession exhibition building was still heavily indebted to Wagner, he ultimately arrived at a consummate and original solution in a building which is stunning even today. Ludwig Hevesi described the "magical impression" made by its gilded laurel cupola in euphoric terms: "... the small building is and will always be memorable in the history of Viennese architecture; the old breakers smashed against it, and it stood as a tangible sign of new possibilities." (see note 19)

Georg-Anton Scheidt
Cigarette case, ca. 1900
Silverplated and embossed metal, cabochon stone, 9 x 9 cm
The universal triumph of the "made in Austria" label was "managed" by the Austrian Museum of Arts and Crafts and led to a modern-day style of mass production whose dangers were not recognized at the time.

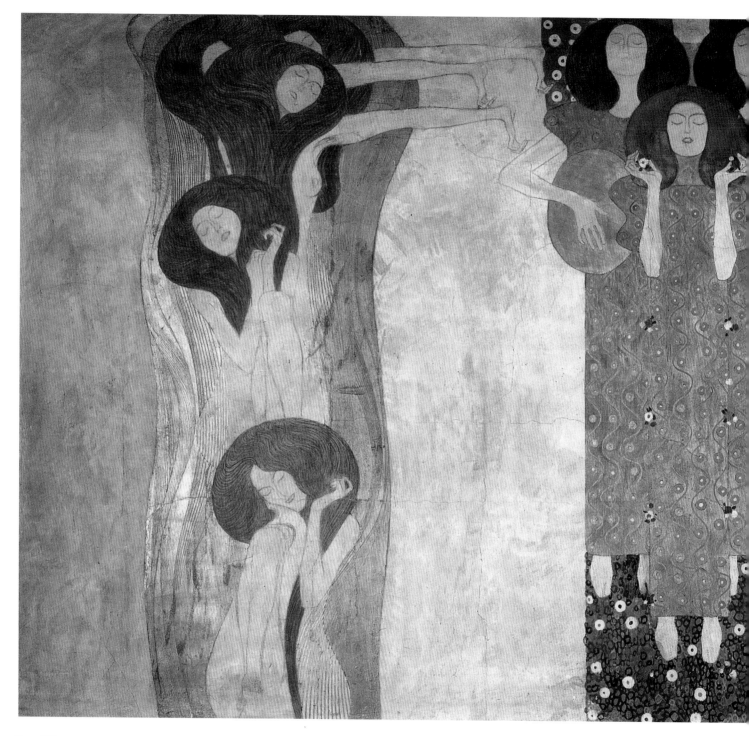

Gustav Klimt
Let this kiss be for the whole world!, *Beethoven* frieze, 1902
Casein paint on plaster, secco technique, gold leaf, gilded
plaster, color gemstones, mother-of-pearl, charcoal, graphite
pencil and pastel crayon, 216 x 1378 cm
Österreichische Galerie im Belvedere, Vienna

"The arts transport us into that ideal realm where we can
alone find pure joy, pure happiness, pure love. Chorus of the
Paradise Angels. 'Freude, schöner Götterfunken' [Joy,
beautiful radiance of the Gods]. 'Diesen Kuß der ganzen
Welt' [Let this kiss be for the whole world!]"
(Commentary in the catalogue to the 14th Secession
Exhibition, Vienna 1902)

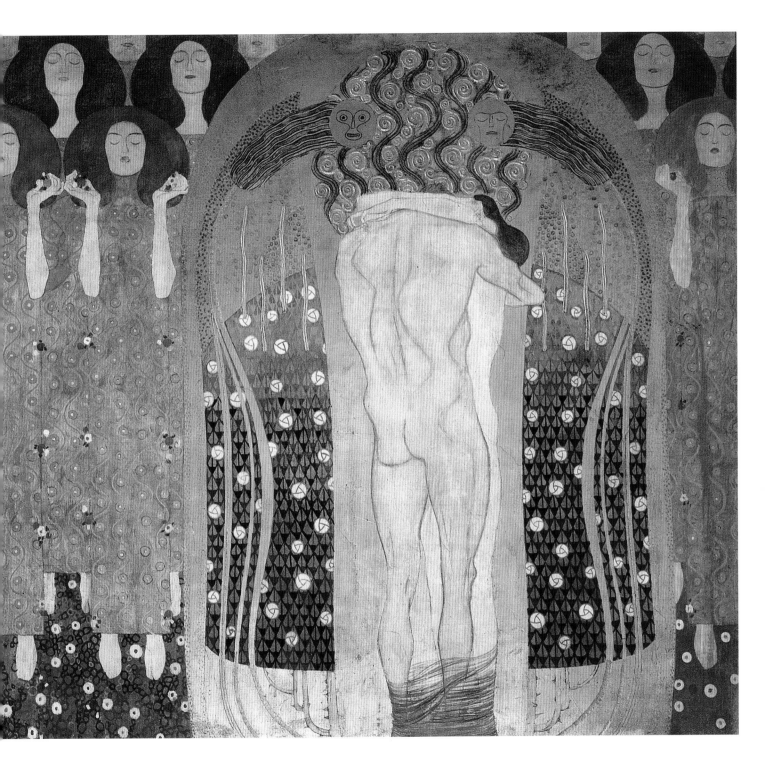

The Beethoven Exhibition – A scandal

... And in [Austria], furthermore, a genius was only ever held to be a lout, and never a lout to be a genius, as happened elsewhere ...
Robert Musil[20]

The Second Exhibition by the Secession took place in its own building, whose interiors by Olbrich, Moser, Hoffmann, and Wagner lent the exhibition an additional dimension, as it were. The Secession's subsequent exhibitions, too, were exemplary in their conception and design, whereby one stood out uniquely from all the rest: the 14th Secession Exhibition of 1902, which centered upon the Beethoven memorial by Max Klinger, "framed" by Klimt's *Beethoven Frieze* (ill. pp. 342–343). But Vienna would not have been Vienna if the singing and cheering had not been interspersed with excesses of bitter invective. An aristocratic art patron and collector who attended a preview became just this "excessive" at the sight of Klimt's frescos. "He shrieked the word in a high, shrill, cutting voice, as if someone had pinched him. It was like the crack of a pistol in the silence. He flung the word up at the walls like a stone: *monstrous*"[21].

Overshadowing all else in the exhibition, the *Beethoven* frieze signified a radical shift in Klimt's work, influenced by Toorop's monumental linear works and mystical understanding of com-

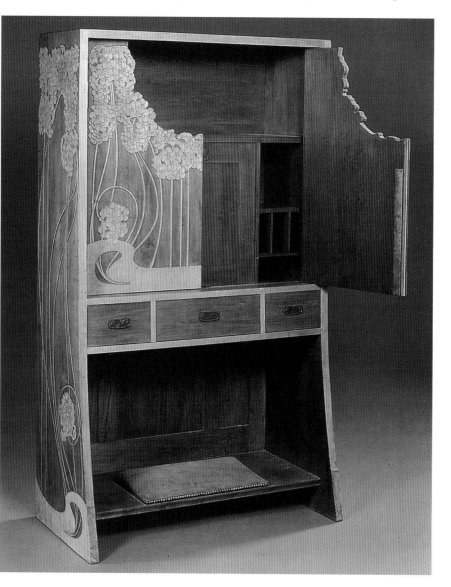

Else Unger, Emilio Zago
Writing desk, ca. 1900
Stained wood, carved relief, copper handles;
Footrest: buckskin,
171 x 101 x 53 cm
Awarded a gold medal at the 1900 World Exposition in Paris
The pliant and pleasing style practised by the artists who had banded together into the – unquestionably highly successful – Secession became a veritable box-office hit. And rightly so, since handicraft was thereby liberated from its narrow confines and allowed to form a synthesis with interior design and the liberal arts, a synthesis which brought with it a sense of "liberated" living. The attractiveness of the handicraft items issuing from Vienna was demonstrated at the World Exposition of 1900 in Paris, where public response to the objects on display was enthusiastic.

position. It marked the start of Klimt's "golden style," in which ornament asserted its independence alongside powerful allegorical figures traced in almost graphic outline. The Beethoven Exhibition marked a turning point in the development of many other artists as well as Klimt, and occupies a key position in the history of the Secession. "The yawning divide between the 'naturalists' and the 'stylists', which in 1905 would become one of the main reasons for the departure of the Klimt group, was already evident at the Beethoven Exhibition ... Viewed in an even wider context, the Beethoven Exhibition clearly documents the transition from the 'aesthetic-decorative' to the 'monumental' phase in which style generally found itself shortly after 1900 ... The Beethoven Exhibition exerted a decisive influence upon every genre in art, in particular the applied arts. The complementary nature of the exhibition paved the way for projects such as the Kunstschau exhibition, the Palais Stoclet and the Steinhof Church."[22]

Vienna Secession style

Even the convolutions of the Jugendstil man's brain are lost in ornament.
Karl Kraus[23]

The pliant and pleasing style practised by the artists who had banded together into the – unquestionably highly successful – Secession became a veritable box-office hit. And rightly so, since handicraft was thereby liberated from its narrow confines and allowed to form a synthesis with interior design and the liberal arts, a synthesis which brought with it a sense of "liberated" living. The attractiveness of the handicraft items issuing from Vienna was demonstrated at the World Exposition of 1900 in Paris, where public response to the objects on display was enthusiastic (ill. opposite page). These graceful objects and pieces of furniture were contemporary, free from historicist additives, yet without being avant-garde; neither in their shape nor their decor did they break new ground. They composed tasteful interiors for educated citizens who didn't want to overload themselves with too much art. It was only natural that the Viennese style would also prove a financial success. The universal triumph of the "made in Austria" label was "managed" by the Austrian Museum of Arts and Crafts (Österreichisches Museum für Kunst und Handwerk) and led to a modern-day style of mass production whose dangers were not recognized at the time (ill. p. 341). This form of

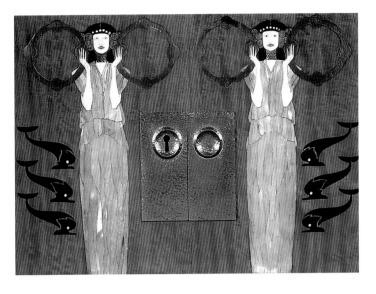

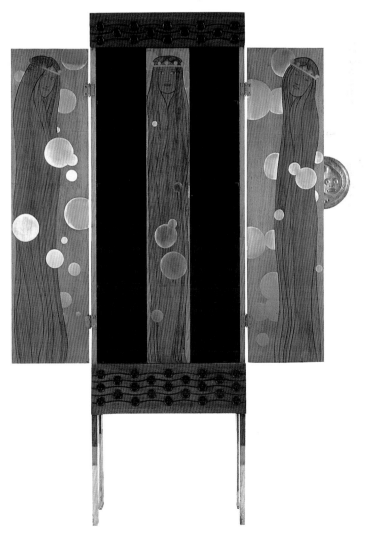

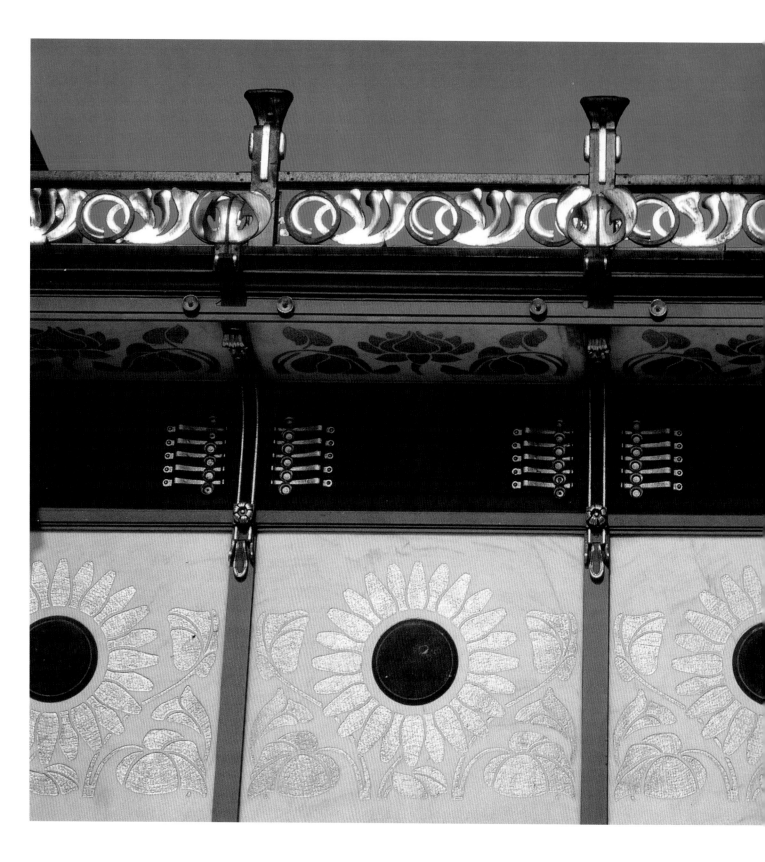

progress considerably displeased Hoffmann, Klimt and Moser, the leading voices of the Secession. "Of the artists who founded the Vienna Secession, Kolo Moser was unabashedly the boldest, and one of those who caused Viennese philistines the most trouble in the early days of the Secession. Wherever there was something to reform in Viennese arts and crafts – and where wasn't that needed? – you could find Kolo Moser working away with perseverance, intrepidness, taste and astounding technical skill. … Blessed with an extraordinarily fine instinct for the practical and aesthetic possibilities latent in the material, and with an innate understanding of how to bring them out through technical means, and at the same time master of what might be called an almost hypertrophic imagination as regards the inventiveness of his forms, Kolo Moser crafted decorative and practical utensils which rank amongst the very best that modernism has produced in this field up till now."[24] (ills. pp. 335, 345). When Moser, Hoffmann and Klimt quit the Secession, the "sacred spring" came to an end; those who remained behind proved unable to sustain the glittering series of Secession exhibitions, and "production" was overtaken by apathy.

Otto Wagner and modern architecture

The shift is so radical, however, that we cannot speak of a renaissance of the Renaissance. What has issued from this movement is a naissance.
Otto Wagner[25]

"In the face of Otto Wagner's genius, however, I strike my sails"[26] – thus the words of that ever-belligerent "architectural revolutionary" Adolf Loos. There could be no better summary of Wagner's outstanding personality. The teacher of Hoffmann, Olbrich, Loos, and Antonio Sant'Elia laid the "foundation stone" of modern architecture (ill. p. 359). "Entirely at odds with Wagner's 'dream' of being – amongst other things – the architect of the Ringstrasse, the consummation of imperial and upper middle-class notions of pomp and lifestyle, was the reality of Otto Wagner the artist of building, the first architect of modern Vienna."[27]

Otto Wagner (1841–1918) early on addressed urban requirements from both a practical and a theoretical angle – in his plans for the Vienna Stadtbahn metropolitan railway network, his Post Office Savings Bank and his essay *Moderne Architektur* (Modern Architecture) of 1895. In the opening years of his career he experienced

Otto Wagner
Karlsplatz station, Vienna Stadtbahn, Wiental line, Karlsplatz 2, Vienna, 1894–99
Karlsplatz station is lent its distinctive character by two pavilions facing each other on either side of the tracks. Unlike the other Stadtbahn stations, which were finished in plaster, these pavilions employ a steel skeleton clad on the exterior with slabs of marble, and on the interior with slabs of white plaster. The slabs bear a sunflower motif which also appears on the semicircular gable. Their Secessionist Jugendstil decor makes these two "functional" buildings appear almost luxurious.

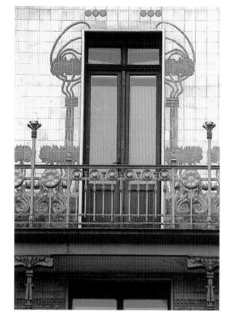

Otto Wagner
Majolica House, detail of the facade, apartment block, Linke Wienzeile 40, District VI, Vienna, 1898–99
The two apartment blocks which Wagner built and rented out at Wienzeile 38 and 40 are milestones along the road to a decent standard of living for "ordinary people". The facades are Secessionist in style and caused a sensation with their splendid fronts, chosen by Wagner bearing in mind the magnificent boulevard which was planned for Wiental. Linke Wienzeile 38 featured gilt medallions and stucco by Moser, while Linke Wienzeile 40 was entirely faced with colorful ceramic tiles bearing a floral-vegetal decor – a forceful testament to the possibility of the successful marriage of ornament and architecture.

Otto Wagner
Front facade of the dispatch offices of *Die Zeit*, Kärntnerstrasse 39 / Annagasse, Vienna, 1902
Iron construction covered with sheet aluminum;
Lights: nickelplated sheet iron, 450 x 332 cm
In Wagner's entry facade for the dispatch offices of the daily newspaper *Die Zeit*, a new material took the spotlight: the iron construction of the entry was clad with sheet aluminum. This front facade is important in the history of architecture insofar as it gave a leading role, for the first time, to the "newborn" material of aluminum.

Vienna's metamorphosis into a metropolis, as the city was lent stature by the monumental buildings springing up along the Ringstrasse in particular. He was not yet involved himself, however; only with his plans for the Stadtbahn railway system in 1894 was he able to make his first contribution towards shaping the new face of the city. Wagner's early buildings were clothed in historicist style, with a pronounced emphasis upon classical architecture. The forms, details and groundplans of his early villas are based upon the Renaissance-style villas of the 19th century, but already demonstrate a clarity of organization and construction. Like Berlage and Behrens, Wagner made a close study of the works of Gottfried Semper; this historical "lesson" saved him and his pupils from abandoning the legacy of architecture and producing trivial or even merely harmless works.

Wagner was less interested in houses for private individuals, however, than in tenements – in other words, in solutions to the housing requirements of broad sections of a conforming urban population. The two apartment blocks which Wagner built and rented out on Wienzeile are milestones along the road to a decent standard of living for "ordinary people". The facades are Secessionist in style and caused a sensation with their splendid fronts, chosen by Wagner bearing in mind the magnificent boulevard which was planned for Wiental. The house Linke Wienzeile 38 featured gilt medallions and stucco by Moser,

while Linke Wienzeile 40 was entirely faced with colorful ceramic tiles bearing a floral-vegetal decor – a forceful testament to the possibility of the successful marriage of ornament and architecture (ill. above).

After protracted preliminary planning of its routing and countless discarded proposals, the construction of the Vienna Stadtbahn was commenced in 1893. In order that this modern mode of transport should be given a contemporary form, Otto Wagner was appointed artistic adviser to the Transport Commission in 1894. His brief was to produce stylish designs for everything from the Stadtbahn stations, bridges, and viaducts, etc., to the interior furnishings of the trains themselves. In order to meet this challenge on time, Wagner enlarged his studio – which already included Olbrich and Hoffmann – to 70 people: a germ cell of modern architecture. The fruits of the collaboration of this team of artists were overwhelming; but a hidebound city bureaucracy destroyed many of their achievements after the First World War. Karlsplatz station is lent its distinctive character by two pavilions facing each other on either side of the tracks. Unlike the other stations, which were finished in plaster, these pavilions employ a steel skeleton clad on the exterior with slabs of marble, and on the interior with slabs of white plaster. The slabs bear a sunflower motif which also appears on the semicircular gable. Their Secessionist Jugendstil decor makes these two "functional" buildings

appear almost luxurious (ill. pp. 346–347). "It can be taken as proven that art and artist always represent their own age."[28] With his Steinhof Church, built in 1902, Wagner realized his thoughts on modernism in sacred architecture; for all its aestheticism, this sacred building is again characterized by impressive functionality.

Naissance – The Austrian Post Office Savings Bank

That Wagner was a "functional Constructivist" is evidenced by his most famous work, the Post Office Savings Bank in Vienna (ill. p. 350) – both in its details and in the design of its main space, the banking hall (ill. below). "The roof of the banking hall, an arched glass skin, is suspended from the supports which can be seen criss-crossing the hall ceiling. The principle of the suspension bridge is thus here being applied to a roof, probably for the first time. In this case, by the way, it didn't work, because Wagner failed to

Otto Wagner
Ceiling light, main banking hall,
Austrian Post Office Savings Bank,
1904–06
Aluminum, 16 cm diameter

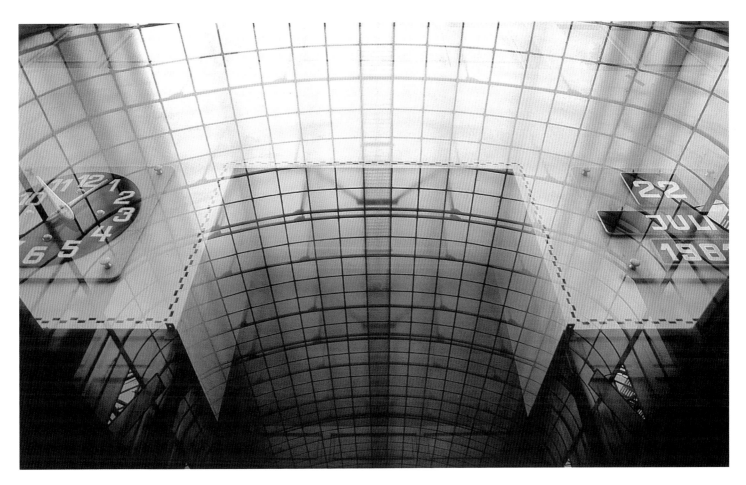

Otto Wagner
Austrian Post Office Savings Bank, part of the facade, Georg-Coch-Platz, District 1, Vienna, 1904–06

protect his glass skin with a second skin of glass … If we understand Wagner correctly, the reason why he didn't do so was because it would have left the principle of the suspended construction less visible to the eye … From the corridor in the story above the hall roof, you could originally see through the windows to the truss in the courtyard; today you look out into the space between the new roof and its suspended skin. The hall is still an architectural sensation. The way in which the supports crisscross the roof, apparently bearing no load at all, is a cause for astonishment, as is the light glass vault … Wagner the classical architect has here created an entirely unclassical space, for he has expressed – and put into practice – the transformation of space as previously understood by architecture *through the construction*. In this respect, Wagner was more modern than Loos; and it is of course no coincidence that the works of his pupils between 1898 and 1910 should appear so extraordinarily modern in their construction."[29] Wagner and his

team of architects also undertook the interior design of the entire Austrian Post Office Savings Bank (ill. p. 349).

Wagner announced his break with the past as early as 1895. The concept of a "naissance" also extended to the person of the architect himself, who was now to be architect and engineer in one. From now on, Wagner the "artist of building" employed modern and unconventional materials, such as aluminum, and clad his facades with slim, contemporary marble slabs, as in the case of Karlsplatz station. In his front facade for the dispatch offices of the daily newspaper *Die Zeit* (Time), a new material took the spotlight: the iron construction of the entry was clad with sheet aluminum. This front facade is important in the history of architecture insofar as it gave a leading role, for the first time, to the "newborn" material of aluminum (ill. p. 348). On the basis of various historical photographs we know that the entry survived at the latest until 1908. Its location remained a focal point of

Opposite page:
Otto Wagner
Armchair for the dispatch offices of *Die Zeit*, 1902
Bentwood, beech, aluminum sleeves and edging, upholstered, 79 cm high
Made by Jacob & Josef Kohn, Vienna
"The word *Baukunst* [architecture] embraces two concepts. *Bau* [building] = the static, regular. *Kunst* [art] = free, plastic, artistic design. What is true of architecture is also true of furniture. We can find principles of architecture, for example, in the design of a chair, which is also governed by the laws of statics. Or we can put it the other way round: like a chair on its four legs, so today's skyscraper stands on its supports. … Both, room and furniture, form a unity … Going beyond its mere function, furniture should stand within the room like a piece of free sculpture, but nevertheless related to it by the task which it is intended … to fulfill."
(Werner Blaser, see note 32)

modernism, however. Subsequent architectural exercises on the same site included a delicatessen with a white-lacquered entry, and the "Loos portal," while the "temple facade" of the Spitz jewelers' shop survived till the mid-1930s. "All modern creation must comply with the new materials and requirements of the present, if it is to be appropriate to modern humankind."[30] Thus the progressive tendency of Wagner's facade design for the offices of *Die Zeit* matched the character of the paper itself, which had evolved out of the weekly of the same name and which kept its sophisticated readership up to date with front-line developments in the arts and the latest "dispatches". Wagner had "vanquished" the Secession style.

Furniture as architecture

Architecture embraces the consideration of the whole physical setting of human life.
William Morris[31]

The armchair designed by Wagner for the *Die Zeit* dispatch offices and made by the Viennese firm of Jacob & Josef Kohn – bentwood with aluminum sleeves and edging – is an exemplary piece of "furniture as architecture". "The word *Baukunst* (architecture) embraces two concepts. *Bau* (building) = the static, regular. *Kunst* (art) = free, plastic, artistic design. What is true of architecture is also true of furniture. We can find principles of architecture, for example, in the design of a chair, which is also governed by the laws of statics. Or we can put it the other way round: like a chair on its four legs, so today's skyscraper stands on its supports. Skin and bones are as clearly distinguished in furniture as

Michael Thonet
Chair no. 14, 1859
Bentwood, 89 cm high
Die Neue Sammlung, Staatliches Museum für angewandte Kunst, Munich
Functionally efficient, organically conceived and in many cases folding, Thonet's chairs were a huge success. This bentwood design, also known as the "Viennese coffeehouse chair", is still manufactured today and has sold about 100 million. The secret of its enduring success lies in its social as well as technical serviceability, its low production costs and its competitive price.

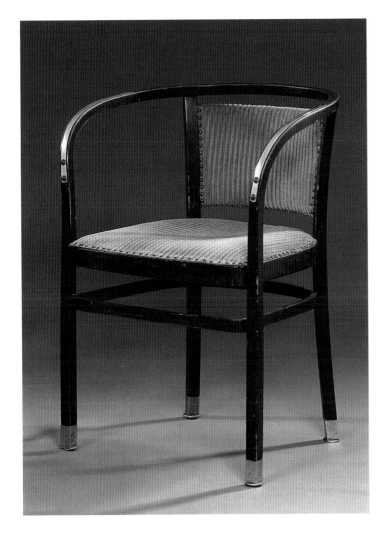

they are in a building. A chair, too, is built ... Does the architect design the furniture for the room or the room for the furniture? Both, room and furniture, form a unity, created on the basis of the same principles. Going beyond its mere function, furniture should stand within the room like a piece of free sculpture, but nevertheless related to its setting by the functional and intellectual task which it is intended to fulfill."[32]

Prior to the 19th century, the materials of building had been wood and brick, stone and mortar for as long as anyone could remember. Suddenly, however, new building materials appeared on the scene which would bring about nothing short of a revolution in architecture: iron and glass, and later, reinforced concrete. The Crystal Palace built in London in 1851 by Joseph Paxton (1801–56) was amongst the first outstanding examples of iron-and-glass construction. Ten years earlier, following continuous experimentation, Michael Thonet (1796–1871) had registered his first patents for bentwood furniture. In the following years he moved his workshop from Boppard on the Rhine to Vienna. Common to both the Crystal Palace and bentwood furniture is their construction principle on the basis of flexible, robust materials. Functionally efficient, organically conceived and in many cases folding, Thonet's chairs were a huge success (ill. p. 351). The famous "coffeehouse chair" is still manufactured today and had already sold 50 million by 1930. The secret of its enduring success lies in its social as well as technical serviceability, its low production costs and its competitive price.

Bentwood and Vienna are synonymous; alongside Thonet, the Kohn company was also producing legendary pieces of furniture, such as Josef Hoffmann's Fledermaus chair and furniture designed by Otto Wagner. Wagner's chair for the *Die Zeit* offices makes clear the correlation between detail and overall construction – a "total work of art" from both an intellectual and practical point of view.

Iridescent color from Bohemia

The ornament plague has been given official recognition and is being subsidized with public money.
Adolf Loos[33]

While the finest examples of the "grammar of ornament" are to be found in the works of the Wiener Werkstätte, ornament as a "universal language of artistic expression," that is, as a design medium *per se*, condensed itself into the glass creations of Austrian Jugendstil. In Loos' con-

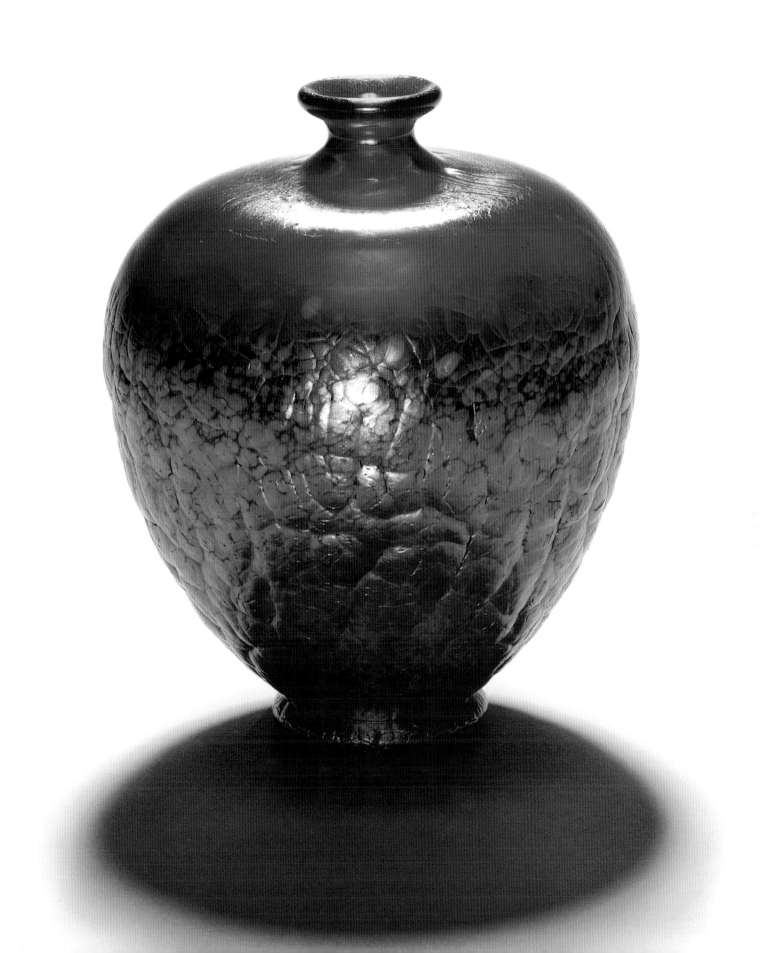

Loetz' Witwe
Peacock vase, before 1900
Luster glass, combed and drawn
waving lines, 16.8 cm high
Peacock feathers, butterfly wings,
and soap bubbles seem to take
concrete form. In 1898 Loetz'
Witwe was granted a patent for its
"luster glass technique". In Paris the
following year, the company showed
its *Papillon* glasses with their
luminous spots of iridescent color for
the first time, together with its latest
Phänomen: glassware incorporating
a decor of glass threads fused either
within or on top of the glass body,
combed, and in some cases
employing metallic colors.

Vilmos Zsolnay
Vase with landscape motif (detail),
ca. 1903
Faience with eosin (metallic luster
glaze), painting, *pâte sur pâte*, 34.5
cm high
Pécs, Hungary

Haida Technical College
Bonbonnière, ca. 1910
Clear glass, painted enamel decor,
23.5 cm high
Made by Joh. Oertel & Co.

demnation of the criminal function of ornament, however logically argued, we may also recognize the philistinism criticized by Karl Kraus. Synesthesia, the goal of art around 1900, finds its expression in a diary entry by Robert Musil, in which he describes the fusion of impressions received simultaneously through his various senses into a *single* sensual impression: "Today, for the first time, I 'experience' my room – this hideous mixture of stylistic blasphemies – as something unified, as a totality of areas of color, organically fused with the icy night outside … "[34] In the broader sense, therefore, it is perfectly possible to be moved by the combination of multiple layers of design.

Glass as the architectural medium of transparency and weightlessness offered Art Nouveau a new discipline, one which extended into the sphere of small objects. Iridescent colors and vegetal modeling find more elegant and noble expression in glass than in other materials. In Bohemia, which boasted a long and glorious tradition of glassmaking, the flowering of handicraft around the turn of the century helped elevate Bohemian glass to new heights and international renown. Many factories produced pieces testifying to the happy alliance of ornamental style and glass (ill. left).

At the forefront of Austrian glassmaking was the Loetz' Witwe company (ills. pp. 352, 353). Physical chemistry, which had emerged as a new discipline around 1870, provided the true foundation for the delicate luster and iridescent glassware issuing from Loetz' Witwe. The natural scientists became artists, producing in their laboratories the new and fascinating color effects which lend the amorphously curved glasses their charm. Peacock feathers, butterfly wings, and soap bubbles seem to take concrete form. In 1898 the firm was granted exclusive production rights to its "luster glass technique". In Paris the following year, Loetz' Witwe showed for the first time its *Papillon* glasses with their luminous spots of iridescent color, together with its latest Phänomen glassware incorporating a decor of glass threads fused either within or on top of the glass body, combed, and in some cases employing metallic colors (ill. above left). Loetz' Witwe developed numerous types of glass, including *Pavonia* and *Persika*, colored glasses with a luster effect, *Calliope*, *Cynthius*, *Formosa* and *Orpheus*, which immortalized in glass the fleeting colors of the rainbow. These supremely artistic creations are anonymous and owe their uniqueness to the sensitivity and imagination of

the glassmaker. From 1903 the Wiener Werkstätte also collaborated with Loetz' Witwe and the arabesque was joined by the "square". The "luster effect" was an Imperial Royal success and also inspired a specific type of pottery (ill. above).

Adolf Loos – Austerity on the attack

The art which afforded the old man his floor and vaulted the Christian's church is now deformed on tins and armbands. The times are worse than we think.
Johann Wolfgang von Goethe[35]

Loos cites Goethe's words in his writings to show that Goethe, too, was a modern man – something not to be disputed. Goethe also seems to have been a model for Loos as regards the all-important question of the "inhabitability" of architecture. After visiting Palladio's Rotonda – Palladio villas are pure architecture – the great German poet is supposed to have observed that it was "inhabitable but not homely".[36] Alexander Pope (1688–1744) went even further; when a member of the English aristocracy showed him

his Palladian villa, Pope recommended: "If I was you, my lord, I would build a small, comfortable brick house next door, through whose windows you could admire your magnificent villa." He expressed the same thoughts in verse: "My noble Lord, it is very fine, / But where will you sleep, and where will you dine?"[37] Which brings us directly to the wittiest lampoon that Loos ever directed at the Secession, *The Tale of a Poor Rich Man*,[38] in which Loos describes the "dream house" of a Jugendstil architect: "Each room composed a perfect symphony of color. Walls, furniture, and fabrics were coordinated in the most exquisite fashion. Each object had its designated place and was orchestrated with the rest into the most wonderful combinations … The architect meant very well. He had thought of everything. Even the tiniest box had its own place, specially made for it. The apartment was comfortable, but it was taxing on the brain. The architect therefore monitored how it was lived in for the first few weeks, to make sure no errors crept in. The rich man tried his very best, but it happened nevertheless that he put down a book and, sunk in thought, placed it in a drawer

Adolf Loos
Exterior view of the Villa Karma for Professor Dr. Theodor Beer, 171 Rue du Lac, Burier, Montreux-Clarens, 1903–06
Even Adolf Loos, the most audacious spirit in architecture, was a child of his time. Under the art that was to be rejected he understood the art of ornament. Beauty and harmony nevertheless remained law. He deprived ornament of its rights and replaced it with costly materials. At the end of the day, the concept of the *Raumplan* (plan of volumes) which he developed was also interior design. His first private house, the Villa Karma on Lake Geneva, was designed for the Swiss neurologist Theodor Beer. Loos took the existing house, thoroughly revamped and reorganized it, and lent it classical proportions. The arrangement of its stairways already looks forward to the free volumes of his famous *Raumplan* concept.

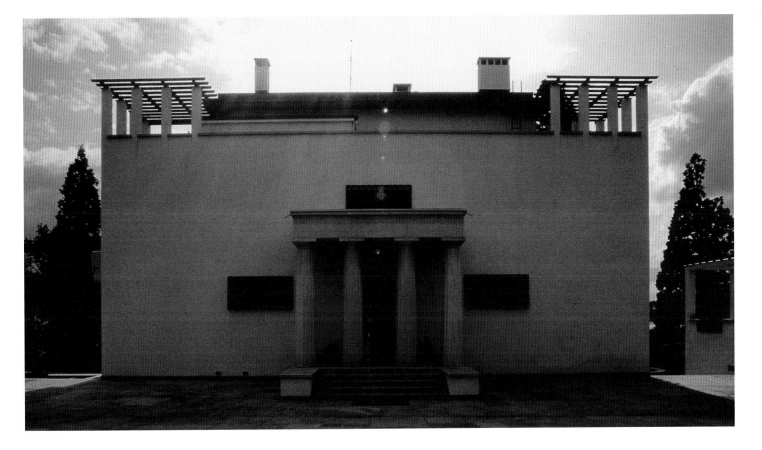

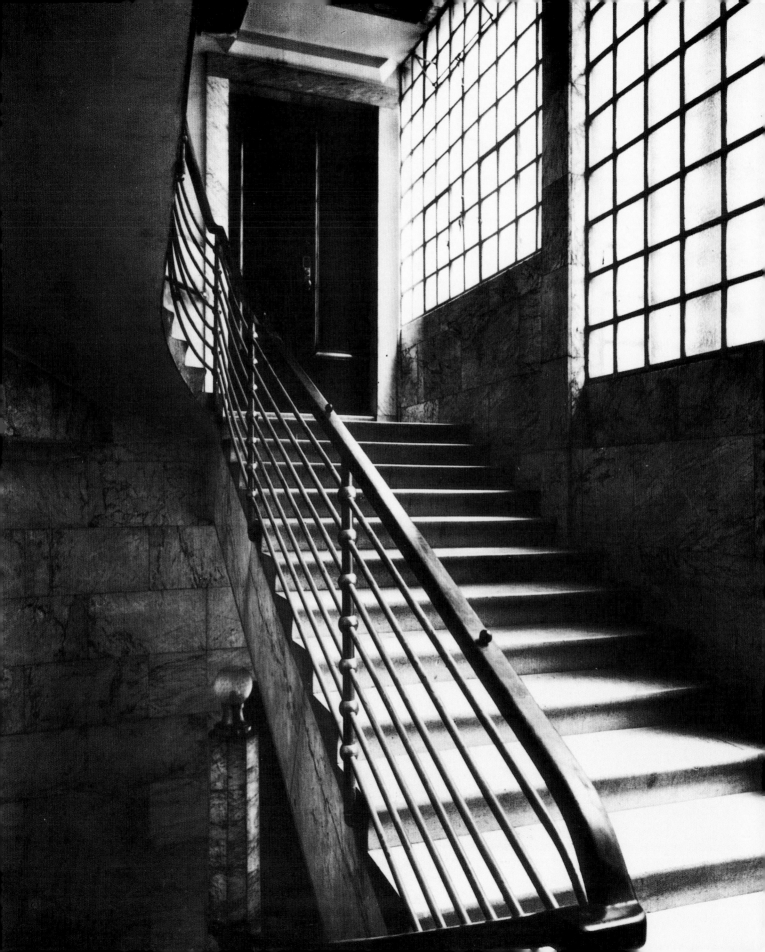

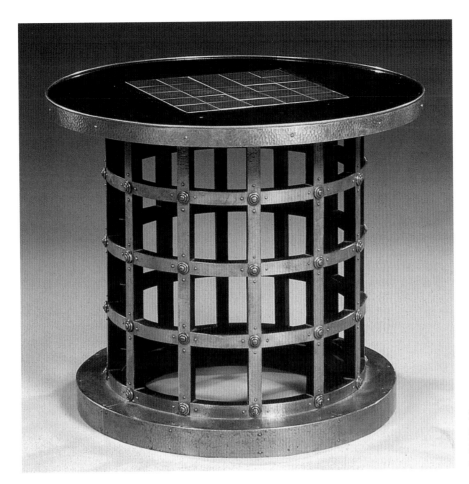

Adolf Loos
Table for the Villa Hirschmann,
Pilsen, ca. 1907
Base: embossed brass;
Tabletop: oak with glazed ceramic
tiles, 65.8 x 48 x 47.8 cm

Adolf Loos
Commercial block for Goldmann &
Salatsch, Michaeler Platz, District
1, Vienna, stairs leading up to the
apartments, 1909–11
The most trenchant observation on
the Michaeler House stems from
none other than Otto Wagner: "We
have refrained from going to the
defense of the work under attack in
public, since we too do not consider it
altogether faultless. But there is one
thing that I can say: more artistic
blood flows through the veins of its
architect than through those of the
architect of many a palais which has
been left in peace because it has
absolutely nothing to say." (see
note 39)

intended for newspapers. Or that he knocked off the ash of his cigar into the hole in the table designed to receive the candlestick ... And sometimes the architect had to unroll the detailed drawings in order to re-establish the correct home for a box of matches." One day the rich man nevertheless decided to make himself a little comfortable and greeted the architect in slippers. The architect was shocked to the core: "'What on earth are those slippers you're wearing?', he ejaculated painfully. The master of the house looked down at his embroidered footwear. But then he sighed with relief. This time he felt entirely blameless. The slippers had in fact been worked to an original design by the architect himself. So he replied superciliously: 'But Mr Architect! Have you forgotten already? You designed the shoes yourself!' 'Indeed', thundered the architect, 'but for the bedroom. Here you are completely ruining the mood with those two impossible splashes of color. Can't you see that?'" Loos' delightful polemic against

interior design, against the total work of art, ends with the question: " ... and how does one die in such rooms?"

Loos, who was born in Brno, was one of the many major Viennese architects and personalities who originated from Bohemia and Moravia, including Olbrich from Troppau, Hoffmann from Pirnitz, and Kafka, Mahler, and Meyrink. The Austro-Hungarian Empire, a melting pot of peoples, was thus also a breeding ground for genius. Loos, the son of a stonemason, completed his architectural training at technical colleges before leaving Europe for two years to discover America. There he worked various jobs – including washing dishes – before returning to Vienna in 1896 to dedicate himself whole heartedly to architecture. Initially linked to the Secession, Loos soon angered the association with his essay on *Die Potemkin'sche Stadt* (The Potemkin City), which appeared in *Ver Sacrum* in 1898. A break with its leading architects was inevitable. Loos' "smooth architecture"

Page 359:
Egon Schiele
Otto Wagner, 1910
Pencil, watercolor, opaque white,
42.5 x 26 cm
Historiches Museum der Stadt
Wien
"In the face of Otto Wagner's
genius, however, I strike my sails" –
thus the words of that ever-
belligerent "architectural
revolutionary" Adolf Loos (see note
26). There could be no better
summary of Wagner's outstanding
personality. The teacher of
Hoffmann, Olbrich, Loos, and
Antonio Sant'Elia laid the
"foundation stone" of modern
architecture.

(ill. p. 355) led him more and more into isolation, and he was worn down, too, by the constant battle against public opinion. Increasing deafness would ultimately make him a complete outsider. Disillusioned, in 1923 he moved to France, where he exerted a profound influence upon modern French architecture, and above all upon Le Corbusier. In 1931 Bauhaus founder Walter Gropius said of the pugnacious Viennese architect: "Adolf Loos is a prophet". But as is so often the case, the prophet was without honor in his own land.

The liberation of beauty from ornament

Yet even Adolf Loos, the most audacious spirit in architecture, was a child of his time. Under the art that was to be rejected he understood the art of ornament. Beauty and harmony nevertheless remained law. He deprived ornament of its rights and replaced it with costly materials. At the end of the day, the concept of the *Raumplan* (plan of volumes) which he developed was also interior design (ill. p. 357). Loos took the ideas of the English, Belgians, French, Germans, and Americans, and those of Gaudí too, combined them with a new concept of living and expanded upon them. His first private house, the Villa Karma on Lake Geneva, was designed for the Swiss neurologist Theodor Beer. Loos took the existing house, thoroughly revamped and reorganized it, and lent it classical proportions. The arrangement of its stairways already looks forward to the free volumes of his famous *Raumplan* concept (ill. p. 355).

The Michaeler House, built in 1909–11, signified an attack by austerity on ornamental Viennese architecture (ill. p. 356). The commercial block was undoubtedly planned as an affront. The utter rejection which confronted Loos and his "classicism" was too much even for the uncompromising fighter, however, and he fell seriously ill. The most trenchant observation on the Michaeler House stems from none other than Otto Wagner: "We have refrained from going to the defense of the work under attack in public, since we too do not consider it altogether faultless. But there is one thing that I can say: more artistic blood flows through the veins of its architect than through those of the architect of many a palais which has been left in peace because it has absolutely nothing to say."[39]

That our turbulent second half of the nineteenth century should seek an expression, a form for its own unique understanding of art, is understandable. But events unfolded faster than art. It was only natural, therefore, that "art", in its haste to catch up with what it had missed, proceeded to seek and – so it believed – find the Grail everywhere, and that so many "artists", upon tapping into the vein of a past style, cried "Eureka" and sought and found enthusiastic followers of the camp they represented. The way that we have raced through every stylistic tendency over the past few decades has been the result of this trend ... Although it satisfied the large majority in the short term, while its products still recalled the good old works of the past, this artistic hangover could not last, since the "works of art" thus created revealed themselves as merely the fruits of archeological studies and lacked any creative value of their own.

THE TASK OF ART, INCLUDING MODERN ART, REMAINS THE SAME AS IT HAS ALWAYS BEEN, HOWEVER. THE ART OF OUR AGE MUST OFFER US MODERN FORMS CREATED BY OURSELVES AND APPROPRIATE TO OUR ABILITIES, TO WHAT WE DO AND DON'T DO ...

Our dress, our fashions are dictated and approved by the public at large, and in this regard rule out even a hint of error. Hence the disharmony is not to be sought here, but must lie by its very nature in the works of contemporary art. And indeed, this is the case.

THINGS WHICH HAVE SPRUNG UP OUT OF MODERN ATTITUDES (whereby we mean, of course, only those which have actually ripened into artistic form) ACCORD PERFECTLY WITH OUR MODERN DAY; COPIES AND IMITATIONS OF EARLIER WORKS, NEVER.

A man in a modern railroad car, for example, will go very well with the station hall, the sleeping car, and indeed all our vehicles. But what would be our reaction if, for example, we saw a figure in Louis XV dress riding a bicycle?

Otto Wagner, *Die Baukunst unserer Zeit – Dem Baukunstjünger ein Führer auf diesem Kunstgebiete*, 4th edition, Vienna, 1914

The total work of art accomplished
The Wiener Werkstätte

A white square on white squares, only alternating with
black ones in the floor. Black is also white; it is simply the
darkest shade of white, just as white is the lightest shade of
black ... There is no sweetness about this white room.
Snow is not sweet, either. Snow is bracing and cold, but
rubbing yourself with it will make you warm.
(In the words of a snob)
Ludwig Hevesi[1]

Art and patronage

Josef Hoffmann, the same age as Adolf Loos and
friends with Joseph Maria Olbrich, was indebted
in his early work to the Secession style and to a
luxuriantly curving, dynamic line, before switch-
ing almost radically to the square and to black
and white. Alongside architecture, his gift for
formal invention expressed itself above all in his
designs for handicrafts and exhibition interiors
and buildings. In view of these artistic talents, he
was somehow destined to become the head of
an enterprise such as the Wiener Werkstätte
(Vienna Workshops), which specialized in the
"total work of art" like no other Art Nouveau or
Jugendstil group of artists. Like the poet and
playwright Hugo von Hofmannsthal, Hoffmann
too was driven by the desire to fuse the
seemingly irreconcilable elements of his age into
one. According to Hofmannsthal, the poet must
"absorb within himself a wholly irrational degree
of the unhomogeneous, ... which can become a
torment to him ... [must] uncover the world of
relationships between the fragmentary elements,
the hidden forms through which the different
parts of life are interlinked."[2] Like a figure from
the Baroque era, Hofmannsthal called for a multi-
lingual reality. Hoffmann's concept of the totality
and harmony of divergent parts, an intellectual

cult of beauty, is also part of the legacy of the
Baroque. He was the architect of the aristocratic
upper middle classes, but also the architect of
whom his pupil Josef Frank (b. 1889) wrote, on
the occasion of his teacher's 60th birthday:
"What modern architecture owes to Hoffmann is
not just the fact that he turned away from
historical ... forms ... but also that he simulta-
neously reclaimed the lightness and trans-
parency which today appear to us as its most
important characteristics."[3]
In the spring of 1905 a storm broke out within the
Secession. Its cause was essentially trivial, but it
brought into the open conflicts which had been
smoldering beneath the surface for a while.
Klimt, Hoffmann, Moser and a further eighteen
of the prominent and dominant members of the
Secession left the association. "The enormous
stature of Klimt and the artists of the Wiener
Werkstätte inevitably led to their dominating the
Secession. The result was jealousy and conse-
quently discontent."[4] For all that he regretted the
split in the highly successful Secession, Hevesi
observed perceptively: "Once again the Viennese
won't go under, because that is one of the few
things for which they have no talent ... "[5] Neither
Vienna nor the Viennese artists went under; on
the contrary, through the Wiener Werkstätte, its
architectural achievements and its handicraft
products, Vienna ultimately rose to international
fame as a center of the new art. On May 19 1903
the firm "Wiener Werkstätte, Productivgenos-
senschaft von Kunsthandwerkern in registrierter
Genossenschaft mit unbeschränkter Haftung"
(Vienna Workshops, manufacturing cooperative
of artist craftsmen in Vienna, cooperative with
unlimited liability) was incorporated in the Vienna
Trade Register. Its directors were Josef Hoffmann

and Koloman Moser, both professors at the School of Arts and Crafts in Vienna, and its treasurer Fritz Waerndorfer, the Viennese manufacturer. In the figure of Waerndorfer we meet another of the generous patrons of art without whose help Art Nouveau, and in this case Jugendstil, could never have reached ultimate fruition. Waerndorfer's business activities – the young banker's son was a textiles buyer – frequently took him to England. In London he came into contact with the Aesthetic Movement and was introduced to the workshops founded as part of the Arts and Crafts Movement. He was impressed most profoundly of all, however, by the works of the Glasgow artists, which he encountered for the first time at their moderately successful show in London. Filled with curiosity, in 1900 Waerndorfer traveled to Glasgow and made the acquaintance of the Mackintoshes, whom he invited to take part in the Eighth Secession Exhibition. The refined charm of the simple Scottish designs made an enduring impact in Vienna, and the 1902 issue no. 23 of *Ver Sacrum* was entirely devoted to the Glasgow School. That same year, Mackintosh designed a music salon for Waerndorfer, "the habitation of the souls of the six princesses" in the words of the Belgian poet Maurice Maeterlinck. "Hoffmann has undoubtedly received much fruitful inspiration from British and Scottish interior designers, who have already staged numerous successful exhibitions in Vienna. The brilliant Scottish artist Charles Rennie Mackintosh in particular has surely opened up many new and far-reaching possibilities for the younger Viennese."[6]

Waerndorfer – not an active artist himself, although indubitably artistic in nature – put up the entire capital for the Wiener Werkstätte, firmly convinced of the important contribution it had to make. In his memoirs, Leopold Wolfgang

Josef Hoffmann
Two elliptical vases with loop handles, 1906
Silver-colored metal, glass inserts, 25 cm high
Within the vast spectrum of materials employed by the Wiener Werkstätte – ranging from fabric to reinforced concrete – precious metals occupied a special place. Unlike Wiener Werkstätte ceramics and glassware, which were not produced in-house but were manufactured in other factories to designs by Wiener Werkstätte artists, the works in silver and metal were executed by the artists themselves. They lend convincing form to the Wiener Werkstätte's functional aesthetic.

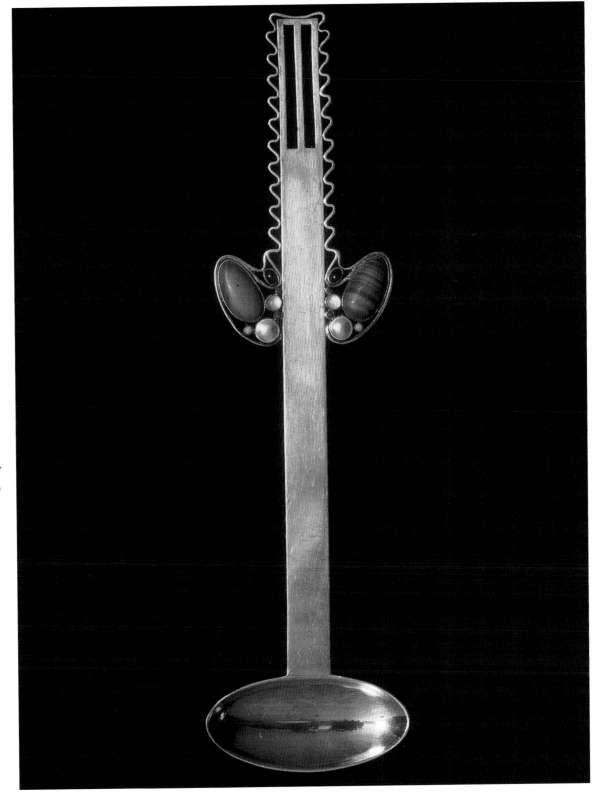

Josef Hoffmann
Serving spoon, ca. 1905
Chased silver, mother-of-pearl,
moonstone, turquoise, coral, small
blue and black stones, 21 cm long
Made by Anton Pribil
"We start from the purpose in hand,
usefulness is our first requirement,
and our strength has to lie in good
proportions and materials well
handled. We will seek to decorate,
but without any compulsion to do
so, and certainly not at any cost.
We use many semi-precious stones,
especially in jewelry – they make up
in beauty of color and infinite variety
what they lack in intrinsic value by
comparison with diamonds. We love
silver for its sheen and gold for its
glitter. In artistic terms, we consider
copper to be just as valuable as
precious metals."
(Josef Hoffmann, Wiener
Werkstätte Work Program,
see note 9)

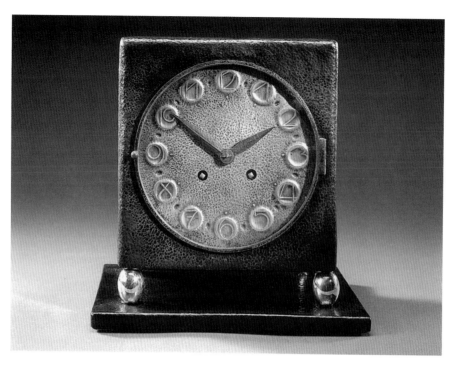

Josef Hoffmann
Clock, ca. 1904
Patinated copper, Alpaca
(nickel silver alloy),
hammered, 21 cm high
Made by Carl Kallert

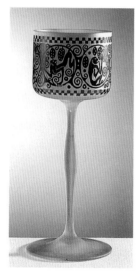

Ludwig Heinrich Jungnickel
Wine glass, "Monkey frieze" decor,
ca. 1911
Frosted glass, black broncit,
18.6 cm high
Wiener Glasmuseum, Lobmeyr
Collection
In his frosted glasses with their black
broncit decor, Jungnickel combines
striking designs with original,
fairytale-like motifs.

Rochowanski[7] describes how, at a meeting in the Café Heinrich, the artists dissatisfied with the Secession obtained from Waerndorfer, without further ado, the 500 crowns they needed to start something new. A few days later the money was all gone, and the exhibition room in which they had already installed their works could not be used. So Waerndorfer approached his wealthy mother and subsequently placed 50,000 crowns at the artists' disposal. Above and beyond his permanent willingness to assist the Wiener Werkstätte, Waerndorfer maintained a lifelong friendship with Gustav Klimt, whom he accompanied on virtually all his trips abroad, since Klimt depended upon his skills as a linguist. The enthusiastic patron was not just a friend and sponsor, but also one of Klimt's and the Wiener Werkstätte's best customers. Depressingly, Waerndorfer's only reward for his exemplary support was to lose his entire fortune – a fate which also befell the industrialist Otto Primavesi. In 1914 Waerndorfer emigrated to America at the behest of his family. As a farmer, textile designer and painter, "Fred" Waerndorfer was homesick for Europe and was never happy in the New World, as his voluminous correspondence with his old friends reveals.

Although the Wiener Werkstätte started out as a commercial success, it – and with it, Waerndorfer – would ultimately founder financially on the conflict inherent in Jugendstil, whose ideology swung like a pendulum between aesthetic exclusivity and the demand that art should be the property of all. Thus the first issue of *Ver Sacrum* proclaimed its creed in 1898 – "We know no distinction between 'fine art' and 'handicraft', between art for the rich and art for the poor. Art is common property."[8] But even if the old distinctions were now erased in theory, in practice the masterly objects crafted by the Wiener Werkstätte remained expensive, the cheaper products of the Secession affordable but mass-produced.

The inspired *métier* of the artist craftsman

We are in no position to chase after daydreams. We stand with both feet firmly planted in reality and need tasks to carry out.
Josef Hoffmann[9]

In the periodical *Deutsche Kunst und Dekoration* (German Art and Decoration) of 1904/5, Josef August Lux (1871–1947) offered a lengthy description of the young Viennese firm: "An arts and crafts enterprise in the grand style has quietly taken shape in Vienna under the direction of its founders Professor Josef Hoffmann, Professor Koloman Moser and Fritz Waerndorfer. This consortium of artist-craftsmen has set up shop in a spacious new building in Neustiftgasse; the 'Wiener Werkstätte' is amply housed on three

floors, with its own workshops for metalwork, gold and silverwork, bookbinding, leather, cabinet-making, and varnishing, as well as its own machine rooms, architectural offices, design rooms, and showroom. Here, in the midst of factory noise, artist-craftsmen pursue their quieter, inspired manual labors. For machinery is by no means absent; on the contrary, the 'Wiener Werkstätte' is fully equipped with all the technical innovations facilitating the production process. Here, however, the machine is not a ruler and a tyrant, but a willing servant and assistant. Thus products bear the stamp not of machine manufacture, but of the spirit of their artistic creators and the skill of practised hands. The characteristic principle of the Werkstätte, and one that must be instilled into every craftsman if he is to achieve the most perfect result possible, is that it is better to work for ten days on one item than to produce ten items in one day. Every object thus embodies the maximum of technical and artistic ability, and its artistic worth resides where it is so rarely found and where it should in truth be sought – not in decorative externals or formal trimmings, but in the seriousness and dignity of mental and manual labor. Every object carries the imprint of both: it is not only designed by the artist, but bears the mark of the maker, the craftsman, the worker who alone manufactured it. This is a further aspect of the socio-political insight of the founders, who aim, through these

and other measures, to increase and reinforce their craftsmen's sense of self-worth and the pleasure which they derive from their work. Raising the level of morale in this way has a beneficial effect upon performance. Other educational steps that have been taken include the banning of all bad language on Werkstätte premises, and on one occasion the dismissal of a member of the administrative staff who was foolish enough to utter a thoughtless remark to a worker.

Acting on the assumption that an intelligent worker would arrive with certain expectations as regards his workplace, the rooms have been furnished and equipped accordingly. Factory and workshop are words that usually prompt a slight shudder in civilized people, with their overtones of grime, unhappiness, and sad, faceless surroundings in which people work not for the love of it, but under the iron rod of financial necessity. Even though we may be told that the view of an industrial zone holds its own beauty, it remains all too true that the church spires of industry – as the towering stacks are sarcastically called – have never yet touched anyone's heart but that of the industrialist who calculates his profits according to the height of his chimneys. Upon entering the 'Wiener Werkstätte', however, one is pleasantly surprised to discover that the workshops are all optimally furnished even from an aesthetic point of view, and provide a happy

Eduard Klablena
Parrots, ca. 1911–12
Stoneware, underglaze painting,
overglaze details, each approx. 10.6
high, approx. 27.5 cm long
Made by Langenzersdorfer Keramik

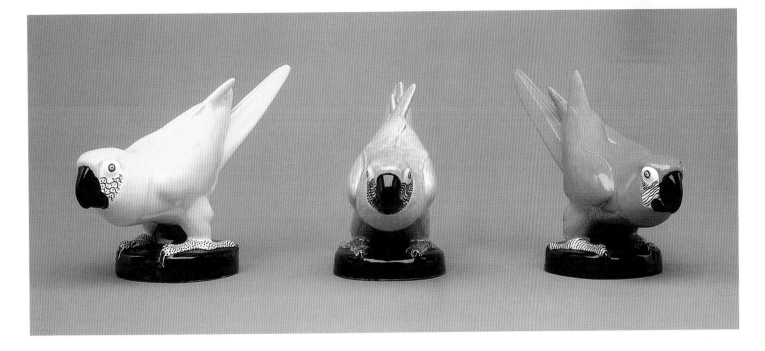

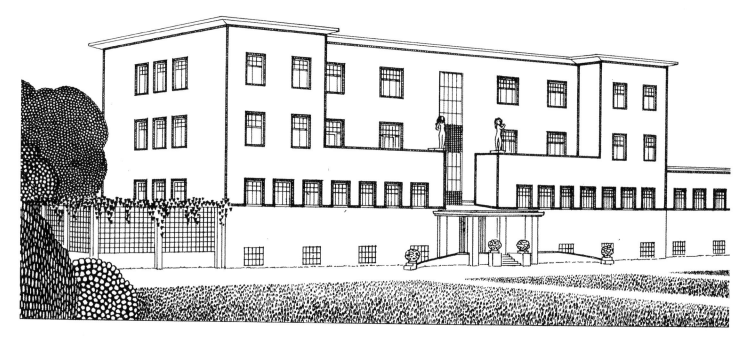

Josef Hoffmann
Purkersdorf Sanatorium,
east facade, perspective drawing,
1904
Ink, graphite
Galerie Metropol, Vienna
In 1904 Viktor Zuckerkandl,
brother-in-law of Wiener Werkstätte
admirer Berta Zuckerkandl,
commissioned Josef Hoffmann and
his colleagues to design a new
building for his Westend
Sanatorium in Purkersdorf near
Vienna. The building, the first major
commission for the Wiener
Werkstätte, has gone down in
architectural history as the
Purkersdorf Sanatorium. A close
relationship is established between
exterior and interior space through
the recurrent use of line, cube, and
plane as aesthetic statement both
within and without. This
relationship is reinforced by a
generous use of glass and transparent
partitions, a second theme running
through both the inside and the
outside of the Sanatorium.

setting for creative activity. Their striking beauty derives from the underlying principle of hygiene, whose case is argued with light, cleanliness, and fresh air. Walls and wood are painted white, iron is painted blue or red. The workshops are each dominated by one particular color, which is also employed for their respective entry books to avoid any confusion. It is easy to imagine that, for some of those on the long list of employees, the whole thing was so new that they felt quite intimidated to start with; none of them, certainly, had ever worked in such superb conditions. The first step was to accustom them to this sound and healthy working environment – not always an easy task, as in the case of teaching people to use the washbasins in the hygienic WCs, for example. Social concerns cease to exist in this enterprise; the 'Wiener Werkstätte' today boasts an elite of artist-craftsmen who feel a sense of solidarity with the firm and are fired by the praiseworthy ambition to do their best in their specialist field. The showroom, which one enters first, offers an overview of the whole. White is the dominant color. Fitted glass cabinets contain numerous art objects made of precious metal, wood, leather, glass and precious stones, together with jewelry and objects of everyday use, all strictly practical in design and honoring the nature of the materials employed …"[10] (ill. p. 363). Lux's contemporary description, quoted here at length, is both informative and perceptive. In founding their workshops, Hoffmann

and Moser drew inspiration from William Morris and John Ruskin, as well as from Charles Robert Ashbee's Guild and School of Handicraft. As a "late flowering" of Jugendstil, the Wiener Werkstätte was able to fulfill both the social and artistic conditions stipulated decades earlier in England, but at the same time point to the future in its sensible integration of the machine into its working processes. Other factors that still seem "modern" today include the "people-centered" and "environmentally friendly" working environment, the use of a "logo" (ill. opposite page) and the encouragement of a "corporate identity" within each workshop, reflected in the use of a color-coding system. As the large number of workshops listed by Lux suggests, the Wiener Werkstätte also answered Henry van de Velde's call for a "synthesis of the arts". Art Nouveau was concerned at all times and in all places with "a true union of art and life". Figuratively speaking, the barriers between art and life were being broken down, inviting everyone and everything to begin a life in beauty. Architects addressing questions of purpose, use and practical demands thereby insisted upon hygiene and suitability, tested materials against requirements, and limited the range of materials employed so as to remain unostentatious and avoid wastage. But however rigorous the emphasis upon practicality in theory, in practice it was nevertheless subservient to the overall concept of homogeneous beauty. Thus the Wiener Werkstätte, too, stood at the disposal

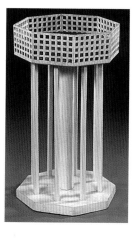

Otto Prutscher
Plant stand, ca. 1905
Wood, painted white, zinc container,
88 cm high, 49.5 cm diameter

of "the swinish luxury of the rich" so despised by Morris. In this *casus belli*, the Wiener Werkstätte – like its English forebear – was denied the satisfaction of using beauty to tear down class barriers. The Wiener Werkstätte nevertheless crossed borders effortlessly: following international acclaim, it opened offices not just in Germany and Switzerland, but also in the USA, and there was not an international exhibition at which the Viennese did not steal the limelight.

Josef Hoffmann and Koloman Moser – Purkersdorf Sanatorium

Hoffmann never attempts to create the illusion of an organism where such a one does not already exist in itself.
Julius Baum[11]

The Wiener Werkstätte achieved the fusion of hygiene, serviceability, and simplicity into a single "work of art" at the first attempt. In 1904 Viktor Zuckerkandl, brother-in-law of Wiener Werkstätte admirer Berta Zuckerkandl, commissioned Josef Hoffmann and his colleagues to design a new building for his Westend Sanatorium in Punkersdorf near Vienna. The building, the first major commission for the Wiener Werkstätte, has gone down in architectural history as the Purkersdorf Sanatorium. A close relationship is established between exterior and interior space through the recurrent use of line, cube, and plane as aesthetic statement both within and without. This relationship is reinforced by a generous use of glass and transparent partitions, a second theme running through both the inside and the outside of the Sanatorium (ill. opposite page). To complement the Sanatorium's rigorously cubist exterior, Koloman Moser designed furniture for the entrance hall, whose matt-varnished lathwork, in its geometric and down-to-earth austerity, reflects the structure of the whole house (ill. right).

The early phase of Hoffmann's oeuvre might be called a "homage to the square"; the square dominated the first years of his career and earned him the nickname of "Quadratl-Hoffmann" (Little Square Hoffmann) (ill. p. 360). His interiors for the Purkersdorf Sanatorium – like the other objects he designed during the same period, 1904–06 – still read as a textbook of early Wiener Werkstätte design even today.

The decorative principle of the cube employed in designs by Jutta Sika (1877–1964) (ill. opposite page), Otto Prutscher (ill. p. 366), Moser and Hoffmann turns our conventions of seeing upside down. In place of fanciful ornamental creations, decoration now consists of simple lines drawn

Wiener Werkstätte registered trademark, from the Work Program, 1905
Aspects of the Wiener Werkstätte that still seem "modern" today include its "people-centered" and "environmentally friendly" working environment, the use of a "logo" and the encouragement of a "corporate identity" within each workshop, reflected in the use of a color-coding system.

Koloman Moser (attributed)
Wardrobe, ca. 1903–05
Wood, painted white with rectangular decor, 190 cm high

Koloman Moser
Armchair for the Purkersdorf Sanatorium, 1903
Painted beech, painted cane seat, 72 x 66.5 x 66 cm
Made by Prag Rudniker
To complement the Sanatorium's rigorously cubist exterior, Moser – keeping the ideal of the total work of art always in his mind – designed furniture for the entrance hall, whose matt-varnished lathwork, in its geometric and down-to-earth austerity, reflects the structure of the whole house.

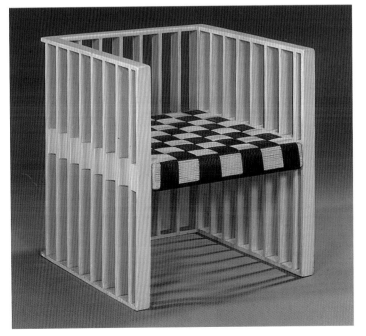

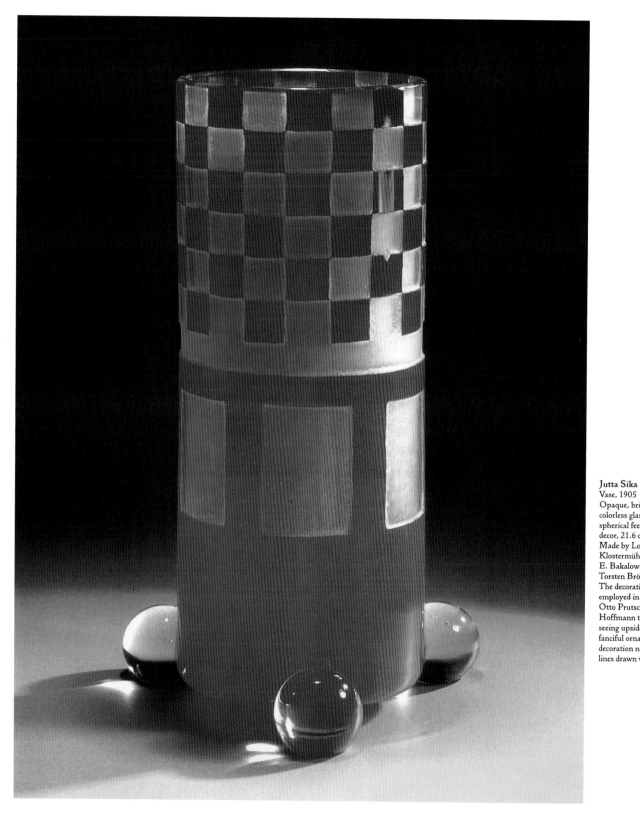

Jutta Sika
Vase, 1905
Opaque, bright red flashing over
colorless glass, three colorless
spherical feet, etched geometric
decor, 21.6 cm high
Made by Loetz' Witwe,
Klostermühle, Bohemia in 1905 for
E. Bakalowits & Söhne, Vienna
Torsten Bröhan Collection
The decorative principle of the cube
employed in designs by Jutta Sika,
Otto Prutscher, Moser and
Hoffmann turns our conventions of
seeing upside down. In place of
fanciful ornamental creations,
decoration now consists of simple
lines drawn with a ruler.

with a ruler. This linear structure cannot be summarized (and thereby simplified) as plain linearism, however. What we read as a single plane suddenly tranforms itself into a representation of several planes. Objects composed of straight lines initially present themselves to the viewer as homogeneous. The conflict between two-dimensional plane and three-dimensional space dramatically activates the viewer's attention. We undergo an experience which runs counter to our desire to fix a form. Here Hoffmann is concerned not with geometry alone, but with the artistic tension created by formal means reduced to their absolute essentials. The elongated grid structure of the Sanatorium with its flat roof (ill. p. 366) – most avant-garde for its day – is taken up in smaller-scale designs for household objects and furnishings. Thus the grid of the windows in the Sanatorium facade is elaborated in planters, tables and étagères. In one example, Koloman Moser effectively develops a plant stand out of the facade (ill. p. 361): in its composition of sheet-iron boxes with black-and-white checkered sides, held by vertical beech supports rising from the cross-struts and frame of the square base, Moser's plant stand duplicates the checkered pattern of the tiling found on the outside of the building – furniture as architecture once more. "It seems rather a pity that, in order to enjoy one of the wonderful white Purkersdorf cubicles, you have to be of somewhat unsound mind."[12]

"Ornamental madness" – Colored squares

And then there is Hoffmann, the man who is never ruffled by anything ... I think he would have made an excellent surgeon. One look at Kolo Moser's face would be enough to reassure even the most fainthearted. If Hoffmann is calm, and Klimt confident of his strength, Moser is impish.
Ludwig Hevesi[13]

Presented with the exceedingly "total" nature of the Wiener Werkstätte's total works of art – even the fresh flower arrangements supplied to the Purkersdorf Sanatorium came under the "artistic direction" of the Wiener Werkstätte – satirical voices in Vienna were quick to be heard. In 1906 the Wiener Werkstätte staged an exhibition entitled "The Laid Table" (*Der gedeckte Tisch*), for which the creative genius Koloman Moser even designed specially shaped pastries – although it was with some difficulty that he found a baker who could actually make them. "The geometric element guides both of our artistic table-layers [Hoffmann and Moser] in their creations, and the new grace at mealtimes will surely have to be: 'Bless these lines which we are about to receive' ... Two strands of macaroni can only be bisected in infinite space ... for which a theoretical grounding and practical tutorials are first necessary ... To carve the beef with stylistic correctness, you need a ruler and dividers; the dumplings are hand-turned by a craftsman, and the only stylistically pure black-and-white

Josef Hoffmann
Brooch, ca. 1905
Silver, malachite, lapis lazuli, moonstone cabuchons, coral,
4.5 x 4.5 cm
"For whenever a new style makes its appearance, it is in architecture that its first indications are to be seen" – the hypothesis put forward by *The Studio* (see note 16) is particularly true of the Wiener Werkstätte's "architectural jewelry". Hoffmann's designs for jewelry, employing precise squares, circles, borders, symmetrical patterns of stylized leaves and standardized flower motifs, reveal the hand of the architect.

Jutta Sika, Koloman Moser,
Jutta Sika, Josef Hoffmann
Four jugs, ca. 1901–05
Porcelain, underglaze painting,
16.8 cm to 18.5 cm high
"... the services by Koloman Moser, Jutta Sika and Therese Trethahn, produced around 1900, were thereafter to be seen in *Das Interieur*, *The Studio* and other specialist magazines. With their highly individual, original forms, and decorative designs, they became 'classic' examples of their kind, inimitable in their simplicity and clarity." (Waltraud Neuwirth, see note 15)

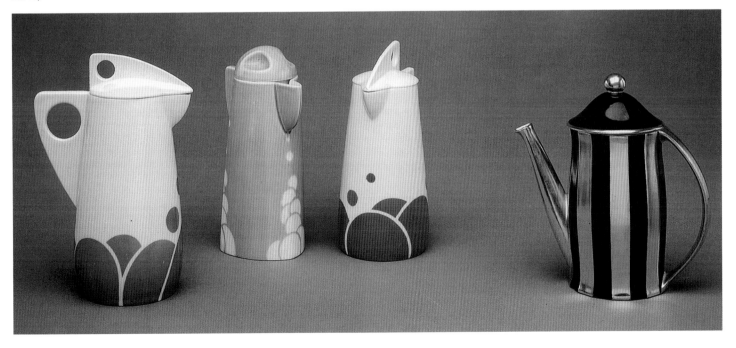

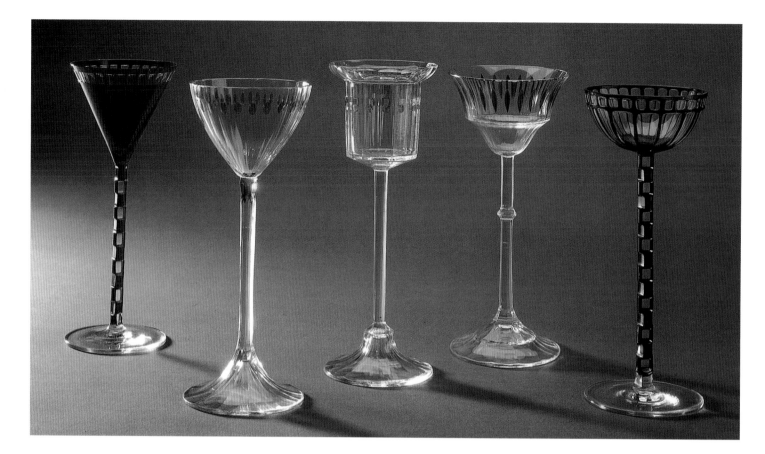

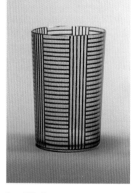

Josef Hoffmann
Tumbler from the "Var. B" set of
glasses, ca. 1910
Frosted glass, broncit decor,
10.4 cm high
Made via J. & J. Lobmeyr, Vienna
Wiener Glasmuseum,
Lobmeyr Collection

desserts are the poppy-seed puddings improved
by Koloman Moser here madness marries
geometry."[14]

But if madness married geometry, so too did
color, as illustrated by the beautiful flashed and
cut glasses by Otto Prutscher (1880–1949), with
their typical faceted and windowed stems (ill.
above). Making bold use of contrast, the
sparkling colors of these glasses embrace the
whole spectrum from violet to turquoise, dis-
solved into checkerboard patterns and "little
squares". The black-and-white decor so charac-
teristic of the Wiener Werkstätte also found its
way into glass, however (ill. left). In the broncit
glassware by the Lobmeyr company, it was
nevertheless "reconciled" with floral ornament;
thus a delicate, vegetal decor flowers within a
geometric framework out of the broncit coating
which offered the artists of the Wiener
Werkstätte a perfect vehicle for their design
aesthetic (ill. opposite page). Up until 1910 the
Wiener Werkstätte's glassware was "published"
by Bakalowits & Söhne, after which Lobmeyr took
over the leading role. Designs by the "disciples

Josef Hoffmann
Jardinière, 1914–15
Frosted glass, broncit decor,
9.3 cm high, 22.1 cm long
Made via J. & J. Lobmeyr, Vienna
To create the broncit decor, the glass
was first coated with a layer of
bronzite, the decorative design then
painted over the top in a protective
varnish, and the remainder of the
bronzite etched away.

Mela Köhler
Fashion designs; three Wiener
Werkstätte postcards, ca. 1907
The Wiener Werkstätte succeeded in
permeating every sphere of life by
artistic means. Dining tables, flower
arrangements and even fashion – as
with van de Velde, a statement of
reformist thinking – were all
integrated into an overall symmetry.

Opposite page:
Otto Prutscher
Five wine glasses, 1905–07
Flashed crystal, heightened color,
cut and ground,
20.5 cm to 21 cm high
The flashed and cut glasses by Otto
Prutscher, with their faceted and
windowed stems, are superlative
examples of the marriage of color
and geometry. Making bold use of
contrast, the sparkling colors of these
glasses embrace the whole spectrum
from violet to turquoise, dissolved
into checkerboard patterns and
"little squares".

Koloman Moser,
Josef Hoffmann
Reception, Flöge fashion salon,
Mariahilferstrasse, Vienna, ca. 1903
Three young women from a well-to-
do middle-class background decided
to venture into business – an almost
revolutionary step around 1900. In
their fashion salon the Flöge sisters –
Emilie Flöge was Klimt's partner –
wanted to place modern dress in a
modern setting. The interior of the
salon's reception was designed by the
Wiener Werkstätte and conveyed to
customers, even before they had
bought anything, the "aesthetic
unison" of this progressive female
firm.

of the square" were also executed by Loetz'
Witze, however, and indeed by almost every
well-known glassworks in Austria (ill. p. 368).
The technical classes run by Hoffmann and
Moser at the Vienna School of Arts and Crafts
during the Secession years had already inspired
a "ceramics renaissance" (ill. p. 369). "… the
services by Koloman Moser, Jutta Sika and
Therese Trethahn, produced around 1900, were
thereafter to be seen in *Das Interieur*, *The Studio*
and other specialist magazines. With their highly
individual, original forms and decorative designs,
they became 'classic' examples of their kind,
inimitable in their simplicity and clarity."[15] Many
of the Austrian ceramic works focused on the
"re-birth" of stoneware, and there arose a wealth
of animated, stylistically assured works (ill. p. 365).
The Wiener Werkstätte succeeded in permea-
ting every sphere of life by artistic means. Dining
tables, flower arrangements and even fashion –
as with van de Velde, a statement of reformist
thinking – were all integrated into an overall
symmetry (ill. p. 371). The flawlessness of its
architecture was taken up without a break in its

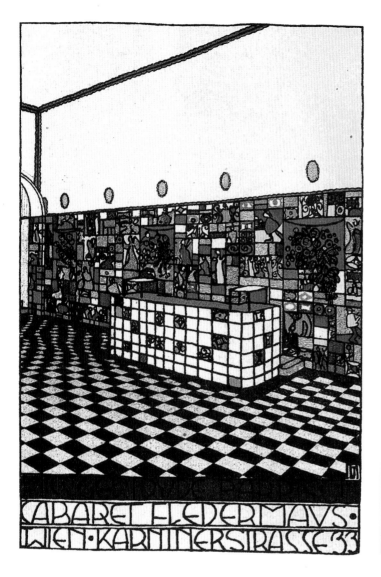

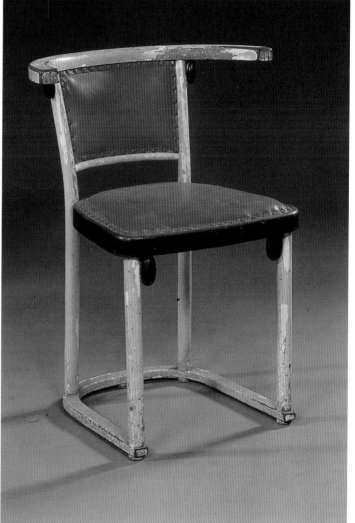

Josef von Divéky
Bar, Cabaret Fledermaus,
Kärntnerstrasse 33, Vienna, 1907
Wiener Werkstätte Postcard No. 75
Architect: Josef Hoffmann
Interior design: Wiener Werkstätte
Rupertinum – Salzburger
Landessammlungen, Salzburg
"In 1907 Fritz Waerndorfer, a
sophisticated gentleman with a great
deal of money and taste – two things
which, as everyone knows, almost
never go together –, decided to
commission the Wiener Werkstätte
to build a cabaret. Both the
colorfully tiled bar and the black-and-
white auditorium were jewels of
intimacy and noblesse." (Egon
Friedell, see note 17)

interiors and utensils. Its best results were always those where client and artist shared a similar vision, as in the case of the Flöge fashion salon, founded by three young women from a well-to-do middle-class background who decided to venture into business – an almost revolutionary step around 1900. In their fashion salon the Flöge sisters – Emilie Flöge was Klimt's partner – wanted to place modern dress in a modern setting. The interior of the salon's reception was designed by the Wiener Werkstätte and conveyed to customers, even before they had bought anything, the "aesthetic unison" of this progressive female firm. Hoffman was considerably influenced by Japanese art and this was particularly evident in the Flöge fashion salon. The

simple, Eastern flavour of the interior and the emphatically two-dimensional decor combined to make the room a perfect foil for its "three-dimensional" subject: the formal inventions of *couture* (ill. p. 371).

Within the vast spectrum of materials employed by the Wiener Wienerstätte – ranging from fabric to reinforced concrete – precious metals occupied a special place. Unlike Wiener Werkstätte ceramics and glassware, which were not produced in-house but were manufactured in other factories to designs by Wiener Werkstätte artists, the works in silver and metal were executed by the artists themselves. They lend convincing form to the Wiener Werkstätte's functional aesthetic (ills. pp. 362, 363, 364). The

Josef Hoffmann
Coffeehouse chair, ca. 1906
Painted bentwood, leather
upholstery, 74 cm high
Made by Jacob & Josef Kohn,
Vienna

same may be said of the Wiener Werkstätte's "architectural jewelry" – proof of the irrefutability of the hypothesis: "For whenever a new style makes its appearance, it is in architecture that its first indications are to be seen."[16] Hoffmann's designs for jewelry, employing precise squares, circles, borders, symmetrical patterns of stylized leaves, and standardized flower motifs, reveal the hand of the architect (ill. p. 369).

Cabaret Fledermaus – A "miracle of design"

"In 1907 Fritz Waerndorfer, a sophisticated gentleman with a great deal of money and taste – two things which, as everyone knows, almost never go together – decided to commission the Wiener Werkstätte to build a cabaret. Both the colorfully tiled bar and the black-and-white auditorium were jewels of intimacy and noblesse."[17] The "miracle of design" that was the Cabaret Fledermaus was executed "unimpeded by the interferings of a patron"[18] (ill. opposite page, left). Alongside furniture designers (ill. opposite page, right), ceramic artists, silversmiths, and designers for its lighting, tableware, and table decorations, the Cabaret Fledermaus offered graphic designers in particular a wide range of activities: posters, tickets, menus, programs, postcards, and even specially designed name-badges for the staff. The "imaginative stroke of decorative originality"[19] – as Hevesi described the colorful mosaic of majolica tiles cladding the Cabaret Fledermaus walls – is found condensed in Michael Powolny's *putti* with their Klimtesque cascades of fruits and flowers, which – executed in both black-and-white and colored versions – testify to the harmonious juxtaposition within the Cabaret Fledermaus of contradictory "design persuasions" (ill. p. 373). "From these rooms, imbued with an artistic sophistication of the highest degree, one can see how much is now possible in Vienna … [Here is] a confident, dignified, honest, almost chaste unfolding of

Michael Powolny
"Spring" (right) and "Autumn" *putti*, ca. 1907
Porcelain, colored underglaze painting; "Spring": 36 cm high; "Autumn": 38 cm high
The "imaginative stroke of decorative originality" – as Hevesi (see note 19) described the colorful mosaic of majolica tiles cladding the Cabaret Fledermaus walls – is found condensed in Michael Powolny's putti with their Klimtesque cascades of fruits and flowers, which – executed in both black-and-white and colored versions – testify to the harmonious juxtaposition within the Cabaret Fledermaus of contradictory "design persuasions".

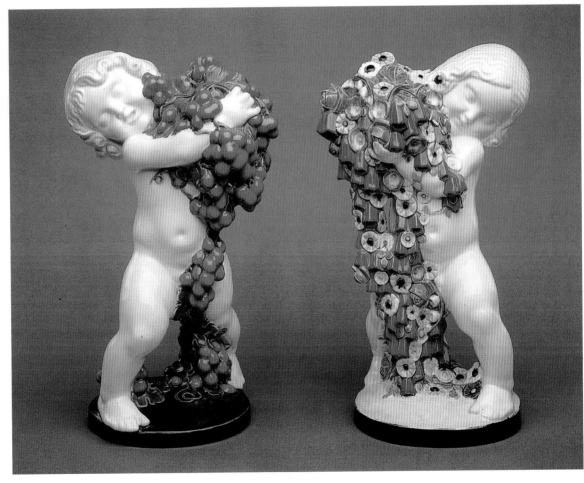

Josef Hoffmann
Palais Stoclet, view of the street
facade from the northwest, Brussels,
1905–11
The Palais Stoclet in Brussels is
universal, complete, flawless,
encyclopedic – a masterpiece of a
thousand years of architectural
history. From 1905–11, in the city
of Victor Horta, Henry van de Velde
and Paul Hankar, Hoffmann,
Klimt and the Wiener Werkstätte
crowned the entire Art Nouveau
movement with their total work of
art. The Utopia of Jugendstil is
made reality in the Palais Stoclet.
From the cutlery to the gardens,
from the facade to the bathroom,
coordination and harmony govern
every facet of this artistic gem.

splendor, the harmony and power of the chromatic idiom, melodious design crystallized out of the purpose in hand,"[20] enthused Berta Zuckerkandl. Karl Kraus couldn't resist a reply: "There was a long debate about whether [the hygienic needs of the audience] would be better served by using the paper on which the art reviews of Ms Zuckerkandl were printed, or by a special dress for the lavatory lady which Professor Hoffmann was to design. In the end, however, it was agreed that the cistern was to be painted white and the beloved checkerboard pattern imprinted upon it."[21] The retort from Oskar Kokoshka: "Kraus has bitten the Fledermaus lavatory attendant in the leg because she's not wearing clothes from the Hoffmann collection."[22]

Palais Stoclet – *The* total work of art

And this is what our age owes to Josef Hoffmann: the universality of his artistic genius.
Peter Behrens[23]

The Palais Stoclet in Brussels is universal, complete, flawless, encyclopedic – a masterpiece of a thousand years of architectural history. From 1905–11, in the city of Victor Horta, Henry van de Velde and Paul Hankar, Hoffmann, Klimt and the Wiener Werkstätte crowned the entire Art Nouveau movement with their total work of art. The Utopia of Jugendstil is made reality in the Palais Stoclet (ill. below). From the cutlery to the gardens, from the facade to the bathroom, coordination and harmony govern every facet of this artistic gem.

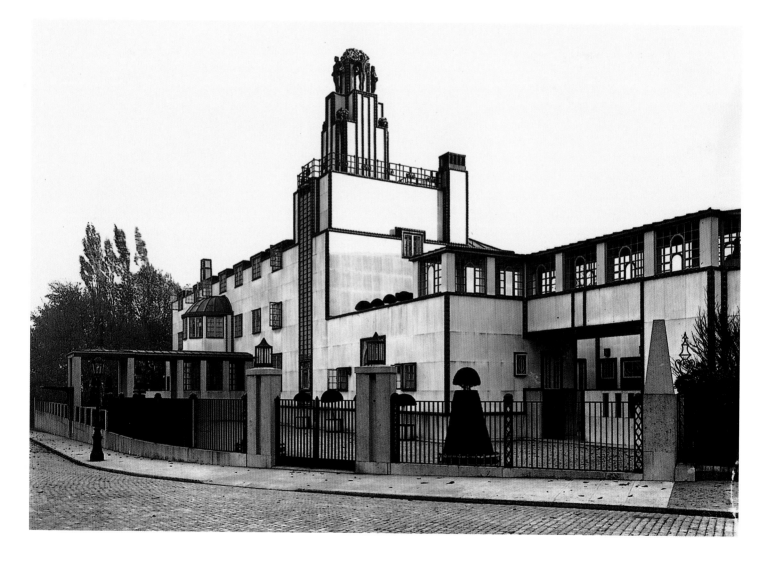

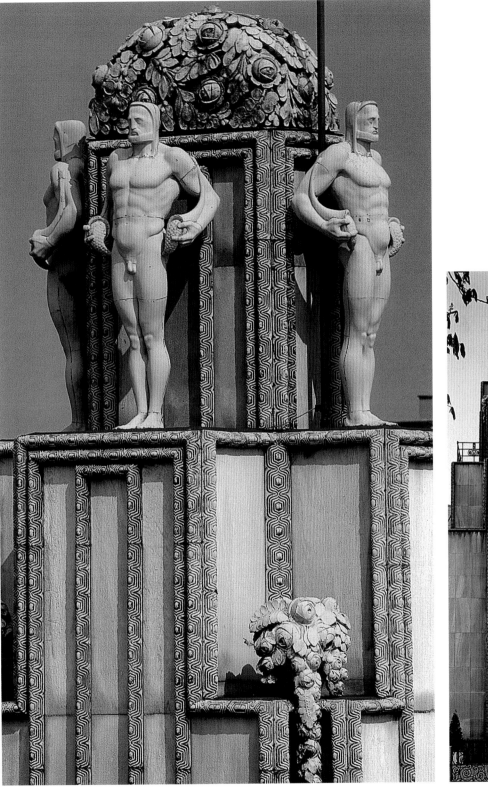

Josef Hoffmann
Tower and figural group, Palais
Stoclet, Brussels, 1905–11
The "sculpture tower" points to the
symbiosis of all the arts – a theme
taken up again in the interior, where
the rooms form a sequence of
contrasting compositions.

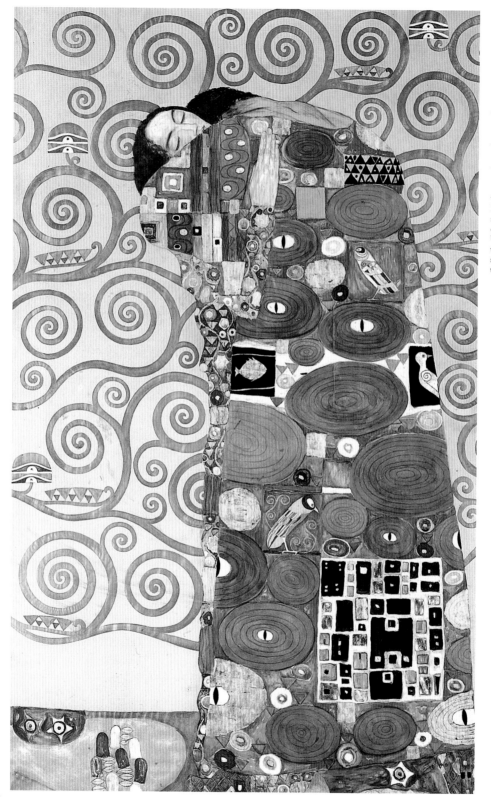

Gustav Klimt
Fulfillment, cartoon for the Stoclet Frieze in the dining room of the Palais Stoclet, Brussels, ca. 1905–09
Watercolor, gouache, paper on wood, 192 x 118 cm
Musée des Beaux-Arts – Palais Rohan, Strasbourg
"Klimt's influence upon the Wiener Werkstätte was palpable, as *vice versa* was its influence upon the middle phase of Klimt's oeuvre. The common ground they shared assumed its most beautiful expression in the frescoes which Klimt designed for the exhibition of Klinger's 'Beethoven', and in his wall frieze for the dining-room in the Palais Stoclet in Brussels, that monument to a Viennese cultural epoch." (Carl Moll, see note 26). Uncompromising in their decorative two-dimensionality, Klimt's wall mosaics are simultaneously a step towards abstraction.

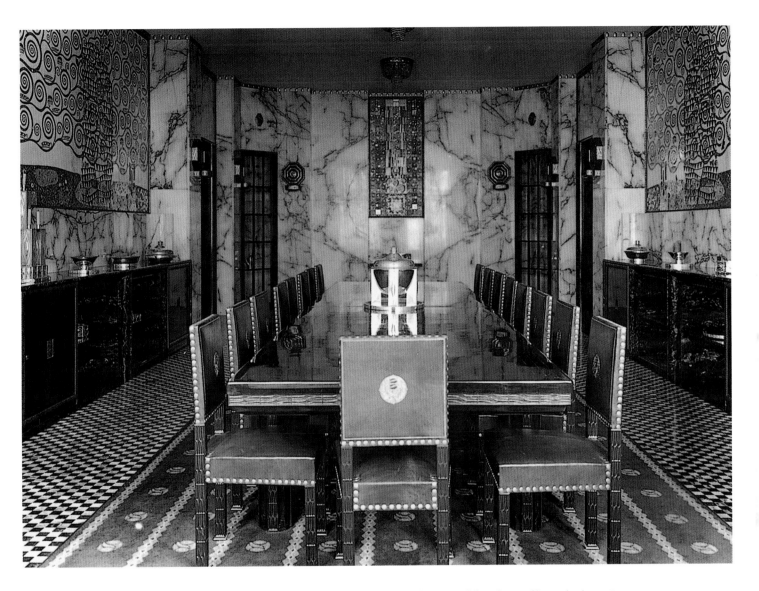

Josef Hoffmann
Dining room, Palais Stoclet,
Brussels, ca. 1905–11
Mosaics by Gustav Klimt, silver
tableware by Josef Hoffmann
The dining room may be seen as
typical of the interior design of the
Palais Stoclet as a whole. The
severity of the room, with its lavish
materials of different colored
marbles, precious woods and gold-
embossed leather, is echoed in the
silverware designed by Hoffmann.
At the same time, it finds both its
contrast and its completion in the
mosaics by Klimt adorning the
walls.

Adolphe Stoclet was the archetypal art patron of
the turn of the century: cosmopolitan, educated,
wealthy, and dedicated to the furtherance of the
arts, his relationship with the Wiener Werkstätte
architects was highly congenial. "His black beard
shot with silver, his manner – charming, with just a
hint of pomposity – and his distinguished appear-
ance lent him a remarkable affinity in style with the
objects [of archaic and overseas art] in his col-
lection, with which he seemed to have an almost
natural rapport. Indeed, the polished marble sur-
faces in the large entrance hall matched him just as
well as they matched his carvings … He was com-
pletely at home in such monumental company."[24]

The preciousness of its materials – marble,
bands of gilt metal – and its seductive air of

nobility rob the building of none of its modernity:
"The Palais Stoclet, now world-famous, belongs
equally to the history of 20th-century art as to the
history of 20th-century architecture."[25] Propor-
tioning and rhythm, skilful deployment of natural
and artifical light, color and surface treatment,
even iconographic characterization are the con-
sistent hallmarks of the overall design.

The house is integrated into its surroundings in
exemplary fashion. Reflections of linear beauty
are mirrored in the waters of the artificial pond,
"organically" duplicating the elegant animation
of the architectural masses. The "sculpture
tower" points to the symbiosis of all the arts (ill.
p. 375) – a theme reiterated in the interior of the
Palais Stoclet, where the rooms form a sequence

Page 379:
Josef Urban
Design for the facade of the Max
Reinhardt Theatre, 50th and 51st
Street, New York, 1929
Watercolor, ink, 37.5 x 28.6 cm
Joseph Urban Archives, Rare Book
and Manuscript Library, Columbia
University, New York
The richly inventive architect Josef
Urban took the Wiener Werkstätte
style to America. In 1922 he put up
the capital for the foundation of the
Wiener Werkstätte of America, Inc.,
and designed the branch's showroom
on Fifth Avenue.

of contrasting compositions. The dining room (ill. p. 377) may be seen as typical of the whole: the severity of the room, with its lavish materials of different colored marbles, exclusive woods and gold-embossed leather, is echoed in the silverware designed by Hoffmann. At the same time, it finds both its contrast and its completion in the mosaics by Klimt adorning the walls (ill. p. 376). "Klimt's influence upon the Wiener Werkstätte was palpable, as *vice versa* was its influence upon the middle phase of Klimt's oeuvre. The common ground they shared assumed its most beautiful expression in the frescoes which Klimt designed for the exhibition of Klinger's 'Beethoven', and in his wall frieze for the dining room in the Palais Stoclet in Brussels, that monument to a Viennese cultural epoch."[26] Uncomp-

romising in their decorative two-dimensionality, Klimt's wall mosaics are simultaneously a step towards abstraction. The 20th century is articulated throughout the Palais Stoclet with every clarity, even in its "secondary" rooms. The bathroom by Hoffmann is functional, the children's bedroom by Ludwig Jungnickel (1881–1965) "child-oriented" in the fairytale character of the animal frieze decorating the walls, a decorative scheme also taken up in other objects designed by the same artist (ill. p. 364).

Linearity, latticework, grid and "little square" would go on to conquer the New World, where Wiener Werkstätte member Josef Urban (1872–1933) translated the formal vocabulary of Hoffmann's early years into the architecture of the 1920s (ill. opposite page).

The immeasurable harm caused in the realm of arts and crafts by shoddy mass production on the one hand, and mindless imitation of old styles on the other, has swept through the entire world like a huge flood. We have lost touch with the culture of our forebears and are tossed about by a thousand contradictory whims and considerations. In most cases the machine has replaced the hand, and the businessman has taken the craftsman's place. It would be madness to swim against this current.

All this notwithstanding, we have founded our workshop. It exists to provide on native soil a point of repose amid the cheerful noise of craftsmanship at work, and to give comfort to all who accept the message of Ruskin and Morris. We make our appeal to all those who value culture in this sense, and we hope that even our inevitable mistakes will not deter our friends from promoting our ideas.

We wish to establish intimate contact between public, designer, and craftsman, and to produce good, simple domestic requisites. We start from the purpose in hand, usefulness is our first condition, and our strength has to lie in good proportions and materials well handled. We will seek to decorate, but without any compulsion to do so, and certainly not at any cost. We use many semiprecious stones, especially in jewelry – they make up in beauty of color and infinite variety what they lack in intrinsic value by comparison with diamonds. We love silver for its sheen and gold for its glitter. In artistic terms, we consider copper to be just as valuable as precious metals. We feel bound to admit that a silver ornament can be just as valuable as an object made of gold and precious stones. The worth of artistic work and of inspiration must be recognized and prized once again. The work of the artist craftsman is to be measured by the same yardstick as that of the painter and the sculptor ...

The substitutes provided by period reproductions are strictly for *parvenus*.

Josef Hoffmann, from the *Wiener Werkstätte Work Program*, Vienna 1905 (see note 9)

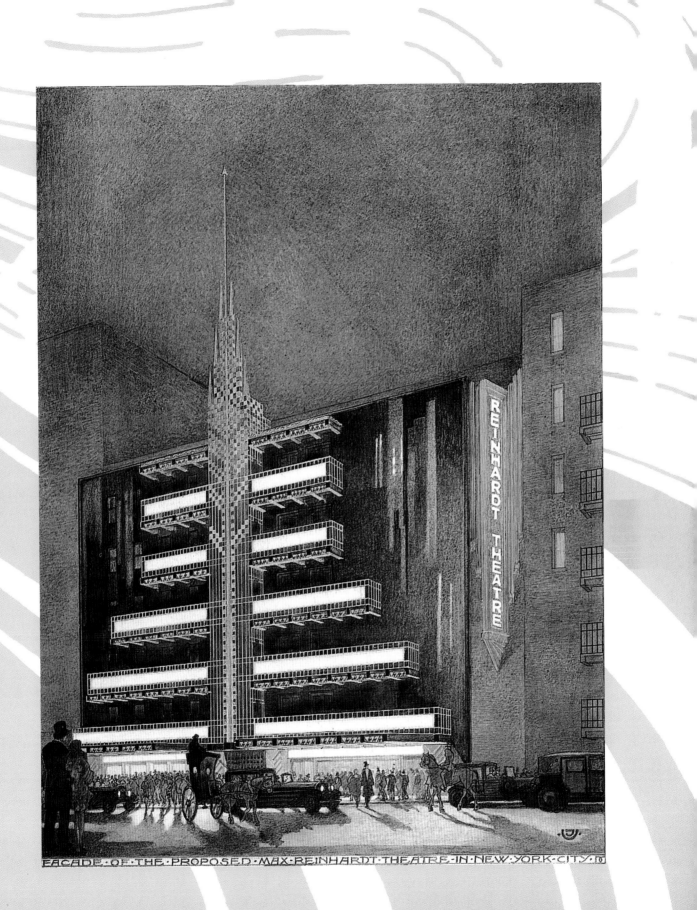

FACADE · OF · THE · PROPOSED · MAX · REINHARDT · THEATRE · IN · NEW · YORK · CITY ·

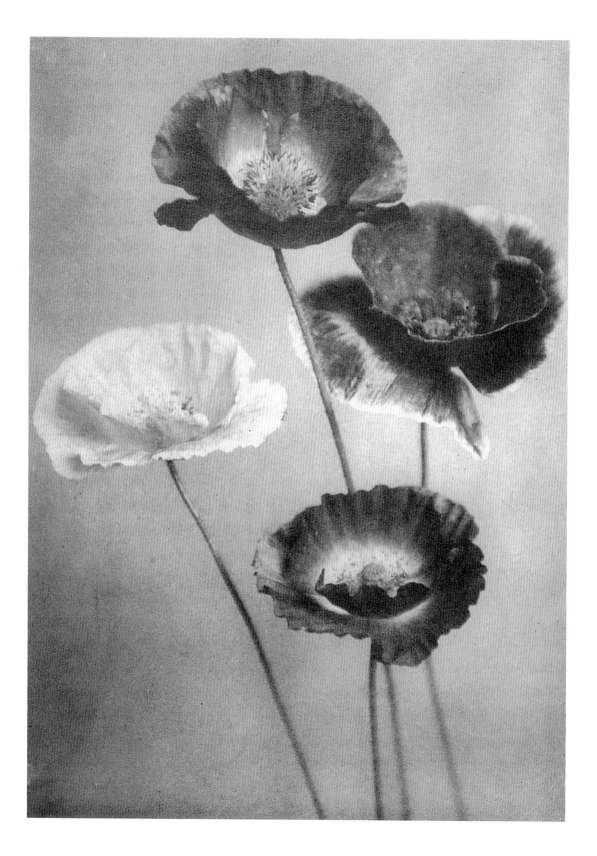

Bibliographic notes

Unless otherwise stated, all foreign language quotes have been rendered into English by the translators.

The final chord and a new beginning (p. 6–23)

1 Johann Wolfgang von Goethe, 1819. Quoted in *Maximen und Reflexionen*, Frankfurt/Main, 1840.
2 Erwin Panofsky. *Sinn und Deutung in der bildenden Kunst*. Cologne, 1975.
3 Dolf Sternberger. *Panorama des Jugendstils*. Quoted in *Ein Dokument Deutscher Kunst 1901–1976*, exhibition catalog, Vol. 1, Darmstadt, 1976.
4 Hans Sedymayr. *Die Revolution der modernen Kunst*. Cologne, 1985.
5 Quoted from Françoise Gilot, *Leben mit Picasso*, Munich, 1965.
6 Kaii Higashiyama. *Das Schöne in der japanischen Kunst*. Quoted in *Japan und der Westen*, edited by Constantin von Barloewen and Kai Werhahn-Mees, Vol. 3, Frankfurt/Main, 1986.
7 Julius Lessing. *Berichte von der Pariser Weltaustellung 1878*. N. p.,1878.
8 Atushi Tanigawa. *Art Nouveau als ein Phänomen der Arabeske*. Quoted in *Art Nouveau – Jugendstil*, exhibition catalog, Tokyo, 1990.
9 Thomas Zacharias. *Japonismus oder das Klatschen mit einer Hand*. Quoted in *Art Nouveau – Jugendstil*, exhibition catalog, Tokyo, 1990.
10 Josef Hoffmann. *Arbeitsprogramm der Wiener Werkstätte*. Vienna, 1905. Quoted from W. H. Schweiger, *Wiener Werkstätte, Design in Vienna 1903–1932*, translated by Alexander Lieven, London, 1984, p. 43.
11 See note 9.
12 Arno Holz. *Gedichtzeile*. Quoted in *Ver Sacrum*, Vol. 2, 1898.
13 Ernst Haeckel. *Kunstformen der Natur*. Quoted from Hermann Obrist in *Pan*, No. 1, 1895.
14 Dolf Sternberger. *Über den Jugendstil und andere Essays*. Hamburg, 1956.
15 See note 14.
16 Jean Moréas. *Le Symbolisme* [Symbolist Manifesto]. Quoted in *Figaro Littéraire*, September 18 1886 (original publication). Quoted from Fritz Heinmann, *Symbolische Kunst*, dissertation, Berlin, 1926.
17 Gustave Flaubert. *Salammbô*. Paris, 1862.
18 Charles Baudelaire. *Les Fleurs du mal*. Paris, 1857.
19 Charles Baudelaire. *Œuvres Posthumes*. Paris, 1908. Quoted in *Journaux Intimes*, edited by Adolphe van Bever, Paris, 1920.

20 Wolfram Waldschmidt. *Dante Gabriel Rossetti*. Jena-Leipzig, 1905.
21 Stefan George. *Teppich des Lebens*. 1900. Quoted in *Werke*, edited by Helmut Küpper, Vol. 1, Munich, 1958.
22 Georg Wilhelm Friedrich Hegel. *Vorlesungen über Ästhetik*. Heidelberg, 1827. Quoted from Hans Joachim Störig, *Kleine Weltgeschichte der Philosophie*, Vol. 2, Stuttgart, 1950.
23 Günther Metken. *Fest des Fortschritts*. Quoted in *Weltausstellungen im 19. Jahrhundert*, exhibition catalog, Munich, 1973.
24 Title of the exhibition catalogue *Traum und Wirklichkeit* [Dream and reality], *Vienna 1870–1930*. Vienna, 1985.
25 Oswald Spengler. *Der Untergang des Abendlandes – Umrisse einer Morphologie der Weltgeschichte*. Edited by Helmut Werner. Munich, 1959.
26 From the television program *Hans Hollein – Architekt und Künstler*, ORF2, March 1996.
27 See note 14.
28 Translation, quoted from André Maurois, *Engländer*, Munich, 1933.

England (p. 24–51)

1 Henry van de Velde. *Zum neuen Stil*. From his writings, selected and introduced by Hans Curjel, Munich, 1955.
2 Translation, quoted from André Maurois, *Engländer*, Munich, 1933.
3 Translation, quoted from Wolfram Waldschmidt, *Dante Gabriel Rossetti*, Jena-Leipzig, 1905.
4 Frédéric Boutet. *Seltsame Masken*. Munich, 1913.
5 D. Frey. *Englisches Wesen in der bildenden Kunst*. Stuttgart-Berlin, 1942.
6 Julius Posener. *William Morris und die Folgen – Vorlesung zur Geschichte der Neuen Architektur III*. Quoted in *59 Arch+*, Aachen, 1981.
7 See note 6.
8 Julius Posener. *William Morris und die Folgen – Vorlesung zur Geschichte der Neuen Architektur III*. Quoted in *59 Arch+*, Aachen, 1981. Quoted from Gabriele Fahr-Becker, *Wiener Werkstätte*, translated by Karen Williams, Cologne, 1995, p. 14.
9 Karl Friedrich Schinkel, 1830/40. *Aus Schinkels Nachlaß*. Edited by Alfred von Wolzogen. Berlin, 1862.
10 Aymer Vallance. *Mr Arthur H. Mackmurdo and the Century Guild*. Quoted in *The Studio*, Vol. 16, No. 73, London, 1899, p. 187.
11 Translation, c.f. Charles Robert Ashbee. *Craftsmanship in Competitive Industry*. London, 1908.

12 See note 11.
13 See note 6.
14 Translation, c.f. Richard William Lethaby. *Architecture and Modern Life*. Essay for the Royal Institute of British Architects, London, 1917. In this essay Lethaby ironically refers to William Morris's critics with whom he does not agree.
15 Henry van de Velde. *Déblaiement d'Art*. Lecture, Brussels, 1894. Quoted in *Zum neuen Stil*. From his writings, selected and introduced by Hans Curjel, Munich, 1955.
16 Translation, c.f. Walter Crane. *Line and Form*. London, 1900.
17 See note 16.
18 See note 16.
19 Friedrich Haack. *Grundriss der Kunstgeschichte – Die Kunst des XIX. Jahrhunderts*. Esslingen am Neckar, 1904.
20 Translation, quoted from André Maurois, *Engländer*, Munich, 1933.
21 Translation, quoted from André Maurois, *Engländer*, Munich, 1933.
22 Inscription on Aubrey Beardsley's grave chosen by Beardsley himself from a short text which accompanied his drawing *The Death of Pierrot* in *The Savoy*, October 6 1896, p. 32.
23 Haldane Macfall. *Aubrey Beardsley. The Man and his Work*. London, 1971.
24 Robert Schmutzler. *Art Nouveau – Jugendstil*. Stuttgart, 1962.
25 Hans Hermann Hofstätter. *Aubrey Beardsley – Zeichnungen*. Cologne, 1977.
26 Translation, quoted from Hans H. Hofstätter, *Aubrey Beardsley*, Zeichnungen, Cologne, 1977.
27 Translation, quoted from Sir John Rothenstein, introduction to Brian Reade's *Aubrey Beardsley*, Stuttgart, 1969.

Glasgow (p. 52–69)

1 Julius Posener. *Charles Rennie Mackintosh – Das englische Landhaus. Vorlesung zur Geschichte der Neuen Architektur III*. Quoted in *59 Arch+*, Aachen, 1981.
2 Quoted from a letter to Andrew McLaren Young, 1967, whilst preparing for the exhibition *Charles Rennie Mackintosh 1868–1928 – Architecture, Design and Painting*, Edinburgh, 1968.
3 See note 2.
4 See note 1.

5 Hermann Muthesius. *The English House*. Edited by Dennis Sharp and translated by Janet Seligmann. Oxford, 1979, p. 52.
6 Quoted in Charlotte and Peter Fiell, *Charles Rennie Mackintosh*, Cologne, 1995, p. 22. Quoted from Gabriele Fahr-Becker, *Wiener Werkstätte*, translated by Karen Williams, Cologne, 1995, p. 59.
7 Ovid. *Metamorphosen III, 509/10 – Narcissus in florem*. Quoted from Dolf Sternberger, *Über den Jugendstil und andere Essays*, Hamburg, 1956.
8 Dolf Sternberger. *Zauberbann*. Quoted in *Über den Jugendstil und andere Essays*, Hamburg, 1956. Quoted from Gabriele Fahr-Becker, *Wiener Werkstätte*, translated by Karen Williams, Cologne, 1995, p. 15.
9 Ludwig Hevesi. *Altkunst – Neukunst*. Vienna, 1909.
10 Wolfram Waldschmidt. *Dante Gabriel Rossetti*. Jena – Leipzig, 1905.
11 Julius Meier-Graefe. *Entwicklungsgeschichte der modernen Kunst – Vergleichende Betrachtung der bildenden Künste zu einer neuen Ästhetik*. Vol. 2. Stuttgart, 1904.
12 Nikolaus Pevsner. *Pioneers of Modern Design*. 1975. Quoted from Charlotte and Peter Fiell, *Charles Rennie Mackintosh*, Cologne, 1995, p. 56.
13 See note 11.
14 Hermann Muthesius. *The English House*. Edited by Dennis Sharp and translated by Janet Seligmann. Oxford, 1979, p. 52. Quoted from Gabriele Fahr-Becker, *Wiener Werkstätte*, translated by Karen Williams, Cologne, 1995, p. 59.
15 See note 9.
16 See note 9.
17 See note 1.

Paris (pp. 70–105)

1 (In slow metamorphosis,/ white marble into white flesh,/ rosy flowers into rosy lips,/ are re-fused in different bodies.) Théophile Gautier. *Affinités secrètes. Madrigar pantheiste*. From the cycle *Emaux et camées*.
2 (We need religion for religion's sake, morality for morality's sake, art for art's sake. The way of usefulness, or even beauty, cannot be via the good and the holy.) Victor Cousin. *Cours de philosophie*. Collected lectures, published in Paris from 1826.
3 Translated from Paul Verlaine, *Confessions*, Paris, 1895.
4 Contemporary account, 1871. Quoted from Günter Metken, *Fest des Fortschritts* [Festival of Progress]. Quoted in *Weltausstellungen im 19. Jahrhundert* [World expositions in the 19th century], exposition catalog, Munich, 1973.
5 See note 4.
6 Ernst Robert Curtius. *Französischer Geist im 20. Jahrhundert* [French spirit in the 20th century]. Marburg, 1952.
7 Quoted from Karl Marx, *Klassenkämpfe in Frankreich* [Class struggles in France]. Quoted in *Neue Rheinische Revue*, 1852.
8 (This piece of iron must be arranged with taste; it must be placed logically, with method, and it is only in this way that you will find true beauty.) Hector Guimard. *La Renaissance de l'Art dans l'Architecture moderne* [The renaissance of art in modern architecture]. Quoted in *Le Moniteur des Arts*, Paris, 1899.
9 Quoted from Hector Guimard. In *Architektur in Paris um 1900* [Architecture in Paris around 1900], exposition catalog, Munich, 1975.
10 Karl Boetticher. *Das Prinzip der Hellenischen und der Germanischen Bauweise hinsichtlich der Übertragung in die Bauweise unserer Tage* [The principle of Hellenic and Germanic building styles with regard to its transference into the building styles of the present day].

Quoted in Schinkel Memorial Speech, Berlin, March 13 1846.
11 Dolf Sternberger. *Zauberbann* [Magic spell]. Quoted in *Über den Jugendstil und andere Essays* [On Art Nouveau, and other essays], Hamburg, 1956.
12 Ludwig Hevesi, *Le Castel Béranger*. Quoted in *Acht Jahre Sezession (März 1897–Juni 1905) – Kritik, Polemik, Chronik* [Eight years of the secession movement, March 1897–June 1905 – A critique, polemic and chronicle], Vienna, 1906.
13 See note 12.
14 See note 12.
15 See note 12.
16 See note 12.
17 See note 12.
18 Sherban Cantancuzino. *Hector Guimard*. Quoted in *The Anti-Rationalists*, edited by James M. Richards and Nikolaus Pevsner, London, 1973.
19 (He said to me: I dreamt this night/ I had tresses round my neck/ I had your hair like a black necklace/ Around my nape and on my breast …) Pierre Louÿs. *La Chevelure*. From the poem cycle *Chansons de Bilitis*, 1895.
20 Hans Hermann Hofstätter. *Symbolismus und die Kunst der Jahrhundertwende* [Symbolism and *fin-de-siècle* art]. Cologne, 1978.
21 Quoted from *Sammlung Ian Woodner* [The Ian Woodner Collection], exhibition catalog, Munich, 1986.
22 Quoted from Atsushi Tanigawa, *Art Nouveau as a Phenomenon of the Arabesque* in *Art Nouveau*, exhibition catalog, Tokyo, 1990.
23 See note 22.
24 I saw the Devil the other night;/ And, underneath his skin,/ It was not easy to determine/ Whether to say of him She or He. Paul Jean Toulet (1867–1920). *Le Garno*. From the cycle *Le Contrerimes*.
25 Enrique Gómez Carillo, who has written a book called *Die Salome*, quoted from the Insel Almanac for the year 1906.
26 (Speak to me softly;/ speak without voice to my soul.) Marceline Desbordes-Valmore (1786–1859). *Elégies*.
27 No byline. In *Neues Wiener Journal*, 1900.
28 Albrecht Bangert. *Jugenstil–Art Deco, Schmuck und Metallarbeiten* [Art Nouveau–Art Deco, ornament and metalwork]. Munich, 1981.
29 Quoted from *René Lalique, Catalog of the Gulbenkian Collection*, Lisbon, 1982.
30 Samuel Bing. *Japanischer Formenschatz* [Treasury of Japanese forms]. Hamburg, 1989.
31 (These nymphs, I want to perpetuate them.) Stéphane Mallarmé. *Le Faune, Eglogue* [The faun, an eclogue]. From the cycle *L'Après-midi d'un faune*.
32 Quoted from *Alfons Mucha 1860–1939*, exhibition catalog, Darmstadt, 1980.
33 Translated from Eugène Samuel Grasset, *La Plante et ses applications ornamentales* [Plants and their use as ornament], Paris, 1897–1899.
34 Alfons Mucha. *Three Statements on Life and Work*. Brno, 1936.
35 Quoted from Julius Meier-Graefe, *Die Doppelte Kurve – Essays* [The double curve – essays], Berlin, 1924.
36 Julian Marchlewski. *Sezession und Jugendstil – Kritiken um 1900* [Secession and Art Nouveau – critiques from around 1900]. Dresden, 1974.
37 Riichi Miyake. *Ein Streifzug durch den europäischen Jugendstil* [A brief survey of Art Nouveau in Europe]. Dortmund, 1991.
38 Quoted from Le Corbusier, *Vers une Architecture*, Paris, 1958, p. 165.
39 Friedrich Ahlers-Hestermann. *Stilwende – Aufbruch der Jugend um 1900* (A change of style – the emergence of youth around 1900). Berlin, 1941.
40 Loïe Fuller. *Quinze ans de ma vie* [Fifteen years of my life]. Paris, 1908.

41 Henri de Toulouse-Lautrec, 1881. Quoted and translated from Maurice Joyant, *Henri de Toulouse-Lautrec 1864–1901, Peintre* [Henri de Toulouse-Lautrec, 1864–1901, painter]. Paris, 1926.
42 Quoted from Armand Lanoux, *Amour 1900* [Love 1900], Hamburg, 1964.

Nancy (pp. 106–129)

1 (I gather mysterious flowers in secret.) Alfred de Musset (1810–1857). *Poésies nouvelles*.
2 (Come too close and you'll be pricked.)
3 (My roots are in the depths of the woods.) Émile Gallé. *Écrits pour l'Art, 1884–1889*. Edited by Henriette Gallé-Grimm, Paris, 1909.
4 (The flora of Lorraine has provided us with models for our art.) *Programme de l'École de Nancy*, 1901. Published in the foreword of the exhibition catalog *Exposition lorraine des arts du décor*, Paris, 1903.
5 Henri Frantz, in *The Studio*, Vol. 28, 1903, p. 109.
6 Joris-Karl Huysmans, *A rebours*, Paris, 1884.
7 Roger Marx, *Émile Gallé – Pyschologie de l'artiste et synthèse de l'oeuvre* [Émile Gallé – psychology of the artist and synthesis of his work]. Quoted in *Bulletin des Sociétés Artistiques de l'Est*, Nancy, 1904.
8 (Let us bless the whim of fate in getting a Japanese born in Nancy.) Émile Gallé. *Le Décor symbolique* [Symbolic decoration]. Inaugural speech at the public session of the Académie de Stanislas, Nancy, May 17 1900. Gallé had been elected a member in 1891. Published in *Mémoires de l'Académie de Stanislas*, Vol. 17, 5th series.
9 Henri Frantz. "Art at Nancy, Émile Galle" in *The Magazine of Art*, March 1897, p. 249.
10 (All objects have outlines; but whence comes the form that moves us?) Émile Gallé, see note 3.
11 Translated from Émile Gallé, see note 3.
12 Philippe Garner. *Émile Gallé*. Munich, 1979.
13 Translated from Marcel Proust, *Le Côté de Guermantes*, in *À la recherche du temps perdu*, Paris 1913–27.
14 Translated from Marcel Proust, *A l'ombre des jeunes filles en fleurs*, in *À la recherche du temps perdu*, Paris 1913–1927.
15 (The decoration of modern furniture will have expression because the artist, in communion with nature, cannot remain insensitive to the nobility of living forms.) Émile Gallé. *Le Mobilier contemporaine orné d'après la nature*. Quoted in *Revue des Arts décoratifs*, Nov./Dec., 1900.
16 Roger Marx, see note 7.
17 Robert Schmutzler. *Art Nouveau – Jugendstil*. Stuttgart, 1962.
18 Translated from Émile Gallé, see note 3.
19 (This wealth of documentation, this warmth of poetic excitement necessary for decorative composition – the artist will never exhaust it in putting together line and color.) *Programme de l'École de Nancy*, 1901, see note 4.
20 Translated from Émile Gallé, see note 3.
21 Julian Marchlewski, see note 36, Paris.
22 Julius Meier-Graefe, see note 35, Paris.
23 Julius Meier-Graefe, *Die Weltaustellung in Paris 1900* [The World Exposition in Paris 1900]. Paris–Leipzig, 1900.
24 (To apply industrially the true principles of decorative art.) Henri Clouzot. *Daum verrerie d'art*. Nancy, 1930.
25 (Because we want more light and shade/ No colour, nothing but light and shade!) Paul Verlaine. *Jadis et naguère*. From the cycle *Art poétique*.
26 Max Bill. *Ich und die Stangenvasen* [Stem vases and I]. Quoted in *Nancy 1900 – Jugendstil in Lothringen* [Nancy 1900 – Art Nouveau in Lorraine], exhibition catalog, Munich–Mainz, 1980.
27 (We have sought to derive from natural documents the methods, components, and character needed to create a

modern style of ornamentation, a color or sculptural clothing suited to modern practice.) *Programme de l'ecole de Nancy*, 1901, see note 4.

Belgium (pp. 130–161)

1 (This spectacle has an indefinable magic, something supernatural, to ravish the mind and the senses.) Jean-Jacques Rousseau (1712–78). *Discours sur les sciences et les arts*. Paris, 1750.
2 Sar Mérodack Joséphin Péladan. *Rosicrucian manifesto*, preface to the catalog of the 1st exhibition of the Salon de la Rose-Croix at Durand-Ruel, Paris 1892. Quoted from Richard Muther, *Geschichte der Malerei im 19. Jahrhundert* [History of painting in the 19th century], Munich, 1893–94.
3 Dolf Sternberger. *Über den Jugendstil und andere Essays* [On Art Nouveau, and other essays]. Hamburg, 1956.
4 (The flesh is sad, alas! and I have read all the books.) Stéphane Mallarmé. *Brise Marine*.
5 Jean Moréas. *Le Symbolisme* [Symbolist manifesto]. Quoted in *Figaro Littéraire*, September 18 1886 (first issue). Quoted from Fritz Heinmann, *Symbolische Kunst* [Symbolic art], Dissertation, Berlin, 1926.
6 Stéphane Mallarmé. Quoted from foreword to exhibition catalog of *Cinquantenaire du Symbolisme*, Paris, 1936.
7 Walter Leistikow. *Moderne Kunst in Paris* [Modern art in Paris]. No place or year.
8 Maurice Maeterlinck. Quoted from Dolf Sternberger, see note 3.
9 Hermann Bahr. In *Ver Sacrum*, 1898.
10 Gottfried Semper. *Vorläufige Bemerkungen* [Provisional remarks]. N.P., 1834.
11 Eugène Emmanuel Viollet-le-Duc. *Dictionnaire raisonné de l'architecture française*. Paris, 1854–69.
12 Quoted from Dolf Sternberger, see note 3.
13 Dolf Sternberger, see note 3.
14 (A double-flight staircase of green marble echoed by a glass ceiling …) *Mémoires Horta*, archives inédites [unedited papers]. Quoted from Horta exhibition catalog, Brussels, 1973.
15 Quoted from Dolf Sternberger, see note 3.
16 Gottfried Semper. *Wissenschaft, Industrie, Kunst* [Science, Industry, Art]. Mainz – Berlin, 1966.
17 No byline. In *Dekorative Kunst* [Decorative art], Vol. 4, 1899.
18 Adolf Loos. T*rotzdem 1900–1930. Sammlung der Dokumente des Kampfes* [Nevertheless 1900–1930. Collected documents of the struggle]. Innsbruck, 1930.
19 (Your eyes, where nothing is revealed,/ Either sweet or bitter,/ Are two cold gems in which mingle/ Gold and iron.) Charles Baudelaire (1821–67).
20 (Snowing white bouquets of perfumed stars.) Stéphane Mallarmé, *Apparition*.
21 Joris-Karl Huysmans. *Le dîner de denil* In *A rebours*, Paris, 1884.
22 Henry van de Velde, maiden speech at Royal Academy in Antwerp, 1893. Published in *L'Art Moderne*, 1893/94 and in *Prinzipielle Erklärungen*, from *Kunstgewerbliche Laienpredigten* [Statements of principle, from lay sermons of arts and crafts], Leipzig–Berlin, 1902.
23 Julius Posener. *Jugendstil* [Art Nouveau]. Lecture, in *59 Arch+*, Aachen, 1981.
24 The first model dates from 1896.
25 Kurt Bauch. *Einleitung* [Introduction]. Quoted in *Jugendstil – Der Weg ins 20. Jahrhundert* [Art Nouveau – the way to the 20th century]. Edited by Helmut Seling, Heidelberg – Munich, 1959.
26 Klaus-Jürgen Sembach. *Henry van de Velde*. In special issue of Zürich-based periodical *DU* on Art Nouveau in Belgien [Art Nouveau in Belgium], May, 1975.
27 Henry van de Velde. *De XX* [Les Vingt]. In *Van Nu en Straks*, 1893.

28 In *Le Précurseur*, May 10 1893. Quoted from *Henry van de Velde – Ein Europäischer Künstler seiner Zeit* [A European artist of his time], exhibition catalog, Hagen, 1992.
29 Henry van de Velde. *Kunstgewerbliche Laienpredigten* [Lay sermons of arts and crafts]. Leipzig–Berlin, 1902.
30 Julius Meier-Graefe. Quoted in *Dekorative Kunst* [Decorative art], Vol. 2, 1898.
31 Julius Meier-Graefe. Quoted in *Illustrierte Frauen-Zeitung* [Illustrated women's paper], May 1 1896.
32 Klaus-Jürgen Sembach, see note 26.

The Netherlands (pp.162–177)

1 Quoted from *Fernand Khnopff 1858–1921*, exhibition catalog, Tokyo, 1990.
2 Dolf Sternberger. *Zauberbann* [Magic spell]. Quoted in *Über den Jugendstil und andere Essays* [On Art Nouveau, and other essays], Hamburg, 1956.
3 (He hewed, filed down and sculpted a perverse ability, a science of parish, without light and without anguish.) Émile Verhaeren. *Le Menuisier*. From the cycle *Les Villages illusoires*.
4 Cornelius Gurlitt. *Im Bürgerhaus*. Dresden, 1887.
5 Quoted from Thomas Zacharias, *Blick der Moderne*, Munich/Zürich, 1984.
6 Hendrik Petrus Berlage. *Gedanken über den Stil in der Baukunst* [Thoughts on style in architecture]. Leipzig, 1905.
7 Julius Posener. *Berlage und Dudok*. Lecture in *48 Arch+*, Aachen, 1979.
8 Piet Mondrian. In *De Stijl*, 1919.
9 Quoted from Thomas Zacharias, see note 5.
10 Dolf Sternberger, see note 2.

Italy and Russia (pp. 178–193)

1 Gabriele D'Annunzio. *Il piacere* [Pleasure]. Milan, 1889.
2 Julian Marchlewski, *Sezession und Jugendstil – Kritiken um 1900* [Secession and Art Nouveau – critical essays around 1900]. Dresden, 1974.
3 (Oriental splendor spoke discreetly to the soul in its sweet native tongue.) Charles Baudelaire (1821–67). *Spleen et idéal, L'invitation au voyage*. From the cycle *Les Fleurs du mal*, Paris, 1857.
4 (… a uniform style that is nothing but Austro-German style.) Quoted from E. Godoli, *Polemiche sull'architettura dell'esposizione* [Critiques of exposition architecture], in *Torino 1902 – Le Arti Decorative Internazionali del Nuovo Secolo* [The international decorative arts of the new century], exhibition catalog, Turin, 1994.
5 F. T. Marinetti, *Establishment and Manifesto of Futurism*, 1909. Quoted from Umbro Apollonio, *Der Futurismus* [Futurism], Cologne, 1972.
6 Quoted from Ute Stempel's epilogue to German-language edition of Gabriele D'Annunzio's *Il piacere* [Pleasure]. Zürich, 1994.
7 See note 7.
8 See note 7.
9 See note 7.
10 Carlo Carrà. *Die Malerei der Töne, Geräusche und Gerüche* [Painting colors, sounds, and smells]. 1913. Quoted from Umbro Apollonio, see note 5.
11 (The renaissance of the decorative arts.)
12 Quoted from Italo Cremona, *Die Zeit des Jugendstils* [The Art Nouveau Era], Munich/Vienna, 1966.
13 Julian Marchlewski, see note 2.

Barcelona (pp. 194–211)

1 Joaquim Torres Garcia. *Mestre Antoni Gaudí – Universalismo constructivo*. Montevideo, 1929.

2 Julius Posener. *Jugendstil*. Lecture in *59 Arch+*, Aachen, 1981.
3 Quoted from Masayuki Irie, *Besuch des Professors Kenji Imai in Barcelona im Jahr 1926* [Professor Kenji Imai's visit to Barcelona in 1926]. Quoted in *Antoni Gaudí*, exhibition catalog, Barcelona–Munich, 1986.
4 Translation, c.f. Richard Ford. *Handbook for Travellers in Spain*. London, 1845.
5 See note 4.
6 *Vicens Vives*, Report on the session of the Unió Catalanista, in the town hall at Manresa, March 27 1892, quoted in *Antoni Gaudí*, exhibition catalog, Barcelona, 1986.
7 Quoted from Joseph Palau i Fabre, *Picasso – Kindheit und Jugend eines Genies, 1881–1907* [Picasso – childhood and youth of a genius, 1881–1907], Munich, 1981.
8 *La Illustración*, Josep Palau i Fabre, see note 7.
9 Roberto Pane. *Antoni Gaudi*. Milan, 1982.
10 Juan Bassegoda Nonell. *Der Mensch Gaudí*. Quoted in exhibition catalog, see note 3.
11 Quoted from César Martinelli, *Gaudí – His Life, His Theories, His Work*, Barcelona, 1975.
12 See note 11.
13 See note 11.
14 Juan Bassegoda Nonell. Introduction to exhibition catalog, see note 3.
15 Juan Bassegoda Nonell, *Mozart und Gaudí – Antoni Gaudí, Barcelona, February 13 1984*. Quoted in exhibition catalog, see note 3.
16 Quoted from Juan Bassegoda Nonell, *Das Religiöse und Mystische* [The religious and the mystic]. Quoted in exhibition catalog, see note 3.
17 *La Illustración*, Juan Bassegoda Nonell, see note 16.
18 Quoted from César Martinelli, see note 11.
19 (Friends, nature is going Psst! Psst! at us.) Le Corbusier. *Vers une architecture*. Paris, 1958.
20 Quoted from César Martinelli, see note 11.
21 James Hillman. *Der Mythos der Analyse*. Frankfurt am Main, 1972.
22 Quoted from Masayuki Irie, see note 3.

Munich (pp. 212–233)

1 Stefan George (1886–1968). *Der Dichter und sein Kreis*. Marbach, 1968.
2 Hans Rosenhagen. *Münchens Niedergang als Kunststadt*. Munich, 1902.
3 Thomas Mann. *Betrachtungen eines Unpolitischen*. Munich, 1918.
4 Thomas Mann. *Gladius Dei*. Munich, 1902.
5 See note 3.
6 August Endell. *Vom Sehen*. Quoted in *Die Neue Gesellschaft*, Vol. 1, 1905.
7 See note 3.
8 August Endell. *Um die Schönheit – Eine Paraphrase über die Münchner Kunstausstellung 1896*. Munich, 1896.
9 Quoted from *Leben und Meinungen des Bildhauers Josef Hartwig*. No single author, Frankfurt/Main, 1955.
10 Quoted from Jürgen Kolbe, *Heller Zauber – Thomas Mann in München 1894–1933*. Munich, 1987.
11 Hermann Obrist. *Nachlaßschriften*. Quoted from Siegfried Wichmann, *Hermann Obrist – Wegbereiter der Moderne*, exhibition catalog, Munich, 1968.
12 August Endell. Quoted in *Berliner Architekturwelt*, Vol. 4, 1902.
13 Hermann Obrist, see note 11.
14 Georg Fuchs. *Hermann Obrist*. In *Pan*, No. 1, Berlin, 1896.
15 See note 11.
16 Hermann Obrist, see note 11.
17 Friedrich Naumann. *Deutsche Gewerbekunst*. Berlin, 1908.

18 Paul Klee, 1898. Quoted in *Tagebücher 1898–1918*, No. 68, edited by Felix Klee, Cologne, 1957.
19 Otto Julius Bierbaum. *Stuck*. Bielefeld–Leipzig, 1899.
20 Quoted from Anton Sailer, *Franz von Stuck – Ein Lebensmärchen*, Munich, 1969.
21 Dolf Sternberger. *Das Reich der Schönheit*. Quoted in *Über den Jugendstil und andere Essays*, Hamburg, 1956.
22 BHStA MK 14 095 (Bavarian State Archives Department I and archive number). Quoted from Thomas Zacharias, *Akademie zur Prinzregentenzeit*. Quoted in *Franz von Stuck und seine Schüler*, exhibition catalog, Munich, 1989.
23 Michael Georg Conrad, Anna Crossant-Rust and Hans Brandenburg (eds.). *Otto Julius Bierbaum zum Gedächtnis*. Commemorative publication, Munich, 1912.
24 In *Jugend*, No. 3, 1896.
25 In *Kunst und Künstler*, 1903.
26 Max Halbe. *Jahrhundertwende*. Munich, 1926.
27 Quoted from Jürgen Kolbe, *Heller Zauber – Thomas Mann in München 1894–1933*, Munich, 1987.
28 Caption accompanying the caricature *Der Münchner Jugend-Brunnen* [The Munich fountain of youth] in: *Simplicissimus*, 1897.
29 Rudolf Alexander Schröder. *Aus Kindheit und Jugend*. Munich, 1934.
30 Walter Gropius in the Preface to the Programme of the State Bauhaus, Weimar, April 1919. Quoted from Hans M. Wingler, *Das Bauhaus*, Cologne–Bramsche, 1975.
31 Julius Posener. *Peter Behrens I – Vorlesungen zur Geschichte der Neuen Architektur III*. Quoted in *59 Arch+*, Aachen, 1981.
32 Georg Fuchs. *Angewandte Kunst in der Secession zu München 1899*. Quoted in *Deutsche Kunst und Dekoration*, Vol. 5, 1899/1900.
33 Dolf Sternberger. *Zauberbann*. Quoted in *Über den Jugendstil und andere Essays*, Hamburg, 1956.

Darmstadt (pp. 234–253)

1 Friedrich Ahlers-Hestermann. *Stilwende – Aufbruch der Jugend um 1900*. Berlin, 1941.
2 Letter from the banker Osthaus to his young son Karl Ernst, the later patron of Henry van de Velde and a great champion of Jugendstil. Quoted from Karl Ernst Osthaus, *Leben und Werk*, Recklinghausen, 1971.
3 Quoted from Golo Mann, *Der letzte Großherzog*, Darmstadt, 1977.
4 See note 3.
5 See note 3.
6 Joseph Maria Olbrich. *Ideen von Olbrich*. Vienna, 1900.
7 Quoted from Henry van de Velde, *Zum neuen Stil*. From his writings, selected and with an introduction by Hans Curjel, Munich, 1955.
8 Ludwig Hevesi. *Acht Jahre Secession (März 1897–Juni 1905) – Kritik, Polemik, Chronik*. Vienna, 1906.
9 See note 6.
10 Erich Mendelsohn. *Das Problem einer neuen Baukunst*. Berlin, 1919.
11 Henry Paris. *Einige Stunden bei Professor Olbrich*. Quoted in *Echo de Paris*, 1906, translated by Micheline Schöffler.
12 Julius Posener. *Peter Behrens I – Vorlesungen zur Geschichte der Neuen Architektur III*. Quoted in *59 Arch+*, Aachen, 1981.
13 Friedrich Nietzsche. *Thus spake Zarathustra*, III, *The Bedwarfing Virtue*. Translated by Thomas Common. London, 1967.
14 Hans Christiansen. In *Deutsche Kunst und Dekoration*, Vol. 2, 1898.
15 Hans Christiansen. In *Die Ausstellung der Künstler-. Kolonie Darmstadt 1901 – Main catalogue: Die Ausstellungsbauten*, Darmstadt, 1901.

16 W. Stöffler. *Kunst und Industrie*. Quoted in *Zeitschrift für bildende Kunst*, 1907.
17 Quoted from *Darmstädter Tagblatt* of July 14 1901.
18 Quoted from Brigitte Rechberg, *Das Überdokument 1901 auf der Mathildenhöhe*. Quoted in *Ein Dokument Deutscher Kunst 1901–1976*, exhibition catalog, Vol. 5, Darmstadt, 1976.
19 Julius Meier-Graefe. *Darmstadt – Athen*. Quoted in *Die Zukunft*, Vol. 39, 1902.
20 Alfred Lichtwark. *Briefe an die Kommission für die Verwaltung der Kunsthalle*. Edited by Gustav Pauli. Hamburg, 1923.
21 Albin Müller. *Aus meinem Leben*. Typed manuscript. Darmstadt, undated (ca. 1940).
22 Paul Ferdinand Schmidt. Commemorative publication upon the 25th anniversary of the reign of his Royal Highness the Grand Duke Ernst Ludwig von Hessen und bei Rhein. Leipzig, 1917.

Berlin (pp. 254–281)

1 Quoted from Henry van de Velde. *Zum neuen Stil*. From his writings, selected and with an introduction by Hans Curjel, Munich, 1955.
2 Wilhelm II. Speech at the inauguration of the Siegesallee, Berlin, December 18 1901.
3 Quoted from Golo Mann, *Der letzte Großherzog*, Darmstadt, 1977.
4 Quoted from *Edvard Munch – Liebe, Angst, Tod*, exhibition catalog, Bielefeld, 1980.
5 Peter Behrens. *Walter Leistikow*. In *Dekorative Kunst*, Vol. 3, 1899.
6 Quoted from Henry F. Lenning, *Julius Meier-Graefe*, New York, 1942.
7 See note 6.
8 Julius Meier-Graefe. *Die doppelte Kurve – Essays*. Berlin, 1924.
9 Paul Wunderlich. *Der Stein und ich*. In *Die Zeit*, No. 37, 1980.
10 Henry van de Velde. *Zum Tode Otto Eckmanns*. In *Innendekoration*, Vol. 8, 1902.
11 G. Mourey. "The Salon of the Champ de Mars" in *The Studio*, vol. 8, 1896, p. 17.
12 Friedrich Nietzsche. *Sils-Maria*. 1884. Quoted from Robert Saitschik, *Dichter und Denker*, Zurich, 1949.
13 Hans Sedlmayr. *Die Revolution der modernen Kunst*. Cologne, 1985.
14 Rainer Maria Rilke. *Worpswede*. Bielefeld–Leipzig, 1903.
15 Walter Gropius. *Monumentale Kunst und Industrie*. Lecture given in Hagen on January 29 1911.
16 Ludwig Hevesi. *Altkunst – Neukunst*. Vienna, 1909.
17 Julius Posener. *Peter Behrens I – Vorlesungen zur Geschichte der Neuen Architektur III*. In *59 Arch+*, Aachen 1981.
18 Count Harry Kessler. *Aus den Tagebüchern* (diary entry of May 16 1926). Frankfurt/Main, 1965.
19 Rainer Maria Rilke. *Über Kunst*. 1898.

Scandinavia (pp. 282–311)

1 Bjørnstjerne Bjørnson. *Das Licht – eine Universitätskantate*. In *Pan*, No. 3, 1896.
2 Edvard Munch. *Diaries*. Quoted from *Edvard Munch 1863–1944*, exhibition catalog, Munich–Salzburg–Berlin, 1987.
3 Gert Reising. *Zur Psyche im Jugendstil*. Quoted in *Ein Dokument Deutscher Kunst 1901–1976*, exhibition catalog, Darmstadt, 1976.
4 See note 2.
5 Gabriele D'Annunzio. *In Vano – Poema paradisiaco*. Quoted from Dominik Jost, *Literarischer Jugendstil*, Stuttgart, 1980.
6 See note 2.

7 See note 2.
8 See note 2.
9 Max Lüthi. *Das europäische Volksmärchen*. Berne, 1947.
10 Jens Thiis. *Gerhard Munthe*. German translation by Jan Opstad. Trondheim, 1904.
11 Quoted from *Gerhard Munthe 1849–1929, Bildteppiche*. Exhibition catalog, Munich–Hamburg–Berlin, 1989.
12 Quoted from Hans Hermann Hofstätter, *Jugendstil – Druckkunst*, Baden-Baden, 1973.
13 See note 10.
14 See note 10.
15 Quoted and translated from *Antell Collection – Ateneum Guide*, Helsinki, 1987.
16 Hugo Simberg. Quoted and translated from *Antell Collection – Ateneum Guide*, Helsinki, 1987.
17 Ville Vallgren. Quoted and translated from *Antell Collection – Ateneum Guide*, Helsinki, 1987.
18 Contemporary review of the Finnish Pavilion at the World Exposition of 1900 in Paris. Quoted and translated from *Finskt 1900*, exhibition catalog, Stockholm, 1971.
19 Walter Leistikow. *Moderne Kunst in Paris*. N.p., n.d.
20 Richard Dehmel in a letter to Arno Holz. Quoted from Richard Dehmel, *Ausgewählte Briefe 1883–1902*, Berlin, 1923.
21 Quoted from *100 Jahre Architektur in Chicago*, exhibition catalog, Munich, 1973.
22 Ulf Hård af Segerstad. *Skandinavische Gebrauchskunst*. Stockholm–Frankfurt/Main, 1961.
23 Henrik Ibsen. *Die Wildente – Dramen*. Ottobrunn bei Munich, 1982.
24 See note 22.
25 See note 22.
26 Dolf Sternberger. *Jugendstil – Begriff und Physiognomik*. Quoted in *Neue Rundschau*, June 1934.
27 Bo Gyllensvärd. *Introduction*. Quoted in *Kina och Norden*, exhibition catalog, Stockholm–Munich, 1970; German edition by Gabriele Sterner.
28 Karl Madsen. *Japansk Malerkunst*. Copenhagen, 1885.
29 Gerhard Munthe and "The movement that from Japan is moving across Europe now" in *Scandinavian Journal of Design History*, no. 4, 1994.
30 Quoted from Erich Köllmann, *Porzellan*, in *Jugendstil – Der Weg ins 20. Jahrhundert*. Edited. by Helmut Seling, Heidelberg–Munich, 1959.
31 Review of ca. 1900. Quoted from Helmut Seling, *Silber und Schmuck*, in *Jugendstil – Der Weg ins 20. Jahrhundert*, edited by Helmut Seling, Heidelberg–Munich, 1959.

New York and Chicago (pp. 312–333)

1 Louis Henry Sullivan, 1901. Quoted from *Kindergarten chats*, New York, 1947, p. 44.
2 Translation, c.f. Charles Robert Ashbee. *Frank Lloyd Wright – Eine Studie zu seiner Würdigung*. Berlin, 1911.
3 Translation, c.f. *The Lost Treasures of Louis Comfort Tiffany*, New York, 1980.
4 See note 3.
5 Quoted from Hugh F. McKean, *Louis Comfort Tiffany*, Weingarten, 1981,
6 See note 5.
7 Cecilia Waern. "The Tiffany or 'Favrile-Glass' – The Industrial Arts of America" in *The Studio*, June 1898.
8 See note 5.
9 Quoted from *Die Lithographie*, exhibition catalog, Bremen, 1976.
10 Kurt Bauch. *Introduction*. In *Jugendstil – Der Weg ins 20. Jahrhundert*, edited by Helmut Seling, Heidelberg–Munich, 1959.
11 Louis Henry Sullivan. *A System of Architectural Ornament According with a Philosophy of Man's Power*. New York, 1924.

12 John Ruskin. "The Lamp of Beauty" in *The seven lamps of architecture.* London, 1849, p. 122.
13 Louis Sullivan. 'The Auditorium and the High Rise 1886–95' in *Ornament in Architecture*, 1892, p. 51.
14 Adolf Loos. *Ins Leere gesprochen 1897–1900.* Innsbruck, 1931.
15 Peter C. von Seidlein. *Die erste Chicago School of Architecture.* Quoted in *100 Jahre Architektur in Chicago*, exhibition catalog, Die Neue Sammlung, Munich, 1973.
16 Louis Sullivan, "The Tall Building Artistically Considered", 1896.
17 See note 16.
18 Louis Henry Sullivan, 1901. Quoted from *Kindergarten chats*, New York, 1947, p. 44.
19 Frank Lloyd Wright. *An American Architect.* New York, 1955.
20 Translation, quoted from Charles Robert Ashbee, *Frank Lloyd Wright – Eine Studie zu seiner Würdigung*, Berlin, 1911.
21 Frank Lloyd Wright, "In the Cause of Architecture" (1908) in *Architectural Record*, New York, 1975, p. 55.
22 Translation, quoted from Charles Robert Ashbee, *Frank Lloyd Wright – Eine Studie zu seiner Würdigung*, Berlin, 1911.
23 Adolf Loos. *Trotzdem 1900–1930. Sammlung der Dokumente des Kampfes.* Innsbruck, 1931.
24 Translation, quoted from Charles Robert Ashbee, *Frank Lloyd Wright – Eine Studie zu seiner Würdigung*, Berlin, 1911.
25 See note 19.
26 Julius Posener. *Frank Lloyd Wright I – Vorlesungen zur Geschichte der Neuen Architektur.* Quoted in *48 Arch+*, special issue celebrating the 75th birthday of Julius Posener, Aachen, 1979.

Vienna (pp. 334–359)

1 Hermann Bahr. Speech on Klimt. Vienna, 1901.
2 Hermann Bahr. Quoted in *Ver Sacrum*, May/June 1898.
3 Adolf Loos. *Ornament und Verbrechen.* Vienna, 1908.
4 Karl Kraus. Quoted in *Die Fackel*, 1908/09.
5 See note 2.
6 Robert Musil. *Der Mann ohne Eigenschaften.* Hamburg, 1952.
7 Inscription on the front of the Secession building by Joseph Maria Olbrich in Vienna.
8 Ludwig Hevesi. *Zwei Jahre Secession.* In *Ver Sacrum*, September/October 1899.
9 Peter Altenberg (1862–1919), Vienna 1918. Quoted in *Peter Altenberg: Vita Ipsa.* Berlin, 1918.
10 Quoted from Christian M. Nebehay, *Gustav Klimt – Sein Leben nach zeitgenössischen Berichten und Quellen*, Munich, 1976.
11 Ludwig Uhland. *Gesammelte Werke.* Vol. 2. Edited by H. Fischer. Stuttgart, 1892.
12 Hans Tietze. *Gustav Klimts Persönlichkeit.* Vienna, 1919.

13 Ludwig Hevesi. *Acht Jahre Sezession (März 1897–Juni 1905) – Kritik, Polemik, Chronik.* Vienna, 1906.
14 Felix Salten. *Geister der Zeit – Erlebnisse.* Vienna–Leipzig, 1924.
15 Carl Moll. *Erinnerungen an Gustav Klimt.* In *Neues Wiener Tagblatt*, January 24 1943.
16 Handwritten note by Koloman Moser, archives of the Vienna City Library. Quoted from Michael Pabst, *Wiener Grafik um 1900.* Munich, 1984.
17 Joseph Olbrich. Quoted in *Der Architekt*, 1899. Quoted from Michael Pabst, *Wiener Grafik um 1900*, Munich, 1984.
18 See note 3.
19 Ludwig Hevesi. *Altkunst – Neukunst.* Vienna, 1909.
20 See note 6.
21 See note 14.
22 Marian Bisanz-Prakken. *Der Beethovenfries von Gustav Klimt in der XIV. Ausstellung der Wiener Secession (1902).* Quoted in *Traum und Wirklichkeit, Wien 1870–1930*, exhibition catalog, Vienna, 1985.
23 Karl Kraus. Quoted in *Die Fackel*, 1902/03.
24 Arthur Roeßler. *Zu den Bildern von Koloman Moser.* In *Deutsche Kunst und Dekoration*, vol. 33, 1913/14.
25 Otto Wagner. *Die Baukunst unserer Zeit – Dem Baukunstjünger ein Führer auf diesem Kunstgebiete.* 4th edition, Vienna, 1914.
26 Adolf Loos. *Die alte und die neue Richtung in der Baukunst.* Quoted in *Der Architekt*, 1898.
27 Peter Haiko. *Otto Wagner 1904–1907.* Quoted in *Traum und Wirklichkeit, Wien 1870–1930*, exhibition catalog, Vienna, 1985.
28 See note 25.
29 Julius Posener. *Otto Wagner – Die Rolle Hans Poelzigs vor 1918. Vorlesungen zur Geschichte der Neuen Architektur II – Die Architektur der Reform (1900–1924).* Quoted in *53 Arch+*, Aachen, 1980.
30 See note 25.
31 Translation, c.f. William Morris. *The Prospects of Architecture in Civilization.* Lecture. London, 1889.
32 Werner Blaser. *Furniture as Architecture – Architektur im Möbel.* Zurich, 1985.
33 Adolf Loos. *Trotzdem 1900–1930. Sammlung der Dokumente des Kampfes.* Innsbruck, 1931.
34 Robert Musil. [Diary Vol. 4] [?1899–1904 or later] *Blätter an dem Nachtbuche – des – monsieur le vivisecteur.* Quoted in *Tagebücher*, edited by Adolf Frisé, Reinbek bei Hamburg, 1976.
35 Adolf Loos. *Trotzdem 1900–1930. Sammlung der Dokumente des Kampfes*, Innsbruck, 1931.
36 Horst Viehoff. *Goethes Leben.* Vol. 1. Stuttgart, 1847–54.
37 Alexander Pope. *Miscellanies.* London, 1728.
38 Adolf Loos. *Das Andere*, 1903. In *Sämtliche Schriften*, edited by Franz Glück, Vienna–Munich, 1962.
39 Quoted from Burkhardt Rukschcio, 1909–1911, *Adolf Loos – Das Haus am Michaelerplatz.* Quoted in *Traum und Wirklichkeit, Wien 1870–1930*, exhibition catalog, Vienna, 1985.

Wiener Werkstätte (pp. 360–379)

1 Ludwig Hevesi. *Ein moderner Nachmittag.* Quoted in *Der kleine Salon*, edited by Hansjörg Graf, Stuttgart, 1970.
2 Quoted from Dominik Jost, *Literarischer Jugendstil*, Stuttgart, 1980.
3 Josef Frank. *Zu Josef Hoffmanns 60. Geburtstage.* Edited by the Österreichischer Werkbund, Vienna, 1930.
4 Carl Moll. *Erinnerungen an Gustav Klimt.* Quoted in *Neues Wiener Tagblatt*, January 24 1943.
5 Ludwig Hevesi. *Acht Jahre Sezession (März 1897 – Juni 1905) – Kritik, Polemik, Chronik.* Vienna, 1906.
6 (No single author) Quoted in *Innendekoration*, Vol. 8, 1902.
7 Leopold Wolfgang Rochowanski. *Josef Hoffmann.* Vienna, 1950.
8 In *Ver Sacrum*, Vol. 1, 1898.
9 Josef Hoffmann. *Arbeitsprogramm der Wiener Werkstätte* [Wiener Werkstätte work program]. Vienna 1905. Quoted from Werner J. Schweiger, *Wiener Werkstätte, Design in Vienna, 1903–1932*, London, 1984.
10 Josef August Lux. *Wiener Werkstätte – Josef Hoffmann und Koloman Moser.* Quoted in *Deutsche Kunst und Dekoration*, Vol. 15, 1904/05.
11 Julius Baum. *Wiener Werkstätte – Vienna.* Quoted in *Deutsche Kunst und Dekoration*, vol. 9, 1906/07.
12 Karl Marilaun. *Gespräche mit Josef Hoffmann.* In *Neues Wiener Journal*, 1918.
13 Ludwig Hevesi. *Altkunst – Neukunst.* Vienna, 1909.
14 Armin Friedmann. *Secessionistische Tafelfreuden.* Quoted in *Neues Wiener Tagblatt*, 1906.
15 Waltraud Neuwirth. *Österreichische Keramik des Jugendstils.* Vienna, 1974.
16 "The Art-Revival in Austria" in *The Studio*, 1906.
17 Egon Friedell. *Jubiläumsband zum 25jährigen Bestehen der WW.* Vienna, 1928.
18 Josef Hoffmann, unpublished manuscript from his estate. Quoted from Werner J. Schweiger, *Wiener Werkstätte – Kunst und Handwerk 1903–1932*, Vienna, 1982.
19 See note 13.
20 Berta Zuckerkandl. *Das Cabaret Fledermaus.* Quoted in *Wiener Allgemeine Zeitung*, 1907.
21 Karl Kraus. *Eine Kulturtat.* Quoted in *Die Fackel*, 1907/08.
22 Oskar Kokoschka. Letter to Erwin Lang. Quoted in *Agathon – Almanach auf das Jahr 48 des 20. Jhs*, edited by Leopold Wolfgang Rochowanski, Vienna, 1947.
23 Peter Behrens. *Josef Hoffmann.* Quoted in *Die Wiener Werkstätte 1903–1928, Modernes Kunstgewerbe und sein Weg.* Commemorative publication. edited by Mathilde Flögl. Vienna, 1929.
24 G. S. Salles. *Adolphe Stoclet Collection.* Brüssels, 1956.
25 Werner Hofmann. *Von der Nachahmung zur Erfindung der Wirklichkeit – Die schöpferische Befreiung der Kunst 1890–1917.* Cologne, 1970.
26 See note 4.

Glossary

à jour enamel
Abbreviated form of *plique à jour* enamel (q.v.).

amethyst
Type of quartz classified as a semiprecious stone and used in jewelry for its violet color.

amourette
Rare type of acacia tree belonging to the mimosa genus, used as a hardwood for inlay work.

androgyne
A creature that is physically and mentally a mixture of both sexes.

appliqué work
A sculptured lump of glass is fused on to the glass while still soft and worked after it cools down.

arabesque
A type of surface ornamentation derived from Islamic art. It consists of a pattern of lines and stylized plant motifs.

arborizing
Relating to sundry species of tree that grow in the open. Derived from *arboretum*, a garden planted with many kinds of trees growing in the open.

Astralit glass
Glass that after being cut appears almost black, but displays a red crystallization in direct sunlight.

baroque pearls
Pearls of irregular shape.

beaten
Sheet metal that has been hammered into shape with the aid of various chasing hammers or beak-irons and hand-hammers or molds.

bentwood
Wood shaped in steam at a temperature of 100–120°C. To prevent the wood cracking during the process, it is clamped and compressed between steel jaws. Straight-grained woods such as beech are particularly suitable.

broncit glass
The surface of the glass is covered with a black or brown, slightly metallic, lustrous coating. The ornamentation is then covered with lacquer and the uncovered undercoat is etched away with hydrofluoric acid so that the drawing is left black or brown on a matt glass surface.

bronze, gilt
The surface of the bronze is painted with a solution of mercury and gold and treated so that the mercury vaporizes and the gold sticks firmly to the undercoat. Also called ormolu.

bureau plat desk
A writing desk invented by the French ébéniste Charles Cressent (1685–1768). It has a rectangular writing surface, usually a leather top and stands on four feet.

buttress
Gothic wall support that is either solid against the wall or used as a prop (flying buttress), to counter the outward pressure from the roof.

cabochon
A precious stone with a dome-shaped cut.

cameo cut
Glass relief modeled on antique cameos.

candelabra
Candlestick with branches.

catenary arches
Arches superimposed on each other.

cantilevered
Having a projecting support carrying a higher part of the building (e.g. an arch).

carding
A process for napping material, in which the spinning material is passed through a card to clean it, remove knotted threads (burls) and expose the fibers. These are parallelized and arranged in a sliver or web as a connected pile. In the raising machine, the dried heads of fuller's teasels are used or any similar specially cultivated thistle-like plant.

caryatids
Pairs of sculptures in the shape of fully draped females acting as columns to support an entablature.

casein paint
Paint that includes casein as a binding agent. Casein is a constituent of lactoprotein, and lime paste or borax is used in its production.

chalcedony
A variety of quartz that takes its name from the ancient Greek city of Chalcedon on the Bosporus.

chamfered
Having a rectangular edge cut off or ground off diagonally.

champlevé enamel
Hollows are gouged or etched out of the metal base and filled with enamel.

chase
To work metal with a graver, chisel, file or similar tool in order to apply ornamentation.

chien yao
Shallow Japanese tea dishes that in earlier times were produced in China. Their glaze recalls rabbit fur, bird's feathers, turtle shells or oil spots. The predominant color tones of dark blue, brown, and green pan out from the center or form cloud-like patches. The glaze is applied in several layers which are fired several times. The result is that, as the light striking the surface varies, the color apparently keeps changing.

china grass
A species of nettle used to make matting.

chromolithic stoneware
Unglazed stoneware adorned with colored decor set in the still-moist body before firing.

chryselephantine
A combination of gold and ivory.

chrysoprase
Semiprecious stone resembling chrysoberyl, a green precious stone.

cire perdue
Bronze casting by means of 'lost wax': the sculpture is modeled in wax that was previously put on a clay core. A casting coat of fine sand or clay is then laid on the wax, hugging the shape of the wax. The wax is subsequently melted away and the bronze poured in the ensuing cavity. After casting, the mold is broken.

cloisonné enamel
Wires or stays are soldered on to the background to hold in the liquid enamel, but they remain visible. (Fr. *cloison* = partition)

Clutha glass
Green, turquoise-brown or even gray-colored glass which is mixed with copper crystals and finishes up shot with schlieren, streaks and bubbles. The name comes from the Anglo-Saxon word for the River Clyde in Scotland, whose cloudy waters are said to resemble the character of the glass.

coccolith slabs
Slabs cut from sedimentary rocks created by limestone algae deposits on the deep North Atlantic seabeds.

combing
Type of decoration obtained with a slate pencil or comb-like implement. The still-soft glass fibers are displaced to form wavy or feathered patterns.

cornice
A S-shape molding running horizontally along the top of a building; alternatively, the top of an entablature.

crackle glaze
Glaze containing deliberately produced fine cracks covering the surface like a web. The crackle arises from the different degrees of expansion between glaze and body.

crown glass
Flat glass for window panes produced by an ancient technique: the glassblower's pipe is revolved quickly to flatten the glass, which is subsequently drawn out by twisting the pontil. The pane that results is cut into semicircles. The thicker center part produces bull's-eye panes.

crystal glaze
Glaze in which crystals are deposited during cooling, more often dark than light but also in a different color.

curtain wall
In a building, an exterior wall with no load-bearing function. The wall components are latched to the frame.

cut glass
Glass finished by polishing or grinding.

Cymric
A range of silverware and jewelry sold by the London Art Nouveau firm Liberty & Co. The Celtic name was a tribute to the Welsh ancestors of Liberty director John Llewellyn.

De Stijl
A school of modern painting and applied art that limited itself to using only basic forms such as vertical and horizontal lines and primary colors. Such pure representation also had ethic objectives. The movement was set up by the Dutchman Theo van Doesburg, who from 1917 published a ideological monthly called De Stijl.

dichroic
Showing two colors in different directions.

Doric order
The most ancient of the three orders (Doric, Ionic, and Corinthian) used on Greek columns. The orders determined the shape and proportions of columns and entablature. In the Doric order (from c. 630 BC) the column has a shaft with no base but with vertical flutes, a rounded beveled capital and square cap.

earthenware
Unglazed, porous and usually darkish clayware, e.g. terracotta.

ébéniste
Cabinet-maker who specialized in veneered furniture, using ebony and other woods for inlays.

eggshell (or quasi) porcelain
A light, thin-walled frit porcelain with a glassy consistency and ivory coloring. Its composition is even today a trade secret of the porcelain manufacturer Haagsche Plateelbakkerij Rozenburg in The Hague.

églomisé see verre églomisé

electrolytic polishing
In glassmaking, a process that replaces mechanical polishing, during which unevennesses in the glass are removed with hydrofluoric acid.

émail see champlevé enamel, cloisonné enamel, mat velouté enamel, plique à jour enamel

émaux mattes
Matt and velvety enamels.

enamel paints
Enamel paints are mixed from pulverized glass and colored oxides. They are rubbed with turpentine and stand oil and applied to glass with an artist's brush. The paints are heated in a chamotte muffle away from steam and smoke until they melt and become shiny. Enamel paints are divided according to their translucency into translucent (i.e. the metal background shines through) and opaque enamels. In the case of translucent enamels, a distinction is made between transparent (like clear glass) and translucid enamels, which are slightly cloudy. Opacity is produced in the opaque paints by the addition of opacifiers, to render their effect independent of the metal background.

engraving
Cutting or etching patterns in wood or metal. see glass engraving, woodcuts, etching

eosin glaze
A product of the Hungarian porcelain manufactory of Zsolnay, in Pécs. The ruby-colored metallic luster glaze was developed by the firm in collaboration with Professor Vince Wartha (Gr. eos = dawn).

étagère
A popular item of Art Nouveau furniture consisting usually of three tiered shelves of different sizes and used for displaying small objects. The shelves are carried by slender supports. Also known as a 'whatnot'.

etched glass
Ornamental glass in which hydrofluoric acid is used either to produce an incised pattern or give a satin, rough or frosted finish. Parts that are not to be treated are protected by an acid-resistant layer or template. The strength of the fluoride mixture determines whether the glass finishes up polished or matt. The protective coat is subsequently washed off in cold, then warm water and finally with soap.

etching on metal
A graphic technique and form of engraving in which a copper plate is coated with acid-resistant, resinous matter called the resist. The image is then scored in it with the etching needle – a sharp steel needle – so deeply that the copper is laid bare. When the acid is then poured on, it eats into the bare areas, etching the pattern into the plate. The longer it is left, the deeper the etching. From the artist's point of view, etching is very like drawing on paper.

faience
Clay objects coated with tin glaze and subsequently cased with a transparent lead glaze.

Favrile glass
A luster glaze developed by Louis Comfort Tiffany reminiscent of mosaic window techniques. Pulverized (precious) metal was applied to the body of the object, in the same way as in flashed glass. Depending on the composition of the metal, the coating that resulted was either matt, lustrous or gloss. In the final stages of the process, vapors containing oxides left a deposit on the outer walls to create a luster effect. The decor thus 'blossomed' out of a chemical but hand-crafted process into a vegetal, linear design without requiring the use of a floral stencil.

Tiffany derived the word favrile from the 17th-century English adjective fabrile, meaning 'relating to craft' or 'masterly', which itself came from Latin fabrilis, i.e. to do with a faber or artificer. The term follis fabrilis (fire-worker) is found in Livy and Cicero, follis being a leather bag, particularly a bellows. The change from Latin b to English v is quite common, e.g. Latin rabidus (raging, crazy) is not only the source of rabid but also the verb rave.

feldspar
Collective term for a large group of rock minerals of different colors, alkaline or alkaline earth silicates of aluminum that are light in color and rich in water.

figura serpentina
Sculptural term for a design in which the figure develops upward from the plinth while twisting round the central axis. From Latin serpentinatus = serpentine.

filigree glass
Glass containing colored threads which constitute a pattern.

flambé glaze
Bright red or purple coloring produced by oxidizing copper in a ferrous glaze. The term is also used to denote an abstract decoration on stoneware which develops during firing by exposing the glaze to different temperatures. The glaze runs, forming blobs and dots or lines.

flashed glass
The glass body is dipped in a molten colored glass mass to be coated in one or more additional layers and then blown to its final shape. A distinction is made between external flashing (clear glass base, colored coating) and internal flashing (colored base, clear coating).

flint glass
Extremely pure lead glass – hollow glass with a high lead oxide content instead of calcium – first developed in 1675 at Ravenscroft in England and used mainly for optical equipment. The term 'flint glass' is inaccurate inasmuch as this originally referred to a glass in which pure silicon in the form of flint was added to the melt.

flowing glazes
The glazes mingle as a result of colored glazes being coated with a slightly fusible glaze containing boric acid. Firing involves oxidization.

flowing colorants
Colorants used for underglaze to which a high percentage of oxide has been added to make them run.

flux
An additive to glazes that melts at a low temperature and causes other components to melt as well.

folio
Book format not less than 11 inches in height.

frit porcelain
Porcelain with a frit coating or decoration, i.e. pulverized glass that is heated until it is soft so that the individual parts stick together superficially but do not melt, unlike in a glaze.

funicular model
An architectural model using weights suspended from a piece of string, to establish the most desirable shape of a structure from a loadbearing point of view.

Futurism
Italian movement in modern art and poetry, launched in 1909 with the publication of a Futurist manifesto by the poet Filippo Tommaso Marinetti (1876–1944). Futurism demanded a complete break with tradition. The painting of the future should represent simultaneity, i.e. fuse several temporally distinct situations in the real world and temporally discrete experiences.
The protagonists of the movement included Giacomo Balla (1871–1958), Umberto Boccioni (1882–1916), Carlo Carra (1881–1966), Luigi Russolo (1885–1947), and Gino Severini (1883–1966).

gilt bronze *see* bronze, gilt, also ormolu

glass engraving
Application of patterns on glass by using wheels attached to a flywheel instead of a grindstone. The grinding agent is a mixture of oil and emery powder. A distinction is made between 1. line engraving; 2. incising (deep-cut, i.e. the pattern is cut into the glass as a negative impression); and 3. cutting away (the pattern is left in relief by cutting away the unwanted areas).

glaze
Glass-like coating on earthenware, to seal porous bodies. All glazes consist of quartz and one or more metal components. Glazing is done mostly by dipping; other processes include pouring on, spraying, and the volatility process.

glaze technique
To varnish a picture with transparent colors.

gouache
Opaque paint using watercolors combined with binding agents and zinc white which after application dries to give a pastel-like effect.

graphite
Soft black material made of carbon.

grès
French term for stoneware.

guéridon
Pedestal table.

half-tones
Black and white photos for reproduction in a book.

hammered *see* repoussé

haute-lisse (high-warp) technique
Weaving method for tapestries and wall-hangings in which the warps are placed, 'high', i.e. vertically (Fr. *haute-lisse*) on the loom.

heliogravure
Manual photogravure process for reproducing a picture photomechanically. Slides and halftone negatives are copied onto pigment paper, as result of which areas exposed to light harden. To reproduce halftones, asphalt powder is melted on to a polished copper plate, and the developed pigment paper is then pressed on to the plate and peeled off the backing paper. Finally, an etching process takes place in which the acid must circulate round the particles of powder. After repeated etching, the gelatine layer of the slide is washed off and the copper plate is ready for the press.

high-fire alkaline glazes
Glazes using fluxes such as feldspar, limestone, plaster or bone ash.

honeycomb glass
Glass with small air inclusions. These can be produced artificially by piercing the soft glass with a needle. After the needle is withdrawn, the outer skin quickly closes up again. If the glass is turned and extended immediately after being pierced, spiral threads of air can also be created.

hyperbola
Mathematical conic section. The hyperbola is the geometric location for all points that have a constant difference of distance from two focuses.

hyperbolic paraboloid
Mathematical concept describing the surface of a saddle, having a parabolic section crossways and a hyperbolic section lengthways.

incrustation
Colored decoration of surfaces by means of inlays of various materials.

intercalaire
Glass already flashed and ornamented is flashed again, mostly with transparent glass, and the transparent flashing is cut away or incised according to the artist's intentions.

iridescent
Having a lustrous surface in the colors of the rainbow. Iridescence is produced with metal oxide vapors from gentle heating in a melting furnace or by luster painting in which a thick coating of luster paint is applied to the finished glass and fired.

ironwood
Any hard, heavy wood such as teak growing mainly in the tropics or subtropics.

jack-in-the-pulpit
A species of arum native to North America (arisaema triphyllum), commonly called jack-in-the-pulpit but also known as Indian turnip. It is a plant with a single cotyledon and tuberous rhizome whose flower is enclosed in a spathe without any petals, a spathe being an upright leaf like a sac.

jardinière
A large flower stand for holding cut or indoor plants.

jet pearls
Gems made of jet, a hard bituminous coal.

Lava glass
Glass imitating obsidian, a silica-rich natural glass.

leaded glazing
A method of joining small panes of glass into windows, using lead cames of various sizes to make up composite fields.

line-etching
A process used in book printing to make printing plates for reproducing matter of a linear nature. In line-etching, the linear negative is copied photochemically on to a zinc plate which is etched after development. The parts protected by color which are to be printed are not eaten away and remain proud.

lithography
The oldest flatbed printing technique, invented by Alois Senefelder (1771–1834) about 1789. It is based on the discovery that grease repels water. The drawing is applied to the lithographic plate using a greasy chalk or brush. The plate is made of Jurassic limestone, the best type of which comes from Bavaria (Solenhofen stone). This is porous enough to suck up both grease and water. The plate is coated with acid and then treated with a solution of gum arabic. This has the effect of allowing parts of the plate not containing the drawing to absorb water. When greasy printing ink is rolled on, only the picture retains the color, the non-pictorial areas, previously treated with damp rollers, repelling it.

luster glaze
An extremely thin glaze in bright colors or with a metallic surface. Lustrous glazes are produced in two ways: one is to use silver chloride or nitrate, which leaves a metallic or pearly sheen, the other involves salts of cobalt, manganese, copper, iron, silver, and bismuth. The glaze is rubbed shiny with carbon black.

majolica
In the 19th century, majolica described all colored and especially multi-colored glazed earthenware not counted as porcelain.

marquetry/marqueterie
Inlay work in wood.

marqueterie de verre
Inlay work in glass. Colored or partially clear glass is pressed into the surface while it is still warm and bonded to the decor during the blowing process or shaping or cooling. Finishing is done with the engraving or grinding wheel.

mat velouté enamel
Glazing technique in which the glazing base is given a velvety texture by means of an etching process.

millefiori glass
Colored glass threads are melted together in a bundle and cut into disks. The cross-section displays a spiral or floral pattern of threads. The disks are subsequently embedded in lumps of hot, colorless glass which are then blown into shape. The end products are usually paperweights. (From Italian *millefiori* = 1000 flowers)

monism
A philosophical doctrine asserting that the multiplicity of reality can be reduced to a single ultimate principle. This can be of a spiritual or material nature, e.g. spirit, God, matter, activity, will or something else. The doctrine was systematized by the German philosopher Christian Wolff (1679–1754).

moonstone
Transparent to translucent feldspar in pale colors ranging from bluish-white to yellow-brown.

mosaic glass
Hollow glass technique already known to the ancient Egyptians. Colored glass threads are melted into a bundle and drawn out into various shapes. The bundles are then cut across to produce little panes that display a floral-like pattern. The pieces are placed on an iron plate and the glass rolled up. On blowing and shaping the glass pieces bond with the hollow glass body.

mosaic window
"Painting with glass," in which glass painted and cut *en masse* is put together to make a painted window.

Murano technique
Murano is an island north of Venice that in medieval times was the center of Venetian glassmaking. "Venetian glass" is a generic concept for all glass that is distinguished for its

lightness and clarity of mass. Filigree and *millefiori* glass and elegant, sophisticated glassware in general are often described as Venetian or Murano glass.

mycologist
A botanist expert in mushrooms and related plants.

navette (shuttle) diamonds
Diamonds ground into the shape of navettes (shuttles on a loom).

nénuphar
The Egyptian waterlily.

nishiki-e
Polychrome printing used in Japanese woodcuts notable for its sophisticated coloring. A development of basic color printing, called *benizuri-e* in Japanese.

opal
Type of quartz valued as a gemstone for its shimmering, changing colors.

opalescent glass
Marbled glass obtained by founding, using a mixture of colored, frosted, and opal glass.

opal glass
Semitranslucent, whitish glass with opalescent luster produced by the addition of horn or bone ash, possibly also stannic oxide.

ormolu
Various methods of achieving a gold appearance on metal mounts on furniture, the most common being gilt bronze.

oxblood glaze
Glowing red glaze produced by reduced copper (i.e. the kiln contains less oxygen during certain stages of firing).

oxidation
Process combining metal with oxygen. Particles of metal are introduced into the glass which then oxidize to produce coloring in the wall of the vessel.

panneau décoratif
Decorative wall or surface panel.

Papillon glass
"Butterfly" glassware made by the firm Loetz' Witwe. It is an iridescent glass with mottled patterns.

parabola
Mathematical conic section. It is a symmetrical curve stretching to infinity, the points on which have the same distance from a fixed point and fixed straight line.

paraboloid
Mathematical term describing a parabolic curved surface.

pastel
Picture painted with pastel colors, which are a mixture of chalk and clay with added coloring and binding agents.

pâte decoration
Decoration in relief, applied *en masse*.

pâte de verre
Pulverized glass paste mixed with a binding agent and soft enough to work. Color can be added as required. The paste is pressed into a pre-prepared mold, built up from inside and often endowed with relief decoration on the inner or outer wall. Firing follows at a low temperature.

pâte sur pâte
A difficult technique used mainly on porcelain. Successive layers of clay slip are carefully applied with a brush on to the bare or pre-fired body, until a differentiated relief is produced.

patinated bronze
Bronze treated with chemicals to produce a light grey-green surface layer or patina.

pattern
Damp wooden or cast iron mold in which liquid glass is founded.

pewter
An alloy in which tin is the principle constituent, used for making utensils and decorative objects. Other constituents may be copper (best quality), antimony or lead (inferior quality).

plique à jour enamel
A process in which enamel windows – frame-like grids with no metal back – are filled with translucent (*plique à jour*) enamel on precious-metal surfaces. The background foil required for the process is subsequently etched away with nitric acid.
Abbreviated form: *à jour* enamel.

porcelain
Vitrified (i.e. baked) body made of kaolin (china clay), feldspar, and quartz. Porcelain is waterproof, impermeable, and translucent.

pot painting
Painting with metal oxides or clays. The mushy mass is poured from the founding vessel on to the clay and subsequently fired.

pressure curve
Structural engineering term for vaulting pressure, i.e. the pressure exerted by the vaulting on the supporting walls, piers or columns.

pulverized glass technique
A process in which the still-hot glass body is coated with a different color of pulverized glass in streaks, flocculent or mixed, then reheated until the powder bonds with the body. The glass is then flashed in a new coating.

putto (plural: putti)
Small naked boy figures with or without wings. Popular chiefly in Renaissance and Baroque art.

ramie fiber [cambric fiber]
Fiber from china grass, a kind of nettle plant.

Régence
The style of French art during the rule of Philippe of Orléans (1715–23). It emphasized decorative elements and the elegance and lightness of line.

repoussé work
Hammered surfaces.

resist (or reserve)
A protective paste applied in dyeing materials or etching materials according to the design, to prevent dye being absorbed or the metal being attacked by the etching acid.

salt glaze
A thin glaze produced by throwing common salt into the kiln once the fire reaches its maturing point. In the steam environment, the salt breaks down into sodium and hydrochloric acid. The sodium combines with the silicic acid of the body to make sodium silicate, which combines with the other components of the clay to make a real glass glazing.

schliere
Transparent streaks in the glass arising from an inadequate firing heat.

secco technique
Painting on dry plaster.

sharp-fire glaze
Underglaze or overglaze colorants that are subjected to a sharp fire, i.e. a fire at a very high temperature. The sharp fire produces motifs whose edges lack sharp, prominent outlines and the effect of which is to create a high degree of softness.

Shunga
A collection of erotic woodcuts (= "Spring pictures" in Japanese).

silver pewter
A lead-free alloy of tin with a silvery sheen.

sinkabe kozo
The interiors of Japanese houses are partitioned with wooden sliding doors. The spatial arrangement was brought to its final form in the Tokugawa period (1605–1867) with the use of paper-covered sliding doors which were frequently painted, as were the wooden pillars. The architecture became more stylish as sinkabe kozo, the tasteful arrangement of rooms, was consciously cultivated.

slip
Clay thinned to a creamy liquid and used for glazes. Slip glazes can be fired at low temperatures as the clay contains natural fluxes. Colors are mostly earthy.

slip painting
Painting in which the slip is applied in layers to the bare or pre-fired body.

stained-glass windows
Windows made of pieces of glass colored with metallic oxides, pigments or enamel. The pieces are joined together with lead fillets to make a design or picture.

stereotomy
A branch of geometry dealing with calculating the surfaces of spatial things, especially the cut stone of vaulted structures.

Stile Liberty
Italian generic term for Art Nouveau, named after the English Art Nouveau store Liberty, whose distribution system made the style popular throughout the world.

stoneware
Pale-colored firing clay mixed with quartz and feldspar. The body is likewise light in color, impermeable, and nontransparent.

Style Guimard
Term for French art circa 1900, named after its chief protagonist Hector Guimard, whose work is notable for its use of line and the interplay of light and contrasts.

Style Métro
A term for the characteristic floral, linear trend in *fin-de-siècle* art, as exemplified in Hector Guimard's structures for the Paris Métro.

Sung Dynasty
Chinese dynasty (961–1278 AD). Sung stoneware is notable for its inventive use of glazes.

Suprematism
School of modern painting established in Moscow in 1913 by the Russian artist Casimir Malevich (1878–1935). It

demanded a return to pure painting, i.e. sharply defined color surfaces such as right angles, squares and circles, on a white background.

symbiosis
Combining different qualities to their mutual benefit.

synesthesia
The blending of sensations from different senses (eyes, ears, smell, etc.), evoked by the excitement of one sense organ during the stimulation of another.

tempera
Paints with water, oil or resinous binding agents.

terracotta
A fired, unglazed article made of colored (white, yellow, brown or most commonly red) firing clay; also a term for a small figure made of alumina.

threaded decor
Liquid glass is dripped on to the glass body and then drawn out in the form of threads, which are then melted to the surface.

tiled panel
A recessed field filled with tiles that make up a pattern or picture.

tourmaline
A precious stone, whose colors vary from brown through red, green and black to colorless.

translucent enamel *see enamel plique à jour*

transparent weaving
Weaving in which the warp that goes through the weft yarn is not stretched taut, resulting in a transparent weave. The quality of yarn plays a decisive part. Whereas for tapestries wool or coarse yarn is used, in transparent weaving wool, silk, and cotton are used.

Tudric
A range of pewter ware sold by the London Art Nouveau store Liberty & Co. The Celtic name was chosen as a tribute to the Welsh ancestors of John Llewellyn, a director of Liberty.

ukiyo-e
Japanese color woodcuts (= "pictures of the floating world").

underglaze
Colored decoration applied to the vessel under the glaze. Contrasts with painting on to the glaze and then firing.

verre églomisé
Special type of back painting in glass developed by the Parisian art dealer Jean-Baptiste Glomy (d. 1786). The glass is coated with black lacquer, and ornaments and figures are left blank or scraped clear. The glass is then given a deposit of metal foil or gold bronze.

vignette
Decorative and margin ornamentation on the printed page. Alternatively, a picture with irregular edges and no frame, that shades away at the sides.

vitrification
External application of colored pulverized glass that is fired but not subsequently flashed again.

woodcut
The earliest form of wood engraving. A drawing is cut into a block of wood, leaving it proud of the background so that it can be used for printing. The finished printed picture is the woodcut.

Zen
Japanese version of Buddhism that seeks union with Buddha and the universe through meditation, an active life force, and great self-control.

zinc glazing
The same as leaded glazing of windows, except that the cames are made of zinc instead of lead.

Biographies

by Priska Schmückle

André, Émile
1871 Nancy – 1933 Nancy
French architect and craftsman
André studied architecture at the École des Beaux Arts in Nancy and embarked on study tours to Egypt, Italy, and Tunisia before finally settling in Nancy in 1901. Initially he collaborated with his father, the architect Charles André (1841–1921). Later, he partnered Eugène Vallin, with whom he worked out a number of basic principles for Art Nouveau architecture. At the École de Nancy, where he and Émile Gallé were the leading lights, André taught applied art and architecture, and he is considered its chief representative in the field of architecture.
As a craftsman, André designed furniture, while as an architect he built several residential houses in Nancy, the facades of which are notable for their highly ingenious compositions using many different materials. André stood apart from his colleagues in Nancy for his free application of Art Nouveau in architecture. He won a number of awards for his work.

Arabia O.Y.
Founded 1874 in Helsinki
Finnish porcelain and ceramics factory
The Arabia company was founded in Helsinki in 1874 as a subsidiary of the Swedish porcelain factory Rörstrands Porslins-fabriker, in order to supply the Finnish and Russian markets. In 1916 it became an independent concern and in 1948 was taken over by the Wärtsila company. Arabia's products represented an important contribution to Art Nouveau within Finnish applied art. In stylistic terms they were largely shaped by the Belgian artist Alfred William Finch (1854–1930), who had lived in Finland since 1897 and who in 1902 became professor of ceramics at the Central School of Arts and Crafts in Helsinki.

Ashbee, Charles Robert
17.5.1863 Isleworth – 23.5.1942 Godden Green, Kent
English architect, interior designer, silversmith, artist craftsman, art theoretician, and poet
After studying humanities at King's College, Cambridge, from 1882 to 1885, Ashbee trained with the architect G. F. Bodley, a specialist in church architecture. In 1888 he founded the School of Handicraft in London – a training workshop for architecture and interior design – which he affiliated with the Guild of Handicraft. In 1902 he moved the school to Chipping Campden in Gloucestershire. The school's work was exhibited in London, Düsseldorf, Munich and Vienna, and was so successful that the school's designs for silverware and furniture were copied by several London firms, especially Liberty's, who sold their versions for the same price but with a higher-quality finish. This brought financial difficulties to Ashbee's school, forcing it to close in 1907. In 1902 Ashbee was made an honorary member of the Munich Academy and in 1915 became professor of English literature in Cairo. He worked as an advisor for urban development in Jerusalem between 1918 and 1922 before returning to England in 1923.
As an architect, Ashbee built with a view to simplicity and function, concentrating mainly on the detached family house, where the building and its interior formed a homogeneous unit. He also restored numerous historical buildings and between 1897 and 1898 worked with Mackay Hugh Baillie Scott on designs for a number of rooms in the New Palace in Darmstadt. Inspired by William Morris, Ashbee took an interest in the problems of art in the industrial age, and published many books and essays on this subject.

Auchentaller, Josef Maria
2.8.1865 Vienna – 31.12.1949 Grado, Italy
Austrian painter, draftsman, and graphic artist
After studying at the Technische Hochschule in Vienna (1886–89), where he won three prizes (in 1886, 1888, and 1889), Auchentaller began studying with Franz Rumpler at the Academy in Vienna. He was professor in Munich from 1893 to 1895. In 1898 he joined the Vienna Secession and worked for the periodical *Ver Sacrum*. He eventually settled in Grado in Italy in 1901, where he later became port master.
Auchentaller's graphic work was heavily influenced by his contemporaries in England. He produced illustrations, etchings, and lithographs for *Ver Sacrum* and designed many posters, counted among the best Art Nouveau posters in Austria, and painted mainly atmospheric landscapes and genre scenes.

Auger, Georges
1864 Paris – 1935 Paris
French goldsmith and jewelry designer
In 1900 Georges Auger took over the company his father, Alphonse Auger (1837–1904), had founded in 1862 (La Maison Auger), renaming it simply 'Georges Auger'. Alongside the rival French firms Vever and Cartier, Auger produced some of the most famous jewelry of his day. Besides jewelry, Auger's company also made many gold-worked articles for the applied arts, such as decorative rapiers, book covers and presentation cups.

Baillie Scott, Mackay Hugh
1865 Douglas, Isle of Man – 1945 Bedfordshire
English architect, interior designer, and arts and crafts designer
After training with C. E. Davis, Bath's city architect, Baillie Scott worked for the architect F. Saunders on the Isle of Man, setting up his own business on the island in 1893. He received commissions from England, Poland, Russia, Germany, and Switzerland. In 1898 he was asked to join the colony of artists in Darmstadt, where he and Charles Robert Ashbee designed several interiors for the New Palace. In 1901 he won first prize in a German crafts competition and returned to England that same year.
Baillie Scott's style is similar to that of the Glasgow Four. He was not as popular and well-known in his native England as he was in the rest of Europe (especially in Germany), where through him English Art Nouveau was introduced to a wider audience.

Balat, Alphonse François Hubert
15.5.1818 Gochenée, Namur – 16.9.1895 Ixelles, near Brussels
Belgian architect
Balat studied architecture at the academies in Namur and Antwerp (1831–38) and after a brief period in Paris (1840–46) set himself up as an architect first in Namur and then in Brussels. In 1852 he was made architect to the Duke of Brabant, who was crowned King Leopold II of Belgium in 1865. Balat received commissions from the Belgian royal family (e.g. the Grand Winter Garden for the Royal Palace at Laeken, for public buildings (the Palais des Beaux-Arts in Brussels, 1875) and for rebuilding and restoration work on numerous palaces. He was also Victor Horta's teacher.

Basile, Ernesto
31.1.1857 Palermo – 26.8.1932 Palermo
Italian architect
The son of the architect Giovanni Battista Basile, Ernesto Basile studied architecture in Palermo until 1878. In 1881 he moved to Rome, where from 1883 he taught at the university as a visiting lecturer. In 1888, he was commissioned to plan the Avenida de Libertacoa in Rio. He returned in 1891 to Palermo, where a year later he was appointed to a chair in architecture. In 1902, he moved his architectural practice to Rome.
Initially his buildings were eclectic in style, but around 1900 he adopted the floral version of Art Nouveau. In later years, he returned to the classical style and was an opponent of 1920s' rationalism. At the Turin Exposition in 1902 he received an award for his architecture and interiors.

Beardsley, Aubrey Vincent

21.8.1872 Brighton – 16.3.1898 Mentone, Alpes-Maritimes
English draftsman, graphic artist, caricaturist, and illustrator
After working as a draftsman in an architect's office and as a clerk for the Guardian Insurance Office (1888–92), Beardsley acted on the advice of Edward Burne-Jones and Pierre Cécile Puvis de Chavannes and started working as a freelance artist in 1892. Beardsley was largely self-taught, but did attend evening classes at the Westminster School of Art for a short time at the suggestion of Burne-Jones. In 1892 he achieved success with his illustrations for Malory's *Morte d'Arthur* and in 1893 designed the first cover for the periodical *The Studio*. From 1894 he worked for *The Yellow Book*, a journal for art and literature, and after his dismissal in 1895 as a result of the Oscar Wilde scandal, became art editor of *The Savoy*. He died from tuberculosis at the age of 25 in 1898.
Beardsley produced book illustrations, complete with ornamental title pages, artistic initials, vignettes, and borders decorated with figures and ornaments, caricatures, designs for invitation cards, and ex libris prints. His work betrays the influence of the Pre-Raphaelites and the flat, surface artwork of Japanese woodcuts, of Greek vase painting and the French Rococo. Beardsley's style is an amalgamation of all of these elements, characterized by his use of strong, black-and-white contrast and his sketched outlines. His style heavily influenced the further development of book illustration and Art Nouveau in Europe and in America. His main works include his illustrations for Oscar Wilde's *Salome* (1894), Ben Jonson's *Volpone* (1896) and Alexander Pope's *The Rape of the Lock* (1896).

Behrens, Peter

14.4.1868 Hamburg – 27.2.1940 Berlin
German architect, painter, graphic artist, industrial designer, applied artist, typeface designer, and book artist
Behrens, who studied painting in Karlsruhe, Düsseldorf, Munich, and with the *luministes* in the Netherlands from 1885 to 1892, was initially drawn to Impressionist painting. As from 1897, however, influenced by Justus Brinkmann's collection of Japanese prints, he turned to applied art and produced works in the ornate Munich Jugendstil style, before arriving at a simpler, rectilinear, and functional style around 1904. From 1899 to 1903 he was a member of the Darmstadt artists' colony, where he designed furniture and furnishings (wallpapers, textiles, decorative glass), as well as theater sets, and where he first turned his attention to architecture. In 1901 he built his own house on the Mathildenhöhe, designing its interiors in a style influenced by Henry van de Velde and Charles Rennie Mackintosh. From 1903 to 1907 he was head of the School of Arts and Crafts in Düsseldorf. His buildings from this period are characterized by simple cubic forms with a linear ornament. From 1907 to 1914 he was a member of the AEG artistic advisory committee in Berlin, in which capacity he designed – alongside all AEG's factories and office buildings – typefaces, advertising material, and electrical goods (including domestic appliances and lighting). In 1922 he was appointed professor of architecture at the Academy in Vienna and in 1936 took over as head of the Architecture Department at the Academy in Berlin.
Behrens' formal influence upon industrial design, architecture, and typography is not be underestimated. His major works include the AEG Turbine Hall in Berlin (1909), in which structural components were for the first time left undisguised as elements of the architecture, the Mannesmann offices in Düsseldorf (1911–12), the German Embassy in St. Petersburg (1911–12), the Hoechst Dyeworks in Frankfurt (1920–25), the Gutehoffnungshütte foundry in Oberhausen (1925) and the State Tobacco Factory in Linz (1933). In his graphic works, which reveal the strong influence of van de Velde, he fused classical motifs with abstract Jugendstil ornament. He also created two new typefaces: Behrens

Italic and Behrens Roman. Behrens was amongst the founders of the Munich Secession (1892), the Freie Vereinigung Münchner Künstler (Free Association of Munich Artists, 1893), the Vereinigte Werkstätten für Kunst im Handwerk (United Workshops for Art in Handicraft) in Munich (1897) and the Deutscher Werkbund (1907). Walter Gropius (1883–1969), Ludwig Mies van der Rohe (1886–1969) and Le Corbusier (1887–1965) all worked in Behrens' Neubabelsberg studio.

Beltrami, Giovanni

26.2.1860 Milan – 1.2.1926 Milan
Italian glass artist
Even during his studies of painting at the Accademia di Brera in Milan, Beltrami showed great interest in glass painting. In 1900 he founded the firm of G. Beltrami & Co. in Milan with three co-students as partners, namely the engineers Guido Zuccaro and Innocenti Cantinotti and the artist Giovanni Buffa. The factory focused its efforts on producing *objets d'art* in glass. In its field, it became the most important workshop in Italy. Its products were successfully exhibited at the Turin Exposition in 1902 and at the Venice Biennale in 1903 and 1905. After Beltrami's death in 1926, the firm slowly dwindled away.

Bergé, Henri

1870 Diarville – 1937 Nancy
French artist, porcelain and glass painter, sculptor
After being apprenticed to the sculptor François Raoul Larche, from 1897 to 1914 Bergé produced decorative designs for vases and *pâte de verre* for Daum Frères' glass factory in Nancy, whose artistic manager he became in 1900. After 1908 he turned to sculpture, making models for glass sculptures for the firms Daum Frères and Almaric Walter. As a member of the École de Nancy, he designed all its graphic items including posters, cards, and menus.

Hendrik Petrus Berlage

21.2.1856 Amsterdam – 12.8.1934 The Hague
Dutch architect, town planner, and designer of furniture and arts and crafts articles
After studying architecture at the polytechnic in Zürich (1875–78), where he was strongly influenced by the theories of Gottfried Semper (1803–79), Berlage was involved in the construction of the waxworks in Frankfurt am Main. He undertook several study tours to Italy, Austria, and Germany (1880–85) before returning to the Netherlands in the 1890s to set up an independent architectural practice. In 1900, together with Jacob van den Bosch and W. Hoeker, he set up the interior furnishings firm 't Binnenhuis Inrichting tot Meubileering en Versiering der Woning, which was awarded a gold medal for its furniture at the Turin Exposition in 1902. In 1911, he embarked on a tour of the U.S.A., where the buildings of Louis Henry Sullivan, Henry Hobson Richardson (1838–86), and Frank Lloyd Wright greatly impressed him. Berlage is one of the most important Dutch representatives of modern architecture. In his buildings, he cast off the shackles of historical imitation; his later buildings are noted for their objective functionality and structural transparency, in which the structural components are all visible. The same applies to his furniture: typically, they have a simple linearity, in which the ornamentation is formed from the structural elements and the appropriate use of materials. In his writings, he endeavored to promote a better understanding of the connections between architecture, art, and society. His principal works include the construction of the Amsterdam Bourse (1898–1903), Holland House in London (1914), a design for the Kröller-Müller Museum (1917), the Gemeente Museum in The Hague (completed 1935), and the town planning for Amsterdam South (1915, which was implemented

by the Wendingen group of architects). His work on style, *Thoughts on Style in Architecture* was published in 1905.

Berlepsch-Valendas, Hans Eduard von

(real name Hans Karl Eduard)
31.12.1849 St. Gallen – 17.8.1921 Planegg, near Munich
Swiss illustrator, designer, craftsman, and painter
After studying architecture at the Zurich Polytechnic (1868–91) and working for a building society in Frankfurt (1873–75), Berlepsch-Valendas attended the Academy in Munich (1875–79). In 1895 he turned away from painting and dedicated himself solely to design and applied art. That same year he joined the Munich Secession. From 1897 onwards he participated in numerous arts and crafts exhibitions, including at the Munich Glass Palace (1897, 1898, 1899), in Darmstadt and Berlin (1898), in Dresden and Vienna (1899), and in St. Louis (1904). He won prizes at both the World Exposition in Paris in 1900 and at the 1902 International Exhibition of Decorative Modern Art in Turin. At his home in Planegg he founded a small school of architecture and applied art.
For Berlepsch-Valendas, the primary task of art was to improve the quality of life. He was the first in Germany to call for a greater appreciation of the decorative arts, in line with the Arts and Crafts Movement with which he had come into contact on a trip to England. Many young artists were influenced by his writings.

Bernhard, Lucian

(real name Emil Kahn)
15.3.1883 Stuttgart – 29.5.1972 New York
German painter, graphic artist, book illustrator, architect, and interior designer
Bernhard studied painting at the Munich Academy. He was self-taught as a designer and architect. After working for the printers Hollerbaum and Schmidt in Berlin, in 1910 he became head of the Deutsche Werkstätte, for which he produced numerous furniture and furnishing designs (wallpapers, carpets, lights). From 1920 to 1923 he taught advertising art at the Berlin Academy of Art. He subsequently emigrated to the United States, where he opened a studio for commercial graphics and interior design in New York, and took up teaching posts at the Art Students League and at New York University. Around 1930 he turned to painting and sculpture.
Bernhard was a member of the Deutscher Werkbund while in Berlin, and in New York became a member of the American Institute of Graphic Arts, the Art Guild, and the Society of Illustrators. He was also joint founder and director of Contempora, an international company for graphics and design in New York.
During his Berlin years Bernhard was Germany's best-known poster artist and exerted a profound influence on the development of functional goods advertising, earning him the title of "father of the advert" (Julius Klinger). In 1905 he won first prize in a poster competition.
His wide-ranging oeuvre includes several typefaces named after him (including Bernhard Gothic, Bernhard Roman and Bernhard Italic), furniture designs, color lithographs and etchings, book designs, trademarks and packaging (including decaffeinated Haag coffee in 1908 and the Adler typewriter in 1909), as well as designs for office buildings, factories, and apartment houses, including their interiors (e.g. the Karl Henkell House in Wiesbaden).

Bilibin, Ivan Yakovlevich

4.(16.)8.1876 Tarkhovka – 7.2.1942 Leningrad (St. Petersburg)
Russian painter, illustrator, graphic artist, and set-designer
While studying law (1896–1900) at the St. Petersburg faculty, Bilibin also attended a drawing course at the Society for the Promotion of the Arts (1895–98). From 1898 to 1904, he studied with the painter Ilya Yefimovich Repin. During this

period, he was also a member of the Mir Iskustva group of artists. From 1907 to 1917 he taught at the Drawing School of the Society for the Promotion of the Arts, designed stage sets and did illustrations and graphics for books and periodicals. After a study tour to Italy and Switzerland, he went to France in 1919, and from there to Egypt (1920–25). In 1936, he returned to Leningrad, where until 1942 he taught at the College for Painting, Sculpture and Architecture of the All–Russian Academy of Arts.

Bilibin was known mainly for his book illustrations. The expressive coloring of his ornamental decorative style was strongly influenced by the folklore of his native land.

Bindesbøll, Thorvald
21.7.1846 Copenhagen – 27.8.1908 Copenhagen
Danish architect, graphic artist, and craftsman
At the same time as studying architecture at the Copenhagen Academy of Art (graduating in 1876), Bindesbøll also acquired a diploma in chemistry at the Polytechnical College (1874).
For Bindesbøll, ornament was of particular importance. Geometric in his earlier works, inspired by the floor mosaics and ceiling decorations of classical antiquity, it later became freer and more organic. In his chairs, he contrasted simple, disciplined forms with a rich ornamentation, while in his architecture he went so far as to subordinate structure to ornament. His oeuvre also includes new contributions to typography, designs for silverware, embroideries, and leather, metal, and ceramic works. In 1882 he won the ordinary gold medal from the Copenhagen Academy of Art, and at the 1900 Paris World Exposition he was awarded a gold medal for his furniture. His most important building was the Foundation for Postal and Telegraph Employees in Copenhagen (1901). His confident feeling for color, line, and context made him a leading designer in all areas of modern Danish art.

Blake, William
28.11.1757 London – 12.8.1827 London
English painter, poet and copper engraver
Blake began taking lessons with Henry Pars at the London School of Drawing at the age of 11. He started training with copper engraver James Basire in 1771 and completed his education with a brief period of study at the Royal Academy of Arts. Blake illustrated works by Edward Young, R. Blair and Dante, among others. Although he was friends with John Flaxman and Johann Heinrich Füssli, during his lifetime Blake remained an unknown, his work ignored. His artwork first received recognition during the mid-19th century, when the Pre-Raphaelites showed an interest in his mystical view of the world and honored him as their precursor.

Blérot, Ernest
1870 Brussels – 1957 Elzenwalle, France
Belgian architect
Blérot was educated at the Collège Saint-Louis and the Académie Saint-Luc in Brussels. In 1897 he made a name for himself as the architect of a residential building (demolished 1989) in the rue Washington in Brussels. From 1900, he worked on building complexes such as the houses in the rue Ernest Solvay, also in Brussels. Thereafter he devoted himself to conversions and interiors of existing residences and mansions. After the First World War he dedicated himself entirely to the reconstruction and restoration of his family seat of Elzenwalle in Voormezele near Ypres.

Blomstedt, Väinö
1.4.1871 Savonlinna – 2.2.1947 Helsinki
Finnish painter, draftsman, illustrator, and textile designer
After studying at the School of Drawing at the Finnish Association of Art in Helsinki (1888–91), Blomstedt went to Paris, where he studied at the Académie Julian (1891), the Académie Colarossi (1893) and in Paul Gauguin's studio (1893–94), which strongly influenced his style. In 1900 he won a bronze medal at the Paris Salon d'Automne. During his long career as a teacher (1900–37) at various art colleges and Helsinki University, he also traveled to Denmark, Germany, England, the Netherlands, Italy, Spain, and above all France, to which he regularly returned.
Through his studies with Gauguin (1848–1903) in Paris, Blomstedt became interested in Symbolism. Back in Finland, however, he re-embraced his native traditions and subsequently became an enthusiastic supporter of the National Romantic movement. Around 1910 he discovered Impressionism and designed textiles in a tapestry style.

Blossfeldt, Karl
13.6.1865 Schielo, Harz – 9.12.1932 Berlin
German photographer
Following an apprenticeship as a modeler in Mädgesprung, Harz, Blossfeldt was awarded a grant in 1884 on the basis of his talent to study at the Unterrichtsanstalt des Königlichen Kunstgewerbemuseums in Berlin. In 1890 he started to work for Professor Moritz Meurer, helping him to develop teaching materials for plant drawing. His photographs from this period were reproduced in Meurer's publications. In 1896 he started his long career as a teacher at various art schools, his final post being at the Hochschule der Bildenden Künste in Berlin (1921–32). Magazines started printing his photos in 1925 and in 1928 his illustrated book, Urformen der Kunst, was published, earning him instant acclaim.
Blossfeldt's photographs show details of plants and organic forms, often enlarged many times and completely concentrated on the object. They depict shapes which were adopted as decorative elements in art and as ornamental forms and structures in architecture.

Boccioni, Umberto
19.10.1882 Reggio di Calabria – 17.8.1916 Verona
Italian painter, sculptor, graphic artist, and writer on art
From 1897 to 1899, Boccioni studied at the Accademia delle Belle Arti in Rome, where his acquaintance with Giacomo Balla (1871–1958) introduced him to Neo-Impressionism. After spells in Paris and Russia, he settled in Milan in 1909 and with Giacomo Balla and Gino Severini (1883–1966) joined the Futurist Movement of Filippo Tommaso Marinetti (1876–1944) and became its spokesman. Boccioni designed Symbolist compositions and vignettes in the Art Nouveau manner. In the development of 20th century art, he counts as a leading theoretician of Futurism, his works including inter alia the Technical Manifesto of Futurist Sculpture (1912) and Futurist Painting and Sculpture (1914).

Boldini, Giovanni
31.12.1842 Ferrara – 12.1.1931 Paris
Italian painter
After attending the Accademia delle Belle Arti in Florence (1864–69), Boldini studied English portrait painting in London from 1869, then in 1872 set up in Paris as a portrait painter. Though he also painted genre and landscape pictures, Boldini was known above all as a major and popular portrait artist for the upper classes, whose sophisticated elegance he captured on canvas most effectively.

Bonnard, Pierre
13.10.1867 Fontenay-aux-Roses – 23.1.1947 Le Cannet
French painter and graphic artist
Initially, Bonnard studied law, but from 1886 he also attended the Académie Julian in Paris and subsequently (from 1888) the École des Beaux-Arts. In 1889, he and his friends Maurice Denis (1870–1943), Paul Sérusier (1864–1927), Ker-Xavier Roussel (1867–1944), and Edouard Vuillard (1868–1940) joined Paul Gauguin's Nabis group of artists, whose works are generally grouped under Symbolism. After his first great success as an artist (a poster for France Champagne in 1890), Bonnard gave up the law. From 1910, he lived alternately in various cities (mainly Paris) and rural regions of France (Dauphiné, Normandy), as the subject matter of his pictures shows.
In his painting, which comprises portraits, landscapes and still lifes, Bonnard went back to Impressionism, which he extended by constructing his pictures in a completely new way and adopting a different palette. As a member of the Nabis group, Bonnard designed sets, costumes, and program vignettes for sundry French theaters and did illustrations for several periodicals, including La Revue Blanche. His lithographical work, e.g. for Paul Verlaine's Parallèlement (1900) and Longus's Daphne et Chloé (1902), strongly influenced modern book graphics.

Bosch, Jacob van den
19.10.1868 Amsterdam – 27.8.1948 Haarlem
Dutch craft artist
Van den Bosch studied at the Arts and Crafts College in Amsterdam from 1885 to 1890. In 1900, he was a cofounder of 't Binnenhuis Inrichting tot Meubileering en Versiering der Woning along with W. Hoeker and Hendrik Berlage, who in their plain furniture laid great emphasis on the appropriate use of materials. Van den Bosch also designed tiles for the firm of Holland and did frescoes and decorative work.

Bosselt, Rudolf
29.6.1871 Perleburg – 2.1.1938 Berlin
German sculptor, medallist, and jewelry and metalware designer
After an apprenticeship as an engraver with the Otto Schulz company in Berlin, and after studying at the School of Arts and Crafts in Frankfurt and concurrently at the Städelschen Institute of Anatomy, also in Frankfurt, from 1897 to 1899 Bosselt attended the Académie Julian in Paris. In 1899 he was appointed to the Darmstadt artists' colony (until 1903), where he designed medals, plaques, decorative and practical bronze utensils, and ivory and tortoiseshell jewelry in a simple, rigorous style. From 1903 he collaborated with the Carl Poellath mint in Schrobenhausen and in 1904 was offered, through Peter Behrens, a post teaching sculpture at the Düsseldorf School of Arts and Crafts, where he devoted himself increasingly to monumental sculpture and tombstone art. After his departure in 1911 he headed the schools of arts and crafts in Magdeburg (1911–25) and Brunswick (1928–31). Bosselt was also one of the founders of the Sonderbund (1909) and took part in the World Expositions in Paris (1900) and St. Louis (1904), as well as in the major German exhibitions.

Bradley, William H.
10.7.1868 Boston, Massachusetts – 25.1.1962 La Mesa, California
American graphic artist
His interest in the graphic works of the English artists William Morris, Edward Burne-Jones, and Aubrey Beardsley, and also in French poster artists such as Jules Chéret, led Bradley, who had trained as a printer, to become a draftsman and illustrator. His works were first published in the English journal The Studio in 1895. That same year, he accepted an invitation from Samuel Bing to show his works in the first Galerie L'Art Nouveau exhibition in Paris. Also in 1895 he founded the Wayside Press in Springfield, Massachusetts, through which he published the small magazine His Book, concerned with the theory and practice of book printing as well as with art and literature in general, and illustrated with

Bradley's own woodcuts. Despite Bradley's personal success as an artist, the Wayside Press went bankrupt in 1897. Bradley subsequently worked as an art teacher and for the type foundry of the American Type Founders Company, for which he published the journal *The American Chap-Book*. Bradley, whose oeuvre consists above all of book illustrations and artistically designed toys, was one of the leading American printers of the first quarter of the 20th century and earned the title "Dean of American Typographers" in the latter years of his life. He may be considered the best representative of American Art Nouveau. Strongly influenced by William Morris, Walter Crane, and Edward Burne-Jones, he was stylistically very close to Aubrey Beardsley, whom for a while he imitated.

Braut, Albert
1874 Roye, Somme – 6.12.1912 Pau
French painter
Braut studied in Paris under Gustave Moreau among others, and became a painter of landscapes and genre pictures. He is best known for his pictures of Paris society. From 1905, he was a regular exhibitor at the Salon des Indépendants and the Salon d'Automne.

Brega, Giuseppe
1877 – 1929
Italian architect
Brega studied architecture at the academy in Urbino. He worked as both architect and designer in the experimental studio of the building ceramics firm Ceramica Ruggeri. He constructed the Villa Ruggeri in Pesaro in 1902, which is considered one of the most important works of the Italian *Stile Liberty*.

Bugatti, Carlo
6.12.1856 Milan – 1940 Molsheim, Alsace
Italian craft artist and painter
Bugatti came from an Italian artistic dynasty whose roots date to the 15th century – the Art Nouveau painter Giovanni Segantini (1858–99) was his brother-in-law. After studying painting at the Accademia di Brera in Milan, he turned to designing furniture, collaborating with the *ébéniste* Mentasi. Around 1890, he and G. Osio set up a furniture-making workshop in Milan and, at almost the same time, another in Paris, where Bugatti was attending the École des Beaux-Arts. In 1898 came the founding of the firm of Carlo Bugatti & Co., which exhibited at the major international expositions. In 1904, he gave up his furniture workshop and went to Paris, where he designed jewelry and everyday articles from silver and also worked as a painter.
Bugatti received several awards (London 1888, silver medal in Paris in 1900, *prix d'honneur* in Turin in 1902). His furniture, which was inspired by African culture, is characterized by functional connections between the design and the many different materials used. Cubic forms rather than ornamentation determined the design.

Bugatti, Rembrandt
16.10.1884 Milan – 8.1.1916 Paris
Italian sculptor and painter
Bugatti trained as a sculptor and painter. Like most Art Nouveau artists, he used nature as his model, studying it primarily in zoos. Whereas his elder brother Ettore Bugatti (1882–1947) constructed cars, Rembrandt Bugatti became known for his small-scale animal sculptures.

Burne-Jones, Sir Edward Coley
(original name Edward Coley Jones)
28.8.1833 Birmingham – 17.6.1898 London
English painter, graphic artist, and handicrafts designer

Burne-Jones's first course of study was theology at Oxford. During his studies, he attended lectures given by the art critic John Ruskin (1819–1900), visited exhibitions of Pre-Raphaelite art and met William Morris. In 1856 Burne-Jones met Dante Gabriel Rossetti; this meeting, combined with his above experiences, convinced him to abandon his theological studies and become an artist. Until 1870 Burne-Jones painted only watercolors and was also a member of the Society of Painters in Watercolors. Post-1870 Burne-Jones did graphic work and illustrations together with his friend William Morris for the Kelmscott Press (including illustrating the works of Geoffrey Chaucer in 1897). He concentrated on designing craft articles (carpets, decorations, stained glass, ceramics, mosaics, jewelry, and furniture) which were manufactured in Morris's factories. The first exhibition of his work was held in 1877 in the Grosvenor Gallery. He joined the Royal Academy in 1895 and received a baronetcy in 1894.
Burne-Jones's characteristic style, his decoratively flowing line, grew out of his studies of Florentine *quattrocento* art. This line, threading through all genres of his work, greatly influenced Art Nouveau and especially Jugendstil in Munich and Vienna. His most famous work is a series of wall hangings which depicts the legend of King Arthur and the Holy Grail.

Burnham & Root
Founded 1873 in Chicago
American firm of architects
Daniel Hudson Burnham (1846–1912) and John Wellborn Root (1849–91) founded the architectural firm of Burnham & Root in 1873. Burnham's organizational and business skills combined with Root's technical and artistic talents to create one of Chicago's most successful partnerships. The buildings they designed were considered masterpieces in their day. For this reason, they were commissioned with the planning of the World's Columbian Exposition of 1893. After Root's death in 1891, Dwight Perkins took his place. Around 1900 the firm turned to urban planning. Its 1909 plan for Chicago remains one of the most important early exercises in this field.
Burnham and Root were members of the Chicago School of Architecture, to which they made an important contribution, although they were harshly criticized by architects such as Louis Henry Sullivan and Frank Lloyd Wright for bringing their architecture into line with that of the East Coast and with broad public taste. Their major works include the Rookery Building (1885–87) and the Reliance Building (1890–94) in Chicago.

Cardeilhac, Ernest
1851 Paris – 1904 Paris
French gold and silversmith
After learning his craft under Harleux, Cardeilhac won a silver medal at the Paris World Exposition in 1889 with his first pieces. In 1900, he took over the management of the gold and silversmith business founded in 1802 by his grandfather Vital Antoine Cardeilhac. Under the artistic direction of Lucien Bonvallet, the firm supplied articles to Samuel Bing's Galerie L'Art Nouveau and for the 1900 World Exposition in Paris. Known for his naturalistic, simple decorative style, Cardeilhac varied his works by using ivory, wood, and various patinas. In 1951, the firm was bought by Christofle & Cie.

Carriès, Jean Joseph Marie
15.2.1855 Lyons – 1.7.1894 Paris
French sculptor and potter
Carriès served an apprenticeship with various sculptors and for a while attended the École des Beaux-Arts in Lyons (1868–74), but thereafter he was self-taught. Deeply impressed by Japanese pottery and other stoneware shown at the 1878 World Exposition in Paris, he set up a pottery

studio in Saint-Amand-en-Puisaye while still a young man. He later added a second workshop at Château Monriveau, Nièvre, which was taken over at his death by his friend Georges Hoentschel. Initially Carriès made superb bronze busts, but later he turned equally successfully to glazed clay sculptures and pots, including strongly *japoniste*, plain vases with fine glazes. His great influence and his success led to the development of an artists' colony in Saint-Amand-en-Puisaye from 1890.

Cartier
Established 1847 in Paris
French jewelry and goldsmith firm
Louis–François Cartier (1819–1904) established his jewelry business in Paris in 1847. There followed several moves before the business finally settled in its present premises in rue de la Paix. In 1871, Cartier attempted to gain a foothold in London, but had to close the branch after only two years. It reopened only in 1902, and since 1921 has been an independent business. In 1874, Alfred Cartier (1841–1925) took over the firm. When his son Louis became a partner in 1898, the company was renamed "Alfred Cartier et Fils". In 1910, Cartier finally achieved world status under the direction of the three brothers: Louis in Paris, Pierre in New York, and Jacques in London. Cartier's speciality was showy pieces of jewelry in the mainstream of 19th-century taste, especially diamonds in gold settings. Fashions of the day were ignored. By the beginning of the First World War, most members of the European royal and aristocratic houses were numbered among its clients.

Cauchie, Paul
7.1.1875 Ath – 1.9.1952 Etterbeek
Belgian painter and architect
Even before he completed his studies at the École des Arts Décoratifs of the Brussels Académie Royale des Beaux-Arts (1893–98), Cauchie had founded (in 1896) a successful fresco business. Though self-taught as an architect, he built himself a house in Brussels in 1905. This was followed in 1918 by the establishment of another business in La Haye making pre-fabricated (and therefore cheap) wooden houses.

Caussé, Julien
Dates unknown
French sculptor
Causse studied under the sculptor Alexandre Falguinere, among others. His sculptures (busts, statuettes, candlesticks) were mainly inspired by mythology and the age of symbolism, and from 1888 were regularly exhibited at the Salon d'Automne in Paris. His best known work is *La fée des glaces* [the Ice Fairy].

Cheret, Jules
31.5.1836 Paris – 23.9.1932 Nice
French painter and graphic artist
A self-taught artist, Chéret completed his apprenticeship at a Paris printing press before joining a London firm that did lithographic work. In 1866 he set up his own printing press in Paris. He sold out in 1891 and turned to arts and crafts, doing textile designs and wall decorations. In 1899 he was awarded the Légion d'Honneur.
Chéret's speciality was advertising posters, which he developed into an art form. He was one of the first, in the mid-1870s, to use color lithography for his poster art. He not only designed the poster, but also the drawing on the lithographic plate. In 1893, under the influence of Henri de Toulouse-Lautrec, he went over to a decorative surface style, and it was his output, together with that of Alfons Maria Mucha, that set the course for the development of Art

Nouveau poster art. Over his 40-year career he designed about 1,200 posters. Their lively, occasionally even frivolous style corresponded exactly to the taste of the Paris salons.

Chini, Galileo
2.12.1873 Florence – 19.2.1956 Florence
Italian painter, potter, and interior designer
Chini learnt his skills in his father's restoration and decoration business, followed by brief spells at various art schools in Florence. From 1897 to 1904 he was artistic director of the porcelain and ceramics business of Arte della Ceramica in Florence. When the firm was taken over in 1907 by the ceramics company of Chini & Co. (Manufatturi Fornaci S. Lorenzo, Mugella), which belonged to a relative of his, he resumed the artistic director's seat, remaining until 1927. He spent the years from 1911 to 1914 in Thailand, whose culture greatly impressed him. From 1896 to 1898, Chini did illustrations for the periodicals *La Fiametta* and *Il Cavalier Cortese*, and between 1901 and 1936 regularly took part in the Venice Biennale. In the 1920s, he did the ceramic decoration for various buildings, particularly projects of the architect U. Giusti.

Christiansen, Hans
6.3.1866 Flensburg – 5.1.1945 Wiesbaden
German painter, graphic artist, craftsman, and writer
After an apprenticeship with a decoration painter in Flensburg and studying at the Munich School of Arts and Crafts (1887–88), in 1889 Christiansen began working as a technical college teacher and a decoration painter in Hamburg. As a member of Oskar Schwindrazheim's Volkskunstverein (Association of Folk Art), he was introduced to Justus Brinkmann and his collection of Japanese prints, which inspired him to develop a new, two-dimensional ornamental style. He was so impressed by the Tiffany glass that he encountered at the 1893 World's Columbian Exhibition in Chicago that he subsequently produced designs for opalescent glassware, in collaboration with the art glazier Karl Engelbrecht. In 1895, while studying at the Académie Julian in Paris, he encountered the Art Nouveau style of Georges de Feure and Henri de Toulouse-Lautrec, which strongly influenced his work. From 1897 he worked for the magazine *Jugend* and turned increasingly towards applied art. In 1898 he was invited to take part in the Darmstadt Exhibition of Arts and Crafts and in 1899 became one of the founder members of the Darmstadt artists' colony. Although he left again in 1902, he continued to live in Darmstadt, spending the winter months in Paris. In 1911 he moved to Wiesbaden, where his philosophical and literary writings were published in 1915. After the First World War he became a successful portrait painter, until the National Socialists banned him from painting because his wife was Jewish.
Christiansen was an important representative of German Jugendstil. Bearing the pronounced stamp of French Art Nouveau, his best-known works include designs for fabrics and wallpapers, characterized by continuously self-repeating serpentine lines. He also designed silver jewelry, stained-glass windows, and delicate items of domestic glass, as well as graphic works and the "Christiansen rose" motif named after him. Even though Christiansen devoted himself chiefly to applied art during his years in Darmstadt, for the large part of his life he remained first and foremost a painter.

Cissarz, Johann Vincenz
22.1.1873 Danzig – 23.12.1942 Frankfurt
German painter, graphic artist, and glass designer
From 1895 to 1896 Cissarz was a master pupil of the Belgian history painter Ferdinand Pauwels (1830–1904) at the Academy in Dresden. After completing his studies, he won commissions for posters and book illustrations and from

1898 onwards was a designer at the Dresdner Werkstätten für Handwerkskunst (Dresden Workshops for Handicraft). In 1903 he was appointed to the artists' colony in Darmstadt, where he was active in the fields of interior design and applied art. After his departure in 1906 he took up a teaching post (as from 1909 a professorship) in book design at the Teaching and Experimental Workshops (Lehr- und Versuchswerkstätte) attached to the School of Arts and Crafts in Stuttgart, and from 1916 to 1940 ran the painting masterclass at the School of Arts and Crafts in Frankfurt. As from 1912 he was also a member of the Deutscher Werkbund. Cissarz was well-known as a poster designer and illustrated books for the Eugen-Diederichs-Verlag publishing house.

Colenbrander, Theodoros Christiaan Adriaan
31.10.1841 Doesburg – 28.5.1930 Keppel
Dutch architect, designer, and potter
After working for several years in his homeland as an architect, Colenbrander spent ten years (1870–80) in Parisian artist circles. He returned to take over the artistic direction of the porcelain factory Haagsche Plateelbakkerij Rozenburg in The Hague. The decoration of his pottery is very lively and often marked by fanciful or odd motifs. Around 1900, he began designing carpets, though he continued working as a designer of porcelain as well.

Combaz, Gisbert
23.9.1869 Antwerp – 18.1.1941 Brussels
Belgian painter and craft designer
Combaz abandoned his law studies to go to the Académie Royale des Beaux-Arts in Brussels. In 1895, he began his long teaching career at various Belgian schools and academies. In the 1930s, he, R. Grousset, H. Maspero and Paul Pelliot published several studies and other works on Oriental art. A highly educated artist, Combaz is considered one of the most important protagonists of Belgian Art Nouveau, for the sheer range of his work.

Cranach, Wilhelm Lucas von
27.9.1861 Stargardô Pomerania – 31.3.1918 Berlin
German painter, interior designer, and jewelry designer
After studying in Weimar and Paris, Cranach, a descendant of the famous painter Lucas Cranach the Elder (1472–1553), worked as from 1893 as a portrait and landscape painter in Berlin. He also designed interiors for several castles in eastern Germany, including Wartburg castle near Eisenach in Thuringia. Influenced by the Russian Joullovski, in the 1890s he turned to gold and silverware designs, which are distinguished by their skillful use of various precious metals and with which he won a gold medal (for a brooch) at the Paris World Exposition of 1900.

Crane, Walter
15.8.1845 Liverpool – 14.3.1915 Horsham, Sussex
English painter, graphic artist, illustrator, and arts and crafts designer
Crane, who studied under the art critic John Ruskin (1819–1900) and the painter William James Linton (1812–97), concentrated his output from 1864 onwards on book illustration. He joined the Art Worker's Guild in 1884 and became one of the leading figures of the Arts and Crafts Exhibitions Society in 1888. Between 1893 and 1899 he held several directorships in succession, first at the Manchester School of Art, then at Reading College and finally at the Royal College of Art in South Kensington. From 1894 onwards he also worked for William Morris's Kelmscott Press.
Crane's work is strongly influenced by the Pre-Raphaelites and also by Florentine *quattrocento* art, which he studied

intensively during his two journeys to Italy (in 1871 and 1888). He is famous for his book graphics, and especially his illustrations for fairy tales, which are reminiscent of Japanese color prints and which were widely publicized in Germany. For the arts-and-crafts trade he designed carpets, wallpaper, embroidery, and majolica tiles. He also made a major contribution to the stylistic development of Art Nouveau as a theoretician.

Dammouse, Albert-Louis
22.10.1848 Paris – 16.6.1926 Sèvres
French sculptor, painter, potter, and glass artist
As the son of a sculptor at the Manufacture de Sèvres, Dammouse grew up with the techniques of porcelain-making. He studied in Paris, initially at the École Nationale des Arts Décoratifs and from 1868 under the sculptor François Jouffroy at the École des Beaux-Arts. He went on from there to work with the potter Marc-Louis Solon (known as Milès) before setting up on his own as a potter in Sèvres in 1871. At the ceramics exhibition in Paris in 1898 he exhibited for the first time small articles made in *pâte de verre*, a technique he had refined and employed successfully for the production of decorative objects. More than most of his contemporaries, Dammouse was influenced by Japanese art. His products, the decoration of which consists largely of marine plants and stylized flowers in grey, green and brown, are noted for their extravagant glazes on *pâte d'émail* (a very fine, opaque type of glass). Dammouse exhibited at numerous exhibitions, and in 1889 was awarded a gold medal.

D'Aronco, Raimondo
31.8.1857 Gemona – 3.5.1932 San Remo
Italian architect
D'Aronco studied at the Accademia delle Belle Arti in Venice from 1877, and was a successful entrant in various competitions even in his younger years. As an architect he worked not only in Italy but also in Turkey, where among other things he restored Hagia Sophia and repaired the Grand Bazaar. At the Turin Exposition of Arts and Crafts in 1902, he was commissioned to design the main building and entrance pavilion.
D'Aronco's style manifests the influence of the Viennese school of Otto Wagner and the Darmstadt architectural style of Joseph Maria Olbrich. Along with Ernesto Basile and Giuseppe Sommaruga (1867–1917), he is the most significant representative of Art Nouveau in Italy.

Daum Frères
Established 1875 in Nancy
French glass factory
Established by Jean Daum (1825–1885) and continued by his sons Jean-Louis Auguste (1854–1909) and Jean-Antonin (1864–1930), throughout the 1880s the glassware factory produced mainly period glass and tableware. In 1891, however, impressed by the success of Émile Gallé, the brothers went over entirely to producing glassware in the Art Nouveau style, in the same year founding the Atelier d'Art à la Verrerie de Nancy with its own training workshop. During this period, Jean-Antonin Daum was responsible for artistic design. In 1900, Henri Bergé, who had worked for the factory since 1897, took over the design workshop. In the same year, the firm was awarded the Grand Prix at the World Exposition in Paris. From 1905 to 1930, Edgar Brandt and Louis Majorelle also worked for Daum, designing iron mountings for the glassware.
From 1902, the firm produced glass decorated with floral and abstract motifs and made with Gallé's techniques and style. In the 1920s, Daum stopped working in the Art Nouveau style, and began producing thick-sided glassware with geometric Art Deco patterns.

Dearle, John Henry
1860 – 1932
English arts and crafts designer
Dearle, who trained as a picture weaver in 1878, was William Morris's assistant and his successor as director of Merton Abbey, one of Morris's workshops founded in 1881 for wallpaper, carpets, tapestry, textiles, and glass. Morris and Dearle were the main producers of designs for these items, inspired by Jacobean textile patterns.

Décorchemont, François-Émile
26.5.1880 Conches – 19.2.1971 Conches
French potter and glass artist
Décorchemont studied at the École Nationale des Arts Décoratifs from 1893 to 1897, where his father taught. In 1902, he established a glassworks to turn out *pâte de verre* wares. His first works were small statues, masks, and bowls, produced by the *cire perdue* method. His translucent pots were decorated with animal and flower patterns. Though an Art Nouveau artist, he used thick glass and a new stylized ornamentation of a type later associated with Art Deco.

Delaherche, Auguste
27.12.1857 Goincourt, near Beauvais – 27.6.1940 Paris
French potter
After studying under the landscape painter Louvrier de Lajolais at the École Nationale des Arts Décoratifs in Paris (1877–82), Delaherche worked in various studios doing glass windows and gold work before taking up pottery in 1883. In 1886, the firm of Christofle & Cie took him on as head of the galvanoplastics department. From 1900, Delaherche concentrated on the production of porcelain and, together with Ernest Chaplet, from 1904 turned out stoneware of such high quality that he has come to be regarded as one of the leading French potters of the *fin-de-siècle*. Delaherche had a special preference for stoneware with variegated glazes, for which he developed several firing techniques. He also favored grooved and openwork decoration.

Den Kongelige Porcelainsfabrik
Founded 1760 near Copenhagen
Danish porcelain factory
The Royal Danish Porcelain Factory succeeded in manufacturing true porcelain only in 1773, through Franz Heinrich Müller. After going bankrupt, in 1799 the factory passed into the possession of the king, and was subsequently called Den Kongelige Porcelainsfabrik – the name by which it is still known today. In 1867 the factory passed into the hands of A. Falck and in 1882 merged with the faience factory Aluminia, whose director, Philipp Schou (1838–1922), also took over the running of the Royal Porcelain Factory. Under the artistic guidance of Emil Arnold Krog (1885–1916), the chemist Adolphe Clément (1860–1933) and his successor, Knud Valdemar Engelhardt, the factory created innovative decors influenced by naturalism and Japanese color woodcuts which, together with the crystal glazes developed by Engelhardt, brought the company international fame.

Divéky, Josef von
28.9.1887 Farmos – 1951 Sopron
Hungarian painter and graphic artist
Divéky, who studied at the Academy of Fine Art in Vienna and as from 1906 under Larisch, Löffler and Carl Otto Czeschka (1878–1960) at the School of Arts and Crafts in Vienna, worked from 1910–14 as a graphic artist in Brussels and Zurich, before settling in Behtlis, Switzerland in 1919. In 1941 he became a professor at the Budapest School of Arts and Crafts. Divéky's work consists chiefly of book illus-

trations, works for magazines and commercial graphics for the Wiener Werkstätte.

Doesburg, Theo van
(real name Christiaan Emil Marie Küpper)
30.8.1883 Utrecht – 7.3.1931 Davos
Dutch painter, architect, and writer on art
Van Doesburg studied painting, and from 1912 was a pupil of the painter Vassily Kandinsky (1866–1944). Along with the architects Jacobus Johannes Pieter Oud and Jan Wils and the painter Piet Mondrian, he was in 1917 a co–founder of the De Stijl group of artists, to which architects, painters, sculptors and poets belonged. Doesburg was the initiator of the group and editor of the eponymous periodical, which had a great influence on the development of abstract art. In 1922 he joined the Dadaists, whom he publicized in the Netherlands. Doesburg painted non-representational pictures, initially restricting himself to rectangular lattice forms, to which he added diagonals in 1924. In his architectural designs he attempted to put De Stijl principles into practice. However, his numerous theoretical writings were still more important, exercising great influence on German art and modern architecture (Bauhaus movement).

Domènech i Montaner, Lluís
1850 Barcelona – 1923
Spanish architect
Montaner took a degree in architecture in 1873 at the University of Madrid and quickly became well-known, thanks to successes in public competitions. In 1875 he began a long period of teaching at the architectural school in Barcelona, becoming director in 1910. He built the Grand Hotel and Café-Restaurant for the World Exposition in Barcelona in 1888, but his work outside that was mainly private houses. His style was imbued with Catalan Gothic architecture, which he varied with elements of Classicism, the Renaissance and Japanese art.

Dresser, Christopher
4.7.1834 Glasgow – 24.11.1904 Mulhouse, Alsace
English botanist, art theoretician, and handicrafts designer
Dresser studied at the Somerset House School of Design from 1847 to 1853 and taught botany there from 1854. He received an honorary doctorate from the University of Jena for his books on botany in 1860. In 1875 he began concentrating on arts and crafts, designing silver tableware and after 1879 also glass, furniture, textiles, and the first Art Nouveau ceramics made in England. After a trip to the Far East in 1876, Dresser became one of the main protagonists of Japonisme and opened a store for imported Japanese goods, Dresser and Holmes, in 1879.
Dresser's work is marked by its simple design and strong line. He was inspired by Asian and Pre-Columbian pottery, and by the vocabulary of forms of Islam, classical antiquity, India, China and the Celts. Dresser also issued many publications on questions concerning the justice of material and function, on the formal design of industrial products, and on botany and its use in arts and crafts.

Dubois, Fernand
28.10.1861 Renaix – 1939 Sosoye
Belgian sculptor, jeweler, and medal-maker
After a brief spell at the Free University of Brussels, Dubois became a pupil of the sculptor Charles van der Stappen. Besides teaching jewelry at the École Professionelle des Arts Appliqués, Dubois successfully exhibited his craft pieces at numerous exhibitions. They included not only jewelry but also sculptures, medals, and everyday articles. His artistic output came to an end in 1925.

Dudovich, Marcello
21.3.1878 Trieste – 1962 Milan
Italian graphic artist
In 1897, the firm of Ricordi took on Dudovich as an artist, where he translated the designs of Metlicovitz, Hohenstein, and Capiello on to lithographic plates. At the same time, he took classes at the Società Artistica e Patriottica. His talent was quickly recognized by the young Bolognese publisher Edmondo Chappuis, who commissioned posters from him. Dudovich developed into one of the most important and successful poster artists of Italian Art Nouveau, but he also did illustrations for various Italian periodicals (including *Italia Ride*) and the German periodical *Simplicissimus*. On top of this, he also worked – especially later in his life – as a painter and interior designer.

Durrio, Paco
(real name Francisco Durrio de Madron)
1875 Valladolid – 1940 Paris
Spanish jeweler and craft artist
From 1883, Durrio lived mainly in Paris, where he exhibited his jewelry with great success at the 1904 Salon d'Automne. Even though most of his life was spent in France, he is considered as a representative of Spanish Art Nouveau, as his work is strongly imbued with the culture of his homeland.

Eckmann, Otto
19.11.1865 Hamburg – 11.6.1902 Badenweiler
German painter, graphic artist, book illustrator, typeface designer, and craftsman
After an apprenticeship as a clerk, Eckmann studied at the schools of arts and crafts in Hamburg and Nuremberg, and as from 1885 at the Academy in Munich. Although successful as a painter, in 1894 he auctioned off all his paintings and dedicated himself exclusively to graphic art and applied art. He contributed to the magazines *Pan* (1895–97) and *Jugend* (1896–97) and from 1897 taught at the Berlin School of Arts and Crafts.
Eckmann is one of the most important representatives of floral Jugendstil. The symbolic image of the swan, which appears throughout his graphic works, illustrations, and textile designs, became the emblem of Jugendstil. Eckmann was influenced by Japanese prints, from which he adopted his free, naturalistic stylization of plants and animals, his renunciation of perspective in favor of a decorative two-dimensionality, his color woodcut techniques and his color mixes, which he developed himself. His oeuvre includes furniture designs, interior decors, works in metal, ceramics, jewelry, and textiles. For the Karl Klingspor printers in Offenbach, he also created the Eckmann Type which bears his name, and which became highly fashionable as *the* Jugendstil typeface.

Eiffel, Alexandre Gustave
15.12.1832 Dijon – 28.12.1923 Paris
French engineer
After graduating in engineering from the École des Arts et Manufacture, Eiffel specialized in the construction of railway bridges (including the Maria Pia bridge over the Douro near Porto 1877–78 and the Truyère Bridge near Garabit 1880–84) and halls. He also became involved in developing metal construction techniques – initially for constructing bridges and later for other structures, especially large glass roofs. His masterpiece is the Eiffel Tower, built for the Paris World Exposition in 1889 and named for him (1885–89). The Tower showed that functionality and structural logic can have an artistic effect of their own.

Eissenloeffel, Jan
10.1.1876 Amsterdam – 17.9.1957 Laren, near Amsterdam
Dutch silversmith, metal artist, and craft artist

After training in art in Amsterdam, in 1896 Eissenloeffel entered the Amsterdam silversmith firm of W. Hoeker, and in the same year took over the metals department of Hoeker's firm Amstelhoek. In 1900, he spent a year in Russia studying the work of Peter Carl Fabergé. In 1907 and 1908 he worked at the Vereinigten Werkstätten für Kunst im Handwerk [Associated Workshops for Art in Handicraft] in Munich, which won him a wide reputation in Germany. Eissenloeffel favored severe forms, which he adorned sparingly with geometric, abstract motifs. His metal work is distinguished for its emphasis on the metal structure. Besides everyday and luxury articles, he also undertook larger items such as wall fountains, fireplaces, and grandfather clocks. His pieces won awards at arts and crafts exhibitions in Turin (1902), Dresden (1904) and Munich (1908).

Endell, August
12.4.1871 Berlin – 15.4.1925 Berlin
German architect and applied art designer
Endell studied philosophy, mathematics, psychology, and aesthetics before turning in 1896 – under the influence of Hermann Obrist – to architecture and applied art. In Munich, he produced designs for handicraft objects and books as from 1897 and worked for the magazines *Pan* and *Dekorative Kunst*, amongst others. That same year he also designed his first architectural work, the Hof-Atelier Elvira, whose decoration made an enduring impact upon Jugendstil. From 1901, in addition to a theater, he also built numerous town houses and villas in Berlin and Potsdam. In 1904 he founded the School of Formal Art, which closed ten years later. In 1918 he became director of the Academy of Art and Applied Art in Breslau.
Particularly during his Munich years, Endell was of great importance for Jugendstil, both as an artist and as a theoretician. Although Obrist exerted a very strong influence upon him, he succeeded in developing an entirely new and individual formal style. His ornament was no longer oriented toward the forms of nature, but consisted of an impressive interplay of forms and colors. In his Berlin years, he moved on to a sober, functional language of form. His major works include the Hof-Atelier Elvira in Munich (1897–98, partially destroyed in 1944, demolished after 1945), the Sanatorium on Föhr (1898), stands for the Mariendorf trotting circuit (1913) and the Theater des Überbrettl in Berlin (1901). Amongst his most important writings are *Formschönheit und dekorative Kunst* [Formal Beauty and Decorative Art, 1898] and *Die Schönheit der Großstadt* [The Beauty of the Metropolis, 1906].

Engelhardt, Knud Valdemar
see Krog, Emil Arnold; Den Kongelige Porcelainsfabrik

Evenepoel, Henri Jacques Édouard
3.10.1872 Nice – 27.12.1899 Paris
Belgian painter and graphic artist
Evenepoel went to the academies of Saint-Josse-Noode and Brussels, then continued his studies from 1893 in Paris under the painter Gustave Moreau (1826–98). His pictures, successfully shown at several exhibitions in France and Belgium, are noted for their intense colors, his favorite subject matter being ordinary life in Paris and Algiers. At first he adopted the style of Édouard Manet (1832–83), Edgar Degas (1834–1917) and Henri de Toulouse-Lautrec, but after an prolonged stay in North Africa (1887–98) he turned to Fauvism. He died from typhoid fever when only 27.

Fabergé, Peter Carl
18.5.1846 St. Petersburg – 24.9.1920 Lausanne
Russian goldsmith and jeweler

Peter Carl Fabergé was the best-known and most inventive member of the Huguenot goldsmith family Fabergé, which first opened a jewelry shop in St. Petersburg in 1842. He joined the business in 1864 after completing his studies in Dresden, Frankfurt, and Paris, and took it over in 1872. Although he had worked for the Imperial Family and the aristocracy of the whole of Europe since the 1860s, it was not until the Paris World Exposition of 1900 that his work became known to a broad public. Up to the outbreak of the First World War, Fabergé's business continued to grow, establishing workshops and showrooms in Moscow, St. Petersburg, Kiev, and Odessa and a branch in London (1905–15). His workforce of 500 included his brothers and sons, who also worked as designers. The October Revolution forced the business to close in 1918, driving the family into emigration in Switzerland.
Besides his famed Easter eggs, Fabergé made icons, clocks, cases, mounted glassware, animal figures in cut gemstones and metal, sumptuous bowls, etc. as well as the biggest jewelry production of the *fin-de-siècle*. The things he made, employing a wide variety of materials, combine functional requirements with highly sophisticated techniques. From 1883 to 1900 Fabergé was a disciple of the Art Nouveau movement. The patterns he designed in this period consisted mainly of plant, insect, and animal designs. After 1900, he went over to more geometric, functional forms.

Feure, Georges de
(real name Georges van Sluijters)
6.9.1868 Paris – 26.11.1943 Paris
Dutch–French painter, graphic artist, set designer, and crafts artist
While apprenticed in the book trade in The Hague, Feure became acquainted with Symbolism. He came so strongly under the influence of Pierre Cécile Puvis de Chavannes that in 1890 he moved to Paris and became a pupil of Jules Chéret. His first commissions were stage sets and illustrations. At the suggestion of the art dealer Samuel Bing (1838–1905), he turned to arts and crafts, and with the architect Theodor Cossmann set up a workshop for arts and crafts in Paris. Feure was so successful at several exhibitions that Bing, whose pavilion he had fitted out for the 1900 Paris World Exhibition, took over the marketing of his products. Before the outbreak of the First World War he moved to England, where he worked mainly as a set designer. In 1928 he returned to Paris, where he was appointed professor at the École Nationale Supérieure des Beaux–Arts.
Feure worked in all fields of arts and crafts. He designed furniture, porcelain, jewelry, textiles, glass windows, glassware, and posters, and did book illustrations. His work is notable for its filigree ornamentation, and has a pronounced feminine effect.

Fidus
(real name Hugo Höppener)
8.10.1868 Lübeck – 23.2.1948 Schönblick, near Woltersdorf
German draughtsman and book illustrator
Fidus studied at the technical high school in Lübeck and at the Academy in Munich. Up to 1889 he was a student under W. Diefenbach, who gave him the name "Fidus" and strongly influenced him. Fidus, who held mystical, theosophical beliefs, made a name for himself as a book illustrator and executed drawings for the magazines *Jugend*, *Pan* and *Sphinx*. In his works he combined realistic figures with abstract, stylized forms.

Fouquet, Georges
1862 Paris – 1957 Paris
French jewelry artist
In 1895, Fouquet took over his father's jewelry business, for

which he had already designed jewelry since 1885. He quickly developed into one of the best French Art Nouveau jewelry artists. For this reason, he was elected president of the jewelry body of the Exposition Internationale des Art Décoratifs et Modernes in Paris in 1925 and again for the international exposition in 1937.
Fouquet made jewelry based on designs by the Art Nouveau artists Eugène Samuel Grasset and Alfons Maria Mucha, among others. His work was inspired by Japanese, Oriental, and Egyptian art.

Frosterus, Sigurd
4.6.1876 Asikkalassa – 1.3.1956 Helsinki
Finnish architect and philosopher of art
Frosterus, who studied under Henry van de Velde, was an early supporter of functionalism. Amongst the principles he embraced were the most rational use of the material, minimum expenditure, and a restriction to constructional essentials. His major works include the Stokman Department Store (1924–31) in Helsinki.

Gaillard, Eugène
31.1.1862 Paris – 1933 Paris
French architect and craft designer
Gaillard was first and foremost a furniture designer. He, Georges de Feure and Edward Colonna (1862–1948) were responsible for the design of Samuel Bing's Art Nouveau pavilion at the Paris Exposition in 1900. In 1906, he published *A propos du mobilier* [On furniture]. As with many other artists of the period, nature was a source of inspiration. In his case, the plant or animal motifs in his decorations were transformed into fanciful patterns rather than used naturalistically.

Gaillard, Lucien
1861 – after 1945
Gaillard learnt his trade from his father, the jeweler Ernest Gaillard, and became known for his goldsmith work, which was based on Japanese models. His special interest was in the various techniques of metalworking, in which he soon became a virtuoso. His silver work was exhibited at the Paris World Expositions of 1889 (where he was awarded a gold medal) and 1900. Impressed by René Lalique, he set about using more fantastic patterns in his jewelry designs. From 1900, he employed Japanese jewelry artists, and tortoiseshell and ivory carvers in his workshop. He expanded his studio and produced costly artefacts from mixed materials which brought him rapid success and another gold medal at the salon of the Société des Artistes Français.

Gallé, Émile
4.5.1846 Nancy – 23.9.1904 Nancy
French glass artist, potter, and furniture designer
Following a period of training in his father's faience and glass factory, Gallé studied philosophy, zoology, and botany and from 1864 to 1866 went to a private art school in Weimar. In 1867, he completed his practical training at the glassworks in Meisenthal (north Lorraine) and worked as a designer at his father's workshops in Nancy, Saint-Clément, and Meisenthal. From 1871, he spent time studying in Paris and London, where he came into contact with Japanese art, which was to have a lasting influence on his work. In 1874, he took over the artistic direction of his father's business. Ten years later, in 1884, he set up a furniture workshop, which by 1886 had expanded into a furniture factory. At the World Expositions in Paris in 1878, 1889, and 1900, he exhibited ceramics, glassware, and furniture with great success, gaining major awards. In 1890, he became a member of the Académie de Stanislas in Nancy and in 1891 of the Société Nationale des Beaux-Arts in Paris. In

1894, he founded the Société Lorraine des Arts Décoratifs and in 1901 the École de Nancy, to which he devoted much effort. His last designs date from 1903, but Gallé glassware continued to be made until 1931. The firm itself closed in 1935.

Gallé is considered one of the most outstanding glassmakers of his time, who made an enormous contribution to the development of the art of glassmaking. Prompted by Chinese cutting techniques, he developed a process for the production of cut and incised flashed glass. In addition, he endeavored very successfully to enhance the brightness of his colors while retaining the transparency of the material. In his furniture, he abandoned the fashionable eclecticism of his time and attempted to develop forms and decoration from natural structures.

Gallen-Kallela, Akseli
26.5.1865 Pori, Björneborg – 7.3.1931 Stockholm
Finnish painter and graphic artist
Gallen-Kallela studied at the School of Art in Helsinki and from 1889 at the Académie Julian and Atelier Cormon in Paris, where the works of Jules Bastien-Lepages (1848–84) and Pierre Cécile Puvis de Chavannes made a profound impression upon him. Back in Finland, he started painting genre scenes of Finnish folk life in the naturalist style. Around 1900 he developed a monumental style close to Symbolism, characterized by strong outlines and flat areas of paint, which combined decorative elements with a powerful expressiveness. Gallen-Kallela, an outstanding portraitist and graphic artist, became the leader of a Romantic, nationalist art which drew its subjects from Nordic myth, and above all the *Kalevala* epic.

Gaudí, Antoni
(full name Antoni Gaudí i Cornet)
25.6.1852 Reus, near Tarragona – 10.6.1926 Barcelona
Spanish architect and craft artist
Gaudí was both devout and socially committed. In order to be able to translate his ideals into practice, he decided to become an architect, and from 1873 to 1878 went to the Escola Superior d'Architectura in Barcelona. Even while he was still a student he gained his first commissions. In 1883, he took over the site management of La Sagrada Familia church, which was financed entirely from offerings and donations, and this project remained closest to his heart to the end of his life. In the same year, he became acquainted with his patron and later friend, Count Eusebio Güell, for whom he built the Palacio Güell in 1885–90. In 1900, the Count commissioned him to build a garden suburb (now the Parc Güell), which reflects Gaudí's endeavors to design and build his structures so that they have the effect of being an organic part of nature.

Gaudí's architecture is different not only from anything that had gone before in Barcelona but also from the work of his contemporaries. His stylistic borrowings are mainly from Catalan Gothic. His efforts to improve Gothic structural systems statically, coupled with his love of experimentation and fantastic imagination, produced some unusual structural forms. His use of multi-colored mosaics in ornamentation and the play of light and space transform his buildings into monumental sculptures. His mosaics, furniture and other craft objects are likewise distinguished for their abstract forms and recreation of objects in unfamiliar guises.

Gesellius, Herman
1876 – 1916
Finnish architect
Together with Armas Eliel Lindgren and Eliel Saarinen, in 1896 Gesellius founded the architectural firm of Gesellius, Lindgren & Saarinen, known as GLS. The international fame of the three architects was based on the Finnish Pavilion which they designed for the Paris World Exposition of 1900. Their most important works included the Suur-Merijoki manor house in Viipuri (1901–03) and the "fortified" Hvittorp House in Kirkkonummi (1901–04). In conjunction with Saarinen, Gesellius built the Remer House near Berlin (1905). GLS was dissolved in 1907.

Gradl the Elder, Hermann
21.5.1869 Dillingen – 17.4.1934 Landsberg am Lech
German painter, sculptor, graphic artist, and craftsman
From 1890 Hermann Gradl studied at the School of Arts and Crafts in Munich, together with his brother Max Joseph (1873–1934). Both became landscape painters and made their first excursions into applied art in the wake of the Glass Palace exhibition of 1898. At the next exhibition in 1899, Hermann Gradl showed works made out of tin, for which he subsequently received commissions from various metalware factories. From 1900 to 1905 he was also engaged as a designer for the Nymphenburg Royal Bavarian Porcelain Factory, for whom he helped win new fame with his artistic stylization of floral motifs. Gradl took part in numerous exhibitions at home and abroad. No ceramic designs by him are known after 1906.

Grasset, Eugène Samuel
25.5.1841 Lausanne – 23.10.1917 Sceaux
Swiss French sculptor, architect, illustrator, painter, and craft artist
After studying architecture in Zurich, Grasset continued his studies from 1871 under Eugène Emmanuel Viollet-le-Duc. Even before the appearance of Art Nouveau, he had designed posters very successfully, which contributed materially to the fact that commissions for posters were subsequently given to artists at all. Unusually, his printing graphics featured a mixed technique of lithography and woodcuts. This combined style, which fitted in well with the Art Nouveau cult of materials, is found in other areas of his work, which besides posters and book illustrations comprised designs for carpets, materials, mosaics, ceramics, glass paintings, and, not least, jewelry. After 1900 he wrote a number of textbooks, and was appointed to a chair at the École normale d'Enseignement du Dessin in Paris.

Greiner, Daniel
27.10.1872 Pforzheim – 8.6.1943 Jugenheim
German sculptor, painter, and graphic artist
Greiner graduated from Giessen University in theology and philosophy and in 1897 became a pastor in the Protestant diocese of Schotten. In 1901, following a dispute with the church synod, he turned to art. After studying at the Academy in Paris and at the School of Sculpture in Berlin, in 1903 he was appointed to the artists' colony in Darmstadt, where he produced architectural and garden sculptures until his departure in 1906. He subsequently founded the Greiner and Guth Workshops for Tombstone Art in Jugenheim and in his latter years devoted himself increasingly to church painting. His political past as a Socialist meant that, as from 1933, his commissions dried up. But, despite his severely straitened circumstances, he nevertheless continued to work as a sculptor and painter.

Gris, Juan
(real name José Victoriano González Pérez)
23.3.1887 Madrid – 11.5.1927 Paris
Spanish painter and graphic artist
Gris abandoned his engineering studies in 1904 to go to the Arts and Crafts College in Madrid. In 1906, he moved to Paris, where he joined the circle around Pablo Picasso and took up "analytical" Cubism. Gris started out as a cartoonist, but he also did sets for the Russian Diaghilev Ballet in Monte Carlo and book illustrations. However, it was mostly still lifes, portraits, and figurative pictures that he painted.

Gris was the main representative of Cubism in France, which he developed independently after the First World War (synthetic Cubism). His considered and technically outstanding pictures count among the masterpieces of this style.

Gruber, Jacques
25.1.1870 Sundhausen, Alsace – 15.12.1936 Paris
French painter and craft designer
A scholarship from the city of Nancy enabled Gruber to study under Gustave Moreau (1826–98) at the École des Beaux-Arts in Paris. In 1894, Gruber returned to Nancy and produced decorative designs for vases for Daum Frères' glass factory, furniture for Louis Majorelle and book bindings for René Wiener. In 1897, he set up his own studio, and from 1900 went over almost entirely to glass mosaics and glass painting. At the same time he taught at the École des Beaux-Arts in Nancy and in 1901 was a cofounder of the École de Nancy.
Gruber was regularly represented at the Salon des Artistes Décorateurs from 1908 and at the Salon des Artistes Français from 1911. From 1920 to 1923 major honours were heaped on him, culminating in the Légion d'Honneur in 1924.

Guimard, Hector
10.3.1867 Lyons – 20.5.1942 New York
French architect, sculptor, and craft artist
Guimard studied in Paris from 1882 to 1885 at the École Nationale des Arts Décoratifs and subsequently at the École des Beaux-Arts. He received his first commission in 1887, to build a café-restaurant in Paris. This commission was succeeded by others. From 1894 to 1898 he taught at the École des Arts Décoratifs in Paris. After the First World War he was quickly forgotten, as Art Nouveau was no longer in fashion. In 1938, he finally emigrated to the United States.
The most important French representative of the organic, floral style of Art Nouveau, Guimard was initially strongly influenced by the Belgian architect Victor Horta, whom he had got to know in 1895. His own style (the "Guimard Style") is distinguished by its linearity and interplay of light and contrasts. As a furniture designer, he looked on furniture and the interior decoration of a house as parts of a total work of art. This led to very unusual designs for much of his furniture, some of which must be considered among French Art Nouveau's finest. His principal works include the Castel Béranger residential building (1894–99), which in 1899 was awarded a prize for the finest facade in Paris, and the station entrances of the Paris Métro (1899–1904).

Gulbransson, Olaf
26.5.1873 Christiania (today Oslo) – 18.9.1958 Schererhof (on Lake Tegern), Germany
Norwegian painter and graphic artist
Gulbransson, who studied at the School of Arts and Crafts in Oslo and was a pupil of Colarossi in Paris, held a permanent position from 1902 with the Munich magazine *Simplicissimus*. In 1929 he took up a teaching post at the Academy in Munich.
Gulbransson is one of the most important caricaturists of the 20th century. In his ironically naive, powerfully expressive drawings, he communicated the essential characteristics of his subject using only the most economic means, and later simply by use of outline. Alongside his work for *Simplicissimus*, he also illustrated books and published many of his caricatures in the Norwegian magazine *Tidens Tegn*. His major works include *Berühmte Zeitgenossen* [Famous contemporaries, 1905], *Aus meiner Schublade* [From my drawer, 1911] and his autobiography *Es war einmal* [Once upon a time, 1934].

Gurschner, Gustav
28.9.1873 Mühldorf – 1970 Vienna
Austrian sculptor and craftsman
Gurschner studied at the Vienna School of Arts and Crafts from 1888 to 1894 and in Munich in 1896, before moving to Paris in 1897 and attaching himself to the Art Nouveau artists Alexandre Charpentier (1856–1909), Jean-Auguste Dampt (1854–1946) and Ville Vallgren. Gurschner showed his works in numerous exhibitions; he took part regularly in the Salon du Champ de Mars in Paris and, after its foundation in 1897, in the exhibitions by the Vienna Secession. In 1900 he became a member of the Hagenbund, showing two marble sculptures in its opening exhibition, while at the 1902 Turin International Exhibition of Decorative Modern Art his works were to be seen in no less than three pavilions – the Austrian, the German, and the French. He subsequently restricted himself wholly to sculpture, in particular for tombs and monuments.

Haagsche Plateelbakkerij Rozenburg
Established in 1883 in The Hague
Dutch china manufacturer
The Haagsche Plateelbakkerij Rozenburg was established by a German, Wilhelm Wolff von Gudenberg, who himself prepared designs until Theodoros Christiaan Adriaan Colenbrander took artistic control. Under Colenbrander's management, the factory gradually went over to producing only Art Nouveau china. Models for the light-dark-contrast and vegetable patterns were taken from Javanese batik, but it was only under the direction of J. Jurriaan Kok (1894–1913) that the company developed a typical "Rozenburg Style". In 1899, in order to be able to produce objects in unusual designs, Kok and the chief chemist M. N. Engelden developed a very thin-sided body called quasi or eggshell porcelain, similar to frit porcelain. This enabled Kok to translate his unusual designs, an interaction of decoration and form, into reality.
Production at the factory was so uniformly arranged that it is not possible to distinguish the work of the various artists who worked there. They included Samuel Schellink (1876–1958), Jacobus Willem van Rossum (1881–1963), Roelof Sterken (1877–1943) and J. H. Hartgring (1876–1951).

Habich, Ludwig
2.4.1872 Darmstadt – 20.1.1949 Jugenheim
German sculptor and craftsman
Habich, a pupil of the Frankfurt sculptor Gustav Kaupert, was one of the founders of the Freie Vereinigung Darmstädter Künstler (Free Association of Darmstadt Artists) in 1898 and in 1899 was amongst the first seven to be appointed to the Darmstadt artists' colony. Alongside his work as an artist, Habich also taught sculpture at Adolph Beyer's art school in Darmstadt as from 1901. In 1906 he left the artists' colony and moved to Stuttgart, where from 1910 to 1937 he held a teaching post at the Academy of Art. In 1937 he returned to Darmstadt, but left the city again after his house was destroyed in the Second World War.
Habich created colossal figures, fountains, monuments and tomb art, small sculptures, and handicraft items. His bronze sculptures were shown at the World Expositions in Paris (1900) and St. Louis (1904). His major works include the oversized figural group Man and Woman (1900–06), the Goethe Temple and Bismarck Fountain, all in Darmstadt, and the War Memorial in Lauterbach.

Hamesse, Paul
1877 Brussels – 1956 Brussels
Belgian architect
Hamesse was a pupil and later a colleague of the architect Paul Hankar until Hankar's death in 1901. Around 1900, he began to enter competitions and built his first (private) houses, mainly in Brussels. From 1903, he won numerous commissions for private houses, shops, and residential buildings, including the Hôtel Cohn-Donnay (today the Café-Restaurant Ultième Hallucinatie).

Hampel, Walter
17.7.1867 Vienna – 17.1.1949 Nussdorf am Attersee
Austrian painter and draughtsman
Hampel was a student at the State School of Handicraft and at the Vienna Academy under Eisenmenger, Angeli and L'Allemand. From 1900 to 1911 he was a member of the Hagenbund.

Hankar, Paul
11.12.1859 Frameries, Hainault – 17.1.1901 Brussels
Belgian architect and furniture designer
Hankar trained as a sculptor, but graduated from the Académie Royale des Beaux-Arts in Brussels as a pupil of the architect Henri Beyaert, for whom he did wrought-iron work. In 1888, he began his partnership with the interior designer Alphonse Crespin (1859–1944). In 1893, he built himself a house, which, along with the Hôtel Tassel by Victor Horta, is considered as the first Art Nouveau building in Brussels. While running his successful architectural practice, Hankar also designed furniture, and from 1894 he contributed to the periodical L'Emulation. For the Brussels World Exposition of 1897, he collaborated with Henry van de Velde, Gustave Serrurier-Bovy and Georges Hobé.
Paul Hankar and Victor Horta were the leading Art Nouveau architects in Brussels. Hankar was an enthusiastic proponent of the doctrines of Eugène Emmanuel Viollet-le-Duc and the English Arts and Crafts Movement, and looked on architecture as a synthesis of the arts.

Hansen, Frida
(real name Frederikke Bolette)
8.3.1855 Stavanger – 12.3.1931 Oslo
Norwegian textile designer
In the 1870s Hansen studied painting, winning a prize at the World's Columbian Exposition in Chicago in 1893 which enabled her to study textile design in Cologne in 1894, and in 1895 to study under Pierre Cécile Puvis de Chavannes in Paris. In 1900 she became a member of the Société Nationale des Beaux-Arts and was represented at the Paris World Exposition by her famous tapestry The Milky Way. Hansen perfected the technique of transparent weaving, which lends her figures an almost ghost-like quality. She was influenced both by Japonisme and the Pre-Raphaelites, and stood squarely within the Art Nouveau tradition in her thematic material.

Haustein, Paul
17.5.1880 Chemnitz – 6.9.1944 Stuttgart
German painter, graphic artist, and craftsman
Haustein, who studied painting at the Academy in Munich, worked for the magazine Jugend in 1898 and was a founder member of the Vereinigte Werkstätten für Kunst im Handwerk [Associated Workshops for Art in Handicraft] in Munich. He also produced designs for Jacob Julius Scharvogel's ceramics factory, the K. L. Seifert lighting factory in Dresden and the Bruckmann & Söhne silverware factory in Heilbronn. In 1900 he was invited to take over as head of the Meissen Royal Saxon Porcelain Factory, and was also offered a teaching post at the Magdeburg School of Arts and Crafts. He decided to remain in Munich, however, until being appointed to the artists' colony in Darmstadt in 1903. Here he developed his metalwork designs, influenced by the Arts and Crafts Movement, for which he won a prize at the World Exposition in St. Louis (1904). In 1905 he was offered, via Bernhard Pankok, a teaching post in metal art at the Teaching and Experimental Workshops (Lehr- und Versuchswerkstätte) attached to the School of Arts and Crafts in Stuttgart, where he remained for 30 years. As a graphic artist, and above all as a book illustrator with a preference for stylized, vegetal ornament, Haustein ranked even in his own day amongst the most important artists of Jugendstil.

Hazenplug, Frank
1873 Dixon, Illinois – after 1908
American graphic artist
From 1894 Hazenplug worked with William H. Bradley, whose position with the Stone and Kimball company in Springfield he eventually took over, after a long and successful period of collaboration. Even though Hazenplug's works betray the strong influence of his elder colleague, in his palette and his use of perspective he nevertheless developed his own style – something visible above all in his posters.

Heine, Thomas Theodor
28.2.1867 Leipzig – 26.1.1948 Stockholm
German painter, graphic artist, and writer
Heine, who studied under Carl Janssen at the Academy in Düsseldorf (1885–88), started working as an illustrator for the magazines Jugend and Fliegende Blätter as from 1892. He attached himself to the young generation of artists around Lovis Corinth (1858–1925), Ludwig Dill (1848–1940) and Wilhelm Trübner (1851–1917) and from 1895 devoted himself to book illustrations and decoration. In 1896, together with Albrecht Langen and Ludwig Thoma (1867–1921), he founded the magazine Simplicissimus, on whose staff he remained, together with his colleagues Olaf Gulbransson, Bruno Paul and Eduard Thöny (1866–1950), until the magazine was banned in 1933. He subsequently emigrated first to Prague, then Brno, Oslo, and finally in 1942 to Stockholm, where he became a Swedish national and was once again able to contribute to magazines.
Heine's graphic works represent a very important contribution to Munich Jugendstil. His animated line and his handling of areas of color recall the art of Japan and Henri de Toulouse-Lautrec. His surviving works include the portfolios Pictures of Family Life and Follies.

Hentschel, Julius Konrad
3.6.1872 Cölln, near Meissen – 9.7.1907 Meissen
German embosser and modeler
In 1889–90 Hentschel completed an apprenticeship as an embosser at the Meissen Royal Saxon Porcelain Factory, where his father, Julius Hentschel, was employed as a figure painter. The factory granted him a scholarship to study at the Academy in Munich from 1891 to 1893. From 1894 to 1897 he worked as an embosser and from 1897 as a modeler for the Meissen works. From 1899 to 1900 he studied at the Dresden Academy and in 1906 took part in the Third German Exhibition of Applied Arts in Dresden. Hentschel made a name for himself as a porcelain painter and designer of figures and tableware (e.g. his Crocus service of 1896) for the Meissen Porcelain Factory.

Hoentschel, Georges
1855 Paris – 8.2.1915 Paris
French architect, collector, and potter
Prompted by his friend Jean Carriès, architect and ceramics collector Georges Hoentschel designed pots in Carriès's style. After Carriès died in 1894, Hoentschel took over his workshop in Nièvre. Among the craftsmen who executed his designs were Émile Grittel, Paul Jeanneney, Nils Ivan Joakim de Barck, and E. Deschamps.

Hoentschel's Art Nouveau work, which includes furniture as well as pots, is notable for its light, Baroque sense of form. Later he went over to simpler forms, and, unlike his contemporaries, moved away from Japanese models.

Hoetger, Bernhard
4.5.1874 Hörde, Westphalia – 18.7.1949 Unterseen, Switzerland
German sculptor, painter, graphic artist, architect, and craftsman
Hoetger, who trained as a stonemason and woodcarver, ran a church decoration workshop from 1895 to 1897 before becoming a master pupil of Carl Janssen at the Academy of Art in Düsseldorf in 1897. In 1911 he was appointed to the artists' colony in Darmstadt, where he created one of his major works, the plane-tree grove on the Mathildenhöhe, which he made into a total work of art with statues and reliefs. From 1924 to 1929 he was active as an architect in the artists' village of Worpswede, near Bremen. In 1943 he emigrated to Switzerland following the destruction of his home in Berlin during the war.
If Hoetger's work initially reflected the influence of Auguste Rodin (1840–1917), in whose atelier he worked from 1900 to 1907, it was Aristide Maillol (1861–1944) who later determined his style. As a result of his friendship with Théopile-Alexandre Steinlen (1859–1923), Hoetger turned to graphic art, and after a spell in Florence (1911–12) also started producing ceramic sculptures. His major works include the plane-tree grove on the Mathildenhöhe in Darmstadt (1912–14), the Brunnenhof in Worpswede (1921), the Café Worpswede (1925), the development of Böttcherstrasse in Bremen with the Paula Modersohn House (1926–30), and private houses in Worpswede (1928) and Berlin (1939–40).

Hoffmann, Josef
15.12.1870 Pirnitz, Moravia – 7.5.1956 Vienna
Austrian architect, graphic artist, and applied artist
After attending the State School of Applied Arts in Brno, Hoffmann studied achitecture at the Vienna Academy under Karl von Hasenauer and Otto Wagner. In 1897 he was one of the founders of the Vienna Secession, which he subsequently left in 1905 as part of the Klimt group. As a member of the Wiener Werkstätte, which he founded in 1903 with Koloman Moser, Fritz Waerndorfer, and Carl Otto Czeschka (1878–1960) and which he headed until 1931, his commissions included a new building for the Westend Sanatorium in Purkersdorf (1903–04), and the Palais Stoclet in Brussels (1905–11). In 1912 he founded the Austrian Werkbund and from 1920 was the head of the Viennese group within the German Werkbund. From 1899 to 1937 he taught at the Vienna School of Arts and Crafts and in 1920 became senior building surveyor to the City of Vienna.
Hoffmann numbered amongst the leading architects of Jugendstil and exerted, in particular through the Wiener Werkstätte, a profound stylistic influence upon the applied arts of his day. His oeuvre was determined by the concept of the total work of art, and he was correspondingly active in every sphere of applied art (furniture, metalwork, glass, leatherwork, jewelry, textiles). The principle of the repetition of identical elements, in particular the square, characterized his ornamental style. Individual components are thereby interchangeable, an innovative development in Jugendstil design.

Hofmann, Ludwig von
17.8.1861 Darmstadt – 23.8.1945 Pillnitz, near Dresden
German painter, graphic artist, and applied arts designer
After attending the academies in Dresden, Karlsruhe, and Munich (1883–89), Hofmann continued his training from 1889 to 1890 at the Académie Julian in Paris, where he became friends with Maurice Denis (1870–1943) and absorbed the influences of Pierre Cécile Puvis de Chavannes and Albert

Besnard (1849–1934), whose wall paintings he copied. In 1890 he joined *Die Elf*, the group of artists formed at the instigation of Walter Leistikow, whose members also included Lovis Corinth (1858–1925), Max Klinger (1857–1920) and Max Liebermann (1847–1935). He painted and taught in Weimar from 1903 to 1908 and in Dresden from 1916 to 1918.
In his work, which also includes woodcuts for books and lithographs, Hofmann combines a traditional, academic style with Art Nouveau motifs. Using the stylistic means of contrast, he lends his pictures a coded meaning whose symbolism is nevertheless clearly recognizable.

Hokusai, Katsushika
21.10.1760 Edo (today Tokyo) – 10.5.1849 Edo
Japanese painter and master of colored woodcuts
Hokusai, a pupil of Katsukawa Shunsho and Shiba Kokan, produced numerous paintings and series of woodcuts and illustrated more than 500 books. He is one of the most versatile *ukiyo-e* artists and famous for his ingenious composition and drawing techniques. His colored woodcuts – the best-known is his series entitled *36 Views of Mount Fuji* – were much sought-after in the second half of the 19th century and had a lasting effect on the development of Art Nouveau.

Horta, Victor
6.1.1861 Ghent – 11.9.1947 Brussels
Belgian architect and designer of craft articles
Horta studied at the fine arts academies of Ghent and Brussels. He started work as an architect in Alphonse Balat's practice, which he took over after Balat died in 1895. In 1892, Horta turned away from historicism and in 1893 built his first Art Nouveau building, the Hôtel Tassel, which was followed by many others throughout Brussels. In 1912, he was appointed professor and in 1927 (to 1931) director of the Fine Arts Academy in Brussels. After a spell in the United States (1916–18), he became involved in the development of new building materials as well.
Horta and Paul Hankar were leading reformers of modern Belgian architecture. Horta's early houses – slender iron constructions – are notable for an unstinting use of glass and linear ornamentation, whereby the models for the lines were the stalks and stems of plants and not, as with other Art Nouveau artists, the blooms and the leaves. After his trip to the U.S.A., Horta turned away from Art Nouveau and went back to classicist forms, as for example on the Palais des Beaux-Arts. His main works include the Hôtel Tassel (1892–93), the Hôtel Solvay (1895–1900), the Maison du Peuple (1896–99) and the Palais des Beaux-Arts (1922–28), all of them in Brussels.

Huber, Patriz
19.3.1878 Stuttgart – 20.9.1902 Berlin
German architect, jewelry designer, and applied artist
Huber studied painting at the School of Arts and Crafts in Mainz and subsequently, from 1897, in Munich, where he soon developed an interest in applied art. While studying in Munich he designed typefaces for the Darmstadt publisher Alexander Koch and took part in competitions held by the magazines *Innendekoration* and *Deutsche Kunst und Dekoration*. From 1899 to 1902 he was a member of the artists' colony in Darmstadt, for which he designed interiors and furniture. In 1902 he took part in the Paris World Exposition and showed a kitchen installation at the "Modern Art of Living" exhibition at the Wertheim Department Store. That same year he opened his own studio in Berlin, working in collaboration with his brother, the architect Anton Huber, and Henry van de Velde. Together with his brother, he developed his so-called "skeleton style", in which struts, pillars, beams, and doors were incorporated into the decor.

Hyland, Fred
Dates unknown
English graphic artist
No biographical information is available for Hyland. He worked for the periodical *The Savoy* and seems to have been part of the circle of artists around Aubrey Beardsley.

Jensen, Georg
31.8.1866 Raavad – 2.9.1935 Copenhagen
Danish ceramicist, gold and silversmith
After an apprenticeship as a goldsmith in Copenhagen, in 1887 Jensen took lessons in sculpture at the Copenhagen Academy. He made his first ceramic pieces in 1899 in the workshop run by Mogens Ballin (1871–1914). After a study trip to Italy and France (1900), he joined forces with Joachim Petersen to found a small porcelain workshop, but the venture was unsuccessful. After this disappointment, Jensen turned back to goldsmithery and in 1904 opened his own studio and shop, making and selling jewelry and silverware. In 1905 his works were included in the International Exhibition in The Hague. In 1907 he entered into a lifelong partnership with the painter Johan Rohde (1856–1935), who supplied many of his designs up till 1935. By 1918 Jensen's studio had grown into a large company with a workforce of over 200. It has employed important artists such as Sigvard Bernadotte af Wisborg (b. 1907) and Harald Niesen.

Jerndahl, Aron
1.1.1858 Östervad, Möklinta – 2.9.1936 Stockholm
Swedish sculptor and painter
After studying at the Academy of Art in Copenhagen (1886–88), Jerndahl worked in the studio of the painter Peter Severin Krøyer (1851–1909). In 1891 he collaborated on the reliefs for the choir in Uppsala cathedral. In 1898 he attended the Technical Evening College in Stockholm and the school run by the Swedish Association of Artists. Jerndahl's works were featured in exhibitions by the Swedish Association of Artists and in exhibitions in Munich (1909) and Düsseldorf.

Jo, Léo
(real name Léontine Joris)
1870 Tournai – 1962 Brussels
Belgian graphic artist
Even as a child, Léo Jo showed a gift for drawing cartoons. She was supported by the sculptor Charles van der Stappen, but he did not want to give her regular lessons, for fear of destroying her natural talent. She did drawings for the periodicals *Samedi*, *Rire*, *Comica*, *Simplicissimus* and *Lustige Blätter*, and also illustrations for children's books and toys. From 1899, she exhibited her work at the Salon de la Libre Esthétique. In 1903, she was represented at the exhibition of the Société Nationale des Aquarellistes et Pastellistes de Belgique, and in 1912 took part in the Xth Venice Biennale.

Jourdain, Frantz
3.10.1847 Antwerp – 1935 Paris
Belgian-French architect, writer, and journalist
Jourdain studied at the École des Beaux-Arts in Paris from 1865 to 1870. In 1883, he was commissioned by E. Cognacq to build a store for Samaritaine. The building was completed in 1905, but extensions were undertaken in 1925 jointly with the architect Frédéric Henri Sauvage. In addition, Jourdain designed some pavilions for the Paris World Exposition in 1900, and took part in the restoration of a number of châteaux. He was a cofounder of a number of artists' organisations, including the Société du Nouveau Paris (1903) and the Salon d'Automne (1905).

Jungnickel, Ludwig Heinrich
22.7.1881 Wunsiedel, Upper Franconia – 14.2.1965 Vienna
German painter, graphic artist, and applied arts designer
Jungnickel, who attended both the School of Arts and Crafts and the Academy in Munich and the School of Arts and Crafts in Vienna, started working as a graphic artist in 1904. From 1911 he taught at the School of Arts and Crafts in Frankfurt. He was a member of the German and the Austrian Werkbund, and of the *Künstlerhaus* group. His main area of activity, however, was his work for the Wiener Werkstätte, for whom he designed the children's room in the Palais Stoclet in Brussels (1905–11). After a trip to Bosnia and Herzegovina (1913), he devoted himself increasingly to drawing. In 1938 he emigrated to Split and later to Abbazia. In 1952 he finally settled back in Austria.

Kayser & Sohn AG, Johann Peter
Founded 1862 in Krefeld-Bockum
German pewter foundry
In 1862 the Düsseldorf-based Kayser family, already in the tin industry, opened a new foundry in the Bockum district of Krefeld. The firm reached its maximum size in 1899 with a workforce of around 400. The Krefeld foundry run by Jean (Johann Peter) Kayser was devoted to mass production, whereby the designs originated from the Cologne studio of Engelbert Kayser. At the exhibitions in Paris (1900), Turin (1902), Düsseldorf and St. Louis (1904), the company enjoyed great success with its "Kayser pewter", a special lead-free alloy of tin and silver distinguished by its lasting gleam – success which it also owed to its outstanding designers: Hugo Leven, Karl Geyer, Hermann Pauser, Karl Berghoff, and Johann Christian Kröner. The decors they designed were inspired both by floral French Art Nouveau and by linear Jugendstil. It was the Kayser company's aim, through its use of the methods of mass production, to make artistically designed, contemporary objects of daily use accessible to a broad section of the public.

Khnopff, Fernand
12.8.1858 Grembergen – 12.11.1921 Brussels
Belgian painter and graphic artist
Having completed his law studies, in 1878 Khnopff began a painting course at the Académie des Beaux-Arts in Brussels, and subsequently became a pupil of Jules Lefebvre in Paris. He was a member of the Belgian artists' groups L'Essor, Les Vingt and La Libre Esthétique. An issue of the periodical *Ver Sacrum* was dedicated to him in 1898. In 1901, he collaborated with the Wiener Werkstätte on the Palais Stoclet in Brussels. Khnopff was the principal Belgian representative of Belgian Symbolism. Influenced by the English Pre-Raphaelites and Gustave Moreau (1826–98), he painted pictures with mystic and allegorical subject matter. His oeuvre includes landscapes, etchings, and book illustrations.

Klablena, Eduard
8.4.1881 Buscan – 6.11.1933 Langenzersdorf
Austrian sculptor and ceramicist
Klablena, who studied at the Vienna School of Arts and Crafts, was taken on by the KPM Royal Porcelain Factory in Berlin in view of his talents as a sculptor. In 1911 he founded his own ceramics studio in Langenzersdorf under the name of Langenzersdorfer Keramik. The studio specialized in representations of animals, generally described as "animal fantasies", and featured in all the major exhibitions at the Austrian Museum of Art and Industry. After 1912 Klablena sold his works through the Wiener Werkstätte.

Kleukens, Friedrich Wilhelm
7.5.1878 Achim, near Bremen – 22.8.1956 Nörtingen

German painter and graphic artist
Kleukens received his training as a draftsman in a silverware factory in Hemelingen and under E. Döpler at the School of Arts and Crafts in Berlin. In 1900, together with Fritz Helmut Ehmke (1878–1965) and G. Belwe, he founded the Steglitz Workshop for Applied Arts and Commercial Graphics, which two years later was affiliated to a printing college. From 1903 to 1906 he taught at the Academy of Graphic Art in Leipzig. In 1907 he became a member of the artists' colony in Darmstadt, where he taught decorative art at the Grand-Ducal Teaching Studio until 1911. In addition, he ran the newly founded Ernst Ludwig Press from 1907 to 1914. In 1919, together with L. C. Wittich, he founded the Ratio Press in Darmstadt, for which he worked until 1930.
Alongside graphic works and drawings inspired by William Morris, Kleuken's oeuvre includes mosaic pictures and ornamental designs which he produced for the 1914 exhibition by the Darmstadt artists' colony.

Klimt, Gustav
14.7.1862 Baumgarten, near Vienna – 6.2.1918 Vienna
Austrian painter and graphic artist
Klimt was just 14 when he won a scholarship to the School of Arts and Crafts in Vienna. Together with his brother Ernst Klimt and his fellow student Franz Matsch, between 1882 and 1892 he carried out a number of major commissions for wall and ceiling paintings. During this period he was also awarded the Golden Order of Merit and the Imperial Prize. In 1897 he was a joint founder of the journal *Ver Sacrum* and the Vienna Secession, which he left in 1905 with a number of his friends, including Josef Hoffmann and Otto Wagner, in order to found the Wiener Werkstätte. In 1917 he was made an honorary member of the Vienna and Munich academies.
Klimt ranks amongst the leading representatives of Viennese Jugendstil. While his early paintings still betrayed the influence of Hans Makart (1840–84), after the death of his brother he moved away from academic painting and developed his own two-dimensional style, in which representational elements are combined with ornament to achieve a decorative effect. Although this style caused several scandals in his own day (e.g. his ceiling paintings for Vienna University, 1900–03), it also made him a pioneer of modernism. His major works include the *Beethoven* frieze (1902), *Judith* (1905–08), *The Kiss* (1908) and his wall mosaics for the Palais Stoclet in Brussels (1909–11).

Knox, Archibald
1864 Isle of Man – 1933 Isle of Man
English silversmith and painter
Knox attended the Douglas School of Art on the Isle of Man from 1878 to 1884 and taught there until 1888. In the 1890s he moved to London, where first he worked for Christopher Dresser and later for Liberty & Co. (his main employer). Liberty's used Knox's designs for its Cymric silver series and after 1903 for the Tudric pewter series. The motifs Knox borrowed from Celtic art later became one of the trademarks of English Art Nouveau. Although Knox's name appears neither on Liberty objects nor in their catalogs (Liberty's did not issue the names of its designers with its goods), we know that Knox was responsible for over 400 Liberty designs. He stopped working for Liberty's in 1912 and resumed his teaching post on the Isle of Man in 1913.

Köhler (-Broman), Mela (Melanie Leopoldina)
18.11.1885 Vienna – 15.12.1960 Stockholm
Austrian graphic artist and craftswoman
Köhler studied at the Hohenberger School of Painting in Vienna and from 1905 to 1910 under Koloman Moser at the Vienna School of Arts and Crafts. In 1907, while still a student, her works were published in the English journal *The*

Studio. Her first exhibition took place in 1908 at the School of Arts and Crafts in London. Köhler illustrated fairytales for the Konegen publishing house and contributed to the Viennese fashion magazine *Wiener Mode*. She was also a member of the Austrian Werkbund and the Wiener Frauenkunst group of women artists. In 1934 she emigrated to Sweden.

Königlich-Sächsische Porzellan-Manufaktur Meissen
[Meissen Royal Saxon Porcelain Factory]
Founded 1710 in Meissen
German porcelain factory
The first European factory to make hard porcelain, the Königlich-Sächsische Porzellan-Manufaktur Meissen was founded in 1710 by the Saxon Elector August the Strong, initially under the name of Kursächsische Manufaktur [Electorate of Saxony Factory]. In 1918 it was renamed the Staatliche Porzellan-Manufaktur Meissen [Meissen State Porcelain Factory]. Around the turn of the century, the sculptor and modeler Emmerich Andersen (1843–1902) introduced the Art Nouveau style. Employing designs by major Jugendstil artists such as Henry van de Velde, Peter Behrens, Joseph Maria Olbrich, and Richard Riemerschmid, the factory produced a large number of dinner services, decorative figures, animal sculptures, and ornamental plates.

Koepping, Karl
24.6.1848 Dresden – 15.7.1914 Berlin
German painter, etcher, and glass artist
After obtaining a diploma in chemistry, from 1869 Koepping studied painting at the Academy in Munich and was subsequently apprenticed to the etcher A. Waltner in Paris. In 1890 he returned to Germany and headed the master studio for copper engraving and etching at the Academy in Berlin. In 1896 his works were reproduced in the magazine *Pan*, of which he was joint publisher. From 1895 Koepping experimented with glass and employed the technical assistance of Friedrich Zitzmann. Their collaboration lasted only a few months, however, after which Koepping's designs were patented and manufactured by the Saxon Technical College and Workshops for Glass Instrument Makers in Illmenau. Through his links with Samuel Bing (1838–1905), Koepping's works were shown at the 1897 Salon d'Automne in Paris.
Koepping, whose works are made of very fine glass, was the foremost glass designer of German Jugendstil. What was new about his glass creations was that, instead of superimposing ornament upon the material, the form itself became the ornament.

Kohn, Jacob & Josef
Vienna
Austrian furniture factory
The company run by the Kohn brothers produced bentwood furniture to designs by leading Wiener Werkstätte artists, using the process patented by Michael Thonet in 1869. At the Paris World Exposition of 1900 they won the Grand Prix for the exhibition room designed by G. Siegel (a pupil of Josef Hoffmann). In 1904 the company comprised four factories and a workforce of around 6,300.

Kok, J. Jurriaan
6.4.1861 Rotterdam – 19.6.1919 The Hague
Dutch architect, designer, and potter
Kok trained as an architect but turned more and more to matters of design, and from 1894 to 1913 became director of the porcelain makers Haagsche Plateelbakkerij Rozenburg in The Hague. Javanese art was his main interest, and he had a comprehensive collection. The fantastic landscapes of the tropical island empire were as much a stimulus to his creativity as the ancient traditions of Javanese crafts, the

decorative sculptures on temple buildings, *Wayang* (shadow theater), and highly developed batik techniques. In the Rozenburg firm, Kok found a porcelain factory that could translate his subtle technical and decorative ideas into reality. As traditional clay bodies were not flexible enough for his unusual designs, Kok and the firm's chief chemist M. N. Engelden embarked on a series of complicated experiments to find a body that would make his designs feasible. In 1899, they finally succeeded in producing a light, thin-sided frit porcelain (today known as quasi or eggshell porcelain) that was ivory in color and had a glass-like consistency.

In Kok's work, the contours of the porcelain coincide with the decoration, which makes use of the whole palette of flower mysticism. The pattern stands out on the sides like a silhouette.

Krog, Emil Arnold
18.3.1856 Frederiksvaert – 7.6.1931 Tilvilde
Danish architect, painter, graphic artist, craftsman, and ceramicist

After an apprenticeship as a mason, from 1874 Krog studied at the Copenhagen Academy of Art, where he passed his architectural exams in 1888. While still a student (1884), he started working for Den Kongelige Porcelainsfabrik in Copenhagen, becoming its artistic director just one year later, in 1885 (until 1916).

The underglaze painting, inspired by Japanese woodcut prints, which Krog executed as decoration brought Den Kongelige Porcelainsfabrik international fame. Krog also supplied the formal designs of many of the factory's porcelain wares. His colleagues included the chemist Adolphe Clément (1860–1933) and his successor, Knud Valdemar Engelhardt, who made a name for himself with his crystal glazes.

Kunimasa, Utagawa
1773 – 1810
Japanese woodcut master

Kunimasa, who nurtured a great love for the theater, attended the school run by Toyokuni, the famous interpreter of *kabuki* scenes. Kunimasa worked as a woodcut master after the great woodcut master Toshusai Sharaku suddenly ended his profession.

Kunimasa's artistic legacy includes many masterly portraits of actors, which on the basis of their use of line and color can be described as extremely modern.

Lachenal, Edmond
3.6.1855 Paris – 10.6.1948 Paris
French potter

Lachenal was apprenticed to the potter Joseph-Théodore Deck (1823–91), whose studio in Paris was a training ground for many Art Nouveau artists, from 1870. In 1884, Lachenal set up his own workshop in Malakoff (Paris) to make faience and glazed and unglazed stoneware. In 1887, the business moved to Châtillon-sous-Bagneux.

Lachenal is considered the inventor of the *émail mat velouté* process. From 1895, he also manufactured pots designed by outside designers, including models by Auguste Rodin (1840–1917). From 1900 he worked for the glassware factory of Daum Frères as well, for whom he produced enameled glass pieces. From 1900 to 1901, he produced faience ornamentation for application to furniture and faience vases, to be combined with gold and silver work as *metallo-céramiques*. Among his pupils was Émile Decœur, who later became a well-known Art Deco potter.

Laeuger, Max
30.9.1864 Lörrach – 12.12.1952 Lörrach
German painter, architect, ceramicist, and sculptor

Laeuger, who studied painting at the Académie Julian in Paris, taught himself pottery. From 1893 he executed lead-glazed ceramic works which were manufactured in the Armbruster workshops in Kandern in the Black Forest. From 1895 to 1913 he was artistic head of the pottery in Kandern and also turned his attention to architectural ceramics. In addition, he designed fabrics for the Engelhardt textiles company in Mannheim. He gained international recognition at the Paris World Exposition of 1900, where he won the Grand Prix. From 1897 to 1913 he taught landscape and interior design at the Technical College in Karlsruhe, where he eventually founded his own workshop in 1916.

Laeuger's works include faience and stoneware vessels distinguished by the simplicity of their form and color, decorative tiles with a sculptural decor, mosaic paintings and architectural ceramics. Many of the buildings which he executed as from 1908, such as the Varieté Köchlin in Basle (1908), and the Paradise Park in Baden-Baden (1925), are decorated with ceramic works.

Lalique, René
6.4.1860 L'Hay-les-Roses, Val de Marne – 1.5.1945 Paris
French goldsmith, jeweler, and glass artist

After training as a goldsmith and studying at the École Nationale des Art Décoratifs in Paris, Lalique went to Sydenham College in London, where he did nature studies. Back in Paris, he sold his jewelry designs to major jewelers, and then tried his hand as a sculptor of small-scale sculpture and designer of fans, textiles, and wallpapers. In 1885, he took over a Parisian jeweler's studio, and forged close ties with the art dealer Samuel Bing (1838–1905) and the poster artist Alfons Maria Mucha. From 1891 to 94 he made a whole series of jewelry items for the famous actress Sarah Bernhardt, and these made his name.

Besides precious stones, gemstones, and pearls, he used materials that had hitherto been uncommon in jewelry, such as enamel, ivory, tortoiseshell, and horn. Work of this kind brought him his first great success at the World Exposition in Paris in 1900. In 1901, he exhibited for the first time jewelry made of clear crystal glass, thus launching himself on a new career as a celebrated Art Deco glass artist. After 1908, he went over entirely to glass, his interest in the material dating to 1894.

Langenzersdorfer Keramik
see Klablena, Eduard

Larche, François-Raoul
22.10.1860 Bordeaux – 2.6.1912 Paris

Larche studied at the École des Beaux-Arts in Paris under the sculptors Alexandre Falguière (1831–1900) and François Jouffroy (1806–82), who had a lasting influence on his work. Larche was regularly represented at the Salon d'Automne in Paris from 1884 to 1991. In 1886 he was awarded the second Grand Prix de Rome, and in 1900 won a gold medal at the World Exposition in Paris. Larche is known for his monumental sculptures, especially the group *La Loire et ses affluents* [The Loire and its tributaries], commissioned by the French state. However, his most famous work is his bronze figure of the dancer Loïe Fuller, designed as a lampstand.

Lavirotte, Jules Aimé
25.3.1864 Paris – 1928 Paris
French architect

A one-time pupil of Antoni Gaudí, Lavirotte adorned his facades with decorative ceramics, his designs being executed by the ceramic artist Bigot. Around 1900, Lavirotte achieved great success with his architecture in Paris. In his two most famous buildings, the apartment block in the

avenue Rapp (1901) and the Céramique-Hôtel (1904), he made use of decorative Art Nouveau floral elements like no other Parisian architect. His decoration is strongly symbolic, and is based on the world of animals and plants.

Lechter, Melchior
2.10.1865 Münster – 8.10.1937 Raron, Valais
German painter, book illustrator, and applied artist

Lechter studied glass painting in Münster and from 1883 to 1895 attended the Academy of Art in Berlin. In 1895 he was introduced to Stefan George (1886–1968), who from now until 1907 commissioned him with the illustration of his books. In 1896 his first exhibition was staged at Gurlitt's gallery, and in 1899 he was commissioned to design the wall decorations for the Pallenberg Room in the Cologne Museum of Arts and Crafts (completed in 1902). In 1909 he founded the Einhorn [Unicorn] Press.

Lechter, whose work is influenced by William Morris and the Pre-Raphaelites, mixed Jugendstil elements with mysterious symbols from George's world. Alongside book illustrations and interior decors, he produced designs for glass paintings and executed drawings and pastels.

Le Comte, Adolf
30.8.1850 Geestburg – 3.1.1921 The Hague
Dutch potter

After completing polytechnic studies, Le Comte went to the arts and crafts schools at Karlsruhe and Nuremberg, followed in 1872 to 74 by a course at the studio for interior design in Paris. From 1877 to 1915 he was artistic director of the tile manufacturer De Porcelyne Fles in Delft. In his early years there, he borrowed patterns from the Renaissance, but his designs were rarely used by the old-fashioned company. In 1885, he developed a new kind of ceramic such as was already being produced in the Haagsche Plateelbakkerij Rozenburg. He took his inspiration from Persian ceramics. Later he did designs for building ceramics, including work at Hamburg Zoo.

Leistikow, Walter
25.10.1865 Bromberg (now Bydgoszcz) – 24.7.1908 Schlachtensee, near Berlin
German painter and graphic artist

Leistikow, who studied under Hermann Eschke from 1883 to 1885 and under Hans Gude from 1885 to 1887, taught at the School of Art in Berlin from 1890 to 1893. In 1892 he became a founding member of the artist's association *Die Elf*, and was also active as a writer. The rejection of his picture *Lake Grunewald* by the organizers of the Berlin exhibition of 1898 was one of the reasons behind the foundation of the Berlin Secession. In 1903 he was amongst the founders of the Deutscher Künstlerbund (German Federation of Artists).

Leistikow, who was inspired amongst others by Pierre Cécile Puvis de Chavannes and by Japanese prints, ranks amongst the great masters of Jugendstil. He developed a decorative linear style which simultaneously separates and emphasizes his forms. He was also active in the sphere of applied art, in particular designing posters, wallpapers, and carpets. His favorite motifs were water, trees, and low-flying birds. In his latter years he devoted himself to landscape painting and portrayed the lake district around Berlin in Impressionistic mood paintings.

Lethaby, William Richard
1857 London – 1931 London
English architect

In 1877 Lethaby started work as an assistant in his friend Norman Shaw's London office. Shaw was a successful architect and helped Lethaby when he set up his own

business in 1889. In an artistic sense, however, Lethaby had more in common with William Morris and Philip Webb than with his mentor. In 1894 he became director of the Central School of Arts and Crafts in London which was run according to the principles of William Morris. In the same year he published a specialist book with Swainson on the Hagia Sophia Basilica in Constantinople. Publications on medieval art and Westminster Abbey followed. His collection of essays, including *Form in Civilization* (1922) and *Architecture and Modern Life* (1917), promoted progressive ideas. His few buildings include Avon Tyrell in Hampshire (1891) and his imaginative Brockhampton Church in Herefordshire (1900–02).

Liberty, Sir Arthur Lasenby
31.8.1843 Chesham – 11.5.1917 The Lee, near Chesham
English merchant
Liberty was the oldest of eight children born to a cloth merchant in Chesham. After having left Nottingham's University School for financial reasons at the age of 16, he started an apprenticeship with a cloth merchant in London, where he devoted himself to his favorite passions, art and the theater. In 1862 he began working for the Farmer & Rogers department store in Regent Street. Farmer & Rogers also ran a store for Oriental goods, where Liberty developed an interest in art from the Far East. In 1875, after 12 years with Farmer & Rogers, Liberty was refused a partnership in the company despite his commercial success. He thus set up his own business in Regent Street, the East India House, which sold all kinds of paraphernalia from the Far East. His store was so successful that Liberty was able to expand continuously over the next few years. Fascinated by the Aesthetic Movement, Liberty set up the Furnishing and Decoration Studio in 1883. The materials and furniture sold there were designed by Modern Style artists and became a big London attraction. In the 1890s Liberty started his own line in silverware (Cymric) and pewter (Tudric). In all areas of handicrafts he concentrated on, Liberty worked with well-known designers who helped characterize the "Stile Liberty".
Liberty's influence on English craftmanship was enormous. His name was synonymous with English Art Nouveau from the early 1890s to the outbreak of the First World War. Despite his poor background, Liberty had become a respected member of society and lived the life of a country gentleman in Thee Manor. He died childless in 1917 and left his emporium to his nephew Ivor Stewart, who changed his name to Stewart-Liberty. Stewart's grandson is the present chairman of Liberty's in London.

Liisberg, Carl Frederik
1860 Aarhus – 1909 Copenhagen
Danish sculptor and porcelain painter
After training as a painter and sculptor, in 1885 Liisberg was engaged by Den Kongelige Porcelainsfabrik in Copenhagen. He was predestined by his artist background for a career as a modeler of animal figures. As a painter, he also introduced the *pâte sur pâte* technique to the Copenhagen porcelain factory. In 1892 he went to St. Petersburg, again introducing the *pâte sur pâte* technique in his position as teacher and trainer at the Imperial Porcelain Factory.

Lilien, Ephraim Mose
23.05.1874 Drohobycz, Galicia – 1925 Badenweiler
Polish painter, graphic artist, and illustrator
After an apprenticeship as a signpainter, Lilien studied under the history painter Jan Matejko (1838–93) at the Krakow School of Art. In 1894 he won an honorary diploma in a competition in his home town. His application to study at the Vienna Academy was rejected, however. In 1896 he started working for a Socialist newspaper in Munich and three years

later founded the Jüdischer Verlag [Jewish Press] in Berlin, for which he acted as editor, publisher, and illustrator. He also founded the Bezalel Society for the Introduction of Art and Industry into Palestine. After several trips to Jerusalem he embarked upon a series of illustrations to the Bible.
Lilien followed in the footsteps of English Art Nouveau, whereby the ornament in his illustrations is characterized by a simpler, tauter design. Over time he abandoned all trace of the lyrical in favor of a rigorous, iconic, symbolic language. Lilien is not just a representative of German Jugendstil, but also – and above all – one of the great Jewish artists.

Lindgren, Armas Eliel
28.11.1874 Tavastehus – 1929 Copenhagen
Finnish architect
Together with Herman Gesellius and Eliel Saarinen, in 1896 Lindgren founded the architectural firm of Gesellius, Lindgren & Saarinen, known as GLS. The international fame of the three architects was based on the Finnish Pavilion which they designed for the Paris World Exposition of 1900. In 1905 Lindgren left the firm to work with Wivi Lönn, one of Finland's first women architects. GLS was dissolved in 1907. Lindgren chiefly built private houses and churches. The works which he designed in collaboration with Gesellius and Saarinen include the Villa Suur-Merijoki in Viipuri (1903) and the "fortified" Hvittorp House in Kirkkonummi (1901–04).

Lindqvist, Selim Avid
19.5.1867 Helsinki – 1939 Helsinki
Finnish architect
Following his studies at the Polytechnical College in Helsinki (1884–88), in 1888 Lindqvist designed the facades for a department store-cum-apartment block built by Elia Heikel. Both here and in the case of the Lundqvist Department Store (1900), he developed an entirely modern Constructivism out of the existing building: a system of load-bearing columns and large shop windows.
Lindqvist, a pioneer of concrete architecture, and Heikel were the first to demonstrate the Chicago style in Finland. Lindqvist's works included office blocks and private houses in Helsinki, buildings for the metropolitan railway network, the Suvilahti Power Station (1908) and distribution stations.

Loetz, Witwe
Founded 1836 in Klostermühle, Bohemia
Austrian glass factory
The glass factory founded in 1836 was purchased in 1840 by Johann Loetz (1778–1848) and run after his death by his widow under the name of Loetz' Witwe [Loetz' Widow]. In the last third of the 19th century the factory developed a type of chemically treated glass, paving the way for its successful production of luxury glassware featuring luster and iridescent glass. In 1898 the company was granted a patent for its "luster glass technique". At the Paris World Exposition of 1900, Loetz' Witwe shared first prize with Tiffany, Gallé, and Daum. The firm ranked amongst the most important glassworks in Europe, and up to 1900 its Jugendstil glasses bore only the company signature, while the designer remained anonymous. From 1903 various Viennese artists worked for the company, in particular members of the Wiener Werkstätte. By 1910, however, the company found itself in increasing financial difficulties, and was converted first into a limited company and then, after the First World War, into an incorporated society. Finally, at the start of the Second World War, the company was dissolved.

Loos, Adolf
10.12.1870 Brno – 23.8.1933 Kalksburg, near Vienna
Austrian architect and applied arts designer
After studying at the Technical College in Dresden, Loos spent

the years 1893 to 96 in Philadelphia (U.S.A.) working various jobs, before finally returning to Vienna in 1896 to set himself up as an architect. The publication of his essay "Die Potemkin'sche Stadt" [The Potemkin city] in the journal *Ver Sacrum* in the summer of 1898 brought an end to the good relationship he had previously enjoyed with the architects of the Vienna Secession. His book *Ornament und Verbrechen* [Ornament and Crime], published in 1908, revealed him as the absolute opponent of ornament and would ultimately lead him into total isolation.
In 1912 he founded a school of architecture, which closed during the First World War. Following a period as chief architect in the Vienna Department of Municipal Housing (1920–22), Loos went to Paris, where he exerted a significant influence upon modern French architecture, and in particular Le Corbusier (1887–1965). In 1928 he returned to Vienna, where he continued to voice his views on an urbane, functional everyday culture, which would later strike a chord with Walter Gropius (1883–1969) and the Bauhaus.
Loos may be seen as the most important pioneer of modern architecture. His buildings are distinguished by their lack of ornament, their geometric simplicity, and their use of materials left in their "natural" state. His major works include the Café Museum in Vienna (1899), the Villa Karma in Clarens, Switzerland (1904–06), the Kärntner Bar in Vienna (1907), the epoch-making Steiner House in Vienna (1910), the commercial block on Michaeler Platz in Vienna (1910), the house for Tristan Tzara in Paris (1925), the Khuner House in Payerbach, Lower Austria (1930) and the Müller House in Prague (1930). He also published the theoretical writings *Ornament und Verbrechen* (1908), *Ins Leere gesprochen* ([Spoken into the void], collected essays 1897–1900; 1902), and *Trotzdem* ([Nevertheless], collected essays 1900–30; 1931).

Lundstrøm, Nils
1865 Stockholm – 1960 Stockholm
Swedish sculptor and modeler
From 1896 to 1936 Lundstrøm profoundly influenced the style of the products issuing from Sweden's leading porcelain factory, Rörstrand, Aktie Bolag Lidköping, near Stockholm. His works from around 1900 are characterized by a soft relief style. He illustrated magnificent floral motifs in delicate colors on vases and tableware.

Macdonald Mackintosh, Margaret
1865 Newcastle-under-Lyme – 17.1.1933 Chelsea
and
Macdonald MacNair, Frances
1874 – 1921
Scottish graphic artists, furniture and arts and crafts designers
The Macdonald sisters, Margaret and Frances, studied embroidery, metalwork, goldsmithery, and other crafts at the Glasgow School of Art at the end of the 1880s. They met their future husbands, Charles Rennie Mackintosh (1868–1928) and Herbert MacNair (1869–1945), at the School and with the two men formed the group The Four in 1893. In 1894 the sisters opened a studio for the applied arts; their husbands supplied designs for furniture which together with the sisters' ideas made up a convincing synthesis of form and decoration. The work of the Macdonald sisters – embroidery, textile designs, jewelry, painted wall panels, hammered metalwork – was inspired by Celtic art and the Pre-Raphaelites. In contrast to other Art Nouveau creations, the sisters' work is more linear and contains far fewer curves.
Margaret is especially well-known for her wall decorations which combined a diversity of materials, such as fabric, plaster, and bronze. On leaving Glasgow for London with her husband in 1915, she turned to painting with watercolors. She took part in 40 exhibitions between 1885 and 1924 and her work was regularly published in art journals such as *The Studio*.

Mackintosh, Charles Rennie
7.6.1868 Glasgow – 10.12.1928 London
Scottish architect, interior designer, artist craftsman, graphic artist, and painter
Mackintosh began an apprenticeship at John Hutchison's architects' office in 1884. He changed his apprenticeship to Honeyman & Keppie in 1899, where he met Herbert MacNair (1869–1945). He also attended evening classes at the Glasgow School of Art, where he met his future wife, Margaret Macdonald, and her sister Frances. In 1890 Mackintosh won several competitions and received his first commissions. The Alexander Thomson Traveling Scholarship he was awarded in 1891 enabled him to visit France, Italy, and Belgium. In 1894 The Four (Mackintosh, MacNair, and the Macdonald sisters) exhibited together for the first time. In 1896 they took part in an exhibition in London organized by the Arts and Crafts Society. At the same time, Mackintosh won an architectural competition with his design for the Glasgow School of Art. From 1896 onwards he and his wife Margaret designed interiors for several tea rooms in Glasgow. Mackintosh also received commissions for villa and house designs at home and abroad, including a music salon for Fritz Waerndorfer. The Mackintoshes moved to London in 1915 where, except for a brief period in Port-Vendres in France (1923–27), they spent the rest of their days, concentrating on graphics and book art.
Mackintosh is one of the main representatives of Art Nouveau and a pioneer with his designs for furniture and textiles. Like his contemporaries, he found inspiration in Symbolism and Japanese art and developed his own individual, incomparable linear style of decoration. His decorative interiors were always restrained and complemented the design of the furniture. Mackintosh also studied the theoretical writings of William Richard Lethaby and John Ruskin (1819–1900). Mackintosh's main works include the Glasgow School of Art (1897–99; extension with the library 1907–09), Miss Cranston's various tea rooms in Glasgow (1897–1911) and Hill House in Helensburgh (1902).

Mackmurdo, Arthur Heygate
12.12.1851 London – 15.3.1942 Wickham Bishops, Essex
English architect, draftsman, and artist-craftsman
Mackmurdo, who studied in Oxford and was friends with the art critic John Ruskin (1819–1900), opened an architect's office in London in 1875. A year later he met William Morris, whose interests he shared. In 1882 Mackmurdo founded the Century Guild of Artists for designers, interior designers, and artists, and in 1884 began publishing the periodical The Hobby Horse. During the next 20 years Mackmurdo designed items in metal, textiles, wallpaper, and furniture for various companies, including Morris, Marshall, Faulkner & Company. He later became one of the founder members of the Society for the Protection of Ancient Buildings and from 1904 onwards concentrated his energies on economic and socio-political questions.
Mackmurdo was one of the main precursors of Art Nouveau and is counted among the pioneers of modern English architecture. His cover for Wren's City Churches (1883) is considered to be the first work with Art Nouveau character.

Magnussen, Erik
14.5.1884 Copenhagen – 24.2.1961 Los Angeles
Danish sculptor, draftsman, and craftsman
Magnussen, who studied under the sculptor Stephan Sinding (1846–1922), first worked in Copenhagen before later moving to Los Angeles. He made a name for himself with his ivory carvings for the Seville carnival and through his work for the film studios in Hollywood. He combined a variety of materials in his jewelry, preferably silver in conjunction with "exotic" materials.

Majorelle, Louis
27.9.1859 Toul – 15.1.1916 Nancy
French painter and craft designer
Majorelle studied at the École des Beaux-Arts in Paris, but after his father's untimely death in 1879 had to abandon his ambition to become a painter in order to take over the family business. At first, he continued the production of furniture and faience ware in neo-Baroque and period styles but, impressed by Emile Gallé and his great success at the World Exposition in Paris in 1889, he began to search for a new style of his own. His most important collaborators in this were Jacques Gruber and Camille Gauthier (1870–1963). While his furniture was initially in the Gallé manner, from around 1900 he gradually evolved a style of his own. Though wrought bronze and brass became the chief ornamentation of his furniture, he did large-scale metal work as well. Until the 1920s, he provided the glass factory of Daum Frères with designs for vase stands and lamp bases. Jointly with Gallé and Eugène Vallin, Majorelle was a board member of the École de Nancy, founded in 1901. In 1905, he carried out the refurbishing of Samuel Bing's Galerie L'Art Nouveau in Paris.

Margold, Emanuel Josef
4.5.1889 Vienna – 2.5.1962 Bratislava
Austrian architect, graphic artist, and applied arts designer
Margold was first a student under Anton Huber (Patriz Huber's father) at the Mainz School of Arts and Crafts and later, in the Department of Architecture at the Vienna Academy, a master pupil of Josef Hoffmann. After completing his studies, he joined Hoffmann in working for the Wiener Werkstätte. From 1911 to 1929 he was a member of the Darmstadt artists' colony, executing the buildings for its 1914 exhibition. In 1929 he set up as an architect in Berlin and devoted himself both at the practical and theoretical level to the Bauhaus style and the design of modern apartment housing. Margold was also a member of the Austrian and the German Werkbund. Alongside his career as an architect, he also designed furniture, wallpapers, glass, and porcelain. From 1912 he designed interiors, fabric patterns, and biscuit tins for the Bahlsen biscuit factory. He also designed the reception rooms for the International Exhibition of Architecture in Leipzig and for the Werkbund exhibition in Cologne.

Martin Brothers
Established in London in 1873
English ceramics workshop
The ceramics workshop was founded in 1873 by the four Martin brothers: Robert Wallace (1843–1923) was the modeler and designer, Walter Fraser (1859–1912) the pot-thrower, chemist, and kiln-maker, Edwin Bruce (1860–1915) designed the decoration and the company stamp, whereas Charles Douglas (1846–1910) was responsible for the management of the company. Their ceramic work in the Japanese style soon reaped success, enabling the brothers to open a studio and a store in Holborn in London in 1879. Art Nouveau began to exert its influence on their products in the 1890s: whereas their objects pre-1890 had been rather severe, they were now adorned with floral motifs and were often shaped like vegetables and became known as vegetable ware. Their vases boasted decoration in cut glass or other refined surface structures reminiscent of Japanese ceramics. It was, however, Robert Wallace's modeled masks and objects d'art in the form of grotesque birds and animals which earned the brothers their fame.

Masó i Valenti, Rafael Julio
1881 (or 1888) Gerona – 1935 Gerona
Spanish (Catalan) architect and designer
Masó studied architecture in Barcelona. Inspired by Charles Rennie Mackintosh and Josef Hoffmann, he developed a very modern style of his own that displays Catalan cultural influences. His principal works include Masramon House (1914) and S'Agarot (1929–35).

Massier, Clément
8.11.1844 Vallauris – 24.3.1917 Golfe-Juan, Alpes-Maritime
French potter
Massier was trained as a potter in his father's pottery in Vallauris, near Cannes, which he ran until 1883, when he set up on his own. From 1887 to 1896, he and the Symbolist painter Lucien Lévy-Dhurmer ran a pottery studio in Golfe-Juan, developing colored metal glazes inspired by Spanish and Moorish faience ware. From 1889, their work was exhibited at world expositions and the Paris Salon d'Automne.

Meissen Royal Saxon Porcelain Factory
see Königlich-Sächsische Porzellan-Manufaktur Meissen

Minne, Georges
30.8.1866 Ghent – 20.2.1941 Sint-Martens-Latem, near Ghent
Belgian sculptor and graphic artist
Minne studied architecture at the Académie des Beaux-Arts in Ghent from 1882 to 1884, and was later a pupil of Charles van der Stappen in Brussels. In 1895, he acquired a studio at the Brussels Academy, and in 1912 a chair in drawing at the Academy in Ghent. Minne is considered the principal figure of fin-de-siècle Belgian sculpture. Although his style is generally bracketed with naturalistic Symbolism, his slender, de-sensualized figures and his rhythmic compositions permit an Art Nouveau labeling as well. Besides sculptures, he illustrated the books of Emile Verhaeren and Maurice Maeterlinck. His main works include the Fountain with Five Kneeling Boys in Essen (designed 1898, executed 1906), and the Rodenbach memorial in Ghent.

Moll, Carl
23.4.1861 Vienna – 13.4.1945 Vienna
Austrian painter and graphic artist
Moll, who studied under Griepenkerl and Schindler at the Academy of Art in Vienna, was a member of the Künstlerhaus board in 1894 and one of the founders of the Vienna Secession in 1897. From 1898 to 1901 he worked for the journal Ver Sacrum, which published most of his woodcuts. In 1905 he left the Vienna Secession with the Klimt group and joined the Wiener Werkstätte, organizing its first exhibition.

Mondrian, Piet
(real name Pieter Cornelis Mondriaan)
7.3.1872 Amersfoort – 1.2.1944 New York
Dutch painter and art theoretician
In his early period, Mondrian adopted a near-Symbolist and Pointilliste approach, under the influence of Kees van Dongen and Jan Toorop. During his stay in Paris (1911–14), he became acquainted with Cubism, which had a long-term effect on his output. Mondrian began to depict his limited range of subjects in ever more advanced and finally geometric abstraction, until by 1915 his pictures consisted entirely of the rhythm of horizontal and vertical lines. These and the most simple basic colors formed the framework for his "neo-plastic" style, the principles of which were set out in his treatise Le Néoplasticisme published in 1920. Mondrian was, with Theo van Doesburg and Bart van der Leck, a cofounder of the De Stijl group of artists in 1917 and the eponymous periodical. In 1940, he emigrated to New York.

Morris, May
1862 – 1938
English arts and crafts designer
May Morris was William Morris's youngest daughter. She trained with her father and designed textiles, wallpaper, and jewelry for his company. She also did embroidery work. In 1888 she took over as manageress of the embroidery workshop in Merton Abbey and was a founder member of the Woman's Guild of Arts in 1907, later becoming its chairwoman. After the death of her father, she published his writings in 24 volumes which appeared between 1910 and 1924.

Morris, William
24.3.1834 Walthamstow, London – 3.10.1896 London
English painter, artist craftsman, designer, writer, and social reformer
Morris studied church history and medieval literature at Exeter College in Oxford, where he also formed a lifelong friendship with Edward Burne-Jones. He started an apprenticeship with the architect George Edmund Street in 1856 and also wrote for the *Oxford and Cambridge Magazine*. Under the influence of Dante Gabriel Rossetti and John Ruskin, he soon turned to painting and writing. In 1861 he set up a firm for the production of arts and crafts, called Morris, Marshall, Faulkner & Company, with Burne-Jones, Rossetti and Philip Webb among the partners. Morris wanted to offer an alternative to factory-made articles with the objects the company fashioned, namely furniture, glassware, woven items, wallpaper, embroidery, painted and stained glass and much more. All had the severe form and treatment of line characteristic of Gothic art. Morris, also a poet and lyricist, set up the Kelmscott Press in 1891, whose products were to be of great importance for the further development of book art. Morris, like his spiritual father John Ruskin, was highly critical of commercialism and turned to politics in the 1880s. In 1883 he joined the Democratic Federation; in 1884 he founded the Socialist League and began publishing the party magazine *Commonweal*. His ideas on social reform and his strict refusal to use machines in the manufacture of arts-and-crafts commodities made Morris the founder of the English Arts and Crafts Movement. He voiced his theories in speeches and in various books and essays, including *The Decorative Arts* (1878) and in his *Collected Works* (1915).

Moser, Koloman
30.3.1868 Vienna – 18.10.1918 Vienna
Austrian painter, graphic artist, and applied arts designer
From 1886 to 1892 Moser studied under Griepenkerl at the Academy in Vienna and from 1892 to 1895 under Franz Matsch at the School of Arts and Crafts in Vienna, where he held a teaching post himself from 1900 to 1918. In 1897 he was amongst the founding members of the Vienna Secession, which he left in 1905 with the Klimt group, and worked for the journal *Ver Sacrum*. Together with Josef Hoffmann, in 1903 he founded the Wiener Werkstätte, whose products were strongly influenced by his predominantly geometric style. As his artistic influence waned, he left the group in 1906 and concentrated exclusively on painting. He later became a member of the Austrian Werkbund founded in 1912.
Moser was active in every sphere of applied art, designing furniture, jewelry, glass, metalware, and book-bindings, together with posters, toys, theater sets, and interiors (e.g. the Westend Sanatorium in Purkersdorf, 1904). Moser was also one of the very few artists to design stamps in the Jugendstil style, including the first stamps for Liechtenstein (1912–18).

Mougin Frères
French ceramics manufacturer

The firm was founded in Paris by the brothers Joseph (sculptor and potter, 1876–1961) and Pierre (1879–1955) Mougin to make stoneware. Their output was exhibited at the Paris Salons from 1900, as a result of which it gained an international reputation and was later much sought-after by museums and collectors. Around 1904 the Mougins transferred the factory to their native city of Nancy, where they collaborated with the artists working there. Mougin Frères successfully continued making articles in the then fashionably modern Art Deco style. Joseph and his children Odile and François went on producing stoneware items until 1960, always in the latest designs.

Mucha, Alfons Maria
24.7.1860 Eibenschütz/Rosice, Moravia – 14.7.1939 Prague
After abandoning his singing studies in 1877 and fruitlessly attempting to gain a place at the Academy in Prague, Mucha went to Vienna, where he worked as a scene-painter. From 1883 he worked for Count Khuen-Belassi, who enabled him to go to the Academy in Munich to study. In 1888, he began a course at the Académie Julian in Paris, but switched to the Académie Colarossi the following year. While continuing his studies, he supported himself by working as an illustrator. In 1891 he made the acquaintance of Paul Gauguin (1848–1903) and began a collaboration with the publisher Armand Colin. In 1894, he had such success with his first poster for Sarah Bernhardt (1844–1923) that the actress signed an exclusive contract with him for six years, and Mucha gained numerous other commissions for posters, interior decorations, jewelry, fashions, and glass windows. Mucha participated in various exhibitions, and at the Paris World Exposition in 1900 he was awarded a silver medal for his furnishing of the pavilion of Bosnia-Herzegovina. In 1901, he was awarded the Légion d'Honneur. In 1906 he emigrated to the United States, where he taught in New York and Chicago and worked as an interior designer. In 1911 he finally settled in Prague, where he won major commissions and in his work became preoccupied above all with Slav sagas.
Mucha's style is reminiscent of Viennese Art Nouveau. It is characterized by artificial flower ornamentation and worldly elegance in the figures, combined with a strongly symmetrical treatment of surface and line and a dependence on color effects. Typically, a chic-looking young female face appears entwined in "hair ornamentation" or painted with mixed colors. The success of his posters enabled him to achieve an important objective, of making the man in the street aware of art.

Müller, Albin
13.12.1871 Dittersbach, Harz Mountains – 2.10.1941 Darmstadt
German painter, architect, and craftsman
After completing a joiner's apprenticeship, from 1893 to 1897 Müller worked as a furniture draftsman and interior designer, which enabled him to finance his studies at the schools of arts and crafts in Mainz and Dresden. He was self-taught as an architect. From 1900 he taught interior design at the Magdeburg School of Arts and Crafts. In 1902 he took part successfully in the International Exhibition of Modern Decorative Art in Turin and also showed works at the 1904 World Exposition in St. Louis and at other major exhibitions. In 1906 he went to Darmstadt, where he became a member of the artists' colony and was professor of interior design from 1907 to 1911. Following the death of Joseph Maria Olbrich in 1908, Müller became the leading architect at the Darmstadt colony. After the First World War he concentrated increasingly upon the development of wood houses, but turned to painting for lack of commissions.
Müller's major works include buildings and interiors for the exhibitions in Darmstadt (1908, 1910, 1914) and buildings and grounds for the German Theater Exhibition in Magdeburg

(1927). Müller was also an important writer on architecture. His publications include *Architektur und Raumkunst* [Architecture and interior design], 1909 and *Werke der Darmstädter Ausstellungen* [Works from the Darmstadt exhibitions], 1917.

Munch, Edvard
12.12.1863 Løten, near Hamar – 23.1.1944 Hof Ekely, near Oslo
Norwegian painter and graphic artist
Munch attended the School of Arts and Crafts in Oslo from 1882 to 1883 and subsequently continued his training alone. From 1885 he lived – with interruptions – in Paris, where he attended Léon Bonnat's art school and was influenced by the art of Paul Gauguin, Vincent van Gogh, Henri de Toulouse-Lautrec, Émile Bernard, and Maurice Denis. He also absorbed influences from the Symbolists and the writer August Strindberg (1849–1912). In 1892 his paintings caused a scandal in Berlin, leading a few years later to the foundation of the Berlin Secession. From 1902 he lived in Germany and in 1906 designed theater sets for Max Reinhardt. In 1908 he finally returned to Norway.
Munch, Norway's most important painter, was one of the forerunners of Expressionism, although his oeuvre also reveals the influences of Art Nouveau and Symbolism. His pictures consider the themes of love, death, fear, and the conflict between the sexes. Munch employed the interplay of line, color, and plane as his primary means of expressing moods and feelings. The motifs of his paintings frequently reappear in different forms in his outstanding graphic oeuvre, which embraces etchings, lithographs, and above all color woodcuts. His major works include *Madonna* (1894–95), *The Dance of Life* (1899–1900), *The Scream* (1893) and several versions of the *Frieze of Life* (started 1893).

Munthe, Gerhard Peter
19.7.1849 Elverum – 15.1.1929 Oslo
Norwegian painter, graphic artist, craftsman, and writer
Having begun his studies in Norway, in 1874 Munthe continued them in Düsseldorf and in 1877 in Munich, where he turned to landscape painting. In 1883 he returned to Norway and painted Early Impressionist-style landscapes. Around 1890 he developed a two-dimensional style influenced by Art Nouveau and at the same time expanded his subject matter to include Norwegian fairytales and sagas. His oeuvre includes numerous designs for tapestries (including *The Horses of the Sea*, 1907), in which he drew upon traditional Norwegian folk art, and woodcut illustrations. His major works include the interior decoration of the Håkonshalle in Bergen with wall paintings and furniture (1910–16, destroyed 1944).

Nerman, Einar
6.10.1888 Norrköping – unknown
Swedish painter and graphic artist
Nerman studied painting at the school attached to the Art Association in Stockholm and was a student under Carl Wilhelmson, before continuing his training in Paris. While still a student, he started working as a graphic artist for various newspapers, including *Søntagsnisse* and *Le Figaro*. Nerman illustrated books, including Hans Christian Andersen's fairytales, and worked for the magazines *Die Dame* and *Pan*. He later emigrated to New York.

Nielsen, Erik
1857 Øksendrup – 1947 Tisvilde
Danish sculptor
After studying sculpture at the Academy in Copenhagen and working freelance, in 1887 Nielsen joined the artistic staff of Den Kongelige Porcelainsfabrik in Copenhagen. He worked

above all as a modeler of animal figures, whose plastic quality and exquisite painting reinforced the company's high standing in this sphere. He continued to work for the factory until 1926.

Nuutajärvi
Founded 1793 in Nuutajärvi
Finnish glass factory

The glass factory was founded in 1793 by Captain Jacob Wilhelm Depont and Harald Furuhjelm. The factory expanded under its subsequent owners and artistic directors and by the second half of the 19th century had become Finland's leading glass factory. In 1856 Nuutajärvi was already engaging outstanding glass designers and glassblowers from Germany and France. It conducted numerous experiments in glass and ceramics which, under the artistic direction of Carl Heitmann (1859–72) resulted in the product range being constantly expanded.

Around 1900, after a number of less successful years, a new company was founded, Costiander and Co., specializing in simple household glassware which nevertheless retained an artistic dimension. Competitions were held, and the first two were won by the architect Walter Jung and the designer Helena Wilenius with entries that were pure Art Nouveau. The factory may thus be seen as one of the pioneers of the marriage of art and mass production.

Social unrest in Finland and the First World War caused great problems for the factory up to 1920. After renewed success in the 1920s with its cut glass, the 1930s brought further decline. After the Second World War Nuutajärvi was bought up and run under the new name of Wärtsilä Group Ltd.

Obrist, Hermann
23.5.1863 Kilchberg – 26.2.1927 Munich
Swiss-German applied artist, draftsman, and sculptor

After breaking off his studies in natural science, in 1887 Obrist traveled to England and Scotland, where he encountered the Arts and Crafts Movement. He subsequently studied at the Karlsruhe School of Arts and Crafts and completed an apprenticeship as a potter. He rapidly went on to win gold medals for his ceramics and furniture at the 1889 World Exposition in Paris. From 1890 to 1891 he attended the Académie Julian in Paris and worked as an art critic in Berlin. In 1892 he founded an embroidery studio in Florence, transferring it to Munich in 1895. In 1896 he exhibited, for the first time, a number of embroideries designed by himself and executed by Berthe Ruchet, with great success. In 1897, together with his Munich friends, he founded the Vereinigte Werkstätten för Kunst im Handwerk [Associated Workshops for Art in Handicraft] and gave lectures throughout Germany on behalf of the Munich Association of Handicrafts. In 1902, together with Wilhelm von Debschitz (1871–1948), he founded the Studio for Applied and Free Art. In 1904, however, Obrist's deteriorating hearing obliged him to hand over the running of the studio to Debschitz. From this point onwards, his activities as an artist also began to diminish.

Obrist exerted a potent influence upon applied art in the 20th century, both as an artist and above all as a theoretician. He was a leading spokesman for Jugendstil, amongst other things through his essay Neue Möglichkeiten in der bildenden Kunst [New possibilities in the visual arts, 1903], and was an important forerunner of the Bauhaus. In line with his insistence that applied art must liberate itself from the pure reproduction of stylistic trends and the forms of nature, he arrived at sheer abstraction in some of his works. Alongside color embroideries, Obrist designed fountains, tombstones, tapestries, wall-hangings, ceramics, metalwork, and much more.

Olbrich, Joseph Maria
22.10.1867 Troppau – 8.8.1908 Düsseldorf
Austrian architect and craftsman

In 1897 Olbrich, a student of the architects Karl von Hasenauer and Otto Wagner at the Academy in Vienna, was amongst the founding members of the Vienna Secession, whose exhibition building he went on to design. In 1899 he took up a post as architect and teacher at the Darmstadt artists' colony, where alongside his activities as an architect he also produced tinware designs and a number of graphic works. In 1907 he was a joint founder of the German Werkbund in Munich.

Olbrich was one of Jugendstil's most productive architects and a forefunner of Expressionist architecture, exerting a strong influence, for example, upon the architect Erich Mendelsohn (1884–1953) in the 1920s. He took part in numerous exhibitions, including the 1902 International Exhibition of Modern Decorative Art in Turin and the 1904 World Exposition in St. Louis. Olbrich's most important works were produced in Darmstadt: the development of the Mathildenhöhe (1900), the Ernst Ludwig House (1899–1901) and the Wedding Tower (1905–08). Other important buildings include the Secession building in Vienna (1897–98) and the Tietz Department Store in Düsseldorf (1907–09, today the Kaufhof Department Store). He published Ideen [Ideas], 1899, Architektur [Architecture], 1901–14, Neue Gärten [New Gardens], 1905 and Der Frauenrosenhof, 1907.

Östberg, Ragnar
14.7.1866 Stockholm – 5.2.1945 Stockholm
Swedish architect and designer

After studying in Stockholm, from 1893 to 1894 Östberg took extensive trips through Europe and America. From 1922 to 1932 he was a professor at the Academy of Art in Stockholm. Östberg primarily concentrated upon villas, although he also designed numerous public buildings in Stockholm. His most famous building is the Stockholm Town Hall (1911–23), which represents a major work of Swedish National Romanticism. He employed elements of Swedish Romanesque and Renaissance art and skillfully mediated between the architecture of the 19th and 20th century. The decorative details of his buildings reveal the influence of the English Arts and Crafts Movement, whereby Östberg in turn made a strong impact upon the English architecture of the 1920s.

Paczka-Wagner, Cornelia
9.8.1864 Göttingen – unknown
German painter and graphic artist

Paczka-Wagner, daughter of the famous political economist Adolf Wagner (1835–1917), studied at the Staufersche Porträtklasse des Künstlerinnen-Vereins in Berlin and with Professor Ludwig Herterich at the Academy in Munich. At the age of 23 she went to Rome and studied copper engraving techniques. She obtained her diploma in Dresden in 1890. She spent some time in Madrid in 1894, where she copied paintings by Velázquez. In 1895 she moved to Berlin where she and her husband, the Hungarian Ferenc Paczka, set themselves up as painters, although she concentrated mainly on graphics. Paczka-Wagner did much work for Pan magazine and won a bronze medal at the World Exposition in Paris in 1900.

Pankok, Bernhard
16.5.1872 Münster – 5.4.1943 Baierbrunn, Upper Bavaria
German architect, painter, graphic artist, sculptor, and craftsman

After an apprenticeship as a restorer and decoration painter in Münster, from 1889 to 1891 Pankok studied painting at the academies in Düsseldorf and Berlin. From 1892 to 1902 he was based in Munich. As a portrait painter and graphic artist, he worked for the magazines Pan and Jugend. His friendship with Hans Eduard von Berlepsch-Valendas prompted him to turn his attention to applied art, and he showed his first efforts in this field at the Munich Glass Palace exhibition of 1897. That same year he was also amongst the founders of the Vereinigte Werkstätten für Kunst im Handwerk [Associated Workshops for Art in Handicraft]. He was commissioned to produce the official catalog for the Paris World Exposition of 1900, which was admired as the most modern German book of its day. In 1902 he founded the Lehr- und Versuchswerkstätte [Teaching and Experimental Workshops] in Stuttgart and from 1913 to 1937 was director of the State School of Arts and Crafts. In 1908 he became a member of the German Werkbund.

Pankok is known above all for his interiors (including interiors for ships and Zeppelins) and handicraft designs employing fantastical ornamental Jugendstil forms. In contrast, his first buildings (around 1900) are more rigorously objective in conception. His contribution to German Art Deco lies in his use of cubic forms with a clear grid. His oeuvre also includes paintings (chiefly portraits), graphic works and stage sets (as from 1909). His major buildings include the registry office in Dessau (1900–02) and the Konrad Lange House in Tübingen (1900–01).

Partridge, Frederick James
1877 – 1942
English jewelry designer

Partridge studied at the Birmingham School of Art from 1899 to 1901 and in 1902 joined Charles Robert Ashbee's Guild of Handicraft, which moved from London to Chipping Campden in Gloucestershire that same year. Partridge opened a workshop in Soho in London where he designed jewelry for Liberty's. Between 1900 and 1908 he spent long periods working in Branscombe in Devon.

Partridge had much in common with the Arts and Crafts Society, yet his designs also incorporated the French style, his favorite material being horn. His colleague, the jewelry designer Ella Naper (1886–1972), was strongly influenced by Partridge.

Paul, Bruno
19.1.1874 Seifhennersdorf, Saxony – 17.08.1968 Berlin
German architect, painter, graphic artist, and craftsman

Paul studied at the Dresden School of Arts and Crafts and subsequently under W. Höker and Wilhelm von Diez at the Academy in Munich. While still a student, he supplied drawings to the magazines Jugend and Simplicissimus. In 1897 he was amongst the founders of the Vereinigte Werkstätten für Kunst im Handwerk [Associated Workshops for Art in Handicraft] in Munich. He won prizes for his interiors at the World Expositions in Paris (1900) and St. Louis (1904). Inspired by the Turin exhibition of 1902, he turned to machine-manufactured furniture. From 1907 he was based in Berlin, where he headed first the college attached to the Museum of Applied Art and from 1924 to 1932 the United State Schools for Free and Applied Art. After resigning his post in protest against National Socialism, in 1934 he moved to Düsseldorf and only returned to Berlin in 1954, where he was involved in rebuilding the city after the Second World War.

Paul was initially an adherent of Jugendstil. His works are distinguished by simple, clear stylistic elements combined with a contemporary functionalism. Although Paul was primarily active as an architect, his furniture designs were of greater significance, in particular his development of the first modular furniture (around 1906). As a draftsman he produced posters, signets, and illustrations. His major architectural works include the Feinhals House in Cologne (1908) and the Kathreiner highrise in Berlin (1927–28).

Picasso, Pablo
25.10.1881 Málaga – 8.4.1973 Mougins, near Cannes
Spanish painter, sculptor, graphic artist, and potter

Picasso studied at the Academy in Barcelona from 1895 to

1897, and set up independently as a painter in 1900. In 1901 his Blue Period began, which lasted until he moved to Paris in 1904. It was succeeded by the Pink Period (1905) and Cubism (1906). He soon won himself a place of honor in Parisian intellectual and artistic circles. In 1907 he became acquainted with Georges Braque (1882–1963), with whom he cooperated closely until 1914. They spent the summer of 1911 with Juan Gris in Céret at the sculptor Manolo's, and in summer 1913 Max Jacob joined the group. When the First World War broke out, the Cubist group fell apart and Picasso returned to Paris. In 1916 he got to know Sergei Pavlovich Diaghilev (1872–1929), for whose ballet company he designed costumes and sets until 1924. In 1917 he traveled with Jean Cocteau (1889–1963) to Rome and in 1919 with Diaghilev to London. From 1924 to 1930 he incorporated Surrealist elements in his work and in this period made wire sculptures. His work from 1936 to 1945 was strongly influenced by events in the Spanish Civil War and the Second World War. In 1947 he finally set up a pottery in Vallauris, near Cannes. From 1950, paintings by great Spanish artists served him as models. In the 1950s, Picasso became politically very active, having joined the French Communist Party in 1944, and this is visible in his art.

Picasso is considered the most important and versatile painter of the first half of the 20th century, who revolutionized artistic vision as a cofounder of Cubism. His work includes, in addition to the paintings, much graphic work (drawings, etchings, engravings and, after 1947, lithography), sculptures, and pottery.

Powell, Harry James
1853 – 1922
English glass artist
In 1873 Powell started work at the family glassworks, James Powell & Son, and became its manager several years later. Although the company was still deeply rooted in the English Stourbridge tradition, it was well-known for the modernity of its products. Harry Powell introduced the style and techniques of fine Venetian glass art to his company and experimented with it. The company was to become one of the forerunners of the Arts and Crafts Movement. Its products were printed in the magazine The Studio on a regular basis and were also shown at the international exhibition in Turin in 1902. Powell's company was one of the first to introduce Art Nouveau to glass art and in its day was heralded the best glassworks in England.

Powolny, Michael
18.9.1871 Judenburg, Styria – 4.1.1954 Vienna
Austrian sculptor and ceramicist
After an apprenticeship as a potter under his father, from 1894 to 1906 Powolny studied at the Pottery Industry College in Znaim and at the School of Arts and Crafts in Vienna, under Metzner and others. In 1897 he was amongst the founders of the Vienna Secession and in 1905/06, together with Berthold Löffler, cofounder of the Wiener Keramik company. From 1905 to 1910 he was employed on the interior design of the Palais Stoclet in Brussels. In 1912 his workshop merged with that of Franz Schleiß to form the Vereinigte Wiener und Gmundner Keramik [Associated Viennese and Gmunder Ceramic]. In his latter years he devoted himself increasingly to teaching. From 1909 to 1936 he taught a special ceramics course designed by himself at the School of Arts and Crafts in Vienna, and from 1932 a sculpture course. Powolny's work makes him one of the most important representatives of Viennese Jugendstil ceramic art.

Prouvé, Victor
13.8.1858 Nancy – 1943 Sétif, near Nancy
French painter, graphic artist, sculptor, potter, and craft artist
After studying drawing at the Civic Art School in Nancy from 1873 to 1876, and under the painter Alexandre Cabanel

(1823–89) at the École des Beaux-Arts in Paris, Prouvé won a travel scholarship in 1888 and went to Tunisia. When he returned, he worked for Émile Gallé as a designer of furniture, jewelry, and glass. In 1890, he moved to Paris where, at the prompting of Pierre Cécile Puvis de Chavannes and Théophiles-Alexandre Steinlen (1859–1923), he took up sculpting. After his success at the Salon du Champ de Mars in 1894, he received commissions for monuments and decorative architectural sculptures on Art Nouveau buildings in Nancy. In 1901, he was a cofounder of the École de Nancy, which he directed from 1904 after the death of his friend Émile Gallé. In 1918, he took over the direction of the new École des Arts Appliqués in Nancy, where he taught until 1930.

Prutscher, Otto
7.4.1880 Bühl – 15.2.1949 Vienna
Austrian architect and craftsman
Prutscher, who studied architecture and applied art at the School of Arts and Crafts in Vienna and attended the Timber Industry College, was a pupil of Josef Hoffmann and Franz Matsch. In 1903 he became a member of the Wiener Werkstätte and taught at the Institute of Graphic Art. In 1909 he took up a teaching post at the School of Arts and Crafts in Vienna, and in 1918 became a vocational school inspector in Vienna. He was also a member of the Austrian and the German Werkbund, the Künstlerhaus and the Central Association of Austrian Architects.
Prutscher produced models for a number of Viennese ceramic and porcelain factories. Around 1900 he turned to glass and influenced artistic glass production in Austria up to the First World War. He worked for Lobmeyr, Bakalowits & Söhne, and Carl Schappel. He also designed jewelry, silverware, fabrics, wallpapers, and interiors.

Puvis de Chavannes, Pierre Cécile
14.12.1824 Lyons – 24.10.1898 Paris
French painter
After completing his studies as an engineer, Puvis de Chavannes taught himself to paint. He was influenced by Eugène Delacroix (1798–1863) and Théodore Chassériau (1819–56). The subjects of his paintings idealize an ancient world of figures. He produced fantastic murals in dim, cold colors, painted in oils on canvas in his studio and then affixed to the walls when finished. His main works include the panels entitled The Life of St. Geneviève in Paris (1874–77) and the murals in the Hôtel de Ville in Paris (1889–93). Puvis de Chavannes was one of the most significant Symbolist painters and thus a great source of inspiration for many Art Nouveau painters in France.

Quarti, Eugenio
1867 Villa d'Almé, Bergamo – 1929 Milan
Italian furniture designer and maker
After training in Paris and completing his practical apprenticeship with Carlo Bugatti, Quarti opened a small shop in Milan called Quarti-Casati. At the Antwerp World Exposition in 1894, he was awarded a silver medal as "a designer of fanciful furniture in an arborizing style." At the Turin exposition of 1898 he won the gold medal. As a successful furniture designer, he was able to expand his business in 1904, after which date he also took part in furnishing larger buildings. By 1905, Quarti-Casati had taken on the proportions of a small industrial business, with a rapidly expanding customer base. After Quarti's death in 1929, his son Mario took over the firm.

Ranson, Paul-Élie
29.3.1861 Limoges – 20.2.1909 Paris
French painter, graphic artist, and craft artist
Ranson was a student at the École des Beaux-Arts in

Limoges from 1884, and from 1888 at the Académie Julian in Paris. In 1888, he teamed up with Paul Sérusier (1864–1927), Maurice Denis (1870–1943) and Pierre Bonnard (1867–1947) to form the Nabis group of artists. In 1908, he established the Académie Ranson in Paris, an art school where the leading artists in Paris taught.
As a member of the Nabis group, Ranson was among those who introduced Japonisme in painting and graphic art. His style, which is often notable for its monochromy and the bold use of outlines, made him an important force for promoting Art Nouveau. As a graphic artist, he was a contributor to La Revue Blanche and also illustrated books for publishers Mercure de France. In addition, he did sets for the Théâtre de l'Oeuvre.

Raspall i Mayol, Manuel
1877 Barcelona – 1937 Barcelona
Spanish architect and watercolorist
Raspall i Mayol gained his architectural diploma in Barcelona in 1905, and thereafter built mainly private houses. He was the city architect in Vallés, where he was responsible for restoration work. His buildings were very strongly influenced by the local culture there. He also painted watercolors, which were exhibited in Barcelona from 1896.

Redon, Odilon
(real name Bertrain-Jean Redon)
22.4.1840 Bordeaux – 6.7.1916 Paris
French painter and graphic artist
Redon was a pupil of the painter and sculptor Jean Léon Gérôme (1824–1904), the graphic artist Rodolphe Bresdin (1325–85) and the painter and graphic artist Henri Fantin-Latour (1836–1904). Influenced by Eugène Delacroix (1798–1863), Hieronymus Bosch (1450–1516) and Francisco de Goya (1746–1828), he depicted a phantasmagoric world of dreams and visions. From 1902, he devoted himself chiefly to painting in oil. His subjects are very rarely pure landscapes. They often contain fanciful and mythical elements as well as flowers. Redon counts as a representative of Symbolism, and was highly esteemed as a pioneer by the Nabis group of artists and later by the Surrealists.

Reed, Ethel
1876 Newburyport, Massachusetts – unknown
American painter and graphic artist
Reed, who received her training from the miniaturist Laura Hill, first made a name for herself aged just 18 with her book illustrations. The English magazine Punch commissioned numerous caricatures from her. In 1895 she made her breakthrough as a poster artist. Reed worked almost exclusively for the publishers Lamson, Wolfe & Company in Boston and New York.

Richard-Ginori, Società Ceramica
Established in Milan in 1896
Italian ceramics manufacturer
The Società Ceramica was created in 1896 by the merger of the firm Ginori in Doccia and Società Richard in Milan. Richard-Ginori was one of the most important Italian manufacturers of ceramics of the time. Its products were shown at various international exhibitions such as Turin in 1902 or Paris in 1925. They reveal the stylistic influence of Otto Wagner.

Ricketts, Charles
(real name Charles de Sousy)
2.10.1866 Geneva – 7.10.1931 London
English painter, graphic artist, and artist craftsman
Ricketts grew up in France and moved to England in 1879,

where he started an apprenticeship with a wood engraver and cutter in London. There he met William Morris and joined the Pre-Raphaelite circle. From 1889 to 1897 Ricketts and Charles Shannon (1863–1937) published the Art Nouveau periodical *The Dial*. In 1896 the two friends set up the Vale Press, a printing works that specialized in luxury book editions for which Ricketts did many of the illustrations. He also worked for the magazine *The Hobby Horse* and in 1922 became a member of the Royal Academy.

In his graphics Ricketts developed his own style, with generous curved lines akin to French Art Nouveau, although one can also clearly detect the influence of Aubrey Vincent Beardsley. Ricketts was also successful with his stage sets and metalwork.

Riegel, Ernst
12.9.1871 Münnerstadt – 14.2.1939 Cologne
German gold and silversmith, ceramicist

Riegel trained from 1887 to 1890 under the engraver Otto Pabst in Kempten and from 1895 to 1900 worked as engraver's assistant to the Munich goldsmith Fritz von Miller, who employed designs by major artists. In 1900 he won a gold medal at the Paris World Exposition, after which he founded his own workshop in Munich. In 1906 he was successfully represented at the Third German Exhibition of Arts and Crafts in Dresden and was subsequently appointed to the Darmstadt artists' colony, where he was given a workshop and a teaching post in applied art. From 1912 he taught at the School of Arts and Crafts in Cologne and from 1920 also headed the goldsmithery course at the Cologne Institute of Religious Art.

Riegel's oeuvre was multi-faceted: he worked both for private individuals and for museums, churches and state departments. His works were published in numerous journals of the day.

Riemerschmid, Richard
20.6.1868 Munich – 15.4.1957 Munich
German architect, craftsman, and painter

Riemerschmid, who studied painting at the Academy in Munich from 1888 to 1890, designed his first items of furniture in 1895, under the influence of the Arts and Crafts Movement, which he knew from the pages of the English magazine *The Studio*. In 1897 he was amongst the founding members of the Vereinigte Werkstätten für Kunst im Handwerk [Associated Workshops for Art in Handicraft] and showed furniture and paintings at the Glass Palace exhibition. He gained true recognition only at the 1899 German Exhibition of Art in Dresden, however. Together with Bruno Paul and Bernhard Pankok, he won a gold medal at the Paris World Exposition of 1900 for his *Room for an Art Lover*. From now on a successful artist, he was commissioned to build the Munich Schauspielhaus theater (1900–01) and worked as a designer for the Meissen Royal Saxon Porcelain Factory (1903–04) and for the Dresdner Werkstätten run by his brother-in-law Karl Schmid. From 1902 to 1905 he taught at the School of Art in Nuremberg. From 1913 to 1924 he was director of the Munich School of Arts and Crafts and from 1926 to 1931 headed the Industrial School in Cologne.

As a founder member of the German Werkbund (1907) and its president from 1921 to 1926, and through his activities as a teacher, association member, and author of numerous ideological essays on art, Riemerschmid was one of the leading figures in German Jugendstil. His oeuvre includes interiors, glassware, fabrics, and wallpapers, as well as numerous buildings, including the Munich Schauspielhaus (1900–01, today the Kammerspiele), the Garden City of Hellerau near Dresden (1907–08, development plan), the Deutsche Werkstätte factory building in Dresden (1909) and the Bavarian Radio building in Munich (1928–29).

Rietveld, Gerrit Thomas
24.6.1888 Utrecht – 26.6.1964 Utrecht
Dutch architect and craft artist

Rietveld completed an apprenticeship as a cabinet-maker, but was given his first job by a jeweler as a designer of jewelry. He subsequently set up a studio of his own in Utrecht. In 1918, he became acquainted with the De Stijl group of artists, remaining a member until the group broke up in 1931.

Rietveld designed villas (e.g. the Schröder house in Utrecht, 1924), terraced housing and exhibition pavilions (e.g. for the Biennale in Venice in 1954) which are noted for their great simplicity and elegance. In his interiors and furniture designs – his best-known piece is the Rood Blauwe Stoel [Red Blue Chair] of 1918 – he was fond of using primary colors, attempting to translate the geometric, functional ideal of the De Stijl movement into practice.

Rizzi, Antonio
18.1.1869 Cremona – 1941 Florence
Italian painter and graphic artist

Rizzi was professor of graphic art at the Academy in Perugia and a contributor to the Munich periodical *Jugend*. His work has a general resemblance to Munich Art Nouveau, in particular the work of Franz von Stuck. As a painter, he produced historical and genre paintings, portraits and sets.

Rode, Gotfred
3.12.1862 Torstedlund, near Aalberg – 14.9.1937 Frederiksvaert
Danish painter and porcelain painter

Rode studied at the Copenhagen Academy and from 1896 to 1933 was employed by Den Kongelige Porcelainsfabrik in Copenhagen as a porcelain painter and designer. From 1902 until his death he taught at the Copenhagen Academy. Rode was married to the well-known painter Ingelbert Kolling (1865–1932).

Rookwood Pottery
Founded 1880 in Cincinnati, Ohio
American pottery

Mary Louise Longworth Nichols founded the Rookwood Pottery in Cincinnati in 1880 and one year later set up an accompanying decorating studio, to which a metal workshop for fittings was also attached. Rookwood pottery reveals a Japanese influence in its ornament, although its decors derive their themes more from the North American culture and landscape. The pottery won a gold medal at the Paris World Exposition of 1889. Following the success of its dark-colored pottery with slip decors, around 1900 the company began producing architectural ceramics. In 1941 it was temporarily closed and the company changed ownership several times up to 1967.

Roosenboom, Albert
1871 Brussels – 1943 Brussels
Belgian architect

Rosenboom was born into an artist family of Dutch extraction, his father being a well-known genre painter in Belgium. After studying at the Académie Royale des Beaux-Arts in Brussels, he worked from 1896 as a draftsman in the architectural office of Victor Horta and Jules Barbier. Later he set up on his own, and in 1900 built himself a house in the rue Faider in Brussels. In the same year, he was appointed to a chair at the École des Arts Décoratifs d'Ixelles. In 1902, he constructed the Magasin de bière in Brussels, still in pure Art Nouveau architectural style. In subsequent years he went back to a historicising architectural approach, from 1905 building numerous buildings in a neo-Rococo style. In a letter to the periodical *Le Home* in 1910, he set out the reasons why he had abandoned Art Nouveau in favour of a historicising style.

Besides numerous building commissions in Brussels, Ypres, Leuven, and Bruly, he undertook restoration work, especially at the châteaux of Boisselles and Elverdinghe.

Rörstrands Porslinsfabriker A.B.
Founded 1726 in Lidköping, near Stockholm
Swedish faience and porcelain factory

The faience factory Rörstrands Porslinsfabriker, founded in 1726, was converted into an incorporated society in 1868. In 1850 it was started producing porcelain and stoneware comparable to that of Den Kongelige Porcelainsfabrik in Copenhagen. It employed the techniques of underglaze painting, crystal glazes and, frequently, relief modeling. The designs originated from the artists Alf Wallander, artistic director from 1895 to 1914, Algot Erikson, E. H. Tryggelin, Nils Lundström, and Waldemar and Karl Lindström. In 1874 the company founded the subsidiary Arabia O.Y. in Helsinki, in order to supply the Finnish and Russian markets.

Rossetti, Dante Gabriel
12.5.1828 London – 9.4.1882 Birchington-on-Sea, Kent
English painter and poet

Apart from a period of study under the painter Ford Madox Brown (1821–93), Rossetti was largely self-taught. William Blake greatly influenced Rossetti in all spheres of his work. Rossetti, like John Everett Millais (1829–96) and William Holman Hunt (1827–1910), rejected academic historicism in painting. Together they formed the Pre-Raphaelite Brotherhood in 1848, which took as its models early Italian painting and nature. Rossetti's linear style, his mystical and sensuous depictions of women and his book illustrations were major contributory factors to the development of Art Nouveau in England. His works include *The Annunciation* (1850), *Beata Beatrix* (1863) and *Dante's Dream* (1870–71). Rossetti was also a poet of great significance.

Rousseau, François Eugène
17.3.1827 Paris – 12.6.1891 Paris
French potter and glass artist

Rousseau took over the ceramics and pottery business of his father in 1855. He worked with the artist Marc-Louis Solon (called Milès) designing decoration inspired by East Asian art. His ceramic work and thick-sided glass with colorations brought him success. In 1885, he sold his business to his pupil and colleague E. Leveillé, who continued trading under the name Rousseau-Leveillé until the 1890s.

Royal Doulton Potteries
Established in 1815 in Staffordshire
English manufacturers of ceramics and porcelain

In 1815 John Doulton founded a company for the manufacture of ceramics and porcelain in Staffordshire. In 1826 the company moved to Lambeth in London and was renamed Doulton & Watts on the basis of a newly formed partnership with John Watts. Henry Doulton took over production in 1835 and after the death of Watts in 1858 the company was again renamed, this time to Henry Doulton & Co. In the years to follow, the factory developed new techniques and production methods for porcelain and stoneware. The company's lines in production spanned all kinds of ceramic work, including terracotta tiling for walls. After initial success, the company's significance began to fade from 1899 onwards. In 1956 the plant was closed. Today the only branch which is still functioning is Doulton Fine China Ltd., Royal Doulton Potteries, Burslem.

Runge, Philipp Otto
23.7.1777 Wolgast, Pomerania – 2.12.1810 Hamburg
German painter, draftsman, writer, and art theoretician

Runge studied at the Copenhagen Academy from 1799 to 1801 where he was influenced by the figure ideals of John Flaxman (1755–1826) and William Blake. He continued his artistic education at the Dresden Academy in 1801. He was introduced to Romantic landscape painting by Caspar David Friedrich in 1802. It was at this time that he executed one of his most famous works, *The Times of the Day*. He started taking drawing lessons in Hamburg in 1803 and turned to portrait painting. He also explored the use of color, the results of which he published in a book in 1810.

Runge is said to have paved the way for Romantic art, not least through his theoretical writings, and to have helped free German painting from the clutches of academic classicism.

Rysselberghe, Octave van
22.7.1855 Minderhout – 30.3.1929 Nice
Belgian architect
Octave van Rysselberghe was a brother of the painter Theo van Rysselberghe (1862–1926). After completing his training at the Academy in Ghent, from 1871 he worked at the law courts in Poelaert. In 1874, he undertook a trip to Italy. He gained his first major architectural commission in 1879, for the Royal Observatory at Uccle. In 1882, he completed a palais for Count Goblet d'Alviella in Brussels, and the following year was runner-up in a competition for the Municipal Hall in Schaerbeek. In 1889, he retired to La Hulpe, where he threw himself with great enthusiasm but little success into growing grapes in hothouses, constructing a hothouse with a surface area of one hectare. The construction of a studio for his brother in 1893 brought him into contact with Paul Otlet, for whom he built a residence in 1894 in partnership with Henry van de Velde. This joint effort led to further cooperative commissions with van de Velde. In 1898, he was appointed professor at the Academy in Brussels without ever giving a lecture. In the following years, he won commissions mainly for houses and interior designs. Towards the end of his life, Rysselberghe retired to the South of France.

Saarinen, Eliel
20.8.1873 Rantasalmi – 1.7.1950 Bloomfield Hills, Michigan
Finnish architect, urban planner, designer, and painter
From 1893 to 1897 Saarinen studied painting at Helsinki University and architecture at Helsinki Polytechnic. He later painted only as a hobby. In 1896, while still a student, he founded the architectural firm of Gesellius, Lindgren & Saarinen, known as GLS, together with Herman Gesellius and Armas Eliel Lindgren. Alongside public buildings they also designed private villas, in which they realized the principle of the total work of work (e.g. Suur-Merijoki manor house in Viipuri, 1903). For this reason, from the 1890s onwards, Saarinen also designed furniture, which like his buildings drew upon Finnish tradition. In 1923 he emigrated to the United States, where he opened an office in Evanston, Illinois, transferring it to Ann Arbor, Michigan in 1924. He taught at the Michigan University of Chicago and from 1948 also headed the Graduate Department of Architecture and City Planning at the Cranbrook Academy of Art in Bloomfield Hills, Michigan.

Saarinen's first buildings were strongly influenced by the Finnish Gothic Revival and the English Arts and Crafts Movement. Their interiors, which frequently originated from the workshop of Akseli Gallen-Kallela, revealed predominantly Art Nouveau elements. In his later buildings, forms became more angular and more abstract. His most important work was Helsinki Central Station (designed 1904, built 1910–14).

Sant'Elia, Antonio
30.4.1888 Como – 10.10.1916 Monfalcone
Italian architect
Sant'Elia studied at the Technical Architectural School in Como, the Accademia di Brera in Milan and the Scuola di Belle Arti in Bologna. His first building was an Art Nouveau villa near Como (1911), which was influenced by the Italian Stile Liberty and the Viennese Secession. Later, his style, like that of Loos, was inspired by the architecture of the great American metropolises. In 1913, he drew up Utopian plans for cities, which made him a pioneer of modern Italian architecture. Sant'Elia was killed at the Front soon after Italy joined the First World War.

Scharvogel, Jacob Julius
3.4.1854 Mainz – 30.1.1938 Munich
German painter and ceramicist
After studying ceramics in London and Paris and experimenting in glass-making in the Bavarian Forest, Scharvogel worked for Villeroy & Boch. In 1897 he was a cofounder of the Vereinigte Werkstätten für Kunst im Handwerk [Associated Workshops for Art in Handicraft] in Munich, where one year later he founded his own workshop. From 1900 he collaborated with the painter Walter Magnussen (1869–1946), the graphic artist Paul Haustein, Theo Schmuz-Baudiss and Emmy von Egidy. At the Paris World Exposition of 1900 he won a gold medal for his stoneware. From 1904 to 1913 he headed the Grand-Ducal Potteries in Darmstadt, which took successful part in the Brussels exhibition of 1910. In 1907 he was amongst the founders of the German Werkbund. From 1915 to 1925 he taught architectural ceramics at the Technical College in Munich and acted as consultant on a project to set up a ceramics industry in Turkey.

Scharvogel may be seen as the first German ceramicist to develop sharp-fired stoneware featuring color glazes. This *grés flammé* was popularly used in Art Nouveau, especially in France. Around 1900 he turned away from decorative ceramics with a pronounced Japanese influence and instead toward the manufacture of functional ceramic items for interiors and architecture.

Schaudt, Johann Emil
14.8.1871 Stuttgart – unknown
German architect
Schaudt studied at the Technical College in Stuttgart and was a pupil of S. Neckelmann and Paul Wallot.

Schechtel, Fyodor Osipovich
1859 Moscow – 4.7.1926 Moscow
Russian architect
Schechtel was an assistant to the architect A. S. Kaminsky, who was a member of the Mir Iskustva artists' group and can be considered his most important teacher. In the 1880s, Schechtel set up his own architectural practice, and also worked with M. Lentovsky as a set designer. He employed the leading avant-garde Russian artists to do the decorative work of his buildings. His most important buildings are in Moscow, namely the Palais Rabushinsky (1902–06, now the Gorky Museum) and Jaroslav Station (1890–1910). In 1901, he was commissioned to build the Russian pavilion at the International Exhibition in Glasgow.

Scheidt, Georg-Anton
1900 Vienna – 1965 Huttar Heriberg
Austrian graphic artist and silversmith
Based in Vienna, Scheidt produced jewelry and silverware in a linear style to designs by Koloman Moser and others.

Schiele, Egon
12.6.1890 Tulln/Danube – 31.10.1918 Vienna
Austrian painter and draughtsman
Schiele studied at the Academy in Vienna from 1906 to 1909. In 1907 he met Gustav Klimt, who would become his spiritual mentor. Up till 1911 he worked in seclusion in his studio in Vienna, although he was a member of various artists' groups and the Federation of Austrian Artists. He exhibited at the Kunstschau in Vienna (1908), with the Sonderbund in Cologne (1912), in the Secessions in Berlin and Vienna (1915–16) and at the Kriegsschau [War Exhibition] in Vienna (1917). He found public recognition only shortly before his death, however.

Schiele initially adopted the ornamental graphic elements of Viennese Jugendstil, before developing, around 1902, the highly personal style that would make him one of the most important representatives of early Viennese Expressionism. His oeuvre includes landscapes, portraits, and above all nudes, which were considered scandalous in his day.

Schmithals, Hans
28.3.1878 Bad Kreuznach – 1964 Munich
German painter and craftsman
From 1902 Schmithals attended the Studio for Applied and Free Art in Munich founded by Hermann Obrist and Wilhelm von Debschitz, in which he later taught wallpaper printing. His first pictures and furniture designs were featured in the 1908 exhibition by the Verband für Raumkunst [Association for Interior Design]. In Munich, together with Wolfgang von Wersin, he founded the Austellungsverband für Raumkunst [Interior Design Exhibiting Society], which in 1913 showed many of his designs. After the First World War he designed the interiors of large buildings in Switzerland, Munich, and Berlin.

Schmithals, who borders on abstraction in his handicraft designs, and in particular in his tapestries, ranks amongst the pioneers of abstract art. The dynamic composition of his paintings is strongly influenced by Obrist.

Schmuz-Baudiss, Theo
4.8.1859 Herrnhut, Saxony – 20.6.1942 Garmisch
German painter and ceramicist
Schmuz-Baudiss studied at the Munich School of Arts and Crafts from 1879 to 1882 and at the Munich Academy up till 1890, before switching from painting to ceramics around 1896. His first vases were shown in the Munich Glass Palace exhibition of 1897. He worked with Jacob Julius Scharvogel and as a designer for the Thuringian firm of Swaine & Co. Schmuz-Baudiss became a member of the Vereinigte Werkstätten für Kunst im Handwerk [Associated Workshops for Art in Handicraft] in Munich in 1897 and took part in all the major exhibitions in Munich, Paris, Leipzig, Dresden, Berlin, and Turin between 1899 and 1902. In 1902 he was appointed to the KPM Royal Porcelain Factory in Berlin. Initially responsible for setting up the underglaze department, from 1908 to his retirement in 1925 he was head of the factory. The decorative techniques which Schmuz-Baudiss developed lent his stylized floral ornament echoes of Scandinavian porcelain. He also reintroduced the *sgraffito* technique. His porcelain was distinguished by its differentiated palette.

Schnellenbühel, Gertraud von
1878 Jena – 1959 Dresden
German craftswoman
Schnellenbühel studied painting under Frithjof Smith and from 1900 under Angelo Jank in Munich. In 1902 she switched to applied art and joined the metalwork course at Debschitz's school. She was supported in her work by Hermann Obrist and produced successful jewelry designs and silverware. At the 1906 Nuremberg Exhibition of Arts and Crafts she showed silver bowls. In 1911 she worked in the workshop of the silversmith and court employee

Adalbert Kinzinger. She took part in the Werkbund exhibition in Cologne in 1914, after which date no further works by her are known or have been published.

Seger, Hermann
26.12.1839 Posen – 30.10.1893 Berlin
German ceramicist
As director of the Chemical Institute at the KPM Royal Porcelain Factory in Berlin (1878–90), in 1880 Seger developed the "Seger porcelain" which bears his name. Seger porcelain is very well suited to carrying color metallic glazes, making it possible to achieve the quality of fine Chinese and Japanese chinaware. Seger pottery featuring oxblood glazes was shown at the 1884 exhibition in the Berlin Museum of Applied Art. Seger exerted a strong influence upon both KPM and the ceramic industry as a whole.

Serrurier-Bovy, Gustave
27.7.1858 Liège – 19.11.1910 Antwerp
Belgian architect and craft artist
Serrurier-Bovy studied at the Académie des Beaux-Arts in Liège in the 1870s. After becoming acquainted with the work of William Morris, he moved to London, where he worked as a designer of interior furnishings in the Modern Style. In 1884, he opened a shop for furniture and decorations in Liège, opening further branches in Brussels in 1897 and Paris in 1899. His own furniture designs display a certain plainness and severity. With his "Silex" range of birch furniture, he was a precursor of fold-up furniture. Serrurier-Bovy was a cofounder of the Brussels Salons de La Libre Esthétique in 1894, and the following year organised L'œuvre Artistique in Liège, an international exposition for applied art. In 1901, he established contact with the artists' colony in Darmstadt. Serrurier-Bovy was exhibited at several exhibitions in London and at the world expositions in Paris in 1900 and St. Louis in 1904. From 1896 to 1903, he was a regular participant at the Salon du Champ de Mars in Paris. His last designs were exhibited at the International Exposition for Arts and Crafts in Brussels in 1910.

Sika, Jutta
17.9.1877 Linz – 2.1.1964 Vienna
Austrian painter, graphic artist, and handicraft designer
Sika, who studied at the Institute of Graphic Art in Vienna from 1895 to 1897 and under Koloman Moser at the Vienna School of Arts and Crafts from 1897 to 1902, took part in numerous exhibitions, including "The Laid Table" in 1906 and at the world expositions in Paris in 1900 and St. Louis in 1904, where she won a bronze medal. From 1911 to 1933 she taught at vocational schools in Vienna. Sika was a cofounder of the Wiener Kunst im Hause [Viennese Art in the Home] association of interior designers, a member of the Austrian and German Werkbund and of the Vereinigung bildender Künstlerinnen Österreichs [Association of Austrian Women Visual Artists].

Silver, Rex
(Real name Reginald Silver)
1879 – 1965
English designer
In 1901 Silver took over his father's design studio for wallpaper and textiles founded in 1880, which supplied the biggest firms in Europe, especially Liberty & Co. in London. Silver also produced designs for the Liberty silver series, Cymric. His career was at its peak in the 1920s and 1930s. The Silver Studio was closed in 1963.

Simberg, Hugo
24.6.1873 Hamina – 11.7.1917 Ahtäri
Finnish painter and graphic artist
From 1895 to 1897 Simberg studied at Akseli Gallen-Kallela's school in Ruovesi, which served as a meeting point for the pioneers of Finnish Art Nouveau. Gallen-Kallela quickly discovered his pupil's remarkable talent and focused his training upon the techniques of graphic art. Together they formed the foundation of modern Finnish graphic art. As a painter, Simberg produced chiefly small-format watercolors and prints. His two favorite themes were the Poor Devil and Death. Simberg may be seen as one of the inspirational forces behind Finnish painting of the turn of the century.

Sohlberg, Harald Oskar
29.11.1869 Christiania (today Oslo) – 19.6.1935 Oslo
Norwegian painter
Sohlberg, who studied painting under W. Krogh at the Royal School of Drawing, spent the years 1895 to 1896 in Paris and 1897 in Weimar. From 1906 to 1911 he continued to attend evening classes with J. N. Nerbst. Sohlberg chiefly painted landscapes and views of architecture. His best-known work is Winter's Night in the Mountains (1914), which today hangs in the National Gallery in Oslo.

Stappen, Charles van der
19.12.1843 Sint-Josse-ten-Noode – 21.10.1910 Brussels
Belgian sculptor
Van der Stappen was a student at the Academy in Brussels from 1859 to 1868, spending 1864 in Paris, where he worked in a sculptor's studio while attending the École des Beaux-Arts. From 1877 to 1879 he lived in Rome, where he worked out the cire perdue technique. After his return, he established the Atelier Libre in Brussels, which soon became a favorite rendezvous for artists such as Constantin Meunier (1831–1905), Victor Horta and Octave Maus (1886–1919). In the 1890s, van der Stappen devoted himself to applied art, and was a cofounder of L'Art, a movement for "Art in Industry". Van der Stappen was exhibited at numerous exhibitions, including those of Les Vingt, the Salon de La Libre Esthétique and the Viennese Secession. His principal works include Teaching Art (1887), a bronze group at the Palais des Beaux-Arts in Brussels and another on the main steps of the City Hall in Brussels.

Steuben Glass Works
Founded 1903 in Corning, New York
American hollow glass works and decorative and domestic glass processing plant
The company, named after the district of Steuben, was founded in 1903 by Frederick Carder (1864–1963) and Thomas G. Hawkes. Under the direction of Carder, an English glass technician who had arrived in the United States in 1902, the company became highly successful. Its range of products was diverse and testified to the influence of René Lalique, Louis Comfort Tiffany, Émile Gallé and the glass styles of other countries. It also developed various techniques for decorating glass. During the First World War its operations were temporarily suspended. In 1918 the company was taken over by the neighboring Corning Glass Works, but Carder remained head of the firm until the 1930s.

Stoltenberg-Lerche, Hans
12.8.1867 Düsseldorf – 17.4.1920 Rome
Norwegian sculptor, graphic artist, ceramicist, and jewelry and glass artist
Stoltenberg-Lerche trained at the Düsseldorf Academy of Art, the Academy of Fine Arts in Florence and under Eugène Carrière and de Saint-Marceaux in Paris. He lived chiefly in Italy and opened a studio in Margellina, where he produced small terracotta figures. He also drew for the Leipziger Illustrierte Zeitung and designed interiors, jewelry, and ceramics. Stoltenberg-Lerche took part in numerous exhibitions, and was particularly successful in Paris: at the 1897 Paris Exposition Nationale de Céramique et des Arts du Feu he was awarded an honorary diploma, and he won a gold medal at the 1900 World Exposition. Together with Frida Hansen, he represented Norway at the Turin exhibition in 1902, and at the Venice Biennale of 1912 he showed glass works for the first time. His works were bought by collectors and museums around the world.

Strathmann, Carl
11.9.1866 Düsseldorf – 29.7.1939 Munich
German painter, graphic artist, and handicraft designer
Strathmann studied at the Academy in Düsseldorf from 1882 to 1886 and subsequently, until 1889, at the Weimar School of Art under Leopold Kalckreuth, whom he followed to Munich in 1890. There he joined the Bohemian set around Lovis Corinth (1858–1925). At an exhibition by the Munich Secession he was profoundly impressed by the mysticism of Jan Toorop and Fernand Khnopff. Although his own painting was strongly influenced by Dutch Symbolism, he published parodies of Symbolist art in the magazines Jugend, Fliegende Blätter and Pan. In 1894 he became a member of the Münchner Freie Vereinigung [Munich Free Association], a splinter group of the Munich Secession which included, amongst others, Peter Behrens, Lovis Corinth, Thomas Theodor Heine, and Otto Eckmann. Around 1900, in the studio which he had founded with A. Niemeyer, he turned increasing attention to applied art, designing fabrics, menus, wallpapers, and tapestries. He is also well-known for his gold medal jewelry, occasionally set with stones. Strathmann renounced traditional illusionistic techniques and emphasized the decorative character of his compositions. He thereby achieved the "fairytale atmosphere" so beloved of Munich Jugendstil.

Strauven, Gustave
1878 Schaerbeek – 1919 Faverge, France
Belgian architect and inventor
From 1896 to 1898, Strauven worked as a draftsman in the architectural office of Victor Horta, later joining the editorial staff of La Gerbe, a periodical for interior decoration and literature. Around 1900, he set up his own architectural practice, winning commissions for private houses, including that of the painter Saint-Cyr in Brussels (1903). After 1907, he devoted more and more time to inventing, and was hardly involved in architectural work.

Stuck, Franz von
(ennobled in 1906)
23.2.1863 Tettenweis, Lower Bavaria – 30.8.1928 Munich
German painter, sculptor, and craftsman
Stuck studied at the School of Arts and Crafts in Munich from 1878 to 1881 and until 1885 at the Academy under Wilhelm Lindenschmit (1829–1895) and Ludwig Löfftz (1845–1910). He rarely attended classes, however, working instead as a handicraft designer and contributing to the magazines Jugend, Fliegende Blätter and the Viennese journal Allegorien und Embleme. In 1888 he started painting in oils and in 1889 won the gold medal at the Munich annual exhibition. In 1892, together with Fritz von Uhde (1848–1911), Bruno Piglhein and Heinrich Zügel (1850–1941), he founded the Munich Secession. In 1895 he took over from Lindenschmit as professor at the Munich Academy. His pupils included Wassily Kandinsky (1866–1944), Paul Klee (1879–1940), Hans Purrmann (1880–1966) and Josef Albers (1888–1976). Between 1897 and 1898, with the assistance

of the architects Jakob Heilmann and Max Littmann, he created his total work of art: the Villa Stuck in Munich, his studio and home. A number of pieces of furniture designed by Stuck were shown at the Paris World Exposition of 1900. Stuck was a central figure in Munich Jugendstil who erased the boundary between fine and applied art. He painted chiefly allegorical, Symbolist nudes and mythical beasts. His major works include *The Twelve Months* (1887), *Sin* (1893), *War* (1894) and *Sphinx* (1895).

Sullivan, Louis Henry
3.9.1856 Boston, Massachusetts – 14.4.1924 Chicago
American architect
After studying briefly in Boston and working in the architectural offices of Frank Furness in Philadelphia and William Le Baron Jenney in Chicago, from 1874 Sullivan studied at the École des Beaux-Arts in Paris, where he explored historicist styles. In 1876 he returned to the United States and in 1881 founded his own architectural practice in Chicago with the German engineer Dankmar Adler. Between then and the ending of their partnership in 1895, the duo produced a number of successful, eclectic works. Although Sullivan won considerably fewer commissions after his split from Adler, the quality of his architecture improved. In 1899 he built his masterpiece: the Schlesinger and Mayer Department Store in Chicago.
Sullivan's oeuvre arose at a turning point in the development of architecture. As the chief representative of the Chicago School of Architecture, he designed the first functional steel-frame buildings in the United States and thereby ranks amongst the pioneers of modern constructivist building. In his own view, form arose from function. The decoration employed on his buildings is Art Nouveau in style. His major works include the Wainwright Building in St. Louis (1890–91), the Auditorium Building in Chicago (1886–88), the Guaranty Building in Chicago (1894–95) and the Schlesinger and Mayer (today the Carson Pirie Scott & Co.) Department Store in Chicago (1899–1904).

Thesmar, André-Fernand
2.3.1843 Châlon-sur-Saone – 5.4.1912 Neuilly-sur-Seine
French enamel artist
Thesmar was apprenticed in a textiles factory, and subsequently worked as a set designer in a studio for industrial design, then at Aubusson tapestries and subsequently in a foundry in Barbédienne. Around 1872, he set up independently in Neuilly, specializing in *émail cloisonné* work, which he later did on porcelain for the Manufacture de Sèvres. He won awards for his work as early as 1874, at an exhibition of the Union Centrale des Arts Décoratifs. At the World Exposition in Paris in 1878 the Japanese government, which had a high regard for his unusual techniques, acquired two of his exhibits. In 1888, he turned out his first artefacts in *plique à jour* enamel. He continued to develop enamel technology, eventually producing transparent enamel on metal. Thesmar's work represents a technically perfect, fragile, often dainty version of French Art Nouveau.

Thonet A. G., Gebrüder
Founded 1849 in Vienna
Austrian furniture factory
Michael Thonet (1796–1871), founder of the firm, was extraordinarily gifted as a craftsman, technician, and designer. After a number of years producing traditional furniture, from 1830 he developed new methods of laminating and bending wood. In 1845 production was transferred from Boppard on the Rhine to Vienna. The present-day Thonet company was founded in 1849 in the Gumpendorf district of Vienna under the name of Gebrüder Thonet [Thonet Brothers]. It was not until the last quarter of

the 19th century, however, that the factory started to be truly successful with its serial manufacture of bentwood furniture, in particular its Chair No. 14, which is still produced today. The company also produced furniture to designs by major Jugendstil artists such as Otto Wagner, Adolf Loos and Josef Hoffmann, and thereby made an important contribution to the history of 20th-century furniture design.

Thorn-Prikker, Jan
5.6.1868 The Hague – 5.3.1932 Cologne
Dutch painter and graphic artist
Thorn-Prikker studied at the Academy of Art in The Hague, but in 1904 moved to Germany, where he worked as a church artist. He taught concurrently at art schools in Krefeld, Hagen, Munich, and Düsseldorf, and from 1923 to his death was a professor at the Arts and Crafts School in Cologne. Thorn-Prikker's work consists principally of frescoes and wall-paintings, but he also did painted glass windows, mosaics and *verre églomisé* work. His graphic work reveals similarities to that of the Macdonald sisters.

Tiffany, Louis Comfort
18.2.1848 New York – 17.1.1933 New York
American glass artist, painter, and craftsman
The son of the famous silversmith Charles Lewis Tiffany (1812–1902) studied painting under Georges Innes and Samuel Coleman in New York and under Leon Bailly in Paris. Originally a painter, by 1879 he had already developed an interest in the decorative arts and set up an interior design business in New York. His biggest commission was the renovation of the White House from 1882 to 83. His firm soon went under, however, and Tiffany devoted himself increasingly to glass. In 1885 he founded the Tiffany Glass Company, renamed the Tiffany Studio after 1900. He also founded a glass factory on Long Island in 1892, run by the Englishman Arthur Nash. The first glasses it produced were sent to Samuel Bing in Paris for inclusion in the opening exhibition of his Galerie L'Art Nouveau in 1895. From 1896 production expanded and became more commercial, as a result of which only a very few pieces of glass bore Tiffany's personal signature. From 1892 to 1905 the company also produced furniture, which was heavily decorated with wood mosaics, metal fittings, and glass spheres and was only loosely related to Art Nouveau. In 1902, after the death of his father, Tiffany took over the Tiffany & Co. jeweler's store in New York.
Tiffany became famous for his iridescent decorative glassware (known as Tiffany glass or Favrile glass) and is also well-known for his colorful, floral-shaped glass lampshades. From the Paris World Exposition of 1889 onwards, Tiffany took part in all the major exhibitions in Europe and became a model for many artists working in glass.

Toorop, Jan
(real names Johannes Theodor)
20.12.1858 Purovedyo, Java – 3.3.1928 The Hague
Dutch painter and graphic artist
Toorop's family returned from Java to the Netherlands in 1869, and Toorop studied at the academies in Amsterdam from 1880 to 1881 and in Brussels from 1882 to 1885. From 1886, he was a member of the *Cercle des Vingt* group of artists. He made several visits to London, returning to Netherlands in 1889, where, under the influence of Georges Seurat (1859–91) and James Ensor (1860–1949), he turned out his first pointilliste paintings. Around 1890, impressed by the poetry of Maurice Maeterlinck (1862–1949) and Emile Verhaeren (1855–1916), he became a devotee of Symbolism. In 1905 he converted to Catholicism, and his pictures dealt increasingly with religious subject matter.
Toorop was the main representative of Symbolism in the Netherlands. His Art Nouveau work is characterized by a

sweeping arabesque linearity bearing evidence of the influence of Beardsley.

Tostrup, Olaf
26.5.1842 Christiania (today Oslo) – 21.6.1882
Norwegian goldsmith
Tostrup, son of the engraver and goldsmith Jakob Ulrik Holfedt Tostrup, studied sculpture at the Royal College in Oslo from 1858 to 1862 and at the Academy in Berlin until 1864. He concluded his training with an apprenticeship under a Paris goldsmith (1864) and under Michelsen in Copenhagen (1865). After a number of study trips, including to Vienna (1873) and Paris (1878), he took over his father's workshop. While his works were initially traditional in style, from 1880 they became more modern.

Toulouse-Lautrec, Henri de
24.11.1864 Albi – 9.9.1901 Château Malromé, Gironde
French painter and graphic artist
Toulouse-Lautrec came from an old aristocratic family. Falls in his childhood left him a cripple. From 1880 he trained as a painter, his teachers being Jules Bastien-Lepage (1848–84) and Léon Bonnat (1833–1922). In 1886, he met Émile Bernard (1868–1941) and Vincent van Gogh (1853–90) in Paris for the first time, and he joined forces with them as the École du Petit Boulevard group of artists. Toulouse-Lautrec set himself up in a studio in Montmartre in Paris, where he had easy access to the world of cabaret. In 1889, he had his first shows in the Salon des Indépendants and the Cercle Volney, but his first important poster, the *Moulin Rouge*, came only two years later. In 1895, he became a regular contributor to *La Revue Blanche*, a literary and artistic periodical. On his travels, he became acquainted with Aubrey Beardsley and Oscar Wilde (1854–1900). He died at the early age of 37.
Influenced by Edgar Degas (1834–1917) and Paul Gauguin (1848–1903) and full of enthusiasm for Japanese color wood engravings, Toulouse-Lautrec developed a highly individual, expressive form of art using a very fluid line and flat color surfaces. He drew the maximum artistic effect from color lithography, and his posters had a great influence on poster art throughout Europe. He did over 500 paintings, more than 3,000 drawings and 368 lithographs. Among his principals works are the paintings *The Ball at the Moulin Rouge* (1890) and *In the Salon of the rue Moulin* (1892); the posters *Moulin Rouge* (1890) and *Ambassadeurs. Aristide Bruant dans son Cabaret* (1892); the lithographs *Le Café Concert* (11 prints, 1893), *Yvette Guilbert* (16 prints, 1894 and 1896) and *Mélodies de Désiré* (13 prints, 1895); and the drawings *Au Cirque* (22 prints, published 1905).

Unger (-Holzinger), Else
25.02.1873 Vienna – unknown
Austrian craftswoman and jewelry designer
Unger attended Josef Hoffmann's architecture course at the School of Arts and Crafts in Vienna and showed what was described as a "blue casket" at the 1900 Paris World Exposition as part of a display of exhibits submitted by the School. She also showed jewelry and enamelwork at the 1902 International Exhibition in Turin and the 1904 World Exposition in St. Louis. Unger was a member of the Wiener Kunst im Hause [Viennese Art in the Home] association of interior designers and produced chiefly silver jewelry.

Urania
Established in 1895 in Maastricht
Dutch pewter and metalwork factory
At the turn of the century, Urania was the sole manufacturer of pewter goods in the Netherlands. The models the

company produced were all designed by artists and were all originals. Urania's range of products included untreated, silver-plated and gold-plated metalware and pewterware. The forms of the items the factory produced were very Belgian; one can detect the influence of Victor Horta and Henry van de Velde. Urania's main sales area was Germany, where the company also had stocks of samples in Berlin and in Aachen.

Urban, Josef

25.2.1872 Vienna – 10.7.1933 New York
Austrian architect, craftsman, and stage designer
Urban, who studied under Karl von Hasenauer at the Academy in Vienna, was a founding member and later, from 1906 to 1908, president of the Hagenbund. In 1911 he emigrated to New York. Starting out as a stage designer, from 1918 to 1933 he was principal designer at the Metropolitan Opera. From 1920 he also designed for the movie industry and established close links with the newspaper magnate Randolph Hearst. He built a theater on Broadway for Ziegfeld's troupe, and opened the Wiener Werkstätte's New York offices and showroom on Fifth Avenue, where he also displayed his own designs.

Vallgren, Ville

15.12.1855 Borgå (today Porvoo) – 13.10.1940 Helsinki
Finnish sculptor
Vallgren was a student under Sjöstrand in Helsinki and from 1877 under Cavalier in Paris, where he lived and worked as an artist until 1913. He subsequently returned to Helsinki. His oeuvre includes bronze sculptures, statuettes of nudes in bronze, silver and china, monuments, portrait busts, and the *Havis Amanda* fountain in Helsinki (1904–07). His small, dancing bronze figures embody the *joie de vivre* so typical of Art Nouveau.

Vallin, Eugène

1856 Herbévillier – 1922 Nancy
French architect and *ébéniste*
Vallin trained at the École des Beaux-Arts in Nancy and his uncle's carpentry workshop, which specialised in church fittings. He took over the business in 1891, and at the Exposition des Art Décoratifs in Paris in 1894 was still exhibiting Gothic-style furniture. However, the influence of Émile Gallé changed all that in the following years, turning him into an Art Nouveau artist. His view was that the only adornment a piece of furniture needed was the harmonious interplay of its formal components. In 1896, he designed the great street gateway for Gallé's furniture workshops, and in 1905 he built the aquarium in the park of the present-day museum of the École de Nancy. In his architectural capacity, he pioneered the use of reinforced concrete. Vallin's sons Georges and Auguste (1881–1967) followed in their father's footsteps and became cabinet-makers.

Vallotton, Félix

28.12.1865 Lausanne – 29.12.1925 Paris
Swiss-French painter and graphic artist
Vallotton studied at the Académie Julian and the École des Beaux-Arts in Paris from 1882 to 1885 and initially concentrated on graphics. He illustrated books and worked for *La Revue Blanche* between 1894 and 1903. His woodcuts were also published in *Simplicissimus* from 1896 onwards. From 1900 he channeled his creative energies toward painting. He was friendly with the Nabis group of artists and was on the founding committee of the Salon d'Automne, together with Pierre Bonnard (1867–1947), Édouard Vuillard (1868–1940), Ker-Xavier Roussel (1867–1944) and Charles Cottet (1863– 1925). He was offered a chair at the Académie Ranson in 1908. The First World War prompted his series of woodcuts entitled *C'est la Guerre* [This is war].

Vallotton's drawings and highly expressive woodcuts with their strong contrast of black and white are reminiscent of Aubrey Beardsley. Their popularity was rapidly spread through publication in various periodicals; they were later to exert a major influence on Expressionism in Germany.

Velde, Henry Clemens van de

3.4.1863 Antwerp – 25.10.1957 Zürich
Belgian architect, graphic artist, painter, craft artist, and writer
From 1881 to 1883, van de Velde studied painting at the Academy in Antwerp, and from 1883 to 1885 was a pupil of Durant in Paris. In 1885, he returned to Belgium and in 1889 joined the *Cercle des Vingt* group of artists. His acquaintance with William Finch (1854–1930) and Octave van Rysselberghe familiarized him with English arts and crafts and William Morris's reform movement. In 1890, he had a physical and mental breakdown, and decided to give up painting. Henceforth he devoted himself to the study of architecture and arts and crafts. In 1896, he was among those who fitted out Samuel Bing's Galerie L'Art Nouveau in Paris. His display of furniture at the Dresden Arts and Crafts Exhibition in 1897 was so successful that from 1898 to 1914 he gained many commissions from Germany. In 1898, he established workshops for applied art in Brussels, with a branch in Berlin (1899). In 1902, he was called to Weimar for the establishment of an arts and crafts school, which he directed from 1906 to 1914. In 1907, he was a founder member of the German Werkbund. After visits to Switzerland (from 1917) and the Netherlands (from 1921), he was recalled to Belgium in 1925 to set up the Institut supérieur des Arts décoratifs in Brussels, whose director he became in 1926. He held concurrently a chair at the University of Ghent. His last major commissions were the Belgian pavilions at the world expositions in 1937, 1939, and 1940. In 1947, he retired to Oberärgeri in Switzerland.

Van de Velde was a leading personality in the development of Art Nouveau and things modern. He endeavored to create an individual but contemporary style in architecture and arts and crafts, and opposed the recreation of historical styles. A core principle of his was that form should be appropriate for the function and the material. The range of his work was vast: furniture, utensils, book bindings, graphics, ceramics, interior designs, architecture, and writing. The latter included *Renaissance in Arts and Crafts* (1901), *Lay Sermons on Arts and Crafts* (1902), *Les Formules d'une esthétique moderne* (1925) and the challenging *Le Nouveau Style* (1931). His own house in Uccle near Brussels (1895) is among his principal works, along with the interiors of the Folkwang Museum in Hagen (1900–02), the Werkbund theater in Cologne (1914, demolished 1920), the university library in Ghent (1935–40) and the Kröller-Müller Museum in Otterlo (1936–54).

Vereinte Kunstgewerbler Darmstadt

[Associated Applied Artists of Darmstadt]
Studio for applied art, architecture, painting, and sculpture
The association was formed in 1902 by Alfred Koch, C. F. Meier and Hans Günther Reinstein, all pupils of Peter Behrens. It was active in the spheres of furniture design, ceramics, metalwork, and book illustration.

Vever

Established in Metz in 1831
French jewelry firm
Established in 1831 in Metz by Pierre Vever, the business moved to Paris in 1871, and in 1881 was taken over by Pierre's grandsons Paul (1851–1915) and Henri (1854–1942). The artists that worked for the firm included the designers Eugène Samuel Grasset, Henri Vollet, Lucien Gautrait, the sculptors René Rozet, and the enamelist Étienne Tourette. Vever became – after Lalique – the leading jeweler in Paris, gaining numerous awards for its work and winning the brothers Paul

and Henri Vever the Légion d'Honneur. Henri was also an outstanding author, critic, and historian, publishing in 1908 the standard work on French 19th-century jewelry *La Bijouterie française au XIXe siècle*. The third volume of this contains biographical information on the leading Art Nouveau artists.

Viollet-le-Duc, Eugène Emmanuel

27.1.1814 Paris – 17.9.1879 Lausanne
French architect and writer on art
Viollet-le-Duc was self-taught as an architect, being driven by his enthusiasm for medieval architecture. He restored medieval buildings, including churches and especially great French cathedrals such as Notre Dame in Paris and Ste-Madeleine in Vézelay. This work did much to improve the care of historic monuments in the 19th century, and made Viollet-le-Duc a principle figure of the historicist style. In accordance with his view of a rationalist conception of architecture, he had later additions to the buildings torn down and replaced in the original Gothic form, as for example at Château Pierrefonds from 1859 to 70, an approach which attracted a storm of criticism. In his own, rather insignificant buildings, which were inspired by medieval art, he employed a floral ornamentation that anticipated Art Nouveau. As a theoretical writer, Viollet-le-Duc had a great influence on the development of modern architecture. His work *Dictionnaire raisonné de l'architecture du XIe au XVIe siècle* (10 vols., Paris 1854–) became a manual for the next generation of architects.

Vogeler, Heinrich

12.12.1872 Bremen – 14.6.1942 Kazakhstan
German painter, graphic artist, and craftsman
Vogeler, who studied painting at the Academy in Düsseldorf from 1890 to 1893, moved in 1894 to Worpswede, where he became a pupil of Fritz Mackensen (1866–1953) and Hans am Ende (1864–1918). On a trip to Florence in 1898 he met and became friends with the writer Rainer Maria Rilke (1875–1926) and subsequently received commissions for book illustrations. In 1908, together with his brother, he founded the Worpsweder Workshops, specializing in furniture and furnishings in Tarmstedt. After the First World War he became an adherent of Communism and founded a socialist college on an artistic basis in Worpswede. From 1922 to 1923 he produced his fresco cycle on the class struggle in Germany. In 1931 he emigrated to the Soviet Union, where he had received commissions for agitprop paintings, and produced pictures in the style of Social Realism.

Vogeler's drawings and etchings, together with his designs for book illustrations and applied art (mirrors, lights, cutlery), were influenced by the Pre-Raphaelites and fell within the sphere of Art Nouveau.

Voigt, Otto Eduard

12.3.1870 Dresden – 14.1.1949 Meissen
Modeler and painter
Voigt completed an apprenticeship at Villeroy & Boch in Dresden and from 1890 to 1895 worked as a painter for the KPM Royal Porcelain Factory in Berlin. In 1896 he became a flower painter for the Meissen Royal Saxon Porcelain Factory, where he carried blue painting to new heights and remained an important member of the artistic team until his departure in 1932. He produced large numbers of painterly designs (plants, animals and landscapes) as well as tableware designs.

Voysey, Charles Francis Annesley

28.5.1857 Hessle, Yorkshire – 12.2.1941 Winchester
English architect, graphic artist, and artist-craftsman
Voysey studied architecture with J. P. Seddon at Dulwich College. In 1882 he started working as a freelance architect

and erected country houses in the London area for which he also designed interior furnishings, such as the furniture, wallpaper, textiles, tiles, and various pieces of equipment. He became a member of the Art Workers Guild in 1884 and his work was first exhibited at the Arts and Crafts exhibitions in London in 1893. In 1936 he was given the title Royal Designer for Industry and in 1940 was awarded a gold medal by the Royal Institute of British Architects.

Voysey's simple houses were designed to blend in with their surroundings and display a greater independence from historical styles than most buildings constructed around 1900. This is also true of his other areas of work: his furniture has a stronger leaning toward geometrical form and his metalwork is plainer in design than was usual for his day. Voysey seemed to anticipate the style of the 1920s. His architecture and forms of decoration influenced Charles Rennie Mackintosh and were instrumental in the development of the Modern Style. Voysey's work was copied almost to excess between the two world wars in England.

Wagner, Otto
13.7.1841 Penzing, near Vienna – 11.4.1918 Vienna
Austrian architect
Wagner studied at the Technical College in Vienna from 1857 to 1860 and at the Royal Academy of Architecture in Berlin from 1860 to 1861, and from 1861 to 1863 attended the School of Architecture at the Vienna Academy, where he later himself became a teacher from 1904 to 1912. His first buildings were villas in the style of the Florentine Renaissance. From 1893 he turned away from historicism and called for a new style suited to the needs of the modern day. In other words, he called for a language of form based on considerations of function, material and construction – one of the principles of modern architecture of the 1920s. He expanded his ideas in his book *Moderne Architektur* [Modern architecture] of 1896. His most important buildings in this new style are those for the Vienna Stadtbahn metropolitan railway (1894–1901) and the Austrian Post Office Savings Bank (1904–06).

Wagner was of major significance for the development of architecture around 1900 and a pioneer of modern architecture. His pupils, who included Joseph Maria Olbrich and Josef Hoffmann, developed his ideas even further. Alongside his activities as an architect, Wagner also produced designs for applied art, particularly during his membership of the Vienna Secession (1899–1905), which he left with the Klimt group.

Webb, Philip
12.1.1831 Oxford – 17.4.1915 Worth, Sussex
English architect, interior designer, and artist-craftsman
After an initial period of training in an advertising agency, Webb was taken on by the architect George Edmund Street, where he met his future employer and friend William Morris. In 1856 he started freelance work as an architect in London and from 1859 to 1860 designed The Red House for Morris in Bexley Heath in Kent. In 1862 he became a partner of the newly-founded Morris, Marshall, Faulkner and Company, for whom he designed interior furnishings even after he left the company in 1875. He was later active in the preservation of historical buildings, developing a new technique to help hinder further decay to buildings by filling out the substance of old walls with new building materials.

Webb was a chief representative of the Domestic Revival in England. In his residential buildings and country houses he sought to effect a similarity with the late medieval style without resorting to historicism. He also designed furniture, embroidery, jewelry, glass, carpets, and interior furnishings. Morris owes many of his designs for wallpaper and textiles to Webb.

Weissemburger, Lucien
1860–1929
French architect
Weissemburger started practising as an architect in Nancy in the 1880s. He first attracted attention in 1900, with the building of the Royer printing press in the rue de la Salpêtrière in Nancy. As a result of this, he was commissioned to build the Villa Majorelle in Nancy in 1901. Weissemburger worked mainly in Nancy, commissions including a joint contract with Victor Prouvé for the Anciens Magasins Réunis in 1907 and the Hôtel-Brasserie Excelsior in 1910, which was fitted out by Majorelle.

Wennerberg, Gunnar G:son
1863 – 1914
Swedish painter and glass artist
As the son of the well-known composer Gunnar Wennerberg, who arranged the celebrated University of Uppsala *gluntar* student songs in the 1840s, Gunnar G:son Wennerberg started his career as a portraitist and flower painter. However, it was the animated floral decors which he executed for the Gustavsberg potteries and for Kosta Glasbruk which made his name. In Paris he had encountered the cased glasses of the École de Nancy and hoped to become a Swedish Gallé. His wish was fulfilled. In 1898 he became a designer with Kosta Glasbruk and over the next five years produced numerous cut and etched glasses – stylistically the purest expression of Art Nouveau. In 1908 he went back to Kosta one last time to develop more stylized and ornamented glassware for the 1909 Stockholm exhibition. In 1909 he moved to Paris.

Wennerberg was the most important Swedish glass artist of the turn of the century and won international acclaim.

Whistler, James Abbott McNeill
10.7.1834 Lowel, Massachusetts – 17.7.1903 London
American painter and graphic artist
Whistler studied painting with Charles Gleyre (1806–74) in Paris and moved to London in 1859. He is considered to be the most important portraitist and landscape painter of his era, whereby his etchings and lithographs are also extremely significant. He was also one of the first 19th-century artists to discover colored Japanese woodcuts. He is heralded one of the precursors of Art Nouveau on the basis of his decoration of the Peacock Room for a private client in London (ca. 1876).

Wiener, René
1855 Nancy – 1940
French bookbinder
Wiener came from a bookbinding family, and trained as a printer and gilder. He took up bookbinding only in 1883, working to designs by Victor Prouvé and Camille Martin. His success was international, and he gained commissions from Art Nouveau artists from Nancy, Brussels, and Paris. Around 1900, at the time of the World Exposition in Paris, he suddenly retired, and two years later, after the death of his daughter, gave up his craft altogether.

WMF – Württembergische Metallwarenfabrik
[Württemberg Metalware Factory]
Founded 1853 in Geislingen
German glass, ceramics, and metalware factory
In 1853 Daniel Straub and the Schweitzer brothers founded the Geislingen plated metal factory, producing household utensils of silverplated sheet copper. Following the departure of the Schweitzer brothers, the company merged with the silvering plant A. Ritter & Sohn, before being converted in 1880 into an incorporated society under the name of Württembergische Metallwarenfabrik. In 1883 it opened a glass works in Württemberg and in 1889 also began producing silverplated cutlery services. Small bronze sculptures were added to the product range in 1894. Around 1907, under the influence of Albert Mayer, production shifted to floral Art Nouveau forms, without thereby relinquishing the historicist style. The company commissioned its designs from the best-known German artists of the day, making it a champion of the marriage of art and industry. Still operating successfully today, the company has regularly modernized itself.

Wolfers, Philippe
16.4.1858 Brussels – 13.12.1929 Brussels
Belgian sculptor, craft artist, glass designer, and jeweler
Wolfers studied sculpture under Isidore de Rudder at the Academy in Brussels before entering the workshops of his father, the goldsmith Louis Wolfers (1820–92) in 1875. From 1880, he designed silver work and jewelry in a neo-Rococo style. His work during the 1880s reveals the influence of naturalism and Japanese art. In 1897, he went over exclusively to jewelry work, and at the International Exposition in Brussels exhibited pieces in ivory, a material that no one had worked with before. Around 1900, he opened branches of his jewelry business in Antwerp, Liège, Ghent, Budapest, Düsseldorf, London, and Paris. After 1910, his style became much more geometric, a tendency that had become quite dominant by the time he came to design the Salon for the Paris Arts and Crafts Exhibition in 1925, where every detail was designed by him: furniture, curtains, carpets, porcelain, and equipment. This was the apogee and at the same time the finale of his artistic career.

Wolfers's success is comparable with that of Lalique, and was of great importance for the entire art of Art Nouveau jewelry. His gold work, which is imbued with Symbolism and uses expensive materials, displays a degree of luxury that mirrors the Decadent consciousness of his time. From 1897 to 1905, he made a whole series of pieces consisting of 109 individual items, and was represented at numerous international exhibitions during the period. Alongside his work as a crafter of jewelry, he did glassware designs, among others for the leading glass manufacturer in Belgium, Val-Saint-Lambert. After 1908, he became more interested in sculpture.

Wright, Frank Lloyd
8.6.1869 Richland Center, Wisconsin – 9.4.1959 Phoenix, Arizona
American architect and applied artist
After studying at the University of Wisconsin in Madison (1885–87), from 1888 Wright worked for the architects Adler & Sullivan in Chicago, where from 1890 he was responsible for all housing designs. In 1893 he left Adler & Sullivan and opened his own office in Chicago. The Japanese Pavilion at the World's Columbian Exposition in Chicago that same year aroused his admiration for Japanese architecture. He became a passionate collector of Japanese prints. In 1905 he made his first trip to Japan and in 1906 organized an exhibition of his Hiroshige prints at the Art Institute of Chicago.

In 1909 and 1910 he traveled to Berlin and collaborated on the book *Ausgeführte Bauten und Entwürfe* [Executed buildings and designs] published by Wasmuth. In 1913 he was back in Japan to finalize the contract for the Imperial Hotel. In 1915 he subsequently opened an office in Tokyo, where his extended stay proved a turning point in his work. After his return to Chicago, he published a number of essays, including "Modern Architecture" (1931), and gave lectures at the university. In 1931 an exhibition on his work was staged in New York, Amsterdam, Berlin, Frankfurt, Brussels, Milwaukee, Eugene, and Wisconsin. In 1932 he established the Taliesin community in Wisconsin, where he withdrew from the public eye. Up till 1940 he worked chiefly as a teacher

and theoretician, after which he again accepted numerous commissions.

Wright was a student of Sullivan and, in line with the latter's thesis that "form follows function", built houses whose forms arise out of their function, material, construction and – not least – their natural setting. A good example of the close relationship established between his houses and their environment can be seen in his Prairie Houses, as they are known – low buildings with flat roofs, built of wood and stone, combined with sweeping terraces and gardens. Wright was very much an isolated phenomenon in his own day, but his influence upon the development of numerous movements in architecture was significant. Since 1910 his writings and buildings have formed a standard part of the curriculum for all modern architects. His major works include Prairie Houses such as the Winslow House in River Forest, Illinois (1893) and the W. R. Heath House in Buffalo (1905), the Imperial Hotel in Tokyo (1916–20), the administrative building for the Johnson Wax Co. in Racine, Wisconsin (1936–39), Falling Water House, built over a waterfall in Bear Run, Pennsylvania (1937–39), and the Guggenheim Museum in New York (1956–59, designed 1943).

Zitzmann, Friedrich
19.9.1840 Steinach, Thuringia – 20.2.1906 Wiesbaden
German glassmaker
Zitzmann spent a number of years working in the glass factories on Murano, near Venice. In the years around 1890, he produced ornamental glasses executed in the Murano technique in a historicist style, which were displayed primarily in the Bayerischer Kunstgewerbeverein [Bavarian Applied Arts Association] in Munich. As a consequence of his collaboration with Karl Koepping in Berlin (1895–96), he refined his technique. Drawing without permission upon Koepping's designs, he produced and sold stylized glasses in vegetal forms, leading to a dispute with Koepping and to the end of their collaboration after just a few months. Koepping's influence was still evident in his work even after their split, however. In 1897 Zitzmann showed iridescent glassware at the Munich Glass Palace exhibition and became a member of the Bavarian Applied Arts Association. He also taught glass-blowing at various colleges.

Zsolnay
Founded 1862 in Pécs
Hungarian ceramics factory
In 1865 Vilmos Zsolnay (1828–1900) took over the ceramic works which his brother, Ignaz Zsolnay, had founded in 1862 in Pécs. The company developed new iridescent and luster techniques, and above all metallic lusterware in various shades. It was best-known for its large vases with a colorful luster effect, decorated with scenes from *Grimm's Fairy Tales*. Zsolnay was one of the best-known ceramics factories of the period around 1900, and won many prestigious awards. After the death of Vilmos Zsolnay in 1900, his son Miklos (1857–1922) took over the running of the firm, which continued to be successful into the 1920s. In 1949 it passed into state ownership and was renamed the Porzelángyár Pécs.

Zumbusch, Ludwig von
17.7.1861 Munich – 28.2.1927 Munich
German painter and graphic artist
Ludwig von Zumbusch, son of the sculptor Kaspar von Zumbusch, studied under Wilhelm von Lindenschmit (1829–95) at the Academy in Munich and under Adolphe William Bouguereau (1825–1905) and Robert-Fleury at the École des Beaux-Arts in Paris. In Munich he worked as a graphic artist and was one of the first contributors to the magazine *Jugend*. His oeuvre consists chiefly of portraits, in particular of children, as well as scenes of children and delicate pastel landscapes.

Zwollo, Frans (senior)
4.4.1872 Amsterdam – 1945 Amsterdam
Dutch gold and silversmith
Zwollo was an apprentice at the firm of Bonebakker in Amsterdam, where his father was artistic director, but he also went to drawing classes at the local art school. He acquired further training as a goldsmith in Paris and Brussels. In 1897 he settled in Amsterdam as a goldsmith, initially designing articles in a Louis Quatorze style, mainly for Bonebakker. In time, he shook off these constraints and designed jewelry, lighting, and appliances with decorative elements in a floral Art Nouveau style. From 1910, his style was pervaded by straight lines, and his decoration became more geometric. He took part in sundry exhibitions from 1900, winning a gold medal in Turin in 1902. Production remained very homogeneous right up to the end of the Second World War, continuing to be influenced by Zwollo's earliest work.

Bibliographical references

Adriani Götz. *Toulouse-Lautrec – Das gesamte graphische Werk.* Cologne, 1976.

Agate, May. *Madame Sarah.* New York, 1969.

Ahlers-Hestermann, Friedrich. *Stilwende – Aufbruch der Jugend um 1900.* Berlin, 1941.

Ahlers-Hestermann, Friedrich. *Bruno Paul, oder: die Wucht des Komischen.* Berlin, 1960.

Alexandre, Arsène. *Jean Carriès – imagier et potier.* Paris, 1895.

Alexandre, Arsène. *Puvis de Chavannes.* London – New York, 1905.

Altenberg, Peter. *Vita Ipsa.* Berlin, 1918.

Amaya, Mario. *Art Nouveau.* London – New York, 1966.

Anscombe, I. and C. Gere. *Arts and Crafts in Britain and America.* London, 1978.

Apollonio, Umbro. *Der Futurismus* [Futurism]. Cologne, 1972.

Arnold, Matthias. *Edvard Munch.* Hamburg, 1986.

Ashbee, Charles Robert. *A Short History of the Guild and School of Handicraft.* London, 1890.

Ashbee, Charles Robert. *Craftsmanship in Competitive Industry.* London, 1908.

Ashbee, Charles Robert. *Frank Lloyd Wright – Eine Studie zu seiner Würdigung* [A study in his honor]. Berlin, 1911.

Bahr, Hermann. *Secession.* Vienna, 1900.

Bahr, Hermann. *Rede über Klimt.* Vienna, 1901.

Bairata, E. and D. Riva. *Giuseppe Sommaruga.* Milan, 1982.

Bajot, Edouard. *L'Art Nouveau – Décoration et Ameublement.* Paris, 1898.

Bangert, Albrecht. *Thonet-Möbel.* Munich, 1979.

Bangert, Albrecht. *Jugendstil – Art Déco, Schmuck und Metallarbeiten.* Munich, 1981.

Bangert, Albrecht and Gabriele Fahr-Becker. *Jugendstil – Möbel und Glas, Schmuck und Malerei.* Munich, 1992.

Bangert, Albrecht and Gabriele Sterner. *Jugendstil – Art Déco.* Munich, 1979.

Barati, E., R. Bossaglia, R. and M. Rosci. *L'Italia Liberty.* Milan, 1973.

Barloewen, Constantin von and Kai Werhahn-Mees (eds.). *Japan und der Westen.* 3 vols, Frankfurt/Main, 1986.

Barten, Sigrid. *René Lalique – Schmuck und Objets d'art.* Munich, 1978.

Bassegoda Nonell, Juan. *Domènech i Montaner.* Barcelona, 1981.

Baudelaire, Charles. *Les Fleurs du mal.* Paris, 1857.

Baudelaire, Charles. *Oeuvres Posthumes.* Paris, 1908. In *Journaux Intimes.* Edited by Adolphe van Bever. Paris, 1920.

Bauer, Roger (ed.). *Fin de siècle – Zur Literatur und Kunst der Jahrhundertwende.* Frankfurt/Main, 1977.

Bayard, Emile. *Le Style moderne – L'Art reconnaître les styles.* Paris, 1919.

Behrendt, Walter. *Der Kampf um den Stil in Kunstgewerbe und Architektur.* Berlin, 1920.

Behrens, Peter. *Feste des Lebens und der Kunst.* Jena, 1900.

Bell, Malcolm. *Sir Edward Burne-Jones – A Record and a Review.* London, 1892.

Benevolo, Leonardo. *Geschichte der Architektur des 19. und 20. Jahrhunderts* (History of 19th- and 20th-century Architecture). 2 vols, Munich, 1978.

Berlage, Hendrik Petrus. *Gedanken über den Stil in der Baukunst* [Thoughts on style in architecture]. Leipzig, 1905.

Bernard, Sacha. *A l'ombre de Marcel Proust.* Paris, 1978.

Bertsch, Georg C., Matthias Dietz and Barbara Friedrich. *Euro-Design-Guide.* Munich, 1991.

Bierbaum, Otto Julius. *Stuck.* Bielefeld – Leipzig, 1899.

Bing, Samuel. *Japanischer Formenschatz.* Hamburg, 1989.

Bjerke, Øivind Storm. *Harald Sohlberg – En Somhetens Maler.* Viborg, 1991.

Blaser, Werner. *Furniture as Architecture – Architektur im Möbel.* Zürich, 1985.

Blount, Berniece and Henry Blount. *French Cameo Glass.* Des Moines, 1967.

Boccioni, Umberto. *Bildnerischer Dynamismus* [Visual dynamism]. Milan, 1913.

Boccioni, Umberto. *Futuristische Malerei und Skulptur* [Futuristic painting and sculpture]. Milan, 1914.

Bohigas, Oriol. *Arquitectura modernista.* Barcelona, 1968.

Borisowa, Helena A. and Grigori J. Sternin. *Jugendstil in Rußland.* Stuttgart, 1988.

Borsi, Franco. *Bruxelles 1900.* Brussels, 1979.

Borsi, Franco and E. Godoli. *Paris 1900.* Brussels, 1976.

Borsi, Franco and Paolo Portoghesi. *Victor Horta.* Rome – Bari, 1982.

Bott, Gerhard. *Jugendstil in Darmstadt um 1900.* Darmstadt, 1962.

Bott, Gerhard (ed.). *Von Morris zum Bauhaus – Eine Kunst gegründet auf Einfachheit.* Hanau, 1977.

Bott, Gerhard (ed.). *The German Werkbund – The Politics of Reform in the Applied Arts.* Princeton, 1978.

Boutet, Frédéric. *Seltsame Masken* (Strange Masks). Munich, 1913.

Brandstätter, Christian. *Buchumschläge des Jugendstils.* Dortmund, 1981.

Brandy-Jones, John. *C. F. A. Voysey – Architect and Designer 1857–1941.* London, 1987.

Breicha, Otto and Gerhard Fritsch (eds.). *Finale und Auftakt, Wien 1898–1914.* Salzburg, 1964.

Bröhan, Torsten. *Glaskunst der Moderne.* Munich, 1992.

Brühl, Georg. *Jugendstil in Chemnitz – Die Villa Esche von Henry van de Velde.* Munich, 1991.

Brunhammer, Yvonne, K. Bussman, K. Koch and R. Koch. *Hector Guimard – Architektur in Paris um 1900.* Münster, 1975.

Buchanan, William (ed.). *Mackintosh's Masterwork – The Glasgow School of Art.* Glasgow, 1989.

Buchert, Josephe. *Fleurs de fantaisie.* Paris, n.d.

Buchheim, Lothar Günther. *Jugendstilplakate.* Feldafing, 1969.

Buddensieg, T. and H. Rogge. *Industrie Kultur – Peter Behrens und die AEG 1907–1914.* Berlin, 1979.

Carrigan, Kristine O. *Ruskin on Architecture – His Thought and Influence.* Madison, 1973.

Champigneulle, Bernard. *Art Nouveau.* New York, 1976.

Cirici Pellicer, A. *El Arte Modernista Catalan.* Barcelona, 1951.

Clouzot, Henri. *Daum verrerie d'art.* Nancy, 1930.

Conrad, Michael Georg, Anna Crossant-Rust and Hans Brandenburg (eds.). *Otto Julius Bierbaum zum Gedächtnis. Festschrift.* Munich, 1912.

Conrads, Ulrich. *Programme und Manifeste zur Architektur des 20. Jahrhunderts.* Berlin – Frankfurt/Main – Vienna, 1964.

Cook, Theodore A. *The Curves of Life.* New York, 1914.

Cousin, Victor. *Cours de philosophie.* Collected lectures, published in Paris from 1826.

Crane, Walter. *Linie und Form* [Line and Form]. Leipzig, 1901.

Cremona, Italo. *Die Zeit des Jugendstils* [The Art Nouveau era]. Munich – Vienna, 1966.

Curtius, Ernst Robert. *Französischer Geist im 20. Jahrhundert.* Marburg, 1952.

D'Annunzio, Gabriele. *Lust.* Zürich, 1994.

Dauberville, Jean and Henry Dauberville. *Bonnard – catalogue raisonné de l'oeuvre peint.* Paris, 1965.

Davey, Peter. *Architecture in the Arts and Crafts Movement.* New York, 1980.

Dehmel, Richard. *Ausgewählte Briefe 1883–1902.* Berlin, 1923.

Dewiel, Lydia. *Schmuck vom Klassizismus bis zum Art Déco.* Munich, 1979.

Dierkens-Aubry, Françoise. *Hortamuseum.* Tielt, 1990.

Dierkens-Aubry, Françoise and Jos Vandenbreeden. *Jugendstil in Belgien – Architektur und Interieurs* [Art Nouveau in Belgium]. Tielt, 1994.

Donelly, Marian C. *Architecture in the Scandinavian Countries.* London, 1922.

Dortu, M. G. *Toulouse-Lautrec et son oeuvre.* New York, 1971.

Drexler, Arthur. *The Architecture of Japan.* New York, 1955.

Duncan, Alastair. *Lampen Lüster Leuchter – Jugendstil Art Déco* [Lamps Chandeliers Lighting]. Munich, 1979.

Duncan, Alastair and Georges de Bartha. *Jugendstil und Art Déco – Bucheinbände*. Munich, 1989.

Eckmann, Otto. *Neue Formen – Dekorative Entwürfe für die Praxis*. Berlin, 1897.

Endell, August. *Um die Schönheit – Eine Paraphrase über die Münchener Kunstausstellung 1896*. Munich, 1896.

Engen, Luc de. *Le Verre en Belgique – Des origines à nos jours*. Antwerp, 1989.

Eschmann, Karl. *Jugendstil – Ursprünge, Folgen*. Herm, 1976.

Faber, Tobias. *Dansk Arkitektur*. Copenhagen, 1977.

Fahr-Becker, Gabriele. *Wiener Werkstätte 1903–1932* (English edition). Cologne, 1995.

Falk, Fritz. *Europäischer Schmuck vom Historismus biz zum Jugendstil*. Königsbach-Stein, 1985.

Fiell, Charlotte and Peter Fiell. *Charles Rennie Mackintosh*. Cologne, 1995.

Fierens, Paul. *La Tristesse contemporaine*. Paris, 1924.

Fischer, Wolfgang Georg. *Gustav Klimt und Emilie Flöge*. Vienna, 1987.

Flaubert, Gustave. *Salammbô*. Paris, 1862.

Fliedel, Gottfried. *Gustav Klimt*. Cologne, 1991.

Flögl, Mathilde (ed.). *Die Wiener Werkstätte 1903–1928, Modernes Kunstgewerbe und sein Weg*. Silver Jubilee issue, Vienna, 1929.

Fontainas, André. *Mes souvenirs du Symbolisme*. Paris, 1924.

Ford, Richard. *Handbook for Travellers in Spain*. London, 1845.

Fraipont, G. *La Fleur et ses applications décoratives*. Paris, n.d.

Frank, Josef. *Zu Josef Hoffmanns 60. Geburtstage*. Ed by Österreichischen Werkbund, Vienna, 1930.

Frey, D. *Englisches Wesen in der bildenden Kunst*. Stuttgart – Berlin, 1942.

Friedell, Egon. *Jubilee issue celebrating 25 years of the Wiener Werkstätte*. Vienna, 1928.

Frottier, Elisabeth. *Michael Powolny – Keramik und Glas aus Wien 1900–1950*. Vienna – Cologne, 1990.

Fuller, Loïe. *Quinze ans de ma vie*. Paris, 1908.

Gallé, Émile. *Notice sur la production du Verre*. Nancy, 1884.

Gallé, Émile. *Ecrits pour l'Art, 1884–1889*. Edited by Henriette Gallé-Grimm, Paris, 1909.

Garner, Philippe. *Emile Gallé*. Munich, 1979.

Garner, Philippe. *Jugendstil-Glas*. Dortmund, 1981.

Gasser, Manuel. *München um 1900*. Berne, 1977.

George, Stefan. *Werke*. Ed. by Helmut Küpper, 2 vols, Munich, 1958.

George, Stefan. *Der Dichter und sein Kreis*. Marbach, 1968.

Geretsegger, H. and M. Peintner. *Otto Wagner*. Salzburg – Vienna, 1964.

Gide, André (ed.). *Anthologie de la Poésie Française*. Paris, 1949.

Gilot, Françoise. *Leben mit Picasso* [Life with Picasso]. Munich, 1965.

Goethe, Johann Wolfgang von. *Maximen und Reflexionen*. Frankfurt/Main, 1840.

Graf, Hansjörg (ed.). *Der kleine Salon*. Stuttgart, 1970.

Grasset, Eugène Samuel. *La Plante et ses applications ornamentales*. Paris, 1897–99.

Graul, Richard. *Die Krisis im Kunstgewerbe*. Leipzig, 1901.

Gravagnuolo, Benedetto. *Adolf Loos – Theory and Works*. New York, 1982.

Gresleri, Giuliano. *Josef Hoffmann*. Bologna – New York, 1985.

Gropius, Tange, Ishimoto. *Katsura – Tradition and Creation in Japanese Architecture*. New Haven, 1960.

Grover, Ray and Lee Grover. *Art Glass Nouveau*. Rutland, Vermont, n.d.

Guerrand, Roger Henri. *L'Art Nouveau en Europe*. Paris, 1967.

Günther, Sonja. *Intérieurs um 1900*. Munich, 1971.

Günther, Sonja. *Josef Hoffman 1870–1956*. Karlsruhe, 1972.

Gurlitt, Cornelius. *Im Bürgerhaus*. Dresden, 1887.

Gysling-Billeter, Erika. *Objekte des Jugendstils*. Berne, 1975.

Haack, Friedrich. *Grundriss der Kunstgeschichte – Die Kunst des XIX. Jahrhunderts*. Esslingen am Neckar, 1904.

Haan, Hilde de and Ids Haagsma. *Architects in Competition – International Architectural Competitions of the last 200 Years*. London, 1988.

Haeckel, Ernst. *Kunstformen der Natur*. Leipzig – Vienna, 1899–1904.

Haftmann, Werner. *Malerei im 20. Jahrhundert*. Munich, 1954.

Hahn-Woernle, Birgit. *Bernhard Pankok*. Stuttgart, 1973.

Halbe, Max. *Jahrhundertwende*. Munich, 1926.

Hamann, Richard and Jost Hermand. *Stilkunst um 1900*. Berlin, 1967.

Hård af Segerstad, Ulf. *Skandinavische Gebrauchskunst*. Stockholm – Frankfurt/Main, 1961.

Harris, Margaret. *Loïe Fuller*. Richmond, 1979.

(Hartwig, Josef), no author. *Leben und Meinungen des Bildhauers Josef Hartwig*. Frankfurt/Main, 1955.

Hase, Ulrike von. *Schmuck in Deutschland und Österreich, 1895–1941*. Munich, 1977.

Hausen, Marika, Kirmo Mikkola, Anna-Lisa Amberg and Tyttii Vatto. *Eliel Saarinen – Projects 1896–1923*. Hamburg, 1990.

Heinmann, Fritz. *Symbolische Kunst*. Dissertation, Berlin, 1926.

Heise, Carl G. *Die Kunst des 20. Jahrhunderts – Malerei, Plastik, Raum, Gerät*. Munich, 1957.

Henderson, Philip. *William Morris – His Life, Work and Friends*. London, 1967.

Henning-Schefold, Monika. *Struktur und Dekoration*. Winterthur, 1969.

Hermand, Jost. *Jugendstil/Art Nouveau – research report 1918–1964*. Stuttgart, 1965.

Hevesi, Ludwig. *Acht Jahre Sezession (März 1897–Juni 1905) – Kritik, Polemik, Chronik*. Vienna, 1906.

Hevesi, Ludwig. *Altkunst – Neukunst*. Vienna, 1909.

Hillman, James. *Der Mythos der Analyse* [The myth of analysis]. Frankfurt/Main, 1972.

Himmelheber, Georg. *Die Kunst des deutschen Möbels. Vol. 3: Klassizismus – Historismus – Jugendstil*. Munich, 1973.

Hocke, Gustav René. *Die Welt als Labyrinth*. Reinbek, Hamburg, 1961.

Hoeber, Fritz. *Peter Behrens*. Munich, 1913.

Hoffmann, Josef. *Arbeitsprogramm der Wiener Werkstätte*. Vienna, 1905.

Hofmann, Jacqueline and Werner Hofmann (eds.). *Wien*. Vienna – Munich, 1956.

Hofmann, Werner. *Von der Nachahmung zur Erfindung der Wirklichkeit – Die schöpferische Befreiung der Kunst 1890–1917*. Cologne, 1970.

Hofstätter, Hans Hermann. *Geschichte der europäischen Jugendstilmalerei*. Cologne, 1963.

Hofstätter, Hans Hermann. *Jugendstil – Druckkunst (printed art)*. Baden-Baden, 1973.

Hofstätter, Hans Hermann. *Aubrey Beardsley – Zeichnungen (drawings)*. Cologne, 1977.

Hofstätter, Hans Hermann. *Symbolismus und die Kunst der Jahrhundertwende*. Cologne, 1978.

Hollamby, Edward. *Red House – Architecture in Detail*. Harlow, 1991.

Hollander, Hans. *Musik und Jugendstil*. Zürich, 1975.

Howarth, Thomas. *Charles Rennie Mackintosh and the Modern Movement*. London, 1952.

Hutter, Heribert. *Jugendstil*. Vienna, 1965.

Huysmans, Joris-Karl. *A rebours*. Brussels, 1884. (Engl. edn?)

Jaffé, Hans. *Piet Mondrian*. Cologne, 1971.

Jencks, Charles. *Le Corbusier and the Tragic View of Architecture*. London, 1973.

Jones, Owen. *Grammar of Ornament*. London, 1918.

Jørgensen, Lisbet Balslev. *Danmarks Arkitektur*. Copenhagen, 1979.

Jost, Dominik. *Literarischer Jugendstil*. Stuttgart, 1980.

Joyant, Maurice. *Henri de Toulouse-Lautrec 1864–1901, Peintre*. Paris, 1926.

Juyot, Paul. *Louis Majorelle – Artiste Décorateur, Maître ébéniste*. Nancy, 1926.

Kemp, W. *John Ruskin – Leben und Werk* [Life and work]. Munich, 1983.

Kessler, Harry Graf. *Gesichter und Zeiten*. Berlin, 1935.

Kessler, Harry Graf. *Aus den Tagebüchern*. Frankfurt/Main, 1965.

Klee, Paul. *Tagebücher (diaries) 1889–1918*. Ed. by Felix Klee, Cologne, 1957.

Knipping, J. B. *Jan Toorop*. Amsterdam, 1947.

Koch, Robert. *Louis C. Tiffany – Rebel in Glass*. New York, 1964.

Kolbe, Jürgen. *Heller Zauber – Thomas Mann in München 1894–1933*. Munich, 1987.

Kornwolf, James D. *M. H. Baillie Scott and the Arts and Crafts Movement*. Baltimore, 1972.

Kubly, Vincent Frederick. *Thomas Theodor Heine 1867–1948, The Satirist as an Artist*. Dissertation, Wisconsin, 1969.

Kühnel, Ernst. *Die Arabeske*. Wiesbaden, 1949.

Kurrent, Friedrich. *Das Palais Stoclet*. Salzburg, 1991.

Lanoux, Armand. *Amour 1900*. Hamburg, 1964.

Le Corbusier. *Vers une architecture*. Paris, 1958.

Legrand, Francine-Claire. *Le Symbolisme en Europe*. Brussels, 1971.

Lehner, Margot. *Als München noch leuchtete*. Munich, 1978.

Leistikow, Walter. *Moderne Kunst in Paris*. N.p., n.d.

Lenning, Henry F. *Julius Meier-Graefe*. New York, 1942.

Lenning, Henry F. *Art Nouveau*. The Hague, 1951.

Lessing, Julius. *Berichte von der Pariser Weltausstellung 1878*. N.p., 1878.

Lichtwark, Alfred. *Briefe an die Kommission für die Verwaltung der Kunsthalle*. Ed. by Gustav Pauli, Hamburg, 1923.

Loos, Adolf. *Ornament und Verbrechen*. Vienna, 1908.

Loos, Adolf. *Ins Leere gesprochen 1897–1900*. Innsbruck, 1931.

Loos, Adolf. *Trotzdem 1900–1930*. Sammlung der Dokumente des Kampfes. Innsbruck, 1931.

Loos, Adolf. *Sämtliche Schriften* [collected works]. Edited by Franz Glück, 2 vols, Vienna – Munich, 1962.

Lüthi, Max. *Das europäische Volksmärchen*. Berne, 1947.

Lux, Joseph August. *Die moderne Wohnung und ihre Ausstattung*. Vienna, 1905.

Mackay, James. *Kunst und Kunsthandwerk der Jahrhundertwende* [Fin-de-siècle art & crafts]. Munich, 1975.

Madsen, Karl. *Japansk Malerkunst*. Copenhagen, 1885.

Madsen, Karl. *Thorvald Bindesbøll*. Copenhagen, 1943.

Madsen, Stephan Tschudi. *Sources of Art Nouveau*. Oslo, 1956.

Madsen, Stephan Tschudi. *Jugendstil – Europäische Kunst der Jahrhundertwende*. Munich, 1967.

Mann, Golo. *Der letzte Großherzog*. Darmstadt, 1977.

Mann, Thomas. *Gladius Dei*. Munich, 1902.

Mann, Thomas. *Betrachtungen eines Unpolitischen*. Munich, 1918.

Marchlewski, Julian. *Sezession und Jugendstil – Kritiken um 1900*. Dresden, 1974.

Martin, Timo and Douglas Sivén. *Akseli Gallen-Kallela*. Helsinki, 1984.

Martinell, César. *Gaudí – His Life, His Theories, His Work*. Barcelona, 1975.

Masini, Lara Vinca. *Art Nouveau*. Florence, 1976.

Maurois, André. *Engländer (Les Anglais?)*. Munich, 1933.

McKean, Hugh F. *Louis Comfort Tiffany*. Weingarten, 1981.

Meier-Graefe, Julius. *Die Weltausstellung in Paris 1900*. Paris – Leipzig, 1900.

Meier-Graefe, Julius. *Entwicklungsgeschichte der modernen Kunst – Vergleichende Betrachtung der bildenden Künste zu einer neuen Ästhetik*. 3 vols, Stuttgart, 1904.

Meier-Graefe, Julius. *Die doppelte Kurve – Essays*. Berlin, 1924.

Mendelsohn, Erich. *Das Problem einer neuen Baukunst*. Berlin, 1919.

Miyake, Riichi. *Stile Liberty and Orientalism*. Tokyo, 1988.

Miyake, Riichi. *Ein Streifzug durch den europäischen Jugendstil*. Dortmund, 1991.

Moorhouse, Jonathan. *Helsinki Jugendstil Architecture 1895–1915*. Helsinki, 1987.

Morris, William and Sir Edward Burne-Jones. *Ornamentation and Illustrations from the Kelmscott Chaucer*. New York, 1973.

Mucha, Alfons. *Drei Äußerungen zum Leben und Werk* [Three statements on his life and work]. Brno, 1936.

Mucha, Jiri. *Alfons Mucha – His Life and Art*. London, 1966.

Müller, Albin. *Aus meinem Leben*. Manuscript (typed), Darmstadt, n.d. (ca. 1940).

Müller, Dorothee. *Klassiker des modernen Möbeldesign*. Munich, 1980.

Musil, Robert. *Der Mann ohne Eigenschaften* [The man without qualities]. Hamburg, 1952.

Musil, Robert. *Tagebücher (Diaries)*. Ed. by Adolf Frisé, Reinbek, Hamburg, 1976.

Muther, Richard. *Geschichte der Malerei im 19. Jahrhundert*. 3 vols, Munich, 1893–94.

Muthesius, Hermann. *Das Englische Haus*. Berlin, 1904.

Muthesius, Hermann. *Kunstgewerbe und Architektur*. Jena, 1907.

Naumann, Friedrich. *Deutsche Gewerbekunst*. Berlin, 1908.

Nebehay, Christian M. *Gustav Klimt – Sein Leben nach zeitgenössischen Berichten und Quellen*. Munich, 1976.

Nebehay, Christian M. *Egon Schiele – Von der Skizze zum Bild. Die Skizzenbücher* (The Sketchbooks). Vienna – Munich, 1989.

Neumeister, Erdman. *Thomas Mann*. Bonn, 1972.

Neuwirth, Waltraud. *Das Glas des Jugendstils – Sammlung des Österreichische Museums für angewandte Kunst, Wien*. Vienna, 1973.

Neuwirth, Waltraud. *Österreichische Keramik des Jugendstils*. Vienna, 1974.

Neuwirth, Waltraud. *Wiener Werkstätte – Avantgarde, Art Déco, Industrial Design*. Vienna, 1984.

Nietzsche, Friedrich. *Also sprach Zarathustra*. Ed. by Karl Schlechta, Munich, 1955.

Noever, Peter and Oswald Oberhuber (eds.). *Josef Hoffmann – Ornament zwischen Hoffnung und Verbrechen*. Vienna, 1987.

Obrist, Hermann. *Zweckmäßig oder Phantasievoll*. Munich, 1901.

Obrist, Hermann. *Neue Möglichkeiten in der bildenden Kunst*. Leipzig, 1903.

Oeser, Hermann. *Von Menschen, von Bildern und Büchern*. Heilbronn, 1922.

Olbrich, Joseph Maria. *Ideen von Olbrich*. Vienna, 1900.

Osthaus, Karl Ernst. *Leben und Werk*. Recklinghausen, 1971.

Ottomeyer, Hans. *Jugendstilmöbel – Möbelsammlung des Müncher*. Munich, 1988.

Pabst, Michael. *Wiener Grafik um 1900*. Munich, 1984.

Palau i Fabre, Josep. *Picasso – Kindheit und Jugend eines Genies, 1881–1907* [Childhood and youth of a genius]. Munich, 1981.

Paley, Morton O. *William Blake*. London, 1978.

Pane, Roberto. *Antoni Gaudi*. Milan, 1982.

Panofsky, Erwin. *Meaning in the Visual Arts*. New York, 1955.

Paret, P. *Die Berliner Secession – Moderne Kunst und ihre Feinde im Kaiserlichen Deutschland*. Berlin, 1981.

Pazaurek, Gustav Edmund. *Kunstgläser der Gegenwart*. Leipzig, 1925.

Pelichet, Edgar. *La Céramique Art Nouveau*. Lausanne, 1976.

Pevsner, Nikolaus. *Charles Rennie Mackintosh*. Milan, 1950.

Pevsner, Nikolaus. *Pioneers of Modern Design*. New York, 1949.

Polak, Ada. *Modern Glass*. London, 1962.

Polak, Bettina. *Het fin-de-siècle in de Nederlandse schilderkunst – de symbolistische beweging 1890–1900*. The Hague, 1955.

Pope, Alexander. *Miscellanies*. London, 1728.

Portoghesi, Paolo. *Hôtel van Eetvelde, Brussels 1894–1901*. Tokyo, 1977.

Posener, Julius. *Anfänge des Funktionalismus*. Berlin – Frankfurt/Main – Vienna, 1964.

Posener, Julius. *Berlage und Dudok*. Lecture in *48 Arch+*, Aachen, 1979.

Posener, Julius. *Frank Lloyd Wright I – Vorlesungen zur Geschichte der Neuen Architektur*. In *48 Arch+*, special issue on 75th birthday of Julius Posener, Aachen, 1979.

Posener, Julius. *Otto Wagner – Die Rolle Hans Poelzigs vor 1918. Vorlesungen zur Geschichte der Neuen Architektur II – Die Architektur der Reform (1900–1924)*. In *53 Arch+*, Aachen, 1980.

Posener, Julius. *Jugendstil*. Lecture in *59 Arch+*, Aachen, 1981.

Posener, Julius. *Vorlesungen zur Geschichte der Neuen Architektur III*. Includes *Peter Behrens I, Charles Rennie Mackintosh – Das englische Landhaus, William Morris und die Folgen*. In *59 Arch+*, Aachen, 1981.

Proust, Marcel. *A la recherche du temps perdu*. Paris, 1913–27.

Rathke, Ewald. *Jugendstil*. Frankfurt, 1958.

Reade, Brian. *Aubrey Beardsley*. Stuttgart, 1969.

Rheims, Maurice. *The Flowering of Art Nouveau*. New York, 1966.

Richards, James M. and Nikolaus Pevsner (eds.). *The Anti-Rationalists*. London, 1973.

Ridder, André de. *George Minne*. Antwerp, 1947.

Rief, Hans H. *Heinrich Vogeler – Das graphische Werk*. Bremen, 1974.

Rilke, Rainer Maria. *Über Kunst*. Munich, 1898.

Rilke, Rainer Maria. *Worpswede*. Bielefeld – Leipzig, 1903.

Rochowanski, Leopold Wolfgang. *Der Formwille der Zeit in der angewandten Kunst*. Vienna, 1922.

Rochowanski, Leopold Wolfgang (ed.). *Agathon – Almanach auf das Jahr 48 des 20. Jahrhunderts*. Vienna, 1947.

Rochowanski, Leopold Wolfgang. *Josef Hoffmann*. Vienna, 1950.

Rosenhagen, Hans. *Münchens Niedergang als Kunststadt*. Munich, 1902.

Rousseau, Jean-Jacques. *Discours sur les sciences et les arts*. Paris, 1750.

Ruskin, John. *The Seven Lamps of Architecture*. London, 1849.

Ruskin, John and Dante Gabriel Rossetti. *Pre-Raphaelism Papers 1854–1862*. New York – London, 1899.

Russel, Frank (ed.). *Art Nouveau Architecture*. London, 1979.

Rykwert, Joseph. *Ornament ist kein Verbrechen*. Cologne, 1983.

Sailer, Anton. *Franz von Stuck – Ein Lebensmärchen*. Munich, 1969.

Saitschik, Robert. *Dichter und Denker*. Zürich, 1949.

Salles, G. S. *Adolphe Stoclet Collection*. Brussels, 1956.

Salten, Felix. *Geister der Zeit – Erlebnisse*. Vienna – Leipzig, 1924.

Schinkel, Karl Friedrich. *Aus Schinkels Nachlaß* (unpublished papers). Ed. by Alfred von Wolzogen, Berlin, 1862.

Schmalenbach, Fritz. *Jugendstil – Ein Beitrag zur Geschichte der Flächenkunst*. Dissertation, Münster, 1934.

Schmidt, Paul Ferdinand. *Festschrift zum 25jährigen Regierungsjubiläum seiner Königlichen Hoheit des Großherzogs Ernst Ludwig von Hessen und bei Rhein* [Silver Jubilee Festschrift for Grand Duke Ernst Ludwig of Hesse]. Leipzig, 1917.

Schmutzler, Robert. *Art Nouveau – Jugendstil*. Stuttgart, 1962.

Schneede, Uwe M. *Umberto Boccioni*. Stuttgart, 1994.

Schotten, Frits. *Brieven tussen Jan Eissenloeffel en A. J. M. Gondriaan 1918–1929*. The Hague, 1989.

Schröder, Rudolf Alexander. *Aus Kindheit und Jugend*. Munich, 1934.

Schweiger, Werner J. *Wiener Werkstätte – Design in Vienna 1903–1932*. London, 1984.

Sedlmayr, Hans. *Die Revolution der modernen Kunst*. Cologne, 1985.

Sekler, Eduard F. *Josef Hoffmann – Das architektonische Werk*. Salzburg – Vienna, 1982.

Seling, Helmut (ed.). *Jugendstil – Der Weg ins 20. Jahrhundert*. Foreword by Kurt Bauch. Heidelberg – Munich, 1959.

Selle, Gert. *Jugendstil und Kunst-Industrie – Zur Ökonomie und Ästhetik des Kunstgewerbes um 1900*. Ravensburg, 1974.

Selle, Gert. *Die Geschichte des Design in Deutschland von 1870 bis heute*. Cologne, 1978.

Sembach, Klaus-Jürgen: *Jugendstil*. Cologne, 1978.

Semper, Gottfried. *Vorläufige Bemerkungen*. N.p., 1834.

Semper, Gottfried. *Wissenschaft – Industrie – Kunst*. Mainz – Berlin, 1866.

Service, Alastair (ed.) *London 1900*. London, 1979.

Sherman, Paul. *Louis H. Sullivan – Ein amerikanischer Architekt und Denker*. Berlin – Frankfurt/Main, 1963.

Simon, Hans Ulrich: *Sezessionismus*. Stuttgart, 1976.

Simon, V. (ed.). *Eberhard von Bodenhausen und Harry Graf Kessler – Ein Briefwechsel (letters) 1894–1918*. Marbach, 1978.

Singelenberg, Pieter. *H. P. Berlage – Idea and Style*. Utrecht, 1972.

Smith, John B. *The Golden Age of Finnish Art*. Helsinki, 1985.

Spencer, Robin. *Aesthetic Movement*. London, 1972.

Spengler, Oswald. *Der Untergang des Abendlandes – Umrisse einer Morphologie der Weltgeschichte*. Ed. by Helmut Werner, Munich, 1959.

Stempel, Ute. Postface to German edition of Gabriele D'Annunzio: *Lust (Il piacere)*. Zürich, 1994.

Sternberger, Dolf. *Über den Jugendstil und andere Essays*. Hamburg, 1956.

Sterner, Gabriele. *Jugendstil – Kunstformen zwischen Individualismus und Massengesellschaft*. Cologne, 1975.

Sterner, Gabriele. *Barcelona – Antoní Gaudí y Cornet, Architektur als Ereignis*. Cologne, 1979.

Sterner, Gabriele. *Oscar Wilde – Salome*. Dortmund, 1979.

Sterner, Gabriele. *Zinn vom Mittelalter bis zur Gegenwart*. Munich, 1979.

Sterner, Gabriele. *Jugendstil-Graphik*. Cologne, 1980.

Sterner, Gabriele. *Der Jugendstil – Lebens- und Kunstformen um 1900, Künstler, Zentren, Programme*. Düsseldorf, 1985.

Störig, Hans Joachim. *Kleine Weltgeschichte der Philosophie*. 2 vols, Stuttgart, 1950.

Straaten, Evert van. *Theo van Doesburg*. The Hague, 1983.

Sullivan, Louis Henry. *A System of Architectural Ornament According with a Philosophy of Man's Power*. New York, 1924??

Sutton, Denys. *James McNeill Whistler – Gemälde, Aquarelle, Pastelle und Radierungen* [Paintings, watercolors, pastel drawings and etchings]. Cologne, 1975.

Tahara, Keiichi. *Jugendstil – Aufbruch zu einer neuen Architektur*. Dortmund, 1991.

Taylor, J. R. *The Art Nouveau Book in Britain*. London, 1966.

Thamer, J. *Zwischen Historismus und Jugendstil – Zur Ausstattung der Zeitschrift "Pan" 1895–1900*. Frankfurt/Main, 1980.

Thiis, Jens. *Gerhard Munthe*. Trondheim, 1904.

Tietze, Hans. *Gustav Klimts Persönlichkeit*. Vienna, 1919.

Torres Garcia, Joaquim. *Mestre Antoni Gaudí – Universalismo constructivo*. Montevideo, 1962.

Traeger, Jörg. *Philipp Otto Runge und sein Werk*. Munich, 1975.

Uecker, Wolf. *Lampen und Leuchter – Art Nouveau und Art Déco*. Herrsching (Bavaria), 1978.

Uhland, Ludwig. *Gesammelte Werke (collected works)*. Ed. by H. Fischer, 6 vols, Stuttgart, 1892.

Vandenbreeden, Jos and Françoise Dierkens-Aubry. *De 19de Eeuw in België*. Tielt, 1995.

Velde, Henry van de. *Kunstgewerbliche Laienpredigten* [Lay sermons for arts & crafts]. Leipzig – Berlin, 1902.

Velde, Henry van de. *Zum neuen Stil* [On the new style]. Selected writings chosen and introduced by Hans Curjel, Munich, 1955.

Velde, Henry van de. *Geschichte meines Lebens*. [Story of my life]. Edited by Hans Curjel, Munich, 1962.

Verlaine, Paul. *Confessions*. Paris, 1895.

Verneuil, M. P. *L'Animal dans la décoration*. Paris, 1898.

Viehoff, Horst. *Goethes Leben*. 4 vols, Stuttgart, 1847–54.

Viollet-le-Duc, Eugène. *Dictionnaire raisonné de l'architecture française*. Paris, 1854–69.

Vogue, Emile de. *Remarques sur l'exposition de 1889*. Paris, 1889.

Wagner, Otto. *Die Baukunst unserer Zeit – Dem Baukunstjünger ein Führer auf diesem Kunstgebiete*. Vienna, 1914.

Wais, Kurt. *Mallarmé*. Munich, 1938.

Waldschmidt, Wolfram. *Dante Gabriel Rossetti*. Jena – Leipzig, 1905.

Waters, Bill and Martin Harrison. *Burne-Jones*. London, 1973.

Weintraub, Stanley. *Aubrey Beardsley – Imp of the Perverse*. The Pennsylvania State University Press, 1976.

Weisser, M. *Handbuch bekannter und unbekannter Künstler aus der Zeit des Jugendstils*. Frankfurt/Main, 1980.

Weisser, M. *Im Stil der 'Jugend'* (about influence of Münchner Illustrierte Wochenschrift on art). Frankfurt/Main, 1980.

Wersin, Wolfgang. *Vom Adel der Form zum reinen Raum*. Vienna, 1962.

Wichmann, Siegfried. *Jugendstil*. Herrsching (Bavaria), 1978.

Windsor, Alan. *Peter Behrens – Architect and Designer 1868–1940*. London, 1981.

Wingler, Hans M. *Das Bauhaus*. Cologne – Bramsche, 1975.

Wit, W. de (ed.). *Louis Sullivan – The Function of Ornament*. St. Louis, 1986.

Wright, Frank Lloyd. *An American Architect*. New York, 1955.

Zacharias, Thomas. *Blick der Moderne*. Munich – Zürich, 1984.

Zeitler, Rudolf. *Skandinavische Kunst um 1900*. Leipzig, 1990.

Zeller, Bernhard. *Wende der Buchkunst*. N.p., n.d.

Zuckerkandl, Berta. *Zeitkunst Wien 1901–1907*. Vienna, 1908.

Zukowsky, John (ed.). *Chicago Architecture*. Munich, 1987.

Periodicals

Apollo, London
Arch+, Aachen
Architectural Record, New York – London, 1891–
Art et Décoration, Paris, 1897–
Berliner Architekturwelt, Berlin
Bulletin des Sociétés Artistiques de l'Est, Nancy
Darmstädter Tagblatt, Darmstadt
De Stijl, Leiden, 1917–1932
Dekorative Kunst, München, 1897–1929
Der Architekt, Wien, 1895–
Deutsche Kunst und Dekoration, Darmstadt, 1897–1934
Die Fackel, Vienna
Die Insel, Berlin, 1899–1901; Leipzig, 1902
Die Neue Gesellschaft, Berlin
Die Welt, Berlin
Die Woche, Berlin, 1899–
Die Zeit, Hamburg
Die Zukunft, N.p.
DU, Zürich
Echo de Paris, Paris
Figaro Littéraire, Paris
G. A. Document, Tokyo
Gazette des Beaux-Arts, Paris
Illustrierte Frauen-Zeitung, Berlin, 1874–1911
Innendekoration, Darmstadt, 1890–1945
Insel-Almanach, Berlin
Jugend, München, 1896–1940
Kunst und Künstler, N.p., 1902–
La Illustracistler, N.p., 1902–
La Libre Esthétique, Brussels, 1894–1914
Le Moniteur des Arts, Paris
Le Précurser, Paris
Mémoires de l'Académie de Stanislas, Nancy
Mir Iskustva, St. Petersburg, 1899–1904
Neue Rheinische Revue, London
Neue Rundschau, Frankfurt am Main
Neue Zürcher Zeitung, Zürich
Neues Wiener Journal, Vienna, 1893–
Neues Wiener Tagblatt, Vienna, 1866–
Pan, Berlin, 1895–1900
Revue Blanche, Paris, 1891–1903
Revue des Arts décoratifs, Paris, 1880–1902
Scandinavian Journal of Design History, Stockholm
Simplicissimus, Munich, 1896–1967
The Artist, London
The Chap Book, Chicago, 1894–98
The Dial, London, 1889–
The Hobby Horse, London, 1884–91
The Magazine of Art, London
The Savoy, London, 1896
The Studio, London, 1893–
The Yellow Book, London, 1894–97
Van Nu en Straks, Brussels and Antwerp, 1893–1901
Ver Sacrum, Vienna, 1898–1903
Wiener Allgemeine Zeitung, Vienna, 1879
Zeitschrift für bildende Kunst, Berlin

Exhibition catalogs (listed chronologically)

Exhibition of Artists' Colony, Darmstadt 1901. Darmstadt, 1901.

Exposition lorraine des arts du décor [Decorative arts of Lorraine]. Paris, 1903.

Cinquantenaire du Symbolisme [Golden Jubilee of Symbolism]. Paris, 1936.

München 1869–1958, Aufbruch zur Moderne [Emergence of Modern Art]. Munich, 1958.

Henry van de Velde. Zürich, 1958.

Art Nouveau – Art and Design at the Turn of the Century. New York, 1960.

Secession – Europäische Kunst um die Jahrhundertwende [*Fin-de-siècle* European art]. Munich, 1964.

L'Avanguardia – Jugendstil – Hans Schmithals. Milan, 1965.

Joseph Maria Olbrich 1867–1908. Darmstadt, 1967.

Charles Rennie Mackintosh 1868–1928, Architecture, Design and Painting. Edinburgh, 1968.

Art Nouveau in England und Schottland. Hagen, 1968.

Jugendstilsammlung Gerhard P. Woeckel [G. P. Woeckel's Art Nouveau collection]. Kassel, 1968.

Hermann Obrist – Wegbereiter der Moderne [Obrist – Forerunner of Modernity]. Munich, 1968.

L'Effort Moderne en Belgique 1890–1940 [Modernist endeavor in Belgium]. Brussels, 1969.

Jugendstilglas – Vorformen moderner Kunst [Art Nouveau glass]. Munich, 1969.

Jugendstil Illustration in München [Art Nouveau illustrations in Munich]. Munich, 1969.

Pankok, Riemerschmid, Paul – Interieurs Münchner Architekten [Interiors by Munich architects]. Munich, 1970.

Kina och Norden (China and The North). Stockholm – Munich, 1970.

Die verborgene Vernunft – Funktionale Gestaltung im 19. Jahrhundert [19th-century functional design]. Munich, 1971.

Loetz Austria – Irisierende Farbgläser des Jugendstils [Art Nouveau iridescent glass]. Munich, 1971.

Pionniers du XXe siècle [20th-century pioneers] – Guimard, Horta, van de Velde. Paris, 1971.

Finskt 1900 [Finnish Art 1900]. Stockholm, 1971.

Wiener Werkstätte. Graz, 1972.

Französische Keramik vom Ende des 19. Jahrhunderts [Hans-Jörgen Heuser Collection of *fin-de-siècle* French pottery]. Munich, 1972.

Hector Guimard – Architektur in Paris um 1900 [Guimard and architecture in Paris ca. 1900]. Munich, 1972.

Jugendstil aus Münchner Privatbesitz [Privately-owned Art Nouveau from Munich]. Munich, 1972.

Weltkulturen und moderne Kunst – Die Begegnung der europäischen Kunst und Musik im 19. und 20. Jahrhundert mit Asien, Afrika, Ozeanien, Afro- und Indo-Amerika [European art and its encounters with other cultures]. Munich, 1972.

Burne-Jones et l'influence des Préraphaelites. Paris, 1972.

Präraffaeliten [The Pre-Raphaelites]. Baden-Baden, 1973.

Horta. Brussels, 1973.

Bernhard Pankok 1872–1943. Stuttgart, 1973.

Hentrich Glass Collection – Jugendstil und 20er Jahre (Art Nouveau and the 1920s). Düsseldorf, 1973.

Finland 1900. Nuremberg, 1973.

World Expositions in the 19th Century. Munich, 1973.

100 Jahre Architektur in Chicago (100 Years of Architecture in Chicago). Munich, 1973.

Frida Hansen – Oeuvrefortegnelse og Biografisk. Oslo, 1973.

Futurismus 1909–1917. Düsseldorf, 1974.

Sir Edward Coley Burne-Jones – Studien, Zeichnungen und Bilder [Burne-Jones's studies, drawings and pictures]. Munich, 1974.

Liberty's 1875–1975. London, 1975.

Architektur in Paris um 1900 [Architecture in Paris ca. 1900]. Munich, 1975.

Morris & Co. Stanford, 1975.
Objekte des Jugendstils (Art Nouveau Articles). Zürich, 1975.
Symbolismus in Europa. Baden-Baden, 1976.
Grotesker Jugendstil (Grotesque Art Nouveau): Carl
 Strathmann 1866–1939. Bonn, 1976.
Die Lithographie. Bremen, 1976.
Japanese Influence on French Art 1854–1910. Cleveland,
 1976.
Ein Dokument Deutscher Kunst [German art] 1901–76.
 Darmstadt, 1976.
Kunstindustrimuseet i Oslo [Oslo Museum of Applied Arts].
 Oslo, 1976.
*August Endell – Der Architekt des Photoateliers Elvira
 1871–1925* [Endell and the Elvira Studio]. Munich, 1977.
Nancy Architecture 1900. Paris, 1977.
Henry van de Velde. Munich, 1977/78.
Simplicissimus (Munich-based satirical magazine
 Simplicissimus, 1896–1944). Munich, 1978.
Silber des Jugendstils (Art Nouveau silver). Munich, 1979.
Bestecke des Jugendstils (Art Nouveau cutlery). Solingen,
 1979.
Edvard Munch – Liebe, Angst, Tod. Bielefeld, 1980.
Worpswede – Eine Deutsche Künstlerkolonie um 1900
 (Worpswede Artists' Colony ca. 1900). Bremen, 1980.
Art Nouveau Belge (Belgian Art Nouveau). Brussels, 1980.
Alfons Mucha 1860–1939. Darmstadt, 1980.
Německá Secese (German Art Nouveau ca. 1900), Prague,
 1980.
Peter Behrens und Nürnberg. Nuremberg, 1980.
Nancy 1900 [Art Nouveau in Lorraine]. Munich – Mainz, 1980.
Ernesto Basile – Architetto [The architect E. Basile]. Venice,
 1980.
Das Wiener Kaffeehaus [Viennese cafés up to 1939]. Vienna,
 1980.
Museum Künstkerkolonie Darmstadt [Darmstadt Artists'
 Colony Museum]. Darmstadt, 1981.
Christopher Dresser – A Victorian Designer 1843–1904.
 Cologne, 1981.
Kunsthandwerk im Grassimuseum (Arts and Crafts in the
 Grassi Museum). Leipzig, 1981.
Daum – Verrerie d'Art [Daum Glass ca. 1900]. Munich, 1981.
Auf den künstlerischen Spuren Emile Gallés [Gallé's glass].
 Cologne, 1982.
René Lalique. Catalog of the Gulbenkian Collection. Lisbon,
 1982.
D'Aronco – Architetto [The Architect R. D'Aronco]. Milan,
 1982.
Franz von Stuck. Munich, 1982.
Adolf Loos. Munich, 1982.
*Richard Riemerschmid – From Art Nouveau to the
 Werkbund.* Munich, 1982.
Kandinsky in Munich 1896–1914. New York, 1982.
Scandinavian Modern Design 1880–1980. New York, 1982.
*"Ver Sacrum" – Viennese Art Nouveau periodical
 1898–1903.* Vienna, 1982/83.
Adolf Loos 1870–1933 [Loos's room design and
 housebuilding]. Berlin, 1983.
*Der Hang zum Gesamtkunstwerk – Europäische Utopien seit
 1800* [The search for a synthesis of the arts]. Zürich, 1983.
Josef Hoffmann, Wien [Hoffmann, Art Nouveau and the
 1920s]. Zürich, 1983.
*Saarinen in Finland – Gesellius, Lindgren, Saarinen
 1896–1907.* Helsinki, 1984.
Saarinen – Suomessa in Finland. Helsinki, 1984.
Le Arte a Vienna [The arts in Vienna]. Milan, 1984.
Aubrey Beardsley in the "Yellow Nineties", 1891–1898.
 Munich, 1984.
Jugendstil Floral Funktional [Art Nouveau, floral and
 functional]. Munich, 1984.
Kunst um 1900 [Art ca. 1900 – Painting, graphic arts, crafts,
 sculpture]. Gera, 1985.
Traum und Wirklichkeit [Dream and reality, Vienna
 1870–1930]. Vienna, 1985.

Emile Gallé. Paris, 1985/86.
Antoni Gaudí. Barcelona – Munich, 1986.
Hof-Atelier Elvira (Elvira Studio) 1887–1928. Munich, 1986.
Odilon Redon – Ian Woodner Collection. Munich, 1986.
Ian Woodner Collection. Munich, 1986.
Bernhard Pankok – Art Nouveau works. Münster, 1986.
Antell Collection – Ateneum Guide. Helsinki, 1987.
Licht des Nordens [Light of the North]. Düsseldorf, 1987.
Edvard Munch 1863–1944. Munich – Salzburg – Berlin, 1987.
*Toulouse-Lautrec – All the graphic works from the
 Gerstenberg Collection.* Munich, 1987.
Edvard Munch 1863–1944. Essen – Zürich, 1987/88.
Le Japonisme. Tokyo – Paris, 1988.
Walter Leistikow. Berlin, 1989.
Tsaarinajan Aarteet – 1000 Vuotta Venäläistä. Helsinki, 1989.
Die Meister des Münchner Jugendstils [Art Nouveau Artists
 of Munich]. Munich, 1989.
Franz von Stuck und seine Schüler [Stuck and his pupils].
 Munich, 1989.
Gerhard Munthe 1849–1929, Tapestries. Munich – Hamburg –
 Berlin, 1989.
Pariser Schmuck [Parisian jewelry]. Munich, 1989.
Secessionismus und Abstraktion – Austrian Art 1900–1930.
 Vienna, 1989.
*Franz von Stuck and the Munich Academy – From Kandinsky
 to Albers.* Bolzano, 1990.
Finnish Art 1900–1990. Munich, 1990.
Art Nouveau. Tokyo, 1990.
Fernand Khnopff 1858–1921. Tokyo, 1990.
El Modernismo. Barcelona, 1990/91.
The Age of van Gogh. Glasgow, 1990/91.
Mingei – The Living Tradition in Japanese Arts. Glasgow,
 1991.
Egon Schiele in the Leopold Wien Collection. Tokyo, 1991.
Henry van de Velde – A European Artist of His Time. Hagen,
 1992.
Japanese Color Woodcuts from Three Centuries. Munich,
 1992/93.
Mingei – Anonymous Craftwork in the Japanese Tradition.
 Munich, 1992/93.
Felix Vallotton – A Retrospective. Lausanne, 1993.
1893 – l'Europe des peintres [Painters' Europe]. Paris, 1993.
Schwarz-Gold – Bronzite Work by J. & L. Lobmeyr, Vienna.
 Vienna, 1993.
Il disegno del nostro secolo [20th-century design]. Milan,
 1994.
*Torino 1902 – Le Arti Decorative Internazionali del Nuovo
 Secolo* [Turin Exposition 1902]. Turin, 1994.
*Ludwig von Hofmann – Drawings, Pastels and Printed
 Graphics.* Albstadt, 1995.
*Autriche, Suède et Finlande – les nouvelles frontières du
 verre européen* [Glass from Austria, Sweden and Finland].
 Luxembourg, 1995.
Boccioni 1912 – Materia. Milan, 1995.
Loïe Fuller – Getanzter Jugendstil [Art Nouveau in dance].
 Munich, 1995.
Georges de Feure. Saint-Germain-en-Laye, 1995.
Symbolism in Europe ca. 1900. Toronto, 1995.
Bauhaus Museum – Art Collections in Weimar. Weimar,
 1995.

Acknowledgments

The present publication would not have been possible
without the support and cooperation of numerous
institutions, museums, libraries, and archives in many
countries. My thanks go to all of them. For the cordial
assistance of private collectors, especially Diana and Dr. Paul
Tauchner of Munich, I owe a profound debt of gratitude. I
should also like to express my deep esteem for the editor of
this book, Christine Westphal of Cologne, who was always
forthcoming with encouragement and, if necessary, critical
advice. Her contribution to the success of my work was
indispensable.

Picture credits

m = middle, l = left, r = right, t = top, b = bottom

AEG, company archives, Frankfurt/Main 270, 272, 273 l, 273 tr, 273 br
© Foto Agence photographique de la réunion des musées nationaux (RMN), Paris 13, 29 r, 32 r, 70, 81, 102, 112, 118, 126, 180 tl, 180 tr, 196 b
Arcaid 64 (photo by Mark Fiennes), 65 (photo by Mark Fiennes), 326 (photo by Alan Weintraub), 327 t (photo by Thomas A. Heinz), 333 (photo by Alan Weintraub)
Albertina, Vienna (Graphische Sammlung) 356
Arabia Museum, Helsinki 293 t
Architekturmuseet (Architecture Museum), Stockholm 309 bl
Archiv Vereinigte Werkstätte, Amira AG, Munich 230 tr
Archive d'Architecture Moderne, Brussels 140 r, 147 b
Archivio fotografico dei Civici Musei d'Udine 180 b
© Artifice, Inc./ GreatBuildings.com 328/329
ArtonFile, Inc©, Seattle (Washington) 330
Artothek Spezialarchiv für Gemäldefotografie, Peissenberg 18 r, 19 (photo by Joachim Blauel), 22 l, 44/5, 90 l, 132, 338, 342/3, 376
Ateneum, Helsinki and the Central Art Archives collection 290 b, 291 b, 292, 293
Author 53, 56, 106, 121 r, 121 l, 214 r, 214 b, 221 tl, 228 tl, 231 br, 257 b, 261 b, 324, 350, 367 l, 370 br, 371 tr, 371 tc, 371 tr, 371 bl
Badisches Landesmuseum Karlsruhe, Museum beim Markt (Applied Art Since 1900 section) 37 t, 37 b, 166 r, 258 l, 304 b, 305 r, 307 tl, 307 tr, 320 r
Bangert, Dr Albrecht 114 r, 203 l
Bastin & Evrard, Brussels 20, 131, 134, 136 r, 137/138, 139, 140 b, 141 t, 142, 143 b, 144 tl, 144 tr, 145 l, 145 t, 145 bl, 145 br, 146 © De Ultième Hallucinatie, Brussels, 147 t, 149, 150 l, 151 l, 152 t, 157 t, 157 bl, 157 br, 161, 170 l, 188 r, 194, 200 l, 206, 278 r, 279, 281 (photo by Toma Babovici), 340, 341 l, 349 b, 375
Bauhaus Museum, Kunstsammlungen zu Weimar, Weimar 274 (photo by Dressler), 278 bl
Bavarian National Museum, Munich 101
Beer, Günter 197, 200 t, 201, 204, 205, 206, 207 t, 208
Bildarchiv Preussischer Kulturbesitz, State Museums, Berlin 259 (photo by Jürgen Liepe)
British Museum, London 33
Bröhan Museum, Provincial Museum for Art Nouveau, Art Deco and Functionalism (1889–1939), Berlin 159 (photo by Martin Adam), 229 t (photo by Hans Joachim Bartsch)
Bröhan Collection/Sammlung Torsten Bröhan, Düsseldorf 368
Cornacchi, Roberto 185
Danske Kunstindustrimuseum, Copenhagen 309 tl, 309 tm
DU, Vol. 26, No. 6, 1966, Zürich 115 l (photo by Franco Cianetti)
Dumont Archiv, Cologne 35 l, 49 tl
Frahm, Klaus, Hamburg 267/277
Franke, Roman, Munich 249
Galerie Peichert 129 (photo by Siegfried Layda)
Gallen-Kallela Museum, Espoo 282, 290 t, 291 t
Gastinger, Mario, Munich 6, 16 r, 17 l, 17 r, 18 l, 24, 26 l, 26 r, 35 r, 46, 49 tr, 49 br, 51, 52, 84 r, 87 r, 87 b, 89, 91 r, 92 l, 93 l, 98 l, 99 tl, 99 bl, 100 l, 100 r, 108, 109, 111, 113 l, 113 r, 116 l, 123 l, 123 tr, 123 br, 124/125, 127 l, 135 l, 168 r, 187 b, 191 l, 193, 195, 202, 215, 217 br, 218 r, 226, 227, 228 bl, 229 b, 231 tlm, 231 tr, 233, 236 l, 239, 250 r, 254, 255, 256, 258 r, 260, 261 l, 261 tr, 263 r, 268, 304 l, 320 l, 322, 323, 334, 337, 339, 353, 354 tl, 365, 367 tr, 369 b, 370 l, 373
Gnamm, Sophie Renate, Munich 9 b, 98 tr, 213, 223, 230 bl, 248 l, 248 t, 265 t, 275 tl, 305 l, 306 b
Grassimuseum, Leipzig 88 l (photo by Matthias Hildebrand)
Haags Gemeentemuseum (Municipal Museum), The Hague

166 l, 169, 170 b, 171, 174 tl, 175 b
Hartz, Jacques, Hamburg 25, 43 r, 122, 266 r, 306 r
Hiraki-Ukiyo-e Museum, Yokohama 11, 12, 15 r
Historisches Museum, Vienna 359
Iparművészeti Múzeum (Applied Arts Museum), Budapest 47 l
Jaulmes, Laurent Sully, Paris 71, 75, 78/79, 105
Joseph Urban Archives, Rare Book and Manuscript Library, Columbia University, New York 379
Kargl, Georg, Vienna 366 t
Koch, Alexander Exhibition of Darmstadt Artists' Colony 241 r
Kröller-Müller Museum, Otterlo 157 l, 165
Kunstgewerbemuseum (Arts and Crafts Museum), Dresden 267 r (photo by H.-P. Klut, SKD)
Kunstindustrimuseet (Applied Arts Museum), Oslo 283 (photo by Teigens Fotoatelier, Oslo), 289 tr (photo by Teigens Fotoatelier, Oslo)
Kunstmuseum im Ehrenhof, Düsseldorf 263 l, 321
Lindo and A. Grassi, Maestri Vetrai, Milan 188 l
Louis C. Tiffany Museum, Nagoya 316
Mathildenhöhe Institute, Museum Künstlerkolonie Darmstadt 234, 237, 238 r, 240 tl, 240 bl, 240 tc, 240 c, 240 br, 241 l, 242, 243, 245 r, 245 c, 251, 253
Mingeikam – Japanese Folk Crafts Museum, Tokyo 9 r, 10 tl, 10 bl, 10 t, 11
Ministero per i Beni Culturali e Ambientali, Verona 187 t
Münchner Stadtmuseum (City Museum), Munich 217 tl, 217 t, 219 220 (photo by Wolfgang Pulfer), 221 bl, 230 br (photo by Wolfgang Pulfer)
Munch Museum, Oslo 278 tl, 285
Musée d'Archéologie et d'Arts décoratifs, Liège 152 b
Musée de l'École de Nancy, Nancy 110, 116 t (photo by Lucien Weissemburger), 120 (photo by Claude Phillipot)
Musée des Arts Décoratifs, Paris (photos by L. Sully Jaulmes) 74 l, 80, 85, 87 l, 94 l, 98 b, 99 r
Musée d'Ixelles, Brussels 135 r
Musée d'Orsay, Paris 23 t (photo by H. Lewandowski), 32 r, 73 r, 119 l, 127 b (photo by R.-G. Ojeda)
Musée du Château, Boulogne-sur-Mer 115 r
Musée Horta, Brussels 144 b
Musée National de l'Automobile, Schlumpf Collection, Mulhouse 182
Musées Royaux d'Arts et d'Histoire, Brussels 153
Museo delle Porcellane di Doccia Fiorentino 178
Museum Bellerive, Zürich (photos by Marlen Perez) 84 l, 156 l
Museum für Kunst u. Gewerbe, Hamburg 244, 286/287 (photo by Kiemer & Kiemer)
Museum Villa Stuck, Munich 221 br, 222
Museum voor Sierkunst (Decorative Arts Museum), Ghent 156 l
NAi Nederlands Architectuur Instituut, Rotterdam 175 t
Nasjonalgalleriet (National Gallery), Oslo 284
National Swedish Art Museum, Statens Kunstmuseer, Stockholm 311
Nordenfjeldske Kunstindustrimuseum, Trondheim 288
Norsk Folkemuseum, Oslo 289 br (photo by Teigens Fotoatelier, Oslo)
Oliver, Anthony, London 57
Parisini, Dr., Vienna 369 t
Philipps, Son & Neale, London 16 l, 69
Philipps-Universität, Forschungsinstitut für Kunstgeschichte (Bildarchiv Foto Marburg), Marburg endpaper, 133, 141 b, 216, 231 bl, 312, 374, 377
Pulfer, Wolfgang, Munich 42 l, 228 tr
R. C. S. Libri & Grande Opere SpA, Milan 47 r, 130
Rheingauer Verlagsgesellschaft mbH, Eltville 212
Richards, Louanne, London 23 r, 228 br, 230 ml, 238 l, 242 m, 245 l, 262, 265 m, 265 b
Rijksdienst Beeldende Kunst, The Hague 163, 167 t, 168 l (photo by RBK The Hague Tim Koster)
Robinson, Cervin, New York 325
Royal Academy of Fine Arts (Library), Architectural Drawings

Collection, Stockholm 309 tr
Royal Photographic Society, Bath 380
Rühl & Borman, Werbefotografie 246/247
Rupertinum, Salzburger Landessammlungen, Salzburg 372 l
Santi Caleca SAS di Santi Caleca, Milan 186
Schlossmuseum, Darmstadt 236 t
Schlossmuseum, Kunstsammlungen zu Weimar, Weimar 224 (photo by Dressler)
Shinkenchiku-Sha, Dept. of Photography, Tokyo 327 b
Smålands Museum, Växjö 307 bl
Sotheby's, Amsterdam 162, 164, 174 tr, 174 r
Sotheby's, London 7, 8, 21 l, 27, 28, 29 l, 30, 32 l, 38, 39 t, 39 b, 40 l, 41, 42 tr, 42 br, 43 l, 54, 58 l, 59 t, 59 l, 60 l, 60 r, 61, 62, 63 l, 63 r, 66 l, 66 b, 67, 77, 82/83, 86, 90 l, 91 l, 93 r, 94 r, 95 r, 107, 114 l, 177, 181, 183, 203 r, 235, 264, 265 r, 271, 275 bl, 309 l, 313, 317 t, 317 b, 318 l, 318 b, 319, 335, 336, 341 r, 349, 351 l, 352, 354 tl, 354 bl, 354 tr, 357, 360, 361, 362, 363, 364 t, 366 bl, 367 r, 372 r
Sotheby's, Monaco 60 r, 60 l, 62, 88 r, 92 r, 95 l, 107, 148, 154/155, 156 b, 266 l, 308, 345 l, 345 b
Sotheby's, New York 127 r, 315, 331
Sotheby's, Rome 184 t, 184 b
Staatliche Graphische Sammlung, Munich 225
Staatliches Museum für angewandte Kunst (Neue Sammlung), Munich 21 tr (photo by Mario Gastinger), 74 r (photo by Mario Gastinger), 158 (photo by Mario Gastinger), 171 (photo by Mario Gastinger), 218 l, 269 (photo by Sophie Renate Gnamm), 351 r
Studio Chevojon, Paris 73 l
Suomen rakennustaiteen museo, Helsinki 294, 295, 297 r, 298 l, 299, 300, 301 l, 301 r, 302, 303 b
Tahara, Keiichi 55, 96, 117, 172/173, 189, 190, 198, 199, 207 b, 346/7, 349 b, 355
Taideteollisuusmuseo, Helsinki 191 l (photo by Rauno Träskelin), 293 b, 298 l
Tate Gallery, London 22 b, 48
The J.Paul Getty Museum, Los Angeles 14/15
Ulmer Museum (loaned by Ministry for Family, Women, Further Education and Art, Badem-Württemberg), Ulm 211 (photo by Mario Gastinger)
Ver Sacrum, Vol. 1. No. 9, 1898, Vienna 3
Victoria & Albert Museum, London 36
© Viollet, Roger, Paris 72, 76 t, 76 l, 83 t, 97, 167 b, 296, 297 l
Verlag Josef Hannesschläger, Neusäss 314 (photo by Siegfried Layda)
Viennese Glass Museum, Lobmeyr Collection 16 t, 364 l, 370 l
Whitworth Art Gallery, University of Manchester 34
Wiesenhofer, Hans, Vienna 348 l
Wipperfürth, Olaf, Paris 2
Wood, Charlotte, London 31

Index